Between 1956 and 1968 the rise of Pop radically shifted the boundaries between popular culture, the vernacular, the everyday, on one hand and the established aesthetic limits of art, photography, cinema and architecture on the other. Pop – neither a movement nor a single group of artists, nor a style, was defined by the British artist Richard Hamilton in 1957 not in terms of the art to which it would give rise but as a description of the characteristics of mass culture that were to become of such enduring interest to visual creators over the next decade: comic strips, industrially designed products, advertisements, magazines, movies and their iconic stars. This book surveys the Pop image as it developed in the work of the most influential artists of the era and those photographers, filmmakers and architects who created parallel transformations in their fields. Providing coverage of American and European work and perspectives, this is the most wide-ranging survey of Pop available.

W9-BTE-827

THEMES AND MOVEMENTS

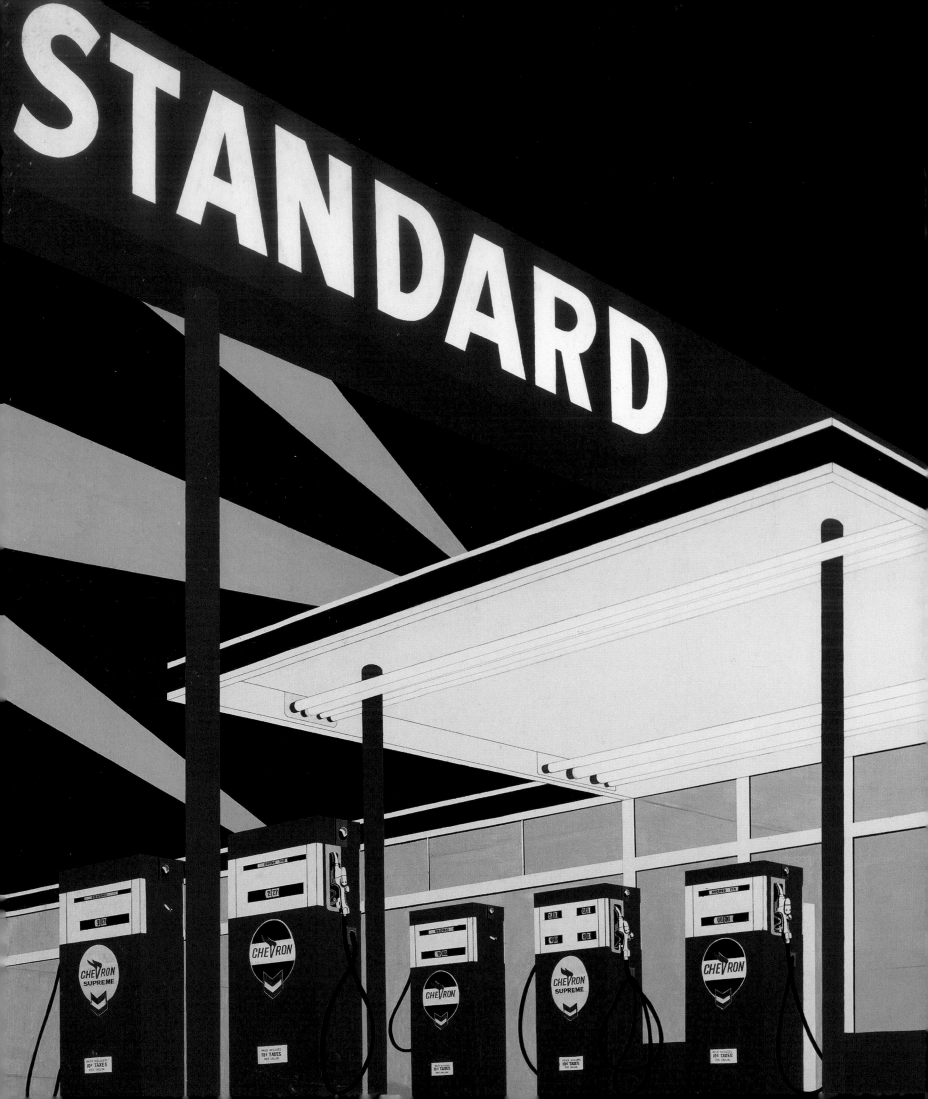

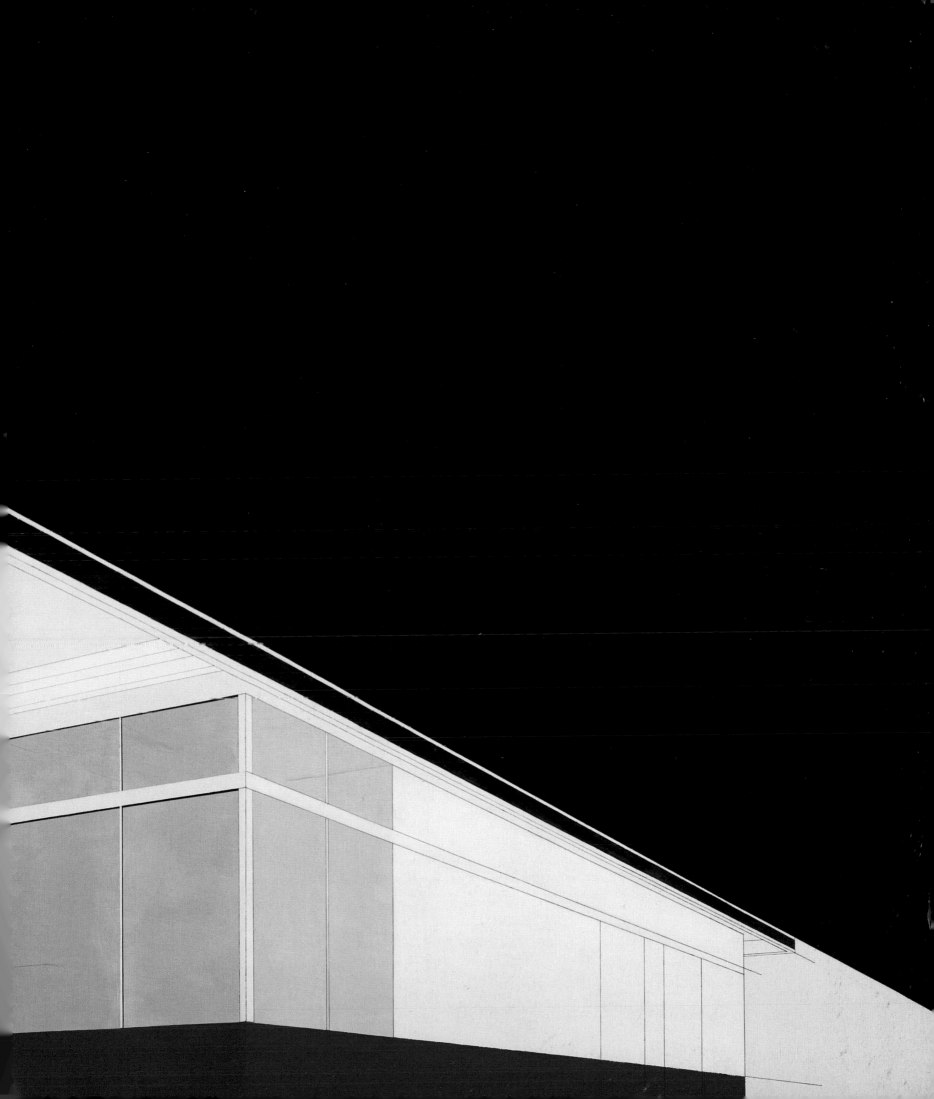

Phaidon Press Limited
Regent's Wharf
All Saints Street
London N1 9PA

Phaidon Press Inc.
180 Varick Street
New York, NY 10014

www.phaidon.com

First published 2005
© 2005 Phaidon Press Limited
All works © the artists or the estates
of the artists unless otherwise stated.

ISBN 0 7148 4363 6

A CIP catalogue record of this book is
available from the British Library.

Designed by Hoop Design

Printed in Hong Kong

cover, Ray Johnson
James Dean
1957 (detail)

inside flap, Sigmar Polke
Bunnies
1966 (detail)

pages 2–3, Ed Ruscha
Standard Station, Amarillo, Texas
1963

page 4, Claes Oldenburg carrying Giant
Toothpaste Tube, London 1966
Photograph by Hans Hammarsköld

back cover and spine, Andy Warhol
Blue Liz as Cleopatra
1962 (detail)

EDITED BY MARK FRANCIS
SURVEY BY HAL FOSTER

POP

WORKS page 42

REVOLT INTO STYLE page 43

CONSUMER CULTURE page 68

COLONIZATION OF THE MIND page 118

SPECTACULAR TIME page 160

HELTER SKELTER page 180

DOCUMENTS page 190

REVOLT INTO STYLE page 193

CONSUMER CULTURE page 211

COLONIZATION OF THE MIND page 246

SPECTACULAR TIME page 272

HELTER SKELTER page 279

PRE-
FACE

BY MARK FRANCIS

'It was drizzling and mysterious at the start of our journey. I could see that it was going to be one big saga of the mist. "Whooee!" yelled Dean. "Here we go!" And he hunched over the wheel and gunned her; he was back in his element, everybody could see that. We were all delighted, we all realized we were leaving confusion and nonsense behind and performing our one and only function of the time, move. And we moved!'

Jack KEROUAC, *On the Road*, 1957

'At worst, one is in motion; and at best,
Reaching no absolute, in which to rest,
One is always nearer by not keeping still.'

Thom GUNN, *On the Move*, 1957

'*Ce n'est pas une image juste, c'est juste une image.*' ('This is not a just image, it's just an image.')

Jean-Luc GODARD, *Vent d'est*, 1970

'Pop is for everyone,' said Andy Warhol in 1967. At once derided and celebrated from the moment of its appearance as the most ephemeral and insignificant of cultural phenomena, Pop has never gone away. This is at the heart of its paradox. Fifty years later, the supposedly fleeting spectacle of Pop is omnipresent and of global dimension. The artists who define Pop have genuinely entered a popular consciousness that transcends the traditional audiences for art, film or music. Nowadays museums, critics and historians can no longer be merely fastidious guardians of an elite culture, founded to protect the status quo from the depravations of kitsch, the vernacular and the popular, but are themselves a constituent part of the culture industry. We can now recognize that the classic period of Pop from 1956 to 1968 is the culmination and apotheosis of the modern period that Manet and Baudelaire, themselves habitués of a nineteenth-century Paris of bars, café-concerts and the life of the streets, were the first to identify and to represent.

Pop was not a movement or a single group of artists, or a style; nor is it confined to a historical moment, though it flourished in certain historical and social circumstances. Its earliest definition, in a letter by Richard Hamilton in 1957, actually describes not the art that would be produced in the name of Pop, but the salient characteristics of modern popular culture itself, the ads, comics, movies and objects which were of such fascination to artists. Pop has a subject — the epic and the quotidian, the real and the surreal — and it has an attitude to this material, an art of attention to the world at hand, in particular to the apparently trivial, insignificant or overlooked. This is then treated in a relatively uninflected manner so that the resulting work is capable of sustaining complex, even contradictory, readings. Even apparently simple

enlargement could 'make strange' a motif, as the Pop artists learned from signs and billboards.

In art the antecedents of Pop were largely European. After Manet's and Degas' exploration of modern urban and suburban life, Eugène Atget's photographs of shop windows and melancholy streets were important to the Dadaists and Surrealists, and to the American photographer Walker Evans. Marcel Duchamp's readymades, René Magritte's disquieting suburban banalities, and Salvador Dalí's extravagant and meticulous paintings of repressed sexuality had a delayed but potent impact in post-war America. In different ways, the graphics of El Lissitzky and the collages of John Heartfield and Kurt Schwitters were Pop *avant la lettre* and were important for the cumulative 'pinboard' aesthetic used by Nigel Henderson, Bruce Conner, Richard Hamilton, and later in Gerhard Richter's *Atlas*. Comics such as *Krazy Kat* by George Herriman, and later Marvel Comics artists such as Jack Kirby and Stan Lee, had both cult and popular audiences. Automobile stylists such as Harley Earl, and customizers like Ed 'Big Daddy' Roth were recognized early as tastemakers in a field in which taste had initially mainly signified class. The animated cartoons of Walt Disney, Chuck Jones and others were admired by artists for their wit and precision. Hollywood was an endless source of beauty and glamour, comedy, camp and Babylonian excess. Elvis Presley's illicit hybrid of white country music and black rhythm and blues, created in Sam Phillips' Sun studios in Memphis from 1954, formed a myth of origin for rock 'n' roll, though Harry Smith's edited 1952 'Anthology of American Folk Music' was a Joycean epic of compilation and juxtaposition which had a formative effect on Robert Frank, Bob Dylan and many other musicians and artists of the 1960s. Dylan himself cites Robert Johnson, Woody Guthrie, the poems of Rimbaud and Brecht's *Pirate Jenny* as the key revelations of his early years, and it is perhaps this combination that gives both a flavour of Pop's cultural richness and depth, and a resolution of its American and European creative sources.

The pinboard or collage was a defining technique of Pop, and the principle of an anthology (such as this) can to a limited extent respect these juxtapositions. The technique was common to art, film and music, and it enabled artists to encompass feelings of nostalgia or ironic distanciation which distinguished Pop from the earlier collages of Dada and the Surrealists. Also common to a great deal of Pop is a recognition of the epiphanic, where banality is at the source of the most vital instances, and the most sublime, such as Richard Hamilton's *Epiphany* of 1964, where a tiny badge reading 'Slip it to me', picked up in Pacific Ocean Park (POP), is enlarged to become a monumental heraldic form, yet retains the lightness of songs by the Drifters or the Beach Boys. There is nothing heavy about the profundity of Pop.

Pop art was intricately linked to other fields, and each fed off the vitality of the other. The Independent Group brought together artists, architects and critics, while Andy Warhol was consecutively a fashion illustrator, painter, sculptor, film maker, producer of the Velvet Underground, magazine publisher, philosopher, historian, diarist, model, photographer and archivist of his times. Photography and film were essential media for many artists, and within film itself, one could consider four genres to be variants on Pop, even if at the same time they were more than that. Hollywood productions created stars such as Marilyn Monroe, who became without doubt the greatest icon of Pop. New Wave European films by Godard, Antonioni, Cammell and Roeg, Pasolini and others, treat modern urban life in the manner of artists. Documentary

films such as D.A. Pennebaker's *Don't Look Back* and *Monterey Pop* undermined traditional barriers between performers and audiences, and are valuable as records of otherwise poorly documented events (Andy Warhol's crucial but ephemeral *Gesamtkunstwerk* that was the 'Exploding Plastic Inevitable' with the Velvet Underground in 1966 survives only in a few photos by Billy Name and a short film by Ronald Nameth). Finally, experimental films by Warhol, Anger, Conner and others used or discarded techniques of montage and editing in ways that were fundamental to Pop, and much later to music television also.

To re-examine Pop at a distance of fifty years it is clear that certain images and themes are pervasive throughout the period: the cars, the movies, the freeways and motels, neon signs and tattoos, the social spaces of the city and the open space of the road, all recur obsessively, and connect the art to wider traditions. Pop was not a set of monolithic assumptions. The mystery, strangeness and innocence in the writing of Jack Kerouac and the early photographs of Robert Frank is replaced by the corrosive humour and violence of Godard's *Weekend* where the road trip ends in destruction and mayhem. But such a productive and provocative period can still only be defined or mapped partially. This book does not encompass Pop work that emerged in Spain, Brazil, Japan and elsewhere. Certain figures are nevertheless indisputably linked to the term, even as they all transcended the limitations of definition in their later work: Andy Warhol, whose films and paintings created a new and simple idea of beauty; Richard Hamilton, whose visionary images were fundamental to each shift from *Just what is it…?* in 1956 to the Beatles' 'White Album' and *Swingeing London* in 1968; Jean-Luc Godard, who moved from an image of Jean Seberg in a white T-shirt in *À bout de souffle* (*Breathless*, 1960) to the Rolling Stones interminably rehearsing 'Sympathy for the Devil' in *One plus One* (1968); and finally Bob Dylan, the lyric and tragic poet of his generation, still condemned, forty years later, to haunt the highways and motels of the world as if he was the central figure of his own odyssey.

SUR-
BY HAL FOSTER
VEY

Pop Art is: Popular (designed for a mass audience)·Transient (short-term solution)· Expendable (easily-forgotten)·Low cost· Mass produced·Young (aimed at youth)·Witty ·Sexy·Gimmicky· Glamorous·Big business·This is just the beginning ...

Richard HAMILTON Letter to Alison and Peter Smithson, 16 January 1957

In the beginning Pop art was an Anglo-American affair that thrived in the latitudes of London, New York and Los Angeles, the primary capitals of the consumer society that developed in the West after World War II. Originally 'Pop' referred to this popular culture at large, not to any particular style of art. The term was first used in this general sense in the early 1950s by the Independent Group (I.G.) in London, a motley milieu of young artists, architects and critics (chiefly Lawrence Alloway, Reyner Banham, Toni del Renzio, Richard Hamilton, Nigel Henderson, John McHale, Eduardo Paolozzi, Alison and Peter Smithson and William Turnbull), who explored the implications of popular culture as a dissident movement within the Institute of Contemporary Arts, which was

otherwise focused on the legacies of pre-war modernisms. Only in the later 1950s and early 1960s did 'Pop' begin to signify a style of art that drew on popular imagery from comics, advertisements and the like. It was applied in this specific manner first to former I.G. artists such as Hamilton and Paolozzi and then to a subsequent generation of British artists trained mostly at the Royal College of Art (primarily Peter Blake, Derek Boshier, Pauline Boty, Patrick Caulfield, David Hockney, Allen Jones, R.B. Kitaj, Richard Smith and Joe Tilson) and of American artists based mostly in New York (chiefly Allan D'Arcangelo, Jim Dine, Robert Indiana, Roy Lichtenstein, Claes Oldenburg, Mel Ramos, James Rosenquist, Andy Warhol, John Wesley and Tom Wesselmann). Other figures sometimes associated with the style emerged at this time in France (e.g., Arman, Alain Jacquet, Martial Raysse, Daniel Spoerri) and a little later in Los Angeles (e.g., Billy Al Bengston, Joe Goode, Ed Ruscha) and in Germany (e.g., Gerhard Richter, Sigmar Polke).[1] However, these artists often diverged from the first two waves of Pop artists, especially from their mostly affirmative posture vis-à-vis consumer society.[2]

The contexts of Pop art were different enough in the United Kingdom and the United States alone. In the early 1950s

Britain remained in a state of economic austerity that made the brash world of American consumerism appear seductive and exotic and I.G. artists treated its images accordingly, that is, as so much cult cargo. For the American artists who emerged ten years later, this consumerist landscape had become almost second nature and they often treated it dispassionately ('the death of affect' is an important topic in Pop art). This difference in perspective underwrote others. The Brits were attracted to new commodities as harbingers of the future, while the Americans sometimes represented products that were slightly dated, already touched by nostalgia. And while both groups were trained in art schools, several Americans also worked as commercial artists: Warhol was an acclaimed illustrator, Rosenquist a billboard painter, Ruscha a graphic designer and so on – and they seemed to transfer such techniques to their art rather directly. As might be expected, then, Warhol and company faced some resistance from an art world dedicated to the lofty principles of Abstract Expressionism and yet the opposition encountered by I.G. artists

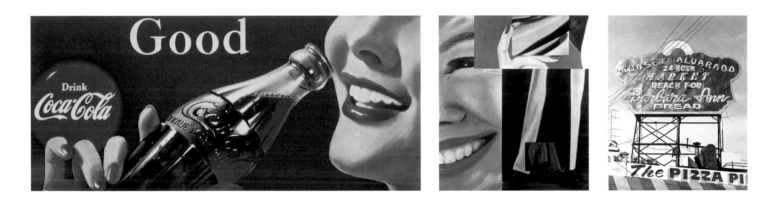

Coca-Cola Advertisement, USA, 1945
James ROSENQUIST Look Alive [Blue Feet, Look Alive], 1961
Ed RUSCHA Sunset Alvarado, Market Sign [Corner of Sunset and Alvarado Looking West], 1961

was deeper still. For British Pop was a 'long front' in a general war between new and old cultures, while American Pop was already at home, so to speak, in the commercial look of the land, if not in the restricted discourse of the art world.[3] (The Los Angeles evoked by Ruscha, for example, appears as if it were always already Pop.)

Yet what unites the different strands of Pop art might be found right here as well: in a common recognition that consumerism had changed the appearance of the world, perhaps even the nature of appearance, and that art must draw on new contents and develop new forms accordingly. (Ironically, this imperative came at a moment when abstract art had won general acceptance for the first time – another point of resentment for some artists and critics opposed to Pop.) Semblance as such appeared to be *mediated* and Pop found its primary subject in this new look of the world, in an iconic visibility that appeared to transform select people and products into so many personalities with special powers. The consumerist superficiality of images and seriality of objects also

affected the mediums of painting and sculpture structurally and Pop registers these alterations as well. For instance, much Pop painting manifests an utter conflation of the painterly and photographic, the handmade and the ready-made, in which the modernist opposition of abstraction and figuration is also greatly complicated. For all its visual immediacy, the typical Pop image is usually produced through various transfers of images and mediums (usually from magazines, comics or news photos to painting, collage or assemblage) that involves still other techniques (such as projectors and silkscreens) in a complex layering of different sources, formats and effects. Juxtaposition remains central, but the Pop image rarely possesses the material hetero-geneity of a Dadaist collage (e.g., a Kurt Schwitters) or a Neo-Dadaist assemblage (e.g., a Robert Rauschenberg). Often in Pop art collage is rendered photographic, painterly or both at once: a diversity of image might be maintained, but usually within a consistency of surface.

under the changed conditions of a 'Second Machine Age' in which 'imageability' becomes the principal criterion.[4] And near the end of the period, the designers Robert Venturi and Denise Scott Brown, who were influenced by Pop art, advocated a postmodern architecture that returned this imageability to the built environment from which it arose.[5] In effect Pop exists in the interval between those two moments – between the decline of modern art and architecture on the one hand and the rise of postmodern art and architecture on the other. Distinctive in its own right, Pop is thus also a crux between two great epochs of twentieth-century culture.[6]

Reyner Banham, the Independent Group and Pop Design

In November 1956 the I.G. architects Alison and Peter Smithson published an essay that included a little poem of early Pop: '[Walter] Gropius wrote a book on grain silos, Le Corbusier one on aeroplanes and Charlotte Perriand brought a new object to the office every morning; but today

Installation view, Group 2 [Richard Hamilton, John McHale, John Voelcker], 'This is Tomorrow' [reconstruction, 'The Independent Group: Postwar Britain and the Aesthetics of Plenty', 1990]
Installation view, Group 2 [Richard Hamilton, John McHale, John Voelcker], 'This is Tomorrow', Whitechapel Art Gallery, London, 9 August – 9 September 1956
MGM poster for Forbidden Planet, 1956

The greatest achievement of Pop art lies in its various transformations of the pictorial image under the pressure of socio-economic changes at large. Here, then, I will focus on a few models of the Pop image developed by key artists from the early 1950s to the early 1970s. Such a view comes with its own costs, such as a scanting of some painters (e.g., Blake, Hockney, Rosenquist, Wesselmann) and a bracketing of all object-makers (e.g., Arman, Dine, Oldenburg, Spoerri); but the gain in concentration may compensate a little for the loss in coverage (certainly such figures are represented elsewhere in the book). What I propose is a partial typology of the Pop image, not a comprehensive history of Pop art as such. My discussion is also framed with brief remarks on design, since Pop emerges in a new space of cultural presentation entailed by a new mode of economic produc-tion. Near the beginning of the period, the I.G. ringleader Reyner Banham imagined a Pop architecture as a radical updating of the modern design of the 'First Machine Age'

we collect ads.' The point here is more polemical than historical (Gropius, Le Corbusier and Perriand were also media-savvy). The Smithsons want to mark a difference, to open up a space: *they*, the old protagonists of modernist design, were cued by functional things, while *we*, the new celebrants of Pop culture, look to 'the throw-away object and the pop-package' for inspiration. This is done partly in delight, the Smithsons suggest, and partly in desperation: 'Today we are being edged out of our traditional role [as form-givers] by the new phenomenon of the popular arts – advertising … We must somehow get the measure of this intervention if we are to match its powerful and exciting impulses with our own.'[7]

This was one battle cry of the Independent Group, which formed as an informal laboratory dedicated to cultural research through private seminars and public exhibitions. The seminars focused on the effects of science, technology and media, while the exhibitions consisted of collaborative displays of often found images and objects, where the ideas

developed in the seminars were put into practice. The crucial I.G. shows were 'Parallel of Life and Art', directed by Paolozzi, the Smithsons and Henderson in 1953; 'Man, Machine and Motion', produced by Hamilton in 1955; and, most famously, 'This is Tomorrow', which grouped artists, architects and designers in twelve teams in 1956. By this time the I.G. had more or less dissolved in order that its members might develop their work individually. In January 1957, two months after the Smithsons published 'But Today We Collect Ads', Hamilton responded with a letter that summed up the concerns of the I.G.: 'technological imagery' (as explored in 'Man, Machine and Motion'), 'automobile styling' (as stressed by Banham), 'ad images' (as investigated by Paolozzi, McHale and the Smithsons), 'Pop attitudes in industrial design' (as exemplified by the *House of the Future* proposed by the Smithsons in 1956) and 'the Pop Art/ Technology background' (the entire I.G., especially in 'This is Tomorrow').[8]

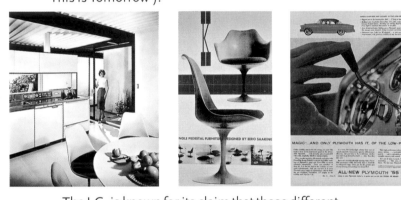

The I.G. is known for its claim that these different expressions are roughly equal in value, that culture is no longer a hierarchical 'pyramid' of high and low arts, but rather a horizontal 'continuum' of cultural practices.[9] This quasi-anthropological view, which anticipates some aspects of cultural studies today, was championed in print by Alloway, who popularized the term Pop, as well as by Banham, who theorized a Pop Age.[10] This egalitarianism of the I.G. countered both the elitist notion of civilization (as represented by Kenneth Clark) and the academic status of modernism (as represented by Herbert Read); it also rejected the sentimental regard for a folk worker culture (as represented by Richard Hoggart). 'American films and magazines were the only live culture we knew as kids,' Banham once remarked of his I.G. associates. 'We returned to Pop in the early fifties like Behans going to Dublin or Thomases to Llaregub, back to our native literature, our native arts.'[11] This comment captures a key paradox of I.G. members: they launched a return to

American Pop as if it were their mother-tongue and in doing so they signalled the partial displacement of 'folk' by 'Pop' as the basis of a common culture.[12] For better or worse, the I.G. was near enough to this American culture to know it well, but also distant enough to desire it still, with the result that they did not question it much. And this apparent paradox points to another also indicated by Banham: that the group was both 'American-leaning' and 'Left-orientated'.[13]

'We have already entered the Second Machine Age,' Banham wrote in *Theory and Design in the First Machine Age* (1960), 'and can look back on the First as a period of the past.'[14] In this classic study, first conceived as a dissertation in the midst of the I.G., Banham also exploited his distance from the initial framers of modern design such as Gropius, Le Corbusier, Siegfried Giedion and Nikolaus Pevsner (his advisor at the Courtauld Institute). He challenged the rationalist biases of these figures – that form must follow function and/or technique – and recovered other imperatives, especially Expressionist and Futurist ones, neglected by them. In doing so Banham advanced the imaging of technology as a principal criterion for design – of the First Machine Age certainly, but also of the Second Machine (or First Pop) Age. According to Banham, the modernists had taken the machine as a model of modern architecture, only to smuggle in a classical aesthetic in the process – a move evident, for example, in *Vers une architecture* (1923) where Le Corbusier juxtaposed a Delage sports-car with the Parthenon. For Banham this was absurd: cars are Futurist 'vehicles of desire', not Platonic type-objects, and only a designer who thrilled to the machine as 'a source of personal fulfillment and gratification' could capture its spirit.[15]

In this regard Banham the Pop prophet was not at odds with Banham the revisionary modernist. In the 1920s and 1930s a passion for an industrial America of Fordist production had influenced much modernist art and architecture; in the 1950s and 1960s this was gradually supplanted by a fascination with a consumerist America of imagistic impact, sexy packaging and speedy turnover that was incipiently post-Fordist. These qualities became the design criteria of the Pop Age for Banham. Far from academic, then, his revision of architectural priorities sought to reclaim an 'aesthetic of expendability', first proposed in Futurism, for the Pop Age, where 'standards hitched to permanency' were no longer so relevant.[16] More than any other critic, Banham led design

Pierre KOENIG Kitchen, Case Study House No. 21, Los Angeles, 1958

Advertisement for the Pedestal or Tulip range of plastic shell furniture designed by Eero Saarinen, 1956

Advertisement for the 1955 Plymouth, *Life* magazine, 11 April 1955. Used as source by Richard Hamilton for his painting *AAH!*, 1962

theory away from a modernist concern with abstract, machinic forms to a Pop language of commercial, mediated images and this was in keeping with a shift in influence away from the architect as a consultant in industrial production to the ad-man as an instigator of consumerist desire. 'The foundation stone of the previous intellectual structure of Design Theory has crumbled,' Banham wrote in 1961; 'there is no longer universal acceptance of Architecture as the universal analogy of design.'[17]

Yet Banham did not regard the passage from the First to the Second Machine Age as a complete break: 'The cultural revolution that took place around 1912 has been superseded', he wrote in *Theory and Design*, 'but it has not been reversed.'[18] Rather, a dialectical transformation of technologies had occurred: from 'the age of power from the mains and the reduction of machines to human scale' (as in the transition from public trains to private automobiles) to 'the age of domestic electronics and synthetic chemistry' (as in

ARCHIGRAM [Peter Cook] Plug-in University Node, 1965. Section elevation drawing
Cedric PRICE Fun Palace, 1961–67. Aerial view drawing

televisions and plastics), technologies had become both more popular and more personal. 'A housewife alone often disposes of more horsepower today than an industrial worker did at the beginning of the century,' Banham argued.[19] And if architecture was to remain relevant in this world – where the dreams of the austere 1950s had become the products of the consumerist 1960s – it had to 'match the design of expendabilia in functional and aesthetic performance': it had to go Pop.[20]

Initially Banham supported the Brutalist architecture of the Smithsons and James Stirling, who pushed given materials and exposed structure to a 'bloody-minded' extreme. 'Brutalism tries to face up to a mass production society', the Smithsons wrote in 1957, 'and drag a rough poetry out of the confused and powerful forces which are at work.'[21] Yet perhaps this very insistence on an 'as found' aesthetic rendered Brutalism too modernist to serve for long as the model style of the Pop Age. As the Swinging Sixties unfolded (in part

driven by the technological investments of the Labour Government under Harold Wilson), Banham began to stress imageability and expendibility above all other values. For Banham Archigram (Warren Chalk, Peter Cook, Dennis Crompton, David Greene, Ron Herron and Michael Webb) best fitted this revised bill and in 1963 this adventurous group did proclaim 'throwaway architecture' as the future of design. Archigram took 'the capsule, the rocket, the bathyscope, the Zipark [and] the handy-pak' as its models[22] and celebrated technology as a 'visually wild rich mess of piping and wiring and struts and cat-walks'.[23] Its projects might appear functionalist – the Plug-in City (1964) proposed an immense framework in which parts could be changed according to need or desire – but, finally, with its 'rounded corners, hip, gay, synthetic colours [and] pop-culture props', Archigram was 'in the image business'.[24] Like the Fun Palace project (1961–67) proposed by Cedric Price for the Theatre Workshop of Joan Littlewood, Plug-in City offered 'an image-starved world a new vision of the city of the future, a city of components … plugged into networks and grids'.[25] Herein lies the ultimate imperative of Pop design for Banham: that it not only express contemporary technologies but also advance them, however delirious the effects might be.

Richard Hamilton and the Tabular Image

If the Smithsons, Archigram and Price 'got the measure' of Pop culture in architecture, who did so in art? What artists reflected on the shift from an industrial vocabulary of 'grain silos and aeroplanes' to a consumerist idiom of 'throwaway objects and pop-packages'? One I.G. member 'to collect ads' early on was Eduardo Paolozzi, who called the collages made from his collection of fragments 'Bunk' – perhaps in an ambivalent homage to Henry Ford, who once remarked that 'History is Bunk'.[26] Many post-war artists refashioned the pre-war device of collage, such as Rauschenberg with his 'combines' and silkscreens of found objects, art images and print reproductions, as well as the *décollageistes* (e.g., Raymond Hains, Mimmo Rotella and Jacques de la Villeglé) with their layered and lacerated posters taken directly from the city streets. Yet in these instances collage evoked a distracted mind bombarded by media messages, whereas Paolozzi deployed collage to make specific connections within Pop culture, especially between product salesmanship

and sex appeal. In one early work, *I Was a Rich Man's Play Thing* (1947), a cover girl of *Intimate Confessions* magazine appears on the same plane as ad fragments for Coca-Cola, Real Gold fruit juice and cherry pie. The sexual innuendos are obvious enough, as is the phallic bomber below the woman with its inscription 'Keep 'Em Flying'. Paolozzi keys the associations among consumption, sex and war by the little explosion of the gun pointed at the cover girl: 'The "Pop!" gunshot cements these terms into equivalence, interchangeability', the critic Julian Myers has argued. 'The body *is* a commodity; advertisement *is* propaganda; propaganda *is* pornography.'[27]

This 'pinboard aesthetic' was also practised by others within the I.G. (Henderson, Turnbull, McHale …), but it was Paolozzi who, one night in April 1952, projected his ads, magazine clippings, postcards and diagrams, in a catalytic demonstration that underwrote the distinctive method of the I.G. exhibitions to come: an anti-hierarchical constellation

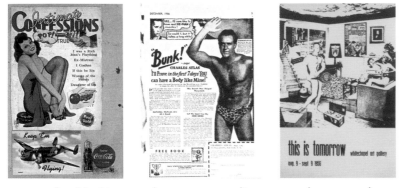

of archival images that are at once disparate and connected. Foreshadowed in summer 1951 when Hamilton projected multiple photographs of natural structures in the show 'Growth and Form', this collage principle was foregrounded in the autumn of 1953 when Paolozzi, the Smithsons and Henderson presented roughly 100 reproductions of modernist paintings, tribal art, children's drawings and hieroglyphs, as well as anthropological, medical and scientific photographs, in 'Parallel of Art and Life'. However, the epitome of the pinboard aesthetic was reached in summer 1956 with 'This is Tomorrow', for which Hamilton constructed his famous little collage, *Just what is it that makes today's homes so different, so appealing?* (enlarged in black and white, it served as a poster for the show). In his own words, the work tabulates the Pop iconography of 'Man, Woman, Humanity, History, Food, Newspapers, Cinema, TV, Telephone, Comics (picture information), Words (textual information), Tape recording (aural information), Cars, Domestic appliances, Space' (Richard Hamilton, *Collected*

Words: 1953–1982, 1985, 24; hereafter *CW*). Clearly indebted to the 'Bunk' collages of Paolozzi, *Just what is it?* also prepares the distinctive version of the Pop image soon developed by Hamilton: a spatial compilation of found figures, commodities and emblems that is 'tabular as well as pictorial' (*CW* 24). Whereas Paolozzi stuck to the material heterogeneity of collage, Hamilton exploited the fetishistic effects of painting, which he used to mimic the lush surfaces of media images. These interests and strategies guided his great suite of tabular pictures that followed: *Hommage à Chrysler Corp.*, *Hers is a lush situation* and *$he*.

Hommage à Chrysler Corp. (1957) takes up the automobile as core commodity of the mid twentieth century, but as a metamorphic 'vehicle of desire' à la Banham, not as a Platonic type-object as in Le Corbusier. '[The car] adopts its symbols from many fields and contributes to the stylistic language of all consumer goods,' Hamilton wrote in 1962. 'It is presented to us by the ad-man in a rounded picture of

urban living: a dream world, but the dream is deep and true – the collective desire of a culture translated into an image of fulfillment. Can it be assimilated into the fine art consciousness?' (*CW* 35) *Hommage* is his first attempt to do so; it is also an early instance of his 'ironism of affirmation', a phrase borrowed from his mentor Duchamp, which Hamilton defined as a 'peculiar mixture of reverence and cynicism' (*CW* 78). Here this mixture is not as paradoxical as it sounds, for *Hommage* is so affirmative of automobile imaging, so mimetic of its moves, as to ironize its fetishistic logic – that is, to expose the manner in which both bodies on display, the new Chrysler and the vestigial showgirl, are broken up into sexy details whose production is obscure. Not only does Hamilton associate body parts by analogy (the breast, say, with the headlight), but in doing so he demonstrates a conflation of commodity fetishism with sexual fetishism, as the two bodies exchange properties (as in commodity fetishism according to Marx) in a way that charges them with erotic force (as in sexual fetishism according to Freud). Foreseen in Surrealism, this doubling of fetishisms is foregrounded throughout Pop.[28]

Signal characteristics of the tabular picture are announced in *Hommage*. First, the composition is 'a compilation of

themes derived from the glossies', several images each for the car, the woman and the showroom (*CW* 31). Not just broken up, the car is also rotated for purposes of display (headlight and bumper from the front, fin and fender from the rear). This manipulation is practised on female figures, too, in other pictures such as *$he*, as if Hamilton wanted to suggest that the skill of Old Master drawing had become a device of semi-pornographic presentation. And in *Hommage* he is fetishistically specific: 'pieces are taken from Chrysler's Plymouth and Imperial ads; there is some General Motors material and a bit of Pontiac' (*CW* 31). At the same time Hamilton also smoothens these parts into near abstraction: if the woman caresses the car in the painting, so too does he caress both figures in paint. Like the car, the woman is reduced to charged parts within a curvaceous line, to breast and lips (which Freud counted among 'the secondary sexual characteristics'), here represented by an 'Exquisite Form Bra' and the big lips of one 'Voluptua', a star of a late-night

curvy lines respectively [*CW* 32]). In this showroom not only have traditional line, colour and modelling become means of product display, but so too have aspects of modern art and architecture become devices of commercial exhibition (again, 'Mondrian' and 'Saarinen').[30] This is another key insight of Pop: that avant-garde and mass cultures have intersected, indeed converged. (As we will see, Lichtenstein shows us a modernism appropriated by the media, in his case in the comics.) Hamilton also mentions 'a quotation from Marcel Duchamp' in *Hommage* and at the time he was busy with his translation of the *Green Box* of notes that Duchamp had prepared for *The Bride Stripped Bare by Her Bachelors, Even* (a.k.a. the *Large Glass*, 1915–23). Perhaps, like the *Large Glass*, the conjunction of Chrysler and showgirl in *Hommage* produces a kind of 'Bachelor Machine', a category of avant-garde representation in which woman and machine, sexuality and commodity, are bound up with one another.[31] But if *Hommage* is a pictorial updating of the *Large Glass*, which is

Marcel <u>DUCHAMP</u> The Bride Stripped Bare by Her Bachelors, Even [The 'Large Glass'], 1915–23
Richard <u>HAMILTON</u> Hers is a lush situation, 1958
Hans <u>BELLMER</u> La Mitrailleuse en état de grâce [Machine-Gunneress in a State of Grace], 1937

'the bachelor' and which is 'the bride'? Unlike Duchamp, who keeps the two figures separate, Hamilton lets them meet, as if to suggest that consumerism had transformed the very rapport of male and female, the very nature of (heterosexual) desire.[32]

American TV show at the time. This is representation *as* fetishization, an almost campy version of what Walter Benjamin once called 'the sex appeal of the inorganic'.[29] Such is the fetishistic crossing of this tabulation – a car is (like) a female body, a female body is (like) a car – and the two commingle in this chiasmus as if naturally. (This crossing is also suggested by the sexist lingo of the time: 'nice chassis', 'great headlights' and so on.)

Everything here is already designed for display: 'The main motif, the vehicle, breaks down into an anthology of presentation techniques' (*CW* 32) and Hamilton does highlight, in paint, the print effects of glossy car panel and shiny chrome fender. They appear as already screened by a lens, as though there were no other mode of appearance but a mediated one. Space is also thus transformed: it has become display-space alone, specifically a showroom based on 'the International Style represented by a token suggestion of [Piet] Mondrian and [Eero] Saarinen' (perhaps in the vestigial grid and the

In his next tabular picture, *Hers is a lush situation* (1958), Hamilton actually commingles the body parts of woman and car: the curves of the implicit female driver become one with the lines of bumper, headlight, fin, windshield and wheel. Another tabulation of magazine images, the painting is generated from a sentence in an *Industrial Design* review of a Buick: 'The driver sits at the dead calm centre of all this motion: hers is a lush situation' (*CW* 32).[33] Perhaps this painting marks the next stage in the Pop evolution of the Bachelor Machine, one that here aligns Hamilton with the Surrealism of Hans Bellmer, for *Hers is a lush situation* can be seen as a graphic updating of *Machine-Gunneress in a State of Grace* (*La Mitrailleuse en état de grâce*, 1937), where Bellmer renders woman and weapon one.[34] But what is still perverse in Bellmer has become almost beautiful here: a lush situation, not a surreal threat. Although Hamilton works to 'assimilate' design into 'the fine art consciousness', the flow can run in the opposite direction too and *Hers is a lush situation* does

show the genre of the Odalisque subsumed in an ad for a Buick (all that remains of the nude, as with the Cheshire cat, is her smile), as if a nude by Matisse were here reworked by an automobile stylist. In the process Hamilton presents line, which is still individual and expressive in Matisse, a medium of rapport between artist and model, as almost engineered and statistical: for all its lushness, 'line' has become 'the right line' for 'the new line' of Buick.

If line is revalued here, so is plasticity, in a way that makes the animate and the inanimate difficult to distinguish. 'More than a substance, plastic is the very idea of its infinite transformation,' Roland Barthes wrote in *Mythologies*, his collection of critiques of consumerist 'myths' published in 1957, a year before *Hers is a lush situation* was painted; 'the whole world can be plasticized and even life itself ...'[35] 'Sex is everywhere', Hamilton argued in 1962, 'symbolized in the glamour of mass-produced luxury – the interplay of fleshy plastic and smooth, fleshier metal' (*CW* 36). This erotic

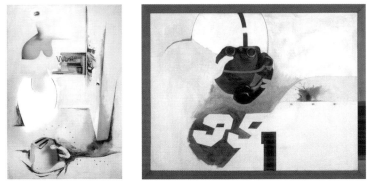

plasticity is a matter not only of charged details but also of abstract analogies: it is as though Hamilton wanted to track the desirous eye in its saccadic jumps across associated forms. Together these two operations inform the hybrid space of his tabular pictures: specific yet sketchy in content, broken yet seamless in facture, collaged yet painterly in technique.

This combination of effects is again at work in *$he* (1958–61), which Hamilton describes as another 'sieved reflection of the ad man's paraphrase of the consumer's dream' (*CW* 36). If a magazine image of a Chrysler provides the layout of *Hommage*, here it is one of a Frigidaire: the home has become another kind of showroom.[36] Hamilton lists no less than ten sources, all credited to particular designers and brands, for the fridge, the woman and the hybrid of toaster and vacuum cleaner below. Yet, like *Hommage*, *$he* draws principally on the magazine genre of the woman or wife who proffers the vehicle or appliance; here, however, it is the product that seems to sell the person (that she has

commodity status is also signalled by the dollar sign in the title). The woman is again reduced to an erotic 'essence' – not breast and lips as in *Hommage*, but eye and hips. As in *Hers is a lush situation*, the hips are in whitened relief, while the eye is a plastic one taped into position: like painting, relief and collage are exploited for fetishistic effect, not the opposite. The eye opens and closes like the fridge, turns on and off like the toaster: apparently in the animate world of Pop products, things can look back at us, even wink at us.[37]

What are the implications of the tabular picture? 'Tabular' derives from *tabula*, Latin for table, but also for writing-tablet, in which, in antiquity, both painting and printing figured as modes of inscription. This association must appeal to Hamilton, who has used both techniques in large part because he finds them, already combined, in the media. 'Tabular' also invokes writing, which Hamilton has involved in his lists and titles. Moreover, his pictures contain traces of the visual-verbal hybrid characteristic of the magazine

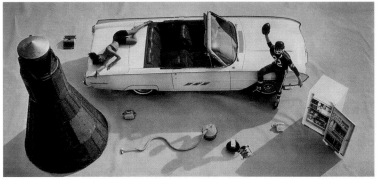

spread and the tabloid layout (perhaps 'tabular' connotes 'tabloid' as well), a hybrid that anticipates the mixed sign that pervades electronic space today – all the 'icons', 'pop-ups' and other lush images that carry insistent directives.[38] Again, some of these pictures are tabular in another sense too – generated by a table of terms, as with *Just what is it?*, or of images, as in *Hommage* and *$he*, or of jingles, as in *Hers is a lush situation* or *Towards a definitive statement on the coming trends in men's wear and accessories* (1962), where the title derives from a *Playboy* review of male fashion.

More directly, 'to tabulate' is 'to set down in a systematic form' (OED) and Hamilton is often concerned with an 'overlapping of presentation styles and methods' – styles and methods that are at once commercial (as in the various display techniques that he evokes), modernist (as in the various abstract signs that he cites) and modernist-turned-commercial. In his own words, 'photograph becomes diagram, diagram flows into text' and all is transformed

Richard HAMILTON *$he*, 1958–61
Richard HAMILTON *Towards a definitive statement on the coming trends in men's wear and accessories* [b], 1962
Richard HAMILTON with Robert FREEMAN [photographer] 'Self-portrait', cover for *Living Arts*, 2, 1963

by painting. At the same time Hamilton wants 'the plastic entities [to] retain their identity as tokens' and so he uses 'different plastic dialects', such as photography, relief, collage, 'within the unified whole' of painting (*CW* 38). Like an ad-man, then, he tabulates (as in correlates) different media and messages and tabulates (as in calculates) this correlation in terms of visual appeal and psychological effect.

It is not always clear when this redoubling of images is analytical and when it is celebratory – in Hamilton in particular or in Pop at large. Yet one thing seems clear enough: his pastiche is not disruptively random, as it is in much Dada and Neo-Dada work. Another insight of Pop (or 'Son of Dada' as Hamilton calls it) is that 'randomizing' had become a media device, a logic within the culture industry.[39] Sometimes he pushes this logic of the random to a demonstrative extreme; at other times his tabular pictures are logical in another sense, that is, typological: for example, the suite of images *Towards a definitive statement on the*

William OVERGARD Drawing for the cartoon Steve Roper's Casebook, 6 August 1961. King Features Syndicates Inc.
Roy LICHTENSTEIN I Can See the Whole Room and There's Nobody in it, 1961. Not to scale: canvas size 122 × 122 cm [48 × 48 in]
Article on Roy Lichtenstein, *Life* magazine, 31 January 1964

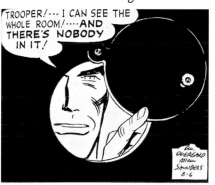

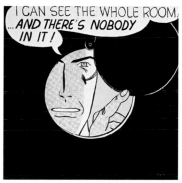

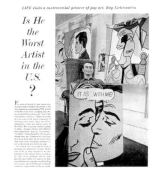

coming trends ... is a 'preliminary investigation into specific concepts of masculinity' (*CW* 46), here typified by President Kennedy, a Wall Street broker *cum* American football player, a weightlifter *cum* track athlete and astronaut John Glenn, each of whom is wired to a particular mechanism of sport, entertainment or media.[40] Suggestively, the word 'tabular' refers not only to graphic inscription; in ancient use it also connotes 'a body of laws inscribed on a tablet' (OED). Might these tabular pictures be seen then as investigations into a new body of laws, a new inscription of subjects, which the society of the First Pop Age requires?

Roy Lichtenstein and the Screened Image

Hamilton intimates a historical convergence between abstract painting and commercial design.[41] Similarly, Roy Lichtenstein suggests that, in composition and in effect, the differences between a grand painting and a good comic or ad have narrowed and, like Hamilton, he exploits this diminished

difference nonetheless. If Hamilton drew on glossy magazines for his images, Lichtenstein turned to tabloid newspapers, a tawdrier resource: in 1960 he began to paint cartoon characters such as Mickey and Popeye and generic products such as tennis shoes and golf balls (Andy Warhol did much the same thing, first independently, at much the same time). Almost immediately Lichtenstein was charged with superficiality; and when he moved to comic strips, mostly of romance and war, the accusations grew more shrill: clearly the apparent banality of his work threatened the assumed profundity of art – of its cultural significance and its ethical effect.[42] His cold surfaces seemed to mock the feverish gestures of Abstract Expressionism in particular and main-stream critics, who had come to appreciate such painting, were not happy.[43] In 1949 *Life* magazine had showcased Jackson Pollock with the not-yet-convinced question 'Is He the Greatest Living Painter in the United States?' In 1964 the same magazine profiled Lichtenstein under the not-altogether-ironic heading 'Is He the Worst Artist in the U.S.?'

The charge of banality centred first on content: Pop appeared to overwhelm fine art with commercial design. Modern artists had long sampled popular culture (posters in Toulouse-Lautrec paintings, newspaper fragments in Picasso collages and so on), but they did so mostly to reinvigorate staid forms with feisty contents. With Pop, on the other hand, the low seemed to overrun the high – despite the fact that, like Hamilton, Lichtenstein only wanted to 'assimilate' his ads and cartoons into fine art. The accusation of banality also concerned procedure: since Lichtenstein seemed to reproduce such images directly, he was branded with a lack of originality and, in one case at least, accused of copyright infringement. (In 1962 Lichtenstein adapted a few diagrams of portraits by Cézanne made by an art historian named Erle Loran in 1943; Loran surfaced to protest loudly.) Lichtenstein did copy, of course, but in a complicated fashion. In the case of the comics, he would select one or more panels from a strip, sketch one or more motifs from these panels, then project his drawing (never the comic) with an opaque projector; next he would trace the image on the canvas, adjust it to the

picture plane and finally fill in with his stencilled dots, primary colours and thick contours – the light ground of the dots first, the heavy black of the outlines last. Thus, while a Lichtenstein painting might look readymade, it is actually a layering of mechanical reproduction (comic), handwork (drawing), mechanical reproduction again (projector) and handwork again (tracing and painting), to the point where distinctions between hand and machine are difficult to recover.[44] Again, Hamilton, Warhol, Rosenquist, Richter, Polke and others produce related conundra of the painterly and the photographic; it is a prime characteristic of Pop art.

Lichtenstein's work abounds in manually made signs of mechanically reproduced images, but it is his signature dots that crystallize the paradox of 'the handmade readymade'. These stencilled marks are a painted depiction of a printed code, the Ben-Day dots devised by Benjamin Day in 1879 as a technique to reproduce an image through gradations of shading translated into a system of dots. The Lichtenstein

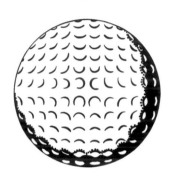

version of these dots underscores the transformation of appearance under mechanical reproduction into screened images – printed, broadcast or otherwise represented beforehand. As we saw with Hamilton, this too is a central concern of Pop, with significant variations again wrought by Warhol, Rosenquist, Richter, Polke and others. But where does the artist as creator stand in this world of reproduction? When Lichtenstein appropriated product images, he effaced the brand names (by contrast Warhol retained 'Campbell's', 'Brillo' and so on); as the critic Michael Lobel has argued, he 'Lichtensteinized' his sources in order 'to make the comics look like his images'.[45] This tension between traces of authorship and signs of its eclipse is pronounced in Lichtenstein, but it was not very anguished for him. 'I am not against industrialization', he remarked modestly in 1967, 'but it must leave me something to do ... I don't draw a picture in order to reproduce it – I do it in order to recompose it. Nor am I trying to change it as much as possible. I try to make the

minimum amount of change.'[46] This is the ambiguous line that Lichtenstein hewed: to copy images from print media but to adapt them to the parameters of painting; to recompose them in the interest not only of pictorial unity but of artistic subjectivity; or, more precisely, to recompose them in such a way as to register these values of unity and subjectivity – to register them precisely as pressured.

The other charge of banality, the one concerning the content of ads and comics, is more difficult to deflect, but here too the Lichtenstein case is not as simple as it seems. His lowly subjects did offend aesthetic taste attuned to Abstract Expressionism, but, formally speaking, Lichtenstein did not put his content to very contrarian purposes. In fact he worked to show that comics could serve some of the same lofty ends set for high art from Rembrandt and Jacques-Louis David to Mark Rothko and Barnett Newman: not only pictorial unity and dramatic focus (as advocated since Diderot and Lessing, if not before) but also 'significant form' and 'the integrity of the picture plane' (as urged by Clive Bell and Clement Greenberg respectively). Jasper Johns had played a similar trick with his paintings of flags, targets and numbers of the mid to late 1950s: those works met the Greenbergian criteria for modernist painting (that it be flat, self-contained, objective and immediate) by means that Greenberg found utterly alien to such painting (the kitschy images of mass culture).[47] Lichtenstein pushed together the poles of fine art and commercial design with equal force: his comics were almost as flat as any flag or target and more vulgar to boot.

Thus Lichtenstein seemed to challenge the oppositions on which pure painting was founded: high versus low, fine versus commercial, even abstract versus figurative. Consider *Golf Ball* (1962), a circle outlined and dimpled in black on white – to signify shadow and light – on a light grey ground. A golf ball is a prime object of suburban banality, but here it also recalls the pristine plus-and-minus abstractions that Mondrian painted forty-five years before. On the one hand, the near abstraction of *Golf Ball* tests our sense of realism, which Lichtenstein shows to be a conventional code, a matter of signs that sometimes possess only scant resemblance to actual things in the world.[48] On the other hand, when a Mondrian begins to look like a golf ball, then the category of abstraction is surely in trouble too. Modernists like Mondrian worked to resolve figure and ground in painting, to collapse illusionist space into

Roy LICHTENSTEIN Golf Ball, 1962
Piet MONDRIAN Pier and Ocean [Sea and Starry Sky], 1914

material flatness. Lichtenstein gives us both the impression of space and the fact of surface (as do most comics) and if there is a radical edge in his Pop it lies here: less in his thematic opposition of low content and high form and more in his structural superimposition of cartoons and commodities with exalted painting. One can see why, when Mickey and Popeye popped up in the metaphysical space once reserved for the numinous rectangles of Rothko and the epiphanic 'zips' of Newman, art lovers were rather upset.

In this way Lichtenstein performed a visual short-circuit: he delivered both the immediate effect of a modernist painting and the mediated look of a print image.[49] Consider another early work, *Popeye* (1961), which shows the spinach-strong sailor knocking out his rival Bluto with a roundhouse left, like a Pop upstart taking a tough Abstract Expressionist to the canvas with a single blow. Most important here is the blow: nearly as impactful as a Pollock painting, *Popeye* smacks the viewer in the head as well. (Lichtenstein liked to

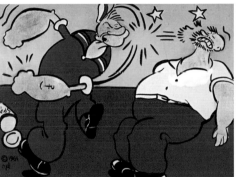

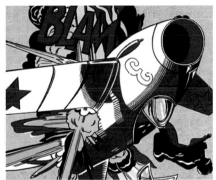

underscore this blow with the onomatopoeic terms of the comics: his punches go 'Pow', his guns go 'Blam', 'Takka-Takka', 'Brattata'.)[50] Thus at the level of effect too, he suggests that Pop is not so different from modernist painting: they propose a similar viewer, one that is projected as all eye, one that takes in the image in a single flash or 'pop'.[51] But to what end is this demonstration made? For the most part Lichtenstein put high and low together less to undo the opposition than to reconcile it; he was proud of his formal sense, his tasteful ability to make good paintings out of mawkish stuff. Yet this 'reconciliation' was hardly his doing alone; like Hamilton, Lichtenstein registered a convergence of old binaries of high and low, modernist and mass, a historical process that transcended all the Pop artists as individuals (perhaps the implacability of this process can be sensed in the impersonality of their canvases).

Lichtenstein was well prepared to gauge the convergence of high and low arts. In the 1950s, first in Cleveland and then in upstate New York, he worked through several styles of modernism: he painted along Expressionist lines, then in a faux-naif manner (in which he adapted Americana themes, as in *Washington Crossing the Delaware*, I, *c.* 1951) and briefly in an abstract mode. In other words, he became adept in avant-garde devices, not only the expressionist brushstroke and the cubist play with signs (black lines to signify a shadow, a white patch to signify a reflection and so on), but also the monochrome painting, the readymade object and the found image, all of which he received as second-hand (sometimes literally so in art magazines). These devices appear in his work in the same way, as mediated, as if quoted; and they are held together by the iconic shapes supplied by the ad or the comic, that is, ironically, by the very representational mode that avant-garde art had worked so hard to overthrow. This is another aspect of his Pop that retains a critical edge – critical in the sense that a historical condition is revealed to us through the very form of the work.

Like Hamilton, then, Lichtenstein demonstrates a commonality between the codes of ads and comics and the styles of the avant-garde. 'Mine is linked to Cubism to the extent that cartooning is,' Lichtenstein once remarked of his pictorial language. 'There is a relationship between cartooning and people like [Joan] Miró and Picasso which may not be understood by the cartoonist, but it definitely is related even in the early Disney.'[52] He might have added Matisse, Mondrian and Fernand Léger (among others), for they all appear in his paintings, read through the language of the comics: the ambiguous signs of light and shadow in Picasso, the bold but suave contours in Matisse, the strict primary colours in Mondrian, the already semi-cartoonish figures in Léger. Of course, these elements are put to different purposes: if in Mondrian the primaries signify pure painting, in Lichtenstein yellow might also signal a beautiful blonde, red a flashy dress, blue a perfect sky and so on. Certainly he recomposed his ads and comics in such a way as to fit them to the picture plane, but, more importantly, he did so both to expose and to exploit these modernist connections.[53] One can draw a dire conclusion from this commingling of modernist art and comic strip: that by the early 1960s most devices of the avant-garde had become little more than gadgets of commercial design. This is a predicament for Pop, indeed for any post-war avant-garde: again,

some of the anti-art measures of old avant-gardes like Dada had become the stuff not only of the art museum but of the culture industry. Or one can take a benign view of this situation: that both fine art and commercial design benefited from this exchange of forms in the interest of values that, in the end, are rather traditional – unity of image, immediacy of effect and so on. Evidently this is how Lichtenstein saw things.

Lichtenstein was adept not only in modernist styles but also in different modes of seeing and picturing, some of which date from the Renaissance, if not antiquity – adept in specific genres like portraiture, landscape and still life, all of which he Lichtensteinized, as well as in general paradigms of painting, such as painting as window, as mirror and (within modernist art) as abstract surface. Not long before him, Rauschenberg and Johns had suggested a further paradigm, 'the flat bed picture plane' (as it was termed by Leo Steinberg): the picture no longer as a vertically oriented frame to look at or through as on to a natural scene, but as a

horizontally worked site where different images might be brought together textually, a 'flat documentary surface that tabulates information'.[54] Lichtenstein proposed his own variant of this model: the picture as an already-screened image

and, as such, a telling sign of a post-war world in which everything seemed subject to processing through mechanical reproduction. This screening bears on the actual making of his art, its commingling of handmade and readymade; yet it also addresses the mediated look of the consumerist world at large, which affects perceiving and imaging *per se*. Emergent here, then, is a mode of seeing that has become dominant only in our own time of the computer screen, in which (as we saw with Hamilton) reading and looking take on the hybrid character of scanning. (Lichtenstein often chose comic-strip figures placed in front of gun sights, televisual monitors, windshields and dashboards, as if to 'compare or correlate the surface of the canvas' with such screens.)[55] Today this is how we are trained to sweep through information, visual, verbal, or both: we scan it and it scans us, tracking keystrokes, counting web hits and so forth. Might Lichtenstein have sensed this shift, both in semblance and in seeing, already latent in the comic strip?

Andy Warhol and the Seamy Image

Andy Warhol also drew on comic strips and newspaper ads, but to different effects. If Lichtenstein worked to recompose his Pop sources in the interest of pictorial form, Warhol tended to decompose such form through repetition and accident. Moreover, when Lichtenstein put Popeye in the place of Pollock, it was a lite sort of subversion; when Warhol repeated photographs of gruesome car crashes or poisoned housewives in the exalted space of such painting, it was scabrous and it remains so forty-plus years later.

For all his radicality, Warhol is the one Pop artist whose name resonates well beyond the art world (he has Pop status in this extended sense too). From his rise in the early 1960s to his death in 1987, he served as the often-still centre of various sub-worlds of art, advertising, fashion, underground music, independent filmmaking, experimental writing, gay culture and star culture. Along with art work that ranges from the extraordinary to the bathetic, Warhol made movies that are *sui generis*, produced the first album of The Velvet Underground and founded *Interview* magazine, among many other ventures (his studio was appropriately dubbed 'The Factory'). He exploited a new way of being in a world of commodity-images where fame is often subsumed by celebrity, newsworthiness by notoriety, charisma by glamour and aura by hype. A native-informant in this spectacle, Warhol had a look of blank indifference that concealed an eye for killer images.

Born in 1928 in Pittsburgh to immigrants from eastern Slovakia (his father worked in coal mines, then in construction), Warhol studied design at the Carnegie Institute of Technology (now Carnegie-Mellon). In 1949 he moved to New York, where he achieved early success as a commercial artist with magazine ads, window displays, stationery, book covers and album jackets for a range of classy clients from *Vogue* and *Harper's Bazaar* to Bergdorf Goodman and Bonwit Teller. He had money enough to buy work by Duchamp, Johns and Stella before he could sell his own art; and he collected all kinds of other things as well: every day was a time capsule for Warhol (he left 612 boxes of ephemera at his death). He did his first paintings of Batman, Nancy, Dick Tracy and Popeye in 1960, the year before he saw Lichtenstein canvases with similar subjects; yet whereas Lichtenstein was clean and hard in his copies of comics and ads, Warhol initially played with manual mistakes and media blurrings. His wonder year was 1962–63: he did his first 'Campbell's Soup Can' and 'Do It

Roy LICHTENSTEIN Frightened Girl, 1964

Yourself' paintings, his first silkscreens of Elvis, Marilyn and other stars, his 'Death and Disaster' images and his first films (*Sleep*, *Blow Job* and *Kiss*, the titles of which declare about all the action that appears on the screen). In 1963, too, Warhol used a Polaroid for the first time and he moved The Factory to East 47th Street, where it became a notorious hangout for bohemian scene-makers and wannabe 'superstars' (the term is another Warhol invention).

His greatest period of art work occurred between his first silkscreens in 1962 and his near-fatal shooting in 1968 (on the third of June, two days before Robert Kennedy was assassinated, Valerie Solanas, a Factory hanger-on, shot Warhol several times).[56] Most important readings focus on this early body of images, especially on the 'Death and Disaster' silkscreens, which are based on news photographs, often too gruesome for publication, of car wrecks and suicides, electric chairs and civil-rights confrontations. These accounts tend either to connect these images to actual

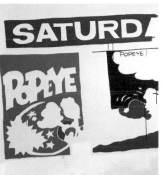

events in the world or, conversely, to propose that the world of Warhol is nothing but image, that Pop images in general represent only other images. Most readings of Warhol – indeed of post-war art based on photography – divide some-where along this line: the image is seen either as *referential*, a document tied to the world, or as *simulacral,* a copy without an apparent original in the world.

The simulacral reading of Warholian Pop is advanced by critics for whom the notion of the simulacrum is crucial to the critique of representation as bound directly to the world. 'What Pop art wants', Barthes writes in 'That Old Thing, Art' (1980), 'is to desymbolize the object', that is, to relocate the meaning of the image away from any deep significance (within the image, beyond the image) towards its own blank surface. In the process, Barthes argues, the artist is also repositioned: 'The Pop artist does not stand behind his work and he himself has no depth: he is merely the surface of his pictures, no signified, no intention, anywhere.'[57] In this

account referential depth and subjective interiority are also victims of the sheer superficiality of Warholian Pop.

The referential view of Warhol is advanced by critics based in social history who relate the work to diverse phenomena, such as the civil rights movement, gay culture, the fashion world and so on. In 'Saturday Disasters: Trace and Reference in Early Warhol' (1987), Thomas Crow disputes the simulacral account of Warhol as impassive and his images as indiscrim-inate. Underneath the glamorous surface of commodity fetishes and media stars lies 'the reality of suffering and death': the tragedies of Marilyn Monroe, Liz Taylor and Jackie Kennedy prompt 'straightforward expressions of feeling' from the artist. Here Crow finds not only a referential object for Warhol but an empathetic subject in Warhol and here he locates the artist's criticality as well. For Crow this criticality lies not in an attack on 'that old thing art' made through an embrace of the simulacral commodity-image (as Barthes and others would have it); rather, it rests in an exposé of 'complacent consumption' made through 'the brutal fact' of accident and mortality. In this way Crow pushes Warhol beyond humanist sentiment to political engagement. 'He was attracted to the open sores in American political life,' Crow writes, in an interpretation of the electric-chair images as agit-prop against the death penalty and of the race-riot images as a testimonial for civil rights. 'Far from a pure play of the signifier liberated from reference', Warhol belongs to the popular American tradition of 'truth-telling'.[58]

In part this reading of Warhol as empathetic and engaged is a projection, but so is the account of Warhol as superficial and impassive, even though Warhol seemed to agree with the latter view: 'If you want to know all about Andy Warhol, just look at the surface of my paintings and films and me and there I am. There's nothing behind it.'[59] Warhol was very savvy about this process of projection, of the way that we fabricate stars and celebrities through our idealization of their iconic force. In any case, neither argument is wrong; in fact they are both

right: his early images of death and disaster are *both* referential and simulacral, connected and disconnected, affective and affectless, critical and complacent.

'I want to be a machine' is a famous utterance of Warhol and it is usually taken to confirm the blankness of artist and art alike. But it might point less to a blank subject than to a shocked one, who takes on what shocks him as a defence against this same shock. 'Someone said my life has dominated me,' Warhol told Gene Swenson in an important interview of 1963. 'I liked that idea.'[60] In this conversation Warhol claims to have had the same lunch every day for the last twenty years (what else but Campbell's soup?). Together, then, the two statements suggest a strategy of pre-emptive embrace of the very compulsive repetition that a consumerist society demands of us all. If you can't beat it, Warhol implies, join it; more, if you enter it totally, you might expose it; you might reveal its enforced automatism through your own excessive example. Deployed critically by the Dadaists vis-

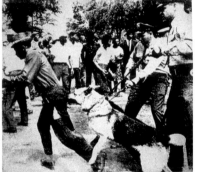 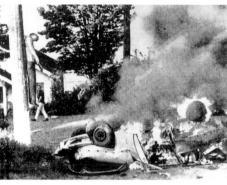

à-vis the military-industrial catastrophe of World War I, this strategy of 'capitalist nihilism' was performed ambiguously by Warhol vis-à-vis Cold War consumerism after World War II.[61]

These remarks reposition the role of repetition in Warhol. 'I like boring things' is another signature saying. 'I like things to be exactly the same over and over again.'[62] In *POPism* (1980) Warhol glossed this embrace of boredom and repetition: 'I don't want it to be essentially the same – I want it to be *exactly* the same. Because the more you look at the same exact thing, the more the meaning goes away and the better and emptier you feel.'[63] Here repetition is both a draining of significance and a defending against affect, and this strategy guided Warhol as early as his 1963 interview with Swenson: 'When you see a gruesome picture over and over again, it doesn't really have any effect.'[64] Clearly this is one function of repetition in our psychic lives: we recall traumatic events in order to work them into a psychic economy, a symbolic

order, a life narrative. Yet the Warhol repetitions are not restorative in this way; they are not about a mastery of trauma, for his repetitions not only reproduce traumatic effects but sometimes produce them as well. Thus several contradictory operations can occur in his work at one time: a warding away of traumatic significance and an opening out to it, a defending against traumatic affect and a producing of it.

Repetition in Warhol, then, is neither a simple representation of a worldly referent nor a sheer simulation of a superficial image. Often his repetition serves to screen a reality understood as traumatic ('screen' in the senses of both 'view' and 'filter'); but it does so in a way that points to this traumatic reality nonetheless. In *Camera Lucida* (1980) Barthes calls this traumatic point of the photograph its *punctum*, which he locates strictly neither in the image nor in the viewer. 'It is this element which rises from the scene, shoots out of it like an arrow and pierces me,' he writes. 'It is what I add to the photograph and what is nonetheless already there.' 'It is acute yet muffled, it cries out in silence. Odd contradiction: a floating flash.'[65] Barthes is concerned here with straight photographs and so he relates the effects of the *punctum* to details of content. This is seldom the case in Warhol; yet a *punctum* does exist for me in the indifference of the passer-by in *White Burning Car*, III (1963). This indiffer-ence to the crash victim impaled on the telephone pole is bad enough, but the repetition of this indifference is galling and this points to the distinctive operation of the *punctum* in Warhol: it works less through content than through technique. Often it appears in the 'floating flashes' of the silkscreen process, in the repetitive 'popping' of the images: it is in these ruptures and repetitions – these nasty seams – that a traumatic reality seems to poke through. In this way different kinds of repetition are put into play by Warhol: repetitions that show a traumatic reality, that screen it and that produce it. And this multiplicity makes for the paradox not only of images that are both affective and affectless, but also of viewers who are made to feel neither whole (which is the ideal of most modern aesthetics: the subject composed in contemplation) nor dissolved (which

is the effect of much popular culture: the subject given over to the dispersive intensities of the commodity-image). 'I never fall apart', Warhol remarks in *The Philosophy of Andy Warhol* (1975), 'because I never fall together.'[66] This is often the effect of his work as well.

The *punctum* is not only a private affair; it can have a public dimension too. Indeed, the breakdown of the distinction between private and public is also traumatic and no one points to this breakdown as incisively as did Warhol. 'It's just like taking the outside and putting it on the inside', he once said of Pop art in general, 'or taking the inside and putting it on the outside.'[67] However cryptic this remark is, it does suggest that a historically novel confusion between private fantasy and public reality is a primary concern of Warholian Pop. Clearly he was fascinated by the subjectivity produced in a mass society. 'I want everybody to think alike,' Warhol said in 1963, at the height of the Cold War. 'Russia is doing it under government. It's happening here all by itself.'[68] 'I don't think

Donahue, and portraits of criminals such as *Thirteen Most Wanted Men* (1964) can be *double entendres* for gay viewers.[71]

However, Warhol did more than evoke the mass subject through its kitsch, commodities and celebrities. Paradoxically enough, he also represented it in its very absence and anonymity, in its very disaster and death, the democratic levellers of famous media icon and unknown mass subject alike. Here again is Warhol in the 1963 interview:

'I guess it was the big crash picture, the front page of a newspaper: 129 DIE. I was also painting the Marilyns. I realized that everything I was doing must have been Death. It was Christmas or Labor Day – a holiday – and every time you turned on the radio they said something like, '4 million are going to die.' That started it.'[72]

And here is Warhol in a 1972 conversation:

'Actually you know it wasn't the idea of accidents and things like that … I thought of all the people who worked on the pyramids and … I just always sort of wondered what happened to them …

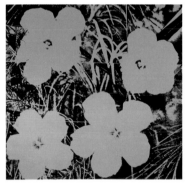
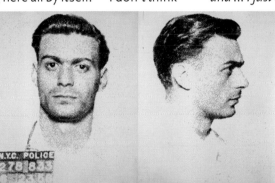

art should be only for the select few,' he added in 1967. 'I think it should be for the mass of American people.'[69] But how does one represent 'the mass of American people'? One way at least to evoke this 'mass subject' is through its proxies – that is, through its objects of consumption, as Warhol did in his serial presentations of Campbell's soup cans, Coke bottles and Brillo boxes from 1962 on, and/or through its objects of taste, as he did through his kitschy flower paintings of 1964 and folksy cow wallpapers of 1966. But can one *figure* this mass subject – that is, give it a body? 'The mass subject cannot have a body', the critic Michael Warner has argued, 'except the body it witnesses.'[70] This principle suggests why Warhol evokes the mass subject through its media icons – from celebrities and politicians such as Marilyn and Mao to all the lurid people that he placed on the covers of *Interview*. At the same time Warhol was also concerned to specify this subject, often along subcultural lines: the Factory was a virtual workshop of queer reinventions of heart-throbs such as Troy

Well, it would be easier to do a painting of people who died in car crashes because sometimes you know, you never know who they are …'[73]

Here his primary concern is not disaster and death so much as the mass subject in the guise of the anonymous victims of history – from the drones of the pyramids to the statistics of the highways. Yet disaster and death are necessary to evoke this mass subject, for in a society of spectacle this subject often appears only as an effect of the mass media (e.g., the newspaper), or of a catastrophic failure of technology (e.g., the plane crash), or, more precisely, of *both* – that is, of the news of such a catastrophic failure. Along with icons of celebrity such as Marilyn and Mao, reports of disastrous death such as '129 Die' is a primary way that mass subjecthood is produced.

For the most part, then, Warhol evoked the mass subject in two opposite ways: iconic celebrity and abstract anonymity. But he might have come closest to this subject through a

figure somewhere between celebrity and anonymity, that is, through the figure of *notoriety*, the fame of fifteen minutes that, in another famous remark, Warhol predicted for us all. Consider this implicit double-portrait of the mass subject: the most wanted men and the empty electric chairs, the first a kind of American icon, the second a kind of American crucifix. What more exact representation of the dark side of the public sphere at this time could there be than this twinning of iconic criminal and abstract execution?[74]

Gerhard Richter and the Photogenic Image

Warhol points to an unexpected discovery of Pop: affect is not necessarily blocked by banality; in fact a traumatic charge might be conveyed through banality. This effect is probed further by Gerhard Richter, perhaps the greatest artist associated with Pop outside its main axis of London, New York and Los Angeles. Born in East Germany in 1932, Richter was trained in Socialist Realist painting at the Kunstakademie in Dresden. In 1959 he travelled for the first time to West Germany, where he visited the international survey of contemporary art, documenta 2, in Kassel; there he was struck by the gestural abstractions of Pollock and Lucio Fontana, among others. Two years later Richter moved to Düsseldorf in order to retrain in such modernist art at its Kunstakademie (he began to teach there a decade later); at this time he met Konrad Lueg, Sigmar Polke and Blinky Palermo, students of the charismatic Joseph Beuys, who was then involved in Fluxus performance. Richter collaborated briefly with Lueg and extensively with Polke in various events sometimes dubbed 'Capitalist Realist' or 'German Pop'. It was thus in a double crucible – of East and West and of realist painting, Fluxus performance and Pop art – that Richter developed his complex aesthetic.

Richter encompasses not only different styles, from representational to abstract, but also diverse classes of image. Influenced by Warhol in particular, many of his early canvases are blurry renditions of banal photographs of everyday life, such as newspaper photos, magazine ads, family snaps, soft-porn shots and aerial views of various cities (Richter is best known for these images), while many of his later canvases recall the old genres of academic painting seen through a fuzzy optic: still lifes, landscapes, portraits, even history paintings. Richter does not collapse low and high categories, as many Pop artists do, so much as he ranges from low to high and back again – back again in so far as his high genres, the landscapes in particular, sometimes approach low forms once more, such as the pretty postcard or the sentimental photo.

In this way Richter places photography and painting at the same level ('I consider many amateur photographs better than the best Cézannes,' he remarked in 1966), even as he also affirms the fragile autonomy of 'traditional art' as such ('in every respect, my work has more to do with traditional art than anything else,' he commented in 1964, not long after the blurry representations first appeared).[75] Along similar lines Richter shows contradictory allegiances to divergent traditions of art, historical and avant-garde, with echoes of the romantic landscapes of Caspar David Friedrich as well as the conceptual provocations of Duchamp, of the colour-field abstractions of Newman as well as the murky media images of Warhol. It is as though Richter wanted to run these different strands together, to put the exalted pictorial formats of the 'Northern Romantic Tradition' from Friedrich through Newman through the anti-aesthetic paces of Warholian Pop.[76] 'All that I am trying to do in each picture', Richter has stated in a characteristic manner at once modest and grand, 'is to bring together the most disparate and mutually contradictory elements, alive and viable, in the greatest possible freedom' (Gerhard Richter, *The Daily Practice of Painting: Writings 1962–1993*, 1995, 166; hereafter *DP*). Yet to what ends does he juxtapose painting and photography, handmade and readymade, abstraction and figuration? Often his Pop peers seem to celebrate the convergence of these terms; Richter also registers this convergence, but only to complicate it – as if to demonstrate that lyrical painting can still exist not only after Auschwitz but after Warhol as well.

Richter presents not only different kinds but also great numbers of images. In 1962 he began to assemble his *Atlas*, a vast compendium of public and private photos, a fraction of which has served as the basis of his paintings. In 1989 Richter described the *Atlas* as 'a deluge of images' with no 'individual images at all', that is, as a compendium whose sheer number of pictures relativizes each one (*DP* 199). Benjamin Buchloh has written incisively of this archive as an 'anomic' repertoire without apparent law or rule and, except for an early juxtaposition of concentration-camp and porn photos, it does not contain much in the way of significant montage.[77] 'It's not a just image', Jean-Luc Godard once remarked, famously, in

his 1970 film *Vent d'est*, 'it's just an image'; and throughout his early period Richter seemed to participate in this same questioning of the truth-claims of photographic representation. In 1964, for example, he appeared to subscribe to a Warholian aesthetic of indifference: 'I like everything that has no style: dictionaries, photographs, nature, myself and my paintings' (*DP* 35). And in 1972 he spoke of the photograph as a 'pure picture' 'free of all the conventional criteria I had always associated with art: It had no style, no composition, no judgment' (*DP* 73). This indifference was a common stance in the 1960s and it was often approached through 'deskilling' operations, such as the appropriations of media images in Pop paintings; the use of everyday photos was a related move. 'I hate the dazzlement of skill,' Richter stated in 1964; painting from photos was 'the most moronic and inartistic thing that anyone could do' (*DP* 23). At the same time, of course, he is a virtuoso painter and his paintings are painstakingly produced. Thus Richter worked not to undo the truth-claims of representation so much as to suspend the Godardian alternative mentioned above – to make 'a just painting' (à la Lichtenstein perhaps) that is also 'just a painting' (à la Warhol perhaps).

More is involved in Richter, then, than the cool pose of the typical Pop artist. For one thing he regards the partial disconnection between work and self effected by his found images and mechanical facture as a kind of *protection*. Throughout the 1960s he spoke of his encounter with photography in traumatic terms: 'For a time I worked as a photographic laboratory assistant: the masses of photographs that passed through the bath of developer every day may well have caused a lasting trauma' (*DP* 22). The trauma here is not simply the photographic usurpation of the representational function of painting anticipated long ago by Baudelaire; in fact Richter unsettles the certainty of this historical fact. Nor is it quite the psychic shock delivered to the subject by the camera as described by Barthes in *Camera*

Lucida. Rather, the trauma of photography for Richter lies both in its sheer proliferation ('the masses of photographs') and in its transformation of appearance ('the bath of developer'). As Buchloh has suggested, this reaction brings him closer to Siegfried Kracauer than to Baudelaire or to Barthes. 'The world itself has taken on a "photographic face",' Kracauer wrote in his great essay on photography (1927): '*It can be photographed because it strives to be absorbed into the spatial continuum which yields to snapshots ... That the world devours them is a sign of the fear of death. What the photographs by their accumulation attempt to banish is the recollection of death, which is part and parcel of every memory image.*'[78]

Like Warhol, Richter documents the 'photographic face' of the modern world disclosed by Kracauer; in some ways he accepts the Kracauerian opposition between the photograph and the 'memory image'. Yet, intermittently, Richter also works to reveal the deathliness of this photographic face, to overcome the apparent opposition of photography and memory, indeed to render the photograph mnemonic *in* painting, *as* painting.[79] For instance, his 1988 suite of images concerning the demise of the radical Baader-Meinhof Group, *18. Oktober 1977*, revives, however momentarily, the old category of history painting, for here Richter effectively transforms ephemeral media photographs into potent memory images. These paintings reveal a historical condition of post-war Germany – that these radicals remain 'unburied', that the question of fascism persists.

How are we to understand his intimation of both a traumatic dimension in photography and a protective potential in painting? For Richter the trauma seems to involve banality – this is a key concern of his Pop too – which he treats both in content and in form. One instance of banal content is the candelabra in *Flemish Crown* (1965), an epitome not only of a homey thing but of petit-bourgeois taste at its homeliest. Yet Richter is also interested in banality that is formal, such as when a camera turns us into an image, congeals our life-being into a cliché. This banalization occurs in the existential flashing of the camera stressed by Barthes, but also, even before, in our automatic posing in front of the apparatus – that is, in our formal conformity with the photographic face of the world. Richter has long tracked our self-fashionings according to stereotypes, sometimes in a manner that borders on artistic travesty. For example, his can-can

Gerhard RICHTER Stadtbild Madrid [Townscape Madrid], 1968
Gerhard RICHTER Plattenspieler [Record Player], from the cycle *18. Oktober 1977*, 1988

34

Ballet Dancers (1966) and soft-porn *Bathers* (1967) are degraded descendants of related subjects by Degas and Cézanne and the travesty is patent in the young strip-teaser of *Olympia* (1967), which updates and transplants the Manet prostitute to the middle-class home. This formal banality is most evident in *Eight Student Nurses* (1966), his Warholian rendering of the young victims of the serial killer Dr Richard Speck who were already 'shot' serially in the nursing yearbook that Richter used as his media source. Yet such banality is perhaps most chilling in *Three Sisters* (1965): posed in matching dresses on a family couch, these girls appear nearly cloned, as if conformity in appearance were the only way for them to attain social recognition, to be seen, at all.

'It's all evasive action,' Richter once remarked of such banality in his art (*DP* 62). Perhaps its role, then, is defensive as well as traumatic; and perhaps the same holds for the function of photography in his art. Painting from photographs

... has a great deal to do with imprecision, uncertainty, transience, incompleteness' (*DP* 74).

'All that is, seems and is visible to us because we perceive it by the reflected light of semblance. Nothing else is visible. Painting concerns itself, as no other art does, exclusively with semblance (I include photography, of course)' (*DP* 181). For Richter the photograph cannot deliver semblance because 'the camera does not apprehend objects, it sees them' (*DP* 35). That is, he regards photography as too implicated in contemporary semblance to capture it on its own; indeed it provides the very consistency of 'reflected light' that it is the task of the painter in turn to reveal; and it is this 'photo-genesis' of the world that Richter strives to paint.[80] Thus his art is less a critique of spectacle than a phenomenology of mediated appearance, of a world become Pop. The semblance that concerned the Romantic painter Friedrich is of a primary nature still illuminated by the light of God; this light is still numinous. The semblance that concerns the Pop

Gerhard RICHTER Flemish Crown, 1965
Gerhard RICHTER Olympia, 1967
Gerhard RICHTER Atlas, sheet 8, Newspaper photographs, 1962–66
Gerhard RICHTER Bathers, 1967

freed Richter from 'conscious thinking', he wrote early on; it is 'neutralized and therefore painless' (*DP* 30). Again like Warhol, he transforms the photograph, the very vehicle of the traumatic threat here, into a defence against this same threat; certainly the greys and the blurs in his painting, both of which register as photographic, can be muting in effect. Of course these elements can function in other ways too: the greys can suggest both the material actuality of paint and the mediated appearance of print, and the blurs can evoke both a memory and a fading of memory, both an obscene scene and an occluded one and so on. Yet, however different these effects, they are all common aspects of the photographic face of the world: they suggest how our very perception, memory and unconscious have become, at least in part, photographic in semblance, and again this is a fundamental demonstration of Pop. For Richter this photographic semblance produces a form of doubt (epistemological, even ontological) that his painting also works to register: 'My own relationship to reality

painter Richter is of a second nature bathed in the glow of the media, a culture of visualities that are photographic and filmic, videographic and electronic. 'Photographs are almost Nature,' Richter has commented (*DP* 187) and many of his natural subjects are presented as already mediated – through magazine ads, tourist scenes and otherworldly landscapes, such as his brilliant *Moonscapes* (1968), images that exist in the first instance only as relayed.

The penetration of appearance not only by photography but by the commodity-image is a given of the Pop moment out of which Richter developed. Just as Minimalist art often adapted the serial logic of industrial production, so Pop art often adapted the simulacral nature of the commodity-image. As we saw with Warhol, such simulation is often taken to trump representation, to undercut its referential claims. Yet, like Warhol, Richter does not simply surrender painting to the simulacral order of our image-world: just as he sometimes wrests an auratic uniqueness from tacky

SURVEY

reproductions, so too does he sometimes restore a piercing referentiality to flimsy representations. Even more than his Pop peers, then, Richter insists on painting as the medium that can still reflect on semblance. 'In order for history to present itself', Kracauer wrote, 'the mere surface coherence offered by photography must be destroyed.'[81] Similarly for Richter 'the picture is the depiction and painting is the technique for shattering it' (*DP* 227). In other words, the photograph delivers a resemblance that the painting in turn must open up, even break apart, in order that semblance – the characteristic nature of contemporary appearance – might be revealed to us. In Richter Pop art reflects not only on how appearance is transformed in consumer society, but also on how we can see, even understand, this transformation: here Pop becomes a philosophical art.

Ed Ruscha and the Cineramic Image

Ed Ruscha also reflects on a world transformed in appearance,

but in his case the primary medium of the transform-ation is not the magazine, the comics, the news photo or the snapshot, but a combination of the automobile, the storefront, the billboard and the cinema, or rather the effects of this combination on the distinctive visuality of Los Angeles, the capital of spectacle in post-war America. Ruscha varies some themes of his Pop colleagues and invents others: like Lichtenstein, he presents banal subjects, but with an enigmatic twist and, like Hamilton, he superimposes design and painting, but with an apparent integration that seems finally to resolve seeing and reading into one form of scanning. 'I began to see the printed word', Ruscha once remarked, 'and it took over from there.'[82]

Born in 1937, Ruscha left Oklahoma in 1956 to attend Chouinard Art Institute in Los Angeles. During the Depression and after World War II, Okies often struck out for California, but artists have tended in the opposite direction, towards New York.[83] His relative disinterest in the East

includes Europe (Ruscha travelled there in 1961, only to remark, rhetorically, that 'there was no art anywhere except in America' –Ed Ruscha, *Leave Any Information at the Signal: Writings, Interviews, Bits, Pages*, 2002, 121; hereafter *LA*) and it was indeed in L.A. that the two events most formative to his art occurred: the first Warhol exhibition at the Ferus Gallery in summer 1962 (where the full array of single 'Campbell's Soup Cans' was first exhibited) and the Duchamp retrospective curated by Walter Hopps at the Pasadena Museum of Art in the autumn of 1963.[84] An earlier catalyst was his discovery of Johns (specifically *Flag*, 1954–55, and *Target with Four Faces*, 1955) in *Print Magazine* in 1957; tellingly, this influence came to him through reproduction.

During this initial period Ruscha worked as a graphic artist: he designed ads briefly, then book covers and magazine layouts (including *Artforum* from 1965 to 1967). While other Pop artists used fragments of print sources, Ruscha often adapted an entire graphic look. As a result some of his early paintings, such as *Annie* (1962), partake equally of abstraction (two broad fields of primary colours – yellow above, blue below) and of design (both the name of the Little Orphan and the plump font of her comic, here in red on the yellow field). In his formats Ruscha registers a convergence between abstract painting and commercial design that is even more thorough than in Hamilton or in Lichtenstein. Yet in his procedure there is no such convergence at all. 'Abstract Expressionism collapsed the whole art process into one act', in a manner foreign to the methodical calculation of design work, Ruscha has suggested; 'I wanted to break it into stages, which is what I do now' (*LA* 228).

His work is indeed premeditated, especially the photo-books, which include *Twentysix Gasoline Stations* (1962), *Some Los Angeles Apartments* (1965), *Every Building on the Sunset Strip* (1966), *Thirtyfour Parking Lots* (1967), *Nine Swimming Pools and a Broken Glass* (1968) and *Real Estate Opportunities* (1970). 'I don't even look at it as photography,' Ruscha comments; 'they're just images to fill a book' (*LA* 49), the parameters of which are set beforehand. Although the subjects are hardly random – several books survey characteristic spaces of L.A. – the presentation is as 'neuter general' as possible: 'they're a collection of "facts" … a collection of "readymades" ' (*LA* 40, 26). Like Warhol and Richter, the young Ruscha dampened his style and statement

('it is not important who took the photos' – *LA* 25) in a way that nonetheless conveys a distinctive version of both. A deadpanness – funny, desolate, usually both – is conveyed in the homely shots of solitary gas stations, the aerial images of empty parking lots and so on; and the apparently arbitrary numbers (why exactly nine pools?) only add to the effect of blank absurdity.

Although his designs are predetermined, an ambiguity often exists within the images or the words or (more often) between the two: both the photo-books and the paintings can produce a flat sort of enigma (here too one feels a connection to Johns). Ruscha speaks of this effect as 'a kind of "huh?" ': 'I've always had a deep respect for things that are odd, for things which cannot be explained' (*LA* 65, 305). Often the 'huh' stems from his use of words, which, as in a 'misspelled grocery sign', might appear both obvious and incorrect, as so many 'incomplete sputterings' or noisome puzzles (*LA* 91, 156). Yve-Alain Bois has underscored how often Ruscha is

drawn to 'noise', to cracks in communication, and some of his verbal works do evoke the poetic figure of the calligram, in which the shape of the text is designed to reinforce the meaning, only to unravel this figure altogether (as Michel Foucault once argued that the word paintings of René Magritte do as well).[85] In Ruscha images and words do not often support one another; rather they stand apart or even in opposition and these crossings cross up the viewer as well.[86] Frequently his words are as suspended in meaning as they are in space. In 1985 he did a painting for a library rotunda in Miami that borrowed a line from *Hamlet*: 'words without thoughts never to heaven go'. This might be taken as his motto, minus the possibility of heaven.

The interest in the odd thing began as an appreciation of the common thing. Early on Ruscha painted some objects 'actual size' (as they are often painted in folk art). For example, in *Actual Size* (1962; see page 91) a fiery can of Spam flies through the space below, while the word 'Spam' appears

in yellow on dark blue in the space above. This image renders the common odd, to say the least (it is also a joke – early astronauts were called 'spam in a can' – that takes on additional meaning with junk e-mail today), and its ambiguity persists: one reason why Ruscha depicts words is that they 'exist in a world of no size' (*LA* 231) and his juxtaposition of 'actual size' and 'no size' renders the pictorial space very uncertain. Does the lower space of *Actual Size* suggest outer space? Does the upper space convey commercial space? How do the two spaces, with paint drips from the upper to the lower, relate to one another?

The potential role of the common as an ambiguous term somewhere between the folk and the Pop is important to consider here. 'Duchamp discovered common objects' (*LA* 330), Ruscha has suggested and, like Johns, Ruscha made them 'the foreground central subject' of his art (*LA* 289).[87] He did so, moreover, in a period when the common had become ever more commodified, the ordinary

ever more standard. (Warhol once suggested the term 'Commonist' as a replacement for 'Pop', as if a collective viewer might still be wrested from consumerism.)[88] Like Hamilton, Lichtenstein and Rosenquist, Ruscha also plays with reified language – with slogans, jingles and the like. He is drawn to terms that hover on the edge of cliché and sometimes he paints them as if to pull them back from this condition via ambiguity and sometimes to push them over, once and for all, into the status of a logo or a brand, along with 'Standard', '20th Century Fox' and the other trademarks that he has depicted. Occasionally, too, Ruscha underscores the paradoxical animation that words and things assume as they become reified in this way: he presents them, sometimes keyed up like special effects, as if they were the only public figures left to portray, the truly dominant features of the landscape, and in L.A. this some-times seems to be the case (the famous Hollywood sign that presides over the city recurs in his work). Ruscha is attracted to hybrid word-images, or

REAL

ESTATE

OPPORTUNITIES

Ed RUSCHA *Every Building on the Sunset Strip* [detail], 1966
Ed RUSCHA *Real Estate Opportunities*, 1970

what he calls 'the icon/logo concept' (*LA* 275); perhaps, like Hamilton, he anticipates our contemporary version of this mixed sign in the computer icon and pop-up.[89] Ruscha also depicts other things in the grip of commodification; indeed, he renders landscape *in toto* as so much real estate (e.g., 'some Los Angeles apartments'). Perhaps in landscape painting, at least since Thomas Gainsborough, land has appeared as property, but with Ruscha landscape becomes real estate *tout court*: in some of the photo-books it is even gridded and numbered as such (e.g., 'every building on the Sunset Strip').[90]

Ruscha often features structures typical of L.A., that 'ultimate cardboard cut-out town': 'Los Angeles to me is like a series of storefront planes that are all vertical from the street and there's almost like nothing behind the façades' (*LA* 244, 223). This flat frontality makes his strange photo-books like *Every Building on the Sunset Strip* suddenly appear to be obvious ways to present the material (here the even buildings

Ed RUSCHA Large Trademark with Eight Spotlights, 1962
Ed RUSCHA A Blvd. Called Sunset, 1975

appear in a strip along the top edge of the book and the odd appear, upside down, along the bottom edge). His L.A. is also a city of billboards and Ruscha seems to fashion his painting after these large screens suspended in the landscape too. Like a painting, Ruscha comments, a billboard is 'paint on a lifted-up surface', 'a backdrop for the drama that happens' and this is how the space in his paintings often serves as well (*LA* 165, 265). Certainly his focus on storefronts and billboards implies an automotive point of view and as Rosalind Krauss has suggested, the car might be his primary 'medium', the unseen vehicle of the L.A. paintings that depict various signs at different scales amid broad horizons and vast skies. The car is also 'a missing link in the [photo] books', Henri Man Barense remarks, 'the conduit between the pools, apartments and, of course, the parking lots and gas stations' (*LA* 213). 'I think of your work', Bernard Blistène comments to Ruscha, 'as a huge field in which you drive – and of the canvas as a kind of windshield' (*LA* 304).[91] Along with the billboard, Ruscha

does rethink the old window model of painting in terms of the windshield. More than most cities, Los Angeles is a horizontal expanse across which one drives from horizon to horizon: 'It's the idea of things running horizontally and trying to take off,' Ruscha remarks. 'The scale and the motion both take part in it' (*LA* 161).[92] This spatiality is a prime subject of his art.

Ruscha also evokes a design culture characteristic of L.A.: '"Hollywood" is like a verb to me,' he has commented. 'They do it with automobiles, they do it with everything that we manufacture' (*LA* 221). Clearly such connoisseurship of car models, surfboards and the like is important to Ruscha (among his studio notes is this one worthy of Banham or Hamilton: 'Core of my aesthetic is the shape of 48 Ford gearshift knob vs 48 Chevy gearshift knob' – *LA* 399).[93] Yet even more than this customizing of special consumer items, Ruscha draws on the specific visuality of cinema, its 'celluloid gloss' and space (*LA* 277). This visuality is at once deep and superficial, illusionist and flat: in the movies space is surface and vice versa and the words (as in credits and subtitles) can appear in the same register as the images. This is to say, simply, that film is projected space and Ruscha intimates this space often in his work. In *Large Trademark with Eight Spotlights* (1962) the yellow spotlights seem to originate in the distance, cut diagonally across the deep space towards us and arrive on the picture plane as though on a movie screen: the lights align with its surface, around the emblem of 20th Century Fox, which also appears to be projected – as if pictorial light and space were here subsumed by the cinematic versions of these qualities. 'I've been influenced by the movies, particularly the panoramic-ness of the wide screen,' Ruscha has remarked. 'Most of my proportions are affected by the concept of the panorama' (*LA* 291, 308). Committed to the landscape mode, he shows us horizontal spaces transformed by Cineramic spectacle, with brilliant sunsets and vast dimensions that often convey a 'deeply Californian version of infinity'.[94] 'Close your eyes and what does it mean, visually?' Ruscha asks about this Hollywood Sublime; 'it means a way of light.' It is a light that is true and

illusory at once, the stuff of Hollywood dreams: 'If you look at the 20th Century Fox, you get this feeling of concrete immortality' (*LA* 221). Yet at the same time Ruscha presents this dream-space as thin and fragile (one of his stretch sunsets contains the words 'eternal amnesia' in small print at the bottom) and sometimes there is a hint of catastrophe or 'crash' in his pictures too (*LA* 214). Like Nathaniel West and Joan Didion, Ruscha suggests that Los Angeles is a mirage and California a myth – a façade about to crumble into the desert, a set about to liquefy into the sea.

Robert Venturi, Denise Scott Brown and the Postmodern Absorption of Pop

If Ruscha registers how the nexus of cars, commodities, advertising and movies had transformed the built environment by the moment of Pop, Robert Venturi and Denise Scott Brown in turn assume this transformation as the basis of further architecture and urbanism. If his *Complexity and*

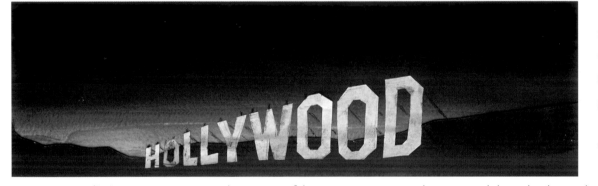

Contraction (1966) was an early critique of the apparent disconnection of modern design from society and history alike, their *Learning from Las Vegas* (1972; hereafter *LV*) was an early advocacy of postmodern design as a rapprochement with both, and Pop influenced their thought (*Learning from Las Vegas* cites Ruscha in particular).[95] According to Venturi and Scott Brown, modern design lacked 'inclusion and allusion' – inclusion of popular taste and allusion to architectural tradition – and postmodern design came into being to correct these faults. Above all, the failure of modern architecture stemmed from its refusal of 'symbolism', or historical ornament, in favour of 'expressionism', or the use of 'architectural elements' alone to convey the meaning of a building (*LV* 101). In this way, they claim, the modern paradigm of 'the duck', in which the form expresses the building abstractly, must cede to the postmodern paradigm of 'the decorated shed', a building with 'a rhetorical front and conventional behind'. 'The duck is the special building that

is a symbol,' Venturi and Scott Brown write in a famous definition; 'the decorated shed is the conventional shelter that *applies* symbols' (*LV* 87).

Learning from Las Vegas originated as a studio, conducted at Yale and in Las Vegas, in autumn 1968. Like Banham a decade before them, Venturi and Scott Brown mark their difference from the modern movement through a strategic turn to Pop imageability:
'*We came to the automobile-oriented commercial architecture of urban sprawl as our source for a civic and residential architecture of meaning, viable now, as the turn-of-the-century industrial vocabulary was viable for a Modern architecture of space and industrial technology 40 years ago*' (*LV* 90).
Yet Banham sought to update the expressionistic imperative of modern architecture vis-à-vis a futuristic commitment to technology – as such his position is truly Pop. For their part Venturi and Scott Brown shun both the expressionistic and the futuristic; indeed they oppose any 'prolongation' of the modern movement and as such their position is distinctly postmodern (*LV* xiii). They accept, not only as given but as desired, the identification of 'the civic' with 'the commercial': however 'ugly and ordinary' the strip and the suburb are, they are taken not merely as normative but as exemplary. In short, theirs is an architectural-urbanist apologia for the consumerist landscape produced by the nexus of car, commodity, advertising and movies.

'Architecture in this landscape becomes symbol in space rather than form in space,' Venturi and Scott Brown declare. 'The big sign and the little building is the rule of Route 66' (*LV* 13). Given this 'rule', *Learning from Las Vegas* often conflates trademarks with public symbols: 'The familiar Shell and Gulf signs stand out like friendly beacons in a foreign land' (*LV* 52).[96] It also often leaps to conclusions: given the vast and fast 'autoscape', only a scenographic architecture can 'make connections among many elements, far apart and seen fast' (*LV* 9). In effect, Venturi and Scott Brown translate important insights concerning this 'new spatial order' into an affirmation of 'the brutal auto landscape of great distances and high speeds' (*LV* 75). This is to naturalize a landscape that

Ed RUSCHA Hollywood Study # 8, 1968

is neither natural nor necessary; it is also to instrumentalize a sensorium of consumerist distraction in design, as they urge architects to think in terms of 'a sequence played to the eyes of a captive, somewhat fearful, but partly inattentive audience, whose vision is filtered and directed forward' (*LV* 74).[97] Here the Miesian motto of modernist clarity in architecture – 'less is more' – becomes a mandate of post-modernist distraction in design – 'less is a bore' (*LV* 139).

Despite its critique of modern architecture, *Learning from Las Vegas* draws its strategy from Le Corbusier. Again, in *Vers une architecture* and elsewhere, Le Corbusier juxtaposed classical structures and machinic commodities, such as the Parthenon and the Delage sports car, in order to advance the new monumentality of the Machine Age. Here, unlike Banham again, Venturi and Scott Brown propose a series of related analogies and they are not altogether ironic: 'Las Vegas is to the Strip what Rome is to the Piazza' (*LV* 18); billboards punctuate Las Vegas as triumphal arches

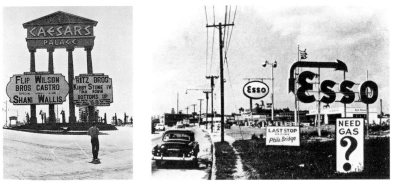

Robert **VENTURI**, Denise **SCOTT BROWN**, John **ZENCUR** Caesars Palace sign, Los Angeles, c. 1965–66, from *Learning from Las Vegas*, 1972

Peter **BLAKE** Road scene, from *God's Own Junkyard: The Planned Deterioration of America's Landscape*, 1964, reproduced in Venturi, et al., *Learning from Las Vegas*, 1972

punctuate ancient Rome; signs mark the Strip as towers mark San Gimignano; and so on (*LV* 106, 107, 117). (Is it coincidental that Venturi and Scott Brown favour the Rome of the Counter-Reformation, the capital of churchly spectacle?) If Le Corbusier moved to classicize the machine (and vice versa) in the First Machine Age, Venturi and Scott Brown move to classicize the commodity-image (and vice versa) in the First Pop Age. Sometimes the analogy between Las Vegas and Rome slips into an equation: the Strip is our version of the Piazza and so the 'agoraphobic' autoscape might as well be accepted (*LV* 49). 'Americans feel uncomfortable sitting in a square,' Venturi and Scott Brown tell us; 'they should be working at the office or home with the family looking at television.'[98]

On this point *Learning from Las Vegas* is nothing if not straightforward: Venturi and Scott Brown wish to 'enhance what is there', that is, to affirm the common-as-commodified – a slight yet significant difference from the 'Commonist' Pop

of Warhol, Ruscha and others (*LV* 3). And here they quote the developer Morris Lapidus as a guide: 'People are looking for illusions ... Where do they find this world of illusions? ... Do they study it in school? Do they go to museums? Do they travel to Europe? Only one place – the movies. They go to the movies. The hell with everything else' (*LV* 80). A new mode of social inscription is affirmed here, one that Pop works to explore, if not critically, then at least ambivalently (as we saw with Hamilton especially). For its part postmodern architecture à la Venturi and Scott Brown is placed in its service – to design its appropriate byways, in effect. Here, too, the postmodern critique of cultural elitism becomes a problematic form of manipulative populism. And yet how popular, let alone sincere, is this populism? If Hamilton practised an 'ironism of affirmation', Venturi and Scott Brown propose an affirmation of irony: 'Irony may be the tool with which to confront and combine divergent values in architecture for a pluralist society' (*LV* 161). But this 'double-functioning' of postmodern design is actually a double-coding of cultural cues – 'allusion' to architectural tradition is offered to an educated elite, 'inclusion' of commercial kitsch to everyone else – that reaffirms rather than over-comes class lines. This pseudo-populism only became dominant ten years later under Ronald Reagan, as did the neo-conservative equation of political freedom and free markets presented in *Learning from Las Vegas*. In this regard Venturi and Scott Brown do count as an avant-garde, but an avant-garde of the Right.

Venturi and Scott Brown cycle Pop icons back to the consumerist environment from which they first emerged – they are built back in, as it were, structurally. Here, then, Pop becomes tautological and the popular no longer challenges the official. In the form of postmodern design, Pop becomes a recipe of accommodation to the 'ugly and ordinary' relieved, again for elite taste, by a spicing of historical allusions. At this point Pop loses whatever edge it had: in its postmodern make-over it is a style of the status quo.

1 This list overlooks many singular artists who developed Pop-like positions before, after or during the Pop heyday, such as the Americans Bruce Conner, Jess, Ed Keinholz, Ray Johnson and Jack Smith, the Swede Öyvind Fahlström, the English Malcolm Morley, the French Niki de Saint Phalle, the German Richard Lindner, the Swiss Peter Stämpfli – and this is only a beginning. For helpful readings of this text I thank Ian Farr and Mark Francis.

2 This is particularly true of French and German artists. If some associated with Nouveau Réalisme, such as Arman and Spoerri, were ambivalent about this consumer society, others such as Jacques de la Villeglé and Raymond Hains were critical of it. Yet, on the score of opposition to consumer society, the true enemy twins of the Pop artists were the Situationists led by Guy Debord. A figure such as Jean-Luc Godard, then, might be positioned somewhere between the Situationists, who were contemptuous of 'spectacle', and the Pop artists, who were often seduced by it. Godard was close enough to the Situationist critique of spectacle to be condemned by the Situationists, but also close enough to the Pop exploration of spectacle to count among the great inventors of the Pop image (at least from *Breathless* [*À bout de souffle*, 1960] through *Week-end* [1967]). I regret that my focus on art prevents an account of his extraordinary cinema, which is nonetheless represented elsewhere in the book.

3 Lawrence Alloway, 'The Long Front of Culture', *Cambridge Opinion*, no. 17 (1959).

4 See Reyner Banham, *Theory and Design in the First Machine Age* (London: Architectural Press, 1960).

5 See Robert Venturi, Denise Scott Brown and Steven Izenour, *Learning from Las Vegas* (Cambridge, Mass.: MIT Press, 1972); hereafter abbreviated *LV* in the text.

6 A brief note on the historiography of Pop art. The key group exhibitions (see bibliography for full details) include: 'New Painting of Common Objects', Pasadena Art Museum, 1962; 'The Popular Image', ICA, London, 1963; 'Six Painters and the Object', Guggenheim Museum, New York, 1963; 'The New Generation: 1964', Whitechapel Art Gallery, London, 1964; 'New York Painting 1940–1970', Metropolitan Museum, New York, 1969; 'American Pop Art', Whitney Museum, New York, 1974; 'Blam! The Explosion of Pop, Minimalism and Performance 1958–1964', Whitney Museum, 1984; 'Made in USA: An Americanization in Modern Art. The 50s and 60s', University Art Museum, Berkeley, Los Angeles, 1987; 'The Independent Group: Postwar Britain and the Aesthetics of Plenty', ICA, London, 1990; 'Pop Art: An International Perspective', Royal Academy of Arts, London, 1991; 'Hand-Painted Pop: American Art in Transition 1955–1962', Museum of Contemporary Art, Los Angeles, 1993; 'Les Années Pop', Centre Georges Pompidou, Paris, 2001; and 'Pop Art: US/UK Connectons, 1956–1966', Menil Collection, Houston, 2001. Besides the catalogues of these exhibitions, the key histories and source books (again in English alone) include: Lucy R. Lippard, ed., *Pop Art* (1966; revised 1970); John Russell and Suzi Gablik, eds, *Pop Art Redefined* (1969); Simon Frith, *Art into Pop* (1987); Paul Taylor, ed., *Post-Pop Art* (1989); Marco Livingstone, *Pop Art: A Continuing History* (1990; revised 2000); Steven Henry Madoff, ed., *Pop Art: A Critical History* (1997); and Cecile Whiting, *A Taste for Pop: Pop Art, Gender and Consumer Culture* (1997).

7 Alison and Peter Smithson, 'But Today We Collect Ads', *Ark*, no. 18 (November 1956). Also see Beatriz Colomina, *Privacy and Publicity: Modern Architecture as Mass Media* (Cambridge, Massachusetts: MIT Press, 1994).

8 Richard Hamilton, *Collected Words 1953–82* (London: Thames & Hudson, 1982), 28; hereafter abbreviated *CW*.

9 Alloway, 'The Long Front of Culture'.

10 Banham revised the notion of a cultural continuum slightly: he thought in terms of a plurality of hierarchies, which safeguarded critical judgment. For an excellent account see Nigel Whiteley, *Reyner Banham: Historian of the Immediate Future* (Cambridge, Massachusetts: MIT Press, 2002).

11 Reyner Banham, 'Who is This Pop?' *Motif*, no. 10 (Winter 1962-63), 13

12 One exception here is folk music, the basis of much pop music and common culture from Elvis to Dylan and beyond.

13 Reyner Banham, 'The Atavism of the Short-Distance Mini-Cyclist', *Living Arts*, no. 3 (1964), 92. The second paradox is only apparent in the sense that the embrace of American culture was construed as a critique of high art and to this extent 'Left-orientated'.

14 Banham, *Theory and Design*, 11.

15 Reyner Banham, 'Vehicles of Desire', *Art*, no. 1 (1 September 1955), 3; *Theory and Design*, 132.

16 Banham, 'Vehicles of Desire', 3.

17 Reyner Banham, 'Design by Choice', *The Architectural Review*, 130 (July 1961), 44. I am indebted to Whiteley on this point.

18 Banham, *Theory and Design*, 12.

19 This sentence appears in the original introduction to Banham, *Theory and Design*, 10. Banham betrays little sense that this shift might involve

20 Banham in 1960 cited in Whiteley, *Reyner Banham*, 162.

21 Alison and Peter Smithson, 'Thoughts in Progress', *Architectural Design* (April 1957), 113.

22 Peter Cook, 'Zoom and "Real" Architecture', *Archigram*, 4 (1964).

23 Reyner Banham, *Megastructure: Urban Futures of the Recent Past* (New York: Harper and Row, 1976), 17.

24 Banham in Peter Cook, ed., *Archigram* (London: Studio Vista, 1972), 5.

25 Reyner Banham, 'A Clip-On Architecture', *Design Quarterly*, no. 63 (1963), 30.

26 Paolozzi also made a collage titled *Bunk! Evadne in Green Dimension* (1952), which looks ahead to the famous Hamilton collage *Just what is it that makes today's homes so different, so appealing?* (1956); it also seems to include the image of a Ford. To say 'history is bunk' might be, here, to suggest that 'history' can also be made from 'bunk' – i.e., from the apparent 'nonsense' (one meaning of 'bunk') of media images.

27 Julian Myers, 'The Future as Fetish', *October*, 94 (Fall 2000), 70.

28 For an early critique of this doubling of fetishisms – as a compounding rather than as a critique – see Laura Mulvey, 'Fears, Fantasies and the Male Unconscious, or "You Don't Know What is Happening, Do You, Mr Jones?"', in *Spare Rib* (1973); reprinted in Laura Mulvey, *Visual and Other Pleasures* (Bloomington: Indiana University Press, 1989). Along with the institutional inequality of the art world at the time, this hyper-fetishism might account for the scarcity of Pop artists who are women, though, as Surrealism suggests, women can also produce fetishistic representations of women. One can count prominent female Pop artists on one hand: Pauline Boty (whose life was cut short by leukemia in 1966), Niki de Saint Phalle, Marisol … Perhaps the economic redomestication of middle-class women as housewives after the war also made Pop representations of consumption less available to women. There is, however, the partial exception of women who were designers – though the best-known, such as Alison Smithson and Ray Eames, were partnered with their husbands. See Cecile Whiting, *A Taste for Pop: Pop Art, Gender and Consumer Culture* (Cambridge: Cambridge University Press, 1997).

29 Walter Benjamin, 'Paris, the Capital of the Nineteenth Century' (1935), in *The Arcades Project*, trans. Howard Eiland and Kevin McLaughlin (Cambridge, Massachusetts: Harvard University, Press, 1999), 8.

30 Foucault once remarked that with subjugation as much as control.

31 See Michel Carrouges, *Les Machines célibataires* (Paris: Éditions Arcanes, 1954).

32 Perhaps Hamilton also had in mind another note concerning the *Large Glass* in which Duchamp speaks of 'the interrogation of the shop window' and 'the coition through the glass pane.' If this is the case, then the 'interrogation' here becomes the enticement of the showroom, a total environment. See *The Essential Writings of Marcel Duchamp* (London: Thames & Hudson, 1975), 74.

33 Banham cited this line in 'Vehicles of Desire'

34 The tabular pictures also suggest an updating of *The Story of the Eye* (1928), where Bataille plays with different conjunctions of sexual objects, human and not.

35 Roland Barthes, *Mythologies* (1957), trans. Annette Lavers (New York: Hill & Wang, 1972), 99. The relation here is one not of direct influence but of parallel responses to similar changes in the object-world.

36 Perhaps not coincidentally, the famous 'Kitchen Debate' between Khruschev and Nixon at the Moscow World's Fair occurred in 1959.

37 In this way Hamilton evokes a world in which artistic aura, fetish objects and the gaze have become confused. For a discussion of this confusion emergent in Surrealism, see my *Compulsive Beauty* (Cambridge, Massachusetts: MIT Press, 1993), 192–206. I stress the fetishistic use of relief and collage here because, in the different context of Constructivism after the Russian Revolution, they were taken up precisely to defetishize the 'bourgeois fetishism' of painting.

38 See T.J. Clark, 'Modernism, Postmodernism and Steam', *October*, 100 (Winter 2002). Early on Hamilton calls this hybrid 'a poster' (*CW* 104).

39 As William Turnbull recalled in 1983: 'Magazines were an incredible way of randomizing one's thinking (one thing the Independent Group was interested in was breaking down logical thinking) – food on one page, pyramids in the desert on the next, a good-looking girl on the next; they were like collages' (in David Robbins, ed., *The Independent Group: Postwar Britain and the Aesthetics of Plenty* [Cambridge, Massachusetts: MIT Press, 1989], 21). On the culture industry see Theodor Adorno and Max Horkheimer, *The Dialectic of Enlightenment* (1944), trans. John Cumming (New York: The Seabury Press, 1972).

40 Perhaps more than any others, these images recall the media collages of Rauschenberg, yet the tabular picture should not be confused with his 'flat-bed picture plane', as Leo Steinberg termed it in 'Other Criteria' (*Other Criteria* [New York: Oxford University Press, 1972]). Both types of picture might be 'horizontal' in operation, not only in the practical sense that they might be assembled on the studio floor, but also in the cultural sense that they might scan across 'the fine/pop art continuum' (as Alloway called it in 'The Long Front of Culture'). Nevertheless, as Hamilton states as early as *Just what is it?*, the tabular image remains pictorial: it is still a vertical picture of a semi-illusionistic space, even though this orientation might be associated with the magazine layout as much as with the painting rectangle (this association might also be distinctive of Pop, especially in Rosenquist and Ruscha). Moreover, the tabular picture is iconographic in a way that Rauschenberg images are not; and in keeping with the I.G., it is also communicative, almost pedagogical, again as Rauschenbergs are not. Further, the desirous eye that Hamilton charts in his pictures is different from 'the vernacular glance' that Rauschenberg evokes in his collages. For further discussion of Rauschenberg see Branden W. Joseph, *Random Order: Robert Rauschenberg and the Neo-Avant-Garde* (Cambridge, Massachusetts: MIT Press, 2003) and Branden W. Joseph, ed., *Robert Rauschenberg* (Cambridge, Massachusetts: MIT Press, 2002).

41 Also in 'Other Criteria' Steinberg argues that, for all its claim to autonomy, late-modernist abstraction (e.g., Kenneth Noland and Frank Stella) is informed by a logic of design, in fact by the very logic of car styling so admired by Banham and Hamilton – again, imagistic impact, fast lines and speedy turnover. That is, he suggests that under the historical pressure of consumer society an ironic identity was forged between modernist painting and its mass-cultural other, whether this other is called 'kitsch' (Greenberg), 'theatricality' (Michael Fried) or 'design'. In this regard what Greenberg and Fried theorize as a strictly optical space of pure painting, Hamilton pictures as a

strictly scopophilic space of pure design; and what Greenberg and Fried theorize as a modernist subject, fully autonomous and morally alert, Hamilton projects as its apparent opposite, a fetishistic subject, openly desirous.

42 'Banality' is a lightning-rod term of the time: witness the controversy sparked by Hannah Arendt with her thesis, in *Eichmann on Trial* (New York: Viking Press, 1963), of 'the banality of evil'.

43 In fact most American Pop artists were deferential to the Abstract Expressionists, whom they felt they must work through, which they sometimes did by way of Johns.

44 See Michael Lobel, *Image Duplicator: Roy Lichtenstein and the Emergence of Pop Art* (New Haven: Yale University Press, 2002); and David Deitcher, 'Teaching the Late Modern Artist: From Mnemonics to the Technology of Gestalt' (Ph.D. dissertation, Graduate Center, City University of New York, 1989).

45 Lobel, *Image Duplicator*, 47.

46 Roy Lichtenstein in John Coplans, 'Talking with Roy Lichtenstein', *Artforum* (May 1967), 34.

47 See Steinberg, 'Jasper Johns: the First Seven Years of His Art', In *Other Criteria*.

48 In this respect Lichtenstein is current with the investigation of realism that Barthes begins to produce in the early 1960s or, in a different vein, with that of Ernst Gombrich, whose *Art and Illusion* (1960) he read at the time.

49 As we will see, Ruscha achieves a related effect with different means.

50 Lichtenstein kept a hand-written list of such terms that begins with 'Thwack' and ends with 'Pok Pok'. Apparently he was interested in how such non-words can also be conventionalized.

51 On this point see the exchange between Michael Fried and Rosalind Krauss in Hal Foster, ed., *Discussions in Contemporary Culture* (Seattle: Bay Press, 1987).

52 Lichtenstein in Coplans, 'Talking with Roy Lichtenstein', 36.

53 When he begins to Lichtensteinize some of these masters directly, with paintings after Picasso, Matisse, Mondrian and others, these connections become too obvious.

54 Steinberg, 'Other Criteria', 88; also see note 40 above. For Steinberg this paradigm signalled a 'postmodernist' break with modernist models of picturing (he was one of the first critics to use the term cogently).

55 See Lobel, *Image Duplicator*, 118–19. As suggested, Hamilton is also alert to the emergence of a hybrid word-image that we scan, as is Ruscha.

56 This is not to say that Warhol did no great work after his shooting: on the contrary, his 'Skulls' (1976) and

'Oxidations' (1978), to name just two series, are magnificent.

57 Roland Barthes, 'That Old Thing, Art', in Paul Taylor, ed., *Post-Pop* (Cambridge, Massachusetts: MIT Press, 1989), 26. With variations this reading is repeated by other theorists such as Michel Foucault, Gilles Deleuze and Jean Baudrillard.

58 Thomas Crow, 'Saturday Disasters', in Annette Michelson, ed. *Andy Warhol* (Cambridge, Massachusetts: MIT Press, 2001), 51, 55, 58, 60.

59 Andy Warhol in Gretchen Berg, 'Andy: My True Story', *Los Angeles Free Press* (March 17, 1963), 3.

60 Andy Warhol in Gene Swenson, 'What is Pop Art? Answers from Eight Painters, Part I', *ARTnews*, 62 (November 1963), 26.

61 Cynical artists such as Jeff Koons and Damien Hirst have since exhausted it vis-à-vis our own hyperconsumer-ist moment. On 'capitalist nihilism' see Benjamin Buchloh, 'The Andy Warhol Line', in Gary Garrels, ed., *The Work of Andy Warhol* (Seattle: Bay Press, 1989) and my 'Dada Mime', *October*, 106 (Fall 2003).

62 Andy Warhol, undated statement cited in Kynaston McShine, ed., *Andy Warhol: A Retrospective* (New York: Museum of Modern Art, 1989), 457.

63 Andy Warhol and Pat Hackett, *POPism: The Warhol 60s* (New York: Harcourt Brace Jovanovich, 1980), 50.

64 Warhol in Swenson, 'What is Pop Art?', 60.

65 Roland Barthes, *Camera Lucida*, trans. Richard Howard (New York: Hill and Wang, 1981), 26, 55, 53. For an account of this connection between Barthes and Lacan, see Margaret Iversen, 'What is a Photograph?' *Art History*, 17, no. 3 (September 1994).

66 Andy Warhol, *The Philosophy of Andy Warhol* (New York: Harcourt Brace Jovanovich, 1975), 81.

67 Warhol in Berg, 'Andy: My True Story', 3.

68 Warhol in Swenson, 'What is Pop Art?', 26.

69 Warhol in Berg, 'Andy: My True Story', 3.

70 Michael Warner, 'The Mass Public and the Mass Subject', in Bruce Robbins, ed., *The Phantom Public Sphere* (Minneapolis: University of Minnesota Press, 1993), 242.

71 See Richard Meyer, 'Warhol's Clones', *The Yale Journal of Criticism*, 7, no. 1 (1994).

72 Warhol in Swenson, 'What is Pop Art?', 60.

73 Andy Warhol in David Bailey, *Andy Warhol: Transcript* (London, 1972), quoted by Benjamin Buchloh in 'Andy Warhol's One-Dimensional Art', in McShine, ed., *Andy Warhol*, 27.

74 When Warhol made his *Thirteen Most Wanted Men* for the 1964

World's Fair in New York, men in power – such as Governor Nelson Rockefeller, Commissioner Robert Moses and elite architect Philip Johnson, who not only helped to design the society of the spectacle, but also sought to represent it (in symbolic events such as the World's Fair) as the fulfilment of the American dream of success and self-rule – could not tolerate it. Warhol was ordered to cover up the image, literally to repress it (which he did, in mockery, with his signature silver paint) and they were not amused when he offered to substitute a portrait of Robert Moses instead.

75 Gerhard Richter, *The Daily Practice of Painting: Writings 1962–1993*, ed. Hans-Ulrich Obrist, trans. David Britt (Cambridge, Massachusetts: MIT Press/London: Thames & Hudson, 1995), 55, 23; hereafter abbreviated *DP* in the text. I am indebted here, as all engaged viewers of Richter are, to the writings of Benjamin Buchloh on the artist.

76 See Robert Rosenblum, *Modern Painting and the Northern Romantic Tradition: Friedrich to Rothko* (New York: Harper & Row, 1975). Especially in his colour-chart paintings Richter seems to fold the etiolated tradition of constructivist painting (e.g., Max Bill) into his mix as well.

77 Benjamin Buchloh, 'Gerhard Richter's *Atlas*: The Anomic Archive', *October*, 88 (Spring 1999).

78 Siegfried Kracauer, *The Mass Ornament*, trans. and ed. Thomas Y. Levin (Cambridge, Massachusetts: Harvard University Press, 1995), 59.

79 Perhaps this ambition is implied, cryptically, in his intention 'not [to] use [photography] as means to painting but [to] use painting as a means to photography' (*DP*, 73).

80 For Richter the semblance of the world is not given; the painter must 'repeat' it or, more exactly, 'fabricate' it in order to capture 'reflected light' as we experience it today, to make it 'valid'. ('I would like to make it valid, make it visible,' he remarked early on of the photograph, in the sense less of affirmation than of understanding [*DP*, 33].) Semblance according to Richter is thus about our apprehension of appearance; it is about human perception, embodiment, agency – not as they are for all time but as they are transformed with social change and technological development.

81 Kracauer, *The Mass Ornament*, 52.

82 Ed Ruscha, *Leave Any Information at the Signal* (Cambridge, Massachusetts: MIT Press, 2002), 151; hereafter abbreviated *LA*.

83 Ruscha: 'In the early 1950s I was awakened by the photographs of Walker Evans and the movies of John Ford, especially *Grapes of Wrath* where the poor 'Okies' (mostly farmers whose land dried up) go to

California with mattresses on their cars rather than stay in Oklahoma and starve. I faced a sort of black-and-white cinematic identity crisis myself in this respect – sort of a showdown with myself – a little like trading dust for oranges. On the way to California I discovered the importance of gas stations. They are like trees because they are there …' (*LA*, 250).

84 The retrospective coincided with the second Warhol show at Ferus Gallery, which included silkscreens of Elvis and Liz. At this time Ruscha also met Richard Hamilton, who was in town for the Duchamp show.

85 Yve-Alain Bois, 'Thermometers Should Last Forever', in *Ed Ruscha: Romance with Liquids 1966–1969* (New York: Rizzoli, 1993); Michel Foucault, *This is Not a Pipe*, trans. Richard Howard (Berkeley: University of California Press, 1983), 19–31. Ruscha is sometimes called 'the Magritte of the American Highway'.

86 Even his early paintings that spell out onomatopoeic utterances like 'oof' and 'smash' do not appear motivated or grounded.

87 Above I suggested a shift from folk to Pop as the basis of a common culture; although first glimpsed by Banham, this process was more pronounced in the US than in the UK. It is registered, for example, by Johns and, more strongly, by Ruscha. His first group show, also curated by Hopps, was called 'New Painting of Common Objects' and it included other connoisseurs of the common such as his friend Joe Goode. On the affirmation of the ordinary in Ruscha see Dave Hickey, 'Available Light', in *The Works of Edward Ruscha* (San Francisco: San Francisco Museum of Modern Art, 1982), 24.

88 Warhol in Swenson, 'What is Pop Art?', 60.

89 As early as 1967 Ruscha depicted the numbers '1984' in a font suggestive of the computer to come. In a late text, 'The Information Man', he mocks, hilariously, another kind of reified language that is statistical and bureaucratic in nature (see *Los Angeles Institute of Contemporary Art Journal*, no. 6 [June–July 1975], 21).

90 Here the suburban, eastern complement of the real-estate photo-books is the Dan Graham piece *Homes for America* made for the December 1966/January 1967 issue of *Arts Magazine*.

91 In at least one instance in Ruscha's work a painting shows a rear-view mirror perspective, with the Hollywood sign seen in reverse at sunset.

92 Also important here is the distracted attention of the driver, which Ruscha also evokes with details that leap out from expanses that go by almost unseen: in the car 'things are automatic … They go by you so fast

that they seem to have a power.' (*LA*,304).

93 Or again: 'I believe an innocuous piece of industrial design can shape your attitudes of the world. In my case that could be the gearshift knob from a 1950 Ford sedan. It's the little things that matter' (*LA*, 400). His 1975 film *Miracle* tells 'a shaggy dog story about a guy who works on a 1965 Mustang, repairing the carburetor. In the beginning, he's a crude mechanic; but he undergoes a transformation from being this crude mechanic to being a lab technician' (*LA*, 172). 'Finish fetish', the artistic version of this customizing, is evident in several other L.A. artists at this time – Billy Al Bengston, Ron Davis and Craig Kaufmann, to name only a few, who experimented with lacquers, polymers, fibreglass, Plexiglas and the like. On this culture of customizing see the title essay in Tom Wolfe, *The Kandy-Kolored Tangerine-Flake Streamline Baby* (New York: Farrar Strauss & Giroux, 1965); also see Reyner Banham, *Los Angeles: The Architecture of Four Ecologies* (New York: Harper & Row, 1971).

94 Dietrich Dietrichsen in Marika Magers, ed., *Ed Ruscha: Gunpowder and Stains* (Cologne: Walter König, 2000), 9. Ruscha: 'I have a very locked-in attitude about painting things in a horizontal mode. I think I'm lucky that words happen to be horizontal.' Already in Oklahoma 'everything was horizontal' (*LA*, 290, 300).

95 Venturi and Scott Brown might share less with Ruscha on Los Angeles than with Tom Wolfe on Las Vegas, especially the Pop language of his Gonzo journalism. See his 'Las Vegas (What?) Las Vegas (Can't hear you! Too noisy) Las Vegas!!!' in *The Kandy-Kolored Tangerine-Flake Streamlined Baby*). Previously Venturi made the connection to Pop in 'A Justification for a Pop Architecture' in *Arts and Architecture*, 82 (April 1965), as did Scott Brown in 'Learning from Pop' in *Casabella*, 359–360 (December 1971).

96 One might argue that this conflation of trademark and public sign is another lesson of Pop. And yet it is rarely affirmed there: for example, in the 'Monuments' of Oldenburg – his giant baseball bats, Mickey Mouses, hamburgers and the like – the radical inadequacy of such a substitution is underscored.

97 From Donald Appleyard, Kevin Lynch and John R. Myer, *The View from the Road* (Cambridge, Massachusetts: MIT Press, 1964), 5.

98 Robert Venturi, *Complexity and Contradiction in Architecture* (New York: The Museum of Modern Art, 1966), 131.

WORK-S

KEN ADAM
KENNETH ANGER
MICHELANGELO ANTONIONI
DIANE ARBUS
ALLAN D'ARCANGELO
ARCHIGRAM
ARCHIZOOM
& SUPERSTUDIO
ARMAN
RICHARD ARTSCHWAGER
DAVID BAILEY
CLIVE BARKER
BEN
BILLY AL BENGSTON
WALLACE BERMAN
PETER BLAKE
DEREK BOSHIER
PAULINE BOTY
MARK BOYLE
& JOAN HILLS
GEORGE BRECHT
MARCEL BROODTHAERS
R. BUCKMINSTER FULLER
RUDY BURCKHARDT

DONALD CAMMELL
& NICOLAS ROEG
PATRICK CAULFIELD
CÉSAR
JOHN CHAMBERLAIN
BRUCE CONNER
SISTER CORITA
ROGER CORMAN
ROBERT CRUMB
GUY DEBORD
JIM DINE
WALT DISNEY
IMAGINEERING
ROSALYN DREXLER
MARCEL DUCHAMP
WILLIAM EGGLESTON
ERRÓ
ÖYVIND FAHLSTRÖM
ROBERT FRANK
LEE FRIEDLANDER
JEAN-LUC GODARD
ERNÖ GOLDFINGER
JOE GOODE
DAN GRAHAM

RED GROOMS
RAYMOND HAINS
RICHARD HAMILTON
DUANE HANSON
NIGEL HENDERSON
DAVID HOCKNEY
HANS HOLLEIN
DENNIS HOPPER
ROBERT INDIANA
ALAIN JACQUET
JESS
GÉRARD JOANNÈS
JASPER JOHNS
RAY JOHNSON
ALLEN JONES
ASGER JORN
ALEX KATZ
EDWARD KIENHOLZ
R.B. KITAJ
WILLIAM KLEIN
YAYOI KUSAMA
GERALD LAING
JOHN LENNON
ROY LICHTENSTEIN

KONRAD LUEG
JOHN McHALE
CHARLES MOORE
MALCOLM MORLEY
CLAES OLDENBURG
EDUARDO PAOLOZZI
D.A. PENNEBAKER
PETER PHILLIPS
MICHELANGELO PISTOLETTO
SIGMAR POLKE
CEDRIC PRICE
ARTHUR QUARMBY
MEL RAMOS
ROBERT RAUSCHENBERG
MARTIAL RAYSSE
RON RICE
GERHARD RICHTER
LARRY RIVERS
JAMES ROSENQUIST
MIMMO ROTELLA
ED RUSCHA
LUCAS SAMARAS
PETER SAUL
CAROLEE SCHNEEMANN

KURT SCHWITTERS
GEORGE SEGAL
COLIN SELF
MARTIN SHARP
JACK SMITH
RICHARD SMITH
ALISON & PETER SMITHSON
DANIEL SPOERRI
FRANK TASHLIN
PAUL THEK
WAYNE THIEBAUD
JOE TILSON
JEAN TINGUELY
THE VELVET UNDERGROUND
VENTURI, SCOTT BROWN &
ASSOCIATES
JACQUES DE LA VILLEGLÉ
WOLF VOSTELL
ANDY WARHOL
ROBERT WATTS
JOHN WESLEY
TOM WESSELMANN
ROBERT WHITMAN
GARRY WINOGRAND

REVOLT INTO STYLE

During the 1950s the idea of Pop was formed through a focus on the specifically American vernacular cultures of ads, movies, automobile styling and popular music. Hollywood and Disneyland turned American family life into melodrama and cliché, while the look of magazines, especially the widespread use of photography, was absorbed into the field of visual art, as it turned away from a dependence on European archetypes, and towards an analysis of the epic and iconic qualities of the everyday. The defining figure of the teenager was invented, while a bohemian rebellion against the stasis and complacency of family values was articulated, especially in San Francisco, the city of the Beats, by artists and writers such as Jess, Allen Ginsberg, Jack Kerouac and Kenneth Anger. Ironically it was in Europe that the first intellectual and visual critiques were made of modern American culture, especially in London, through the activities and influence of the Independent Group. Just as the attitude of Marlon Brando, James Dean and Elvis Presley turned into an image, so the revolt against bourgeois standards was itself transformed into style.

Jack KEROUAC

Original typescript of *On the Road*

1951

Teletype printed paper scroll

l. 36.5 m [120 ft]

Preserved as a 120-foot long scroll, this manuscript is the relic of Kerouac's frenetic typing of *On the Road* during three weeks of caffeine-induced wakefulness in 1951 at the New York apartment of Carolyn, wife of his friend Neal Cassady, on whom the book's young narrator Dean Moriarty is modelled. A continuous stream of prose, using no paragraph marks and little punctuation, its jump-cut, fast-paced fictional narrative conveys Kerouac's first-hand experience of travelling across the United States, like a 'beat' down-and-out, in an aimless search for life and intensity. Edited and published six years later, *On the Road* soon became a cult book, turning the values of the Beat poets, musicians and artists (for whom 'beat' had many more connotations, such as the rhythm of blues and jazz) into a widespread social phenomenon. In another manuscript (*c.* 1952–54), for the *Book of Dreams*, Kerouac cut and pasted newspaper fragments of headlines, hip slogans and advertising jingles. Media messages typeset in display fonts were transformed into collage-poems.

opposite

Robert FRANK

Santa Fe, New Mexico

1955-56

Gelatin silver print

30 × 40 cm [12 × 16 in]

One of 83 photographs published in *Les Américains*, Robert Delpire,
Paris, 1958; *The Americans*, Grove Press Inc., New York, 1959, with
an introduction by Jack Kerouac

Originally from Switzerland, after travelling the world Frank came to the United States
in 1953. From 1955 to 1957, aided by a Guggenheim grant, he traversed the country
observing with his camera the ordinary realities that were seldom if ever portrayed
by mainstream photography of the time. The resulting book, *The Americans*, was
originally published in France as a socio-political survey with a text by Alain Bosquet,
then reissued in the US without the text and with a new introduction by Jack Kerouac,
in which he described the photographer as sucking 'a sad poem right out of America
on to film, taking rank among the tragic poets of the world'. Vastly influential as
a document of real, lived experience, *The Americans* also closely observed post-war
capitalism's rapid transformation of the landscape. Here Frank captures the iconic
quality of a gasoline station, with its huge double-message sign and robot-like pumps
– a subject later explored in different ways by Pop artists such as Ed Ruscha, Allan
d'Arcangelo and Alain Jacquet.

opposite
Rudy BURCKHARDT
Jumbo Malted, New York
c. 1940
Gelatin silver print
28 × 35.5 cm [11 × 14 in]

Like Walker Evans before him, in the early 1940s Swiss-born Rudy Burckhardt began
to photograph the hand-painted advertising billboards that increasingly dominated
American roadsides and city main streets. One famous photograph of Astor Place,
New York (1947) he nicknamed the 'Coca-Cola Goddess', its central subject being
the huge advertisement that dwarfs and conceals most of the buildings over which
it looms. The photograph shown here is composed of a detail from one of Burckhardt's
series of views of New York street stalls and shops, where he focused on the smaller-
scale advertising logos and painted signs designed to lure passers-by in a more
subliminal way. Here he zooms in on details of the brand signs for Coca-Cola and
a popular malted milk drink of the time, in a composition that foreshadows the work
of Pop painters in the early 1960s.

opposite
William <u>KLEIN</u>
Broadway by Light [details]
1958
35mm film, 14 min., colour

Klein's first film, *Broadway by Light* was released two years after the publication of his photo book *Life is Good and Good for You in New York: Trance Witness Revels* (Éditions du Seuil, Paris, 1956), a project financed by *Vogue* magazine. Klein laid it out using their state-of-the-art photostat machine, enabling him to enlarge his street photos and combine them with his own typography in an unprecedented way, creating one of the first examples of a sustained 'Pop' approach to word and image. The title of his film is a play on words: Broadway has no night due to the saturation of neon and illuminated signs around Times Square. Shot with a borrowed camera over a series of nights, the film progresses from electric signs to various movie marquees, framing technicians while they dismantle and arrange the names of film stars and titles of upcoming features. The first film with a recognizably Pop subject and process, it explores an integral part of Manhattan's visual rhythm through a non-narrative method. It was through Klein's contacts in France, such as Chris Marker and Alain Resnais, who had assisted publication of the book, that post-production was funded and the film distributed.

Bruce <u>CONNER</u>
A MOVIE
1958
16mm film, 12 min., black and white, sound
Two consecutive stills from torpedo sequence

In his first film, Conner montaged and juxtaposed found footage in a way that derived from his practice of assemblage and collage. His selection emphasizes the existence of readymade filmic moments from newsreels, Hollywood out-takes and home movies. The montage of melodramatic and shocking images suggests a hostile critique of modern life. Destruction, death and sex are dominant references. The film was a landmark in the history of avant-garde cinema, both for its liberating technique and its engagement with contemporary mass-media forms of representation.

Kenneth <u>ANGER</u>
Puce Moment
1949
16mm film, 6 min., colour, soundtrack
With Yvonne Marquis

Released as a self-contained fragment from *Puce Woman*, an abandoned feature-length production centred on the image of faded Hollywood actresses decaying in their mansions, this short film focuses on one such subject and the fetishistic ritual and magic surrounding her. Joseph Cornell's earlier silent film *Rose Hobart* (1936) had edited a 1930s B movie down to isolate just those scenes in which the heroine appears centre frame, beautiful and mysterious. In Anger's film an actress (played by Yvonne Marquis) in exaggerated make-up and art deco-style atire, parodies silver screen glamour while exuding a powerful mystique, conveyed through extreme camera angles, a distorted musical soundtrack and a magical, eroticized sequence where she seems to be floating through space on her puce couch. The film's imagery anticipates the later work of Jack Smith and Andy Warhol.

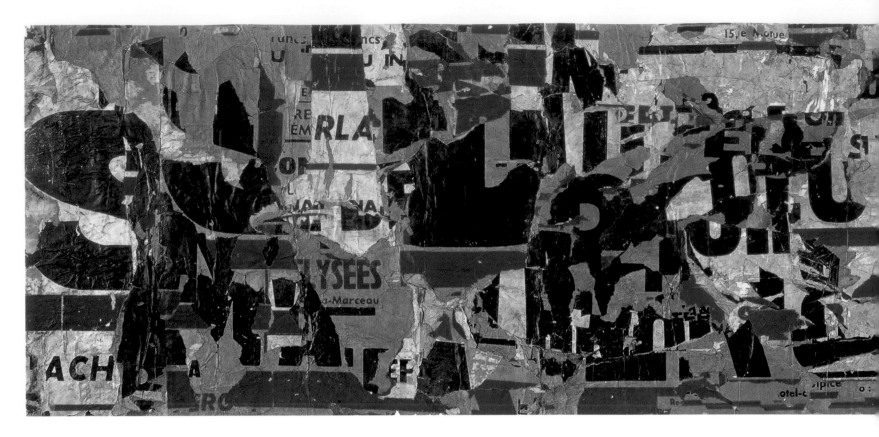

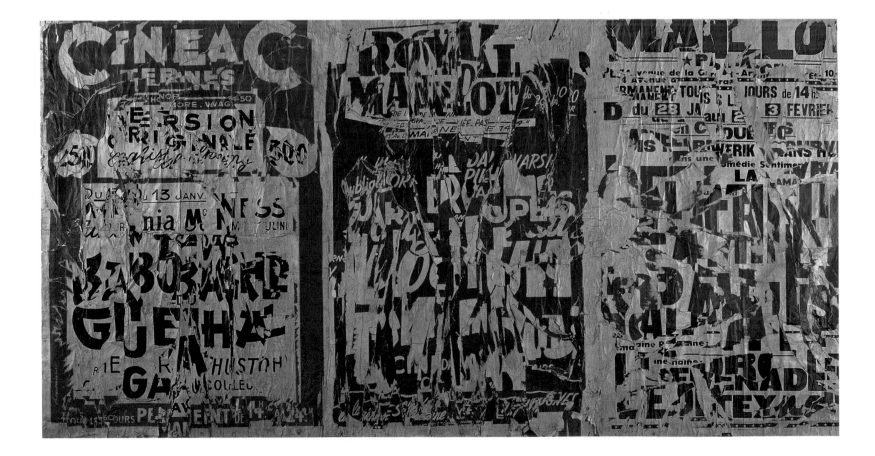

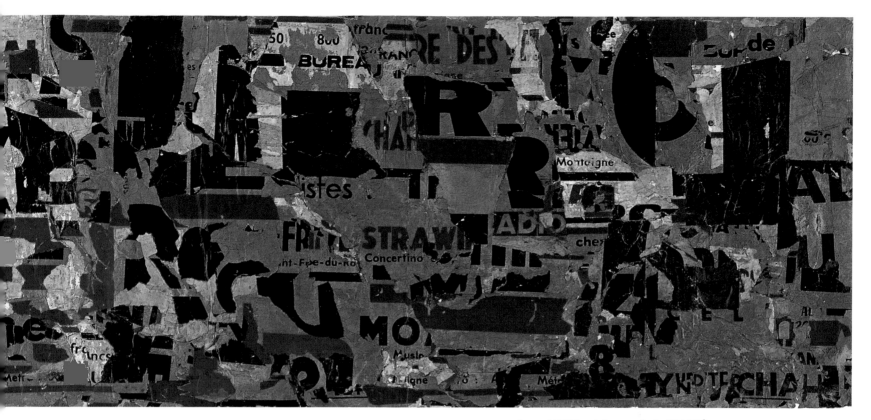

Raymond <u>HAINS</u> and Jacques de la <u>VILLEGLÉ</u>
Ach Alma Manetro
1949
Décollage: torn posters collaged on paper, mounted on canvas
58 × 256 cm [23 × 101 in]
Collection, Musée national d'art moderne, Centre Georges
Pompidou, Paris

Drawing its title from the three word-fragments still legible in a vast field of lacerated street posters, *Ach Alma Manetro* was Hains and Villeglé's first collaboration. Reversing the constructive build-up of layers characteristic of collage, they began to use large-scale, found posters which they peeled away to reveal the graphic residues of older posters underneath. Described as *décollagistes* (literally, 'un-collagists'), these artists worked with the advertising material that was proliferating in the Paris streets, obliterating the traces of fascist propaganda that had covered the city during the wartime occupation. As the commodity-driven era of the 1950s approached, public space was transformed by the new billboard advertising made possible through the development of large-scale colour offset lithography. Deliberately oppositional, *décollage* presented the remains of these consumerist signs and messages in a fragmented and already obsolescent state.

opposite
Jacques de la <u>VILLEGLÉ</u>
Les Triples de Maillot
Triples of Maillot
1959
Décollage: torn posters collaged on paper, mounted on canvas
117 × 224 cm [46 × 88 in]
Collection, Museum Moderner Kunst Stiftung Ludwig, Vienna

Villeglé became engaged with ideas of urbanism and public space when working for an architect in the early 1950s. Around 1954 he met the poet and artist François Dufrêne, then involved with Lettrism, who was also working with torn posters. The Lettrists focused on written or spoken individual letters as the core of a new poetic language which they believed could be the basis of a new culture. Villeglé saw *affiches sauvages* (literally, 'wild posters', implying both real defaced or unofficial flyposted bills and his own meticulously fabricated works) as 'a site of confrontation between those in charge of maintaining the order of public space and those who seize the liberty of speech in the same location … The anonymous passer-by re-routes the message, opening up a new arena of freedom.'
– Jacques de la Villeglé, interview, Centre d'art contemporain d'Istres, 2004

Kurt SCHWITTERS
Untitled [For Käte]
1947
Collage on paper
10.5 × 13 cm [4 × 5 in]
Collection, Kurt Schwitters Archiv, Sprengel Museum, Hannover

As a refugee in wartime London Schwitters began to use in some of his Merz assemblages the comics that came into circulation via American servicemen. In this intricate, small-scale work a cartoon drawing of a woman is surrounded by a cluster of male figures from various other comic strips, evoking different time periods and cultures. Some of the hands, arms and heads of the figures are taken from several sources and recombined together. The postage mark and inscription suggest a meaningful, personal rearrangement of these stereotyped figures and gestures. In his 1962 *Artforum* article 'The New Painting of Common Objects', the critic John Coplans listed this work as one of the hidden landmarks in Pop's development; it was part of a series to be shown in 1947 at Rose Fried Gallery, New York. Schwitters died a week before the opening and the show was cancelled.

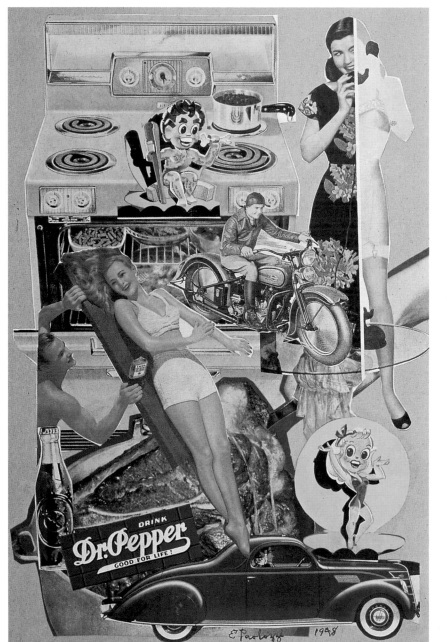

Eduardo PAOLOZZI
Dr Pepper
1948
Collage on paper
36 × 24.5 cm [14 × 9.5 in]

From childhood Paolozzi had collected pictures from popular magazines. After studying art in London he spent two years (1947–49) in Paris, where he became acquainted at first hand with surrealist collage and saw Mary Reynolds' Duchamp collection which included Duchamp's walls covered with magazine images. Paolozzi acquired the latest magazines from American ex-servicemen studying in the city and filled several scrapbooks with images, calling one *Psychological Atlas* (*c.* 1947–53). He later called his collages 'readymade metaphors'. While the playful Freudian symbolism of the juxtaposed icons draws on surrealist precedents, Paolozzi maintains the integrity of each figure or object so that it still conveys much of the intended effect of the original. The titles, as here, usually come from the most conspicuously advertised product in the composition. The figure of the young woman at right holding a telephone comes from an advertisement for Ivory Flakes washing powder for delicate garments. The tagline was 'What makes a gal a good number?' The ad was later decoded in Marshall McLuhan's text 'Love Goddess Assembly Line', in *The Mechanical Bride: Folklore of Industrial Man* (1951).

Eduardo PAOLOZZI

Meet the People

c. 1948

Collage on paper

36 × 21 cm [14 × 8.5 in]

Collection, Tate, London

From 1947 to 1951, former Hollywood B-movie star Lucille Ball, whose portrait is a focal point in this collage, played the wacky wife of a straight-laced banker on the popular CBS radio programme *My Favorite Husband*. Its success led to her famous pioneering sitcom *I Love Lucy*, which CBS launched on television in 1951. Paolozzi may not have known or intended this reference (the photo is promoting a 1944 film) but it happens that 1948 was the year she became a household name, at least in the USA, due to the radio show: a commonly recognized icon in magazines and on the airwaves, like the food and drink products, the serving suggestion and the mouse cartoon character, which all seem to be vying for equal billing in the artist's composition. This and the collage below are among those which Paolozzi reproduced in *Bunk*, an edition of 47 silkscreen prints and lithographs, in 1972. Before this date the originals were generally considered as working materials and rarely exhibited.

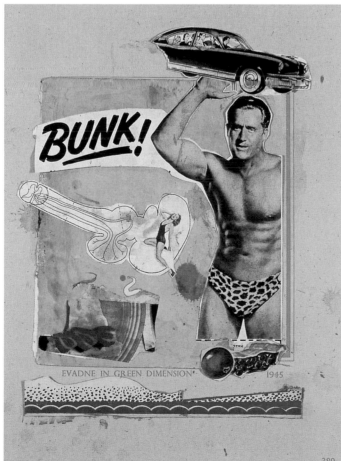

Eduardo PAOLOZZI

Bunk! Evadne in Green Dimension

c. 1952

Collage on paper

32.5 × 24.5 cm [13 × 9.5 in]

Collection, Victoria & Albert Museum, London

This became the signature collage in the *Bunk* series described above. The figure of the man and the slogan 'Bunk!' are taken from a 1936 version of the long-running advertisement for Charles Atlas's body-building technique, which Paolozzi found in the December issue of the *Mechanics and Handicrafts* magazine of that year. 'Bunk!' also implicitly alludes to the famous statement made to the *Chicago Tribune* in 1916 by Henry Ford, founder of the Ford Motor Company: 'History is more or less bunk … We want to live in the present.' In the spring of 1952, Paolozzi presented his scrapbook collages, derived from popular magazines, comics, science fiction and pulp fiction book covers, as a rapid-fire sequence of projections from an epidiascope, at one of the first meetings of the Independent Group in the Institute of Contemporary Arts, Dover Street, London. Due to the projector's limitations, only a section of each page could be shown at one time. What was crucial was the presentation of mass-media imagery for serious consideration.

Robert RAUSCHENBERG

Bed

1955

Combine painting; oil and pencil
on pillow, sheet and patchwork
quilt on wood supports

191 × 80 × 20.5 cm

[75 × 31.5 × 8 in]

Collection, The Museum of Modern
Art, New York

From 1948 to 1950 Rauschenberg
studied at Black Mountain College, North
Carolina, returning to teach there in 1952,
where he collaborated with the
choreographer Merce Cunningham, the
composer John Cage and others on the
first attempt to fuse painting, dance,
poetry and real-life chance events –
a prototype 'happening'. Otherwise
based in New York from 1949 onwards,
Rauschenberg continued to question the
aesthetics underlying contemporary
critics' espousal of geometric and
gestural abstract painting, and to explore
the possibility of acting 'in the gap'
between art and life. By 1955 he had
devised a new type of artefact which he
named a Combine, arrived at by the
combination of traditional supports and
areas of gestural painting with everyday
objects of use or discarded found
materials. *Rebus*, *Monogram* and this
work, *Bed*, are among the foundational
works, all produced in that year. Here the
pillow, sheet and quilt are positioned as
they would be in a functioning bed,
retaining all the associations that a bed
might evoke, yet these materials are
overlaid with daubs and drips of coloured
paints, hovering between the expressive
and the 'artless'. The whole ensemble is
brought, uncomfortably, into the
traditional art arena by being mounted
on a wall.

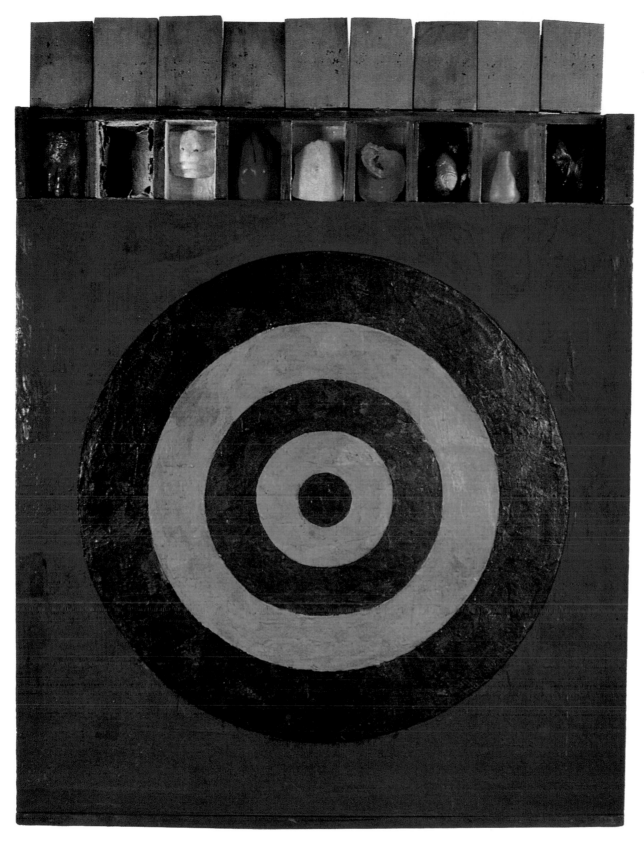

Target with Plaster Casts
1955
Encaustic and collage on canvas;
wood compartments and hinged
lids, painted plaster casts
129.5 × 112 × 6.5 cm
[51 × 44 × 2.5 in]

Johns had begun working with encaustic and making plaster casts of his and friends' heads and body parts in 1954. Encaustic was a rarely used technique in which pigment is combined with hot wax and applied to a surface. Johns wished to leave a material trace of the process of building up the image, brushstroke by brushstroke, and encaustic enabled this. He also often incorporated collage elements, usually from newspapers. By early 1955 he had begun his Flag and, slightly later, Target paintings, realizing that such generic designs are 'ready-made' and familiar, instantly recognized but at the same time no longer looked at with any attention. By making a painting which was unusually similar to yet significantly different from the real thing, Johns raised questions about the boundaries between art and the visual signs and objects found in the common culture. More than flags, which usually have specific referents, the target is a universal sign. It also focuses the attention of the viewer on the act of vision, since that is a target's function. In this work, above the target painting a series of plaster casts of body parts are painted various colours and set into little hinged wooden compartments. Originally intended to spring open when pressed and trigger sounds from behind the target, the compartments were retained after Johns abandoned this idea. After he coloured the casts and their surrounds, they reminded him of watercolour paint dishes, an association he recalled in a small-scale work in the series (1960) which has three paint dishes and a brush beneath the target.

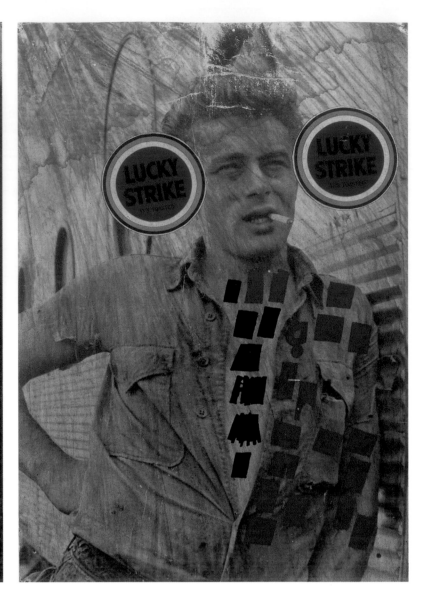

Ray <u>JOHNSON</u>

Elvis Presley # 2

1956-57

Ink, collage, paper on cardboard

23.7 × 19 cm [9.5 × 7.5 in]

Ray <u>JOHNSON</u>

James Dean

1957

Tempera, ink and collage on photograph

30 × 24 cm [12 × 9 in]

In his artworks of the mid 1950s, Johnson was ahead of his time in the use of photocopying techniques and content based on publicity stills of screen icons such as Marilyn Monroe and James Dean, or rock and roll idols such as Elvis Presley. A number of the collages were made in series, and involved cutting up pieces of paper painted black or red into small, irregularly shaped pieces which were then glued on to photocopied images. Other areas were painted with washes of colour and sometimes other elements were added, such as the trademark target logos from Lucky Strike cigarette packets, in the James Dean collage. Johnson's use of low-tech photocopying is indicative of his celebration of mechanical reproduction and democratic techniques for the production and distribution of his work. He distributed much of his work through the mail, and established the New York Correspondence School to do so. He called the collages 'moticos', a word coined by a chance method when asking his friend Norman Solomon the word he was reading. His answer: 'osmotic'. Johnson stored the moticos in cardboard boxes and showed them on the New York streets and in Grand Central Station.

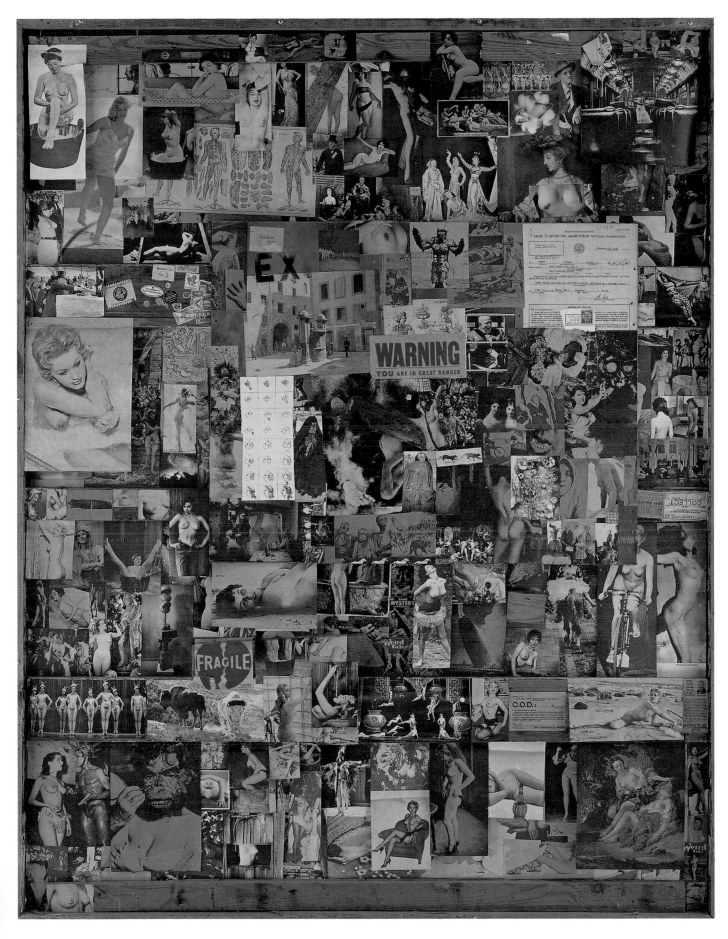

Bruce <u>CONNER</u>
UNTITLED [detail]
1954-61
Paper collage, wood, glue, nails,
paint, staples, metal, tar,
feathers, plastic, etc.,
on Masonite
162 × 126 × 10.5 cm
[64 × 49.5 × 4 in] framed
Collection, Walker Art Center,
Minneapolis
Reverse panel of two-sided work

This early, two-sided work, of which the reverse is shown here, was first intended to be one-sided only. Conner assembled distressed cardboard circles, one dark, the other light, and two rectangles, one made from a flattened metal can, the other from a piece of metal screening, surrounded by a wooden frame with visible screws attaching it to the board on which the other elements are fixed. Having seen paintings with museum seals and stickers from various collections and exhibitions attached to them, Conner then decided to attach 'seals' from magazines such as *Good Housekeeping*. This led to the decision to fill the entire area with a collage of material from many different sources in commonly available ephemera, ranging from the sexy pictures that soldiers, prisoners and others would collage in a similar way inside lockers, to postcard reproductions, postage stamps, etc. The semi-pornographic images contrast sharply with the accomplished, Kurt Schwitters-like assemblage on the other side. Initially the back, which Conner likened to the 'unconscious' of the front, was intended to be seen only by those who handled the work. From around 1960 he suggested a free-standing installation so that both sides could be viewed.

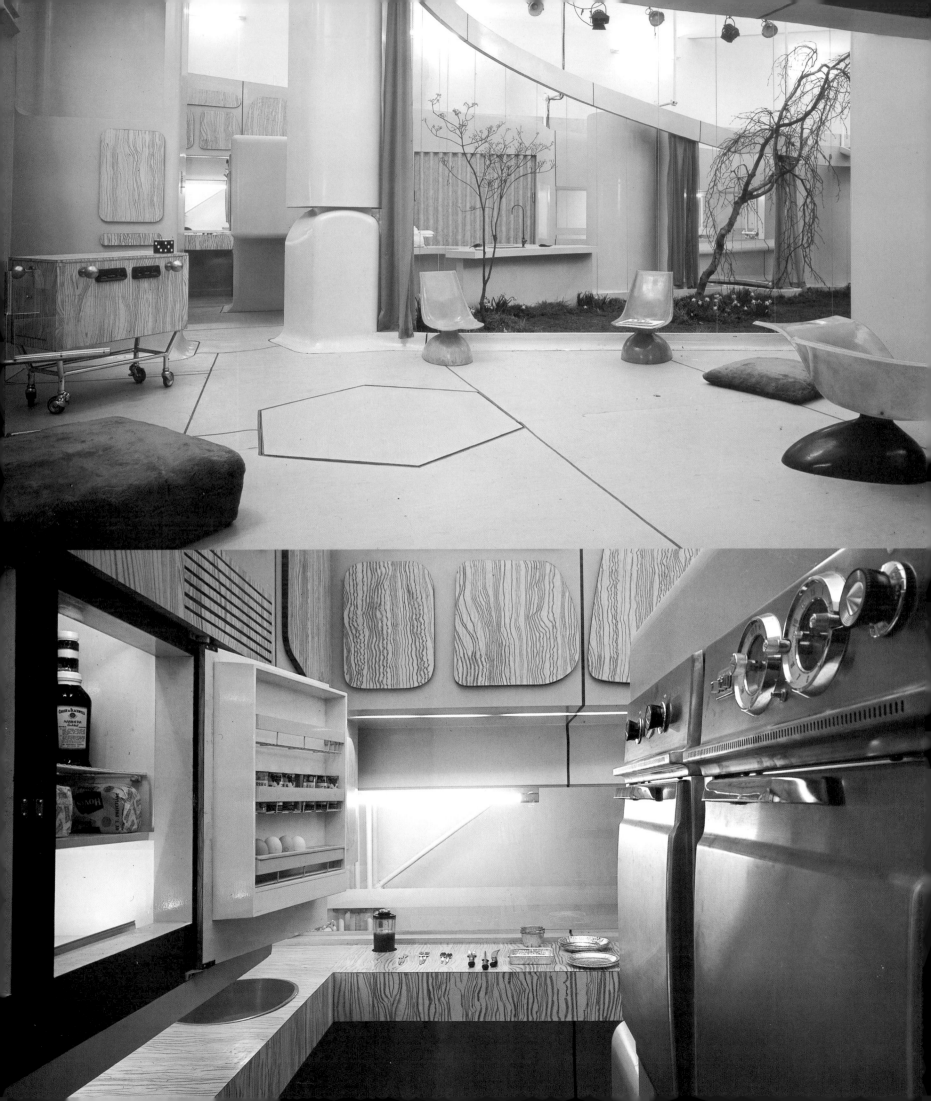

opposite

Alison and Peter SMITHSON
House of the Future
1956
Prototype realized for the Daily Mail Ideal Home Exhibition, London,
March 1956
top, Central living room with Tulip chairs and adjustable height
hexagonal table in recessed position in floor
bottom, detail of kitchen

The Smithsons developed a social housing concept based on mass-production solutions pioneered by the motor industry in Detroit. The House of the Future had a decentralized plan characterized by loops and bifurcations. All the rooms were to be lit by a central oval patio, allowing three exterior walls to be without doors or windows. The structures could thus be 'plugged in' to a system of rows, two deep and back to back. Endless extendibility distinguished this project from other mass-produced housing prototypes such as Buckminster Fuller's Dymaxion House (conceived in the late 1920s and first built in 1945, this structure used tension suspension from a central column or mast, was sold for the price of a car, and could be shipped worldwide in its own metal tube). The Smithsons drew on both the latest sociological theories and the most futuristic product designs of the time, such as the plastic chairs in the top photograph, based on Eero Saarinen's designs, and the hexagonal table that recedes into the floor when not in use. Crucially, they looked beyond their professional field to vernacular culture and the mass media for inspiration, becoming exponents of what would several years later emerge as the notion of Pop architecture.

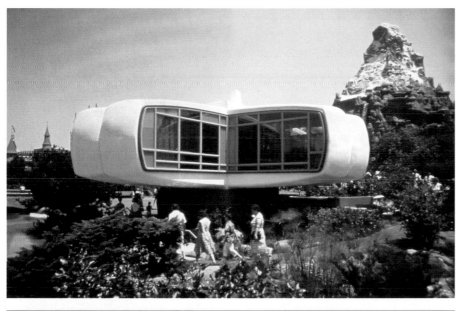

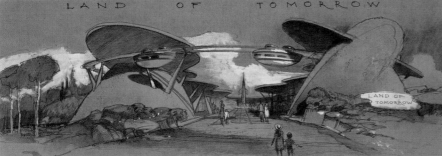

WALT DISNEY IMAGINEERING
Monsanto House of the Future [exterior view], Tomorrowland,
Disneyland, Anaheim, California
1957
Designed by Hamilton and Goody

In 1952 Walt Disney started a subsidiary which he named WED Enterprises, later Walt Disney Imagineering, to design and develop the first theme park. This would be clean, futuristic and utopian, in contrast to its predecessors. Disney's concept of the 'Imagineer' introduced an expanded notion of the creative team, in which architects, designers, animators and fabricators worked together to create a total, artificial world, based on the hyperreal realm of Disney cinema but situated in a real location. The first Disneyland opened in July 1955, divided into four areas, one of which, Tomorrowland, materialized popular images of a future synonymous with technical progress. Here the visions of science fiction, such as rocket rides, were juxtaposed with prototypes for buildings and product designs which would soon be realized commercially, such as moulded plastic furniture and advanced kitchen appliances. To coincide with the launch Disney promoted Tomorrowland in special TV features such as 'Man in Space'. Over the next few years Tomorrowland was updated several times.

WALT DISNEY IMAGINEERING
Entrance of 'Land of Tomorrow', Disneyland, Anaheim, California
c. 1954
Drawing by Herbert Ryman

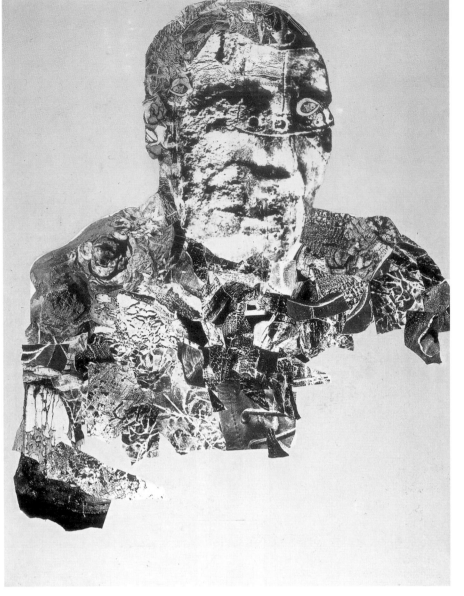

Nigel HENDERSON
Head of a Man
1956
Collage on paper
160 × 121.5 cm [63 × 48 in]
Collection, Tate, London

This work was first installed in the Patio and Pavilion conceived by Group 6 (Nigel Henderson, Eduardo Paolozzi, Alison and Peter Smithson), one of the teams of artists and architects in the group show 'This is Tomorrow' at the Whitechapel Art Gallery, London, 9 August – 9 September 1956. Seeking a visual language to convey the trauma he suffered in the Second World War, Henderson developed various experimental techniques such as a type of photogram made by placing objects, often including recuperated bombsite material, directly on light sensitive paper. He described these kinds of image as 'stressed' photographs, and this 'self-portrait' can be seen as the culmination of this body of work. Here he collaged such photograms, along with fragments of photographs he had taken of blitz damage in London's East End, into the form of his own face. The original installation – likened by the critic Reyner Banham to a garden shed excavated after an atomic holocaust – emphasized the existential pessimism of Henderson's work which, like many of Paolozzi's sculptures, used vernacular elements in a way that departed from the more progressive agendas of other Independent Group members.

opposite
Richard HAMILTON
Just what is it that makes today's homes so different, so appealing?
1956
Collage on paper
26 × 25 cm [10.5 × 10 in]
Collection, Kunsthalle Tübingen, Germany

Incorporating the word 'Pop', blazoned across the giant candy on a stick held by the muscleman, this collage has become iconic of the birth of the movement. However, the first recorded use of the term Pop art was by Hamilton in a letter to Alison and Peter Smithson on 16 January the following year. The collage (made from material largely supplied by John McHale and selected with the collaboration of Hamilton's wife Terry and the artist Magda Cordell) was originally used as artwork for a black and white poster, one of a series made for the group show 'This is Tomorrow' in the late summer of 1956. Also reproduced in black and white in the catalogue, even as a monochrome image it is likely to have given a startling impression of a future where hi-tech gadgetry, mass-media communications and images, especially the stereotyping of sex-appeal, would pervade all areas of everyday life. Partly prescient (the comic strip framed on the wall predates Roy Lichtenstein's first cartoon-based paintings by five years, and the allusion to space travel in the ceiling predates the first Sputnik rocket launch), the collage also refers to and parodies 1950s products and styles of imagery. A 'plundering' of what the Independent Group then referred to as the 'popular arts', it has been likened to an index of the themes and types of imagery that would emerge in 1960s Pop.

Richard HAMILTON
Hommage à Chrysler Corp.
1957
Oil, metal foil and collage
on panel
122 × 81 cm [48 × 32 in]
Collection, Tate, London

Both in style and theme this painting draws upon Hamilton's close study at the time of Marcel Duchamp's 'Large Glass': *The Bride Stripped Bare by Her Bachelors, Even* (1915–23). In Duchamp's work, the 'Bachelor Machine' and the section representing the 'Bride' inhabit separate areas. In Hamilton's painting, the disembodied red lips which stand in, metonymically, for the ubiquitous showroom girl included in car advertisements, occupy the same space as the schematic delineation of a 'latest model' car's stylistic features. The use of pastel colours and the allusiveness of the curves suggest a further level of conflation between fetishized woman and fetishized industrial object. Hamilton would develop these themes in a series of texts over the next few years and in paintings such as *Hers is a lush situation* (1958) and *$he* (1958–61).

John MCHALE
Machine-made America I
1956-57
Collage on paper
74 × 58.5 cm [29 × 23 in]

This is one of a series of large-scale collages McHale produced between 1956 and 1958. In each, the clusters of found material from magazines are formed into configurations which include the suggestion of a face, usually emerging from an unearthly, robotic body. The imagery here is more overtly technological than in most of the others. It includes plumbing, a car's grille, a refrigerator door, a television and various industrially produced structures and highrise buildings. Comprised of images from the 1950s present or recent past, the collage's overall form suggests an alien, futuristic presence. McHale's vision of the future oscillated between optimism and scepticism. In line with Marshall McLuhan's theory of contemporary culture's passage from the mechanical, emblematized by printing and the purely visual, to the aural and participatory, McHale emphasized mass communications both through the incorporated images such as the TV set, and the seemingly staring, gesturing forms of his composite figures.

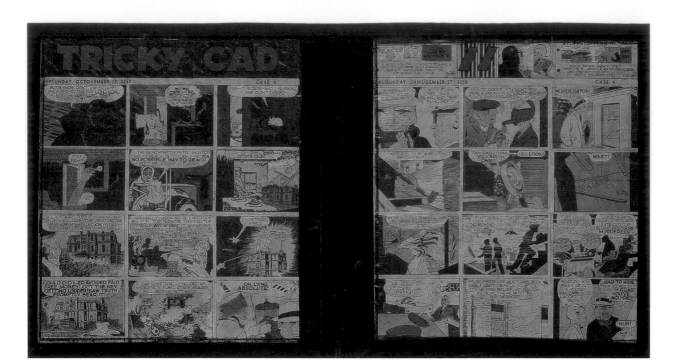

above

JESS

Tricky Cad, Case V

1958

Collage of newspaper comic
strips, cellulose acetate film,
black tape, fabric and paper
on paperboard

33.5 × 63.5 cm [13 × 25 in]

Collection, Hirshhorn Museum
and Sculpture Garden, Smithsonian
Institution, Washington, D.C.

In the late 1950s Jess began working
on a series of works he called 'paste
ups', using images from the comic strips
of American newspapers. Based on the
Dick Tracy crime detective story, Tricky
Cad is one of a number of anagrams
of the hero's name created by cutting
up and rearranging the words in the
cartoon's taglines, speech- and thought-
bubbles. While the language content is
thus subverted, the overall visual format
and elements remain largely intact.

Peter BLAKE

Self-portrait with Badges

1961

Oil on board

175 × 122 cm [69 × 48 in]

Collection, Tate, London

Blake's enthusiasms for both the latest
pop phenomena from America (which
he had not yet visited) and British folk
art, such as old pub signs, are poignantly
contrasted in this naive-style painting
of the artist assuming a self-consciously
hip look while posing in a run-down
London back garden. American-style
'cuffed' jeans, baseball shoes and denim
jackets (which were only just beginning
to be distributed outside the United
States) were in fashion among a small
group of trend-setters such as London
art students. The badges, however, are
a mostly outmoded, eclectic selection
from a collection Blake started in the mid
1950s. Among other themes the badges
commemorate the Union Jack, and the
Stars and Stripes – much larger,
indicating Blake's preference; the First
World War; the Boy Scouts; Road Safety;
the British comedian Max Wall; Pepsi;
Elvis Presley (by 1961 already a bit
passé) and Dan Dare from the 1950s
children's comic *The Eagle*.

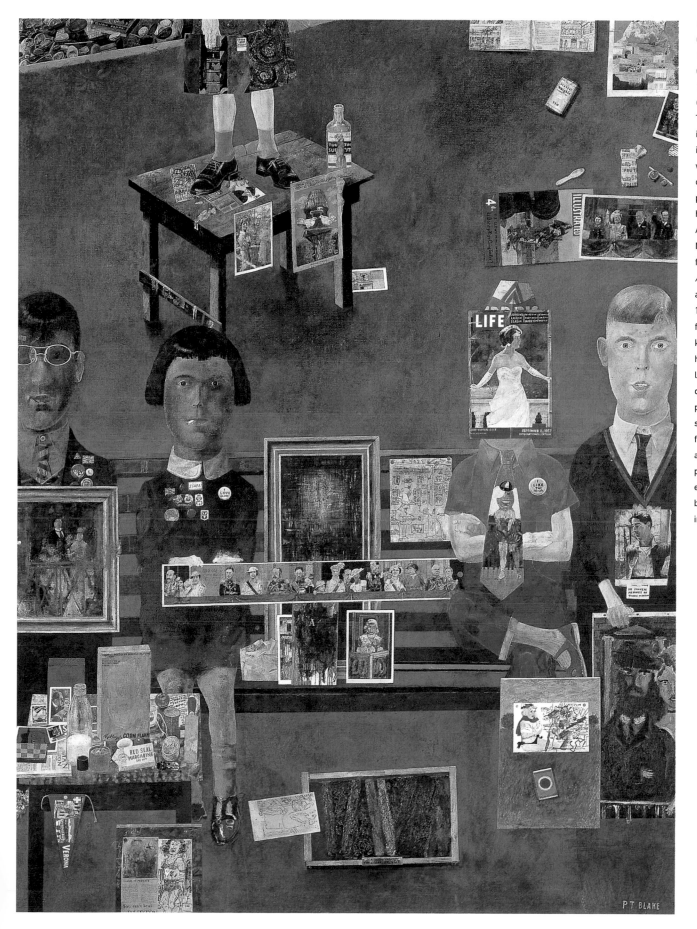

Peter <u>BLAKE</u>
On the Balcony
1955-57
Oil on canvas
121.5 × 91 cm [48 × 36 in]
Collection, Tate, London

This picture, mostly painted in 1955 and inscribed 'unfinished' on the back, was intended as Blake's diploma composition while at the Royal College of Art. One of its starting points was the American painter Honoré Sharrer's oil sketch for her mural *Workers and Pictures* (1943). Acquired for The Museum of Modern Art, New York, reproduced in the catalogue for its landmark exhibition *Fourteen Americans* (1946) and also displayed in a loan exhibition at the Tate Gallery in 1956, it depicts groups of working families, each standing behind a well-known masterpiece. While a Manet hovers in front of the the figure on the far left in Blake's composition, other types of image and object, from contemporary popular sources, abound. They include snapshots, official images of the Royal family, magazine covers, bottles, jars and cigarette packets. Areas of flat painting are contrasted with *trompe l'oeil* effects elsewhere. The theme 'On the balcony' appears within the painting in 27 different variations.

opposite

Jasper JOHNS

Flag above White with Collage

1955

Encaustic with collage on canvas

57 × 49 cm [22.5 × 19.5 in]

Collection, Kunstmuseum, Basel

The first of the Flag paintings was conceived of after Johns dreamed in 1954 of painting a flag, and it slightly predates the first Target paintings of 1955. As the year progressed he began to make variations on, or additions to, the representation of the flag, such as the area of white ground beneath it in this example. It was when a selection of the Flags and Targets were exhibited in Johns' first solo show at Leo Castelli Gallery, New York, in January 1958, and subsequently reproduced in various art magazines, that they attracted widespread attention among other artists and critics. While the Targets at least resembled abstract modernist painting, the Flags were more startling and confounding, some appearing at first glance to be 'artless' facsimiles of the real thing. The thick texture, built up from the layers of encaustic that bind the collaged paper and pigment together, draws attention to the painting as an object in the world, rather than as a neutral flat surface to be used for either illusionistic depiction or abstract marks. This effect is reinforced here by the uneven application of pigment, which allows fragments of the underlying newspaper pages to remain evident, in particular the four photographed faces on the right.

Jasper JOHNS

Painted Bronze

1960

Oil on bronze

14 × 20.5 × 12 cm [5.5 × 8 × 5 in]

Collection, Museum Ludwig, Cologne

During 1959 Johns made meticulously crafted bronze sculptures of commonplace objects such as flashlights and lightbulbs, continuing his investigation of objects as symbols by questioning notions of the real in relation to its representation. The following year he fabricated a realistic Savarin brand coffee can, full of paintbrushes, and these ale cans, titling both works *Painted Bronze*. The choice of Ballantine beer cans derives from an anecdotal story the artist heard of Willem de Kooning describing their dealer Leo Castelli's ability to sell virtually anything, even two beer cans. Johns literalized the notion in this work. The cans, though identical in brand and painted details, are actually of two different designs. The left can is an old-fashioned model, opened by puncturing the surface (as seen in the two perforations), whereas the other is a newer version with a ring-pull. This consideration of minor product development demonstrates the subtle manner in which, through repetition, Johns attempted to address a mundane sameness through an almost unnoticeable difference.

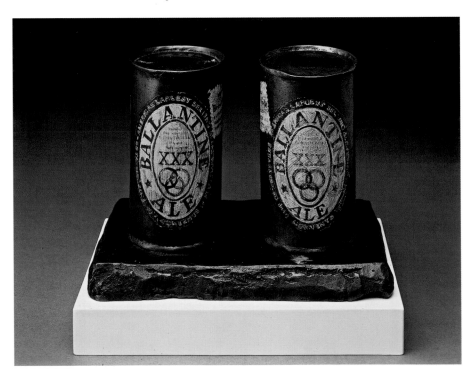

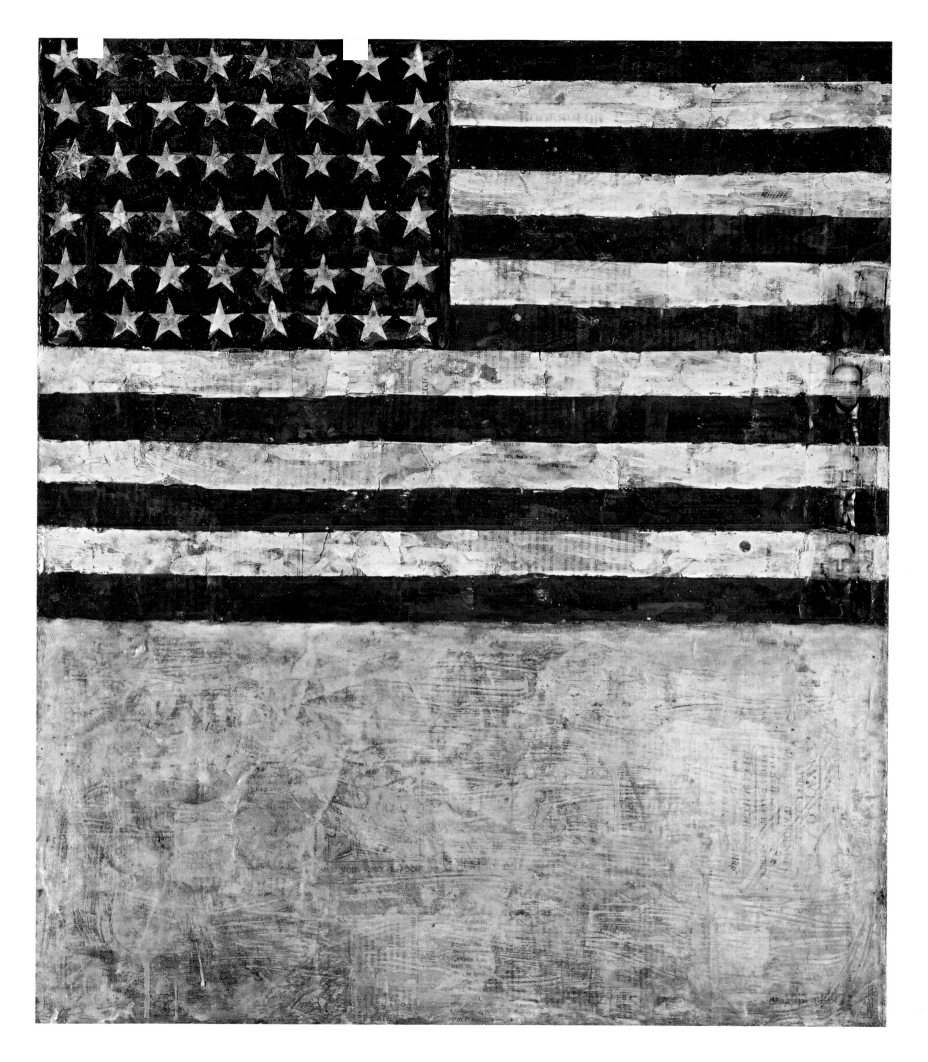

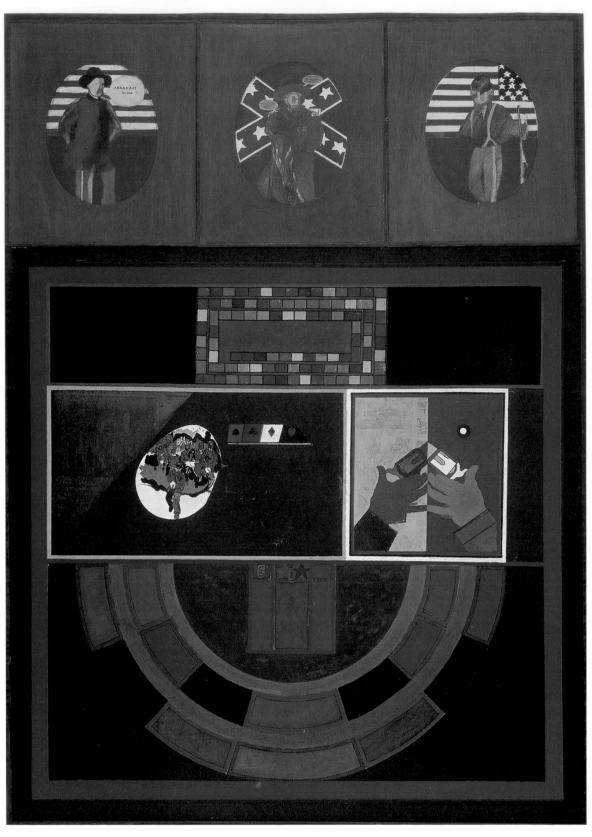

Peter PHILLIPS

War/Game

1961

Oil, enamel and newspaper on four
canvases with wood

217 × 156.5 cm [85.5 × 61.5 in]

Collection, Albright-Knox Art
Gallery, Buffalo, New York

In one of his rare paintings with a
specific theme – the contemporaneous
commemoration of the American Civil
War – Phillips combined figures derived
from American comic strips with devices
that echo heraldic forms (he had taken
a course on the subject at art school).
All is framed within what he called
a 'game format', recalling elements of
the layouts of board games and pinball
machines. The work's techniques and
construction are quite elaborate. The
three figures at the top were painted on
individual canvases and are united with
the rest of the composition by their
polished wood frames. The 'game' area
below combines areas of matt, polished
or waxed oil paint as well as black gloss
enamel sanded to a smooth finish with a
pumice stone. The stars, the small target
and the two hands holding the gun form
a bridge between heraldry, the corporate
logo and the everyday painted sign.

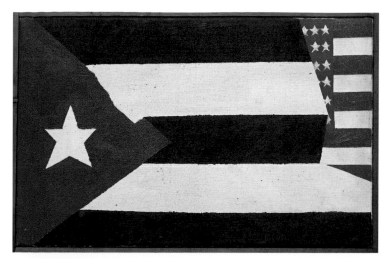

Derek <u>BOSHIER</u>
Situation in Cuba
1961
Oil on canvas with wood frame
33 × 51 cm [13 × 20 in]

Jasper Johns' Flag paintings – often seen in reproductions – were a source of stylistic inspiration to young British Pop artists in the early 1960s, a group that included Derek Boshier for a short period (1960–62). An avid reader of American social commentators on the consumer society such as Marshall McLuhan, Vance Packard and J.K. Galbraith, Boshier expressed a political stance rare in the work of his generation. This painting refers to the United States' attempt to regain control of Cuba after the 1959 socialist revolution led by Fidel Castro, when the US unsuccessfully invaded the Bay of Pigs on 17 April 1961. In the neat conceit of this painting the American and Cuban flags appear to encroach upon and retaliate towards one another.

Peter <u>BLAKE</u>
Girlie Door
1959
Collage and objects on hardboard
122 × 59 cm [48 × 24 in]

At the end of the 1950s Blake extended the notion of collage-type painting that he had explored in *On the Balcony* (1955–57), to include real or constructed doors, lockers and other everyday objects covered with pasted-on pictures from magazines and other sources. He also placed toys, ephemera and found objects in box-like constructions, sometimes resembling windows or shop displays. *Girlie Door* is more demure than a similar work of the same year, *Locker*, on which Brigitte Bardot and other pin-up girls cover all the panels of Blake's Royal Air Force locker from his national service years (1951–53). For Blake personal associations and enthusiasm for the popular culture around him took the place of any studied theoretical position, for which another artist might have felt the need, to justify such artefacts in relation to artistic precedents.

CONSUMER CULTURE While in Europe related

tendencies such as 'new realism' emerged at the start of the decade, by the early

1960s New York had become the centre of an art world in which Pop's identity was

at first derided, then quite quickly established. Strands of derivation and influence

drawn from Dada and Surrealism were traced by museum exhibitions and the

mass media. The lasting value of works by artists such as Warhol, Lichtenstein

and Oldenburg, underlying their apparently ephemeral and trivial appeal, lay

in the artists' complex, yet deadpan, attitude to their subjects, which viewers

could not easily establish as celebratory, accepting or critical. While early Pop

seemed to conflate and revel in sensual images of food and sex, a darker note

became apparent after the deaths of Marilyn Monroe and the young President

Kennedy provided artists with indelible visual evidence of the violence, corruption

and injustice of contemporary life.

opposite

ARMAN

'Le Plein' exhibition, Galerie Iris Clert, Paris, October 1960
Detail of accumulated objects in gallery window

Arman presented 'Le Plein' ('Full') at the gallery of Iris Clert in Paris two years after
she hosted Yves Klein's exhibition of 1958 that became known afterwards by the title
he gave to the installation inside: 'Le Vide' ('The Void'). Klein had removed everything
from the gallery space except an empty vitrine, and painted all the surfaces white.
This 'dematerialization' allowed the possibility of pure sensibility becoming the
subject of the work. Arman's gesture presented the exact opposite: he filled the
gallery from floor to ceiling with as much junk as he could fit in. On 27 October 1960,
four days after 'Le Plein' opened, the critic Pierre Restany launched the manifesto of
the Nouveaux Réalistes ('new realists'), embracing the qualities of mass-produced
objects, whether new or discarded: 'the real perceived in itself and not through the
prism of conceptual or imaginative transcription'. The pile of lightbulbs seen in this
view of the gallery window signals the emergence in this period of Arman's practice
of accumulation: assembling together, usually in a box frame construction under
perspex, a mass of everyday objects of the same type.

Guy DEBORD and Asger JORN
Mémoires
1959
Sample page from colour and black and white litho printed artist's
book, unpaginated, sandpaper binding. Printed by Verner Permild,
Copenhagen, published by L'Internationale situationniste, Paris
Bound in a disruptive, erasive material – sandpaper – this experimental book
presents fragments of text and sometimes images culled from printed ephemera,
within formless areas of colour evoking Debord's notion of 'psychogeography'.
Emerging from the Lettrist movement around 1957, the Situationists criticized the
capitalist system for dividing society into actors and spectators, producers and
consumers, thus diverting and stifling imaginative and creative freedom. They
proposed counter-diversions, through which these patterns would be undermined.

Jean TINGUELY
Hommage à New York
Autodestructive work presented at the Museum of Modern Art, New York,
17 March 1960
Tinguely's late 1950s experiments with kinetic art-machines were brought to a new
level with this ambitious self-destructive construction. Made from urban detritus,
it was commissioned to be sited in a dome designed by R. Buckminster Fuller,
displayed in the courtyard area at the Museum of Modern Art, New York. Some of its
intended features, such as the discharge of various odours, failed to materialize at
its public unveiling: it also failed to self-destruct completely before being extinguished
by the Fire Department. It was nevertheless a landmark, both as a fusion of the fields
of art and technology and as a statement about industrialized society's cycles of
production, consumption, waste and destruction.

Wolf <u>VOSTELL</u>

Coca-Cola

1961

Dè-coll/age: peeled posters on paper, mounted on hardboard

2 panels, 210 × 310 cm [83 × 122 in] overall

Collection, Museum Ludwig, Cologne

Behind an advertising poster for a family-sized Coca-Cola bottle Vostell revealed underlying posters of Cowboy shoot-outs and the toothy smiles of bucolic youth. The Coca-Cola brand had already become synonymous with exported American value systems. Vostell used such associations with a critical perspective. His version of the practice of décollage, which he spelled 'dè-coll/age', was inspired by a front-page headline in the newspaper *Le Figaro*, describing a plane crash. Vostell's works draw attention to social detachment and disintegration in post-war industrialized societies. As well as making wall-based and sculptural works, he orchestrated performance actions which referred to everyday tragedies.

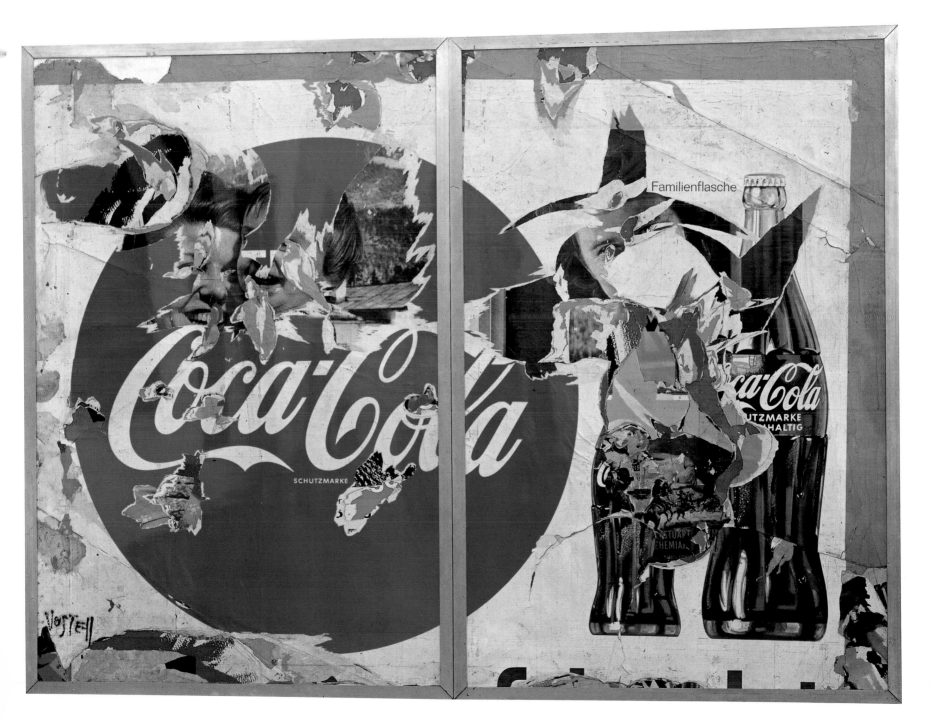

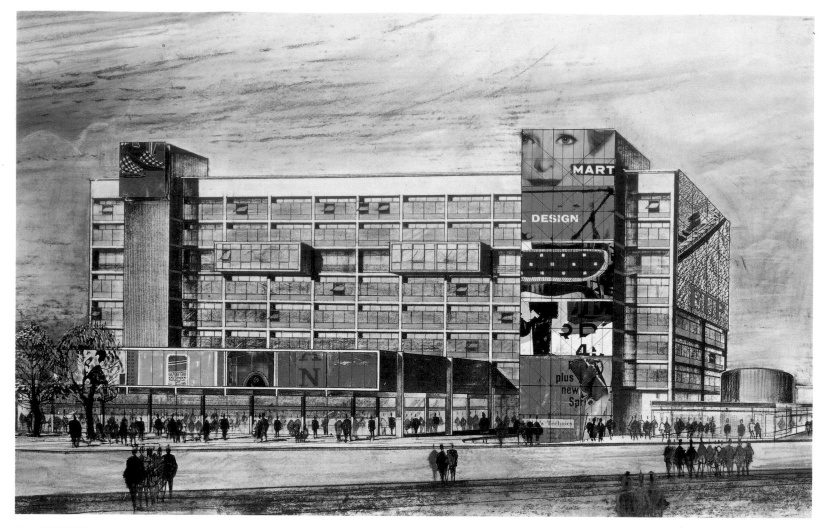

Ernö <u>GOLDFINGER</u>

Project for commercial centre at Elephant and Castle, London

1960

Mixed media on panel

58.5 × 122 cm [23 × 48 in]

Perspective elevation drawing by Hugh Cannings

RIBA Drawings Collection, Victoria & Albert Museum, London

With the adoption of high-rise buildings to meet the post-war housing shortage in Britain, Goldfinger began designing monumental structures that became icons of Brutalism – for a short time considered by the critic Reyner Banham as the leading style of Pop architecture. His proposal for one of Britain's first shopping and cinema complexes revealed its construction through the exposure of elements and structural systems. Panels set on the external surfaces of the building would fuse advertising with the fabric of the architecture. Mass communications such as changing signs and billboards would engage the people on the external plaza of the building as well as those who entered the structure.

opposite

Cedric <u>PRICE</u> [with Joan Littlewood]

Fun Palace

1959–61

from top, Photomontage perspective drawing, second proposal for Lea River site; Elevation cross-section drawing, second proposal; Perspective drawing, first proposal for Camden Town site

Collection, Centre Canadien d'Architecture, Montréal

The Fun Palace was an unrealized project commissioned specifically for London but designed to be located anywhere for any amount of time. It would have non-committal structuring, making it flexible enough for its exterior, interior and individual components to be rearranged as needed. Unlike other public amenities, it would always be open and would provide limitless possibilities of experience on active and passive levels of engagement. Joan Littlewood, a prominent director of avant-garde theatre, promoted the notion of a theme park based on everyday life, a laboratory for educational and experiential play that would synthesize popular culture, fine art and common urges in one locale. In collaboration with Littlewood and the cybernetic theorist Gordon Pask, Price brought form to these ideas by designing a ten-storey structure that could be assembled and dismantled at short notice. The Fun Palace was a key influence on later projects such as Archigram's Plug-in City (1964) and Renzo Piano and Richard Rogers' Centre Georges Pompidou (1972–76).

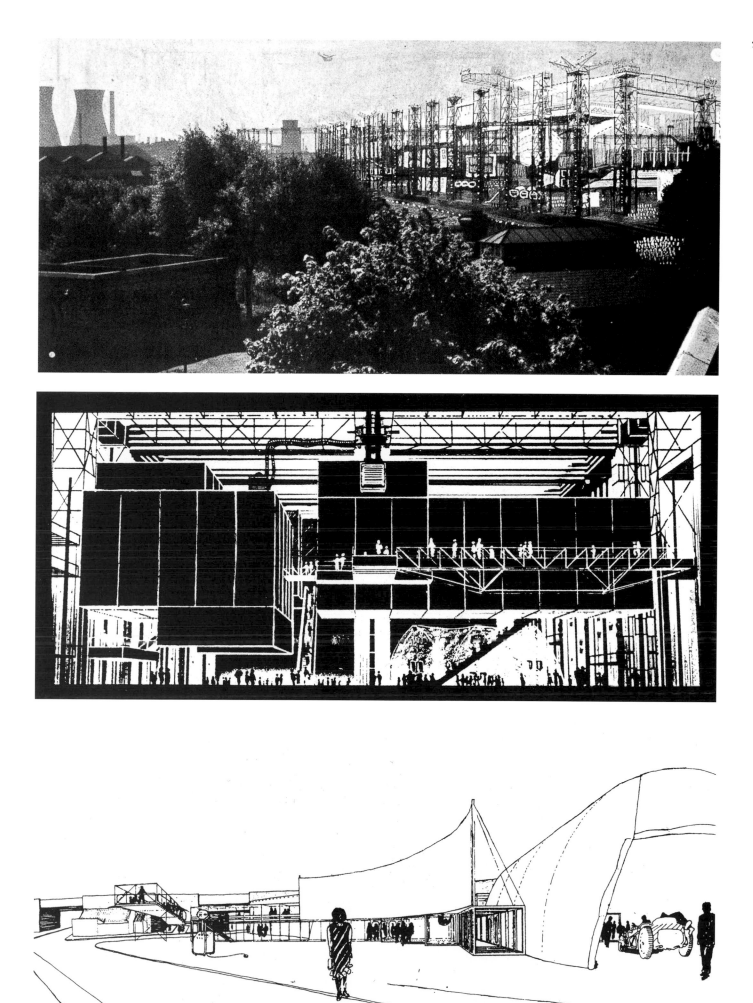

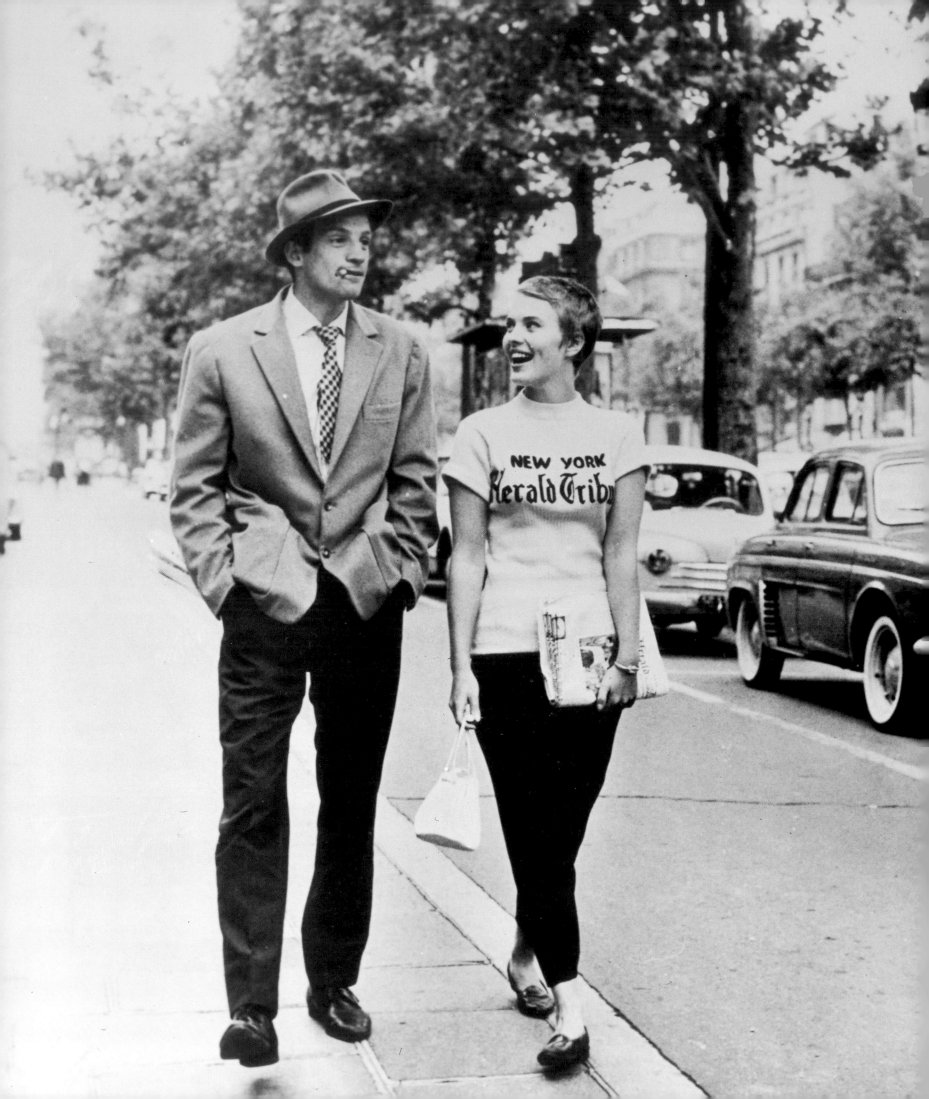

opposite
Jean-Luc GODARD
À bout de souffle
Breathless
1960
35mm film, 90 min., black and white, sound
With Jean-Paul Belmondo, Jean Seberg

Godard's first feature-length film was formative in the development of New Wave filmmaking, which asserted a radical freedom from mainstream cinema's established narrative and aesthetic conventions. Michel (played by Belmondo) is a hapless hoodlum who models himself on the gangsters in Hollywood films. He shoots a policeman, almost accidentally, then turns to his American student girlfriend Patricia (played by Seberg) for protection. The film follows their time together on the run, ending with Michel being shot dead by police on the street. Godard's cinematographer, Raoul Coutard, disrupted contemporary viewers' expectations by shooting the Paris streets from rooftops or pedestrian vantage points, as in Russian Constructivist films of the 1920s, or bringing them close up to the actors inside a moving car. More radical than this, however, is the extensive use of jump-cuts – the narrative 'jerk' effected by deleting consecutive sections from the filming of a continuous action within the same shot and the same scene. This technique, close to that of comic strips, formally reinforces Godard's exploration of the gap between real-life action and popular culture; between Michel and the cinematic figures he tries to imitate; between the film's artifice and viewers' conditioned responses. Godard's films, continually radical and political, but also funny and popular, and also his writings in *Cahiers du Cinema*, formed a major influence on both New Wave filmmakers and artists during the 1960s.

Frank TASHLIN
The Girl Can't Help It
1956
Eastmancolor Cinemascope, 97 min., sound
With Jayne Mansfield, Tom Ewell

In the 1930s Tashlin directed a number of Warner Brothers' 'Looney Tunes' animated cartoons. Jean-Luc Godard admired the way Tashlin adapted elements of plot construction and comic timing from the cartoon strip to the feature film to create skilful, humorous satires on the icons and obsessions of 1950s American society. This transposition might be seen as a parallel development in cinema to the adoption of comic strip material and Hollywood iconography by Pop artists in the early 1960s. In addition to Jayne Mansfield's famous role as the stereotypically voluptuous girlfriend of a gangster who wants her to become a pop star despite her inability to sing, the film showcases real rock 'n' roll, rhythm and blues, and jazz musicians, including Eddie Cochran, Fats Domino, Little Richard and Gene Vincent.

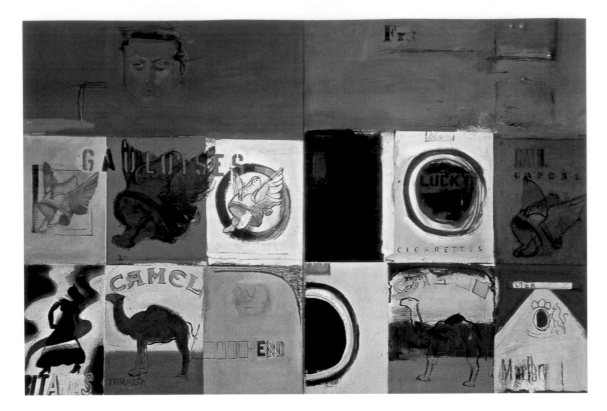

Larry RIVERS
Friendship of America and France [Kennedy and de Gaulle]
1961-62
Oil on canvas
130 × 194.5 × 11 cm [51 × 76.5 × 4.5 in]

Rivers' assessment of popular culture began in the 1950s, when he addressed history painting through a vernacular of commercial symbols he referred to as 'common references'. His early subjects revolved around his Jewish immigrant family background and an American folk history of myths and heroes that became whimsical in his renderings. This painting, based on John F. Kennedy and Charles de Gaulle's meetings over the Cuban crisis in 1962, is one of two works the artist made referring to the event. It was painted shortly after Rivers moved to Paris, and shows how he synthesized cultural moments and figureheads with popular iconography, such as the juxtaposed American and French cigarette brand icons. Sharing some characteristics with the work of Rauschenberg and Johns, the canvas stands out from the wall due to the depth of its support, emphasizing its presence as an object.

opposite
Daniel SPOERRI
Lieu de repos de la famille Delbeck
Resting Place of the Delbeck Family
1960
Table-top with preserved remains of meal; enamel plaques on reverse [not shown]
57 × 55 × 20 cm [22.5 × 22 × 8 in]

Here the residue on the table after a meal is transformed into a readymade still life. The assemblage appears to have been constructed at random by someone else – the 'Delbeck family' – the objects glued into place exactly as discarded, rather than placed in a composition by the artist. This impression is reinforced by the plaques on the underside of the table-top, each commemorating the name of a member of the family. Preserving the evidence of banal domestic scenes, Spoerri conceived his *tableaux-pièges* (snare pictures) as a medium to highlight grim living conditions, his social commentary setting the work aside from the more formally structured objects of his Nouveau Réaliste contemporaries.

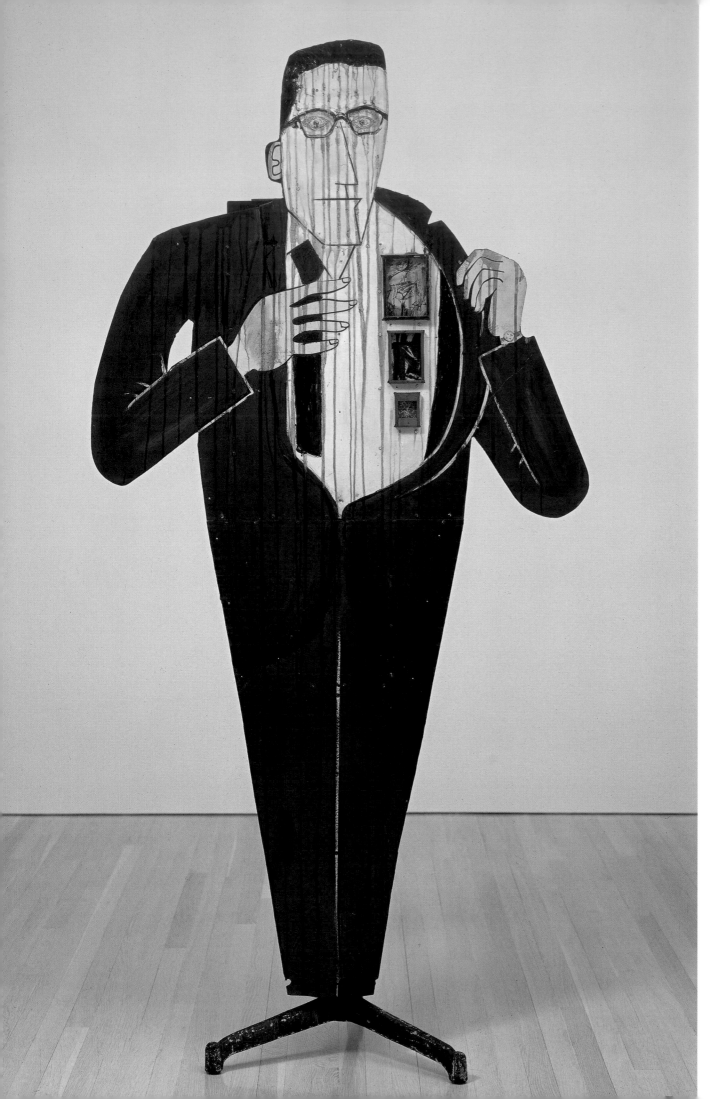

Edward <u>KIENHOLZ</u>
Walter Hopps Hopps Hopps
1959
Paint and resin on wood, printed
colour reproductions, ink on
paper, vertebrae, telephone
parts, sweets, dental moulds,
metal, pencil and leather
221 × 106.5 × 53 cm
[87 × 42 × 12 in]
The Menil Collection, Houston

Kienholz created this life-sized sculpture of his friend and associate using a freestanding gasoline station advertisement (the Bardhal Man, a cartoon detective). The title is a play on Hopps' name, Walter Hopps III. Kienholz portrays the gallerist and critic, wearing his characteristic thin tie and horn-rimmed glasses, as a street hustler, opening his jacket to reveal miniature replicas of paintings by Willem de Kooning, Jackson Pollock and Franz Kline. At the back of the figure, in several compartments, Kienholz placed phony art documentation and assorted lists he had dictated to Hopps. Walter Hopps was later director of the Pasadena Museum of Art, where in 1962 he presented 'New Painting of Common Objects', an exhibition that signalled the rise of American Pop art.

Alex <u>KATZ</u>
Frank O'Hara
1959–60
Oil on wood
152.5 × 38 cm [60 × 15 in]

Working on a large scale, Katz's realist images were transformed, developing into a 'synthetic' painting style, formally rigourous and iconic, while retaining a fidelity to appearance. *Frank O'Hara* is one of the earliest examples of his 'cut-out' series of portraits – freestanding, flat paintings of both front and back – often depicting art-world figures. O'Hara, a poet and curator at the Museum of Modern Art, used pop imagery in his poetry, incorporating everyday sights and experiences he encountered while walking around New York. Investigating the established boundaries of form in a similar way to Rauschenberg's combines, Katz's cut-outs mixed flat painting and sculpture.

Jim DINE
Car Crash
1960
Happening, Reuben Gallery, New York
centre left, Jim Dine with Judy Tersch

Dine had experienced a car crash in 1959. This work raised the question of the difference between real and imagined experience. The gallery was lined with his drawings and paintings. 'All of the works contained crosses – usually the blocky symbol of the Red Cross – and some had tyre-like circles. The white, freshly painted display room was simple, neat and clean … several large cardboard crosses hung from the ceiling' (Michael Kirby, *Happenings*, 1966). Dressed in silver, with silver face paint and red lipstick, Dine repeatedly drew anthropomorphic cars on a blackboard. He grunted, communicating only through drawing. The performance engaged with the daily spectre of reported accidents and deaths, a theme that Andy Warhol would also explore from 1963 with his series of paintings and screenprints based on disasters.

right
Red GROOMS
The Magic Train Ride
1960
Happening, Reuben Gallery, New York, part of 'Four Happenings',
8–11 January 1960

Before meeting Allan Kaprow, whose *Untitled* event in New Brunswick in April 1958 is considered the first Happening, Grooms had staged *A Play Called Fire* at the Sun Gallery, Provincetown, Massachusetts, during August and September of the same year. There he made an 'action' painting as a public performance. After meeting Kaprow in the summer of 1959 and seeing the exhibition of the Japanese Gutai group, who explored similar ideas, at the Martha Jackson Gallery in September, Grooms moved away from painting towards non-narrative based, improvisatory events such as *The Magic Train Ride*. These lasted around ten minutes and were performed by non-actors. Spoken references to New York city landmarks and comic strip characters such as Dick Tracy grounded these events in popular culture. Bob Dylan later wrote of the connection he felt with Grooms' work: 'It seemed to be on the same stage. What the folk songs were lyrically, Red's songs [sic] were visually – all the bums and cops, the lunatic bustle, the claustrophobic alleys …'
– Bob Dylan, *Chronicles*, 1, 2004

opposite
Claes OLDENBURG
Snapshots from the City
1960
Happening, Judson Gallery, Judson Memorial Church, New York,
29 February and 1–2 March 1960

This was Oldenburg's first Happening: a performance enacted in an environment he created, called The Street. It represented the culmination of his urban investigations, developed through his work as a street reporter and sketch artist in Chicago before moving to New York in 1956. He produced objects made from cardboard and burlap – cars, signs, figures – and painted them in a rough, cast-off style. These were then torn and tattered to evoke the chaos and aggression of city life. The performance engaged the audience in the mundane, involving them in their environment. Through his persona Ray Gun, he explored the possibility of making 'hostile objects human'.
– Claes Oldenburg quoted in Barbara Rose, *Claes Oldenburg*, 1970

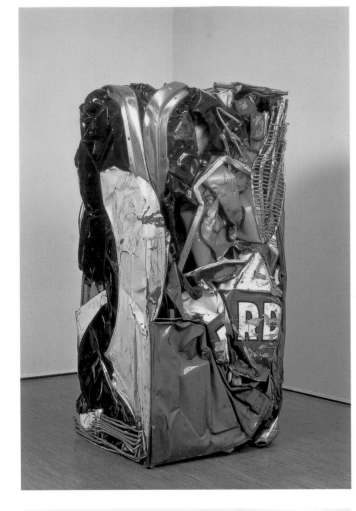

CÉSAR
Compression 'Ricard'
1962
Directed compression of car
153 × 73 × 65 cm [60.5 × 29 × 25.5 in]
Collection, Musée national d'art moderne, Centre Georges Pompidou, Paris

In the spring of 1960 a scrap-iron facility near Paris installed the latest American technology for compressing scrap metal. The machine produced bales of different weights and sizes, fed by a system of cranes and magnetic winches. César believed this operation created a new form of visual metamorphosis, emerging from an industrial process. He directed the car compression workers to produce individual units like this one branded with a Ricard logo, and presented them as readymades. The critic Pierre Restany saw these *Compressions* as a major transitional development in the appropriation of the real into the sphere of art.

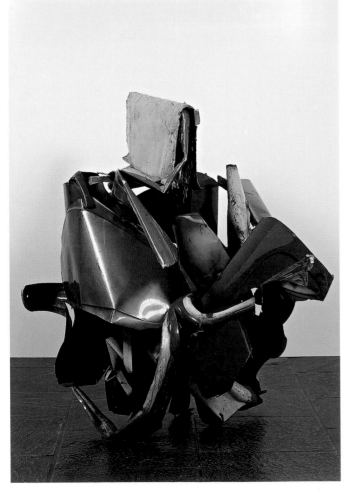

John CHAMBERLAIN
Jackpot
1962
Painted steel and gold paper
152.5 × 132 × 117 cm [60 × 52 × 46 in]
Collection, Whitney Museum of American Art, New York

Influenced by David Smith, whose welded steel sculptures he saw in the early 1950s, Chamberlain began incorporating crumpled automobile parts into his work. By 1959 he was using these parts exclusively, in sculptures that he presented without pedestals or stands. Unlike César, who made use of mechanical crushing techniques, Chamberlain assembled the components himself, based on shape and colour (often dictated by the Detroit manufacturers, although frequently the overall structure was sprayed with additional colours). The appropriation of the automobile as a source material makes reference to American consumerist culture, with its power and symbolic freedom subjected to the violence of Chamberlain's process. Chamberlain's gesture has been interpreted as an ironic comment on an industrial culture of expendability.

Claes <u>OLDENBURG</u>
The Store
1961
Ray Gun Mfg. Co., 107 East 2nd
Street, New York

Oldenburg's sense of what constituted an art object began to change as he looked towards commercial spaces. 'I saw, in my mind's eye, a complete environment based on this theme … I began wandering through stores – all kinds and all over – as though they were museums. I saw the objects displayed in windows and on counters as previous works of art.' (Claes Oldenburg quoted in John Rublowsky, *Pop Art*, 1965). He discovered a line of paints, Frisco Enamel, that came in seven bright colours that he felt symbolized the idea of The Store. Parodying the tastes of a materialist society he created objects (such as a wedge of pie, dresses, a shirt and tie) from burlap or muslin dipped in plaster and bound with chicken-wire, then painted them with Frisco Enamel straight from the can. Oldenburg first showed these works in 'Environments, Situations, and Spaces' (Martha Jackson Gallery, New York, March 1961). However, he was dissatisfied with the installation and made a more complete environment in his own studio, a storefront called the Ray Gun Manufacturing Company, which he opened in December 1961. The Store was both a commercial and an artistic success. He changed the name of his studio to the Ray Gun Theater and became a fixture on the Lower East Side.

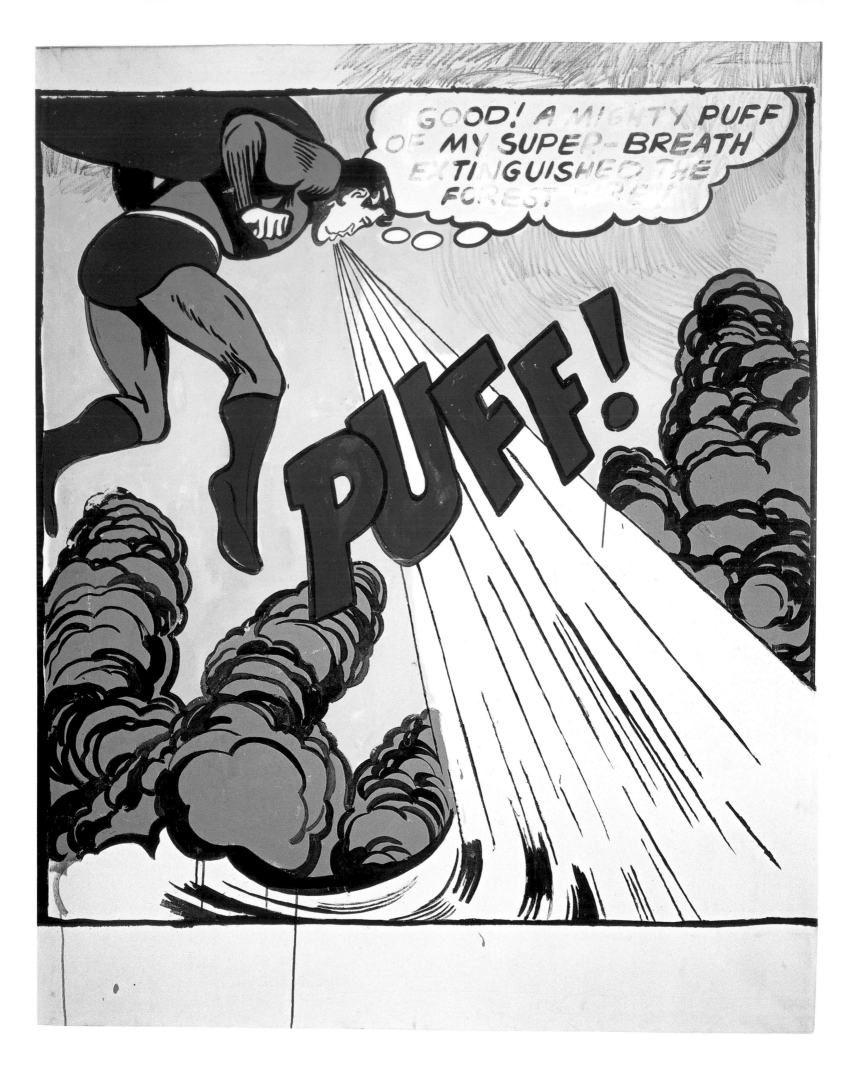

opposite

Andy <u>WARHOL</u>

Superman

1961

Casein and wax crayon on cotton duck

170 × 132 cm [67 × 52 in]

Warhol's *Superman* and a small group of other paintings such as *Dick Tracy* (c. 1961) are among the first to use comic-strip material as primary subject matter. They were made in tandem with his works based on newspaper small ads. *Superman* is based on a panel from *Superman's Girl Friend, Lois Lane* (24, DC/National Comics, April 1961); Warhol's archives show that he used two frames from this strip for reference. He painted the contours over the colours, reversing the accepted norm of colour following line. The monumental scale and traces of painterliness, such as the self-conscious drips, have been viewed as placing the work in a dialogue with the predominant style of gestural painting that prevailed until the end of the 1950s. This was one of the paintings displayed at the Bonwit Teller department store, shown below. Some of the crayon drawing in the work was added after that date.

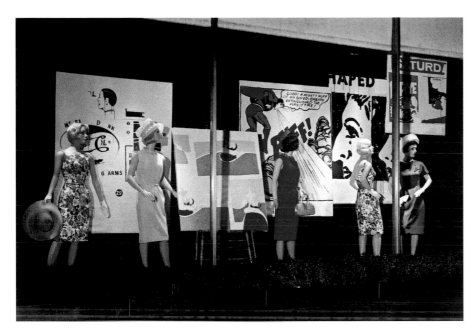

Andy <u>WARHOL</u>

Five paintings in display window at Bonwit Teller, New York, April 1961. *left to right*, Advertisement, 1961; Little King, 1961; Superman, 1961; Before and After [1], 1961; Saturday's Popeye, 1961

By the late 1950s Warhol was already well known in the advertising world as a commercial artist, specializing in promotions for fashionable women's shoes. His success enabled him to employ assistants and collect works of modern art. A number of prominent artists, from Salvador Dalí in the late 1930s to Jasper Johns and Robert Rauschenberg not long before Warhol, had been invited to style window displays in Manhattan's most exclusive department stores. Unlike his predecessors Warhol did not lose the opportunity to combine this commission with an exhibition of his latest paintings, presented to thousands of onlookers near the fashionable intersection of Fifth Avenue and 57th Street. This presentation by the as yet unknown artist preceded his first contact with an art dealer. Later that spring when visiting the Castelli Gallery he encountered Roy Lichtenstein's work for the first time. The realization that they were both making paintings, albeit very different kinds, based on comic strip figures, influenced Warhol to move on to different subjects by 1962.

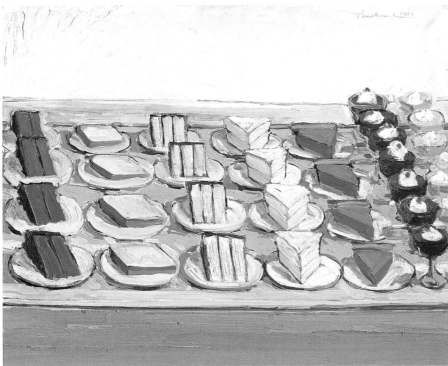

Wayne <u>THIEBAUD</u>

Desserts

1961

Oil on canvas

61 × 76 cm [24 × 30 in]

A West Coast painter who described himself as a 'realist', Thiebaud was co-opted by some critics as a Pop artist after his work began to be shown in New York in 1962. This was due to his typical subject matter – pinball machines, window or counter displays of rows of products – as well as the merging of sign and referent: 'I like to see what happens when the relationship between paint and subject-matter comes as close as I can get it – white, gooey, shiny, sticky oil paint [spread] out on top of a painted cake to "become" frosting. It is playing with reality – making an illusion which grows out of an exploration of the properties of materials.'

– Wayne Thiebaud, quoted in Lucy R. Lippard, *Pop Art*, 1966

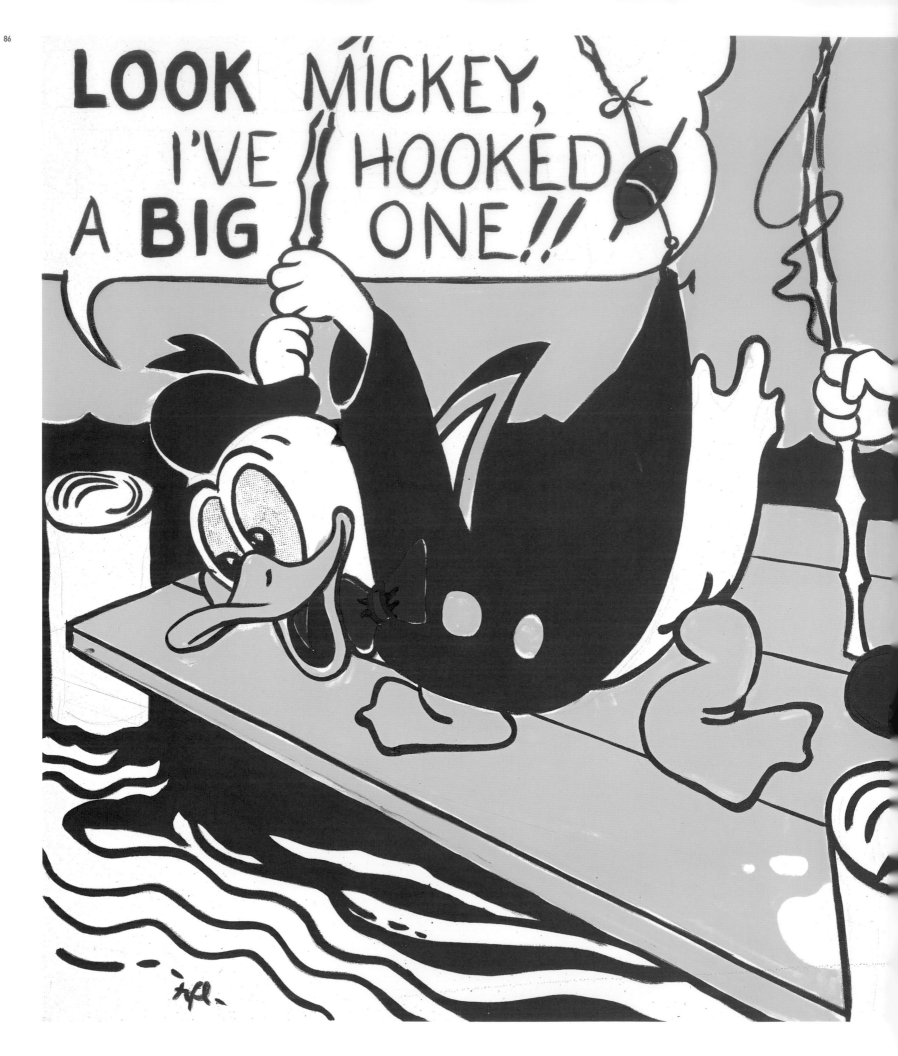

Roy <u>LICHTENSTEIN</u>

Look Mickey

1961

Oil on canvas

122 × 175 cm [48 × 69 in]

Collection, National Gallery of Art, Washington, D.C.

Painted in the summer of 1961, this was the first work in which Lichtenstein derived a subject directly from a printed comic strip. Featuring the Disney characters Donald Duck and Mickey Mouse, it shows the artist's first use of dialogue balloons and his first painted rendering of the dot patterns created by printers' halftone plates for colour separations (known as Ben Day dots). This was achieved on this occasion by applying them with a plastic-bristle dog-grooming brush dipped in oil paint. Lichtenstein would later refine his techniques for reproducing these dots, which became, ironically given their mechanical origin, a signature of his style. Although cartoon figures had started to appear in earlier works, such as a group of 1958 ink drawings, he now embarked on a radical departure from the abstract painterly style he had employed for over a decade, making paintings that many viewers at first took to be magnified facsimiles of the original sources. The large canvases in fact differed in a number of ways from the original pictures and texts, usually taken from segments of comic strips in newspapers, or other small-scale printed ephemera. This tension between the traces of the artist's hand, and creative intelligence, and his mimicking of the mechanically reproduced nature of the original sparked a heated debate among critics as to the status of these images as fine art. During this period most critics and curators would not have considered the possibility of acknowledging the original creators of cartoon strips as artists. By late 1963 the artist and critic Brian O'Doherty coined the term 'handmade readymade' to describe Lichtenstein's work.

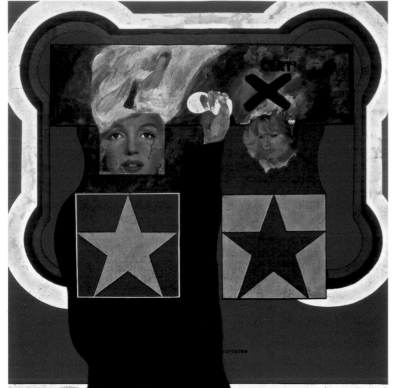

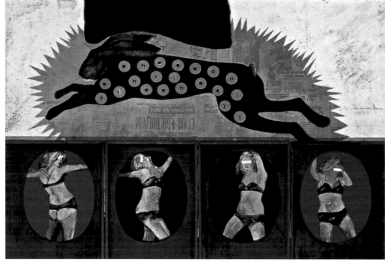

Peter <u>PHILLIPS</u>

For Men Only - starring MM and BB

1961

Oil, wood and collage on canvas

274.5 × 142.5 cm [108 × 56 in]

Collection, Centro de Arte Moderna, Fundação Calouste
Gulbenkian, Lisbon

This is one of a number of paintings in which screen icons such as Marilyn Monroe
and Bridget Bardot (the MM and BB of the title) become the focal point of a composition
with a structure derived from sources such as heraldry and the layout of board games
or amusement arcade machines. Collaged photographs are combined with both
'hard-edge' and gestural areas of painting. In the lower section views of a painted
erotic figure in a bikini are framed by realistic wooden 'peep-holes'. 'I look on what
I am trying to do now as a multi-assemblage of ideas inside one format … my
awareness of machines, advertising, and mass communications is not probably in
the same sense as an older generation that's been wihout these factors; I've been
conditioned by them and grew up with it all and use it without a second thought.'
– Peter Phillips, statement, *The New Generation*, 1964

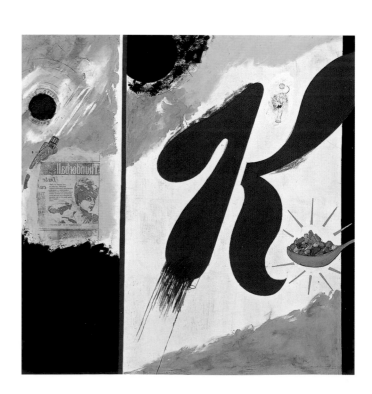

right

David HOCKNEY

Tea Painting in an Illusionistic Style

1961

Oil on canvas

185 × 76 cm [73 × 30 in]

Collection, Tate, London

This is one of the few paintings by Hockney that could be described as in a pure Pop idiom. The canvas is shaped to the everyday object depicted – the box of a brand of tea which is a British 'household name'. Hockney's title, however, describes the painting as 'in an illusionistic style' rather than purely illusory. The presence of a ghostly figure (apparently seated in the box), the misspelling of the word 'tea' on one side, and Hockney's loose, painterly style make the illusion obvious in its falsity. His exploration of process connected Hockney with the ideas of Johns and Rauschenberg, and he has cited as an influence Larry Rivers, who in 1961 visited the painting studios at the Royal College of Art where he was studying. 'This is as close to Pop art as I ever came. But I didn't use it because I was interested in the design of the packet or anything; it was just that it was a very common design, a very common packet, lying around … To make a painting of a packet of tea more illusionistic, I hit on the idea of "drawing" it with the shape of the canvas. It meant that the blank canvas was itself already illusionistic and I could ignore the concept of illusionistic space and paint merrily in a flat style – people were always talking about flatness in painting.'
– David Hockney, 'The Tea Paintings', *David Hockney by David Hockney*, 1976

opposite

Derek BOSHIER

Special K

1961

Oil, collage, pencil on canvas

121.5 × 120.5 × 2.5 cm [48 × 47 × 1 in]

Boshier was unusual among the British Pop artists of the 1960s in presenting an overt critique of the accelerated and globally spreading capitalism emanating from the United States. In a number of paintings of this period there is a suggestion that people are becoming like their products and imprisoned by brand logos. America's provisional control over import/export economies, ranging from the crisis in Cuba to the food products in the average urban household, gave rise to the notion of the consumed consumer. For Boshier, Americanization was being sold through the basic choices of branded nourishment: 'You are what you eat'.

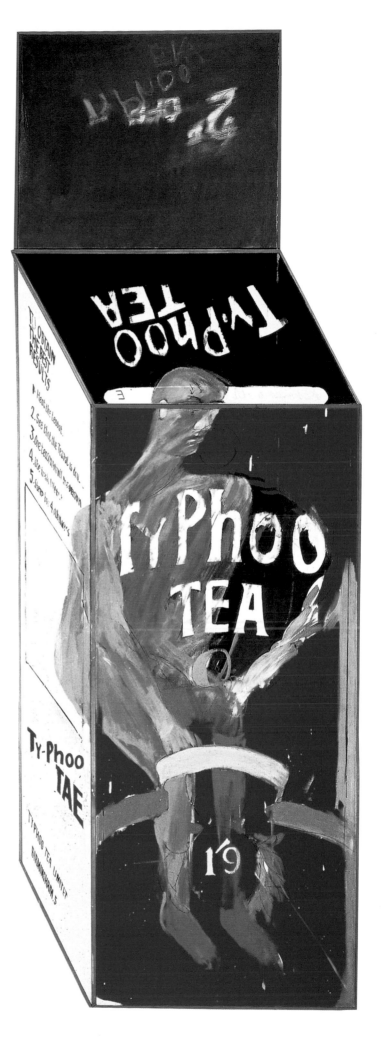

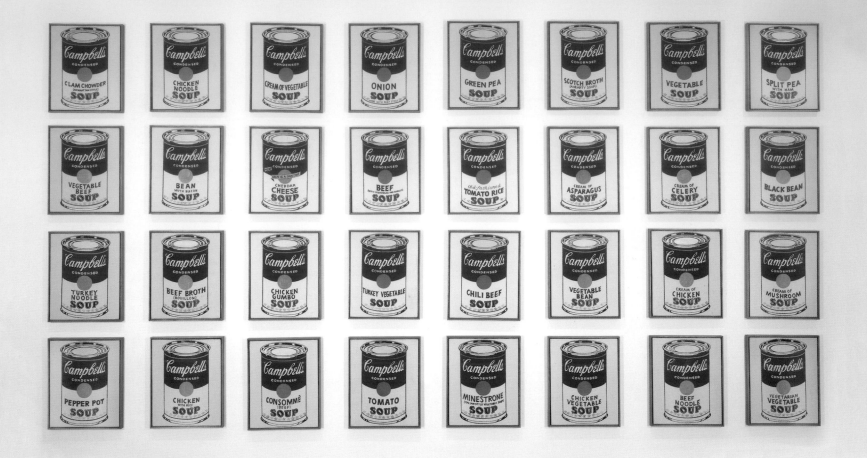

Andy WARHOL
32 Campbell's Soup Cans
1962
Casein, metallic paint and pencil on linen
51 × 40.5 cm [20 × 16 in] each
Collection, The Museum of Modern Art, New York

From 1961 Warhol made images of Campbell's Soup cans repeatedly, with variations –
open, crushed or pristine; realistic in colour and not; standing alone or in groups;
large and small; sketchy or precise – and in different media. The paintings of *32
Campbell's Soup Cans* (first exhibited at the Ferus Gallery, Los Angeles, in July 1962)
echo the image that appeared as a logo on the company's envelopes. Warhol referred
to their product list, adding 'Turkey Vegetable', which had been omitted. The name
of each variety is the only feature that distinguishes each painting from its neighbour.
Conceived as related compositions but not necessarily a single work, it was Irving
Blum's acquisition of the whole set that led to them being considered a series.
For their first showing Blum, co-director of the Ferus Gallery, devised a narrow ledge
on which they rested, which critics have compared with a supermarket shelf. These
are among the last of Warhol's handmade paintings and were assisted by the use of
stencils, a precursor of the silkscreens he began to use shortly afterwards.

opposite
Ed RUSCHA
Actual Size
1962
Oil on canvas
183 × 170 cm [72 × 67 in]
Collection, Los Angeles County Museum of Art

Twenty-four years old and as yet unknown, Ruscha was invited to participate in the
group show 'New Paintings of Common Objects' (Pasadena Museum of Art,
September–October 1962) which presented New York artists such as Dine,
Lichtenstein and Warhol alongside West Coast contemporaries. He submitted this
painting. Warhol's *32 Campbell's Soup Cans* had been on show in the local Ferus
Gallery during July and August, but the precedent for *Actual Size* goes back to 1961
when Ruscha made a series of objective-style, frontal view, centred black and white
photographic studies of household items he later titled *Product Still Lifes* (1961/99).
Subjects included a Sun Maid raisins packet, a tin of Wax Seal car polish and a Spam
can. In *Actual Size* Ruscha depicts the Spam brand logo from the top of the can's
design and presents it as a monumentally enlarged text in the upper part of the
painting, underneath which is an exact painted rendition of the product – to actual
scale. This is portrayed 'flying' across the white canvas with a fiery trail of 'Spam logo'
yellow, surrounded by paint marks which seem less like an index of painterliness
than sign-painter's drips which have not been cleaned up or overpainted. The title
invites speculation on the different relations between iconographic or textual signs
and their referents.

Tom WESSELMANN

Still Life # 21

1962

Acrylic and collage on board, with recorded pouring sound

122 × 152.5 cm [48 × 60 in]

The billboard size Wesselmann adopted in both the *Still Life* and *Great American Nude* series brought about a change in materials, as he painted directly on to the canvas, as well as affixing found imagery from advertising and posters. He spoke of 'assembling a situation resembling a painting, rather than painting' (*ARTnews*, 1964). Wesselmann later incorporated actual objects, including radios and fans, into his works, moving into the viewer's space. Here he added a recorded sound to accompany the image of the drink being poured into a glass. The direct lifting of imagery meant that Wesselmann's intervention was reliant on composition, as the objects retain their original forms and associations. As here, there is usually no central focal point; images are distributed evenly across the picture plane.

James ROSENQUIST
President Elect
1960-61/64
Oil on masonite
213.5 × 365.5 cm [84 × 144 in]
Collection, Musée national d'art moderne, Centre Georges
Pompidou, Paris

Rosenquist's billboard-sized paintings are based on pictures he cut out from magazines and other ephemera and collaged into working drawings. In this case, a campaign poster for John F. Kennedy, an automobile advertisement and another for cake merge into one another in what seems to be a political statement. Even here, however, as in Rosenquist's other works, the possible significance of the juxtapositions remains open to the viewer. *President Elect* is the first studio painting in which he translated the techniques he had learned as a billboard painter. He had continued to work commercially when he moved from Minnesota to New York in 1957 to attend art school, and now used the hyperrealism and vast scale of the cinema or advertising poster, but combined these qualities with a frozen approximation of cinematic montage that marks the point of transition from one subject-area to another. 'Painting is probably more exciting than advertising – so why shouldn't it be done with that power and gusto, that impact ... When I use a combination of fragments of things, the fragments or objects or real things are caustic to one another, and the title is also caustic to the fragments ... The images are expendable, and the images are in the painting and therefore the painting is also expendable.'
– James Rosenquist, statement, *ARTnews*, 1964

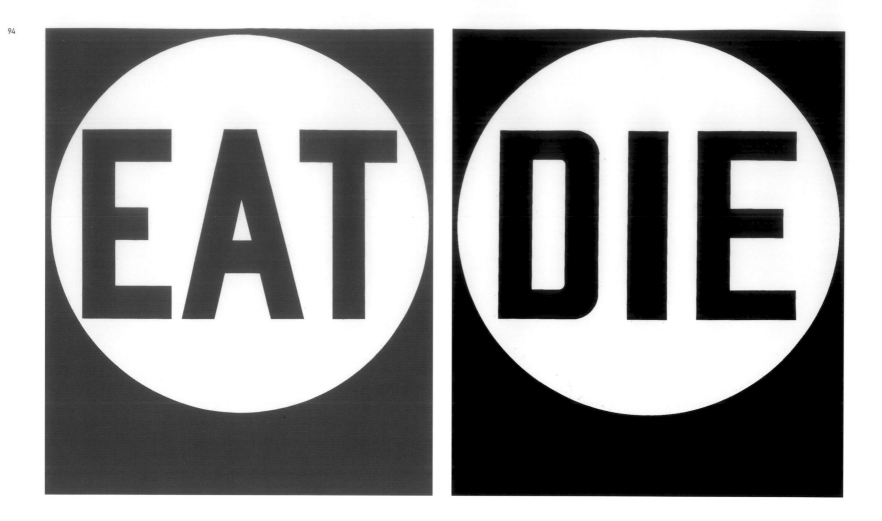

Robert INDIANA
EAT/DIE
1962
Oil on canvas
2 panels, 183 × 152.5 cm [72 × 60 in] each

Using words and numbers as images, Indiana often adapted formats derived from signage. Using a hard-edged painting style and flat areas of pure, unvaried colour, the work brings together the formally abstract and impersonal with the symbolically redolent. The sign-like impact of the visual field in this diptych recalls the illuminated signs for roadside diners that were a feature of the American landscape in the 1950s and early 1960s. The word 'eat' was loaded with personal significance for Indiana: his mother ran a dinner service for travellers and she referred to eating in the last words she spoke to him at her death in 1949. 'Eat' appears both singly and combined with other charged words in a number of works. The electric sign he made for Philip Johnson's building at the 1964 New York World's Fair comprised the word 'eat' twice, crossing in an X form at the central letter. Indiana was the subject (eating a mushroom) in Andy Warhol's 45-minute film *Eat* (1963).

Richard <u>SMITH</u>
Staggerly
1963
Oil on canvas
226 × 226 cm [89 × 89 in]
Collection, National Museum of Wales, Cardiff

The title is a modified spelling of the traditional blues song *Staggerlee*. Smith's paintings of this period filter everyday forms, such as branded box packaging, into his own pictorial language of abstraction. Here a form based on a Lucky Strike cigarette packet is abstracted and tripled in a rhythm that derives from observations Smith made in his experimental films, in particular *Trailer* (1962), a perspectival study of a cigarette box. Only the basic shapes of the brand logo have been retained, making the reference subliminal and at the same time close to the use of generic abstract forms such as stripes and chevrons by 'hard-edge' painters such as Kenneth Noland. The canvas was designed around the shape of the composition, an approach that eventually led Smith to make relief-paintings that project areas of the work into the space around the viewer.

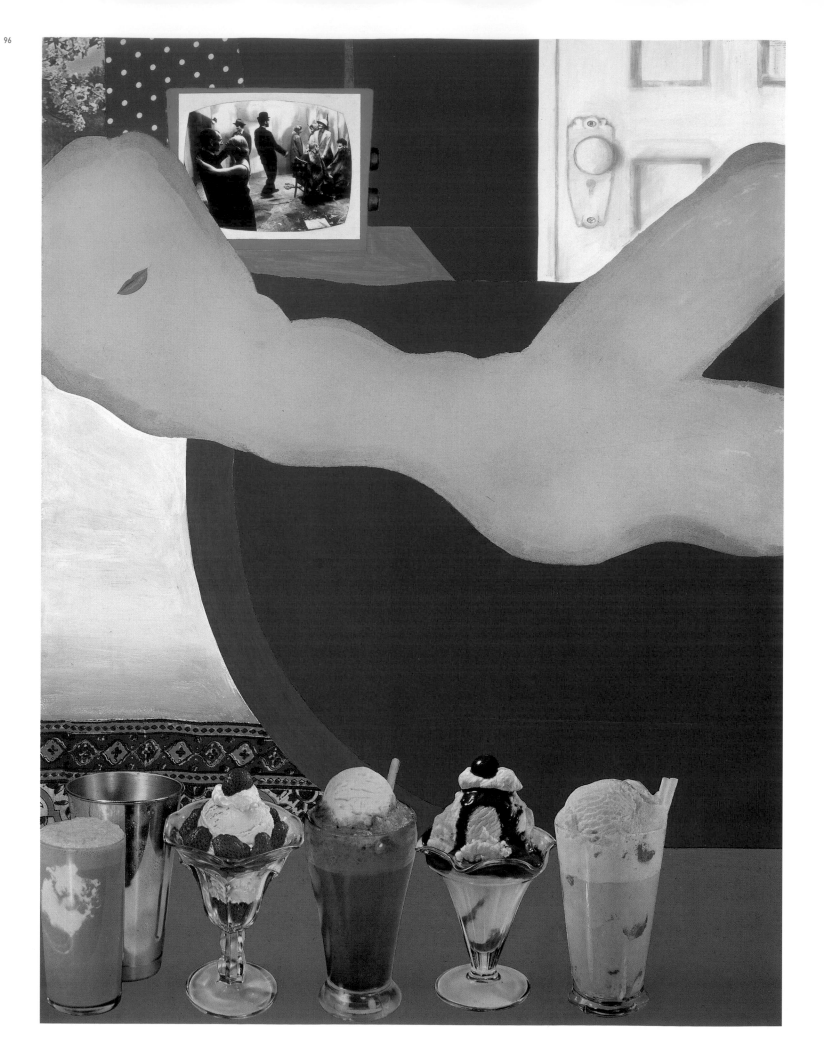

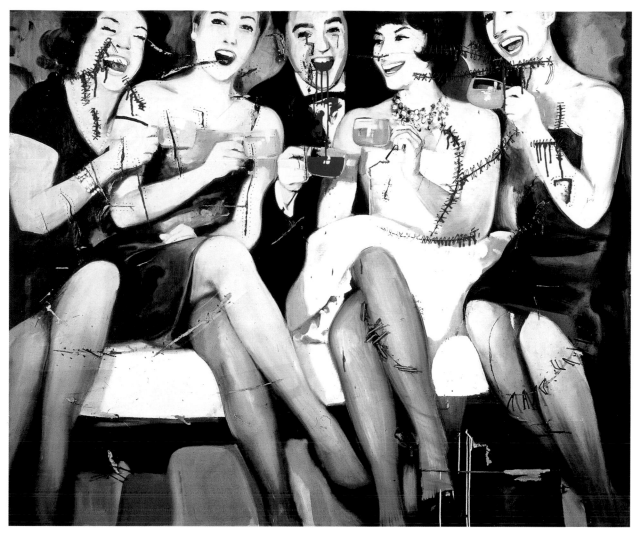

Party
1962
Tacks, cord, oil on canvas
and newspaper
150 × 182 cm [59 × 72 in]
Rather than the advertisements and cartoons referenced by the American Pop artists, Richter used found photographs. Having worked through the canon of Western art-historical styles on his arrival at the Dusseldorf academy, he developed a photorealistic style that for a time he identified with the term 'Capitalist Realism'. This painting is derived from a photograph included in sheet 9 of the artist's extensive image archive begun in 1962: *Atlas*. Both comical and disturbing, this particular work is distinctive for being treated as an object. Richter splattered the image with drips of paint and slashed the canvas, then stitched it, repairing the painting after the brutalizing, as it were, that it had undergone. Realism is unsettled by the gothic transformation of the drinking man into a ghoulish figure by the use of red paint, and the appearance of one of the women's legs 'in colour', when all else is 'in black and white'.

opposite
Tom <u>WESSELMANN</u>
Great American Nude # 27
1962
Enamel, casein and collage on panel
122 × 91.5 cm [48 × 36 in]
Painted in a flat and schematic manner, a female nude lounges in a domestic setting, her mouth the only discernable feature, with an ensemble of ice-cream sundaes and other drinks in the foreground. The figure is composed in a style that distantly echoes the early modern painters, such as Matisse, whom Wesselmann admired. The use of collage material in the canvas was, he stated, a practical solution to being unable to paint certain objects with the accuracy he required. Raising questions of authorship and originality, this approach became a feature of much work in the Pop idiom. Wesselmann's later nudes in the series included three-dimensional objects, such as furniture and bathroom fittings. 'I refuse to draw the line betweeen flat paintings and three-dimensional structures. I'm aware of the differences between real and imitation but I don't attach much significance to the distinction.'
– Tom Wesselmann, interview, *Time* magazine, 1966

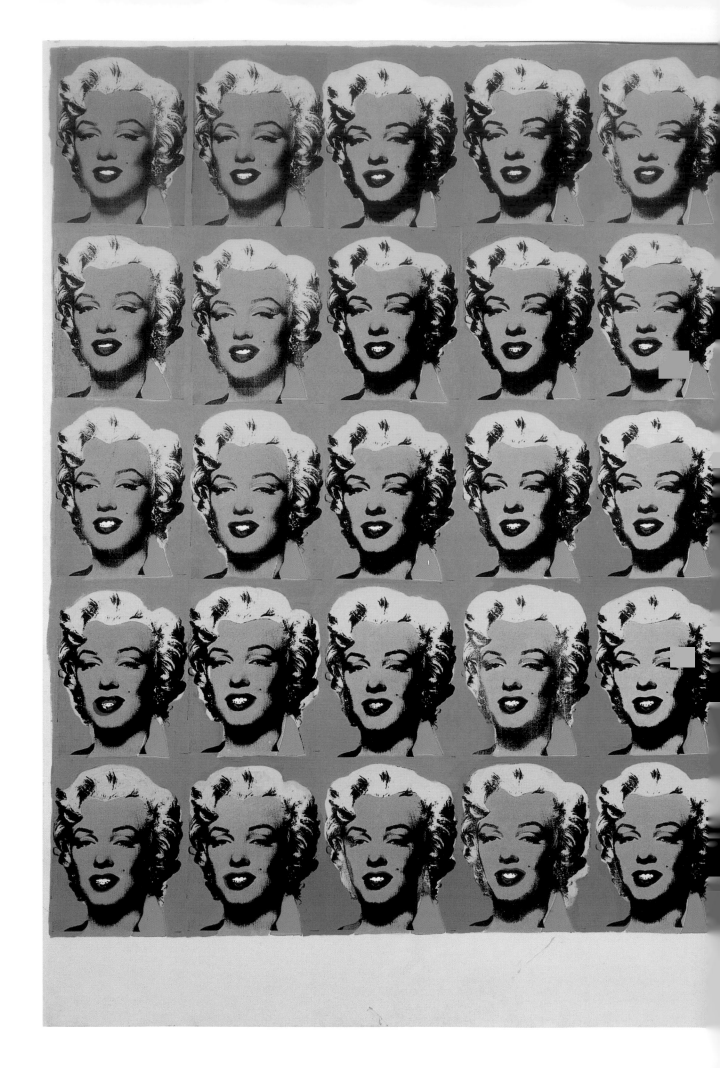

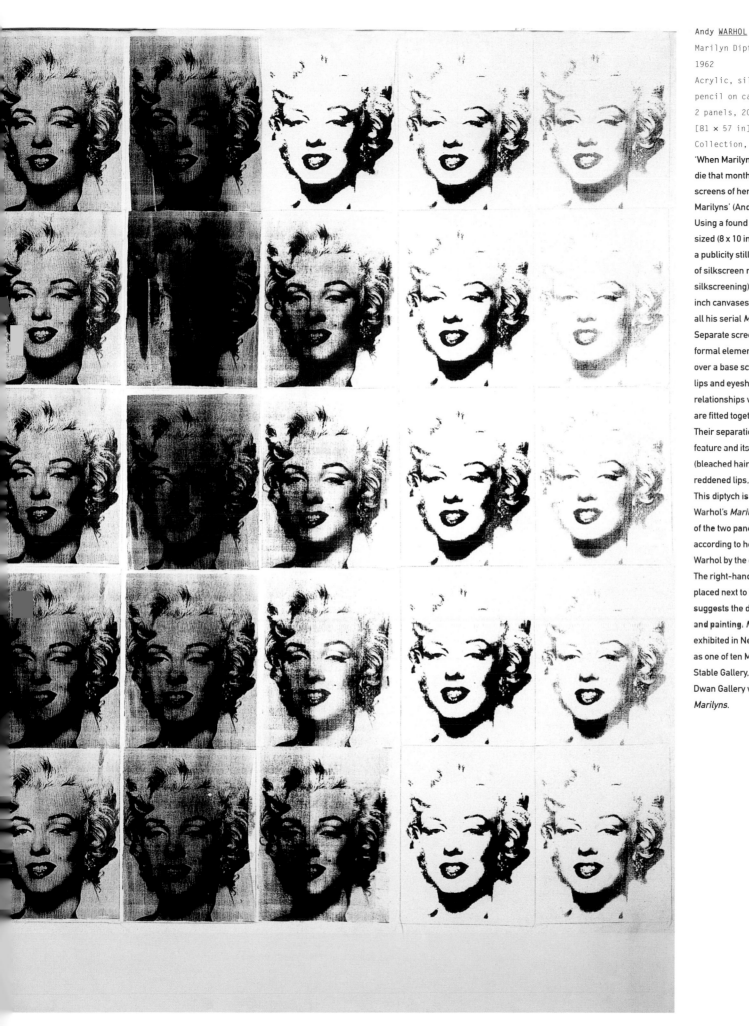

Marilyn Diptych
1962
Acrylic, silkscreen,
pencil on canvas
2 panels, 205.5 × 145 cm
[81 × 57 in] each
Collection, Tate, London

'When Marilyn Monroe happened to
die that month, I got the idea to make
screens of her beautiful face – the first
Marilyns' (Andy Warhol, *Popism*, 1980).
Using a found image – a standard-
sized (8 x 10 in) photograph, possibly
a publicity still – Warhol had two sizes
of silkscreen made (his first use of
silkscreening), for 20 x 16 and 15 x 11
inch canvases, and from these he made
all his serial *Marilyn* compositions.
Separate screens were used for the
formal elements in the coloured works,
over a base screen of black. The hair,
lips and eyeshadow, in intense colour
relationships with very little overlap,
are fitted together like a jigsaw.
Their separation draws attention to each
feature and its treatment and artificiality
(bleached hair, plucked eyebrows,
reddened lips, garish eyeshadow).
This diptych is the canonical example of
Warhol's *Marilyns*, though the treatment
of the two panels as a whole was,
according to her account, suggested to
Warhol by the collector Emily Tremaine.
The right-hand panel, in black and white,
placed next to the coloured panel
suggests the division between drawing
and painting. *Marilyn Diptych* was first
exhibited in New York in November 1961,
as one of ten Marilyn images at the
Stable Gallery, while simultaneously the
Dwan Gallery was showing *25 Colored
Marilyns*.

The Kiss

1962

Oil on canvas

203 × 173 cm [80 × 68 in]

From 1961 onwards, Lichtenstein showed a sustained interest in the typologies of comic books and their genres, such as combat or romance. *The Kiss* combines the two in a large-scale representation of a romantic encounter that appears at first sight to be a replica of a single comic-strip cell. Lichtenstein borrowed the basic composition and style from the original, and approximated the dots of the printing process. However, despite the implied removal of artistry, there are numerous modifications in positioning, scale and emphasis, and in the use of different thicknesses of line and areas of pure colour to activate positive and negative space.

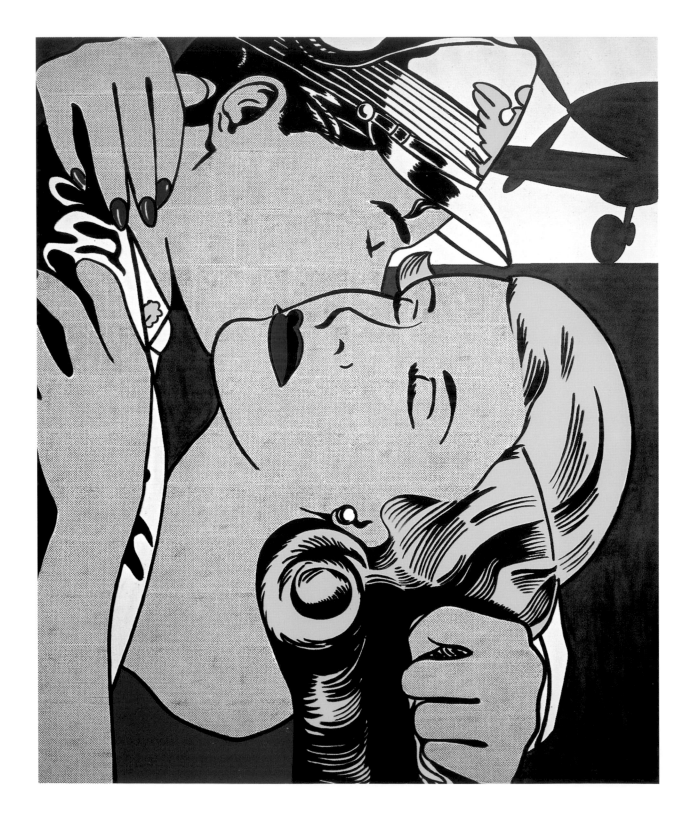

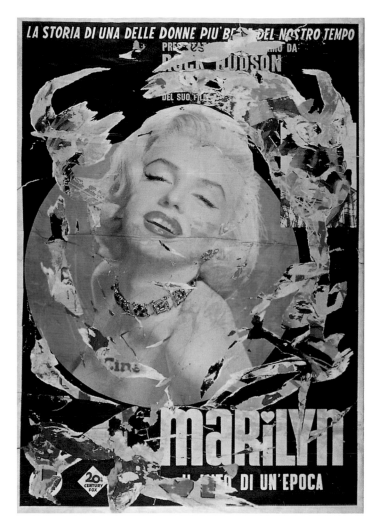

Mimmo <u>ROTELLA</u>

Marilyn

1962

Décollage: peeled posters on paper mounted on canvas

133 × 94 cm [52.5 × 37 in]

First presented at the Galerie J, Paris, in 1962, Rotella's décollages featuring posters of Marilyn Monroe became a substantial body of work. One of the early pioneers of this technique, he differed from the French artists Hains and Villeglé in his retention of more of the poster's composition and much of its informational content. The cinema posters he used were mostly produced by the Cinecittà feature film studios, located in Rome where he lived. Rotella's use of film posters was based on their prevalence in society as an integral part of the metropolitan fabric. Taking advantage of their availability, and fascinated by their natural evolution on the street, becoming torn, covered over and defaced, he preserved the way in which they extend cinematic fantasy and also act as a marker for collective memory.

Wolf <u>VOSTELL</u>

Marilyn Monroe

1962

Dè-coll/age and collage

157 × 122 cm [62 × 48 in]

Collection, Museum Moderner Kunst, Vienna

Vostell's 'dè-coll/age' works conveyed his view of art and life as inextricably linked. His imagery was taken from a wide range of sources, as likely to feature serious reportage as advertising for consumer products or paparazzi photography. The use of Marilyn Monroe iconography by artists proliferated in quick succession around the world, as artists such as Mimmo Rotella in Italy and Vostell in West Germany explored her manufactured image, like Warhol, soon after her death in 1962. Here the obsessive arrangement of publicity photos, magazine covers and news cuttings follows a 'pin-board aesthetic', fetishizing the model; their partial obliteration and over-painting might suggest the eliminative process of marking up a contact sheet, or vandalism and the gradual entropy of printed images decaying in the streets.

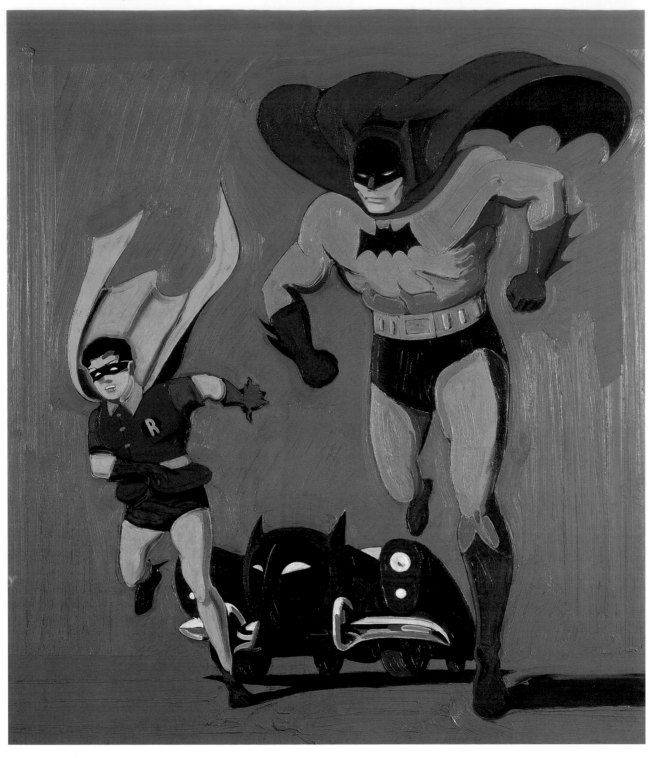

Mel RAMOS
Batmobile
1962
Oil on canvas
127.5 × 112 cm [50 × 44 in]
Collection, Museum Moderner Kunst Stiftung Ludwig, Vienna

At the end of 1961, Ramos began painting comic-book figures inspired by childhood
memories and his enduring admiration for the form. With *Batmobile* he established
a style of composition in which these figures are placed in a brightly coloured
background. Here Batman and Robin are running directly towards the viewer, the
batmobile behind them establishing a point of diminishing and dynamic perspective.
Ramos uses this action and depth of field to assert the picture surface. However, he
used comic-strip imagery less for its formal potential than for the values embodied
by the particular figures he selected. In contrast to Lichtenstein's use of a single,
recognizable frame, Ramos presents his heroes in situations of his own devising.

Öyvind <u>FAHLSTRÖM</u>
Sitting …
1962
Tempera on paper mounted on canvas
159 × 201 cm [62.5 × 79 in]
Collection, Moderna Museet, Stockholm

This was the first large-scale work the artist made after arriving in New York from Sweden in 1961. Since the early 1950s he had developed a form of representation he called *signifiguration*. This was characterized by forms that are between the figurative and non-figurative, hinting at meaning. Their meaning was affected by being placed in a new position and by their relationship to the whole picture. This process could be compared to a game-structure. Fahlström devised an equivalent of narrative by using 'time phases' similar to the frames in comic strips. The narrative scheme of *Sitting …* is based on a section drawing of a house, with progressions from room to room. He also introduces figurative elements, such as Batman's cape, marking a departure from *signifiguration* and a new stage in his work. The title came from wordplay: 'Sitting like Pat [Oldenburg] with a bat in her hat'. The *character-forms* in the painting are divided into different 'families' according to various characteristics. *Sitting …* initiated a series of paintings and drawings and an unfinished *Sitting … Directory* of drawings for each *character-form*.

Happy Birthday
1962
Oil and pencil on canvas with oil on glass milk bottle
170.5 × 170 × 7.5 cm [67 × 70 × 3 in]
Collection, San Francisco Museum of Modern Art

Goode produced 13 milk bottle paintings, varied in palette, starting in 1961 and
culminating in his first solo exhibition, at Dilexi Gallery, Los Angeles, in 1962. Two of
the series were dedicated to his daughter: *Happy Birthday*, in pale pink and dark red,
celebrated her second birthday, and *One Year Old* (1962), with both canvas and bottle
painted a pale cream, her first. Emptied of one liquid, then coated with another (paint)
the bottles stand in front of a colour field that invites contemplation of the relationship
between the physical and spiritual. Goode's concern was less with consumerism than
with the everyday object. The bottles came from the Alta-Dena Dairy Company, which
delivered milk to doorsteps across California. *Happy Birthday* was used on the cover
of *Artforum* (August 1962), in the issue that included John Coplans' review of the
Pasadena Art Museum's 'New Painting of Common Objects'.

opposite
Jim DINE
3 Panel Study for Child's Room
1962
Oil, charcoal, child's rubber raincoat, plastic toys [train, Popeye,
car, gun], metal coat hanger, metal hook, wood, on 3 joined canvases
213.5 × 184 cm [84 × 73 in]
The Menil Collection, Houston

The collection of objects in this study of a domestic interior belonged to Dine's sons
Jeremy and Matthew. It was included in Dine's solo exhibition at the Sidney Janis
Gallery, New York, in early 1963. Dine was interested in objects as signs of possession,
in the traces left by human interaction, and in presenting the objects themselves as
part of the work rather than describing them with paint. The inclusion of his children's
handprints, stencilled on to the canvas, raised questions about the status of types
of painting: 'Is it an "event"? Is it a "popular" or "vulgar" way of painting?' (Öyvind
Fahlström, *New Paintings by Jim Dine*, 1963). Dine's use of objects with intimate,
personal associations and the 'homemade look' of his works distanced him from
mainstream Pop art's engagement with mass-media images and serial production,
although they shared a common concern with the everyday.

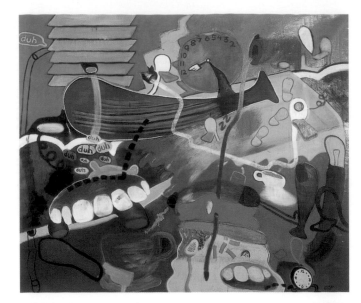

Peter SAUL
Ducks in Bed
1962
Acrylic on canvas
188 × 219 cm [74 × 86 in]
Collection, Sintra Museu de Arte Moderna, Sintra, Portugal

Born and educated in California, Saul lived and worked in Europe from 1956 to 1964, but was exhibited in New York as a West Coast Pop artist from 1962. His fusion of a gestural painterly approach with cartoon-style imagery during this period has been compared with the later work of Philip Guston. A number of contemporaneous paintings convey a sense of violent out-of-control frenzy, with titles such as *Bathroom Sex Murder* or *Super Crime Team*. *Ducks in Bed* is lighter and more hilarious, although all of Saul's work has a basis in serious social satire and dissent. The use of 'bad taste' colour combinations is part of the artist's sustained repudiation of high culture in favour of the directness of material connected to the everyday.

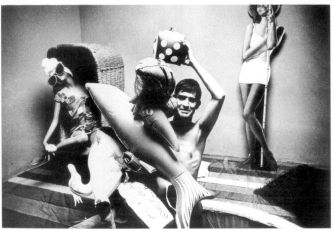

Martial RAYSSE
Raysse Beach
1962
Detail of installation, 'Dylaby', Stedelijk Museum, Amsterdam, 1962
Photograph by Ed Van der Elsken, with the artist in the foreground

Shown at the group exhibition 'Dylaby' at the Stedelijk Museum, Amsterdam, where it was inaugurated by a performance, this installation included a paddling pool, plastic flowers, inflatable toys, towels, dressed-up mannequins and life-sized photographs of women in bathing suits, enlarged from advertising images. Everything was brightly, synthetically coloured. Lamps simulated Mediterranean light and radiators produced torrid blasts of heat. A neon sign, the artist's first use of the medium (later incorporated into paintings to highlight a feature or line), declares the work 'Raysse Beach' – a world composed almost entirely of synthetic manufactured products designed for the leisure industry.

opposite
BEN
Le magasin de Ben
Ben's Boutique
1958-73
Wood, board, paint, found objects
350 × 500 × 350 cm [138 × 197 × 138 in]
Collection, Musée national d'art moderne, Centre Georges Pompidou, Paris

The Fluxus artist Ben Vautier, known from this period onwards simply as Ben, conceived this project in the late 1950s but did not present it as art until 1960, when its connection with Pop began to become apparent. The boutique, set up in various real shopfronts, the first of which was in his home town of Nice, was a place where he could freely nominate every object to hand as art. He made it evident that he was a mediating filter through which the object was transformed. The process simply involved the signing of his name or cheerful witticisms on to the objects, in his recognizably cursive handwriting. Ben's presence, living in the shop, added to the acceptance of the common object as art and generated public interest in the work.

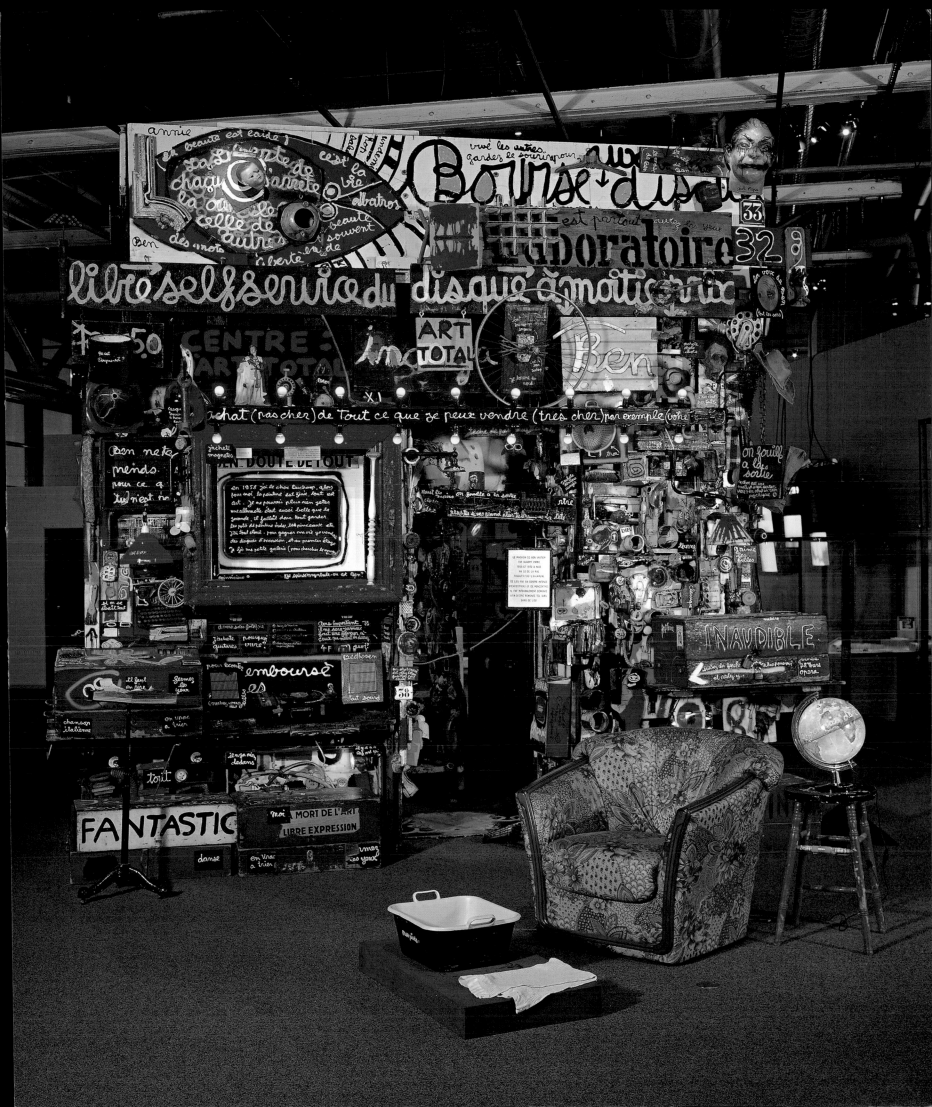

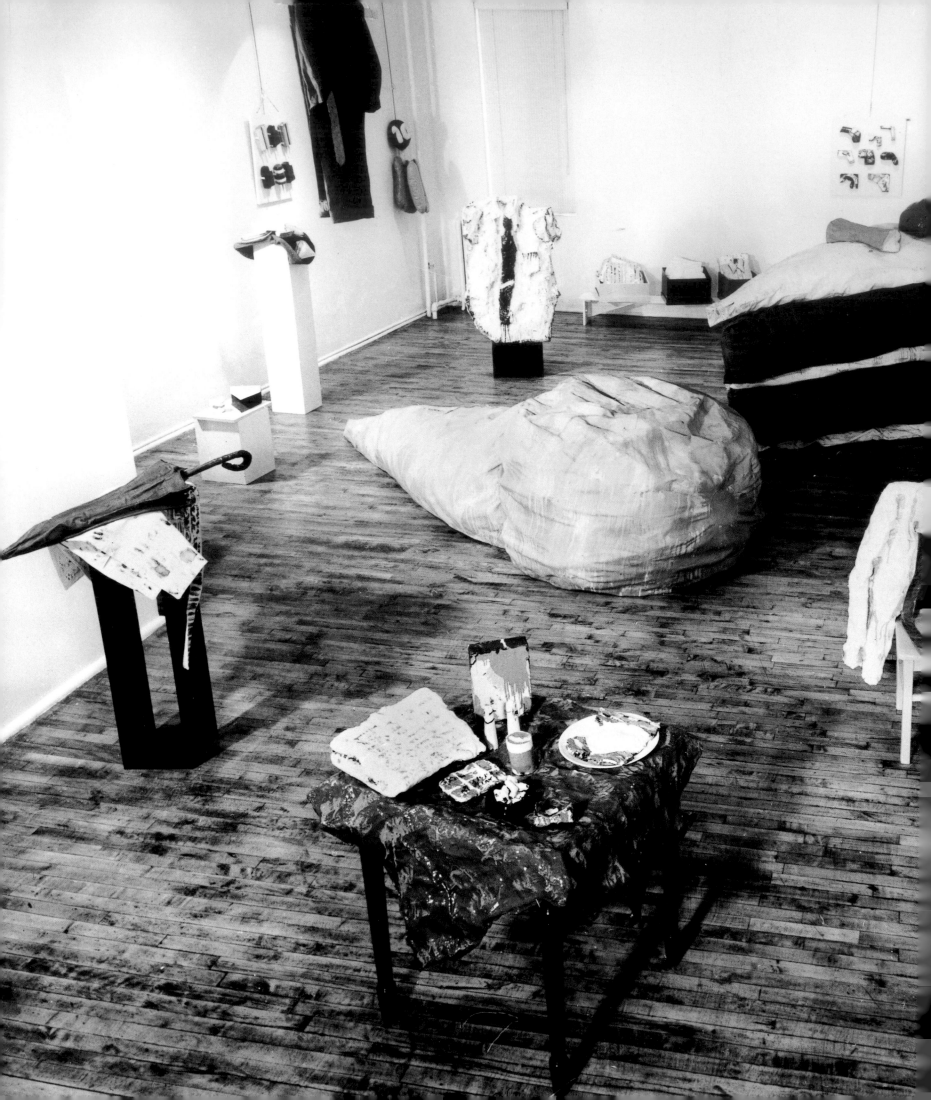

'The Store'

Environment at Green Gallery, New York, 24 September-20 October 1962

Towards the end of his Store project that had begun in 1961, Oldenburg began to produce work in softer materials, such as canvas or vinyl, stuffed with filling material. Monumental in scale, the pieces were made with the collaboration of his first wife, Pat Oldenburg. They included a giant slice of chocolate cake, a giant hamburger and various giant ice-cream cones, one lying on the floor, another suspended from the ceiling. With the earlier, painted plaster works such as a series of pies and tarts displayed in a vitrine, a large selection of Oldenburg's objects was displayed in this environment at the Green Gallery in the autumn of 1962. The objects were set out informally as if in the room of a house, some draped over chairs, scattered on a table or perched on a radiator. There the resemblance to reality ended. Ranging across widely divergent scales, the works activate the physical and associational responses to objects of those who encounter them. 'You might ask what is it that has made me make cakes and pastries and all those other things. I would say that one reason has been to give a concrete statement to my fantasy. In other words, instead of painting it, to make it touchable, to translate the eye into the fingers.'

– Claes Oldenburg, 'Oldenburg, Lichtenstein, Warhol: A Discussion', *Artforum*, 1966

Lee FRIEDLANDER

Newark, N.J.

1962

Gelatin silver print

31.5 × 47 cm [12.5 × 18.5 in]

In 1962 Friedlander began documenting the American urban landscape, several years after Robert Frank's *The Americans*. Capturing the increasing dominance of products and brands in everyday life, one of the features of a number of his compositions is the store or café window, both revealing the interior and fusing it, through its reflective surface, with impressions from the street outside, including the reflection of the photographer himself. Here advertising signs across the busy street outside compete with the Coca-Cola-with-fries and ice cream promotional signs inside. The human subjects seem to be framed between these references, which exert a stronger impression than the occasion for their standing to attention at the window and the boy's clutching of the American flag.

CONSUMER CULTURE

Dennis <u>HOPPER</u>
Double Standard
1961
Gelatin silver print
40.5 × 61 cm [16 × 24 in]

This photograph of a street junction in Los Angeles situates the photographer and the viewer in the driver's seat. The gasoline station at the intersection of Melrose Avenue and Route 66 is the focal point, underlining the expansion of consumerism into the architectural environment. The station doubles its exposure with two large signs, but the photographer's title also suggests a social comment. Hopper was closely involved with the American Pop scene in the 1960s, photographing Rosenquist, Ruscha and Lichtenstein. This photograph was reproduced on the poster for Ruscha's second solo exhibition at the Ferus Gallery, Los Angeles, in 1964, where he showed his paintings with gasoline stations as subjects.

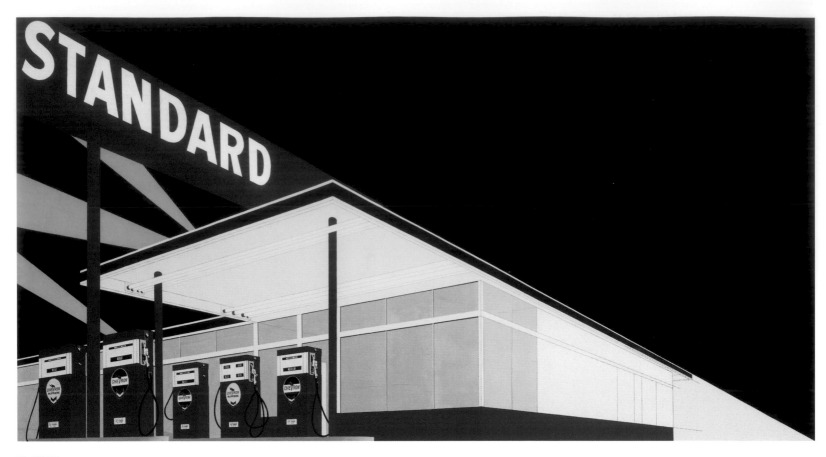

Ed RUSCHA
Standard Station, Amarillo, Texas
1963
Oil on canvas
164 × 309 cm [64.5 × 122 in]
Collection, Hood Museum of Art, Dartmouth College, Hanover,
New Hampshire

Ruscha's graphic style of painting partly arose through his training, like a number of Walt Disney's animators, at the Choinard Art Institute, Los Angeles. In paintings such as *Large Trademark with Eight Spotlights* (1962), portraying the Twentieth Century Fox logo, and the gasoline station paintings of the following year, he introduced an elongated format and an exaggerated single-point perspective. The cinematically derived stylization is here combined with the viewpoint of the car driver traversing the suburban landscape. Ruscha's paintings were often based on his own photographs. Also in 1963 he produced his artist's book of photos taken in 1962 along Route 66, *Twentysix Gasoline Stations*.

opposite
Allan D'ARCANGELO
Full Moon
1962
Acrylic on four canvases
166.5 × 157.5 [65.5 × 62 in]

D'Arcangelo described his canvases of the early 1960s as painted 'without gesture, without brushstroke, without colour modulation, without mysticism and without personal angst, because these qualities would have obscured the intention of the paintings. The work is pretty much preconceived, and the execution is relatively mechanical' (*Allan D'Arcangelo: Paintings of the Early Sixties*, 1978). His hard-edged aesthetic was developed to reduce and concentrate an image into its most basic recognizable form. *Full Moon* is one of a series of works that tap into the American unconscious: this road could be anywhere and nowhere; it evokes the reduction of the natural world to dark forms passing by the windows of a car; and it surrealistically conflates the moon with a petroleum company's illuminated sign. In later works he added objects to his canvases, such as a rear-view mirror.

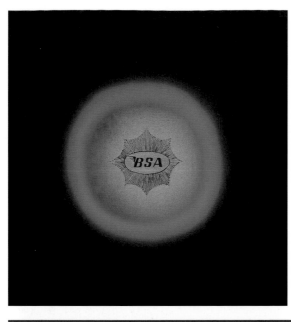

left

Billy Al BENGSTON

Birmingham Small Arms I [BSA]

1961

Oil on canvas

87.5 × 94 cm [34.5 × 37 in]

Collection, Orange County Museum of Art, Newport Beach, California

Inspired by the Flag and Target paintings by Jasper Johns that he saw in 1958, the Californian painter Bengston was associated with Pop in the early 1960s. He had several solo exhibitions at the Ferus Gallery, Los Angeles, where he showed paintings of single, centrally placed motifs – hearts, with titles such as *Grace* (Kelly) and *Kim* (Novak), or sergeants' stripes, such as *Elvis* and *Clint*. For his exhibition there in November 1961 Bengston produced a dozen works depicting motorcycle parts surrounded by glowing colours. An ex-professional motorcycle racer, he was an enthusiast of the Californian trend of customizing with spray paint, epitomized by hot-rod pinstriper Von Dutch. This influenced his move to spray lacquer paintings the following year. He began to use masonite rather than canvas to produce a harder and smoother surface, and developed abstract forms no longer linked to identifiable logos.

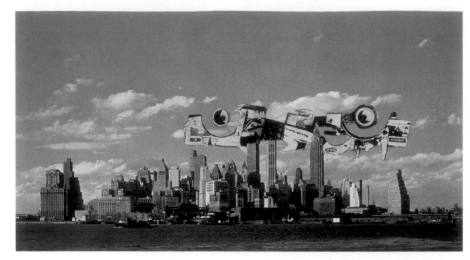

Hans HOLLEIN
Superstructure over Manhattan
1963
Coloured collage on paper
11 × 22 cm [4.5 × 9 in]

Hollein's collages took mass-produced industrial forms and incorporated them – greatly enlarged – into urban or natural environments. In *Superstructure over Manhattan* a form resembling a gigantic yellow mechanical vehicle is affixed to the familiar skyline. Hollein referred to his work as creating 'urban macrostructures'. In opposition to the functionalist conformity of the International Style he used his structures to investigate the limits of architecture. Citing technical advancements, Hollein advocated a pure architecture not limited by formal rationalism: 'Architecture is without purpose. What we build will find usefulness. Form does not follow function.'
– Hans Hollein, *Arts & Architecture*, August 1963

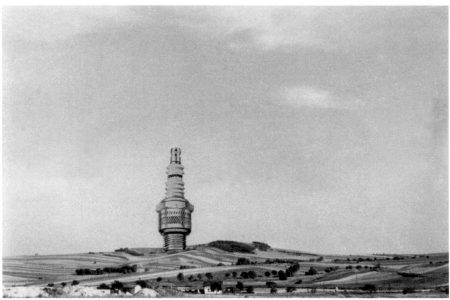

Hans HOLLEIN
Highrise Building: Sparkplug
1964
Photomontage on paper
12 × 18 cm [5 × 7 in]
Collection, The Museum of Modern Art, New York

Highrise Building: Sparkplug is part of the *Transformation* series, a group of works which, like the above example, propose the introduction of incongruous and monumentally scaled forms into the environment. Hollein's work can be viewed as a European counterpart to the later outdoor monuments of Claes Oldenburg. Here the urbanity of a giant sparkplug is contrasted with domesticated farmland. The use of photomontage rather than models or drawings broke from traditional architectural precedents. The difficulty of building such a structure renders this work a theoretical investigation into the nature of architecture. Hollein later stated: 'Everyone is an architect. Everything is architecture.'
– Hans Hollein, 'Alles ist Architektur', *Bau*, 1968

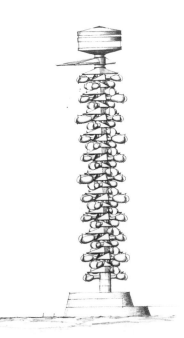

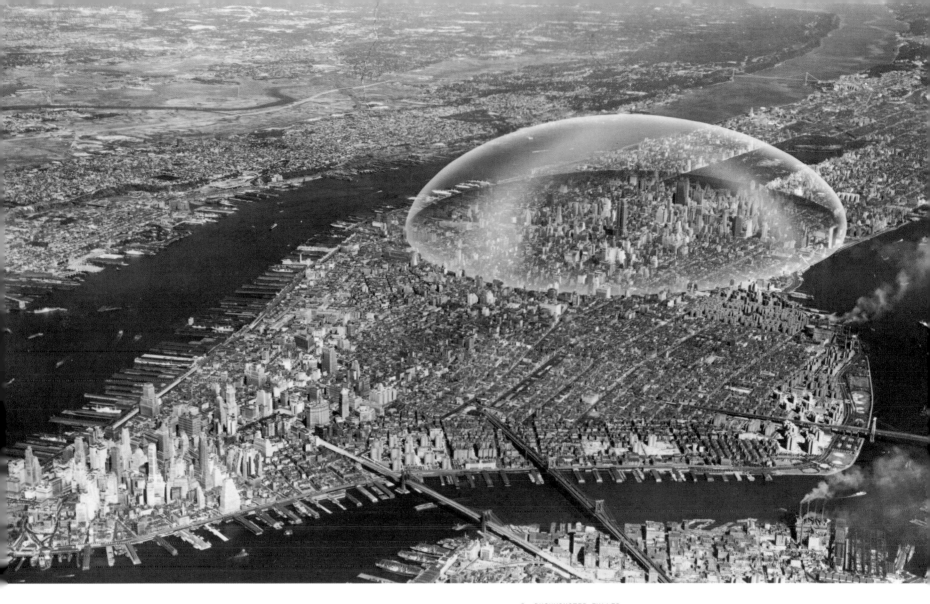

R. BUCKMINSTER FULLER

A Dome Partially Covering Manhattan

1960

Photomontage

Collection, Buckminster Fuller Institute, Santa Barbara, California

This photomontage shows a proposed giant dome designed by Fuller and his assistant Shoji Sadao. It demonstrates the endless potentials of scale and utility of Fuller's invention, the geodesic dome, which exemplified 'tensegrity' (a word he invented, combining tension and integrity). Struts and cables were set in an overlapping triangular formation, a pattern based on his early studies of structural systems found in nature. Becoming proportionately stronger and lighter the larger it is, this structure would stretch to 3.2 kilometres (2 miles) in width and a height of 1.6 kilometres (1 mile). It would be covered in a protective, translucent veil, sheltering the fifty-block area from the natural elements. No fuel-burning vehicles would be allowed inside, making the climate uncontaminated and stabilized.

opposite

Arthur QUARMBY

Corn on the Cob [Emergency Mass Housing Units No. 3]

1962

Ink on tracing paper

36.5 × 53 cm [14.5 × 21 in]

Collection, FRAC Centre, Orléans, France

Quarmby was a pioneer of the use of plastic in architecture. A flexible new material, it allowed the easy creation of structure, texture, durability and colour. For Quarmby it revolutionized design, avoiding the constraints inherent in most orthodox materials. Mass-production was possible, leading to the development of component-constructed architecture. Believing that the house could have a simple function, like the car or the refrigerator, in *Corn on the Cob* Quarmby suspended generic apartment pods from pre-stressed concrete branches. Their design satisfied the bare minimum of needs, removing the nostalgic idiosyncrasies associated with defining one's own home. From below the structure's penthouse, a twin-jab crane would reposition each unit. This idea of industrial flexibility was further developed in Archigram projects such as Plug-in City (1964).

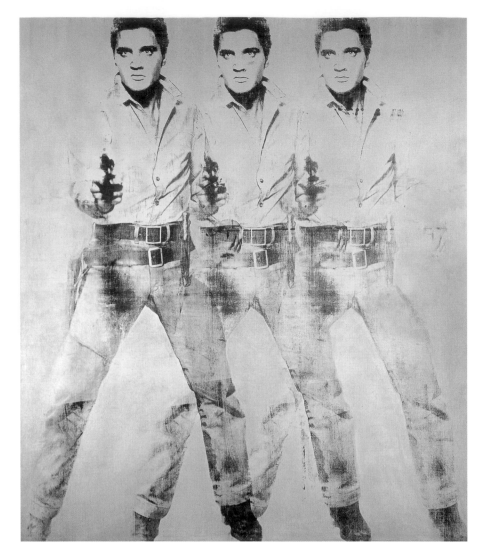

Andy WARHOL
Triple Elvis
1963
Aluminium paint and silkscreen ink on canvas
208.5 × 180.5 cm [82 × 71 in]
Collection, Virginia Museum of Fine Arts, Richmond

With his assistant Gerard Malanga, Warhol developed the silkscreen technique of the *Elvis* series shown at the Ferus Gallery in 1963. The effect was one of blur or 'strobe', suggesting a stop-motion image and the passage of time. Unlike Warhol's previous method of overlapping that required masking, the figure itself could be moved independently once the rectangular background had been dropped out. He began to use silver spray paint in May or June to achieve an opaque, unmodulated and reflective surface. Warhol did not always cut the canvases in the studio, leaving Irving Blum to prepare them for the Ferus exhibition, where a single 11-metre (37-ft) canvas with sixteen figures of Elvis was shown along one wall. This was later divided into five paintings. The actual photo source for the *Elvis* series has not been identified, although the Warhol archive contains a postcard of Elvis Presley in this pose, as a gunslinger in Don Siegel's Western *Flaming Star* (1960).

opposite
Andy WARHOL
Silver Liz
1963
Silkscreen, acrylic and spray paint on canvas
101.5 × 101.5 cm [40 × 40 in]

Using different coloured backgrounds, Warhol made several versions of this image based on a publicity photograph of Elizabeth Taylor. The silver paintings, in what became his preferred square format, were probably made first, with the exhibition at the Ferus Gallery in mind, and were the first project on which Malanga worked with Warhol as his assistant. At the exhibition in October 1963 the *Silver Liz* series was shown in the back space, with the *Elvis* series in the main gallery. Warhol first used silver in early 1963 for some of the *Electric Chairs* and the *Tunafish Disasters*. With *Elvis* and *Silver Liz*, this implicit connection between silver and death was replaced with an evocation of 'silver screen' glamour.

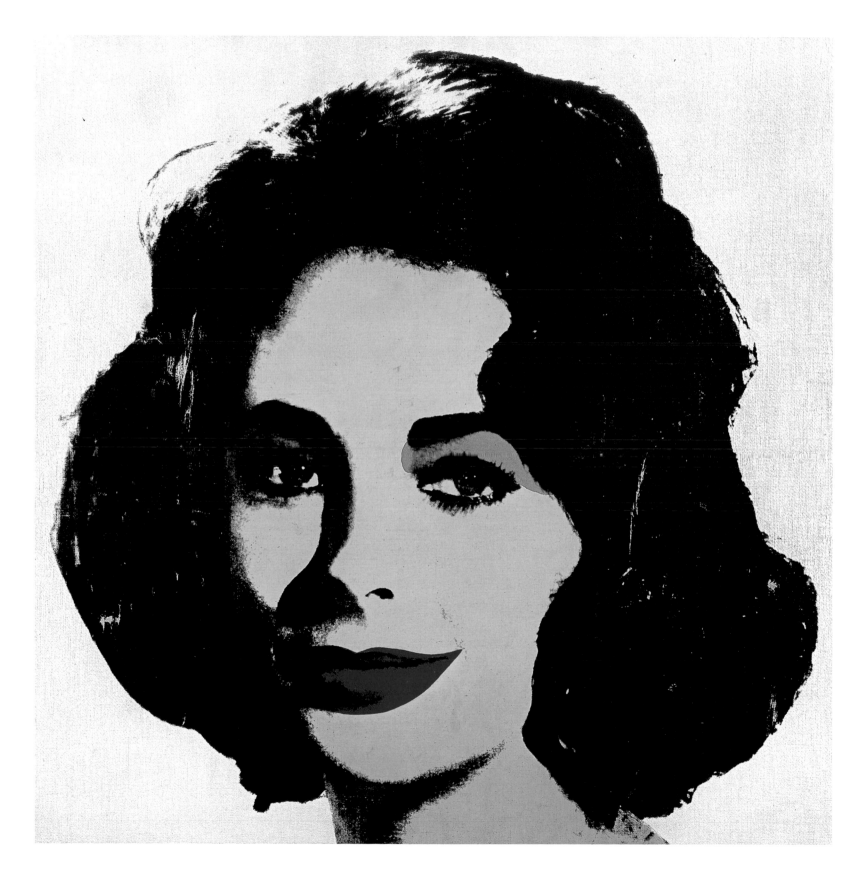

COLONIZATION OF THE MIND

The cultural impact of American films and music, spread by merchant seamen and by the presence of American troops, was pervasive and widespread, especially so in Europe, where artists reacted in appreciation or in parody. Artists from East Germany, such as Gerhard Richter and Sigmar Polke, who had moved to the more prosperous 'economic miracle' of the West, and in Britain Richard Hamilton, Colin Self and others, reacted with a sharply caustic wit to the promises of capitalism and the tensions of the Cold War. Some of the earliest supporters of Pop art were European collectors, gallerists and museum curators. There were close, if uneasy, relationships with other developments like Fluxus and Happenings, and avant-garde film established an international network. Jean-Luc Godard and Michelangelo Antonioni made films in a European language and landscape, but which referred to Hollywood genres and narrative structures. By the mid 1960s the universal appeal of American glamour was countered with a wide range of local variants which took issue with the hegemony and uniformity of mainstream culture.

opposite
George SEGAL
Cinema
1963
Plaster, illuminated Plexiglas, metal
300 × 244 × 76 cm [118 × 96 × 30 in]
Collection, Albright-Knox Art Gallery, Buffalo, New York

The monochrome, white plaster figures of Segal's early work are placed in ordinary, mundane scenes. Made using plaster bandages applied directly to a live model, the resulting works are an index of the surface of public life. In *Cinema* Segal uses an illuminated cinema display board, emblazoned self-referentially with 'CINEMA' in place of a film title. The anonymous, mummy-like figure is frozen in motion as he places the letter 'R' at the far right of the listings board. This active stance is unusual in Segal's work; his figures are most often at rest, in poses that suggest lassitude or withdrawal, such as *Bus Riders* (1962) and *Woman on a Chicken Crate* (1958). Segal arrests a 'real' moment with vivid directness. ' … daily life has a reputation for being banal, uninteresting, boring somehow. And somehow it still strikes me that daily life is baffling, mysterious and unfathomable.'
– George Segal, interview with Amber Edwards for the documentary *George Segal: American Still Life*, June 1998 – August 1999

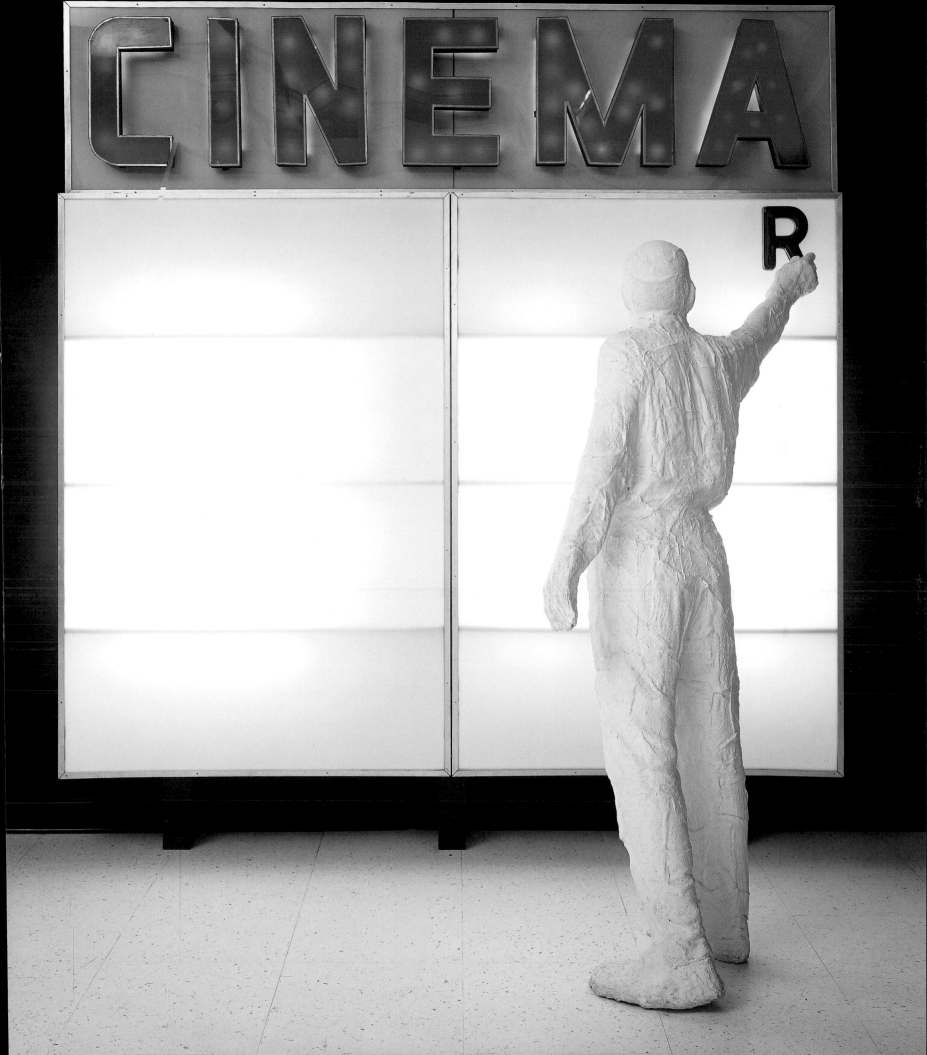

Jack SMITH
Flaming Creatures
1963
16mm film, 41 min., black and
white, silent
With Francis Francine
[in foreground]

Flaming Creatures stars Francis Francine, later the drag-queen sheriff of Warhol's *Lonesome Cowboys* (1968). Smith used out-of-date film, resulting in faded and overexposed imagery. Ornamentally framed silent-movie credits are interrupted by posturing 'creatures' (drag queens, mermaids, vampires and naked poets) and an eclectic soundtrack selected by composer Tony Conrad, which includes Latin pop, rock 'n' roll, bullfighting music and a Chinese song. Fetishized lipstick application is performed by the entire cast to a litany of cosmetic products; a boisterous orgy follows, in which male and female become indistinguishable. Smith's censored 'underground' film was compared by the critic Susan Sontag to 'the casualness, the arbitrariness and the unrestrainedness of Pop art'. (*The Nation*, 1964)

Kenneth ANGER
Scorpio Rising
1963
16mm film, 29 min., colour, sound
With Victor Childe [pictured] and Bruce Byron

A film with no dialogue and rapidly intercut scenes, *Scorpio Rising* begins with young men polishing and fixing their motorcycles to a pop music soundtrack. It was one of the first avant-garde films to use popular music, ranging from Elvis Presley to Ray Charles, as a counter-cultural medium. Anger also refers to B-movies (particularly the 'criminal youth' subgenre and László Benedek's motorcycle movie *The Wild One* [1954]); Hollywood myths; the occult works of Aleister Crowley; and male homoerotic photography, as popularized during the 1950s by Bob Mizer's *Physique Pictorial*. The story climaxes at a Hallowe'en party where masked gang members subject a guest to a ritual sexual initiation, after which Scorpio (Byron) desecrates a local church with Hell's Angels' adopted symbols: swastikas and skull-and-crossbones. Finally there is a motorcycle race in which the death of the hero is implied.

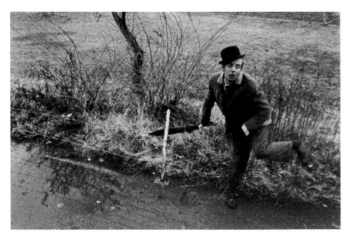

Ron RICE
The Queen of Sheba Meets the Atom Man
1963/82
16mm film, 109 min., black and white, sound
With Taylor Mead

Rice's films are characterized by improvisation and collaboration with his actors. Here Mead plays a child-like beatnik clown. Attracted to products by advertisements, yet not understanding their functions, he rubs a box of cereal over his clothes and inserts the prongs of an electric plug into his nose. Winifred Bryan plays an alcoholic who fights affectionately with him; later the two embrace and collapse amidst the disorder of her apartment. Rice had intended his film to be a three-hour epic protest against industrialization and Hollywood values. His unsophisticated style attempted to reflect life on the streets. He died before editing a final version; between 1979 and 1982 Mead restored and completed the 109-minute version, adding a soundtrack.

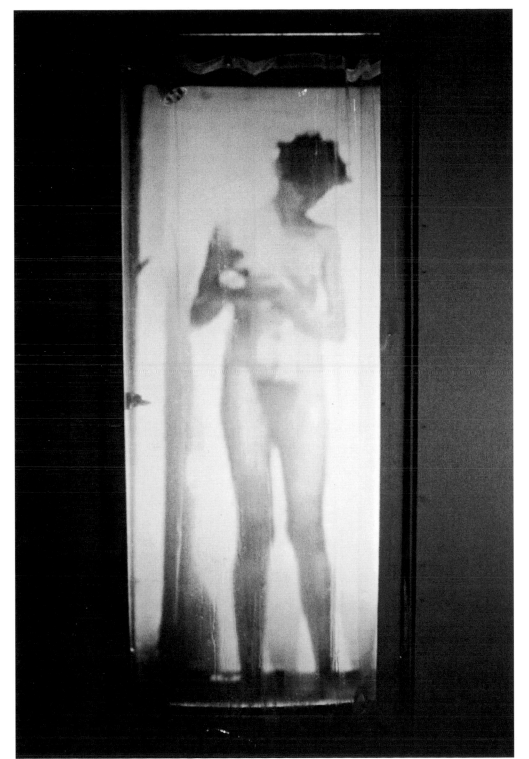

Robert <u>WHITMAN</u>
Shower
1964
16mm film loop, colour, silent;
projector, shower stall and
curtain, water, water pump
203 × 76 × 76 cm [80 × 30 × 30 in]
Whitman first exhibited *Shower* in 1966
at the New York event '9 Evenings of
Theater and Engineering', which
presented new uses of technology by
artists in music, dance and Happenings.
Whitman and Robert Rauschenberg,
together with engineers Billy Klüver and
Fred Waldhauer, subsequently founded
the project E.A.T. (Experiments in Art
and Technology). The life-sized image
of a woman (Mimi Stark) taking a shower
is projected on to the back wall of a real
shower cubicle. Behind a plastic curtain
running water flows from the nozzle and
drains away, turning from clear to green
to purple, in a nod to the traditional
depiction of the bathing nude in painting.
Shower is one of a series of four films;
the others are *Window* (1963), *Dressing
Table* (1964) and *Sink* (1964). They project
filmed everyday actions on to the objects
associated with them. Whitman involved
viewers directly in these environments;
during the first presentation of *Shower*,
the effect was so convincing that some
viewers momentarily believed they were
intruding on a real person's privacy.

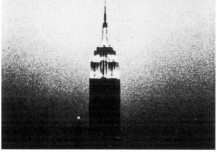

Andy <u>WARHOL</u>

Empire

1964

16mm film, 8 hours, 16 frames per second, black and white, silent

Between 8 p.m. and 3 a.m. during the night of 25–26 July 1964, *Empire* was filmed in New York from the window of an office high up in the Time-Life Building that offered an unobstructed view of the Empire State Building. It begins with a white screen. As the sun sets, the haze clears and the building emerges. Its exterior floodlights are switched on, then over the next six and a half hours its interior lights flicker on and off until the floodlights switch off. It remains shrouded in darkness for the remainder of the film. *Empire* was produced with a team: the young filmmaker John Palmer, Gerard Malanga, Marie Desert and the filmmaker and critic Jonas Mekas. The one-to-one principle of real-time recording was first established by Warhol in *Sleep* (1963), a continuous shot of the poet John Giorno sleeping. In *Empire* editing was rejected completely. Screening at the silent-film speed of 16 frames per second (they were shot at 24 f.p.s.) further slowed down Warhol's already 'narrative-free' films and added an uncanny quality of dreamlike time.

Andy <u>WARHOL</u>

Kiss

1963-64

16mm films, approx. 50 min. in total, 16 frames per second, black and white, silent

Warhol began shooting the *Kiss* films in the autumn of 1963. They were first screened at the Gramercy Arts Theater on West 27th Street, New York, where they were titled *The Andy Warhol Serial*, as they were shown in weekly four-minute instalments. Warhol's idea for *Kiss* – close-ups of male and female or same gender couples kissing each other for approximately three minutes each – is believed to come from cinema studio regulations forbidding actors to touch lips for more than three seconds.

Jean-Luc GODARD
Le Mépris
Contempt
1963
35mm film, 103 min., colour, sound
With Brigitte Bardot, Michel Piccoli [*in film still*] and Fritz Lang,
Jack Palance

Le Mépris is a film about personal integrity in the face of monoculture and the mass-produced imagery of advertising and television. A writer is hired by a business-like producer (Palance) to 'sex-up' a script based on Homer's *Odyssey* and increase its popular appeal, against the wishes of the film director (Fritz Lang, who plays himself), who wants to produce an art film true to the original Greek setting and story. The writer's wife finds the producer's ideas distasteful, and he must learn to balance her ideals against commercial demands. A central motif of *Le Mépris* is the adoption of parallel characteristics in the leading players of those portrayed in the film-within-a-film: the writer, Paul (Piccoli) becomes Odysseus, Camille (Bardot) his wife Penelope. This device highlights the artificiality of film itself. *Le Mépris* has been seen as an ambivalent satire on Hollywood-style values.

Andy WARHOL
Screen Test [Billy Name]
1964
16mm film, 4 min., 16 frames per second, black and white, silent

Warhol's *Screen Tests* were filmed from early 1964 to November 1966. The 'star' subjects included visiting filmmakers, fashion models and members of the Factory entourage such as Gerard Malanga, Edie Sedgwick and the photographer Billy Name, who features in this film strip. They were seated in front of a tripod mounted camera and usually asked to be as still as possible and not to blink while the camera was running. There were exceptions, such as the *Screen Test* of the drag actor Mario Montez in February 1965, in hilarious dialogue with the scriptwriter for many of Warhol's films, Ronald Tavel. More than 500 *Screen Tests* were made. Some of them were incorporated into longer films such as *13 Most Beautiful Boys* and *13 Most Beautiful Women* (both 1964).

George BRECHT
Repository
1961
Assemblage; storage unit containing watch, tennis ball, thermometer,
India rubber and plastic balls, baseball, piece of ebony, statuette,
wooden jigsaw pieces, toothbrushes, phial, crayons, glass, pocket
mirror, bottle caps, keys, fabric, coins, photographs, playing cards,
postcards, dollar, page of thesaurus, plastic tomato, painted wooden
beads, blue lightbulb, ball of string, painted metal toy motorbike
102.5 × 26.5 × 7.5 cm [40.5 × 10.5 × 3 in]
Collection, The Museum of Modern Art, New York

This assemblage comprises everyday objects placed in the compartments of a wall cabinet according to size. Brecht narrowed the intervention of the artist to the selection and arrangement of these mass-produced items in a work that evokes the legacies of Marcel Duchamp's readymades and Joseph Cornell's box-sculptures. Brecht studied under John Cage with fellow Fluxus artists such as George Maciunas. The group experimented with the involvement of chance in composition. Brecht moved from paint splashes, folds and blots on canvas during the 1950s via assemblages to scripted events, such as *Exit* (1961), performed any time anyone walked out of any place. He believed that the task of the artist was to stimulate the imagination of the viewer.

opposite
Joe TILSON
A-Z Box of Friends and Family
1963
Mixed media on wood
233 × 152 cm [92 × 60 in]

A–Z Box of Friends and Family has become emblematic of the British Pop scene in the early 1960s. It is both a personal memento of the friends who enjoyed the hospitality of Tilson and his artist wife Jos, and the demonstration of a collaborative way of making art in which all could share, including the couple's young children. Its varied contents are unified by the tabular, compartmented wooden structure, reminiscent of a printer's tray for holding metal type. This was a format that Tilson, originally trained as a carpenter, had developed in a series of works that juxtapose words and images as elements. He positioned the participants' contributions in an alphabetical scheme using the initial letter of either their first or last name: Richard Hamilton in the 'R' compartment, Allen Jones in 'J', Ronald Kitaj in 'K'. Other Pop artists who contributed include Peter Blake (B), David Hockney (D) and Peter Phillips (P). Artists working outside of Pop also appear – such as the painter Frank Auerbach, the sculptor Anthony Caro and the experimental artist John Latham. Tilson himself contributes the ziggurat in 'Z', one of the archetypal forms that would become central in his later practice as he moved away from Pop. The key to all the works and their creators is concealed behind the question mark.

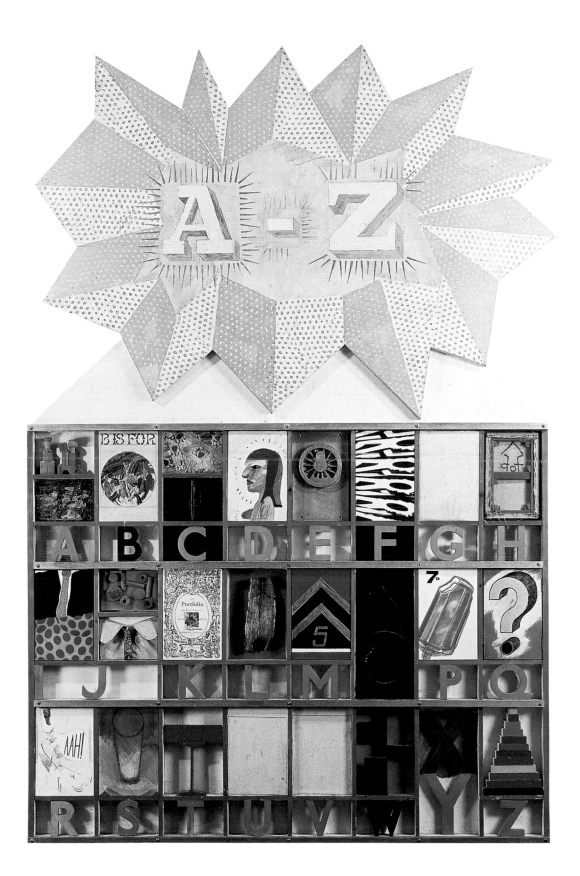

Patrick <u>CAULFIELD</u>

Engagement Ring

1963

Oil on panel

122 × 122 cm [48 × 48 in]

Caulfield was one of the young Pop artists from the Royal College of Art to attract attention at the 'Young Contemporaries' exhibition (RBA Galleries, London, 1963). He painted apparently trivial subject matter in a flat graphic style, investigating cliché in subjects familiar to the viewer. The ring here is presented as a symbol, placed centrally on a grid background. There is an absence of visible brushwork and painterly intervention; the starkly monochrome, hard-edged composition recalls painted advertising signs. In other works he depicted various objects on backgrounds of unmodulated colour. ' ... it was a reaction which I shared with other people against academic work, the idea of English painting in muted tones where marks were never quite finished. It seemed a reason to use very crisp black lines.' – Patrick Caulfield, interview with Marco Livingstone, *Aspects*, 15, 1981

Lucas <u>SAMARAS</u>

Self-portrait Box

1963

Construction in wood, red, white and blue woollen thread, nails, 50 photographic portraits of the artist

Closed box, 9.5 × 15 × 11.5 cm [4 × 6 × 4.5 in]

The first period during which boxes appeared in Samaras' work began in 1962 and lasted until 1967, by which point sixty had been made. He ceased making them again until much later in his career. Typically he found or purchased a nineteenth-century box and covered the surface entirely with materials such as the pins and coloured threads in this example. These cheap and visually arresting materials sometimes spew from the inside out, transforming the container into a rebarbative object: repellent to touch. He referred to the boxes anthropomorphically, as mouths. Here Samaras introduced his self-portrait, which became the central subject of his oeuvre.

Robert <u>WATTS</u>

Plate of Shrimps and Clams

1963-64

Chrome-plated metal on ceramic plate

h. 7 cm [3 in] ø 14.5 cm [6 in]

Like his fellow artists from the Fluxus group, George Brecht and Ben Vautier, in the early 1960s Watts began to make works that crossed over with the concerns of Pop art. His lifesize objects drew on his background in engineering, applying a scientific approach to questions of the effect and processes of naming an object as art. His investigations led to such projects as casting everyday items and foodstuffs in metal, which he then plated in chrome, and the creation of his own postage stamps that could actually be used.

Colin SELF
Leopardskin Nuclear Bomb No. 2
1963
Painted wood, aluminium, steel, fabric
95 × 80 × 42 cm [37.5 × 31.5 × 16.5 in]
Collection, Tate, London

Self depicted animals or animal characteristics as a metaphor for the aggression of human behaviour, convinced of the apocalyptic implications of the nuclear age. *Leopardskin Nuclear Bomb No. 2* combines both of these concerns. In 1963 he also began a series of drawings of metamorphic creatures, called *Mortal Combat*. Self's work of this period was overtly political, at variance with the seemingly dispassionate nature of most Pop art. He recognized that the artists of his generation were from outside the traditional art world, being both left-wing and from working-class backgrounds, and saw their role as revolutionary. 'Pop art was the first art movement for goodness knows how long to accept and reflect the world in which it lives … Art still seemed to be hoping cars and aeroplanes "went away" and horses made a comeback so they could re-do *The Haywain*.'
– Colin Self, from an unpublished letter to Marco Livingstone, 1 December 1987

COLIN SELF HOT DOG 10.

Colin SELF
Hot Dog 10
1965
Pencil and watercolour on paper
45 × 58.5 cm [18 × 23 in]

In 1965 Self began to concentrate on the sausage in a bun as one of his subjects, initiating a series of drawings and paintings in which they feature, as well as several sculptures. It is likely that his travels in the United States during that year, following an earlier trip in 1962, reinvigorated his awareness of the ubiquitous fast-food staple. Since 1961, hot dogs had featured in the paintings of American artists such as Wayne Thiebaud and Roy Lichtenstein; and Claes Oldenburg had produced his giant hamburger sculpture. Self adds an almost surrealist dimension to this Pop subject. His depiction of the enveloped sausage infuses it with connotations that are by turns erotic, comical and menacing.

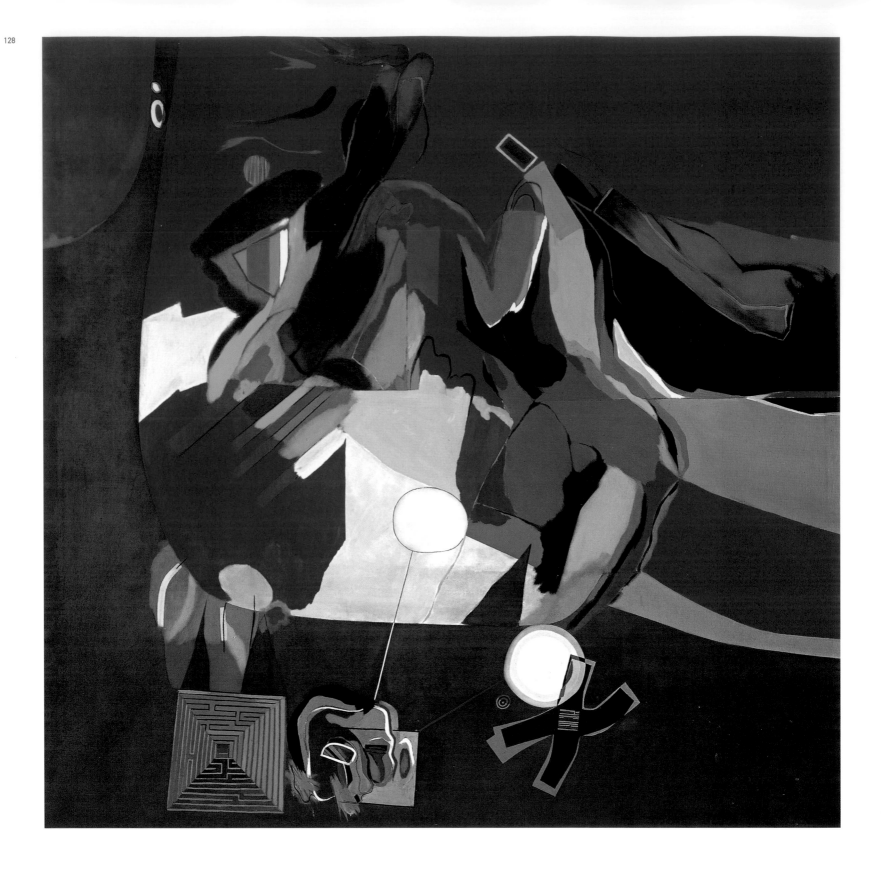

COLONIZATION OF THE MIND

opposite

Allen JONES
Thinking about Women
1961
Oil on canvas
152 × 152 cm [60 × 60 in]
Collection, Norfolk Art Society, Norwich, England

Associated with the rising Pop generation through his brief time at the Royal College of Art, London (1959–60) Jones adapted the ideas and formal language of early modern painters such as Kandinsky and Klee to develop a vividly contemporary synthesis of figuration and abstraction. This painting is as large as a billboard, its striking hues as intense as those used by contemporary colour field painters, optical artists and graphic designers. The sense of blurred, rapid movement is reminiscent of cinematic effects. The white circles linked by lines to the head in the foreground suggest the 'thought balloons' of cartoons. Other features, such as the square partially enclosing the head in the foreground, and the indeterminate, androgynous appearance of the right-hand figure, recur in a number of Jones's paintings of the 1960s, where he drew on Jungian and Nietzschian ideas about the merging of male and female characteristics as a metaphorical element in his work.

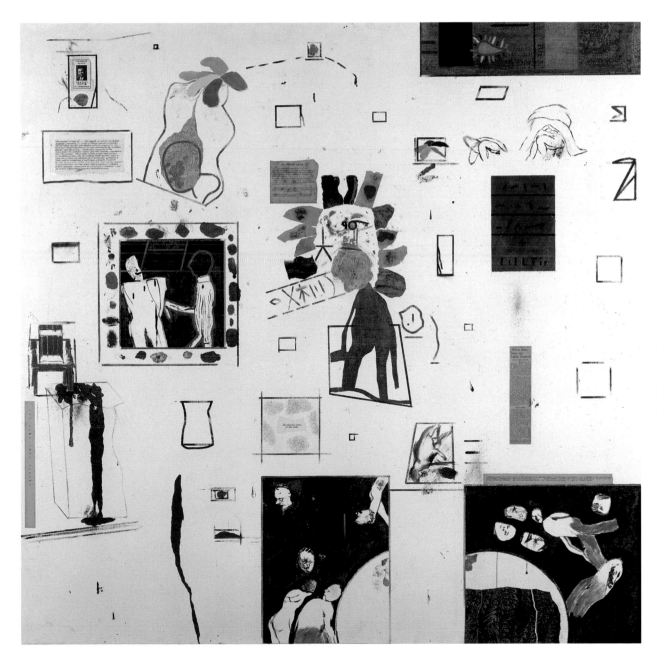

R.B. KITAJ
Reflections on Violence
1962
Oil and collage on canvas
152.5 × 152.5 cm [60 × 60 in]
Collection, Hamburger Kunsthalle, Hamburg

Georges Sorel's book *Reflections on Violence* (1908) suggested this work's title and many of its themes, such as 'another victim of communism'; 'the homicidal throne'; 'the lunacy doctor'. The French philosopher developed the notion of anarcho-syndicalism and set out his theory of 'violence' as the power of the proletariat to seize the means of production from the bourgeoisie through direct action. Kitaj explicitly noted his source in early exhibition catalogues. Discrete images are loosely dispersed around the canvas, without emphasis on one particular element, highlighting Kitaj's intention of equality in these interrelationships. He referred to pictorial languages and iconography, as well as literary texts. In the pinboard-like composition of *Reflections on Violence* Kitaj included representations of Native American pictographs (and a citation of his source, a Smithsonian Institution study from 1893), interspersed with doodles and textual material, including a newspaper clipping with the headline 'When nuns may use birth control'. Kitaj's detailed allusions to literature and politics separated him from mainstream Pop art, although he also drew on similar visual sources.

Gerald LAING
Anna Karina
1963
Oil on canvas
366 × 213.5 cm [144 × 84 in]

This vast painting was the centrepiece of Laing's student solo exhibition, 'Paintings from Photographs/Photographs from Paintings', at St Martin's School of Art, London, in March 1963. Its source is a tiny newspaper photo of the French film actress who worked with Jean-Luc Godard, in her role as a prostitute in Godard's film *Vivre sa vie* (1962, released in Britain as *It's My Life*). In related works Laing portrayed other subjects from independent European cinema, such as Brigitte Bardot, in contrast to the Hollywood icons of American Pop. Rather than using silkscreen techniques like Warhol, or replicating the basic form of printers' colour half-tone dots that Lichtenstein found in cartoon strips, Laing both reduced (to black and white only) and complicated his hand-painted dot-screen patterns. These were based on the many variations of screen angle and corresponding effects – such as 'square' or 'diamond'-shaped dots – available to printers. Made up of separate panels, the painting is both like and very unlike a huge film poster; the mesmerizing optical effects of the screen pattern have become central.

John WESLEY
Brides
1966
Acrylic on canvas
167 × 94 cm [65 × 37 in]

Brides has a fairy tale or fantasy atmosphere reminiscent of the erotic, 'decadent' work of the Art Nouveau artist Aubrey Beardsley. Wesley's invented imagery and mannered style also allude to the graphic characteristics of cartoon strips. His paintings are flat compositions of minimal lines and uniform surfaces, avoiding gradations of tone and illusionistic space. Often Wesley's black outlines surround areas of either monotone shades or a limited palette of bubble-gum pink and sky blue. Many of his paintings employ repetition as a means of testing the viewer's attention to inconspicuous differences in detail. The roots of his interest in industrialized sameness grew from his work as an illustrator for the engineering corps. Repetition was also a device for his surrealist humour, as recorded by his wife, author Hannah Green: '"It better be funny" Jack says […] meaning life, the human predicament … repetition makes things funny and it puts things in their proper perspective. "If you say foot foot foot foot foot foot foot foot foot long enough, then foot becomes hilarious", Jack says. "If you paint forty Nixons, it puts Nixon in his place."'
– Hannah Green, *Unmuzzled Ox*, 1974

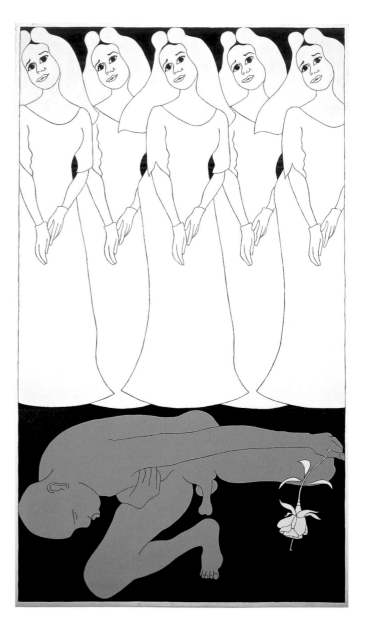

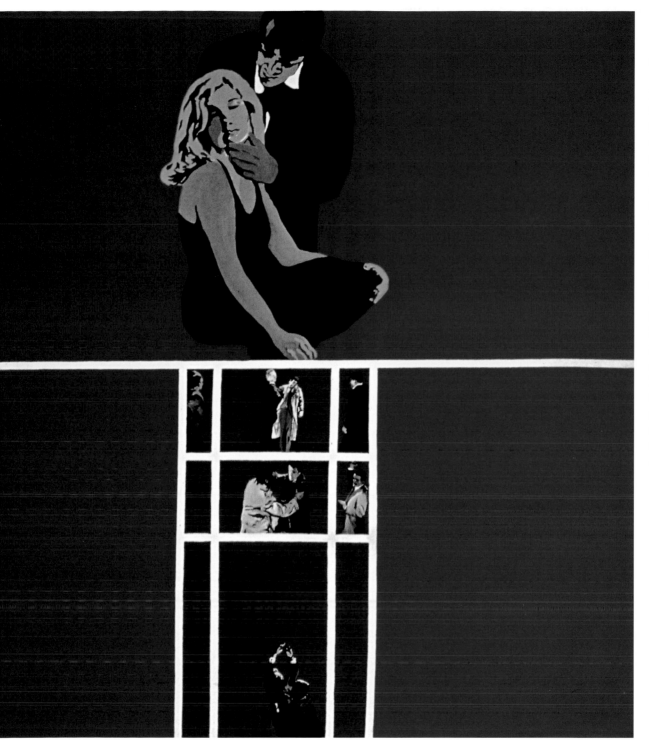

Rosalyn DREXLER
Love & Violence
1964
Oil over paper collage on canvas
173 × 155 cm [68 × 61 in]

Drexler's work offers a caustic angle on the otherwise male-dominated perspective of Pop. Her paintings make direct references to film noir and tabloid reporting, assembling scenes that emphasize female subjugation in social situations as depicted in the media, underlined by her loaded titles such as *Love and Violence* and *I Won't Hurt You*. Drexler cut images from selected sources, attaching them to the canvas and then painting over them. Underlying their reductive, almost cartoon-like figuration, most of the early works include the original collaged images beneath, just visible at the edges of the painted field. The palette is limited to primary and secondary colours, with the subjects rendered in gradations using black and white. Drexler was among the first Pop artists to use the sequential imagery of film and television, quoting and translating the image in motion on to the canvas.

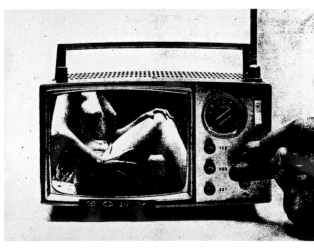

Wallace BERMAN
Untitled
1964
Verifax collage on paper
18 × 25 cm [7 × 10 in]

This is one of a series of collages Berman made using an outmoded Verifax photocopier. Each work contains single or multiple repetitions of the same visual frame: a portable radio, with a hand in the foreground. In place of the radio speaker is a TV screen (originally Berman used an image of a TV set but preferred the radio's fusion of language and sound associations with the visual). Forging an implicit connection between global communications and the free association of the unconscious mind, in each collage a different image appears on the screen, ranging from the esoteric (magic mushrooms, Hebrew symbols, the Buddha) to the mass-mediatized (astronauts, film stars, naked women).

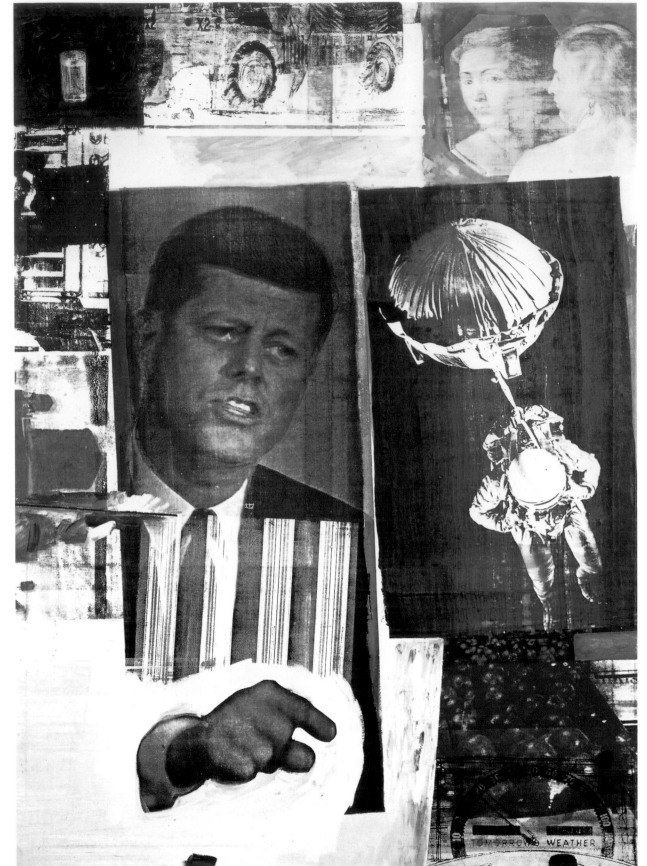

Robert RAUSCHENBERG
Retroactive II
1963
Oil, silkscreen and ink on canvas
203 × 152.5 cm [80 × 60 in]
Collection, Museum of
Contemporary Art, Chicago

Rauschenberg and Warhol coincidentally began using silkscreen in the same year. Rauschenberg built up his images using almost 100 re-usable screens, repeating subjects in various colours and degrees of technical refinement. Among these are reproductions of paintings by Rubens and Velázquez, charts, diagrams, dials, cityscapes, advertisements, photographs of astronauts in space and of President J.F. Kennedy. He worked with these images between the autumn of 1962 and the spring of 1964. Drag marks, caused by pulling ink across the screen, counter the illusionism of the photographic material; layered paint and printing overlaps the images. Historically specific, *Retroactive II* also makes a broader comment on information overload and image saturation.

opposite
Andy WARHOL
Orange Car Crash [5 Deaths
11 Times in Orange]
1963
Acrylic and silkscreen ink
on linen
220 × 209 cm [86.5 × 82 in]
Collection, Galleria Civica
d'Arte Moderna, Turin

Among other things, Warhol associated his 'death' and 'disaster' series with a car accident warning he heard broadcast in late 1962: 'Every time you turned on the radio they said something like "4 million are going to die". That started it. But when you see a gruesome picture over and over again, it doesn't really have any effect.' This work is among those he completed in October 1963 for his upcoming show at Ileana Sonnabend's Paris gallery: 'My show in Paris is going to be called "Death in America". I'll show the electric chair pictures [Disasters] and the dogs in Birmingham [Race Riots] and car wrecks and some suicide pictures.' Their often sublime scale and horrifying subject matter is poignantly and ironically counterposed with the offering of the same image in various colours, such as red, orange, white or silver.
– quotes from Andy Warhol, interview with Gene Swenson, 1963

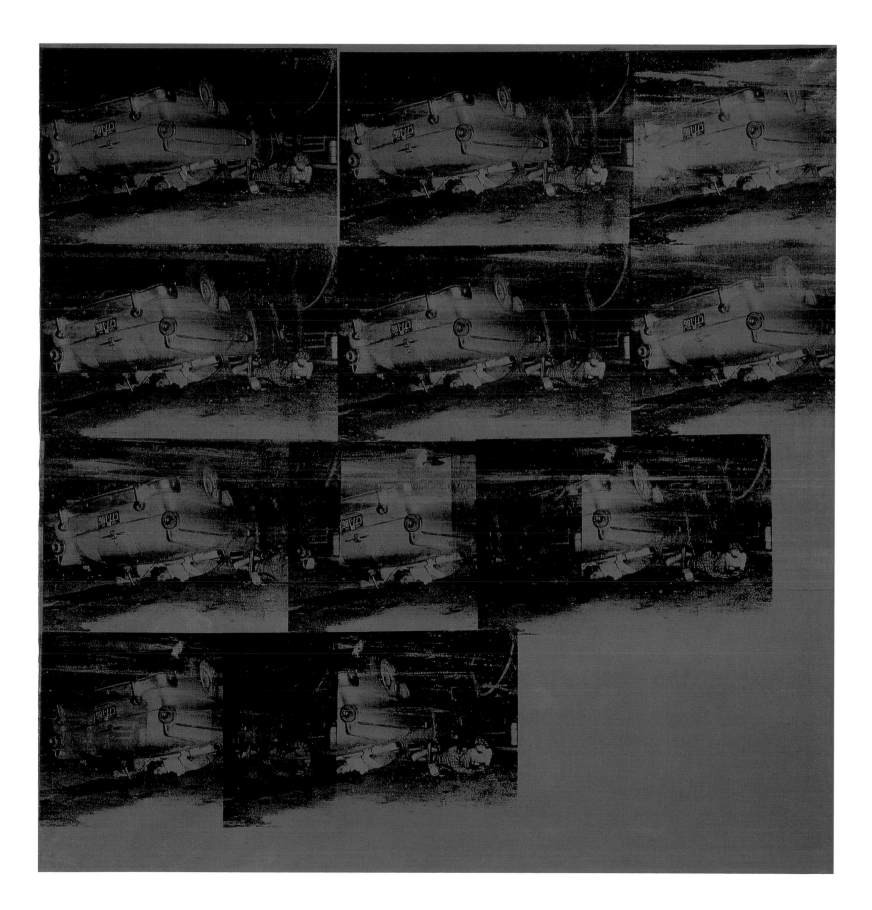

Öyvind FAHLSTRÖM

Performing KK, No. 2 [Sunday Edition]

1964

Tempera on paper mounted on canvas

132 × 86.5 cm [52 × 34 in]

During 1963–64, Fahlström continued to develop a relationship between his system of *character-forms* (see *Sitting ...* , 1962, page 103) and more immediately recognizable figurative forms taken from sources such as comic strips. This painting appropriates a panel from George Herriman's comic *Krazy Kat*. The idea of the 'cat and mouse' game has become the basis of a pictorial game with many elements and allusions.

'... The association of disparate elements to each other thus makes game rules, and the work of art will be a game structure.

 This, among other things, leads to presupposing an active, participating spectator who – whether he is confronted with a static or variable work of art – will find relationships which will make him able to "play" the work ...'

– Öyvind Fahlström, 'A Game of Character', *Art and Literature*, 3, New York, 1964

Konrad LUEG and Gerhard RICHTER

Leben mit Pop. Eine Demonstration für kapitalistischen Realismus [Living with Pop. A Demonstration for Capitalist Realism]

View of installation and event at Möbelhaus Berges furniture store, Dusseldorf, 11 October 1963

Living with Pop was an exhibition that positioned certain German artists within the discourse of Pop art. Lueg and Richter organized the event at the Möbelhaus Berges, a famous furniture store in Dusseldorf. Attached to each invitation was a green balloon that bore the exhibition's title and, if inflated beyond capacity, would make the onomatopoeic sound 'pop'. The visitors were given numbered programmes that instructed them to move through an ordered succession of exhibition spaces, which were themed around the showroom displays. Artworks, including a crude *papier mâché* sculpture of John F. Kennedy by Richter, were integrated throughout the multi-storey establishment as a way of contextualizing generic images into simulated arrangements of the modern home, in effect putting the entire store and its aesthetics of standardized living on display. The image shows, left to right, Lueg and Richter in Exhibition Room 1, seated within the showroom setting, unengaged with the viewer, just another fixture, a living piece of furniture.

Martial <u>RAYSSE</u>
Souviens-toi de Tahiti en
septembre 61
[Remember Tahiti in September 61]
1963
Photograph, acrylic and
silkscreen on canvas, with
parasol and beach ball
180 × 170 × 45 cm
[71 × 67 × 18 in]
Collection, Louisiana Museum of
Modern Art, Humlebaek, Denmark

By 1962 Raysse had moved on from environmental assemblages to the pictorial, although he still included three-dimensional elements. Rather than representing a parasol and a beach ball, like the American artist Jim Dine he added these objects to the canvas. The source image for this work is a photograph of a woman on a beach, which has been screenprinted and then painted in flat areas of exceptionally bright, synthetic colour. The sunbather is shown applying suntan lotion, her right arm and left leg coloured bright green, the rest of her body coloured amber-orange. The work emphasizes the artificiality and synthetic glamour of consumer culture and the anonymous women used to represent it. The young woman's green arm and leg fuse her image with the corresponding colour in the ball and sun shade. Raysse was one of Pop's chief exponents and critics in France during the 1960s.

ARCHIGRAM
Plug-In City
1964
Axonometric drawing; mixed media on card
76 × 69.5 cm [30 × 27.5 in]
Collection, The Museum of Modern Art, New York

This project was the culmination of ideas the group was exploring from 1962 onwards, from capsule homes to philosophies for a living city. The master plan transformed the city into a system that could be configured flexibly to fit the needs of civic development. It replaced the static structuring of traditional urban planning with architecture that was mass-produced and expendable, free from the nostalgic inhibitions that hindered active changes within the built environment. The mainframe of the structure would have a lifespan of forty years and provide conduits for the transportation of goods and services to the standardized office and living units. The whole arrangement divided the functions of the citizen's life into zones that were easily updated and relocated. Restructuring would be undertaken using an elaborate crane system, moving individual units within the network. This flexible and temporary configuration led to the development of the Walking City project.

Ken ADAM
War Room
1962-63
Preparatory drawing for set in Stanley Kubrick's film *Dr Strangelove*

Creating film sets for the *James Bond* series, *Star Trek* and *Dr Strangelove*, Adam contributed to a new consciousness of architectural symbolism, disseminated through cinema. This imaginary War Room evoked a widely recognized collective notion of the place where the fantastical paranoia of a looming nuclear holocaust might be orchestrated. The triangular construction is reminiscent of bomb shelters of the era. Adam's use of architectural forms to express psychological states anticipated later projects by architects such as Frank Gehry and Daniel Libeskind.

Arthur QUARMBY
Pneumatic Paraboloid
1963
Inflatable dome realized with students at Bradford College of Art, England

The *Pneumatic Paraboloid* was a plastic dome inflated using low-pressure air compression. Quarmby's pneumatic structures could potentially occupy any amount of space, even on the grandest of scales. The use of air as a constructive component moved architecture in an organic direction: these forms could take on a variety of shapes, flexible enough to fit into complex spaces within the built environment. The dome's resemblance to a woman's breast is a rare example of humour in architecture. Quarmby later made transparent plastic sets for Robert Freeman's film *The Touchables* (1966).

ARCHIGRAM [Ron HERRON]
Cities: Moving [detail]
1964/73
Collage and airbrush painting on paper mounted on card
Left panel of two-panel work, 88 × 182 cm [34.5 × 72 in] overall

The Walking City proposal envisioned the geographical and constructional fixity of cities being superseded by nomadic, articulated structures. The structure was envisioned as capable of hovering around the globe freely. It would connect with energy and data ports or other moving city structures, for social and commercial exchange. The overall appearance of the Walking City was inspired by the fantasies of science fiction, and in this case is a hybrid of insect and UFO. Meticulously organized, it would house everything needed to sustain a society. The leg extensions would function as supports, engaged when the metropolis was stationary.

left to right

Pauline BOTY
It's a Man's World I
1964
Oil on canvas
153 × 122 cm [60 × 48 in]

Pauline BOTY
It's a Man's World II
1965
Oil on canvas
125 × 125 cm [49 × 49 in]

Boty often painted representations of collaged material from mass-media sources within her pictures, establishing relationships between mediated images of glamour, power or eroticism, and a more local background context. Here in the left-hand painting of what eventually became a diptych [not shown to relative scale], the background shows an English 'stately home', over which are superimposed images of male figures symbolic of achievement in all active spheres of public life, from literature and politics to sport and pop music. The only female presence is Jacqueline Kennedy, the glamorous First Lady, shown at Kennedy's side in the fatal Dallas motorcade. In the right-hand painting (seen in an earlier stage in Bailey's photograph opposite), the view from the house is interrupted by a similar montage arrangement, except that this time it portrays women in passive poses typical of sex magazines. Boty was more critical of sexist attitudes of the time than most male Pop artists, although she was herself glamorized by photographers and filmmakers such as Ken Russell, in his television documentary on the London Pop scene, *Pop Goes the Easel* (1962).

opposite
David BAILEY
Pauline Boty
1964
Gelatin silver print
30.5 × 25.5 cm [12 × 10 in]
Photograph published in *Vogue* magazine, September 1964

Bailey's arresting portrait of the artist and London icon of glamour is artificially lit by cold, hard light and presented at an oblique angle, like an updated form of Russian constructivist photography. He used a single-kilowatt Mole-Richardson Scoop lamp, mirroring the use of high-contrast effects in television and film lighting. Bailey's original portraits of iconic figures were central to the mediation of British Pop style. An early version of *It's a Man's World II* is shown in the background.

Claes <u>OLDENBURG</u>
Bedroom Ensemble 1
1963
Wood, vinyl, metal, fake fur, other media
305 × 518 × 609.5 cm [120 × 204 × 240 in]
Collection, National Gallery of Canada, Ottawa

Bedroom Ensemble was first installed as one of 'Four Environments' at the Sidney Janis Gallery, New York, in January 1964 (the other artists were James Rosenquist, George Segal and Jim Dine). It replicates a kitsch version of a bedroom complete with dressing table, mirror and an air-conditioner that cooled the room throughout the exhibition. Like a stage set, the false perspective of the environment alters the viewer's perception of what at first appears as a real domestic space. The apparent functionality of the objects is also misleading – the vanity mirror distorts, the drawers do not open and the bed is hard. Oldenburg's use of fake pelts and synthetic, easy-clean materials popular at the time highlights the ensemble's artifice.

Richard <u>ARTSCHWAGER</u>
Description of a Table
1964
Formica
66.5 × 81 × 81 cm [26 × 32 × 32 in]
Collection, Whitney Museum of American Art, New York

Artschwager trained as a fine artist under Amédée Ozenfant and then worked as a commercial furniture-maker in the 1950s, combining his creative and industrial skills to create his first sculptures in the early 1960s. *Description of a Table* focuses on surface, creating a table-sculpture in the form of a cube. It is covered in formica, a standard material found in many American homes and with its own connotations of illusion – the 'wood effect' used to create an impression of luxury and wealth – and inferences of mass-production. Over this, Artschwager painted the tablecloth in white and the negative spaces in black. He referred to it as 'three-dimensional still life'. Like Oldenburg, with whom he collaborated, Artschwager used simulation and obvious artificiality to reassess common objects. 'By killing off the use part, non-use aspects are allowed living space, breathing space. Things in a still-life painting can have monumentality – and I don't think their monumentality has been lessened because their ediblity or other use has been either taken away or not put into them.'
– Richard Artschwager quoted in Jan McDevitt, *Craft Horizons*, 1965

Andy WARHOL

Brillo Box [3 ¢ off]

c. 1963-64

Silkscreen and house paint on plywood

33.5 × 40.5 × 29 cm [13 × 16 × 11.5 in]

Collection, The Andy Warhol Museum, Pittsburg

In the winter of 1963–64, after experimenting with a prototype of a Campbell's Soup can, Warhol embarked on his first sculptures. He began to replicate cardboard boxes for products such as Brillo soap pads, Campbell's tomato juice and Del Monte peach halves. The yellow versions of the *Brillo Box* were among the first. Invoices from this period indicate that initially 50 examples were made. Warhol instructed a cabinet maker to construct the boxes out of plywood to the exact dimensions of the originals. Then they were painted to simulate either the cardboard or the printed background colours, over which the relevant brand label was silkscreened on all sides. The boxes were assembled in Warhol's studio in production lines (likely to be the context for the adoption of the Factory as the studio's name). A selection of the sculptures was exhibited at the Dwan Gallery, Los Angeles, in February 1964 and the Stable Gallery, New York, in April. They were stacked up or laid along the gallery floors, making the experience of being in the space similar to navigating through a grocery warehouse. These serial accumulations of identical objects, which were indistinguishable from their non-art counterparts, went further than Warhol's two-dimensional work in questioning traditional notions of artistic status and value.

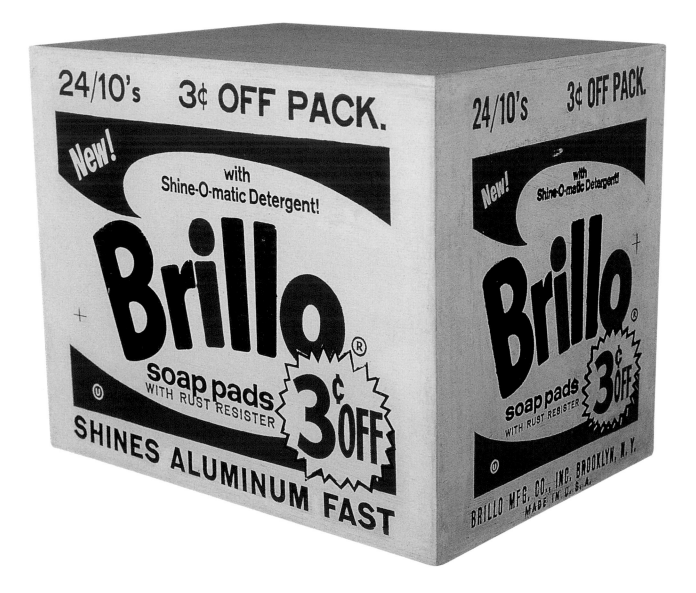

Marcel <u>DUCHAMP</u>
En prévision du bras cassé
[In Advance of the Broken Arm]
1915/64
Readymade: snow shovel; wood and galvanized iron
132 × 35 cm [52 × 14 in]
Replica of original lost in 1915
Collection, Musée national d'art moderne, Centre Georges
Pompidou, Paris

With his readymades, Duchamp removed objects from their ordinary context and re-presented them as art. He considered *In Advance of the Broken Arm* to be one of the most important of his 'unassisted' readymade objects, such as *Bottle Rack* (*Sèche-bouteilles*, 1914). Although the object was presented unaltered, like the bottle rack, Duchamp substituted a factually descriptive title with a phrase that invites speculation on the object's possible symbolic meaning. After a long period when Duchamp's work was known only to a relatively small group of artists and their circle, he became widely recognized in the mid 1960s. In 1964 he collaborated with the scholar and dealer Arturo Schwarz on new editions of eight of his readymades, which gave them new currency. The legacy of Duchamp apparent in the work of a number of American artists such as Dine and Warhol led to the term 'Neo-Dada' sometimes being applied to their work before 1962 when the term Pop art became predominant. The Nouveaux Réalistes also alluded to this legacy in their manifesto produced to accompany their second Paris group show in 1961, entitled '*À 40° au-dessus de Dada*' ('At 40 degrees above Dada').

Jim <u>DINE</u>
Black Shovel, No. 2
1962
Oil on canvas and shovel
214.5 × 91.5 cm [84.5 × 36 in]
Collection, Whitney Museum of American Art, New York

Dine's early paintings refer to the human body through subjects such as clothing, hair and skin. This developed into the use of common associative objects such as soap, garden implements and household appliances, investigating bodily surrogates through absence and appendage. He referred to tools as 'an extension of one's own hand'. Dine frequented hardware shops, studying the design of tools and the latent notion that their evolution was an anecdote in the history of civilized man. Unlike his contemporaries, Dine did not use simulation or manipulation of scale and proportion, but rather a straightforward placement of objects on the canvas by hanging or attachment, treating them as relics. In *Black Shovel, No. 2*, the artist unifies the shovel with the canvas by covering them both with black paint. This integrated the object into a visual field, transfiguring form into texture and colour.

Alain JACQUET

Le Déjeuner sur l'herbe

1964

Quadrochrome silkscreen and celluloid varnish on canvas

175 × 197 × 2 cm [69 × 77.5 × 1 in]

Collection, Musée d'art contemporain, Val de Marne/Vitry, France

Silkscreening a greatly magnified photographic image, Jacquet produced a figurative representation verging on abstraction. Based on a snapshot-type photo and mimicking printers' reproduction processes, the painting updates Manet's *Le Déjeuner sur l'herbe* (1863), a turning point in the emergence of modern art, which was itself based on a 1510 engraving by Marcantonio Raimondi after Raphael's *Judgement of Paris*. Jacquet's use of mechanical processes (the critic Pierre Restany called his work 'Mec Art') was motivated by the visual effects they made possible. Distortion, disintegration and the slight variation with repetition characteristic of silkscreening allowed him to investigate the extent to which an everyday image would remain recognizable after undergoing, or despite, these interferences.

'' ''0 000
'r als sein Vor-
'n Stelle er ge-
iat die Zeichen
1 bis 1500 ccm
gesenkt, dabei
auf 12 Monate

m 1100 D der
, England und
Einliter-Wagen
Cardinal, Mor-
M) begegnen.
für die Neu-
Fiat hat allen
n ausgereiftes,
ilaren zur Zu-
iufendes Auto-

generellen Ex-
orgesehen und

Gerhard RICHTER

Alfa Romeo [mit Text]

1965

Oil on canvas

150 × 155 cm [59 × 61 in]

This is one of several paintings that derive from a found picture on a printed page, with the residual details of surrounding text included in the image. A number of these works depict cars: a speeding pair of Fiats, a Ferrari and, here, the rear view of an Alfa Romeo SZ 2600. Meticulously executed in graduated greyish tones, the painting appears to replicate its source almost mechanically. The crop of the image and text reduces their meaning content, foregrounding graphic composition and tonal effects. This simulation of a mechanistic form of reproduction, with minimal traces of the artist's hand, allies Richter's painting with the objective filter of photography.

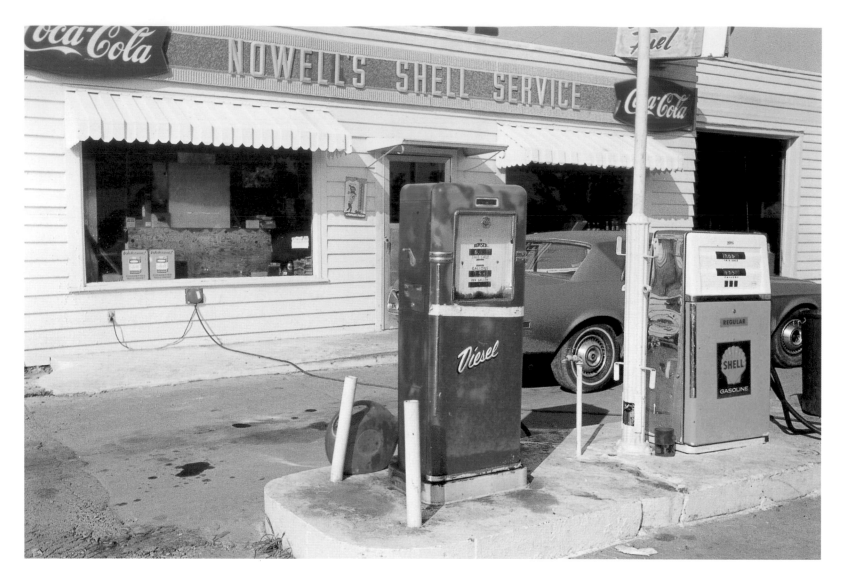

William <u>EGGLESTON</u>
Webb, Mississippi
1964
Dye transfer print
39.5 × 57 cm [15.5 × 22.5 in]

Colour had occasionally been employed by a few major photographers for specific subjects: in the 1930s Paul Outerbridge used a colour process for still life and nudes, and later Eliot Porter mastered the dye-transfer process introduced by Kodak in 1946 for his nature photographs. Despite this, in the mid 1960s the monochrome aesthetic was still considered essential to serious art photography and reportage. Eggleston was among the first to embrace the 'vulgar' attributes of colour, turning Kodachrome slides into dye-transfer prints to convey the particular vernacular qualities of everyday scenes and objects in the Southern states where he lived and worked. He departed from the photographers he admired, such as Walker Evans, in another respect by avoiding the carefully framed frontal composition in favour of angles reminiscent of amateur snapshots. This is one of the earliest examples of his work in colour. It was not until Eggleston's retrospective at The Museum of Modern Art, New York, in 1976 that colour photography was exhibited as art in a major museum.

Garry <u>WINOGRAND</u>
Tally Ho Motel, Lake Tahoe
1964
Cibachrome print
40 × 58 cm [16 × 23 in]
Collection, Center for Creative Photography, University
of Arizona at Tucson

Winogrand worked mainly in black and white. In this saturated colour photograph holidaymakers are seen at a motel, relaxing by the pool. The car in the foreground and the coach on the signpost point to two American symbols: pioneers of the old West and the newly mobile consumers of the 1960s. Winogrand found subjects in the everyday spaces of post-war architecture – roadsides, shopping malls, motels, airport lounges. In 1964 he was awarded a bursary by the Guggenheim Foundation, which he used to tour the United States taking photographs of contemporary American life one year after the Kennedy assassination. While on the road, Winogrand took thousands of photographs. He later submitted a selection of the prints to 'New Documents' at The Museum of Modern Art, New York, in 1967, though only his black and white photographs were shown. That exhibition also showed Diane Arbus and Lee Friedlander, with whom he shared the documentary style sometimes called the 'snapshot aesthetic'.

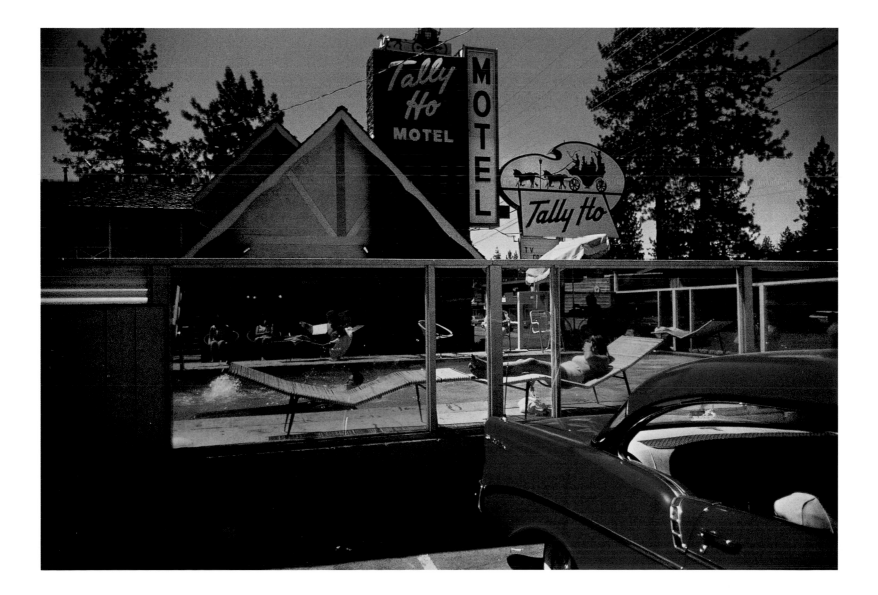

Yayoi <u>KUSAMA</u>
Kusama's Peep Show, or Endless Love Show
1966
Hexagonal room with mirrored walls, floor and ceiling, peep hole, small coloured lightbulbs in ceiling, flashing on and off in sequence
210 × 240 × 205 cm [83 × 94.5 × 81 in]
Installation view with the artist in the environment, Castellane Gallery, New York, March 1966

Since her arrival in New York in the late 1950s, Kusama had explored accumulation and serial repetition in works that paralleled the innovations of her contemporaries such as Andy Warhol and the Nouveaux Réalistes in Europe. While critically engaged with Pop, she had arrived at endless replication as the outcome of a mental condition characterized by compulsive obsession. Accompanied by loud pop music, this installation adapted the form of a peep show. Instead of a woman (Kusama's presence here was a temporary performance) the viewer peering through the peep hole would see endless patterns of coloured lights – a sublime intimation of infinity.

Carolee <u>SCHNEEMANN</u>
Meat Joy
1964
First performed at Festival de la libre expression, organized by Jean-Jacques Lebel, American Cultural Center, Paris, 25-30 May 1964

Schneemann's Happenings were structured, yet each realization of a work was spontaneous and different. *Meat Joy* was partially improvised by the participants. Near-naked, writhing men and women wriggled with fish, sausages, chickens, paint, plastic and each other in an 'erotic rite'. Lighting specialists and sound engineers (who played a soundscape of Parisian street noises and Motown songs) reacted to the performers and the audience, who were in close proximity. Schneemann encouraged 'a celebration of flesh as raw material ... sensual, comic, joyous, repellent'. The Festival de la libre expression combined exhibitions with Happenings, performances and film screenings; other participants included Jasper Johns, Merce Cunningham and Andy Warhol. Performances of *Meat Joy* took place later in 1964 in London and New York.

– quotations from Carolee Schneemann, *More Than Meat Joy*, 1979

ERRÓ

Foodscape

1964

Oil on canvas

201 × 301 cm [79 × 118.5 in]

Collection, Moderna Museet, Stockholm

Erró (Gudmunder Gudmundsson) trained as a mosaic artist in Florence after studying
at the Academies in Reykjavik and Oslo. In *Foodscape* his subject covers the surface
of the canvas in continuous patterning. Displays of party food, of the kind sold ready-
prepared, disappear into a deep recessional space. *Foodscape* is a depiction of never-
ending consumption. Erró was a political Pop artist, taking as his subjects the Cold
War and American consumerism. Using images of mass-produced items Erró first
completed a collage, which he then projected on to canvas and painted. He took part in
European Happenings including *Catastrophe* (1962) with Jean-Jacques Lebel, and
recorded the work of his friend Carolee Schneemann.

Roy LICHTENSTEIN

Yellow and Green Brushstrokes

1966

Oil and magna on canvas

214 × 458 cm [84.5 × 180.5 in]

Collection, Museum für Moderne Kunst, Frankfurt am Main

Begun in the autumn of 1965, Lichtenstein's series of *Brushstroke* paintings was initiated after he saw a cartoon in Charlton Comics' *Strange Suspense Stories*, 72 (October 1964). One scene shows an exhausted yet relieved artist who has just completed a painting. This depicts two massive brushstrokes that take up the entire surface area. The absurdity of using a small paintbrush to create an image of two monumental brushstrokes was explored in many different variations. Transforming an expressive act that was mythologized for its immediacy and primal origins into a cartoon-like, mechanically produced-looking image, Lichtenstein created a reflexive commentary on gestural painting.

opposite

Richard HAMILTON

My Marilyn

1965

Oil and collage on photographs on panel

102.5 × 122 cm [40.5 × 48 in]

Collection, Ludwig Forum für Internationale Kunst, Aachen

These images of Marilyn Monroe by the photographer George Barris were published posthumously. She had control over such publicity shots and her preferences are shown in her markings on these contact sheets – crossing through those she did not like, partially obliterating some, and ticking those she cleared. Photography became central to Hamilton's work in the mid 1960s as he investigated the line between photography and painting, and the construction of illusion. He takes the editing process of the photographer and film star a step further, collaging the photographs directly on to the canvas, defacing some discarded images and reworking others. Images are presented more than once, at different scales, and with different levels of intervention with paint. Hamilton took an intellectual approach to Pop art, analysing mass media: ' … the expression of popular culture in fine art terms is, like Futurism, fundamentally a statement of belief in the changing values of society. Pop-Fine-Art is a profession of approbation of mass culture.' – Richard Hamilton, 'For the Finest Art Try – POP', *Collected Words*, 1982

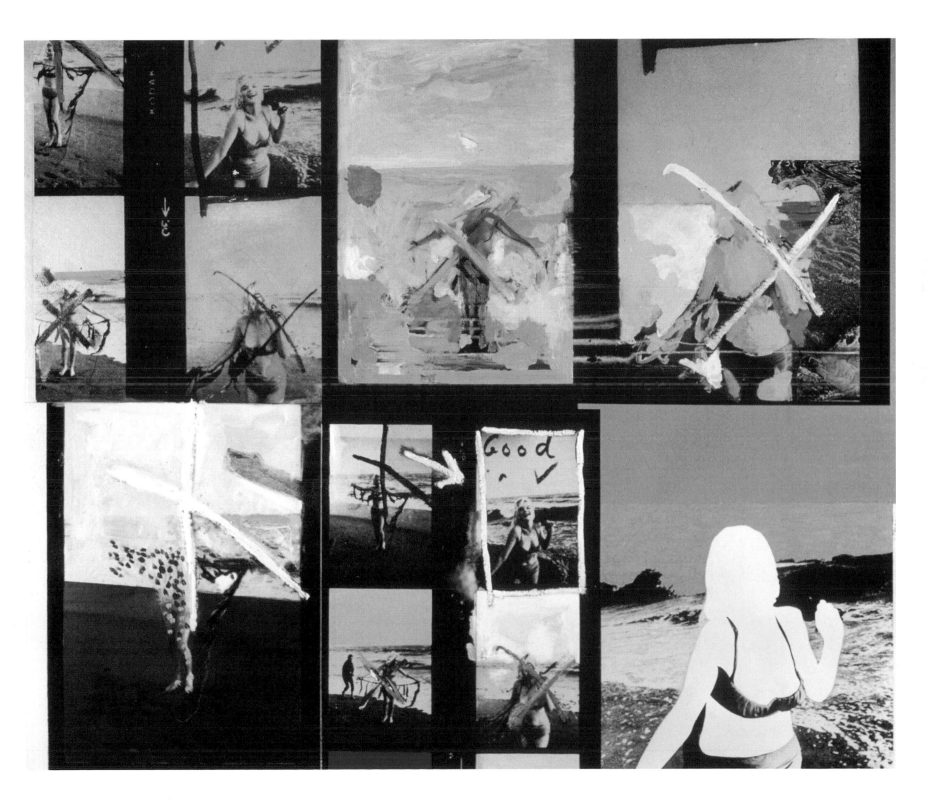

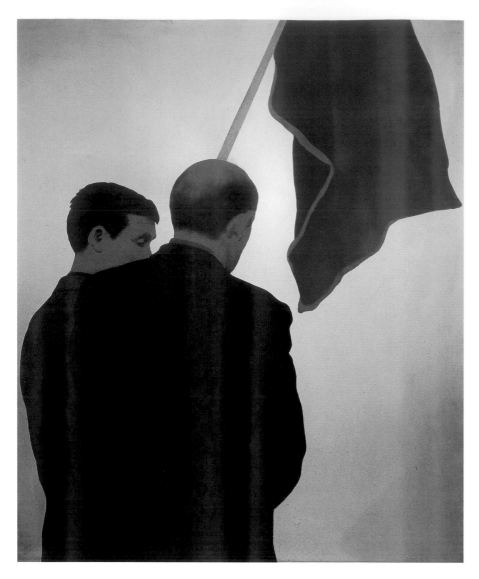

Michelangelo PISTOLETTO
Biandera rossa [Red Banner]
1966
Painted vellum paper on chromed
steel sheet
120 × 100 cm [47 × 39.5 in]

Pistoletto's 'mirror' works developed from a series of self-portraits made in the early 1960s. He painted figures on reflective backgrounds of black, gold or silver, positioning the figurative images within a monochrome field. This removed any temporal or spatial context from the composition and focused on the figures' existential presence. The reflective quality encapsulated Pistoletto's emerging interest in the contingencies of time and physical presence between the viewer and the artwork. The polished steel background became analogous to the doorway to a tangible space. Adhering to its surface, the figures he painted on paper are depicted lifesize. His initial subjects were scenarios of people leaning against the frame, looking into the mirror without a reciprocating reflection. *Biandera rossa* shows a fragment of a protest. Viewers reflected in the mirror background are invited to consider themselves in relation to the work's subject and the moment at which the painting has created an active register of their position in the gallery.

Marcel BROODTHAERS
L'Oeil [The Eye]
1966
Painted image on paper, glass
h. 29 cm [11.5 in] ⌀ 9 cm [3.5 in]

Until 1964 Broodthaers had been a poet associated with a radical group of Belgian surrealist writers. In the mid 1960s he linked the questions Pop art raised with aspects of Magritte's work, such as his juxtaposition of visual and verbal signs for objects. Observing the transformation of art into merchandise, Broodthaers noted how 'this has accelerated to the point at which artistic and commercial values are super-imposed. And if we are concerned with the phenomenon of reification then art will be a particular instance of that phenomenon – a form of tautology.'
– Marcel Broodthaers, 'To be *bien-pensant*, or not to be. To be blind', 1975

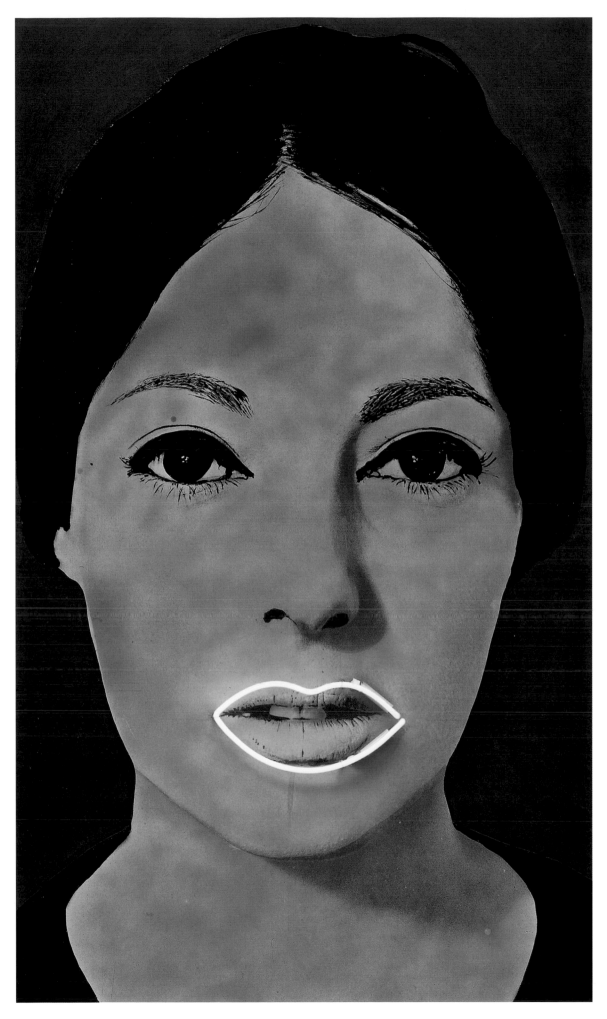

Peinture à haute tension
High Voltage Painting
1965
Photograph, oil and fluorescent
paint on canvas with neon
162.5 × 97.5 cm [64 × 38.5 in]
Collection, Stedelijk Museum,
Amsterdam

By 1965 Raysse had become critical of
the conclusive discourse around what
was nominated Pop, considering it to be
a superficial codification of beauty. He
viewed many of his contemporaries as
creating 'idols not icons'. In response to
the imagery in works such as Warhol's
Marilyn series, he formulated an
alternative kind of representation that
he referred to as 'hygiene of vision'.
In works such as *Peinture à haute
tension* he attempted to 'sanitize'
depictions of beauty, moving away from
the cult of personality to an archetypal
figure, as found in anonymous fashion
models. His use of neon to outline the
woman's lips emphasizes their
sensuality but also creates a humorous
play on the electric dangers of attraction
and contact.

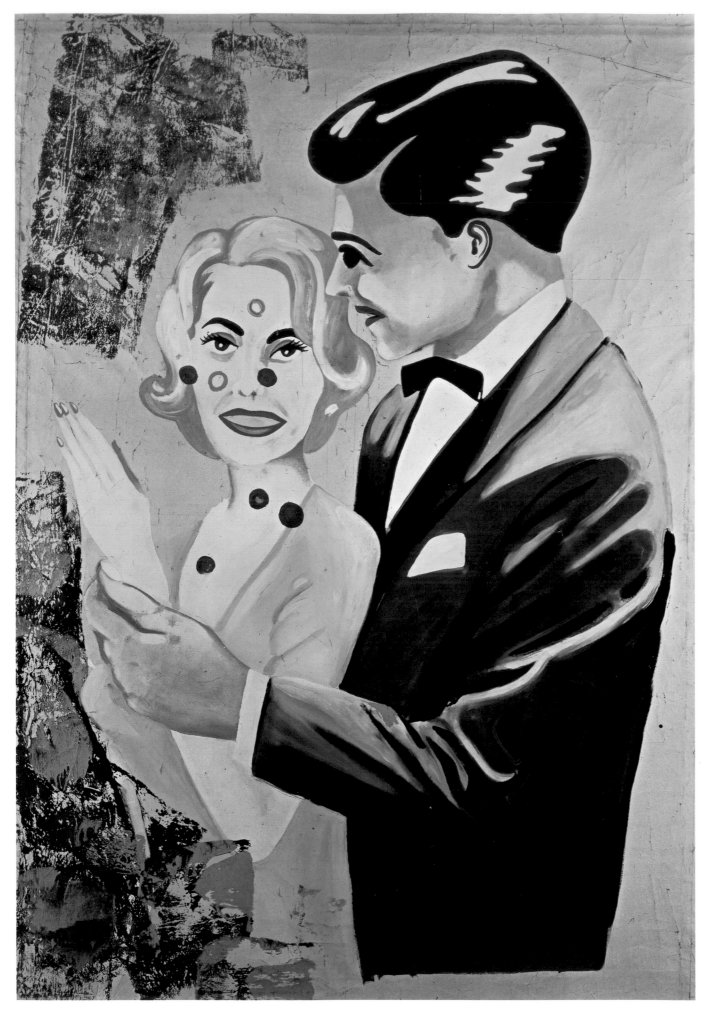

Sigmar POLKE
Liebespaar II [Lovers II]
1965
Oil and enamel on canvas
200 × 139.5 cm [79 × 55 in]

Polke originally drew on mass-media sources as a vehicle for provocation. He undermined painterly convention, deliberately creating 'bad' paintings. The evidence of compositional planning in *Liebespaar II* makes the lack of finish, anatomical anomalies and what look like attacks on the surface, at the far left, all the more disquieting. As a challenge to 'good' taste, Polke aimed to produce a truly ugly painting. After leaving East Germany he trained at the Düsseldorf Academy and became a member of the short-lived Capitalist Realist group, with Gerhard Richter and Konrad Lueg (later to become the gallerist Konrad Fischer). Polke later lived with a band of friends, working collaboratively and delegating the execution of work to them, in an echo of Andy Warhol's Factory.

Sigmar POLKE
Bunnies
1966
Synthetic polymer on linen
149 × 99.5 cm [59 × 39 in]
Collection, Hirshhorn Museum and Sculpture Garden, Smithsonian
Institution, Washington, D.C.

Polke chose Playboy bunnies, hostesses at Hugh Hefner's men's clubs, as a subject symbolic of Western decadence. He mocked manufactured American Pop and the standards of consumer society in which these women are objects, setting a standard of female beauty, dressed as rabbits. In *Bunnies* he presented them through a screen of dots based, as in Lichtenstein's paintings, on the enlargement of printing screen patterns. However, unlike Lichtenstein, Polke blurred and rearranged the dots. 'I love all dots. I am married to many of them. I would like all dots to be happy. Dots are my brothers. I too am a dot. Once we all played together; now each goes his separate way. We meet only at family celebrations, and then we ask each other "How's it going?"' – Sigmar Polke, statement in *Graphik des Kapitalistischen Realismus: Werke von 1964 bis 1971*, Galerie René Block, West Berlin, 1971

Claes OLDENBURG
Proposed Colossal Monument for Park Avenue, New York: Good Humor Bar
1965
Crayon and watercolour on paper
60.5 × 45.5 cm [24 × 18 in]
Collection, Solomon R. Guggenheim Museum, New York

In 1965 Oldenberg moved to a huge new studio space, and began to design colossal, even impossible, monumental sculpture. His drawings placed enlarged everyday objects in public spaces as civic monuments. The Good Humor Bar was a type of ice-cream on a stick. The objects he selected were often phallic, such as lipsticks, hot dogs and drill-bits, and small, playing on unexpected differences in scale. During a trip to London in 1966 he continued this theme, using collage to suggest the replacement of the statue of Eros at the centre of Piccadilly Circus with a group of towering cosmetics (*Lipsticks in Piccadilly Circus*, 1966). A combination of financial and planning constraints prevented such projects being realized until in 1969 Yale School of Architecture commissioned *Lipstick, Ascending, on Caterpillar Tracks*, on which Oldenburg supervised industrial technicians to produce his first Pop monument.

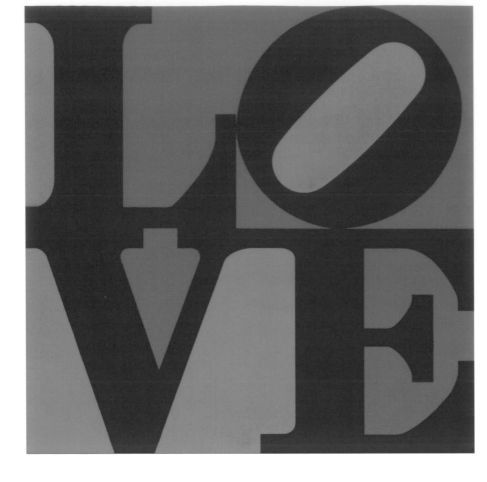

Robert INDIANA
LOVE
1966
Oil on canvas
183 × 183 cm [72 × 72 in]
Collection, Indianapolis Museum of Art

As Susan Elizabeth Ryan records (*Robert Indiana: Figures of Speech*, 2000), the composition of *LOVE* originated in some handmade Christmas cards Indiana made in 1964. He placed stencil letters to fill each of the four corners of a square so that they touched each other, tilting the 'O'. He placed paper over the top and made rubbings in coloured crayon. Then in 1965 he responded to an invitation from The Museum of Modern Art for an artist-designed Christmas card by submitting oil on canvas paintings of the composition in a number of colour variations. The museum chose the red, green and blue version for its striking optical effect and the cards were sold widely before this painting and other variations such as the kaleidoscope-repeat *LOVE* walls were publicly exhibited at the Stable Gallery, New York, in May 1966. The colours also conveyed a personal symbolism for Indiana, the red and green evoking the logo of the gasoline company, Phillips 66, for which his father had worked, and the blue its setting against the clear Midwestern sky of his childhood. Marking a new departure in Indiana's compositions – cool and formalist yet vibrantly resonant – *LOVE* coincided with the first large New York shows of Op art ('The Responsive Eye', 1965) and Minimalism ('Primary Structures', 1966). It also resonated widely during the 'Summer of Love' period of 1966–67; due to various factors beyond the artist's control the composition has been appropriated and visually quoted extensively ever since.

Sister CORITA [Frances Kent]
Make Love not War
1965
Silkscreen on paper
Dimensions variable

Frances Elizabeth Kent, who became a nun, Sister Mary Corita, was a controversial figure during the 1960s, whose slogans for social awareness and political responsibility made her position in the church and popular culture fraught with tensions. Her artistic training was in serigraphy; through the low-tech economies of silkscreening, she made her messages colourfully present and affordably available. She used simple framing devices, from square cut-outs to the camera lens, to remove compositions from the everyday and transfer them to prints. She would often start with the logos and slogans of popular brands; she then transformed the ethos of their messages while retaining their form, challenging their ownership of language.

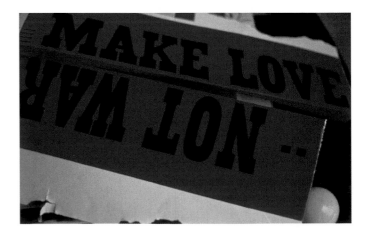

Richard <u>HAMILTON</u>

Epiphany
1964
Cellulose paint on panel
ø 122 cm [48 in]

Epiphany is the only work of this period in which Hamilton transliterated a mass-produced object directly, enlarged and reproduced as a painting. He bought the badge on which *Epiphany* is based from a joke shop at Pacific Ocean Park (POP), Venice Beach, California, while on his first trip to the United States to see Marcel Duchamp's retrospective exhibition at the Pasadena Art Museum in 1963. It provoked an ephiphanic moment, a sudden realization that summed up his responsiveness to American Pop and its freedom from European historical concerns. Its complementary colours also echo the optical effects of Duchamp's *Fluttering Hearts* (1936).

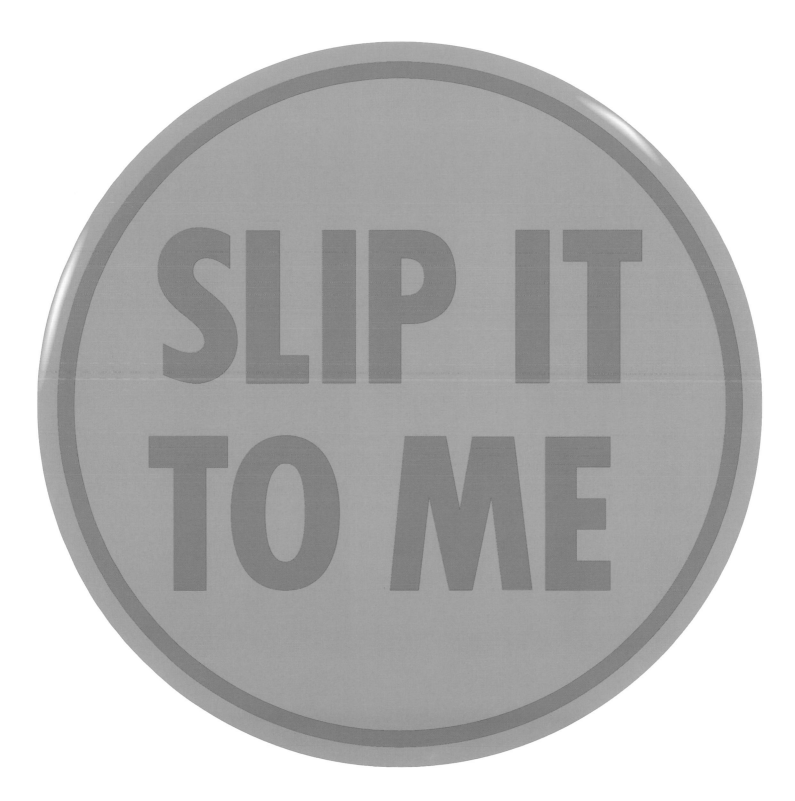

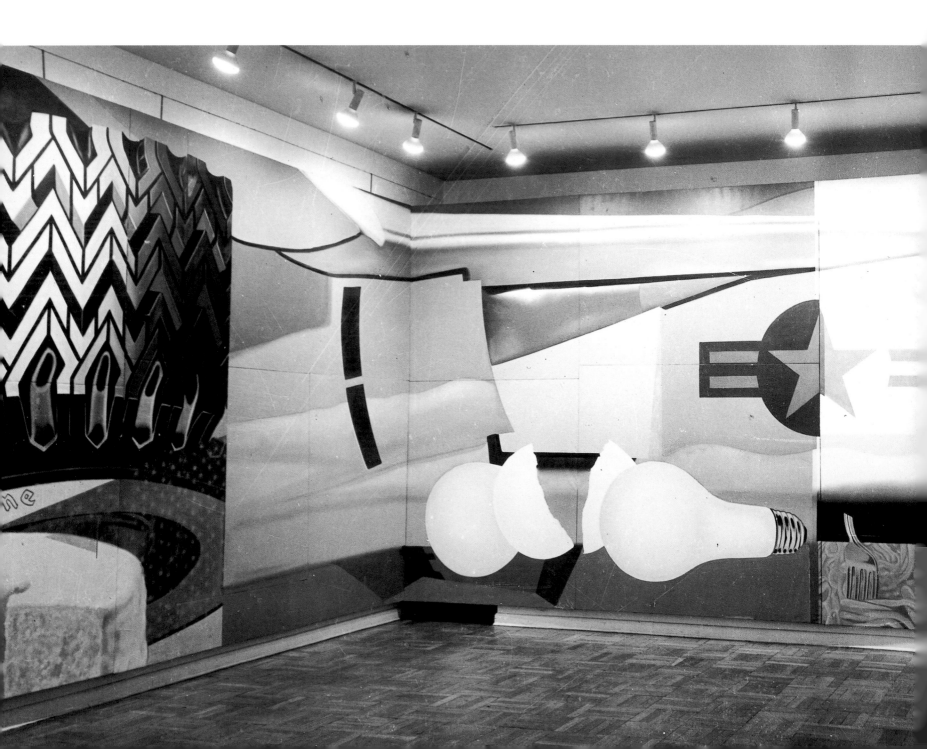

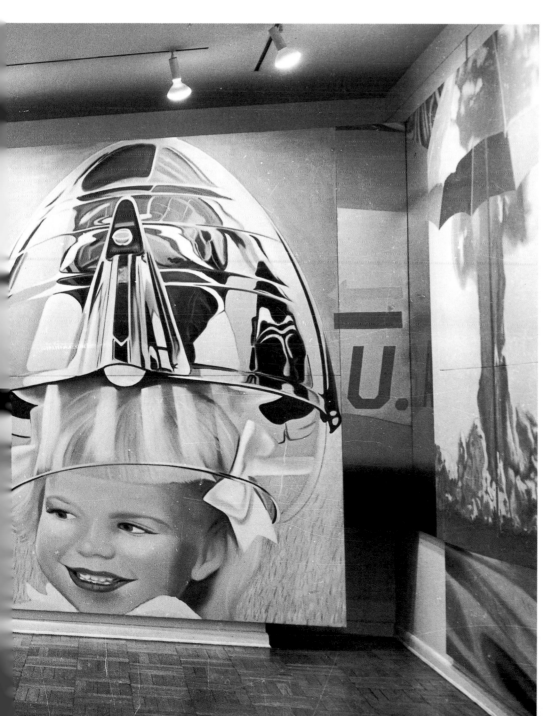

James <u>ROSENQUIST</u>

F-111

1964-65

Oil on canvas with aluminium

305 × 2,621.5 cm [120 × 1,032 in]

Collection, The Museum of Modern Art, New York

left, Installation view, Leo Castelli Gallery, New York, 1965

F-111 was labelled 'the world's largest pop painting' when it was first exhibited at the Leo Castelli Gallery in April 1965. It consists of fifty-one interlocking sections over 26 m (86 ft) long in total. In the Castelli Gallery it covered all four walls, surrounding the viewer. The central horizontal element running through the composition, the eponymous F-111, was a new, controversially expensive bomber; the painting was executed during the Vietnam conflict. Pictorial elements including rubber tyres, a young girl under a hairdresser's hairdryer, a bomb blast and a mass of spaghetti, combine the visual rhetoric of the military-industrial complex with consumer commodity advertising imagery. Rosenquist's sleek, polished style and billboard scale (even the aeroplane is represented larger than life) can induce claustrophobic, overwhelmed responses. It is impossible to see the entire painting at once. Although it remained complete, Rosenquist was willing to sell the painting in sections, entertaining the ideas of disintegration this would raise.

SPECTACULAR TIME

Around 1967, the 'Summer of Love', it seemed that the alternatives to corporate, industrial and imperialist America had themselves turned into a colourful, nomadic, psychedelic cliché. Artists became popular figures in unprecedented ways, and links were established between their work and fashion, film and advertising, thereby spreading their influence further. Some (Andy Warhol, Peter Blake, Richard Hamilton) even designed Pop album covers. All cultural life was increasingly co-opted into a spectacular and inescapable merger of advertising, television and consumption. This repressive tolerance of all forms of communication subsumed even marginal phenomena into the totality. The utopian freedom which seemed within reach only a short time previously now appeared to artists in different fields to be a mirage. While the spectators for art, music and film increased they also became more passive and easily manipulated. A step back to basics, and an analysis of the vernacular and the traditional, was presented in Ed Ruscha's *Every Building on the Sunset Strip* and other works, which created the conditions for a structural understanding of the world's appearance, for individual imagination, and for a recognition of the artist's more nuanced role with regard to the public sphere.

opposite
Andy WARHOL
Silver Clouds
1965-66
Helium-filled Scotchpack [silver foil-coated Mylar]
87.5 x 126.5 cm [34.5 x 50 in] each
Installation view, 'Andy Warhol. Wallpaper and Clouds',
Leo Castelli Gallery, New York, April 1966

The *Silver Clouds* were presented in a double installation at the Leo Castelli Gallery, New York, in April 1966. In the front gallery, they were intended to float between the floor and the ceiling. The walls of the adjacent gallery were papered with *Cow Wallpaper* (shown overleaf). The idea for the *Silver Clouds* dates back to 1964, when Warhol met Billy Klüver, the engineer at Bell Laboratories who had worked with artists such as Robert Rauschenberg. Originally they discussed collaborating on a floating light bulb, then on a cloud-shaped form. Neither was feasible using the silver material they located (Scotchpak, used by US Army suppliers to wrap sandwiches). It was heat-sealable and relatively impermeable to air or helium but could only be shaped to a basic geometric form. Most viewers referred to the works as 'silver pillows', missing the elemental reference that Warhol retained in his title.

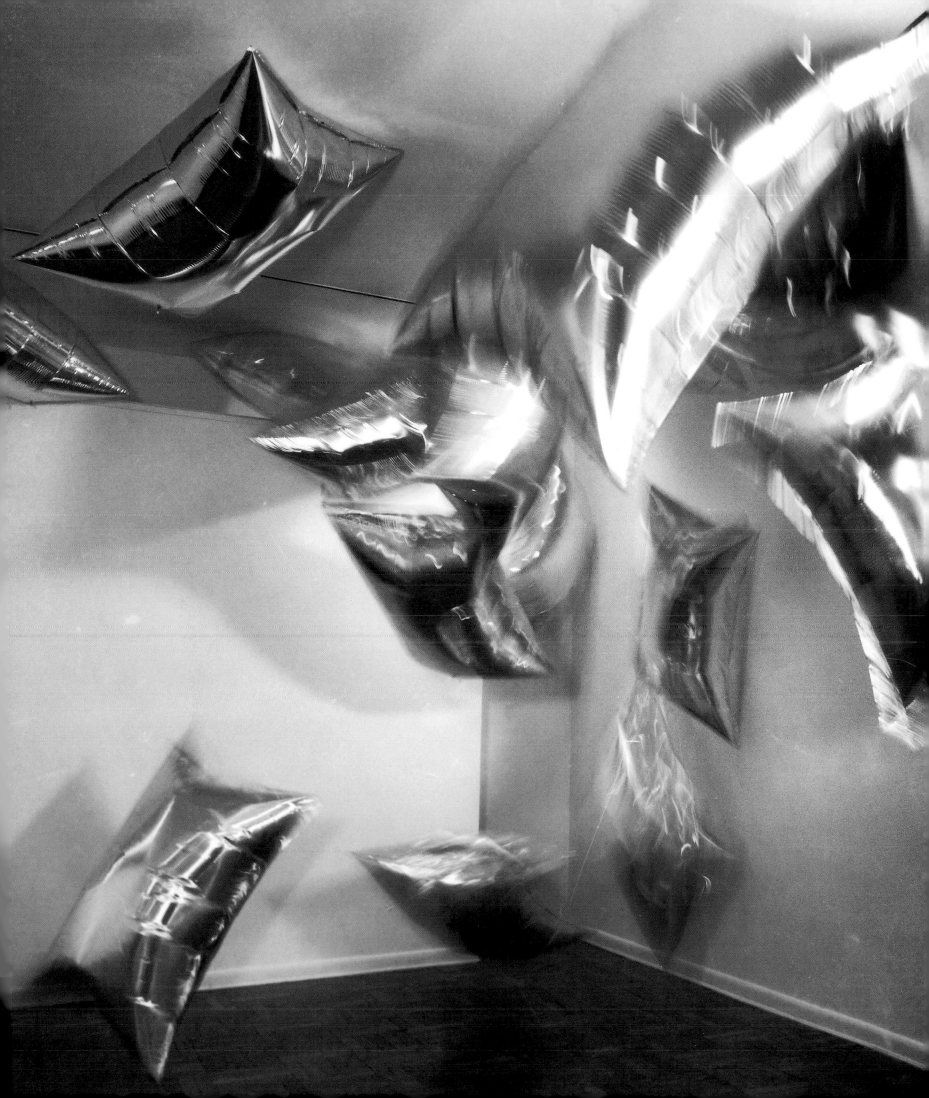

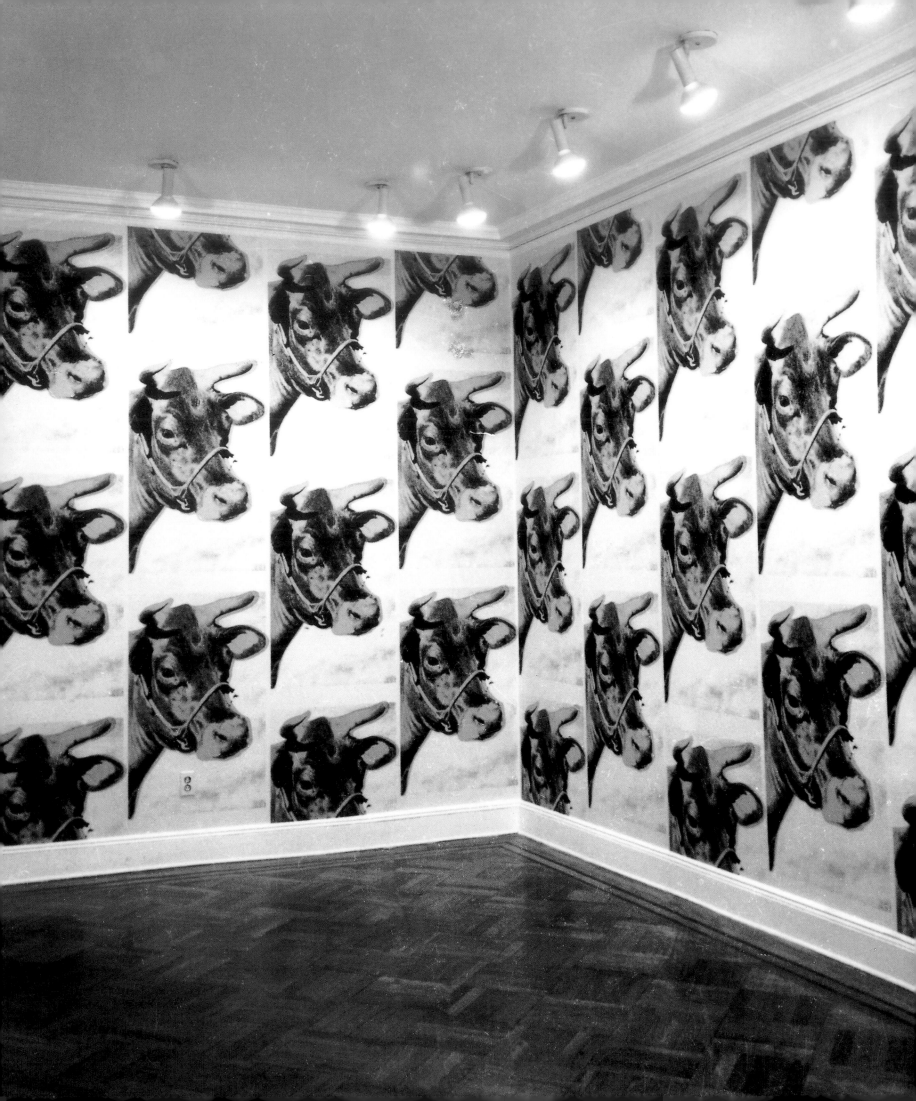

Andy WARHOL
Cow Wallpaper
1966
Silkscreen ink on wallpaper
Dimensions variable
far left, Installation view, 'Andy Warhol. Wallpaper and Clouds',
Leo Castelli Gallery, New York, April 1966
left, detail of wallpaper

The entire wall space of the second gallery at Leo Castelli was covered with this wallpaper. The *Cow Wallpaper* refers to nature but the colours could not be more unnatural. Going beyond the bright hues of the *Flowers* series, the magenta/red and gold/yellow combination produces a dazzling 'day-glo' effect. The *Silver Clouds* and the *Cow Wallpaper* could be viewed, respectively, as 'finishing off' Warhol's sculptural and painting practice to date. The *Silver Clouds* replaced the hard-edged definition, mass and presence of the box sculptures with randomness, dispersal, insubstantiality and reflectiveness. The *Cow Wallpaper* replaced the production of multiple but varied individual paintings (such as the *Flowers*, installed as a grid in the same space a year before) with a uniform, all-over wall covering. Both works were ephemeral, manufactured products that were potentially unlimited and without value (not for sale). Both replaced discrete artworks with an ambient environment.

Andy WARHOL
The Chelsea Girls
1966
16mm film, 195 min., black and white and colour, sound, double
screen projection

Apart from two scenes for which Ronald Tavel supplied scripts, *The Chelsea Girls* comprises six and a half hours of improvised, 'real' dialogue and monologue by members of Warhol's entourage, including Brigid Berlin, Susan Bottomley (International Velvet) and Nico, who lived at the Chelsea Hotel at the time the film was made. From June 1966, scenes were shot at the hotel, in the Factory and at the Velvet Underground's apartment. In August Jonas Mekas asked Warhol for a new film to screen and twelve of the scenes were assembled into *The Chelsea Girls*. The reels of film were shown on two screens. This reduced the performance duration to three and a quarter hours. Most of the film is in black and white. Occasional scenes in intense colour, created by lighting effects, appear on one screen: an echo of the contrasts in Warhol's *Silver Clouds/Cow Wallpaper* installation. The film opened at the Filmmakers' Cinematheque in September 1966. Due to its popularity it was soon transferred to larger venues in New York, becoming an art house cinema box office success and touring to other major cities across the United States.

Diane ARBUS
The King of Soul, backstage at the Apollo Theater in Harlem
1966
Gelatin silver print
Published to accompany 'James Brown is Out of Sight', by Doon Arbus,
The Sunday Herald Tribune Magazine, New York, 20 March 1966
Diane Arbus was commissioned, with her daughter Doon as writer, for a portrait of
James Brown by Clay Felker's New York magazine in March 1966. This image shows the
singer backstage, probably at Madison Square Garden, where he performed that month.
She transforms the flamboyant performer into a disturbing and ambiguously monstrous
figure, turning towards the camera in profile against a harshly lit wall on which his
shadow is cast. In 1967 The Museum of Modern Art, New York, included Arbus, with Lee
Friedlander and Garry Winogrand, in the influential exhibition 'New Documents'.

Lee FRIEDLANDER
Aretha Franklin
1967
Cibachrome print
38 × 38 cm [15 × 15 in]

Lee Friedlander was a regular photographer for Atlantic Records, providing images for their record covers and publicity materials. He therefore had privileged access to musicians while recording in the studio, many shot close-up and in colour. This intense image captures the great gospel and soul singer Aretha Franklin in full flow, at the time of her hit record *Respect*, which had great impact for the Civil Rights movement and for other activists. Friedlander amassed an enormous archive of his photographs of American musicians, who worked in every popular genre from jazz to country and western music.

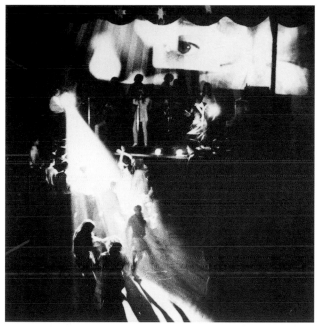

Andy WARHOL and THE VELVET UNDERGROUND
'The Exploding Plastic Inevitable Show', The Dom, New York, 1 April
1966
Photograph by Billy Name

Warhol's *Silver Clouds/Cow Wallpaper* installation coincided with this event in which he attempted to transcend the boundaries between visual art, film, music and performance in a total art work. The Velvet Underground, whom Warhol, Gerard Malanga and Paul Morrissey had met in December 1965, performed on stage surrounded by new spectacular innovations such as a light show (so blinding at times that the band adopted sunglasses as much for eye-protection as to look cool); back-projections (such as Warhol's film *Vinyl*); and choreography (Gerard Malanga and Mary Woronov's frenetic dancing). Documented by the filmmaker Ronald Nameth and the photographer Billy Name, this event was a short-lived experiment in Warhol's practice as an artist but initiated the spectacular rock events that expanded the fusion of various media with live performance in the late 1960s.

Mark BOYLE and Joan HILLS
Aldis light projection from Son et Lumière for Earth, Air, Fire and
Water
1966

The *Son et Lumière for Earth, Air, Fire and Water* project used technological means to provide a sensory experience modelled on the characteristics of the natural elements. The visual component was created through physical reactions between coloured oils and water transpiring in a special compartment within a slide projector. The projection was accompanied by recorded or performed sounds of environmental reactions such as volcanic eruptions, gusting winds or falling water. The process was simple and flexible and the overall effect was the result of chance. Screened privately until the technique and desired presentation had been refined, the first major performance took place in 1966 in Liverpool. At that time Boyle also performed the 'sounds and lights' for *Bodily Fluids and Functions* using actual body substances instead of dyed surrogates. The events served as an exploration of interior and exterior relationships between visual and aural textures through their natural rhythms. Boyle staged these projections on tour with the bands Soft Machine and the Jimi Hendrix Experience. The optical effects were widely adopted and became the backdrop for many acid-rock concerts.

Richard <u>HAMILTON</u>
People
1965–66
Oil and cellulose on photograph on panel
81 × 122 cm [32 × 48 in]

Hamilton used postcards as source imagery in several works, including *People* and *Whitley Bay* (1965), both of which were based on pictures of the coastal resort in north-eastern England. For *People*, Hamilton created a 35mm negative showing a small portion of a postcard and made a standard format monochrome print from it, which he then re-photographed. He repeated the enlargement process many times until the prints had lost formative meaning. Retracing his steps he was then able to pinpoint exactly the last legible stage, which was used to construct this hybrid photograph/painting. While the image verges on abstraction the viewer can still discern individuals and groups, even ages and dynamics between people.

Michelangelo <u>ANTONIONI</u>
Blow-Up
1966
35mm film, 111 min., colour, sound
With David Hemmings

Like Hamilton's paintings of the same year, Antonioni's film examines the limits of our perception of reality as mediated through photography. Bored with the artificiality of fashion shoots, a photographer embarks on a voyeuristic form of reportage. From a distance he snaps what seems a romantic rendezvous between a middle-aged man and woman. She pursues him to try to confiscate the images. Thinking he witnessed an illicit affair he processes and enlarges the pictures to greater and greater magnifications (the prints used in the film were made by the photographer Don McCullin). He pins them on his wall in sequence, like film stills. They reveal a man with a gun in the shadows of the bushes. He speculates that he foiled a potential murder but further blow-ups reveal what could be a dead body. The photographs are then stolen. Without them he is left with nothing as evidence of what might have taken place.

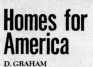

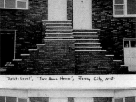

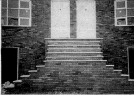

Dan GRAHAM

Homes for America

1966–67

Colour and black and white photographs, texts

2 panels, 101.5 × 84.5 cm [40 × 33.5 in] each

1970 revised version of the artist's original paste-up for

Arts Magazine, New York

Graham's essay 'Homes for America', describing new large-scale, suburban housing projects, is laid out on a double-page spread. It is illustrated with his Kodak Instamatic snapshots, which document such projects in New Jersey. The essay describes the methodology of domestic construction in terms similar to those used to describe the work of his contemporaries such as Sol LeWitt, whose work he had shown in a short-lived New York gallery just previously. The houses form repeated geometric patterns, like serial units of minimalist sculpture, which Graham designates 'serial logic'. On first publication, in *Arts Magazine* (December 1966/January 1967), the editors substituted Graham's photos with a cropped print of a Walker Evans photograph. With this project, Graham began his engagement with vernacular architecture and the popular cultures and subcultures outside the gallery system.

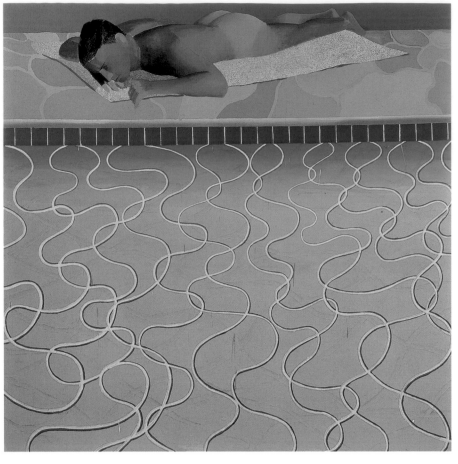

David <u>HOCKNEY</u>
Sunbather
1966
Acrylic on canvas
183 × 183 cm [72 × 72 in]
Collection, Museum Ludwig, Cologne

In *Sunbather* and related works, Hockney combines his simplified realism of depiction with features derived from modernist abstraction, such as the wavy lines signifying the pool's reflection of sunlight. Those traditional subjects of painters, bathers and reclining nudes, are here updated in several ways: they are contemporary Californian men; they are openly gay, representing the newly assertive visibility of the West Coast scene; and like their surroundings they glow with the bright hues Hockney obtained by switching from oils to synthetic polymer paints.

opposite
Malcolm <u>MORLEY</u>
Coronation and Beach Scene
1968
Acrylic on canvas
228 × 228 cm [90 × 90 in]
Collection, Hirshhorn Museum and Sculpture Garden, Smithsonian
Institution, Washington, D.C.

This scene of holidaymakers at a beach café, contrasted with the pomp of Queen Elizabeth II's coronation, is founded on a lineage of subjects that Morley was exploring during the mid 1960s. The coupling of moneyed decadence with aristocratic celebrations of continued rule highlights new and old caste systems. His preoccupation with the decadent leisure class had emerged in his previous paintings of cruise liners seen from afar followed by compositions that zoomed in to close-ups of the passengers' activities on deck. This work scrutinizes social details through the generic postcard images that the artist collected. The sense of removal from his subject came from Morley's own English working-class upbringing and exile in America. His brand of Photorealism, self-dubbed 'Super-realism', came from a meticulous translation of the image on to canvas. By sectioning the postcard with a grid, Morley would render each square individually, disregarding any hierarchy of parts, as if each component were an image in itself.

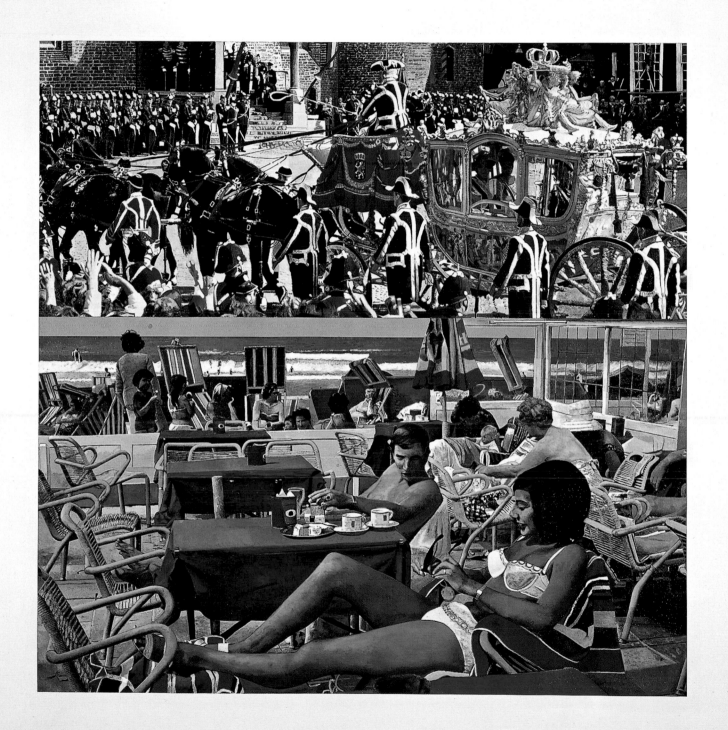

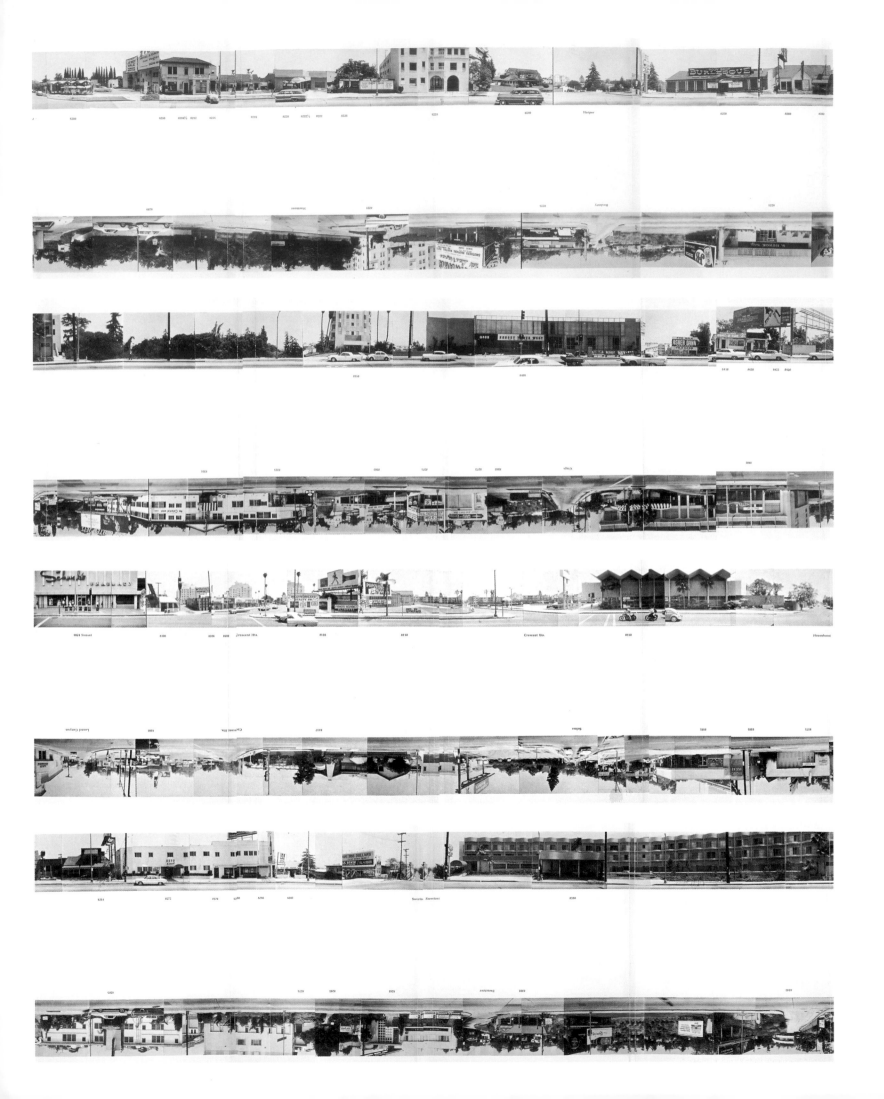

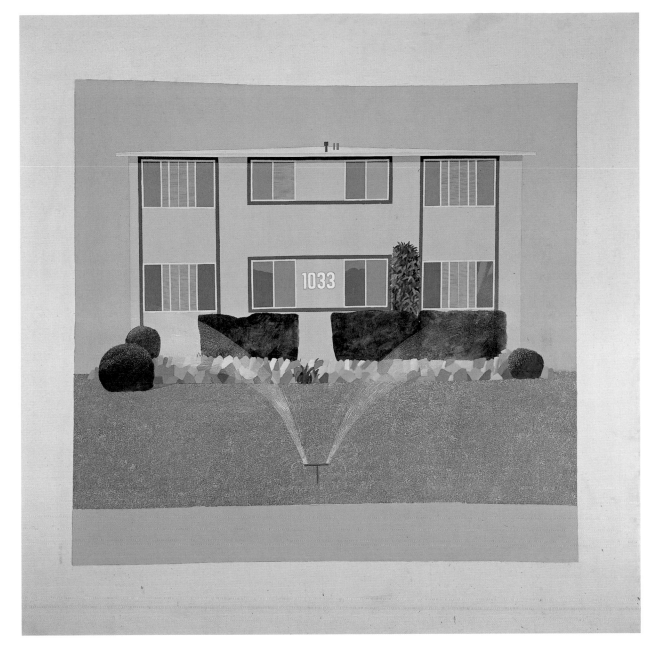

Neat Lawn
1967
Acrylic on canvas
244 × 244 cm [96 × 96 in]

Hockney first visited Los Angeles for an extended period in 1964, returning there in the summer of 1966 for a year. After 1961 he no longer considered himself a Pop artist according to the criteria of early Pop but his Californian paintings connect with the expansion of Pop imagery by contemporaries such as Ed Ruscha and Malcolm Morley. Like Morley, Hockney draws on postcard and brochure styles of depiction as one of his many sources, and like Ruscha he focuses on the contemporary vernacular setting of Los Angeles suburban life – the neat modern architecture and manicured grounds, the ubiquitous palm trees and private swimming pools. *Neat Lawn* exemplifies the cool exoticism this environment represented to the northern English artist.

opposite
Ed <u>RUSCHA</u>
Every Building on the Sunset Strip
1966
Artist's book, offset litho, black and white photographs, text, accordion folded and glued, softbound
18 × 14.5 cm [7 × 5.5 in] closed, 761 cm [299.5 in] extended

Ruscha produced his first artist's book, *Twentysix Gasoline Stations*, in 1963, a meticulously produced but cheap, widely available edition comprising photographs taken along Route 66 between Los Angeles and Oklahoma City. In *Every Building on the Sunset Strip* Ruscha again explored the long, open highway and a dead-pan, serial use of images. Unstaged, the photographs have a documentary feel, presenting the street as a kind of readymade. The buildings are seemingly bland but reveal the conformity and rigid design systems of the environment. By the mid 1960s increased car ownership in America had led to expanded housing developments, freeway systems, billboards, drive-in movies, drive-in diners and even drive-in churches. Ruscha's viewpoint is from the road: he took the photographs using a motorized Nikon camera mounted on the back of a pickup truck. The concertina-folded book opens out to a 7.6 m (25 ft) strip of photographs. Each building is identified by its street number. The south side of the street from east to west runs along the top of the pages; the buildings on the opposite side of the street are printed facing the buildings across the street as they did in actuality.

Bruce CONNER
REPORT
1963-67
16mm film, 13 min., black and white, sound

These are the final images of the film. The word 'sell', prominent on the keyboard, puts the events and images in the context of a myth the viewer 'buys into'. Conner started work on the film in the immediate aftermath of Kennedy's assassination. The film deals with the media's reaction to the incident and its absorption into cultural consciousness. The soundtrack is composed of newsreaders and police radio operators reacting to the attack as it happened, in aural loops – the shooting itself is not shown. Conner collated newsreel, archival footage and his own shots. He also used intercut sequences of stroboscopic black and white frames. 'Whenever you look at any black and white or almost any contrasting image, a certain amount of that impression is kept on the retina of the eyeball' (interviewed by Peter Boswell, 11 February 1986). He was interested in this 'persistence of vision' and in the reduction of events to iconic images. Conner's use of rapid editing, inter-cutting and repeated images was intended to induce in the viewer a sense of uneasy déjà vu. These disruptions also highlighted the narrative nature of accepted film norms.

Jean-Luc GODARD
Pierrot le fou
Pierrot the Mad
1965
16mm film, 110 min., colour, sound
With Anna Karina

In *Pierrot le fou* (1965), Godard began to embark on a radical blurring of distinctions between narrative and the cinematic essay. While this was anticipated in his earlier films, they maintained a surface illusion of plot and various features of narrative construction. These were now more overtly abandoned. The characters address the audience directly. In front of a group of American sailors they improvise a Brechtian performance on the topics of Hollywood and Vietnam. Their statements and actions are interspersed with static frames showing details of advertisements, paintings or entries in journals. From this point onwards, Godard's methodology as a filmmaker moves towards Marxist social critique, particularly in *La Chinoise* (1967), centred on a group of Maoist students in Paris, which anticipates the events of 1968.

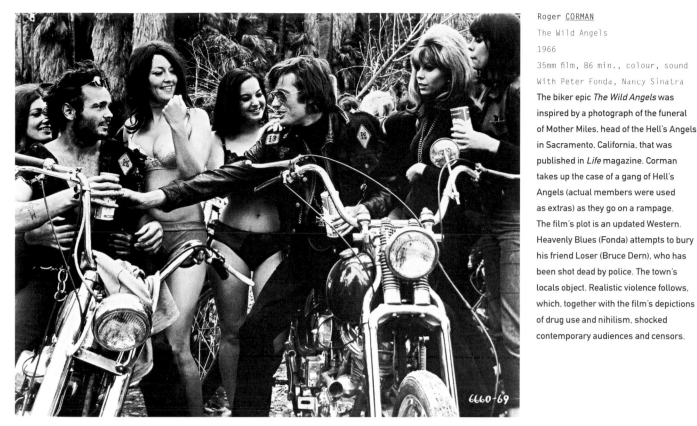

Roger <u>CORMAN</u>
The Wild Angels
1966
35mm film, 86 min., colour, sound
With Peter Fonda, Nancy Sinatra

The biker epic *The Wild Angels* was inspired by a photograph of the funeral of Mother Miles, head of the Hell's Angels in Sacramento, California, that was published in *Life* magazine. Corman takes up the case of a gang of Hell's Angels (actual members were used as extras) as they go on a rampage. The film's plot is an updated Western. Heavenly Blues (Fonda) attempts to bury his friend Loser (Bruce Dern), who has been shot dead by police. The town's locals object. Realistic violence follows, which, together with the film's depictions of drug use and nihilism, shocked contemporary audiences and censors.

Kenneth <u>ANGER</u>
Kustom Kar Kommandos
1965
16mm film, 3 min., colour, sound
With Sandy Trent

Kustom Kar Kommandos is a fragment of an abandoned project, from which Anger's original, comprehensive notes survive. He made this small segment (a single scene) as a showreel to try to raise funds to complete his envisaged thirty-minute film. Anger applied similar formal techniques to those seen in his earlier film about bikers, *Scorpio Rising* (1964), to the theme of customization and hot-rod fetishes among Californian teenagers. A young man wearing tight jeans polishes his car with a giant powder puff, manipulates the gears and cleans the chassis. The rock 'n' roll song 'Dream Lover' by the Parris Sisters is played on a repeating loop.

Clive <u>BARKER</u>
Splash
1967
Chrome-plated steel, chrome-plated brass and painted wood
86.5 × 38 × 35.5 cm [34 × 15 × 14 in]
Collection, Tate, London

Originally a painter, from 1962 onwards the British artist Barker focused on making sculptures that further developed the dialogue between representation, replication and real objects initiated by Jasper Johns and Jim Dine. Starting with media such as leather and zips, by 1965 he had focused on the use of metals such as bronze, brass and steel, usually combined with various finishes such as chrome or gold plating. Between 1966 and 1968 he fabricated the wide range of three-dimensional objects that mark the high point of his Pop period. These included replicas of artists' palettes and boxes of paints, cigars, displays of sweets, the chair of Vincent Van Gogh, splashes and droplets of water falling into a bucket, and Coca-Cola bottles, presented singly or in groups. Barker's primary interest was in the contrast between materiality, solid and liquid, and the effects of his highly reflective surfaces. *Splash* conflates various preoccupations of art in the late 1960s: it is 'photorealistic' but monochrome and reflective; it draws on the ideas of both the readymade found object and the industrially fabricated 'specific object' of Minimalism, yet it enacts a literal demonstration of traditional representational values.

opposite
Paul <u>THEK</u>
Meat Piece with Brillo Box
1964-65
Silkscreen ink and household paint on plywood, beeswax and Plexiglas
43 x 43 x 35.5 cm [17 x 17 x 14 in]
Collection, Philadelphia Museum of Art
From the series *Technological Reliquaries*, 1964-67

Thek acquired one of Warhol's *Brillo Boxes*. He removed its blank bottom face and inserted one of his beeswax sculptures inside. 'Gazing into the Plexiglas bottom of the case, we are appalled. The motifs of the mouth with tongue and the television as framing device have shifted to three dimensions in order to mount a full-scale attack on consumer culture. "No ideas but in things", Warhol implied. "No ideas but in flesh", Thek countered. In the *Technological Reliquaries* series, to which this piece belongs, elaborate containers, often of coloured plastic, house lumps of what resemble raw meat. The choice of the *Brillo Box* was deliberate. Yet though Thek had visited the Factory and met Warhol, there can be little doubt that he meant this as a reproach, not only on Warhol himself but also on his particular interpretation of Pop …'
– Stuart Morgan, 'The Man Who Couldn't Get Up', *frieze*, 24, 1995

 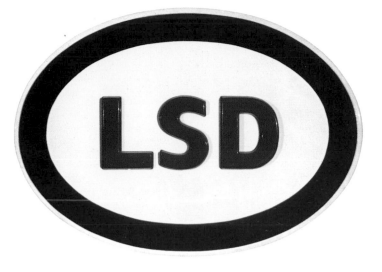

above

Öyvind <u>FAHLSTRÖM</u>

ESSO-LSD

1967

Plastic signs

2 panels, 89 × 127 × 15 cm [35 × 50 × 6 in] each, hung 30 cm [12 in] apart

Edition of 5, manufactured by B. Nässil & Co. AB Skyltfabrik, Sundbyberg, Sweden

Collection, IVAM: Instituto Valenciano de Arte Moderno, Valencia

Consistency of style, form and materials were irrelevant to Fahlström, nevertheless these paired fabricated plastic signs are distinct from his other work of the period. The left-hand component of *ESSO-LSD* is an exact replica of an existing sign for the petroleum company. Its counterpart on the right, however, has been colonized, as it were, by the acronym for the psychotropic drug. The viewer is provoked to reflect on the possible associations of these words, the combination of which is as striking as Robert Indiana's *EAT/DIE* (1962). Like Indiana, Fahlström began as a poet, but of a different kind: he pioneered concrete poetry in the early 1950s. *ESSO-LSD* draws on those precedents as well as Duchamp's readymades and word play. Fahlström's first experience with LSD in 1967 had proved a turning point. In texts such as the manifesto *Take Care of the World* (1966) he proposed alternative models of society in which new, 'good' forms of consciousness-expanding drugs would contribute to 'greater sensory experiences and ego-insight'.

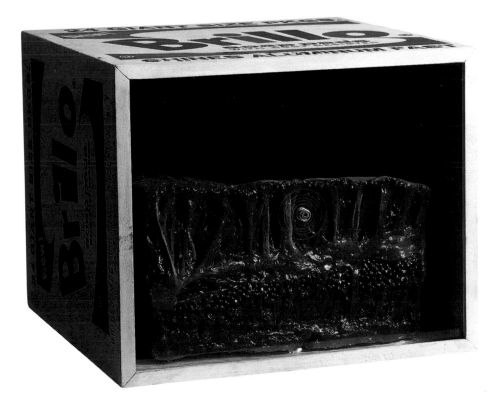

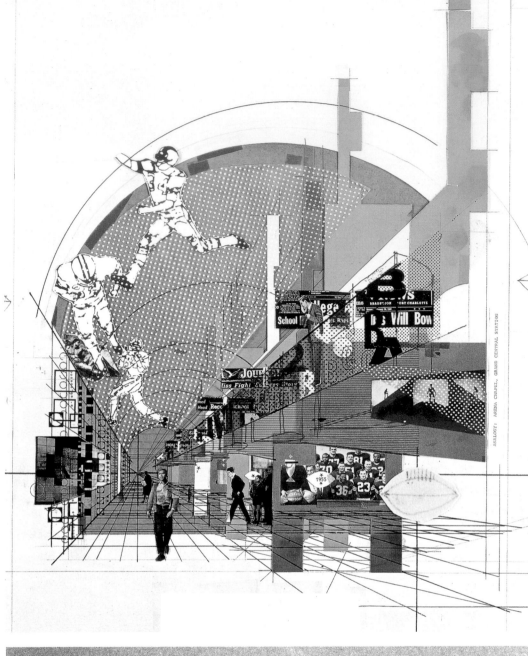

National College Football Hall
of Fame Competition
Rutgers University, New
Brunswick, New Jersey, 1967
left, Interior perspective
below left, Elevation model

Venturi and Rauch proposed a return to symbolism in their design for the National College Football Hall of Fame. The scheme mixed projections and graphics with volumetric architectural spaces. Robert Venturi in particular was concerned with context and meaning in architectural design, and engagement with the commercial realities of the American vernacular. The exterior was designed with a large 'Bill-Ding-Board' (a bank of LEDs) on the side facing the highway, on which a sequence of images would be played to passing motorists. The small scale of the objects to be displayed inside the building, such as footballers' shirts, inspired the idea of filmic projections (of great moments from football history), creating volume within the space. Using light and pictures to transform space was a staple of theatrical production, but a relatively new concept for architecture. A grandstand rear of the building was to overlook a football field.

ANALOGY: ARENA CHAPEL, GRAND CENTRAL STATION

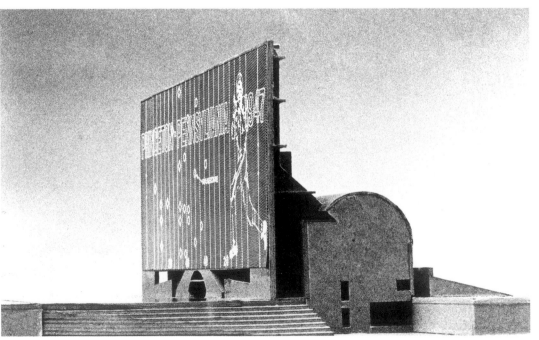

Charles MOORE
Moore House
1966
New Haven, Connecticut

Moore moved to New Haven in 1965 after being named head of the Yale Architectural School. He was highly criticized for his eccentric designs, which parodied the formal elements of classical architecture, turning functional logic into decoration and mannerism. His assimilation of styles established the early notions of Postmodernism in the field. The renovation of this two-storey, nineteenth-century wooden house was a challenge of restructuring within limited spatial dimensions. After gutting the interior and creating a unified space, Moore designed three modest towers for bedrooms, added layers of circular plywood as connective divides and coated the entirety in apple green and lemon yellow. His interior design ran in tandem with his architectural convictions. One bedroom ensemble is entered through door panels perforated by large numbers. The walls and ceiling are adorned with white stars on a blue ground, leading up to a hemispherical recession in the ceiling, painted to suggest the cupola of the US Capitol.

ARCHIZOOM [Andrea Branzi, Gilberto Corretti, Massimo Morozzi] and SUPERSTUDIO [Adolfo Natalini]
View of 'Superarchittetura' exhibition, Galleria Jolly 2, Pistoia, Italy, December 1966

This exhibition introduced the radical approaches of Archizoom Associates and Superstudio, bringing the Pop sensibilities of consumer culture to the wider dialogue of architecture and urban theory. 'Superarchitecture' was based on the logic, rate and scale of modern-day consumption and production. The word 'super' carried associations of quality and possibility, ranging from Superman to the supermarket, in this case expressed in an ultra-baroque illustration of potential directions for planning. They considered the orthodox architect's role as an urban problem-solver to be too focused on serving an individual's experience within a codified environment. Through the elimination of the functional building, Archizoom and Superstudio put their efforts into a progressive master plan, updating the means of engagement to serve contemporary living standards. For these two groups, the exhibition was a way to sever ties with the past and signal the end of modernist architecture.

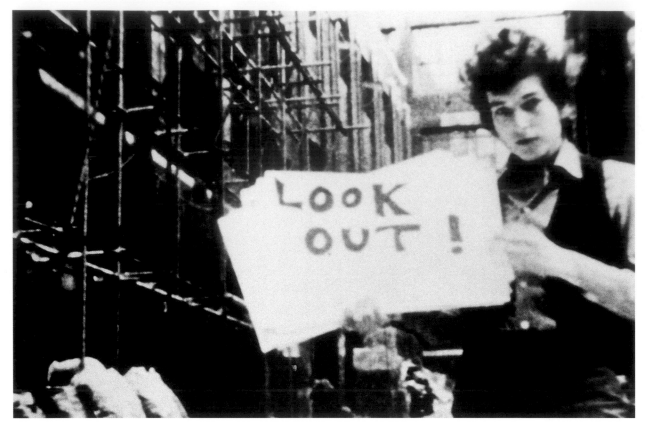

D.A. PENNEBAKER

Don't Look Back

1967

35mm film, 90 min., black and white, sound

With Bob Dylan

In this sequence from Pennebaker's film, the singer Bob Dylan holds up cards with the lyrics of his 'Subterranean Homesick Blues' as they are simultaneously heard on the soundtrack. *Don't Look Back* was a portrait of Dylan filmed during his tour of Britain in 1965, and Pennebaker's first sustained exercise in what he called Direct Cinema. This movement, which he co-founded with Richard Leacock and Albert Maysles, allowed the subjects of documentary films to speak for themselves. Voice-over narration was avoided, and sound was held to be as important as the image. These goals were aided by the development of lightweight, professional-quality 16mm equipment during this period.

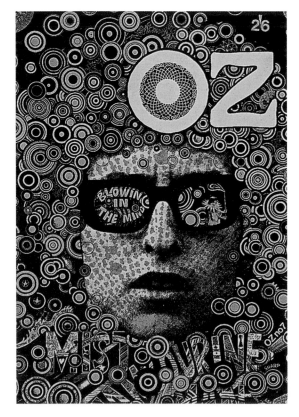

Martin SHARP

'Blowing in the Mind' cover of *Oz* magazine

1967

Offset litho magazine cover reproduction of original silkscreen print

Martin Sharp came to London from Sydney, Australia to work on the underground magazine *Oz*. Psychedelic images he designed as posters were also adapted, as here, for use on the magazine's covers. A friend of musicians such as Eric Clapton, he became an influential designer of record album covers and concert posters.

The original graphic *Blowing in the Mind* was created for Bob Dylan's record *Mister Tambourine Man*. Dylan's hair is represented by bubbling circles that disperse into the environment as a literal echoing of the song's hallucinogenic references.

Psychedelic graphics became a widespread artform in the late 1960s. Other notable artists include Rick Griffin, John Van Hammersveld, Alton Kelley, Victor Moscoso, Stanley Mouse and Wes Wilson.

Gérard JOANNÈS

Poster announcing the publication of *L'Internationale Situationniste*, 11

1967

Offset litho printed drawing on paper

53 × 33 cm [21 × 13 in]

In 1962 the original artist members of the Situationist International had been excluded by the group in Paris, dominated by Guy Debord, Raoul Vaneigem and Michèle Bernstein, who developed it into a political organization. For them there was no situationist art, only situationist uses of art. In 1967 Vaneigem published *The Revolution of Everyday Life* to present the SI's theories to a mass audience. He collaborated with graphic artists such as Joannès, who appropriated the style of comic strips to achieve the same objectives. A further context for this poster was the collaboration in 1966 between the SI and a student union at the University of Strasbourg on a critique published as a pamphlet: 'The Poverty of Student Life'. This called for a revolt by students similar to those that had taken place at Berkeley, California, and elsewhere, and was the trigger for the 1968 student revolution in which the Situationists played a leading role.

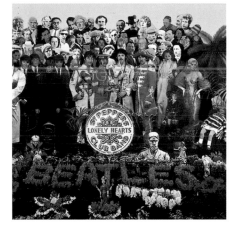

Peter BLAKE with Jann Haworth and Michael Cooper

The Beatles: Sergeant Pepper's Lonely Hearts Club Band

1967

Assemblage and photomontage photographed and printed as colour offset litho album cover

Blake and his collaborators, including his wife, the artist Jann Haworth, created a nostalgic montage of images of twentieth-century icons from literature, politics, Hollywood cinema and Pop music, and the band's own early 1960s incarnation in identical tailored suits stipulated by their first manager, Brian Epstein. At the centre, they have been reincarnated and even renamed in what would become the most influential 'concept album'. Outmoded, imperial-looking uniforms are transformed into other-wordly costumes, placing the band in their own self-defined realm, evoking the mystical and psychedelic transcendence that is the subject of many of the lyrics.

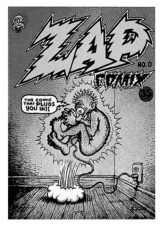

Robert CRUMB

Cover of *Zap Comix* No. 0

1968-69

Drawing printed as colour offset litho comic-book cover

After Crumb's *Zap Comix* was launched in the winter of 1968–69, Öyvind Fahlström wrote of him: 'You could say that he makes Pop art in the true sense of the word: art for the people, popular art' (*Dagens Nyheter*, 5 October 1969). One of his cartoons inspired Fahlström's 1969 installation *Meatball Curtain (for R. Crumb)*. Crumb had originally been discovered by the MAD magazine cartoonist Harvey Kurtzman in the late 1950s. With the launch of *Zap Comix* this underground tradition emerged in an influential new form: alternative magazines, posters and books produced directly by counter-cultural artists.

HELTER SKELTER

After the euphoria and fantasies of revolution that marked the high point of the 1960s, the year of 1968 offered a sharp rebuke. The events of May 1968 in Paris, Prague and elsewhere showed that the aspirations of students and workers could be ignited into action and provoke the authorities into violent suppression. Cultural and societal changes were reflected in the very title of Richard Hamilton's painting *Swingeing London*, a defining image which brought together the hedonistic worlds of art and popular music, incarcerated by the establishment. Andy Warhol was, by contrast, shot by a disaffected acolyte. The resulting paradoxes and inversions were acutely imagined in the films *Performance* and *Zabriskie Point*, which reflected the immediate futility of revolutionary action and the sterility of psychedelia. The Manson family's grotesque interpretation of the Beatles' 'White Album' was only symptomatic of the hiatus reached by the end of the decade.

opposite

Robert VENTURI, Denise SCOTT BROWN, Steven IZENOUR

Photographs of Las Vegas from 1965-66, first published in *Learning from Las Vegas*, MIT Press, Cambridge, Massachusetts, 1972

These phototgraphs echo Edward Ruscha's images of gas stations and roadside architecture, documenting the existing urban environment. Venturi, Scott Brown and Izenour's approach to architecture suggested the incorporation of elements from vernacular American style into building design. In *Learning from Las Vegas* they challenged the prevailing modernist aesthetic by presenting commercial roadside buildings and signage as inspiration for a new, symbolic architecture. Venturi responded to Mies van der Rohe's dictum 'less is more' with 'less is a bore'. The group encouraged a consideration of the practical realities of people's lives in architectural design. Scott Brown's essay 'Learning from Pop' (*Casabella*, December 1971) argued for the importance of such buildings as supermarkets and hot dog stands in informing future planning.

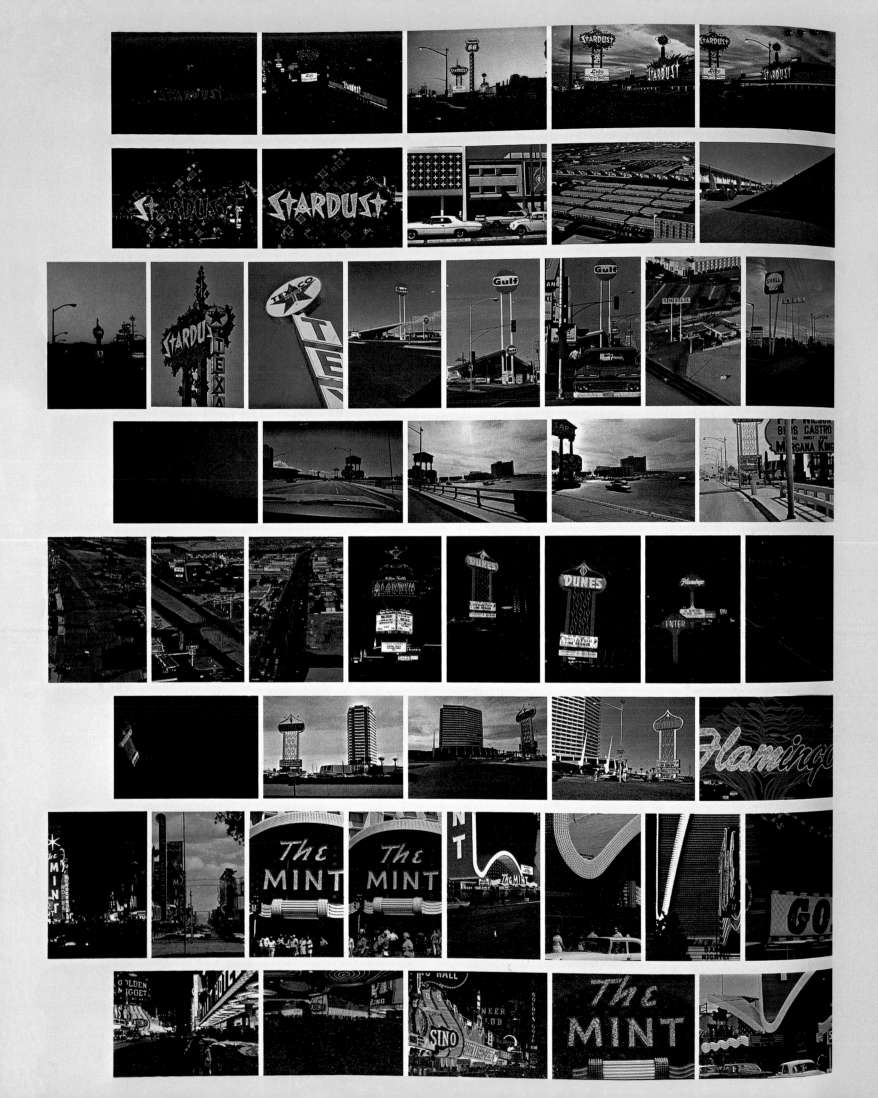

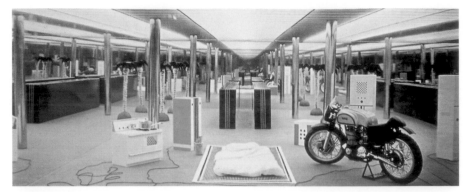

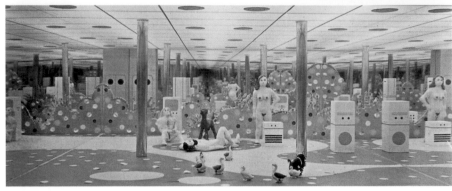

ARCHIZOOM [Andrea Branzi, Gilberto Corretti, Paolo Deganello,
Massimo Morozzi, Lucia and Dario Bartolini]
No Stop City, No Stop Theatre, Monomorphic Quarter, Internal
Landscape [details]
1968-70
Maquettes; wood, metal, board, paper, tempera, acrylic and mirrors,
with internal lighting
Collection, Centro Studi e Archivio della Communicazione,
Universita di Parma

Archizoom's *No Stop City* was a pointed comment on city planning and development. The project produced designs emphasizing dystopian possibilities. A single, unified and infinite building was shown divided into functional zones for daily behaviours including dwelling and work, leisure and consumption, removing the need for designated functional structures such as the home or office. The models were filled with representative goods for each theme and lined with mirrors, so that the viewer saw an endless repetition. This vision of an unending metropolis integrated all buildings into a single superstructure, implying infinite desire and consumption. According to Andrea Branzi, the group was inspired by repeated imagery in the work of Andy Warhol, and the music of Philip Glass and Brian Eno.

John LENNON
'You Are Here' exhibition, Robert Fraser Gallery, London, July 1968
Installation view showing charity collection boxes

Lennon and Yoko Ono, both artists as well as Pop musicians, released 365 helium balloons into the London air to begin this show. Each balloon contained a tag bearing the message 'You are here' and a request to be mailed back to the Robert Fraser Gallery with a return address. This conceptual use of language pinpointed individuals in space and time, extending the exhibition to each of their locations simultaneously. The gesture was echoed in the gallery by a display of the same text on a large circular screen and again on small buttons that visitors could take away. A collection of found charity boxes, with styles varying from homemade to mass-produced, was installed in a separate space. Towards the rear of the gallery, on a pair of plinths, was a hat bearing the text 'For the artist. Thank you.' and a jar of buttons, signalling Lennon's own appeal for alms.

opposite
Richard HAMILTON
Swingeing London 67
1968
Photo-offset lithograph poster on paper
70.5 × 50 cm [28 × 20 in]

In February 1967 Mick Jagger of the Rolling Stones and the art dealer Robert Fraser were arrested for possession of cannabis and other drugs. Fraser was given a six-month sentence and Jagger was conditionally discharged on appeal. Hamilton, who was represented by Fraser, responded to the event with this poster and a series of six mixed-media paintings of which the first is shown overleaf. From newspaper cuttings he selected the material in this collage, reproduced as a photo-offset lithograph and published by an Italian distributor of art posters. The texts present many varied accounts of the incident and descriptive details about the protagonists, their actions, statements, appearance and lifestyles, with photos presented like evidence. The title puns ironically on *Time* magazine's portrayal of London in April 1966 as 'The Swinging City', a centre of liberated permissiveness, contrasted with a statement by the judge: 'There are times when a swingeing sentence can act as a deterrent.'

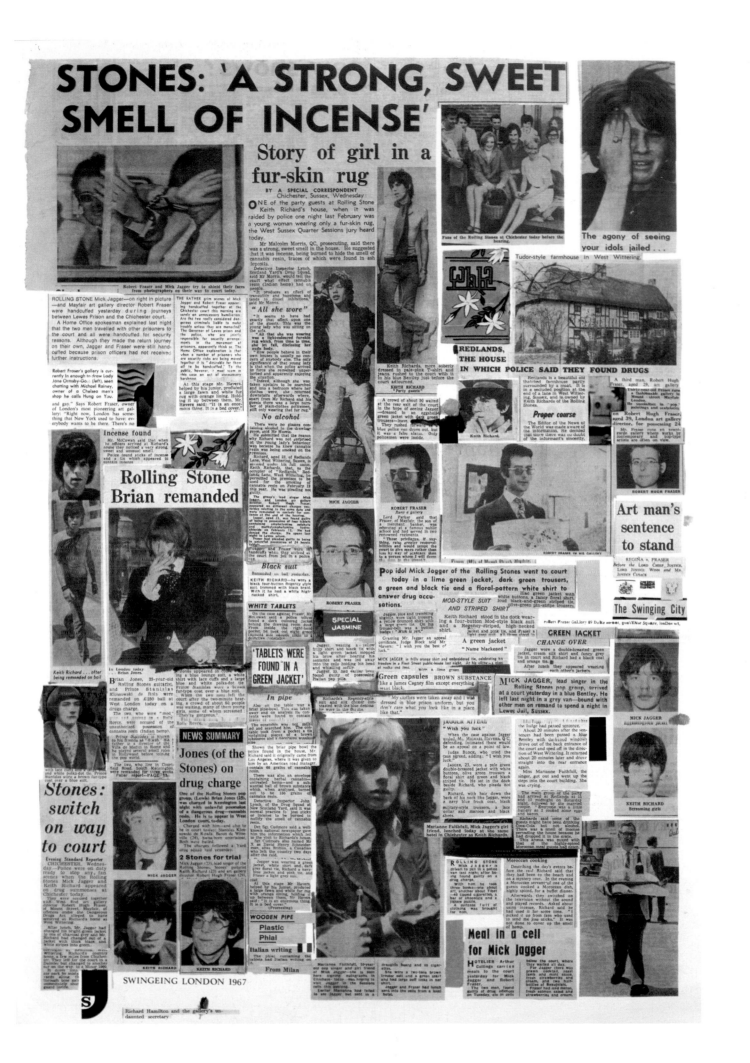

Swingeing London 67 [a]
1968-69
Silkscreen and oil on canvas
67 × 85 cm [26.5 × 33.5 in]

The source for this painting, the first in
a series of six varied treatments of the
same image, was the press photograph
reproduced at the top left of the
Swingeing London 67 poster shown
on the preceding page. Charged with
cannabis possession, Mick Jagger and
the gallery owner Robert Fraser are
handcuffed together inside a police
vehicle, stretching out their restrained
hands in front of their faces in the glare
of photographers' flashbulbs. Hamilton
obtained the original photograph from
the *Daily Mail.* It was enlarged and
retouched to remove the outside of the
police vehicle and extend the interior.
The resultant image was then silk-
screened in black over a coloured
oil painting of the same subject.
The indeterminacy of this process
led Hamilton to experiment with six
variations. In version (a) the painting
underneath the screenprint is the most
developed and self-sufficient of the
series. In the others he experimented
with various media, techniques and
effects, such as airbrushing, replacing
oils with enamel or acrylic, and
increasing or reducing contrast or
light and shade.

Jean Luc GODARD
One Plus One
1968
35mm film, 99 min., colour, sound
top, Keith Richard rehearsing with the Rolling Stones
below, Junkyard scene

Approached by the English producer Eleni Collard in 1968 to make a film in London, Godard originally devised a narrative scheme in which a French girl, named Eve Democracy, is seduced by a neo-fascist white Texan, then falls in love with an extreme-left Black militant. The ensuing conflicts would be framed by parallel themes of 'creation', reflected by the Rolling Stones rehearsing in their studio, and 'destruction': Eve's suicide. The more developed structure of the final film analyses the relationships between democracy and revolution, art and exploitation, rhetoric and the power of the media. Intercut with documentary-style sequences, it comprises three fictional episodes. In the first, set in a car junkyard, militants based on the Black Panthers read aloud texts, largely from Eldridge Cleaver's novel *Soul on Ice* (1968) in which he attacked white bourgeois values, in particular the appropriation and exploitation of black music. In the second, Eve Democracy is interviewed by the media in a woodland area, only permitted to answer yes or no to questions about freedom and revolution. In the third, a pornographic magazine shop is the setting for a symbolic portrayal of links between fascism and forms of visual representation. These scenes are intercut with Eve writing graffiti and the Rolling Stones rehearsing the song 'Sympathy for the Devil' in their studio. In the original cut, the final performance of the song fades out midway and the screen also fades to black: the revolution remains unfinished. For commercial reasons, the distributors added the full recording. When this version of the film premiered at the London Film Festival in November 1968 Godard attacked the producer and asked the audience to demand their money back.

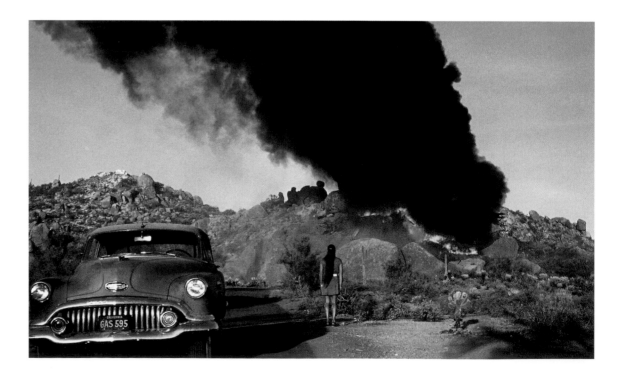

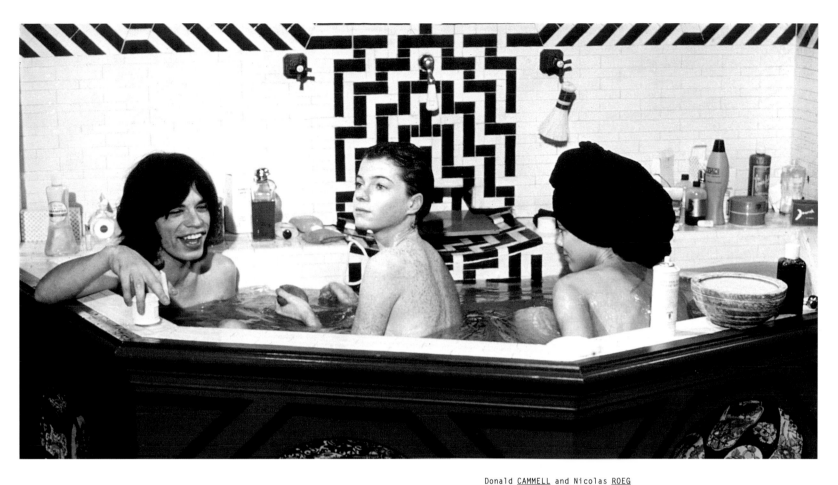

Donald CAMMELL and Nicolas ROEG
Performance
1968-69
35mm film, 96 min., colour, sound
With James Fox, Mick Jagger, Anita Pallenberg
Filmed in 1968 but not released until 1970, *Performance* brought two underworlds of 1960s London into collision. The narrative is divided into two distinct parts: an exposé of the ultraviolent gangland of London's East End, followed by the drug-fuelled counter-culture of 1960s bohemia. The main character, Chas Devlin (played by James Fox), is forced into hiding after his violent lifestyle becomes threatening. In order to escape certain peril, he must change his identity and seek refuge in a Notting Hill apartment owned by an effete rock star, Turner (played by Jagger). With Nicolas Roeg's careful editing and camera techniques, the film dissolves into a coloured tableau infused with sex and drugs, an evocation of the characters' intoxicated states. Throughout the film, Chas is continually confronted with the question of his own identity and a notion that he is always performing. Turner faces the same questions and the film eludes a definite resolution, choosing instead role reversals between the two, making each the other's doppelgänger.

opposite
Michelangelo ANTONIONI
Zabriskie Point
1969
35mm film, 110 min., colour, sound
Ironically funded by MGM studios who wished to cash in on counter-cultural youth, *Zabriskie Point* metaphorically portrayed late 1960s America, and by extension advanced industrial society, at war with itself. A white male student involved in college campus protests in Los Angeles buys a gun and fires in retaliation at the police when he sees a black student being shot. To escape capture he steals a small plane and flies to Death Valley, where he encounters another lone figure: a young woman driving around the desert in a 1950s car. From the outpost Zabriskie Point they venture to the heart of the desert, consummating their relationship in a hallucinatory, mirage-like scene, surrounded by scores of other similar couples. They paint the plane with psychedelic patterns and slogans and he flies back to LA. She returns to her employer, a property tycoon with a 'model home' overlooking the desert, who intends to build over the indigenous peoples' land. When she hears that the student was shot dead by police as he landed, she gazes towards the clifftop building and vengefully imagines it exploding in flames. The explosion is repeated again and again, first as a distant shot of the structure igniting, then moving in closer and closer to the details of shattered mass-produced items floating in the sky, accompanied by a Pink Floyd soundtrack. This climactic scene has become emblematic of anti-consumerism.

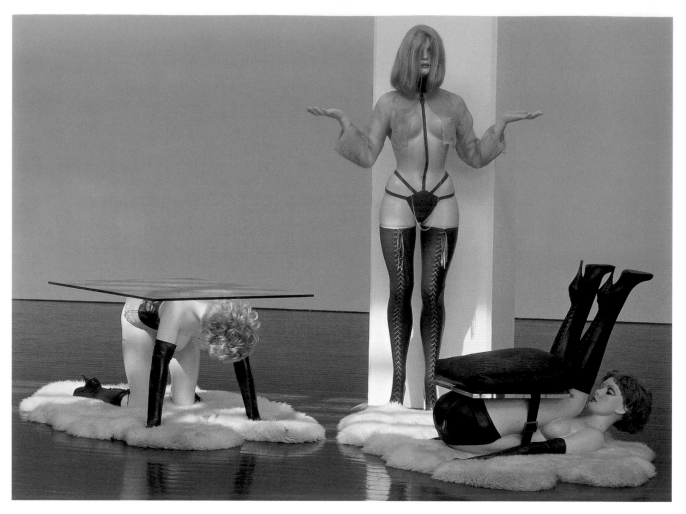

Allen JONES
Table, Hat Stand and Chair
1969
Painted fibreglass, metal, glass, leather, hair, synthetic fibre rugs
Table, 61 x 145 x 84 cm [24 x 57 x 33 in], Hat Stand, 185 x 107 x 30 cm
[73 x 42 x 12 in], Chair, 84 x 108 x 84 cm [33 x 42.5 x 33 in]
Collection, Ludwig Forum, Aachen

This ensemble of three slightly larger than lifesize figures, produced in an edition
of six, extended into three-dimensional forms the stylized and fetishistic portrayal
of women that was a principal subject in Jones's painting since the mid 1960s.
These sculptures of female figures in servile and abject positions (albeit laced with
a counter-inference of dominatrix-like irony) coincided with the rise of the second
wave of feminism in the late 1960s, engendering much debate and critique.
In subsequent statements and interviews Jones differentiated between condemning
the sculptures themselves and viewing them as a catalyst for debates about political
issues. His concern was to investigate forms of representation. One of the sources
for the imagery in these works is Roger Vadim's science fiction film *Barbarella* (1968),
an adaptation of a French S&M comic strip, in which the semi-naked Jane Fonda
inhabits futuristic environments of inflatable plastic and fur.

Duane HANSON
Riot [Policeman and Rioter]
1967
Painted fibreglass
Lifesize

The arrival of Hanson's highly realistic figure sculptures in the late 1960s aligned
him in the view of art commentators with the Photorealist painters who emerged
out of Pop during the early 1970s. As that decade progressed Hanson focused on
a meticulous, illusionistic portrayal of vernacular American scenes: the tourist
in a museum or the working woman pushing her supermarket trolley. The political
undercurrent is less immediately visible in these than in his earlier works such as
Riot (Policeman and Rioter) and *Bowery Derelicts* (1969). Hanson's deceptive realism
was achieved by departing from accepted sculptural materials and aesthetics.
The sculptures are made of synthetic substances such as fibreglass or polyvinyl
acetate and emulate the truth-to-life of figures in a waxworks museum.

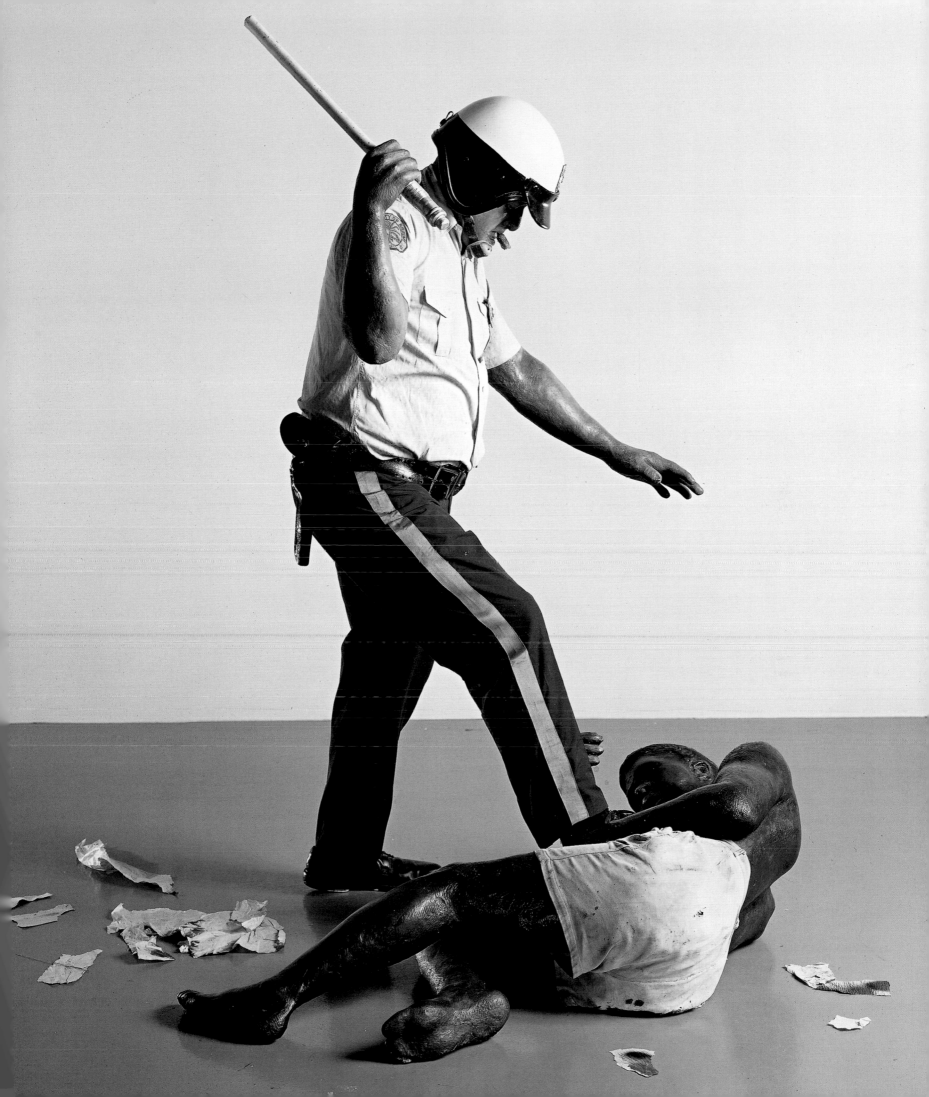

DOCU-MENTS

LAWRENCE ALLOWAY
KENNETH ANGER
ARCHIGRAM
DORE ASHTON
REYNER BANHAM
ROLAND BARTHES
GREGORY BATTCOCK
JEAN BAUDRILLARD
MARCEL BROODTHAERS
BENJAMIN H.D. BUCHLOH
JOHN CAGE
NIK COHN
JOHN COPLANS
ARTHUR C. DANTO
GUY DEBORD
BOB DYLAN
UMBERTO ECO
ÖYVIND FAHLSTRÖM
ALAN FLETCHER
MICHAEL FRIED
HENRY GELDZAHLER
ALLEN GINSBERG
JEAN-LUC GODARD
DAN GRAHAM
THOM GUNN

RICHARD HAMILTON
HANS HOLLEIN
ANDREAS HUYSSEN
ROBERT INDIANA
JASPER JOHNS
ELLEN H. JOHNSON
JILL JOHNSTON
DONALD JUDD
MIKE KELLEY
BILLY KLÜVER
HILTON KRAMER
STANLEY KUNITZ
JOHN LENNON
ROY LICHTENSTEIN
KONRAD LUEG
IAN MACDONALD
PAUL MCCARTNEY
JOHN MCHALE
MARSHALL MCLUHAN
GREIL MARCUS
JONAS MEKAS
LAURA MULVEY
BRIAN O'DOHERTY
FRANK O'HARA
CLAES OLDENBURG

CARL PERKINS
CEDRIC PRICE
PIERRE RESTANY
GERHARD RICHTER
ROBERT ROSENBLUM
JAMES ROSENQUIST
ED RUSCHA
PETER SELZ
JACK SMITH
ALISON & PETER
SMITHSON
SUSAN SONTAG
LEO STEINBERG
G.R. SWENSON
HUNTER S. THOMPSON
ROBERT VENTURI
ANDY WARHOL
TOM WESSELMANN
TOM WOLFE

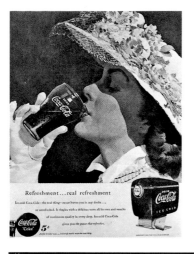

1. [see page 193]
Coca-Cola advertisement
c. 1940s
reproduced in Marshall
McLuhan, *The Mechanical
Bride: Folklore of
Industrial Man* [New
York: Vanguard Press,
1951]

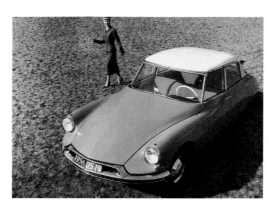

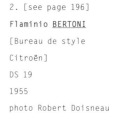

2. [see page 196]
Flaminio BERTONI
[Bureau de style
Citroën]
DS 19
1955
photo Robert Doisneau

3. [see page 201]
Kenneth ANGER
Hollywood Babylone,
cover
[Paris: J.J. Pauvert,
1959]

4. [see page 206]
Robert RAUSCHENBERG
Coca-Cola Plan
1958
Combine painting
68 × 64 × 12 cm
[26.5 × 25 × 5 in]
The Museum of
Contemporary Art, Los
Angeles

5. [see page 217]
Eugene ATGET
Boulevard de Strasbourg,
Corsets, Paris
1912
Albumen print
22.5 × 18 cm [9 × 7 in]

6. [see page 217]
Joseph CORNELL
Untitled [Penny Arcade
Portrait of Lauren
Bacall]
1945–46
Box construction
52 × 36 × 14 cm
[16 × 14 × 6 in]

7. [see page 217]
Walker EVANS
Times Square, New York,
USA
1930
The Metropolitan Museum
of Art, New York

8. [see page 225]
Claes OLDENBURG
Floor Cake
1962
Synthetic polymer paint
and latex on canvas
filled with foam rubber
and cardboard boxes
148 × 290 × 148 cm
[58.5 × 114 × 58.5 in]
The Museum of Modern
Art, New York

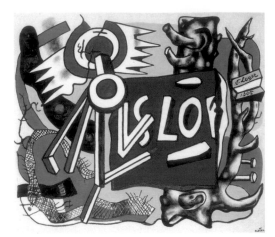

9. [see page 238]
Fernand LÉGER
Le Tronc d'Arbre sur
Fond Jaune
[Treetrunk on Yellow]
1945
Oil on canvas
112 × 127 cm
[44 × 50 in]
National Gallery of
Scotland,Edinburgh

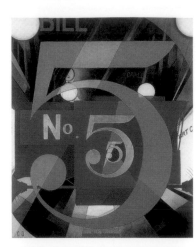

10. [see page 238]
Charles DEMUTH
The Figure 5 in Gold
[Homage to William
Carlos Williams]
1928
Oil on cardboard
90 × 76 cm
[30 × 35.5 in]
The Metropolitan Museum
of Art, New York

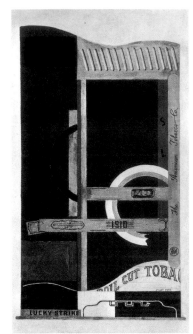

11. [see page 238]
Stuart DAVIS
Lucky Strike
1921
Oil on canvas
84.5 × 45.5 cm
[33 × 18 in]
The Museum of Modern
Art, New York

12. [see page 244]
Piero MANZONI
Merda d'artista
[Artist's Shit]
1961
Can, paper label,
artist's faeces
h. 5 cm [2 in]
ø 6.5 cm [2.5 in]

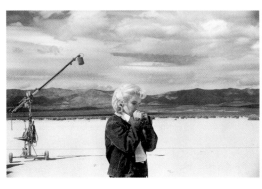

13. [see page 246]
Eve ARNOLD
Marilyn prepares by
herself for the
important sequences at
the end of the film The
Misfits
1961
Black and white
photograph

14. [see page 250]
Jack SMITH
Untitled [Mario Montez]
c. 1964
Solarized photograph
24 × 19 cm
[9.5 × 7.5 in]
The Plaster Foundation,
New York

15. [see page 281]
Stanley KUBRICK
2001: A Space Odyssey
1968
film still

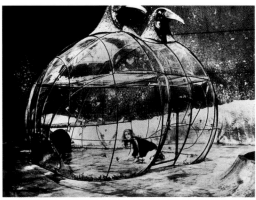

16. [see page 281]
Roger VADIM
Barbarella
1968
film still

REVOLT INTO STYLE

The earliest analyses of post-war popular culture, by Reyner Banham and Roland Barthes, were published in Europe, as were the first books by the photographer Robert Frank, *The Americans*, and the filmmaker Kenneth Anger, *Hollywood Babylon*, both in Paris. In America, other than Jack Kerouac, it was the poets Allen Ginsberg, Thom Gunn (a recent arrival from England) and Frank O'Hara who initially paid literary homage to the signs of change and upheaval in modern life. At first there seemed to be no language, and no context, to discuss the work of the artists who were to draw on the vast resources of design, advertising or movies, and it was not until considerably after the fact that serious academic attention was paid to the complex interactions between these fields.

Marshall McLUHAN
The Mechanical Bride [1951]

1. Coca-Cola advertisement

COKES AND CHEESECAKE

In *God is My Co-pilot*, the GIs agreed that what they were fighting for was, after all, the American girl. To us, they said, she meant cokes, hamburgers and clean places to sleep. Now, the American girl as portrayed by the coke ads has always been an archetype. No matter how much thigh she may be demurely sporting, she is sweet, nonsexual, and immaturely innocent. Her flesh is firm and full, but she is as pure as a soap bubble. She is clean *and* fun-loving.

In short, she is a cluster-symbol which embraces at one extreme Abe Lincoln's 'All that I am and all that I hope to be I owe to my darling mother', and, at the other, Ziegfield's dream of the glorified American girl as a group of tall, cold, glittering, mechanical dolls. The gyrations and patterns assumed by these dolls in a revue is intended to convey, if not the Beatific Vision, at least a Jacob's ladder of angelic hierarchies linking earth and heaven. We are pictorially encouraged to meet and mingle with these divine creatures in a sort of waking sleep, in which the male is not emotionally committed and in which the innocence of the doll is as renewable as a subscription to *The American Home*.

Coke ads concentrate on the 'good girl' image as opposed to the dominant 'bad girl' of popular entertainment — though there has been some recent tendency in Hollywood to blend the two types. The 'good girl' is the nineteenth-century stock model which has long been merged with the mother image. So Margaret Mead's observations in *Male and Female* are especially relevant to understanding the success of coke ads. It is, she suggests, a result of our child-feeding habits that 'Mouths are not a way of being with someone, but rather a way of meeting an impersonal environment. Mother is there to put things — bottles, spoons, crackers, teethers — into your mouth'. And so, she adds, the American GI abroad puzzled foreigners by endless insistence on having something in his mouth most of the time. Gum, candy, cokes.

Apparently, this has proved to be good advertising for Coca-Cola. The coke has become a kind of rabbit's foot, as it were, for the foreigner. And *Time*'s cover (15 May 1950) pictures the globe sucking a coke. Love that coke, love that American way of life. Robert Winship Woodruff, coke executive, says, 'We're playing the world long.' That would seem to be a very small gamble, with the globe itself becoming a coke sucker [...]

Cokes as a soft drink naturally started out to appeal to the soft emotions. The wholesome harmlessness of the drink is insisted upon most succesfully by the wholesome girls and situations which envelop the drink. These, in turn, have become linked to the entire range of home-mother-hygiene patterns which embrace a wide range of basic thoughts and feelings. So that it would be hard to suggest a more central item of current folklore, or one more subtly geared to evoke and release the emotions of practical life today [...]

[Herbert] Marshall McLuhan, *The Mechanical Bride: Folklore of Industrial Man* [New York: Vanguard Press, 1951; first British edition, London: Routledge & Kegan Paul, 1967] 118-20.

Reyner BANHAM
Vehicles of Desire [1955]

The new brutalists, pace-makers and phrase-makers of the anti-academic line-up, having delivered a smart KO to the Land Rover some months back, have now followed it with a pop-eyed OK for the Cadillac convertible and automobile aesthetics are back on the table for the first time since the twenties. The next time an open Caddy wambles past you, its front chrome-hung like a pearl-roped dowager, its long top level with the ground at a steady thirty inches save where the two tailfins cock up to carry the rear lights, reflect what a change has been wrought since the last time any architect expressed himself forcibly on the subject of the automobile.

That was in the twenties when Le Corbusier confronted the Parthenon and the Bignan-Sport, and from then to the new brutalists the Greek Doric motor car with its upright lines, square styling, mahogany fascia and yellowing nickel trim has remained the *beau ideal* of world aesthetes from Chicago to Chelsea Polytechnic. So great has been the aesthetic self-aggrandizement of architects, so great the public's Ruskin-powered terror of them, that when Le Corbusier spoke, no-one dared to argue, and it has been placidly assumed ever since that all artefacts should be

designed architect-wise, and that later automobiles which deviated from the Doric norm of the twenties were badly designed. But what nonsense this is. Far from being *uomini universali*, architects are by training, aesthetics and psychological predisposition narrowly committed to the design of big, permanent single structures, and their efforts are directed merely to focusing big, permanent human values on unrepeatable works of unique art.

The automobile is not big – few are even mantelpiece high – it is not permanent – the average world scrapping period has lately risen, repeat risen, to fifteen years – and they certainly are not unique. The effective time-base against which the impermanence of the automobile should be reckoned is less than even fifteen years, because the average resale period – the measure of social obsolescence – is only three to six years, while technical obsolescence is already acute after eight to ten years. And as to uniqueness, even relatively unpopular cars have a bigger annual output than all but the most sought-after, prefabricated, serially produced buildings. This is a field where the architect is rarely qualified to work or to pass judgment, and automobiles designed by architects are notoriously old-fashioned, even where – like Walter Gropius' Adler coupés – they introduce marginal novelties such as reclining seats.

The technical history of the automobile in a free market is a rugged rat-race of detail modifications and improvements, many of them irrelevant, but any of the essential ones lethal enough to kill off a manufacturer who misses it by more than a couple of years. The 'classic' automobiles whose 'timeless' qualities are admired by aesthetes are nowadays the product of abnormal sales conditions – the slump-crazy market on which Citroën's *traction-avant* was launched was as freakish as the commercially and ideologically protected one on which Dr Porsche launched the Volkswagen. On the open market, where competition is real, it is the cunningly programmed minor changes that give one manufacturer an edge over another, and the aesthetics of body styling are an integral part of the battle for margins. Under these circumstances we should be neither surprised nor shocked to find that styling runs the same way as engineering development, and in any case there can be no norms of formal composition while the automobile remains an artefact in evolution, even though particular models are stabilized.

In fact it is a great deal more than an artefact in evolution as a concept while standardized in any passing type; it is also numerous as a possession while expendable as an individual example, a vehicle of popular desire and a dream that money can just about buy. This is a situation with which no pre-industrial aesthetic ever had to cope; even Plato's side-swipe at the ceramic trade in the *Philebus* falls a long way short of our current interpretative needs, for the Greek pot, though numerous and standardized, had long given up evolving and was not conspicuously expendable. But we are still making do with Plato because in aesthetics, as in most other things, we still have no formulated intellectual attitudes for living in a throw-away economy. We eagerly consume noisy ephemeridae, here with a bang today, gone without a whimper tomorrow – movies, beachwear, pulp magazines, this morning's

headlines and tomorrow's TV programmes – yet we insist on aesthetic and moral standards hitched to permanency, durability and perennity.

The repertoire of hooded headlamps, bumper-bombs, sporty nave-plates, ventilators, intakes, incipient tailfins, speed-streaks and chromium spears, protruding exhaust pipes, cineramic windscreens – these give tone and social connotation to the body envelope; the profiling of wheel-arches, the humping of mudguards, the angling of roof-posts – these control the sense of speed; the grouping of the main masses, the quality of the main curves of the panels – these balance the sense of masculine power and feminine luxury. It is a thick ripe stream of loaded symbols – that are apt to go off in the face of those who don't know how to handle them.

The stylist knows how, because he is continually sampling the public response to dream-car prototypes, fantasy vehicles like Ford's fabulous Futura, but other people must be more careful. As the New York magazine *Industrial Design* said, when reviewing the 1954 cars, 'The most successful company in the history of the world makes automobiles; in 1953 General Motors' sales totalled $10,028,000,000, an unheard of sum. Under the circumstances, passing judgement on a new crop of cars is like passing judgement on a nation's soul.'

But coupled with this admirable caution, *Industrial Design* also possesses a shame-faced, but invaluable, ability to write automobile-critique of almost Berensonian sensibility. In its pages, fenced about with routine kow-tows to the big permanent values, one will find passages like 'the Buick ... is perpetually floating on currents that are permanently built into the design. The designers put the greatest weight over the front wheels, where the engine is, which is natural enough. The heavy bumper helps to pull the weight forward; the dip in the body and the chrome spear express how the thrust is dissipated in turbulence towards the rear. Just behind the strong shoulder of the car a sturdy post lifts up the roof, which trails off like a banner in the air. The driver sits in the dead calm at the centre of all this motion – hers is a lush situation.'

This is the stuff of which the aesthetics of expendability will eventually be made. It carries the sense and the dynamism of that extraordinary continuum of emotional-engineering-by-public-consent which enables the automobile industry to create vehicles of palpably fulfilled desire. Can architecture or any other twentieth-century art claim to have done as much? And, if not, have they any real right to carp?

All right then, *hypocrite lecteur*, where are you now with the automobile? As an expendable, replaceable vehicle of popular desires, it clearly belongs with the other dreams that money can buy, with *Galaxy*, *The Seven-Year Itch*, *Rock, Rattle 'n' Roll* and *Midweek Reveille*, the world of expendable art so brilliantly characterized by Leslie Fiedler in the August issue of *Encounter*. The motor car is not as expendable as they are, but it clearly belongs nearer to them than to the Parthenon, and it exhibits the same creative thumbprints – finish, fantasy, punch, professionalism, swagger. A good job of body styling should come across like a good musical – no fussing after big, timeless abstract virtues, but maximum glitter and

maximum impact.

The top body stylists – they are the anonymous heads of anonymous teams – aim to give their creations qualities of apparent speed, power, brutalism, luxury, snob-appeal, exoticism and plain common-or-garden sex. The means at their disposal are symbolic iconographies, whose ultimate power lies in their firm grounding in popular taste and the innate traditions of the product, while the actual symbols are drawn from science fiction, movies, earth-moving equipment, supersonic aircraft, racing cars, heraldry and certain deep-seated mental dispositions about the great outdoors and the kinship between technology and sex. Arbiter and interpreter between the industry and the consumer, the body stylist deploys, not a farrago of meaningless ornament, as fine-art critics insist, but a means of saying something of breathless – but unverbalizable – consequence to the live culture of the Technological Century.

Reyner Banham, 'Vehicles of Desire', *Art*, 1 [London, 1 September 1955, 3; reprinted in Mary Banham, et al., eds, *A Critic Writes: Essays by Reyner Banham*, Berkeley and Los Angeles: University of California Press, 1997] 3-6.

Alison and Peter SMITHSON
But Today We Collect Ads
[1956]

Traditionally the fine arts depend on the popular arts for their vitality, and the popular arts depend on the fine arts for their respectability. It has been said that things hardly 'exist' before the fine artist has made use of them, they are simply part of the unclassified background material against which we pass our lives. The transformation from everyday object to fine art manifestation happens in many ways; the object can be discovered – *objet trouvé* or *l'art brut* – the object itself remaining the same; a literary or folk myth can arise and again the object itself remains unchanged; or, the object can be used as a jumping-off point and is itself transformed.

Le Corbusier in Volume 1 of his *Oeuvre Complète* describes how the 'architectural mechanism' of the Maison Citrohan (1920) evolved. Two popular art devices – the arrangement of a small zinc bar at the rear, with a large window to the street, of the café, and the close vertical patent-glazing of the suburban factory were combined and transformed into a fine art aesthetic. The same architectural mechanism produced ultimately the Unité d'Habitation.

The Unité d'Habitation demonstrates the complexity of an art manifestation, for its genesis involves: popular art stimuli, historic art seen as a pattern for social organization, not as a stylistic source (observed at the Chartreuse D'Ema 1907), and ideas of social reform and technical revolution patiently worked out over forty years, during which time the social and technological set up, partly as a result of his own activities, met Le Corbusier half-way.

Why certain folk art objects, historical styles or industrial artefacts and methods become important at a particular moment cannot easily be explained.

Gropius wrote a book on grain silos,
Le Corbusier one on aeroplanes,
And Charlotte Perriand brought a new object to the office every morning;
But today we collect ads.

Advertising has caused a revolution in the popular art field. Advertising has become respectable in its own right and is beating the fine arts at their old game. We cannot ignore the fact that one of the traditional functions of fine art, the definition of what is fine and desirable for the ruling class and therefore ultimately that which is desired by all society, has now been taken over by the ad-man.

To understand the advertisements which appear in the *New Yorker* or *Gentry* one must have taken a course in Dublin literature, read a *Time* popularizing article on Cybernetics and to have majored in Higher Chinese Philosophy and Cosmetics. Such ads are packed with information – data of a way of life and a standard of living which they are simultaneously inventing and documenting. Ads which do not try to sell you the product except as a natural accessory of a way of life. They are good 'images' and their technical virtuosity is almost magical. Many have involved as much effort for one page as goes into the building of a coffee-bar. And this transient thing is making a bigger contribution to our visual climate than any of the traditional fine arts.

The fine artist is often unaware that his patron, or more often his patron's wife who leafs through the magazines, is living in a different visual world to his own. The pop-art of today, the equivalent of the Dutch fruit and flower arrangement, the pictures of second rank of all Renaissance schools, and the plates that first presented to the public the Wonder of the Machine Age and the New Territories, is to be found in today's glossies – bound up with the throw-away object.

As far as architecture is concerned the influence on mass standards and mass aspirations of advertising is now infinitely stronger than the pace setting of *avant-garde* architects, and it is taking over the functions of social reformers and politicians. Already the mass production industries have revolutionized half the house – kitchen, bathroom, utility room and garage – without the intervention of the architect, and the curtain wall and the modular prefabricated building are causing us to revise our attitude to the relationship between architect and industrial production.

By fine art standards the modular prefabricated building, which of its nature can only approximate to the ideal shape for which it is intended, must be a bad building. Yet generally speaking the schools and garages which have been built with systems or prefabrication lick the pants off the fine art architects operating in the same field. They are especially successful in their modesty. The ease with which they fit into the built hierarchy of a community.

By the same standards the curtain wall too cannot be successful. With this system the building is wrapped round with a screen whose dimensions are unrelated to its form and organization. But the best post-war office block in London is one which is virtually all curtain wall. As this building has no other quality apart from its curtain wall, how is it that it puts to shame other office buildings which have been elaborately worked over by respected architects and by the Royal Fine Arts Commission.

To the architects of the twenties 'Japan' was the Japanese house of prints and paintings, the house with its roof off, the plane bound together by thin black lines. (To quote Gropius, 'the whole country looks like one gigantic basic design course'.) In the thirties Japan meant gardens, the garden entering the house, the tokonoma.

For us it would be the objects on the beaches, the piece of paper blowing about the street, the throw-away object and the pop-package.

For today we collect ads.

Ordinary life is receiving powerful impulses from a new source. Where thirty years ago architects found in the field of the popular arts, techniques and formal stimuli, today we are being edged out of our traditional role by the new phenomenon of the popular arts – advertising.

Mass production advertising is establishing our whole pattern of life – principles, morals, aims, inspirations, and standard of living. We must somehow get the measure of this intervention if we are to match its powerful and exciting impulses with our own.

Alison and Peter Smithson, 'But Today We Collect Ads', *Ark*, 18 [London, November 1956, 49–50; reprinted in Stephen Henry Madoff, ed., *Pop Art: A Critical History*, London and Berkeley: University of California Press, 1997] 3–4.

Allen **GINSBERG**
Howl [1955–56]

I saw the best minds of my generation destroyed by madness, starving hysterical naked,

dragging themselves through the negro streets at dawn looking for an angry fix,

angelheaded hipsters burning for the ancient heavenly connection to the starry dynamo in the machinery of night,

who poverty and tatters and hollow-eyed and high sat up smoking in the supernatural darkness of cold-water flats floating across the tops of cities contemplating jazz [...]

who chained themselves to subways for the endless ride from Battery to holy Bronx on benzedrine until the noise of wheels and children brought them down shuddering mouth-wracked and battered bleak of brain all drained of brilliance in the drear light of Zoo,

who sank all night in submarine light of Bickford's floated out and sat through the stale beer afternoon in desolate Fugazzi's, listening to the crack of doom on the hydrogen jukebox,

who talked continuously seventy hours from park to pad to bar to Bellevue to museum to the Brooklyn Bridge,

a lost battalion of platonic conversationalists jumping down the stoops off fire escapes off windowsills off Empire State out of the moon,

yacketayakking screaming vomiting whispering facts and memories and anecdotes and eyeball kicks and shocks of hospitals and jails and wars [...]

Allen Ginsberg, *Howl* [San Francisco: City Lights, 1956] 9-11.

Carl **PERKINS**
Blue Suede Shoes [1956]

You can burn my house, you can steal my car
Drink my liquor from an old fruit jar
Do anything that you wanna do
But uh uh, honey, lay off of my shoes
But don't you step on my blue suede shoes
Well you can do anything
But lay off of my blue suede shoes [...]

Carl Perkins, *Blue Suede Shoes*, 1956.

Frank **O'HARA**
A Step Away from Them [1956]

It's my lunch hour, so I go
for a walk among the hum-coloured
cabs. First, down the sidewalk
where labourers feed their dirty
glistening torsos sandwiches
and Coca-Cola, with yellow helmets
on. They protect them from falling
bricks, I guess. Then on to the
avenue where skirts are flipping
above heels and blow up over
grates. The sun is hot, but the
cabs stir up in the air. I look
at bargains in wristwatches. There
are cats playing in sawdust.

On
to Times Square, where the sign
blows smoke over my head, and higher
the waterfall pours lightly. A
Negro stands in a doorway with a
toothpick, languorously agitating.
A blonde chorus girl clicks: he
smiles and rubs his chin. Everything
suddenly honks: it is 12:40 of
a Thursday.

Neon in daylight is a
great pleasure, as Edwin Denby would

write, as are light bulbs in daylight.
I stop for a cheeseburger at Juliet's
Corner. Giulietta Masina, wife of
Federico Fellini, è bell' attrice.
And chocolate malted. A lady in
foxes on such a day puts her poodle
in a cab.

There are several Puerto
Ricans on the avenue today, which
makes it beautiful and warm. First
Bunny died, then John Latouche,
then Jackson Pollock. But is the
earth as full as life was full, of them?
And one has eaten and one walks,
past the magazines with nudes
and the posters for Bullfight and
the Manhattan Storage Warehouse,
which they'll soon tear down. I
used to think they had the Armory
Show there.

A glass of papaya juice
and back to work. My heart is in my
pocket, it is Poems by Pierre Reverdy.

Frank O'Hara, 'A Step Away From Them', 16 August 1956.
First published in *Evergreen Review*, 1:3 [New York, 1957;
reprinted in *The Collected Poems of Frank O'Hara*, ed.
Donald Allen, New York: Alfred A. Knopf, 1971] 257-8.

Roland BARTHES
The New Citroën [1957]

I think that cars today are almost the exact equivalent of
the great Gothic cathedrals: I mean the supreme creation
of an era, conceived with passion by unknown artists, and
consumed in image if not in usage by a whole population
which appropriates them as a purely magical object.

It is obvious that the new Citroën has fallen from the
sky in as much as it appears at first sight as a superlative
object. We must not forget that an object is the best
messenger of a world above that of nature: one can easily
see in an object at once a perfection and an absence of
origin, a closure and a brilliance, a transformation of life
into matter (matter is much more magical than life), and in
a word a *silence* which belongs to the realm of fairy tales.
The *D.S.* – the 'Goddess' – has all the features (or at least
the public is unanimous in attributing them to it at first
sight) of one of those objects from another universe which
have supplied fuel for the neomania of the eighteenth
century and that of our own science-fiction: the *Déesse* is
first and foremost a new *Nautilus*.

This is why it excites interest less by its substance
than by the junction of its components. It is well known
that smoothness is always an attribute of perfection
because its opposite reveals a technical and typically
human operation of assembling: Christ's robe was
seamless, just as the airships of science-fiction are made
of unbroken metal. The *D.S.* 19 has no pretensions about

being as smooth as cake icing, although its general shape
is very rounded; yet it is the dovetailing of its sections
which interest the public most: one keenly fingers the
edges of the windows, one feels along the wide rubber
grooves which link the back window to its metal surround.
There are in the *D.S.* the beginnings of a new
phenomenology of assembling, as if one progressed from
a world where elements are welded to a world where they
are juxtaposed and hold together by sole virtue of their
wondrous shape, which of course is meant to prepare one
for the idea of a more benign Nature.

As for the material itself, it is certain that it promotes a
taste for lightness in its magical sense. There is a return to
a certain degree of streamlining, new, however, since it is
less bulky, less incisive, more relaxed than that which one
found in the first period of this fashion. Speed here is
expressed by less aggressive, less athletic signs, as if it
were evolving from a primitive to a classical form. This
spiritualization can be seen in the extent, the quality and
the material of the glass-work. The *Déesse* is obviously the
exaltation of glass, and pressed metal is only a support for
it. Here, the glass surfaces are not windows, openings
pierced in a dark shell; they are vast walls of air and space,
with the curvature, the spread and the brilliance of soap-
bubbles, the hard thinness of a substance more
entomological than mineral (the Citroën emblem, with its
arrows, has in fact become a winged emblem, as if one was
proceeding from the category of propulsion to that of
spontaneous motion, from that of the engine to that of the
organism).

We are therefore dealing here with a humanized art,
and it is possible that the *Déesse* marks a change in the
mythology of cars. Until now, the ultimate in cars belonged
rather to the bestiary of power; here it becomes at once
more spiritual and more object-like, and despite some
concession to neomania (such as the empty steering
wheel), it is now more *homely*, more attuned to this
sublimation of the utensil which one also finds in the
design of contemporary household equipment. The
dashboard looks more like the working surface of a
modern kitchen than the control-room of a factory: the
slim panes of matt fluted metal, the small levers topped by
a white ball, the very simple dials, the very discreteness of
the nickel-work, all this signifies a kind of control exercised
over motion, which is henceforth conceived as comfort
rather than performance. One is obviously turning from an
alchemy of speed to a relish in driving.

The public, it seems, had admirably divined the
novelty of the themes which are suggested to it.
Responding at first to the neologism (a whole publicity
campaign had kept it on the alert for years), it tries very
quickly to fall back on a behaviour which indicates
adjustment and a readiness to use ('*You've got to get used
to it*'). In the exhibition halls, the car on show is explored
with an intense, amorous studiousness: it is the great
tactile phase of discovery, the moment when visual
wonder is about to receive the reasoned assault of touch
(for touch is the most demystifying of all senses, unlike
sight, which is the most magical). The bodywork, the lines
of union are touched, the upholstery palpated, the seats
tried, the doors caressed, the cushions fondled; before the

wheel, one pretends to drive with one's whole body. The
object here is totally prostituted, appropriated: originating
from the heaven of *Metropolis*, the Goddess is in a quarter
of an hour mediatized, actualizing through this exorcism
the very essence of petit-bourgeois advancement.

Roland Barthes, 'La Nouvelle Citroën', *Mythologies* [Paris:
Éditions du Seuil, 1957; trans. Annette Lavers, London:
Jonathan Cape/New York: Hill & Wang, 1972] 88-90.

Roland BARTHES
Plastic [1957]

Despite having names of Greek shepherds (Polystyrene,
Polyvinyl, Polyethylene), plastic, the products of which
have just been gathered in an exhibition, is in essence the
stuff of alchemy. At the entrance of the stand, the public
waits in a long queue in order to witness the accomplish-
ment of the magical operation par excellence: the
transmutation of matter. An ideally-shaped machine,
tubulated and oblong (a shape well suited to suggest the
secret of an itinerary) effortlessly draws, out of a heap of
greenish crystals, shiny and fluted dressing-room tidies.
At one end, raw, telluric matter, at the other, the finished,
human object; and between these two extremes, nothing;
nothing but a transit, hardly watched over by an attendant
in a cloth cap, half-god, half-robot.

So, more than a substance, plastic is the very idea of
its infinite transformation; as its everyday name indicates,
it is ubiquity made visible. And it is this, in fact, which
makes it a miraculous substance: a miracle is always a
sudden transformation of nature. Plastic remains
impregnated throughout with this wonder: it is less a thing
than the trace of a movement.

And as the movement here is almost infinite,
transforming the original crystals into a multitude of more
and more startling objects, plastic is, all told, a spectacle to
be deciphered: the very spectacle of its end-products. At
the sight of each terminal form (suitcase, brush, car-body,
toy, fabric, tube, basin or paper), the mind does not cease
from considering the original matter as an enigma. This is
because the quick-change artistry of plastic is absolute: it
can become buckets as well as jewels. Hence a perpetual
amazement, the reverie of man at the sight of the
proliferating forms of matter, and the connections he
detects between the singular of the origin and the plural of
the effects. And this amazement is a pleasurable one,
since the scope of the transformations gives man the
measure of his power, and since the very itinerary of plastic
gives him the euphoria of a prestigious free-wheeling
through Nature.

But the price to be paid for this success is that plastic,
sublimated as movement, hardly exists as substance. Its
reality is a negative one: neither hard nor deep, it must be
content with a 'substantial' attribute which is neutral in
spite of its utilitarian advantages: *resistance*, a state which
merely means an absence of yielding. In the hierarchy of
the major poetic substances, it figures as a disgraced
material, lost between the effusiveness of rubber and the
flat hardness of metal; it embodies none of the genuine

|2. Flaminio Bertoni

produce of the mineral world: foam, fibres, strata. It is a 'shaped' substance: whatever its final state, plastic keeps a flocculent appearance, something opaque, creamy and curdled, something powerless ever to achieve the triumphant smoothness of Nature. But what best reveals it for what it is is the sound it gives, at once hollow and flat; its noise is its undoing, as are its colours, for it seems capable of retaining only the most chemical-looking ones. Of yellow, red and green, it keeps only the aggressive quality, and uses them as mere names, being able to display only concepts of colours.

The fashion for plastic highlights an evolution in the myth of 'imitation' materials. It is well known that their use is historically bourgeois in origin (the first vestimentary *postiches* date back to the rise of capitalism). But until now imitation materials have always indicated pretension, they belonged to the world of appearances, not to that of actual use; they aimed at reproducing cheaply the rarest substances, diamonds, silk, feathers, furs, silver, all the luxurious brilliance of the world. Plastic has climbed down, it is a household material. It is the first magical substance which consents to be prosaic. But it is precisely because this prosaic character is a triumphant reason for its existence: for the first time, artifice aims at something common, not rare. And as an immediate consequence, the age-old function of nature is modified: it is no longer the Idea, the pure Substance to be regained or imitated: an artificial Matter, more bountiful than all the natural deposits, is about to replace her, and to determine the very invention of forms. A luxurious object is still of this earth, it still recalls, albeit in a precious mode, its mineral or animal origin, the natural theme of which it is but one actualization. Plastic is wholly swallowed up in the fact of being used: ultimately, objects will be invented for the sole pleasure of using them. The hierarchy of substances is abolished: a single one replaces them all: the whole world can be plasticized, and even life itself since, we are told, they are beginning to make plastic aortas.

Roland Barthes, 'Le plastique', *Mythologies* [Paris: Éditions du Seuil, 1957; trans. Annette Lavers, London: Jonathan Cape/New York: Hill & Wang, 1972] 97-99.

Alan FLETCHER
Letter from America [1957]

The impact of America on a visitor is partly tempered by his previous knowledge gained from the cinema, periodicals and hearsay. Of course I knew that American cars were big, but it never occurred to me that they were all big. Rapidly one has to readjust one's scale of values to the environment, and as an observer I find the most striking impressions are given by those things which require this readjustment most.

I am more aware of the potentialities of a brash aluminium diner (a static stratocruiser) than of Corbusier's sophisticated United Nations building. The former has the advantage of surprise, an unreality equal to meeting a man from Mars, whereas Corbusier's building is international. I was already acquainted with its language

before I even saw it.

My impressions then, centre on those aspects of everyday life accepted as normal by the Americans, but which appear to me unusual, extreme, and in some cases stimulating. In fact – Americana.

They say that dogs in New York walk faster than anywhere else in the States. At rush hour commuting New Yorkers drive out of Manhattan at sixty miles per hour, bumper to bumper, while the subway – reminiscent of the Paris Metro in appearance and smell – feeds harassed passengers out to Brooklyn and neighbouring suburbs. By day the streets of New York are a kaleidoscope of colour. The dazzling hues of automobiles form constantly changing and brilliant patterns within the rigid design of gridded streets and vertical buildings. The flat areas of pink, blue, chocolate and red are punctuated with the chequered square of taxis. Meccano-like neon structures rear against the sky, and the garish colours and tinsel of advertisements lie haphazardly across the faces of buildings.

By night the city is transformed. The skyscrapers blend into the night sky and glittering neons write across a drop of millions of twinkling lights. Many of the signs, seemingly suspended in the blackness above the sidewalk's glare, give a feeling of disbelief as the interweaving shapes and lines grow and then fade away into nothingness. The moving lights of Coca-Cola reflect from a waterfall which cascades down to the bright lit street and then silently disappears just above the sidewalk without a splash or drop of water.

Dream-cars, those mobile wonders of mechanical comfort, assuredly six years ahead of design say the manufacturers producing their 1957 models, have reached such an unprecedented length that the proud owner can no longer close his garage doors. Dressed in brilliant colours and girdled with chromium they are the gay deceivers of credit and instalment plans. An unkind truism, voiced by an American, explained that everyone thought chrome was silver! The automobile is king of the jungle, and the pedestrian, if not exactly the prey, must conform to a lesser role or meet a nasty end. Life literally centres on the wheel [...]

Alan Fletcher, 'Letter from America', *Ark*, 15 [Royal College of Art, London, 1957].

Thom GUNN
Elvis Presley [1957]

Two minutes long it pitches through some bar:
Unreeling from a corner box, the sigh
Of this one, in his gangling finery
And crawling sideburns, wielding a guitar

The limitations where he found success
Are ground on which he, panting, stretches out
In turn, promiscuously, by every note.
Our idiosyncrasy and our likeness.

We keep ourselves in touch with a mere dime:

Distorting hackneyed words in hackneyed songs
He turns revolt into a style, prolongs
The impulse to a habit of the time.

Whether he poses or is real, no cat
Bothers to say: the pose held is a stance,
Which, generation of the very chance
It wars on, may be posture for combat.

Thom Gunn, 'Elvis Presley', *The Sense of Movement* [London: Faber & Faber, 1957; reprinted in *Collected Poems*, London: Faber & Faber, 1993] 57.

Jean-Luc GODARD
Hollywood or Bust [1957]

According to Georges Sadoul, Frank Tashlin is a second-rank director because he has never done a remake of *You Can't Take It With You* or *The Awful Truth*. According to me, my colleague errs in mistaking a closed door for an open one. In fifteen years' time people will realize that *The Girl Can't Help It* served then – today, that is – as a fountain of youth from which the cinema now – in the future, that is – has drawn fresh inspiration.

As a matter of fact, the cinema is in any case too resolutely modern for there to be any question of it following any path other than an open one, a perpetual aesthetic inauguration. Its history differs all the more sharply from that of the theatre or the novel in that it is the exact opposite. Whereas literary experts nowadays praise a play or book only in so far as it conclusively seals all exits around it (cf. James Joyce's *Ulysses* or Samuel Becket's *Fin de Partie*), we on the other hand praise *To Catch a Thief*, *Eléna et les hommes*, *Voyage to Italy* or *Et Dieu ... créa la femme* because these films conclusively open new horizons. The moral: explain Frank Tashlin by Frank Tashlin.

Taught in a good school – Hollywood scriptwriting – he is no more frightened of mise-en-scène than Debbie Reynolds was scared by Dick Powell in *Susan Slept Here*. There is an excellent reason for this: before becoming a gagman in cartoons, Frank Tashlin was the author of a number of strips in various papers. A glance at 'Juliettte de mon coeur' in *France-Soir* is enough to tell you that the narrative technique in this strip is years in advance of most current French films. Within a scene, a change of shot is accomplished with a bold inventiveness which Laviron[1] would be well advised to get his IDHEC pupils to copy. This bold invention – at once incisive and nonchalant – is the trait which makes Tashlin like no one else, not even the latter-day Lubitsch, not even Cukor, since Tashlin would have no use for a Garson Kanin.[2]

All this is the more evident in *Hollywood or Bust* because it is a commercial chore, where a filmmaker worthy of the name has the right to betray his secrets quite shame-lessly. In this piece of slapstick, Tashlin takes Hollywood at its word. For word, read bust, or Anita Ekberg's bust as it happens. So *Hollywood or Bust* means those of Anita, or Shirley, or Dorothy, or Pat, or Jane,[3] as *Will Success Spoil Rock Hunter?* will shortly demonstrate again.

Hollywood or Bust is to *The Girl Can't Help It* as – making due allowance – [Molière's] *L'École des femmes* is to *Le Misanthrope*. Taking Howard Hawks' beloved theme of a journey, Tashlin indulges a riot of poetic fancies where charm and comic invention alternate in a constant felicity of expression. The plot is thin, certainly, but the merit is all the greater. To have turned Dean Martin into a comedian is feat enough to rate his director a place at the very top.

Louis Jouvet quotes somewhere this definition of the theatre by Alfred de Vigny: a thought which is metamorphosed into a mechanism. So Tashlin, a man of the cinema and of the cinema in colour, does the opposite of Vigny's dictum. The proof is Jerry Lewis' face, where the height of artifice blends at times with the nobility of true documentary.

To sum up, Frank Tashlin has not renovated the Hollywood comedy. He has done better. There is not a difference in degree between *Hollywood or Bust* and *It Happened One Night*, between *The Girl Can't Help It* and *Design for Living*, but a difference in kind. Tashlin, in other words, has not renewed but created. And henceforth, when you talk about a comedy, don't say 'It's Chaplinesque'; say, loud and clear, 'It's Tashlinesque'.

Translator's footnotes

1　Jean Laviron, a French director, Professor since 1944 at L'Institut des Hautes Études Cinématographiques, the film school in Paris.

2　Garson Kanin wrote several films for Cukor, but Godard is probably thinking in particular of the Judy Holliday-Jack Lemon comedy, *It Should Happen to You*.

3.　Shirley Maclaine, Dorothy Malone [*Artists and Models*], Pat Crowley [*Hollywood or Bust*], Jayne Mansfield [*Will Success Spoil Rock Hunter?*].

Jean-Luc Godard, 'Hollywood or Bust', *Cahiers du Cinéma*, 73 [Paris, July 1957; reprinted in *Godard on Godard*, trans. and ed. Tom Milne, New York: Da Capo Press, 1972; reissued with new foreword by Annette Michelson, 1986] 57-58.

Richard HAMILTON
Letter to Peter and Alison Smithson [1957]

Dear Peter and Alison,

I have been thinking about our conversation of the other evening and thought that it might be a good idea to get something on paper, as much to sort it out for myself as to put a point of view to you.

There have been a number of manifestations in the post-war years in London which I would select as important and which have a bearing on what I take to be an objective:

Parallel of Life and Art
(investigation into an imagery of general value)

Man, Machine and Motion
(investigation into a particular technological imagery)
Reyner Banham's research on automobile styling

Ad image research (Paolozzi, Smithson, McHale)
Independent Group discussion on Pop art – Fine art relationship
House of the Future
(conversion of Pop art attitudes in industrial design to scale of domestic architecture)

This is Tomorrow
Group 2 presentation of Pop art and perception material attempted impersonal treatment. Group 6 presentation of human needs in terms of a strong personal idiom.

Looking at this list it is clear that the Pop art / Technology background emerges as the important feature.

The disadvantage (as well as the great virtue) of the TIT show was its incoherence and obscurity of language.

My view is that another show should be as highly disciplined and unified in conception as this one was chaotic. Is it possible that the participants could relinquish their existing personal solutions and try to bring about some new formal conception complying with a strict, mutually agreed programme?

Suppose we were to start with the objective of providing a unique solution to the specific requirement of a domestic environment e.g. some kind of shelter, some kind of equipment, some kind of art. This solution could then be formulated and rated on the basis of compliance with a table of characteristics of Pop art.

Pop art is:
Popular (designed for a mass audience)
Transient (short-term solution)
Expendable (easily-forgotten)
Low cost
Mass produced
Young (aimed at youth)
Witty
Sexy
Gimmicky
Glamorous
Big business

This is just the beginning. Perhaps the first part of our task is the analysis of Pop art and the production of a table. I find I am not yet sure about the 'sincerity' of Pop art. It is not a characteristic of all but it is of some – at least, a pseudo-sincerity is. Maybe we have to subdivide Pop art into its various categories and decide into which category each of the subdivisions of our project fits. What do you think?

　Yours,
　Richard

Richard Hamilton, Letter to Peter and Alison Smithson, 16 January 1957; reprinted in Richard Hamilton, *Collected Words* [London: Thames & Hudson, 1982] 24.

Richard HAMILTON
Hommage à Chrysler Corp.
[1958]

The artwork on the opposite page [*Hommage à Chrysler Corp.*] is not a reproduction of an existing drawing. It was conceived and executed as a piece of 'artwork' in the sense in which the term is used by technical artists and process engravers when referring to drawings, made specifically for reproduction. I was asked to provide a drawing which could be reproduced by a line block: a greater tonal range than could be achieved with a line block seemed essential to the pictorial quality of the things I had been doing. The only way to get half tone was to build it into the drawing with ready-made material. I decided to put an existing painting into a form which a line block could assimilate by using drawn marks, pieces of blown up half tone prints, Plastitone and mechanical tints applied by the process engraver to specification. My paintings, lately, have all had aluminium foil applied to certain areas. The editors of *Architectural Design* permitted an additional line block which would enable me to simulate this essential feature of the theme.

Partly as a result of the 'Man Machine and Motion' exhibition, biased by the pop art preoccupation of the Independent Group at the ICA and using directly some material investigated by Reyner Banham in his auto styling research, I had been working on a group of paintings and drawings which portray the American automobile as expressed in the mag-ads. The painting *Hommage à Chrysler Corp.*, of which this is a version, is a compilation of themes derived from the glossies. The main motif, the vehicle, breaks down into an anthology of presentation techniques. One passage for example (though this sequence has been evened out to meet the needs of reproduction) runs from a prim emulation of in-focus photographed gloss to out of focus gloss to an artist's representation of chrome to ad-man's sign meaning 'chrome'. Pieces are taken from Chrysler's Plymouth and Imperial ads, there is some General Motors material and a bit of Pontiac. The total effect of Bug Eyed Monster was encouraged in a patronizing sort of way.

The sex symbol is, as so often happens in the ads, engaged in a display of affection for the vehicle. She is constructed from two main elements – the Exquisite Form Bra diagram and Voluptua's lips. It often occurred to me while I was working on the painting that this female figure evoked a faint echo of the Winged Victory of Samothrace. The response to the allusion was, if anything, to suppress it. Marinetti's dictum 'a racing car … is more beautiful than the Winged Victory of Samothrace' made it impossibly corny. In spite of a distaste for the notion it persists.

The setting of the group is vaguely architectural. A kind of showroom in the International Style represented by a token suggestion of Mondrian and Saarinen. One quotation from Marcel Duchamp remains from a number of rather more direct references which were tried. There are also a few allusions to other paintings by myself.

Richard Hamilton, 'Hommage à Chrysler Corp', *Architectural Design*, 28:4 [February 1958] 120–1.

Lawrence <u>ALLOWAY</u>
The Arts and the Mass Media
[1958]

In *Architectural Design* last December there was a discussion of 'the problem that faces the architect today – democracy face to face with hugeness – mass society, mass housing, universal mobility'. The architect is not the only kind of person in this position; everybody who works for the public in a creative capacity is face to face with the many-headed monster. There are heads and to spare.

Before 1800 the population of Europe was an estimated 180 million; by 1900 this figure had risen to 460 million. The increase of population and the industrial revolution that paced it has, as everybody knows, changed the world. In the arts, however, traditional ideas have persisted, to limit the definition of later developments. As Ortega pointed out in *The Revolt of the Masses*: 'the masses are today exercising functions in social life which coincide with those which hitherto seemed reserved to minorities'. As a result the élite, accustomed to set aesthetic standards, has found that it no longer possesses the power to dominate all aspects of art. It is in this situation that we need to consider the arts of the mass media. It is impossible to see them clearly within a code of aesthetics associated with minorities with pastoral and upper-class ideas because mass art is urban and democratic.

It is no good giving a literary critic modern science fiction to review, no good sending the theatre critic to the movies, and no good asking the music critic for an opinion on Elvis Presley. Here is an example of what happens to critics who approach mass art with minority assumptions. John Wain, after listing some of the spectacular characters in P.C. Wren's *Beau Geste* observes: 'It sounds rich. But in fact – as the practiced reader could easily foresee … it is not rich. Books with this kind of subject matter seldom are. They are lifeless, petrified by the inert conventions of the adventure yarn.' In fact, the practiced reader is the one who understands the conventions of the work he is reading. From outside all Wain can see are inert conventions; from inside the view is better and from inside the conventions appear as the containers of constantly shifting values and interest.

The Western movie, for example, often quoted as timeless and ritualistic, has since the end of World War II been highly flexible. There have been cycles of psychological Westerns (complicated characters, both the heroes and the villains), anthropological Westerns (attentive to Indian rights and rites), weapon Westerns (colt revolvers and repeating Winchesters as analogues of the present armament race). The protagonist has changed greatly, too: the typical hero of the American depression who married the boss's daughter and so entered the bright archaic world of the gentleman has vanished. The ideal of the gentleman has expired, too, and with it evening dress which is no longer part of the typical hero-garb.

If justice is to be done to the mass arts which are, after all, one of the most remarkable and characteristic achievements of industrial society, some of the common objections to it need to be faced. A summary of the opposition to mass popular art is in *Avant Garde and Kitsch* (*Partisan Review*, 1939; *Horizon*, 1940), by Clement Greenberg, an art critic and a good one, but fatally prejudiced when he leaves modern fine art. By kitsch he means 'popular, commercial art and literature, with their chromeotypes, magazine covers, illustrations, advertisements, slick and pulp fiction, comics, Tin Pan Alley music, tap dancing, Hollywood movies, etc.'. All these activities to Greenberg and the minority he speaks for are 'ersatz culture … destined for those who are insensible to the value of *genuine* culture … *Kitsch*, using for raw material the debased and academic simulacra of *genuine* culture welcomes and cultivates this insensibility' (my italics). Greenberg insists that 'all kitsch is academic', but only some of it is, such as Cecil B. De Mille-type historical epics which use nineteenth-century history-picture material. In fact, stylistically, technically and iconographically the mass arts are anti-academic. Topicality and a rapid rate of change are not academic in any usual sense of the word, which means a system that is static, rigid, self-perpetuating. Sensitiveness to the variables of our life and economy enable the mass arts to accompany the changes in our life far more closely than the fine arts which are a repository of time-binding values.

The popular arts of our industrial civilization are geared to technical changes which occur, not gradually, but violently and experimentally. The rise of the electronics era in communications challenged the cinema. In reaction to the small TV screen, movie makers spread sideways (CinemaScope) and back into space (Vista Vision). All the regular film critics opposed the new array of shapes, but all have been accepted by the audiences. Technical change as dramatized novelty (usually spurred by economic necessity) is characteristic not only of the cinema but of all the mass arts. Colour TV, the improvements in colour printing (particularly in American magazines), the new range of paperback books; all are part of the constant technical improvements in the channels of mass communication.

An important factor in communication in the mass arts is high redundancy. TV plays, radio serials, entertainers, tend to resemble each other (though there are important and clearly visible differences for the expert consumer). You can go into the movies at any point, leave your seat, eat an ice-cream, and still follow the action on the screen pretty well. The repetitive and overlapping structure of modern entertainment works in two ways: (1) it permits marginal attention to suffice for those spectators who like to talk, neck, parade; (2) it satisfies, for the absorbed spectator, the desire for intense participation which leads to a careful discrimination of nuances in the action.

There is in popular art a continuum from data to fantasy. Fantasy resides in, to sample a few examples, film stars, perfume ads, beauty and the beast situations, terrible deaths, sexy women. This is the aspect of popular art which is most easily accepted by art minorities who see it as a vital substratum of the folk, as something primitive. This notion has a history since Herder in the eighteenth century, who emphasized national folk arts in opposition to international classicism. Now, however, mass-produced folk art is international: Kim Novak, *Galaxy Science Fiction*, Mickey Spillane, are available wherever you go in the West.

However, fantasy is always given a keep topical edge; the sexy model is shaped by datable fashion as well as by timeless lust. Thus, the mass arts orient the consumer in current styles, even when they seem purely, timelessly erotic and fantastic. The mass media give perpetual lessons in assimilation, instruction in role-taking, the use of new objects, the definition of changing relationships, as David Riesman has pointed out. A clear example of this may be taken from science fiction. Cybernetics, a new word to many people until 1956, was made the basis of stories in *Astounding Science Fiction* in 1950.' SF aids the assimilation of the mounting technical facts of this century in which, as John W. Campbell, the editor of *Astounding*, put it, 'A man learns a pattern of behaviour – and in five years it doesn't work.' Popular art, as a whole, offers imagery and plots to control the changes in the world; everything in our culture that changes is the material of the popular arts.

Critics of the mass media often complain of the hostility towards intellectuals and the lack of respect for art expressed there, but, as I have tried to show, the feeling is mutual. Why should the mass media turn the other cheek? What worries intellectuals is the fact that the mass arts spread; they encroach on the high ground. For example, into architecture itself as Edmund Burke Feldman wrote in *Arts and Architecture* last October: 'Shelter, which began as a necessity, has become an industry and now, with its refinements, is a popular art.' This, as Feldman points out, has been brought about by 'a democratization of taste, a spread of knowledge about non-material developments, and a shift of authority about manners and morals from the few to the many'. West Coast domestic architecture has become a symbol of a style of living as well as an example of architecture pure and simple; this has occurred not through the agency of architects but through the association of stylish interiors with leisure and the good life, mainly in mass circulation magazines for women and young marrieds.

The definition of culture is changing as a result of the pressure of the great audience, which is no longer new but experienced in the consumption of its arts. Therefore, it is no longer sufficient to define culture solely as something that a minority guards for the few and the future (though such art is uniquely valuable and as precious as ever). Our definition of culture is being stretched beyond the fine art limits imposed on it by Renaissance theory, and refers now, increasingly, to the whole complex of human activities. Within this definition, rejection of the mass produced arts is not, as critics think, a defence of culture but an attack on it. The new role for the academic is keeper of the flame; the new role for the fine arts is to be one of the possible forms of communication in an expanding

framework that also includes the mass arts.

1 Although for purposes of this general article I have
 treated the mass arts as one thing, it is in fact highly
 specialized. *ASF* is for scientifically and technically
 minded readers, whereas *Galaxy SF* leans towards
 mainstream stories. SF editorials tend to stress the
 unlikeness of the field to the rest of the mass media.
 There are, in fact, a multitude of audiences within the
 great audience [*Mademoiselle*, for example, is aimed at
 female readers·from eighteen to thirty], but here I just
 want to separate the popular from the fine arts.

Lawrence Alloway, 'The Arts and the Mass Media',
Architectural Design, 28:2 [February 1958] 84-5

Lawrence ALLOWAY
The Long Front of Culture
[1959]

The abundance of twentieth-century communications is an embarrassment to the traditionally educated custodian of culture. The aesthetics of plenty oppose a very strong tradition which dramatizes the arts as the possession of an elite. These 'keepers of the flame' master a central (not too large) body of cultural knowledge, meditate on it, and pass it on intact (possibly a little enlarged) to the children of the elite. However, mass production techniques, applied to accurately repeatable words, pictures and music, have resulted in an expendable multitude of signs and symbols. To approach this exploding field with Renaissance-based ideas of the uniqueness of art is crippling. Acceptance of the mass media entails a shift in our notion of what culture is. Instead of reserving the word for the highest artefacts and the noblest thoughts of history's top ten, it needs to be used more widely as the description of 'what a society does'. Then, unique oil paintings and highly personal poems as well as mass-distributed films and group-aimed magazines can be placed within a continuum rather than frozen in layers in a pyramid. (This permissive approach to culture is the reverse of critics like T. S. Eliot and his American followers – Allen Tate, John Crowe Ransom, who have never doubted the essentially aristocratic nature of culture.)

Acceptance of the media on some such basis, as entries in a descriptive account of a society's communication system, is related to modern arrangements of knowledge in non-hierarchic forms. This is shown by the influence of anthropology and sociology on the humanities. The developing academic study of the 'literary audience', for example, takes literary criticism out of textual and interpretative work towards the study of reception and consumption. Sociology, observant and 'cross-sectional' in method, extends the recognition of meaningful pattern beyond sonnet-form and Georgian-elevations to newspapers, crowd behaviour, personal gestures. Techniques are now available (statistics, psychology, Motivation Research) for recognizing in 'low' places the patterns and interconnections of human acts which were once confined to the fine arts. The mass media are crucial in this general extension of interpretation outwards from the museum and library into the crowded world.

One function of the mass media is to act as a guide to life defined in terms of possessions and relationships. The guide to possessions, of course, is found in ads on TV and cinema screens, hoardings, magazines, direct mail. But over and above this are the connections that exist between advertising and editorial matter: for example, the heroine's way of life in a story in a woman's magazine is compatible with consumption of the goods advertised around her story, and through which, probably, her columns of print are threaded. Or, consider the hero of two comparable Alfred Hitchcock films, both chase-movies. In the pre-war *39 Steps* the hero wore tweeds and got a little rumpled as the chase wore on, like a gentleman farmer after a day's shooting. In *North by North West* (1959) the hero is an advertising man (a significant choice of profession) and though he is hunted from New York to South Dakota his clothes stay neatly Brooks Brothers. That is to say, the dirt, sweat and damage of pursuit are less important than the package in which the hero comes – the tweedy British gentleman or the urbane Madison Avenue man. The point is that the drama of possessions (in this case clothes) characterize the hero as much as (or more than) his motivation and actions. This example, isolated from a legion of possibles, shows one of the ways in which lessons in style (of clothes, of bearing) can be carried by the media. Films dealing with American home-life, such as the brilliant women's films from Universal-International, are, in a similar way, lessons in the acquisition of objects, models for luxury, diagrams of bedroom arrangement.

The word 'lesson' should not be taken in a simple teacher-pupil context. The entertainment, the fun, is always uppermost. Any lessons in consumption or in style must occur inside the pattern of entertainment and not weigh it down like a pigeon with *The Naked and the Dead* tied to its leg. When the movies or TV create a world, it is of necessity a *designed* set in which people act and move, and the *style* in which they inhabit the scene is an index of the atmosphere of opinion of the audiences, as complex as a weather map.

We speak for convenience about a mass audience but it is a fiction. The audience today is numerically dense but highly diversified. Just as the wholesale use of subception techniques in advertising is blocked by the different perception capacities of the members of any audience, so the mass media cannot reduce everybody to one drugged faceless consumer. Fear of the Amorphous Audience is fed by the word 'mass'. In fact, audiences are specialized by age, sex, hobby, occupation, mobility, contacts, etc. Although the interests of different audiences may not be rankable in the curriculum of the traditional educationist, they nevertheless reflect and influence the diversification which goes with increased industrialization. It is not the hand-craft culture which offers a wide choice of goods and services to everybody (teenagers, Mrs Exeter, voyeurs, cyclists), but the industrialized one. As the market gets bigger consumer choice increases: shopping in London is more diverse than in Rome; shopping in New York more diverse than in London. General Motors mass-produce cars according to individual selections of extras and colours.

There is no doubt that the humanist acted in the past as taste-giver, opinion-leader, and expected to continue to do so. However, his role is now clearly limited to swaying other humanists and not to steering society. One reason for the failure of the humanists to keep their grip on public values (as they did in the nineteenth century through university and Parliament) is their failure to handle technology, which is both transforming our environment and, through its product the mass media, our ideas about the world and about ourselves. Patrick D. Hazard[3] pointed out the anti-technological bias of the humanist who accepts only 'the bottom rung ... of the technological ladder of communication', movable type. The efforts of poets to come to terms with industry in the nineteenth century (as anthologized by J. F. Warburg) are un-memorable, that is to say, hard-to-learn, uninfluential in image-forming. The media, however, whether dealing with war or the home, Mars or the suburbs, are an inventory of Pop technology. The missile and the toaster, the push-button and the repeating revolver, military and kitchen technologies, are the natural possession of the media – a treasury of orientation, a manual of one's occupancy of the twentieth century.

Finally it should be stressed that the mass media are not only an arena of standardized learning. Not only are groups differentiated from the 'mass', but individuals preserve their integrity within the group. One way to show this is to appeal to the reader's experience of the media, which he can interpret in ways that differ in some respects from everybody else's readings. While keeping their essentially cohesive function, providing a fund of common information in image and verbal form, the media are subject to highly personal uses. This can be shown by quoting a reader's reaction to a science fiction magazine cover:

'I'm sure Freud could have found much to comment, and write on, about it. Its symbolism, intentionally or not, is that of man, the victor; woman, the slave. Man the active; woman the passive. Man the conqueror; woman the conquered. Objective man, subjective woman; possessive man, submissive woman! ... What are the views of other readers on this? Especially in relation with Luros' backdrop of destroyed cities and vanquished man?'

The commentary supplied by this reader, though cued by the iconography of *Science Fiction Quarterly*, implies clearly enough his personal desire and interest. However, it is no greater a burden of meaning that he puts on the cover than those attached to poems by symbol-conscious literary critics. The point is that the mass media not only perform broad, socially useful roles but offer possibilities of private and personal deep interpretation as well. At this level Luros' cover is like a competitor of the fine arts, in its capacity for condensing personal feelings. However, it is the destiny of the popular arts to become obsolescent (unlike long-lived fine art). Probably the letter writer has already forgotten Luros' cover (from the *early* fifties) and replaced it by other images. Both for their scope and for their power of catching personal feeling, the mass media must be reckoned as a permanent addition to our ways of

interpreting and influencing the world.

1 *Contemporary Literary Scholarship*, ed. Lewis Leary [New
 York, 1958].

Lawrence Alloway, 'The Long Front of Culture', *Cambridge
Opinion*, 17 [Cambridge, 1959; reprinted in Suzi Gablik and
John Russell, eds, *Pop Art Redefined*, London: Thames &
Hudson/New York: Praeger, 1969; and Brian Wallis, et al.,
eds, *Modern Dreams: The Rise and Fall and Rise of Pop*,
Cambridge, Massachusetts: MIT Press, 1988] 30–33.

Kenneth ANGER
Hollywood Babylon [1959]

CON GAME

In 1951 the police raided a deluxe pleasure house nestled in the hills above Sunset Strip, apprehending its madam, Billy Bennett, and seizing her customers ledger. The ledger was to become famous, for it was a golden book of Hollywood celebrities, habitual clientele of the establishment, some of whom had left their Oscars on the mantelpiece in gratitude for 'services rendered'. (The tip-off came from some well-known restaurateurs along the Strip, who were outraged at Billy's plans to 'go legit' and open a proper, swank and competing restaurant on their high-toned turf.) Dozens of male stars, as well as producers and scenarists, suddenly took off for the four corners of the world, accepted work in Europe or suddenly needed vacations. The studios applied pressure and succeeded in hushing the matter up; within a few months the 'vacationers' trickled back to California.

In 1952, the movie capital had not entirely recovered from the Billy Bennett Affair when a little magazine, published in New York, appeared on news stands all over the country. This new offspring of yellow journalism soon became the talk of the town and *Confidential* acquired a reputation as the worst kind of rag – but everyone read it anyway.

Its motto was 'Tells the Facts and Names the Names'. Scandal sheets were nothing new. There had been successful professional gossipmongers for decades, including the vicious Westbrook Pegler, malicious Walter Winchell, that holy terror Elsa Maxwell and of course Tinsel Town's own innuendo specialists, Hedda and Louella. But perfidious *Confidential* carried things further than any of the rumour-mongers had done, went into greater detail and did not hesitate to affirm that the stories it published were a faithful account of the facts.

Confidential's publisher, Robert Harrison, had conceived the idea for the magazine after watching the daily televised Kefauver crime investigations. When he observed that these journalistic reports on vice, crime and prostitution eclipsed all other programmes in the ratings, he deduced that the public was hungry for gossip and that a publication which presented such material in a spicy manner and did, in effect, name names, would go over big.

Harrison had started out in the Twenties as an office boy of the *Daily Graphic*, a scandal sheet which in many ways was a precursor of *Confidential*. He then worked for Martin Quigley, pious publisher of *Motion Picture Herald*,

and on his own had put out a fetish series: Hi-Heeled-Women-with-Whips-type magazines, whose circulations were falling off by the time he conceived the *Confidential* idea. The first issue did phenomenally well, and sold 250,000 copies. At its peak, *Confidential* was selling four million copies on news stands – a record for American 'journalism.'

Harrison embarked on a large-scale attack on the private lives of America's most famous citizens. His formula was simple: a well-known name, an unflattering photograph and a story, fairly short, which presented a sordid episode in a mocking humorous manner. He knew what his customers wanted. He confided to friends: 'Americans like to read about things which they are afraid to do themselves.' With the success of the magazine, its victims were increasingly those Hollywood luminaries whose private lives were of most morbid interest to the public. Harrison set up an 'agency' in Hollywood, run by his niece, Marjorie Mead. It was given the pretentious moniker 'Hollywood Research Incorporated'. Shady shamuses, would-be starlets, has-been hams and faded journalists were hired to rattle, prattle and tattle. The success of *Confidential* enabled Harrison to pay up to $1,000 per gossip item, assigning him a fine stable of spies. Sometimes eminent show-biz personalities themselves would be informants on colleagues. Mike Todd called Harrison from California to fill him in on a juicy story concerning Harry Cohn, much-hated president of Columbia.

Many 'researchers' were call girls. In fact, the nucleus of the organization was the bevy of pin-up girls who adorned the bars of Sunset Strip. In bed, these high-priced floozies received the confidences of famous stars, while a miniature tape recorder inside their purse, left carelessly open on the bedside table, recorded by night the indiscretions devoured later by avid readers.

Hollywood Research unearthed compromising photographs and films and made use of the latest technical refinements: infra-red and ultra-rapid film, high-powered telephoto lenses. This was the fashion in which the domestic feuds of Anita Ekberg and Anthony Steele were snooped upon. When particularly compromising material had been gathered, an agent of Hollywood Research visited the star involved with a copy in hand. It was suggested to the victim that the original might be purchased. Some paid, panic stricken; others refused. Stories which were not bought out of existence included: 'Lizabeth Scott Among the Girls', 'Dan Dailey in Drag', 'Errol Flynn and His Two-Way Mirrors', 'The Best Pumper in Hollywood? M-M-M Marilyn M-M-Monroe!' 'Joan Crawford and the Handsome Bartender'.

This reign of terror lasted for four years. Considerable, but unacknowledged, assistance was given Harrison by two of New York's established gossipists, Walter Winchell and Lee Mortimer. Mortimer, columnist and film critic for the now-defunct *Daily Mirror*, would meet Harrison in a phone booth, slip him a juicy story, and if by chance they turned up that evening in the same nitery, the two men would pretend to be feuding and not speak to each other. Harrison often gave Winchell friendly plugs in the magazine, in stories in which someone else was given the

axe (e.g., 'Winchell was Right about Josephine Baker', etc.). In return, Winchell often plugged the magazine on television.

While the success and obscenities of *Confidential* increased with every issue, there was practically no film star who escaped its 'revelations'. Some were victims of a whole series of stories: Marilyn, Orson, Lana, Ava, Frank and Jayne [...]

Kenneth Anger, *Hollywood Babylon* [Paris: Jean-Jacques
Pauvert, 1959; first US edition, San Francisco: Straight
Arrow Books, 1975; reprinted, New York: Bell Publishing
Company, 1981] 371–9.

John McHALE
The Expendable Icon [1959]

Architects and designers are professionally concerned with communicating visually and, where not actively engaged, we are all participants in the process of mass-communications. We use newspapers, magazines, radio, TV and the movies. This preliminary enquiry into the iconic content of the mass media has relevance then on two counts – simply as visual and as part of the common communications network.

The emphasis on the term 'icon' derives from a preoccupation with the actual function of much visual communication. Aside from conveying simple messages about the disposition of perceptual reality in the everyday world, there is the more complex communication, by sign, symbol, or 'loaded image', of statements about man's total environmental situation. Historically this latter function has been the traditional role of the fine arts. The provision of 'usable images', 'configurations of human experience', 'symbolic constructs of reality', which enabled man to locate in, and deal with, his environment – both internal and external – to use a shaky dichotomy. Such constructs might be totems, masks, a ritual dance, a poem or a cathedral.

Generally, before our own period, they tended to be permanent over a long time span, contained within a fixed cosmogony, linked to a monolithic dogma and, though localized, claimed universality as prime condition of their acceptance.

Initially here the enquiry is narrowed down to the ways in which the acceptable and usable images of human action and experience, the icons of our time, are to be found now more in the technological folk arts – the mass media. That the fine arts sector has been generally concerned with the exclusion of man as subject is not within the province of this article.

Generalizing broadly, the rise of mass-communication coincides with the onset of the second Industrial Revolution – of mass production of identical, replaceable products for astronomical numbers of consumers. It is coincident also with advances in physical science which, through technology, have pushed man's frontiers almost to the stars. Culturally a period of enormous expansion and exploration; the whole range of the sensory spectrum has been extended – man can see more, hear more, travel

faster – experience more than ever before. His environment extensions – movie, TV, picture magazine – bring to his awareness an unprecedented scope of visual experience.

Such accelerated changes in the human condition require an array of symbolic images of man which will match up to the requirements of constant change, fleeting impression and a high rate of obsolescence. A replaceable, expendable series of icons.

Awareness of the importance attached to the ways in which human beings react visually to a kind of pragmatic total image, built up variously from actual perception and internal association, has been part of our climate of ideas for some time. The work of Arnheim and Ames in Gestalt psychology and visual perception has demonstrated this in detail. Motivation research's axiom, 'that what people cho[o]se in a product is nearly always the *image* rather than the reality' and studies such as Boulding's 'The Image – Knowledge in Life and Society' have dealt with various aspects of the subject. Even more relevant to our present purpose is Schilder's proposition, that the image of our own body physiologically, with which we operate, is largely of a temporal fluctuating nature and built up of isolated sensation, perception of others, and fragmentary associations.

It remains to sort out more closely the image to which we refer in the present context – that more specifically in the nature of an icon. It is hardly necessary to note that the term 'image' has been taking something of a beating. Together with the additive 'loaded', it has formed a useful portmanteau into which one could stuff any sort of stimulating visual experience – from a close up of the human eye to a macroscopic view of the earth's curvature as taken from a rocket. Anything which supplied visual kicks was an 'image'; if it had some particular detailed relevance it was a 'loaded image'. The practice of collecting such material has been widespread. But such is the scope, volume and pace of the mass media that the simple act of extracting an image from the continuum to pin up, thereby alters its status, and almost becomes in itself an academic gesture. This poses a very neat relation between observer and observed, and has in its way hindered assessment of the media content. Almost as soon as a trend becomes recognizable, and can be labelled, the image series has become obsolete. As on TV 'Only Yesterday' is ancient history. A noteworthy technique of assessment, employed by Seldes in the US, was the sampling of a total cross-section throughout all media produced in one day. Other explorations in the field by US workers have mainly been in the area of statistical survey and tabulation of content. Marshall McLuhan's qualitative study, *The Mechanical Bride*, remains a classic of its kind, though its strong moral overtones render many conclusions outmoded. Also on the qualitative side, there are in this country the scholarly and detailed researches in iconography by Alloway and Banham.

But in such a process, the mass media, where the only real constant is change, classification is permanently tentative. Expendability is built in and so furnishes an initial criteria. Rapid turnover in iconography in any sector varies strictly according to acceptance, to a success which is its own accelerator. The content of the mass media

image which might be regarded as iconic in nature is that in which man (or woman) is the key figure. At the risk of sounding Whitmanesque one can say that this is the era of the common man. For the first time in recorded history he occupies the centre of the picture. In the mass media he certainly has the main role. Content, in the main, is about people. A count of space allocated in popular magazine, movie or TV, overwhelmingly shows that the main interest and subject is man. On TV, by its nature a leveller, all events have equal status, and the ordinary man on the quiz show or giveaway programme can automatically have as much screen time, and reach as large an audience, as the biggest celebrity. In the movies which, unlike TV, remain slightly larger than life, even the star is more often than not still tailored carefully to the 'ordinary Joe'. When mass-circulation tends to be regarded as supranational, and soap commercials are automatically made in at least four languages, such iconic configurations as emerge in the media have a much stronger claim to universality than any of their historical predecessors. They are, at any rate, consumed in common by more people.

We can, then, set up a positive tendency to an anthropocentric icon – richly symbolizing, describing, locating man in the modern world. A shifting image of his culture is provided in manners which assist him in his various roles and orientations. Marshall McLuhan on advertising, in an adversely critical article of 1947, said, 'The dramatic ad is the maker of "patterns of living" as much as the movie idol ... provided temporary emotional strategy for millions of adolescents ... help old and young to get help. As social catalysts they help overcome boy/girl shyness ... console and encourage the forlorn ... they analyse the causes of every type of human failure and indicate scientifically certified formulae for instant success or money back results.' Reversing the moral tone in which they are delivered, his comments, used positively, refer to the whole of the mass communications network.

Categories of material selected to illustrate this article, from such a huge field, are purely expedient. They could be established simply or to the extent to which they overlap. For example, the series tagged 'On the Space Frontier' blurs off at the edges into 'Re-designing Man', and even into 'Out of Frankenstein by I.B.M.'. The Presley, Dean, Monroe group share common attributes and function in similar areas. Categories might almost be invented at random, and pictures to fit them found as easily. Each temporary category shown here could be the subject of lengthy iconographic study, and cross-category features like 'Gesture' could also be most fruitful avenues to explore. The degree to which a particular image group may be common to a number of media channels is also important and illustrates the potency of the image and cross-fertilization which takes place throughout the media continuum. Material shown is drawn variously from advertisements, fashion sections, movie stills, SF magazines, etc.

But simply using the tagged category as a verbal convenience to define an operative area has value in that it shows the width and coverage of the mass communications network. As a device it enables attention to be drawn to and emphasis given in a richly fertile field of

visual experience which covers every major (and most minor) aspects of human activity. It is here that modern man finds and creates his own expendable icons to fit the particular need of his time.

The emphasis on the 'iconic' quality of such ephemeral material – glanced at and half-forgotten immediately – may still seem undue when the term is used straight. As noted earlier its previous connotations were permanence, universality and relation to a fixed set of beliefs. But today's images take their character from the channels which carry them, and, though the single image is expendable, by immediate circulation on a concretely universal scale, and by repetition in various forms, its overall functioning rates the 'iconic' title.

Features of the iconic image worth stressing are the repetition and persistence of certain image groupings of man in various environmental relations. That within presentation there is no dependence on classical attitude, gesture or previous historical iconography – and no act of faith required for acceptance. A continued renewal and adjustment of iconography rather, whose constant is a pragmatic relation to performance via topicality.

The content of the iconic image, which in this text is stressed as the human being, should also be taken as including a range of certain technical objects in common use. These have been omitted for space reasons, but their design symbolism includes them very definitely in the main theme, and raises them to a quasi-totemic level. The automobile is an obvious one (cf. 'Vehicles of Desire' – Reyner Banham, *Art*, September 1955), also the juke box, certain items of domestic equipment, etc.

Scant treatment accorded areas such as the movies, fashion and the comic strip, in no way minimizes their importance. Comment is already available on these fields by writers mentioned and others.

In addition, there are certain personal preoccupations which might have been dealt with at length. For example, the multi-ordinal character of the pictorial structure in much icon material – the ways in which enormous close-ups, serial, X-ray, micro- and macroscopical views are used and the fragmentary, blurred and out of focus qualities which give ambivalence to an image. As indicated before, a most potent area for exploration – gesture – almost absent from the fine arts, proliferates in the mass media. It seems to reach particular significance currently in relation to the communicating device – the microphone, TV and film screen – from person to person, to multitude, from car to car, to aeroplane – a multiple image of communication.

In consideration of such a wide and rapidly changing process – the mass media – any selection and comment as is given in this text can only be a compressed and particular view. Without holding a brief for internal consistency the 'expendable icon', as formulation, has shown a pragmatic and operable edge in use, by the kind of cross-section of the field it exposes. The juxtaposition of image revealed is its warrant of validity, and it has served adequately if it serves to indicate fresh avenues for further enquiry.

John McHale, 'The Expendable Icon', 1 and 2, *Architectural Design*, 29:2 & 3 [London, February-March, 1959].

Jonas MEKAS
A Call for a New Generation of Film Makers [1959]

The establishment of the Independent Film Award marks the entrance of a new generation of filmmakers into American cinema.

The time has long been ripe for it. We had expected it to happen with the breaking up of the Hollywood monolith into small independent film companies. But our hopes proved to be only wishful thinking. Most independent companies soon became small Hollywoods in themselves.

The only independent artist left in dramatic feature film, Orson Welles, is constantly being bended down and butchered, as he was in *Touch of Evil*.

The only free filmmaking being done was in the short experimental film. However, lately, it too has become sterile, and has been frozen into a genre. Film experimentation has degenerated into 'making experimental films'.

Still, experimental filmmakers, and such artists as Orson Welles, kept the spirit of free cinema alive in America. We praise them not so much for their achievements as for the course they have faithfully followed.

However, to break the stifling conventions of the dramatic film the cinema needs a larger movement than that of the experimental filmmakers.

We think that such a movement is about to begin.

The first signs of a larger stir-up are visible. Several dramatic films, some already completed, some about to be finished in coming months — films such as John Cassavetes' *Shadows*, Morris Engel's *Weddings and Babies*, Alfred Leslie's and Robert Frank's *Beat Generation*, Edouard Laurot's *Sunday Junction*, Jerome Hill's *The Sand Castle*, to mention only a few — clearly point up a new spirit in American cinema: a spirit that is akin to that which guides the young British filmmakers grouped around Free Cinema, a spirit which is being felt among the French film newcomers such as Claude Chabrol, Alexandre Astruc, Francois Truffaut, Roger Vadim, Georges Franju, and a spirit which is changing the face of the young Polish cinema.

Basically, they all:

Mistrust and loath the official cinema and its thematic and formal stiffness; are primarily preoccupied with the emotional and intellectual conditions of their own generation as opposed to the neorealists' preoccupation with materiality; seek to free themselves from the over-professionalism and over-technicality that usually handicaps the inspiration and spontaneity of the official cinema, guiding themselves more by intuition and improvisation than by discipline. (As the postwar emergence of neorealism freed cinematography from the conventions of studio lighting, thereby coming closer to visual truth, so the new generation of filmmakers may eventually free direction, acting and sets from their dead and commercial conceptions, and go on to seize the truth of their experiences and their dreams.)

Obviously, this is not what the 'professionals' want.

These filmmakers will be severely criticized and perhaps even accused of betraying cinema. However, they come closer to the truth with their nakedness than the 'professionals' with their pretentious expensiveness.

It is wrong to believe (Cocteau said it long ago) that good films can be made in 35mm only, as it is wrong to believe that only the 16mm experimental filmmakers can be really free.

John Cassavetes' film, *Shadows*, proves that a feature film can be made with only $15,000. And a film that doesn't betray life or cinema. What does it prove? It proves that we can make our films *now* and by *ourselves*. Hollywood and the miniature Hollywoods of our 'independents' will never make *our* films.

A $15,000 film is financially unbeatable. Television cannot kill it. The apathy of the audience cannot kill it. Theatrical distributors cannot kill it. It is free.

Therefore, it is time to bring our film up to date. Hollywood films (and we mean Hollywoods all over the world) reach us beautiful and dead. They are made with money, cameras and splicers, instead of with enthusiasm, passion and imagination. If it will help us to free our cinema by throwing out the splicers and the budget-makers and by shooting our films on 16mm as Cassavetes did, let us do so.

Our hope for a free American cinema is entirely in the hands of the new generation of filmmakers. And there is no other way of breaking the frozen cinematic ground than through a *complete* derangement of the official cinematic senses.

Jonas Mekas, 'A Call for a New Generation of Filmmakers', *Film Culture*, 19 [New York, 1959] 1–3.

Reyner BANHAM
Epitaph 'Machine Aesthetic' [1960]

It is still little more than a century since the idea arose that the design of consumer goods should be the care and responsibility of practitioners and critics of fine arts. This conviction was part of the nineteenth-century democratic dream of creating a universal elite, in which every literate voter was to be his own aristocratic connoisseur and arbiter of taste — the assumption being that the gap between the fine arts and the popular arts was due only to the inadequate education of the 'masses'. This view of popular taste drew much of its strength from a romantic misconception of the Middle Ages: it assumed that because only well-designed and artist-decorated artefacts had survived from Gothic times, then all mediaeval men, from prince to peasant, must have possessed natural good taste. (Actually, all the evidence suggests is that only the expensive objects warranting elaborate decoration were sufficiently well made to last five or six centuries, and we know practically nothing of the inexpensive artefacts of the period because few have survived.)

Nevertheless, this view of mediaeval goods did not entirely perish even after Art Nouveau's floridity had been rejected by the generation of designers and theorists who established themselves after 1905. Adolf Loos, rejecting all ornament, read the evidence to mean that later generations, with debased taste, had allowed all undecorated mediaeval craftwork to be destroyed, while carefully conserving the depraved and untypical ornamented examples. Loos, while an extremist, is fairly typical of his contemporaries who rejected all forms of ornament because they could find no meaning in it, and turned to the concept of 'pure form' because it offered proof against fallible human taste.

This and other attitudes of their generation were synthesized after World War I by Gropius and Le Corbusier, in writings that postulated a sovereign hierarchy of the arts under the dominance of architecture, and a common dependence on laws of form that were objective, absolute, universal and eternally valid. The illusion of a common 'objectivity' residing in the concept of function, and in the laws of Platonic aesthetics, has been a stumbling block to product criticism ever since.

In the century of fine art product criticism now finishing, every school of thought, every climate of opinion, has had to formulate its attitude towards industrial production. In contrast to all earlier formulations, the 'neo-academic' synthesis just described — a mystique of form and function under the dominance of architecture — has won enthusiastic acceptance. It is the result of telescoping the Loosian ideas of pure, undecorated machine forms and futurist ideas of the mechanized urban environment as the natural habitat of twentieth-century man. But this telescoping, which brought machine products within the orbit of pure aesthetics, was achieved at the cost of ignoring three fundamental fallacies, which may be labelled: simplicity, objectivity and standardization.

Geometrical *simplicity* has been identified as a basic preference of Platonic aesthetics since the end of the last century, and Plato's celebrated quotation that absolute beauty is found in 'forms such as are produced by the lathe, the potter's wheel, the compass and the rule' has been one of the most frequently quoted justifications for abstract art, and for supposing that product design should follow its laws. Neo-academic critics of 1900–1930 could see in such fields as bridge-building and vehicle design, quite accidentally, the same sort of rule-and-compass geometry of which Plato approved.

Although these resemblances are obviously a mere coincidence depending on the aesthetic atmosphere of the period and the primitive condition of vehicle design, the neo-academic critics took them as proof of the *objectivity* of their attitude. Engineers were believed to be working without aesthetic contamination and according to immutable physical laws. To this misconception, they added a confusion between the meaning of objectivity in mechanical engineering laws and in the laws of aesthetics (the latter meaning that their logic is impeccable, not that their factual basis has been subjected to scientific evaluation). The neo-academics then succeeded in circulating the belief that all mechanically-produced articles should be simple in form, and answer to abstract and supposedly permanent laws based on architectural

practice. The final absurdity of this view is found in Herbert Read's influential book, *Art and Industry*, epitomized in two quotations. The first draws an unwarranted conclusion from an impeccable observation: 'The engineer's and the architect's design approach one another in aesthetic effect. Entirely different problems are being solved, but the same absolute sense of order and harmony presides over each.' The aesthetic prejudice suggested in this conclusion reveals itself in another, quite meaningless as a statement of fact but instructive as a rhetorical flourish: 'The machine has rejected ornament.'

Somewhere in this confusion lies the third of the concealed difficulties – *standardization*. This word has been used in a muddled way by many 'machine aesthetes' in a manner that suggests a mark, an ideal, at which to aim. But in engineering, a standardized product is essentially a norm stabilized only for the moment, the very opposite of an ideal because it is a compromise between possible production and possible further development into a new and more desirable form. This double expendability, which involves not only the object itself but also the norm or type to which it belongs, is actually what excludes mass-produced goods from the categories of Platonic philosophy.

We live in a throw-away economy, a culture in which the most fundamental classification of our ideas and worldly possessions is in terms of their relative expendability. Our buildings may stand for a millennium, but their mechanical equipment must be replaced in fifty years, their furniture in twenty. A mathematical model may last long enough to solve a particular problem, which may be as long as it takes to read a newspaper, but newspaper and model will be forgotten together in the morning, and a research rocket – apex of our technological adventure – may be burned out and wrecked in a matter of minutes.

It is clearly absurd to demand that objects designed for a short useful life should exhibit qualities signifying eternal validity – such qualities as *divine* proportion, *pure* form or *harmony* of colours. In fairness to Le Corbusier, it should be remembered that he was the first to raise the problem of permanence and expendability in engineering: 'Ephemeral beauty so quickly becomes ridiculous. The smoking steam engine that spurred Huysmans to spontaneous lyricism is now only rust among locomotives; the automobile of next year's show will be the death of the Citroën's body that arouses such excitement today.' Yet, recognizing this much, he declined to accept the consequences. He singled out the work of Ettore Bugatti for special praise, using components from his cars as examples of engineering design that supported his fine-art view of product aesthetics.

As a result, the engines of Bugatti cars have been regarded as models of the highest flights of engineering imagination – *except* by some of the most distinguished automobile designers. Jean Gregoire, for example, on whose work in the field of front-wheel drive all subsequent vehicles of this type depend, has refused to find the Bugatti engine admirable. He speaks from inside engineering:

In a particular component, mechanical beauty

corresponds to the best use of materials according to the current state of technique. It follows that beauty can vary, because the technique, upon which the utilization of material depends, is progressive.

He goes on to develop a type of product criticism that is unique and instructive:

As might be expected, Bugatti was proud of his eyes. He loved engines that had straight sides and polished surfaces behind which manifolds and accessories lay hidden … At the risk of making the reader jump six feet in the air, I consider many American engines, surrounded as they are by forests of wire and bits and pieces, and designed without thought for line, to be nearer to beauty than the elegant Bugatti engines. An engine in which the manifolds are hidden in the cylinder-head, the wiring concealed under the covers, and the accessories lurk under the crankcase – all for the sake of beauty – is less good-looking than the motor where the manifolds are clearly seen.

This deliberate rebuttal of neo-academic standards must make us ask by what standards he judges what he sees. A comparison between the Bugatti engine and an American V-8 will serve for study. The Bugatti offers a rectangular silhouette with a neutral, unvaried handicraft surface, compartmented into forms that answer closely the Platonic ideals of the circle and square. (With these words one might also describe, say, a relief by Ben Nicholson, and we should remember that Bugatti had been an art student of the same generation as the pioneers of abstract art.) The Buick V-8 of 1955, on the other hand, presents a great variety of surface materials, none of them handwrought, in complex, curving, three-dimensional forms composed into a block with an irregular and asymmetrical silhouette. No doubt impeccable functional reasons could be found for these differences, but one should also note that both engines show considerable care in their visual presentation.

The Bugatti, riding high between the sides of a narrow bonnet, is meant to be seen (as well as serviced) from the side. The Buick, spreading wide under a low 'alligator hood', has its compounds grouped on top, not only for easy access but also to make an exciting display. The Bugatti, as Gregoire noted, conceals many components and presents an almost two-dimensional picture to the eye, while the Buick flaunts as many accessories as possible in a rich three-dimensional composition, countering Bugatti's fine-art reticence with a wild rhetoric of power. This difference – basically the preference of a topological organization to a geometrical one – might be likened to the difference between a Mondrian painting and a Jackson Pollock, but this would be no answer to our present problem because it merely substitutes one fine-art aesthetic for another.

If we examine the qualities that give the Buick engine its unmistakable and exciting character, we find glitter, a sense of bulk, a sense of three-dimensionality, a deliberate exposure of technical means, all building up to signify power and make an immediate impact on whoever sees it. Now these are not the qualities of the fine arts: glitter went

out with the gold skies of Gothic painting, Platonic and neo-academic aesthetics belong to the two-dimensional world of the drawing board. But if they are not the qualities of the fine arts, they are conspicuously those of the popular arts.

The words 'popular arts' do not mean the naïve or debased arts practiced by primitives and peasants, since they inhabit cultures in which such artefacts as Buicks have no part. The popular arts of motorized, mechanized cultures are manifestations like the cinema, picture magazines, science fiction, comic books, radio, television, dance music, sport. The Buick engine, with its glitter, technical bravura, sophistication and lack of reticence admirably fulfills the definition of 'pop art' of Leslie Fiedler:

Contemporary popular culture, which is a function of an industrialized society, is distinguished from other folk art by its refusal to be shabby or second rate in appearance, by a refusal to know its place. Yet the articles of popular culture are made, not to be treasured, but to be thrown away.

This short passage (from an essay on comic books) brings together practically all the cultural facts that are relevant to the Buick.

We have discussed the absurdity of requiring durable aesthetic qualities in expendable products, but we should note that aesthetic qualities are themselves expendable, or liable to *consumo* or wastage of effect, in the words of Dorfles and Paci; and this using up of aesthetic effect in everyday objects is due, precisely, to that daily use. We can see the correctness of this in communications jargon: the 'signal strength' of many aesthetic effects is very low; and being unable to compete with the 'random noise' aroused in situations of practical use, any low-strength signal (fine arts or otherwise) will be debased, distorted or rendered meaningless where use is the dominant factor. Such situations require an aesthetic effect with high immediate signal strength; it will not matter if the signal strength is liable to taper off suddenly, if the object itself is expendable, since the signal strength can always be kept up if the signal itself is so designed that use acts on it as an *amplifier*, rather than as random noise.

In other words, if one opens the Bugatti hood and finds that motor covered with oil, one's aesthetic displeasure at seeing a work of fine art disfigured would be deepened by the difficulty of repairwork when the ailing component proves to be hidden away inside the block 'for the sake of beauty'. In similar circumstances, the Buick would probably be far less disfigured by an oil leak, and its display of components makes for much easier repairs, so that visual gratification is reinforced by the quality of the motor as an object of use.

More than this, the close link between the technical and aesthetic qualities of the Buick ensures that both sets of qualities have the same useful life, and that when the product is technically outmoded it will be so aesthetically. It will not linger on, as does the Bugatti, making forlorn claims to be a perennial monument of abstract art. This, in fact, is the solution to Le Corbusier's dilemma about the imminent death of the 'body that now causes excitement'.

If these products have been designed specifically for transitory beauty according to an expendable aesthetic, then they will fall not into ridicule, but into a calculated oblivion where they can no longer embarrass their designers. It is the Bugatti that becomes ridiculous as an object of use, by making aesthetic claims that persist long after its functional utility is exhausted.

We may now advance as a working hypothesis for a design philosophy this proposition: 'The aesthetics of consumer goods are those of the popular arts.' But this still leaves us with the problem of how such a hypothesis may be put into a working methodology.

Unlike criticism of fine arts, the criticism of popular arts depends on an analysis of content, an appreciation of superficial rather than abstract qualities, and an outward orientation that sees the history of the product as an interaction between the sources of the symbols and the consumer's understanding of them. To quote Bruno Alfieri about the 1947 Studebaker, 'The power of the motor seems to correspond to an aerial hood, an irresistible sensation of speed.' He sees a symbolic link between the power of the motor and the appearance of its housing, and this is made explicit by the use of an iconography based on the forms of jet aircraft. Thus we are dealing with a *content* (idea of power), a *source* of symbols (aircraft), and a *popular culture* (whose members recognize these symbols and their meaning). The connecting element between them is the industrial designer, with his ability to deploy the elements of his iconography – his command and understanding of popular symbolism.

The function of these symbol systems is always to link the product to something that is popularly recognized as good, desirable or exciting – they link the dreams that money can buy to the ultimate dreams of popular culture. In this they are not, as many European critics suppose, specific to America. They can be found in any progressive industrialized society. An example in Italian design is the Alfa Giulietta whose diminutive tail-fins might be defended in terms of body fabrication, the need to carry the tail-lights, or the abstract composition of the side elevation. But how much more effective they are in evoking the world of sports cars and aerodynamic research that is one of the ultimate dreams of automobilism. Not all iconographies are so specific; such concepts as the good life in the open air, the pleasures of sex, and conspicuous consumption are other sources of symbols, and it is clear that the more specific any symbol is, the more discretion must be used in its application.

These trends, which become more pronounced as a culture becomes more mechanized and the mass-market is taken over by middle class employees of increasing education, indicate the function of the product critic in the field of design as popular art: Not to disdain what sells but to help answer the now important question, 'What *will* sell?' Both designer and critic, by their command of market statistics and their imaginative skill in using them to predict, introduce an element of control that feeds back information into industry. Their interest in the field of design-as-popular-symbolism is in the pattern of the market as the crystallization of popular dreams and desire – the pattern as it is about to occur. Both designer and

critic must be in close touch with the dynamics of mass-communication. The critic, especially, must have the ability to sell the public to the manufacturer, the courage to speak out in the face of academic hostility, the knowledge to decide where, when and to what extent the standards of the popular arts are preferable to those of fine arts. He must project the future dreams and desires of people as one who speaks from within their ranks. It is only thus that he can participate in the extraordinary adventure of mass-production, which counters the old aristocratic and defeatist nineteenth-century slogan, 'Few, but roses', and its implied corollary, 'Multitudes are weeds', with a new slogan that cuts across all academic categories: 'Many, because orchids'.

Reyner Banham, 'Epitaph "Machine Aesthetic"', *Industrial Design*, 7 [London, March 1960] 45–58.

Robert ROSENBLUM
Jasper Johns [1960]

The situation of the younger American artist is a particularly difficult one. If he follows too closely the directions established by the 'Old Masters' of that movement inaccurately but persistently described as Abstract Expressionism or Action Painting, he runs the risk of producing only minor embellishments of their major themes. As an alternative approach, he may reconsider the question of a painting's reference to those prosaic realities banished from the Abstract Expressionist universe. Like many younger artists, Jasper Johns has chosen the latter course, yet unlike them, he has avoided the usually tepid compromise between a revolutionary vocabulary of vehement, molten brushwork and the traditional iconography of still lifes, landscapes, or figures. Instead, Johns has extended the fundamental premises rather than the superficial techniques of Abstract Expressionism to the domain of commonplace objects. Just as Pollock, Kline or Rothko reduced their art to the most primary sensuous facts – an athletic tangle of paint, a jagged black scrawl, a tinted and glowing rectangle – so, too, does Johns reduce his art to rockbottom statements of fact. The facts he chooses to paint, however, are derived from a non-aesthetic environment and are presented in a manner that is as startlingly original as it is disarmingly simple and logical.

Consider his paintings of the American flag. Suddenly, the familiar fact of red, white and blue stars and stripes is wrenched from its everyday context and forced to function within the rarified confines of a picture frame. There it stands before us in all its virginity, an American flag accurately copied by hand, except that it now exists as a work of art rather than a symbol of nationalism. In so disrupting conventional practical and aesthetic responses, Johns first astonishes the spectator and then obliges him to examine for the first time the visual qualities of a humdrum object he had never before paused to look at. With unerring logic, Johns can then use this rudimentary image as an aesthetic phenomenon to be explored as Cézanne might study an apple or Michelangelo the human

form. But if this artistic procedure of reinterpreting an external reality is essentially a traditional one, the variations on Johns' chosen theme seem no less extraordinary than its first pristine statement.

To our amazement, the American flag can become a monumental ghost of itself, recognizable in its tidy geometric patterns, but now enlarged to heroic size and totally covered with a chalky white that recalls the painted clapboards of New England houses. No less remarkable, this canvas-flag can be restored to its original colours, but unexpectedly considered as a palpable object in space from which two smaller canvas-flags project as in a stepped pyramid. Or in another variation, the flag, instead of being tripled outward into space, can be doubled vertically, coloured an arid slate-grey, and painted with erratic and nervous brushstrokes that threaten the dissolution of those once immutable geometries of five-pointed stars and parallel stripes.

If we expect to salute flags, we expect to shoot at targets. Johns, however, would have us realize that targets, like flags, can be the objects of aesthetic contemplation and variation. The elementary patterns of concentric circles, as recreated by Johns in a monochromatic green or white target, are to be stared at, not aimed at, and offer the awesome simplicity of irreducible colour and shape that presumes the experience of masters like Rothko, Still and Newman. Again, as with the flags, this symbolic and visual monad can be transformed and elaborated. Such is the case in another target, whose circles are painted in different colours and whose upper border is complicated by a morbid exhibition of plaster body fragments. Or then, there is a target drawing in which, as in the double grey flags, the impetuous movement of the pencil disintegrates the circular perfection of the theme. Johns' capacity to rediscover the magic of the most fundamental images is nowhere better seen than in his paintings of letters and numbers. In 'Gray Alphabets' he makes us realize that the time-worn sequence of A to Z conveys a lucid intellectual and visual order that has the uncomplicated beauty and fascination of the first page of a children's primer. Similarly, the 'Gray Numbers' presents another chart, whose inevitable numerical patterns are visually translated into that ascetic geometric clarity so pervasive in Johns' work. At times, Johns even paints single numbers, as in 'Figure One', in which the most primary of arithmetical commonplaces is unveiled as a shape of monumental order and a symbol of archetypal mystery. Such works look as though they might have been uncovered in the office of a printer who so loved the appearance and strange meaning of his type that he could not commit it to practical use.

If the almost hypnotic power of most of Johns' work is in part the result of his disconcerting insistence that we look at things we never looked at before, it is equally dependent upon his pictorial gifts. In general, he establishes a spare and taut equilibrium of few visual elements whose immediate sensuous impact is as compelling as the intellectual jolt of monumental flags and targets in picture frames; and his colours have a comparable clarity and boldness. Nor should his fastidious technique be overlooked. Most often he works

with a finely nuanced encaustic whose richly textured surface not only alleviates the Puritanical leanness of his pictures, but emphasizes the somewhat poignant fact that they are loved, handmade transcriptions of unloved, machine-made images. Although Johns has devoted most of his young career to the manipulation of target, flag, number and letter themes, he has also made many other discoveries. There are, for example, the chilly expanse of mottled grey geometries that becomes a tombstone for the Victorian poet whose name seems to be carved at its base; and the small open book, transformed from reality to art by the process of painting, and therefore concealing, the print on its page, and by fixing its mundane form in a position of heraldic symmetry within a framed box. And no less inquisitive about the interplay between art and reality are the 'Drawing with Hooks', an intellectual and visual speculation on the curious mutations of two- and three-dimensional illusions when a canvas with two projecting hooks is viewed from both the front and the side; and the more recent 'Thermometer', in which painted calibrations, fixed by the artist's brush, permit us to read on a real thermometer those fluid variations of temperature determined by nature rather than by art.

It remains to be said that Johns' adventurous inquiries into the relationship between art and reality have often been equated with Dada, but such facile categorizing needs considerable refining. To be sure, Johns is indebted to Duchamp (if hardly to other, more orthodox Dadaists), whose unbalancing assaults on preconceptions were often materialized in terms of a comparably scrupulous craftsmanship, yet he is far more closely related to the American Abstract Expressionists. For if he has added the new dimension of prosaic reality to their more idealized realm, he has nevertheless discovered, thanks to them, that in the mid-twentieth century, the simplest visual statements can also be the richest.

Robert Rosenblum, 'Jasper Johns', Art International, 4:7 [New York, September 1960, 74-7; reprinted in Steven Henry Madoff, ed., Pop Art: A Critical History, Berkeley and Los Angeles: University of California Press, 1997] 11-13.

John CAGE
On Robert Rauschenberg, Artist, and His Work [1961]

[...] There is no more subject in a *combine* than there is in a page from a newspaper. Each thing that is there is a subject. It is a situation involving multiplicity. (It is no reflection on the weather that such and such a government sent a note to another.) (And the three radios of the radio combine, turned on, which provides the subject?) Say there was a message. How would it be received? And what if it wasn't? Over and over again I've found it impossible to memorize Rauschenberg's paintings. I keep asking, 'Have you changed it?' And then noticing while I'm looking it changes. I look out of the window and see icicles. There, dripping water is frozen into object. The icicles all go down. Winter more than the

others is the season of quiescence. There is no dripping when the paint is squeezed from a tube. But there is the same acceptance of what happens and no tendency towards gesture or arrangement. This changes the notion of what is beautiful. By fixing papers to canvas and then painting with black paint, black became infinite and previously unnoticed.

Hallelujah! The blind can see again. Blind to what he has seen so that seeing this time is as though first seeing. How is it that one experiences this, for example, with the two Eisenhower pictures which for all intents and purposes are the same?[1] (A duplication containing duplications.) Everything is so much the same, one becomes acutely aware of the differences and quickly. And where, as here, the intention is unchanging, it is clear that the differences are unintentional, as unintended as they were in the white paintings where nothing was done. Out of seeing do I move into poetry? And is this a poetry in which Eisenhower could have disappeared and the Mona Lisa taken his place? I think so but I do not see so. There is no doubt about which way is up. In any case our feet are on the ground. Painting's place is on the wall, painting's place, that is, in process. When I showed him a photograph of one of Rauschenberg's paintings, he said, 'If I had a painting, I'd want to be sure it would stay the way it is; this one is a collage and would change.' But Rauschenberg is practical. He goes along with things just as they are. Just as he knows it goes on a wall and not any which way, but right side up, so he knows, as he is, it is changing (which one more quickly? and the pyramids change). When possible, and by various means, he gives it a push: holes through which one sees behind the canvas the wall to which it is committed; the reflective surfaces changing what is seen by means of what is happening; lights going on and off[2] and the radios. The white paintings were airports for the lights, shadows and particles. Now in a metal box attached by a rope, the history kept by means of drawings of what was taken away and put in its place, of a painting constantly changing.

There is in Rauschenberg, between him and what he picks up to use, the quality of encounter. For the first time. If, as happpens, there is a serries of paintings containing such and such a material, it is as though the encounter was extended into a visit on the part of the stranger (who is divine). (In this way societies uninformed by artists coagulate their experiences into modes of communication in order to make mistakes.) Shortly the stranger leaves, leaving the door open.

Having made the empty canvases (*A canvas is never empty*), Rauschenberg became the giver of gifts. Gifts, unexpected and unnecessary, are ways of saying yes to how it is, a holiday. The gifts he gives are not picked up in distant lands but are things we already have (with exceptions, of course: I needed a goat and the other stuffed birds,[3] since I don't have any, and I needed an attic in order to go through the family things (since we moved away, the relatives write to say: do you still want them?), and so we are converted to the enjoyment of our

possessions. Converted from what? From wanting what we don't have, art as pained struggle. Setting out one day for a birthday party I noticed the streets were full of presents. Were he saying something particular he would have to focus the painting; as it is he simply focuses himself, and everything, *a pair of socks*, is appropriate, appropriate to poetry, a poetry of *infinite possibilities*. It did not occur to me to ask him why he chose Dante as a project for illustration. Perhaps it is because we've had it around so long so close to us without bothering to put it to use, which becomes its meaning. It involved a stay in Florida and at night looking for help a walk through land infested with rattlesnakes. Also slipping on a pier, gashing his shin, hanging, his foot caught, not yelling for help. The technique consists in having a *plan: Lay out stretchers on floor watch markings and join.*[4] Three stretchers with the canvas on them no doubt already stretched. Fulfilling this plan put the canvas in direct contact with the floor, the ground thereby activated. This is pure conjecture on my part but would work. More important is to know exactly the size of the door and techniques for getting a canvas out of the studio. (*Combines* don't roll up.) Anything beyond that size must be suitably segmented [...]

By now we must have gotten the message. It couldn't have been more explicit. Do you understand this idea? : *Painting relates to both art and life. Neither can be made.* (*I try to act in that gap between the two.*) The nothingness in between is where for no reason at all every practical thing that one actually takes the time to do so stirs up the dregs that they're no longer sitting as we thought on the bottom. All you need do is stretch canvas, make markings, and join. You have then turned on the switch that distinguishes man, his ability to change his mind: *If you do not change your mind about something when you confront a picture you have not seen before, you are either a stubborn fool or the painting is not very good.* Is there any need before we go to bed to recite the history of the changes and will we in that bed be murdered? And how will our dreams, if we manage to go to sleep, suggest the next practical step? Which would you say it was: wild, or elegant, and why? Now as I come to the end of my rope, I notice the colour is incredibly beautiful. And that embossed box [...]

1 *Factum I* and *Factum II* [1957].

2 *Charlene* [1954].

3 *Odalisque* [1955] and *Canyon* [1959].

4 *Coca-Cola Plan* [1958].

John Cage, 'On Robert Rauschenberg, Artist, and his Work', Metro, 2 [Milan, 1963, 37-51; reprinted in John Cage, Silence: Lectures and Writings, London: Calder & Boyars, 1968] 41-6.

John CAGE Jasper Johns: Stories and Ideas [1963]

Passages in italics are quotations from Jasper Johns found in his notebooks and published statements.

On the porch at Edisto. Henry's records filling the air with Rock-n-Roll. I said I couldn't understand what the singer was saying. Johns (laughing): That's because you don't listen.

Beginning with a flag that has no space around it, that has the same size as the painting, we see that it is not a painting *of* a flag. The roles are reversed: beginning with the flag, a painting was made. Beginning, that is, with structure, the division of the whole into parts corresponding to the parts of a flag, a painting was made which both obscures and clarifies the underlying structure. A precedent is in poetry, the sonnet: by means of language, caesurae, iambic pentameter, license and rhymes to obscure and clarify the grand division of the fourteen lines into eight and six. The sonnet and the United States flag during that period of history when there were forty-eight? These are houses, Shakespeare in one, Johns in the other, each spending some of his time living. I thought he was doing three things (five things he was doing escaped my notice).

He keeps himself informed about what's going on particularly in the world of art. This is done by reading magazines, visiting galleries and studios, answering the telephone, conversing with friends. If a book is brought to his attention that he has reason to believe is interesting, he gets it and reads it (Wittgenstein, Nabokov, McLuhan). If it comes to his notice that someone else had one of his ideas before he did, he makes a mental or actual note not to proceed with his plan. (On the other hand, the casual remark of a friend can serve to change a painting essentially.) There are various ways to improve one's chess game. One is to take back a move when it becomes clear that it was a bad one. Another is to accept the consequences, devastating as they are.

Johns chooses the latter even when the former is offered. Say he has a disagreement with others; he examines the situation and comes to a moral decision. He then proceeds, if to an impasse, to an impasse. When all else fails (and he has taken the precaution of being prepared in case it does), he makes a work of art devoid of complaint.

Sometimes I see it and then paint it. Other times I paint it and then see it. Both are impure situations, and I prefer neither.

Right conduct. He moved from objecting to not objecting. Things beneath other people to do are not that way for him. America. Walking with him in the garden of the Museum of Modern Art, she said, 'Jasper, you must be from the Southern Aristocracy.' He said, 'No, Jean, I'm just trash.' She replied, 'It's hard to understand how anyone who's trash could be as nice as you are.' Another lady, outraged by the beer cans that were exhibited in the gallery, said, 'What are they doing here?' When Johns explained that they were not beer cans but had taken him much time and effort to make, that if she examined them closely she would notice among other things fingerprints, that moreover she might also observe that they were not

the same height (i.e. had not come off an assembly line), why, he asks, was she won over? Why does the information that someone has done something affect the judgment of another? Why cannot someone who is looking at something do his own work of looking? Why is language necessary when art so to speak already has it in it? 'Any fool can tell that that's a broom.' The clothes (conventions) are underneath. The painting is as naked as the day it was born. What did I say in Japan? That the Mona Lisa with moustache or just anything plus a signature equals addition, that the erased De Kooning is additive subtraction, that we may be confident that someone understands multiplication, division, calculus, trigonometry? Johns.

The cigars in Los Angeles that were Duchamp-signed and then smoked. Leaning back, his chair on two legs, smiling, Johns said: My beer cans have no beer in them. Coming forward, not smiling, with mercy and no judgment he said: I had trouble too; it seemed it might be a step backward. Whenever the telephone rings, asleep or awake he never hesitates to answer. *An object that tells of the loss, destruction, disappearance of objects. Does not speak of itself. Tells of others. Will it include them? Deluge.*

Why this palaver about structure? Particularly since he doesn't need to have any, involved as he is with process, knowing that the frame that will be put around the all that he makes will not make the environment invisible? Simply in order to make clear that these flags-numbers-letters-targets are not subjects? (That he has nothing to say about them proves that they are not subjects rather than that he as a human being is absent from them [...])

John Cage, 'Jasper Johns: Stories and Ideas', *Jasper Johns* [New York: The Jewish Museum, 1964].

Lawrence ALLOWAY
The Development of British Pop Art [1966]

Pop art has been linked to mass communication in facetious ways as well as in straight arguments: references to the mass media in Pop art have been made the pretext for completely identifying the source with its adaptation. It is supposed to follow from this that the Pop artists are identical to their sources. There is a double flaw in the argument: an image in Pop art is in a new context, at the very least, and this is a crucial difference; and, in addition, the mass media are more complex and less inert than this view presupposes. The quick fame of *some* of the artists has been compared maliciously with the here-tonight, gone-tomorrow public life of *some* performers, such as singers on 45-records or the blankest of starlets. In the late 1940s and early 1950s, American abstract art created new references for art and for its spectators, whereas in the subsequent decade this normative function has belonged to Pop art. Instead of such influential propositions that have been generally absorbed ('When is a painting

finished?' 'How little can a painting be made of?'), other propositions have arisen from Pop art: How close to its source can a work of art be and preserve its identity? How many kinds of signs can a work of art be at once?

The subject is one I feel close to because I was around during the development of English Pop art and a witness to the expansion of American Pop art in the 1960s. I have no great desire to write in the first person, but as the literature on the subject is incomplete (and rarely consulted), and as I knew the artists, a first-hand chronicle is probably the best way for me to write about a less-than-charted scene. The term 'Pop art' is credited to me, but I don't know precisely when it was first used. (One writer has stated that 'Lawrence Alloway first coined the phrase "Pop art" in 1954';[2] this is too early.) Furthermore, what I meant by it then is not what it means now. I used the term, and also 'Pop Culture', to refer to the products of the mass media, not to works of art that draw upon popular culture. In any case, sometime between the winter of 1954–55 and 1957 the phrase acquired currency in conversation, in connection with the shared work and discussion among members of the Independent Group (see below).

Misrepresentation of British Pop art has been widespread. Critical lethargy apparently prevents a check of the events of the 1950s. Take the following sentence by Martin Friedman:[3] 'Peter Blake (along with Richard Hamilton) was one of the British progenitors of Pop art which evolved during the mid-1950s *more or less* simultaneously in England and America' (my italics). In fact, Blake and Hamilton, as Pop artists, are in every way unlike one another: they have different sources, different references, a different speed. Furthermore, they are not even 'progenitors', they *are* Pop artists, whereas an artist who *is* a 'progenitor' of great importance, Eduardo Paolozzi, is not even mentioned by Friedman. Another quotation that shows lack of contact with the subject comes from Alan Solomon:[4] 'One of the most unfortunate and destructive accidents, destructive because it has caused so much public confusion, is the attachment of the term "Pop art" to this group. The term Pop art originated in England, in reference to a group of artists who were much more committed to a consciousness of their own social restlessness and to a sense of the need for alteration of established values' than 'American painters, who simply take life as they find it; who, instead of derogating and rejecting our vulgar civilization, set out optimistically to celebrate it on a basis of their own devising.' Aside from Solomon's strange belief that the label rather than the works of art themselves caused 'public confusion', he is clearly inattentive to the realities of British Pop art which are subordinated crudely to his thesis. The fact is that the term Pop art did not originate 'in reference to a group of artists', nor were English artists in opposition to popular culture (as we called it, rather than 'vulgar civilization').

A potent preliminary move in the direction of Pop art in England occurred from 1949 to 1951, the period in which Francis Bacon began using photographs in his work. A series of screaming heads which derived, partially, from a still from the film Battleship Potemkin: the image of the nurse wounded in the eye, with broken pince-nez, in the Odessa steps sequence. Though mixed with other

elements, the photographic reference was conspicuous and much discussed at the time. Bacon followed it up by using other photographic sources, particularly the motion studies of people and animals made in the 1890s by Eadweard Muybridge.[5] Bacon's use of mass-media quotations differs from earlier uses by painters, in that recognition of the photographic origin of the image is central to his intention. In fact, his art at this time depended on being stretched between the formal painting style of the grand manner and topical, photographically derived episodes of motion or violence. It should be remembered that Bacon was the only British painter of an earlier generation who was regarded with respect by younger artists in London. Moore, Nicholson, Pasmore, Sutherland (the equivalent in age of de Kooning, Newman, Pollock, Still) were considered to be irrelevant to any new art in the 1950s.[6] The use of the photographic source, its quotation and partial transformation, is, of course, central to later developments in Pop art, though Bacon himself is clearly not a Pop artist.

The photograph, as a document of reality and a source of fantastic imagery, was to be taken far beyond Bacon's use of it to evoke the texture of reality. There existed, perhaps, some feeling that admirable as Bacon was, *Potemkin* was an old movie and not a new one, and Muybridge, though magical, was a period figure. In an exhibition called 'Parallel of Life and Art', a collection of 100 images at the Institute of Contemporary Arts in London, in 1953, the range of photographic sources was suddenly exploded. The show included a motion study (Marey instead of Muybridge, a nude man on a bicycle) and also X-ray, high-speed, and stress photographs, anthropological material, and children's art. The images were blown up photographically and hung on the gallery walls, from the ceiling, and as screens to surround the spectator environmentally. The maze form made it possible to create a non-hierarchic profusion of images from all sources. The show was organized by Paolozzi, photographer Nigel Henderson, and architects Alison and Peter Smithson, all of whom were subsequently connected with the study of Pop culture in England. Henderson contributed technical knowledge, but also his own photographs of graffiti and detritus. (His photographs of street games, though not included in the exhibition, expressed a growing interest in activity rather than in theory, in records rather than in ideals.) Similarly, the Smithsons went some way to replace Palladian Man and Modular Man by glamorous images of the home from slick magazines,[7] though it is doubtful that, in the long run, this seriously modified the professionalism of the trained architect.

The Institute of Contemporary Arts was, at this time, a meeting place for young artists, architects, and writers who would not otherwise have had a place of contact, London having neither a café life like that of Paris nor exhibition openings such as in New York. A small and informal organization, the Independent Group (IG), was set up within the Institute for the purpose of holding exploratory meetings to find ideas and new speakers for the public programme. It was first convened in winter 1952–53 by Peter Reyner Banham; the theme of the programme was techniques. The one meeting that I was invited to (I didn't go) was on helicopter design. The IG missed a year and then was reconvened in winter 1954–55 by John McHale and myself on the theme of popular culture. This topic was arrived at as the result of a snowballing conversation in London which involved Paolozzi, the Smithsons, Henderson, Reyner Banham, Hamilton, McHale and myself. We discovered that we had in common a vernacular culture that persisted beyond any special interest or skills in art, architecture, design or art criticism that any of us might possess. The area of contact was mass-produced urban culture: movies, advertising, science fiction, Pop music. We felt none of the dislike of commercial culture standard among most intellectuals, but accepted it as a fact, discussed it in detail and consumed it enthusiastically. One result of our discussions was to take Pop culture out of the realm of 'escapism', 'sheer entertainment', 'relaxation', and to treat it with the seriousness of art. These interests put us in opposition both to the supporters of indigenous folk art[8] and to anti-American opinion in Britain.

Hollywood, Detroit and Madison Avenue were, in terms of our interests, producing the best popular culture. Thus expendable art was proposed as no less serious than permanent art; an aesthetics of expendability (the word was, I think, introduced by Banham) aggressively countered idealist and absolutist art theories. Subjects of the IG in the 1954–55 season included: Banham on car styling (Detroit and sex symbolism); the Smithsons on the real dreams of ads versus architectural ideals; Richard Hamilton on consumer goods; and Frank Cordell on popular music (he actually made it). In one way or another, the first phase of Pop art in London grew out of the IG. Paolozzi was a central figure, as were William Turnbull, Theo Crosby and Toni del Renzio. Meetings were always very small, and by the end of the season we all knew one another's ideas so well that one of the last meetings turned into a family party with everybody going to the cinema instead [...]

1 A motive for this kind of hostility is art critics'
 traditional fear of art quantified by reproduction
 techniques and twentieth-century distribution patterns.
 Two writers who discuss the implications and the
 processes, repectively, of the quantification of art are
 André Malraux [in the 'Musée imaginaire' section of
 Psychologie de l'art] and William M. Ivins, jnr., in
 Prints and Visual Communication [London, 1954]. It is
 essential to distinguish between such writers and those
 who merely contribute to the mass media, e.g., newspaper
 critics. Journalists are habitually as conservative and
 elite-minded as critics in small-circulation journals
 [though they may aim at different elites]. For
 objections to quantification see Edgar Wind, *Art and
 Anarchy* [London, 1963; New York, 1964]; and Harold
 Rosenberg, *The Anxious Object* [New York, 1964; London,
 1965].

2 Jasia Reichardt, Pop Art and After', *Art International*,
 VIII: 2 [Lugano, 1963].

3 *London: The New Scene* [Walker Art Center, Minneapolis,
 1965].

4 Alan Solomon, 'The New American Art', *Art International*,
 VIII: 2 [1963].

5 Ronald Alley, catalogue notes in John Rothenstein,
 Francis Bacon [London and New York, 1964].

6 The reputation of Victor Pasmore is in some ways an
 exception to the split between the generations: his
 wayward experimentalism as he gave up painting and
 adopted a version of Constructivism [1951-54] was
 discussed, though not emulated, by younger artists.

7 Alison and Peter Smithson, 'But Today We Collect Ads',
 Ark, XVIII [London, 1957].

8 For urban folk art as craft, see John Piper's study of
 engraved glass in *Victorian Pubs, Buildings and
 Prospects* [London, 1949]; also Barbara Jones organized
 an exhibition 'Black Eyes and Lemonade' [Whitechapel Art
 Gallery, 1951], gathering folk art and working-class
 objets d'art. For a pre-Independent Group discussion of
 the exhibition, see *Athene*, the Journal of the Society
 for Education in Art [London, August 1951]. This area is
 separated from Pop art by a tendency to see Victoriana as
 something bizarre and amusing, whereas Pop artists use
 newer if not absolutely current objects and images. They
 view popular culture straight, not nostalgically; in
 London, Peter Blake is the main exception to this rule,
 attracted to old Valentines as well as to the Everly
 Brothers.

Lawrence Alloway, 'The Development of British Pop Art', in
Lucy R. Lippard, *Pop Art* [London: Thames & Hudson, 1966] 27-
32.

Greil MARCUS
No Money Down: Pop Art,
Pop Music, Pop Culture [2002]

[...] Eduardo Paolozzi was the most playful, aesthetically omnivorous member of England's Independent Group – the small post-war combine of architects, visual artists and critics who were drawn to the commercial imagery of American culture, who could not see themselves in what Independent Group member Richard Hamilton called 'hard-edged American painting': Abstract Expressionism, Jackson Pollock, the new art everyone was supposed to be thrilled by. With rationing still a fact of daily life in Britain, the Independent Group was eager to get out of the War, out of the post-war, into a new, real life.

As an artist, Paolozzi was already living it. 'Wherever he went', his Independent Group comrade Lawrence Alloway remembered, 'he was, you know, bending things, drawing things, turning paper plates into something, so that he was habitually an improvising working artist ... He was kind of someone who had this itchy creativity on a continuous basis, always being bombarded by mass media imagery.'

'Bombarded' is probably the wrong word – though Alloway's choice of it tells you a lot about how he saw pop culture. 'Bombarded' means attacked, inundated, smashed. The glee, the promiscuousness with which Paolozzi scavenged for his images – images taken from women's magazines, advertisements, comic books –

suggests it would be closer to the mark to say he was always exposing himself to mass-media imagery. It might be closer than that to say Paolozzi was swimming in it – like Carl Barks's Uncle Scrooge, swimming through oceans of coins in his money bin. Like the Berlin dada collage artist Hannah Höch, swimming through the imagery of her own post-war, in the 1920s, yes, criticizing the subjugation of women, satirizing gender roles, but also revelling in fashion and style, shoes and make-up.

Walter Benjamin spoke of 'Art in the Age of Mechanical Reproduction'; what you can see in Paolozzi's work is the thrill of mechanical reproduction. At the centre of his collage *I Was a Rich Man's Plaything* is the cover of an issue of *Intimate Confessions*, with a smiling woman in a skimpy red dress and black stockings, her legs drawn up to her chest. Pasted in is a man's hand holding a big, ugly, fearsome-looking handgun to to the head of the rich man's plaything – unless she is, as described on the right side of the magazine cover, the 'Ex-Mistress', the 'Woman of the Streets', or the 'Daughter of Sin', or unless they're all the same person. Out of the barrel of the gun comes a cloud of smoke and the word 'POP!' There's cherry pie and Coca-Cola, the logo 'Real Gold' and a fighter plane.

'I think we were fundamentally anti-pop', the architect Peter Smithson of the Independent Group said in 1976. 'That is', he said, 'the interest in current phenomena, current imagery – imagery that was thrown up by production, by advertising, and so on, that was studied by the Independent Group – each person in the group was studying it for his own reasons. One emerges from it as one went into it, with more information, with one's lines established. But certainly, those who used the information directly – it was like, isn't that a handsome picture of a handsome layout which I could parody for a fine art picture?'

It's no fun to read this today – 'one emerges from it' as if from a swamp, from the modern market in which people actually live, 'as one went into it', confirmed in one's conviction that one cannot be changed by the market, that one is immune to it, superior to it. 'One's lines' are 'established' – that is, one's distance from the world in which people actually live is plotted on a map. But you don't feel any of this coming out of Paolozzi's work. You feel that thrill of mechanical reproduction – the collage-maker, the guy who saw *Intimate Confessions* on the news stand and said to himself, *I have to have that*, who then brought it home and said, *Now, what am I going to do with this?*

This is someone who liked to argue with what wasn't yet called pop culture – the cheap, fast sounds and images that in the years immediately after the Second World War seemed to be coming together everywhere, the sounds and images connecting to each other in ways that seemed at once natural and inexplicable, the artefacts of this emerging folk culture of the modern market speaking in code, speaking a secret language. Cutting and pasting, Paolozzi is someone who is trying to learn that language and speak it himself.

The thrill of mechanical reproduction – in Paolozzi's post-war collages you can sense someone saying, *This stuff is out there, everyone is seeing it, everyone is*

responding to it, I am responding to it. I'm turned on by the woman on the cover of this month's 'Intimate Confessions', but I'll bet someone else is much more excited by a Coca-Cola bottle – and not in a different way. I've got to do something with my reaction – I've got to make it into my own language. I've got to tell people about this. I've got to make this into something so I don't forget it – not the magazine, I can keep that, but the feeling I had when I saw it on the news stand this morning.*

'I don't make the mistake of assuming that because people like cheap art, their feelings are cheap, too', the late filmmaker Dennis Potter once said, explaining why pop songs were so important in his work, from *Pennies from Heaven* to *The Singing Detective* to *Lipstick on Your Collar*, his paean to the time he shared with the Independent Group – and Potter was also defining the pop ethos, defining what I think is happening in Paolozzi's collage. 'When people say, "Oh, listen, they're playing our song"', Potter said, 'they don't mean, "Our song, this little cheap, tinkling, syncopated piece of rubbish is what we felt when we met." What they're saying is, "That song reminds me of the tremendous feeling we had when we met." Some of the songs I use are great anyway, but the cheaper songs are still in the direct line of descent from David's Psalms.'

Chuck Berry's 'No Money Down' is a follow-up to his first hit, the 1955 'Maybellene'. In that first song the singer is chasing Maybellene's Cadillac in his beat-up Ford – he catches her, but the chase draws the Ford's last breath. So now he's down at the dealer's – to buy his own Cadillac. The use of a melodramatic, stop-time beat later used for the theme of the *Pink Panther* movies, with Peter Sellers as Inspector Clouseau – Da Dadada *Da* Da ... Da ... – lets Berry open the story in the slyest, most confiding voice, as if a crime is about to be committed. *This is a great story*, he's whispering. *This is much too good to tell out loud. You won't believe what I got away with.*

The car salesman tells Berry he can have whatever he wants – in an hour. Sounds good: Berry starts off demanding a yellow convertible. He wants a big motor – with 'Jet off-take.' The salesman doesn't blink; Berry doesn't slow down. In fact he picks up the pace, and now you can see everyone in the bar, on the street, wherever it is that he's telling this story, gathering around to hear what happens next, what's at stake, who wins, who loses. Now the storyteller is practically a preacher, offering salvation: What it is – how to get it.

I told the car dealer, Berry says, *that I wanted a complete fold-out bed in my back seat – and before he could get a word out I told him what else I wanted:*

> I want short-wave radio
> I want a TV and a phone

– it's 1956, but he knows what he wants –

> I want four carburetors
> Two straight exhausts
> I'm burning aviation fuel
> No matter what the cost
> I want railroad air horns

> And a military spot
> And I want a five-year guarantee
> On everything I got

Then he gets down to the money, time for serious business, no kidding around:

> I want ten-dollar deductible
> I want twenty-dollar notes
> I want 35 liability
> And that's all she wrote!

Now, this is as much a fantasy, a montage of advertisements and commercial slogans, as *I Was a Rich Man's Plaything*. If Eduardo Paolozzi and Chuck Berry aren't speaking exactly the same language – and they might be – they can certainly talk to each other, each telling the other stories he'd want to hear, and pass on. But the kind of apology, explanation, and rescue job one has to perform on Paolozzi, if you see his work as I do – rescuing him from the doubts and fears of those around him – would be completely meaningless with 'No Money Down'. It would be ridiculous. In terms of detail, layering, recolouring, collage, glamour and speed, in Chuck Berry's 'No Money Down' – or his 'You Can't Catch Me' or 'No Particular Place to Go', or for that matter K.C. Douglas's 'Mercury Blues', or the Beach Boys' '409' or 'Fun, Fun, Fun' – there's no apparent distance at all.

Whatever distance or irony there might have been in anyone's intention – Chuck Berry's, K.C. Douglas's, Brian Wilson's – is long gone before the song ever gets out into the world, to the public, into the market, where people will start talking about it. After all, in the terms of the market, car songs are part car, and cars are part car songs: you hear them in the car.

Lawrence Alloway's questions of aesthetics – his speaking of establishing one's lines, of 'isn't that a handsome picture of a handsome layout which I could parody for a fine art picture' – are really questions of ethics: how one remains clean. Such a question can hardly come up in pop music, which when it began, in the 1950s, was not only part car. With payola – with small, regional, independent record labels like Berry's Chess in Chicago, Elvis Presley's Sun in Memphis, or the Penguins' Dootone in Los Angeles paying disc jockeys to play their records, the only way they could get their records on a radio dominated by huge New York corporations like Columbia and RCA – with bribery, lies, manipulation and even extortion, pop music was part used car salesman.

In 1991, Kirk Varnedoe, then curator of painting and sculpture at the Museum of Modern Art in New York, published a book called *A Fine Disregard: What Makes Modern Art Modern*. The title – and the theory it spoke for – came from a stone marker that stands at the gates of the Rugby School in England, one of the most elite, exclusive, and aristocratic schools in the world. Varnedoe rests all of modern art on this stone, which commemorates the exploits of one William Ellis Webb, who, in 1823, 'With' the stone says, 'a fine disregard for the rules of football as played in his time, first took the ball in his arms and ran

with it, thus originating the distinctive feature of the rugby game.'

It seems to me that the determinant word here is less 'disregard' – for rules, expectations, and so on – than 'fine'. That is, we are being reassured that modern art remains *art*. More than that: we are being reassured that it remains the province of the sort of people who for centuries have attended the Rugby School – or who sit on the boards of art museums. We are being told modern art will not go too far – say 'disregard' without a modifier, after all, and you have no idea what kind of riff-raff you might have to let in next.

We are being told that we can keep one sort of art here and another sort of art over there, based on class, intent, and attitude – the class, intent, and attitude of the audience as well as the artist. 'A fine disregard' – art remains the province of those fine enough to appreciate it on the terms on which it should be appreciated.

It's because of this idea of what art is, and what it is for – and I am singling out Kirk Varnedoe only because he gave such a precise voice to what is, in fact, a vast chorus – that there is, I think, really very little true pop visual art: very little that actually tells stories of and in the modern market, that does not keep its distance – its distance from the images it seizes, its distance from the noise it seeks to replicate, its distance from the speed, flash and glamour it wishes to capture and contain: its distance from itself.

The 1990 show 'High and Low', curated by Kirk Varnedoe and Adam Gopnik – we're back at the Museum of Modern Art – exhibited works of pop art alongside their 'handsome picture of a handsome layout which I could parody for a fine art picture' sources. I was curious to go, because I had never understood why George Herriman's *Krazy Kat* comic strips, or *Steve Canyon* and *True Romance* comic books, were lesser art – or, rather, why they were not greater art – than the pop art classics Philip Guston and Roy Lichtenstein made of them.

Displayed together, there was one undeniable difference: the Guston and Lichtenstein pictures were much bigger. I remembered the San Francisco painter, filmmaker and assemblage artist Bruce Conner once saying he had to leave New York because he liked to work on what he called real scale – and because of the cost of living in New York when he left in the 1950s, Conner said, he would have had to work on Roy Lichtenstein scale. Here it was.

I looked at the huge pictures, still baffled. What was added, or for that matter taken away? Where was the critical vision – or any vision, beyond that of the original artists? There's no equivalent in Lichtenstein's remakes of *Steve Canyon* and *True Romance* panels to what members of the Situationist International were doing with them in Paris at the same time.

The Situationist International was a tiny, revolutionary circle of critics, so extreme they celebrated the 1965 Watts riots as 'a critique of urban planning'. They also had a sense of humour. They photocopied favourite comics panels – and put new words in the speech balloons, thus forcing square-jawed Steve and teary Priscilla to speak of alienation and the Paris Commune as if people actually cared about such things. By contrast, what Lichtenstein offered was not rewriting but, in that word utterly loaded with elitism, privilege, entitlement – with droit de seigneur – appropriation. The artist is saying, *I myself have found this image strangely appealing, powerful, odd, perverse, charming, amusing. Now I'll translate it – or, really give it voice, let it speak to the audience that matters, because on its own terms, and our terms, it is mute. I will give it the imprimatur of art – otherwise, it will pass as if it had never been.*

This is not pop art – art that wants to, that can, that does tell stories about the modern market of which it is a part, or that, in whatever manner, it wishes to join – and it is not art that can really hear the stories the market is telling. This art – like Robert Rauschenberg's collages – I always think of the lifeless *Retroactive 1*, from 1964, with John F. Kennedy pointing a finger at the center and an astronaut in the top left corner, but even Rauschenberg's much better work, such as the 1963 *Kite*, is not really different – or I think of James Rosenquist's collage murals, such as his 1960–61 *President Elect*, unless it was, as it has been recently argued, 1964: Kennedy smile, chocolate cake, Chevrolet – this art is all distance.

You can see, you can feel this distance dissolve when what's before you is a kind of frenzy of recombination, of translation, of an artist diving all the way into his or her material, certain there is a secret in the noise and speed and promises of post-war life, certain that the artist can find the secret and make it into a story anyone can understand.

A few – not many – did their work here. As opposed to Rauschenberg's this-stuff-in-our-cultural-atmosphere-is-sort-of-weird-to-me-it-ought-to-be-sort-of-weird-to-you, Richard Hamilton's unmatched House Beautiful collage – his famous *Just what is it that makes today's homes so different, so appealing?* – which is a much better way of asking the question 'What makes modern art modern?' – this picture is almost real life. You can't look at this and just get it, mentally write it up, which is to say write it off: establish your own distance from it […]

Greil Marcus, extract from 'No Money Down: Pop Art, Pop Music, Pop Culture' [2002, previously unpublished].

CONSUMER CULTURE Coincident with the emergence of

Pop art as a phenomenon, especially in New York, artists themselves became their own best advocates. Some wrote articulate and poetic manifestos (Claes Oldenburg, Gerhard Richter), while Donald Judd provided the most rigorous kind of published peer review. The interview form, transcribed from lecture panels or radio discussions, became a ready means to describe and debate their own practice, sometimes brilliantly parodied and undermined by Andy Warhol. From 1968 *Rolling Stone* and Warhol's own *Interview* magazine systematized the genre into a fundamental basis of celebrity culture.

Pierre RESTANY
The New Realists [1960]

In vain do wise academicians or honest people, scared by the acceleration of art history and the extraordinary toll of our modern age, try to stop the sun or to suspend time's flight by running counter to the hands on a watch.

We are witnessing today the depletion and sclerosis of all established vocabularies, of all languages, of all styles. Individual adventures which are still scarce in Europe and America confront this deficiency — by exhaustion — of traditional means, and regardless of their scope, they tend to define the normative bases of a new expressivity.

It is not about an additional formula for oil or enamel media. Easel painting (like no other means of classical expression in painting or sculpture) served its time. It now lives out the last seconds, still occasionally sublime, of a long monopoly.

What else is proposed? The thrilling adventure of the real perceived in itself and not through the prism of conceptual or imaginative transcription. What distinguishes it? The introduction of a sociological relay to the essential stage of communication. Sociology comes to the rescue of consciousness and chance, whether with a choice of poster defacement, the look of an object, household garbage or salon scraps, the unleashing of mechanical affectivity, the diffusion of sensitivity beyond the limits of its perception.

All these adventures (both present and future) abolish the abusive distance created between general objective contingency and individual expressive urgency. The whole of sociological reality, the common good of human activity, the large republic of our social exchanges, of our commerce in society, is summoned to appear. There

should be no doubts about its artistic vocation, if there were not still as many people who believed in the eternal immanence of pseudo-noble genres and painting in particular.

At the more essential stage of total affective expression and the exteriorization of the individual creator, and through the naturally baroque appearances of certain experiences, we make our way towards a neo-realism of pure sensitivity. Therein lies at the least one of the paths for the future. With Yves Klein and Tinguely, Hains and Arman, Dufrêne and Villeglé, some very diverse premises have been stated in Paris. The ferment is fertile, as yet unpredictable in its total consequences, and certainly iconoclastic (due to the icons themselves and the stupidity of their worshippers).

Here we are up to our necks in the bath of direct expressivity and at forty degrees above dada zero, without any aggression complex, without typical polemic desire, without other justifying urges except for our realism. And that works, positively. If man succeeds in reintegrating himself into the real, he identifies the real with his own transcendence, which is emotion, sentiment, and finally, poetry.

Pierre Restany, 'Les Nouveaux Réalistes', preface to the exhibition catalogue *Arman, Dufrêne, Hains, Yves le Monochrome, Tinguely, Villeglé* [Milan: Galleria Apollinaire, 16 April 1960; reprinted in *Les Nouveaux Réalistes*, Paris: Musée d'art moderne de la Ville de Paris, 1986; trans. Martha Nichols, in Kristine Stiles and Peter Selz, eds, *Theories and Documents of Contemporary Art*, Berkeley and Los Angeles: University of California Press, 1996] 306-7.

Claes OLDENBURG
I Am for an Art … [1961]

I am for an art that is political-erotical-mystical, that does something other than sit on its ass in a museum.

I am for an art that grows up not knowing it is art at all, an art given the chance of having a starting point of zero.

I am for an art that embroils itself with the everyday crap & still comes out on top.

I am for an art that imitates the human, that is comic, if necessary, or violent, or whatever is necessary.

I am for an art that takes its form from the lines of life itself, that twists and extends and accumulates and spits and drips, and is heavy and coarse and blunt and sweet and stupid as life itself.

I am for an artist who vanishes, turning up in a white cap painting signs or hallways.

I am for art that spills out of an old man's purse when he is bounced off a passing fender.

I am for the art out of a doggy's mouth, falling five stories from the roof.

I am for the art that a kid licks, after peeling away the wrapper.

I am for an art that joggles like everyone's knees, when the bus traverses an excavation.

I am for art that is smoked, like a cigarette, smells, like a pair of shoes.

I am for art that flaps like a flag, or helps blow noses, like a handkerchief.

I am for art that is put on and taken off, like pants, which develops holes, like socks, which is eaten, like a piece of pie, or abandoned with great contempt, like a piece of shit.

I am for art covered with bandages. I am for art that

I am for an art that is political-erotical-mystical, that does something other than sit on its ass **in a museum**

Claes OLDENBURG, I Am for an Art ... [1961]

limps and rolls and runs and jumps. I am for art that comes in a can or washes up on the shore.

I am for art that coils and grunts like a wrestler. I am for art that sheds hair.

I am for art you can sit on. I am for art you can pick your nose with or stub your toes on.

I am for art from a pocket, from deep channels of the ear, from the edge of a knife, from the corners of the mouth, stuck in the eye or worn on the wrist.
I am for art under the skirts, and the art of pinching cockroaches.

I am for the art of conversation between the sidewalk and a blind man's metal stick.

I am for the art that grows in a pot, that comes down out of the skies at night, like lightning, that hides in the clouds and growls. I am for art that is flipped on and off with a switch.

I am for art that unfolds like a map, that you can squeeze, like your sweety's arm, or kiss, like a pet dog. Which expands and squeaks, like an accordion, which you can spill your dinner on, like an old tablecloth.

I am for an art that you can hammer with, stitch with, sew with, paste with, file with.

I am for an art that tells you the time of day, or where such and such a street is.

I am for an art that helps old ladies across the street.

I am for the art of the washing machine. I am for the art of a government cheque. I am for the art of last war's raincoat.

I am for the art that comes up in fogs from sewer-holes in winter. I am for the art that splits when you step on a frozen puddle. I am for the worm's art inside the apple. I am for the art of sweat that develops between crossed legs.

I am for the art of neck-hair and caked tea-cups, for the art between the tines of restaurant forks, for the odour of boiling dishwater.

I am for the art of sailing on Sunday, and the art of red and white gasoline pumps.

I am for the art of bright blue factory columns and blinking biscuit signs.

I am for the art of cheap plaster and enamel. I am for the art of worn marble and smashed slate. I am for the art of rolling cobblestones and sliding sand. I am for the art of slag and black coal. I am for the art of dead birds.
I am for the art of scratchings in the asphalt, daubing at the walls. I am for the art of bending and kicking metal and breaking glass, and pulling at things to make them fall down.

I am for the art of punching and skinned knees and sat-on bananas. I am for the art of kids' smells. I am for the art of mama-babble.

I am for the art of bar-babble, tooth-picking, beerdrinking, egg-salting, in-sulting. I am for the art of falling off a barstool.

I am for the art of underwear and the art of taxicabs.

I am for the art of ice-cream cones dropped on concrete. I am for the majestic art of dog-turds, rising like cathedrals.

I am for the blinking arts, lighting up the night. I am for art falling, splashing, wiggling, jumping, going on and off.

I am for the art of fat truck-tires and black eyes.

I am for Kool-art, 7-UP art, Pepsi-art, Sunshine art, 39 cents art, 15 cents art, Vatronol art, Dro-bomb art, Vam art, Menthol art, L & M art, Ex-lax art, Venida art, Heaven Hill art, Pamryl art, San-o-med art, RX art, 9.99 art, Now art, New art, How art, Fire sale art, Last Chance art, Only art, Diamond art, Tomorrow art, Franks art, Ducks art, Meat-o-rama art.

I am for the art of bread wet by rain. I am for the rats' dance between floors. I am for the art of flies walking on a slick pear in the electric light. I am for the art of soggy onions and firm green shoots. I am for the art of clicking among the nuts when the roaches come and go. I am for the brown sad art of rotting apples.

I am for the art of meows and clatter of cats and for the art of their dumb electric eyes.

I am for the white art of refrigerators and their muscular openings and closings.

I am for the art of rust and mould. I am for the art of hearts, funeral hearts or sweetheart hearts, full of nougat. I am for the art of worn meathooks and singing barrels of red, white, blue and yellow meat.

I am for the art of things lost or thrown away, coming home from school. I am for the art of cock-and-ball trees and flying cows and the noise of rectangles and squares. I am for the art of crayons and weak grey pencil-lead, and grainy wash and sticky oil paint, and the art of windshield wipers and the art of the finger on a cold window, on dusty steel or in the bubbles on the sides of a bathtub.

I am for the art of teddy-bears and guns and decapitated rabbits, exploded umbrellas, raped beds, chairs with their brown bones broken, burning trees, firecracker ends, chicken bones, pigeon bones and boxes with men sleeping in them.

I am for the art of slightly rotten funeral flowers, hung bloody rabbits and wrinkly yellow chickens, bass drums & tambourines, and plastic photographs.

I am for the art of abandoned boxes, tied like pharaohs.

I am for an art of watertanks and speeding clouds and flapping shades.

I am for US Government Inspected Art, Grade A art, Regular Price art, Yellow Ripe art, Extra Fancy art, Ready-to-eat art, Best-for-less art, Ready-to-cook art, Fully cleaned art, Spend Less art, Eat Better art, Ham art, pork art, chicken art, tomato art, banana art, apple art, turkey art, cake art, cookie art.

add:

I am for an art that is combed down, that is hung from each ear, that is laid on the lips and under the eyes, that is shaved from the legs, that is brushed on the teeth, that is fixed on the thighs, that is slipped on the foot.

square which becomes blobby

Claes Oldenburg, 'I Am for an Art … ' in *Environments, Situations, Spaces* [New York: Martha Jackson Gallery 1961; reprinted in an expanded version in Claes Oldenburg and Emmett Williams, eds, *Store Days: Documents from The Store, 1961; and Ray Gun Theatre, 1962*; New York: Something Else Press, 1967] 39-42.

Reyner BANHAM
An Alphabetical Chronicle of Landmarks and Influences, 1951–1961 [1961]

APPLIANCE

The increasing mechanization of households in the Western world, and the beginning of mechanization of households in other continents, gave a special status to electrical and other power-operated tools in the eyes of manufacturers, designers and consumers. The rise of 'do-it-yourself' acquainted many householders with small power tools for the first time, but also introduced a degree of mechanization into the creative work of painters, sculptors and designers, thus giving them an increased first-hand knowledge and sympathy for the world of appliance design – the whole output of Charles Eames (q.v.) can be related in one way or another to the mechanization of the designers' workshop, but appliances also claimed a widely recognized function as indicators of the social status of their owners. The diversification of different types of refrigerators and washing-machines, not to mention the almost annual increase in the screen size of television sets, became a recognized method of indicating or claiming improved social and financial status, and was duly damned by puritanical critics and sociologists. At the same time, however, certain less grandiose appliances became the accepted symbols of intellectual status – the possession of an Olivetti typewriter (q.v.) or a Braun gramophone or radio became one of the standard ploys in the world of intellectual snobbery […]

BRAND IMAGE (OR HOUSE STYLE)

During the 1950s it became the practice in all large industrial concerns to inculcate into the minds of the public a recognizable style to identify their products or services. In many cases this was a process of necessary rationalization where a large firm found itself with a number of different styles and a number of different designers. Where unification of style was undertaken as a form of rationalization and in good taste, this process was known as 'creating a house style', but where it was undertaken as part of an advertising campaign it was called 'fixing the brand image'. Examples of both processes can be seen in the stabilization of the design of filling-stations and filling-station equipment by such companies as Shell/BP or Esso, both of whom developed international styles in the period; in the restyling programmes undertaken by brewery companies like Courage in the earlier 1950s, and Watney towards the end of the decade; and in the restyling of chain stores […]

DETROIT

If the most suspect aspects of commercial design were symbolized by any one object or class of objects in the 1950s it was by the American automobile and by Detroit, the centre of the United States automobile industry – the

phrase 'Detroit-Macchiavellismus' was coined in Germany to describe everything that was felt to be hateful about US design. At the same time, there was a visible tendency to admire Detroit products for their unconventionality and boldness, and even in some circles serious attempts to discuss objectively their social and moral implications. In many ways Detroit was a symbol also for the War of the Generations, and the language of American automobile advertising became the language of revolt among the young. The hard core of any admiration for Detroit, however, was the belief that here was a language of visual design, no longer based on subjective standards like 'good taste', but on objective research into consumers' preference and motivations. The phrase 'an objective aesthetic' could be taken to refer either to the absolute logic of pure form or to absolute subjection to market research statistics [...]

ERGONOMICS

The most important branch of design science by the end of the 1950s was undoubtedly ergonomics, which seemed likely to push matters of taste and aesthetics well into the background. As the derivation of the word suggests, the earliest studies to receive the name were concerned with economy of human effort in the operation of mechanical equipment, notably complicated electronic and aeronautical equipment developed towards the end of the War, some of which taxed the mental and physical capacity of its operators beyond the limits of efficiency. By the end of the decade, however, the term had been expanded by thinkers and readers in many parts of the world to cover all forms of relationships between man and equipment, including purely physical studies of human engineering and the communicative studies of control systems and others, in which matters of mental capacity and perception of vision were involved. Unlike most words or phrases, which are promoted to the level of slogans or catchwords, Ergonomics has generated little facile optimism, except for a faith that by patient and painstaking research the relationship between men and their tools can be improved. At one level this has meant quite simply the reshaping of the handles of traditional tools, but at other levels it has meant exercises as abstract as the devising of new sets of symbols for the keys on the control panels of computers [...]

MOTIVATION RESEARCH

The branch of advertising regarded with the gravest suspicion in alarmist literature (q.v.) was Motivation Research, which formed the theme of Packard's first book *The Hidden Persuaders*. The object of this rather dubious science was to establish the 'real' or subconscious reasons for buying one product or another. It is thus, in a sense, a sub-branch of ergonomics since it deals with a particular, though short-lived, relationship between man and equipment, and was cautiously welcomed by broad-minded ergonomists as an extension of our precise knowledge of man. Conversely, the manipulative intentions of its practitioners were clearly liable to anti-social perversion, but any mass take-over of consumers' minds seems to have been prevented by the imprecision of

MR techniques of investigation [...]

POP ART

Alongside ergonomics (q.v.) one of the emergent concepts, though a bitterly disputed one, of the 1950s, was that of Pop art. This was distinguished from earlier vernacular arts by the professionalism and expertise of its practitioners (i.e. rock-n-roll singers, TV stars, etc.). The concept was widely discussed in Europe and the United States, and impinges on industrial design at two points – two points which are not altogether independent of one another. Firstly, its visual manifestations, as in advertising or Detroit car-styling, were often endowed with a vitality (not always bogus) that seemed absent from the fine arts and from 'good' design. Secondly, the protagonists of Pop art at an intellectual level, i.e. those who insisted that it should be taken seriously and discussed rationally, maintained that there was no such thing as good and bad taste, but that each identifiable group or stratum of society had its own characteristic taste and style of design – a proposition which clearly undermines the argument on which nearly all previous writing about taste in design had been based. This position was not adopted by any established authority in design, but was given serious discussion at some schools and was certainly accepted by a large part of the student body in *most* schools [...]

Extracts from 'An Alphabetical Chronicle of Landmarks and Influences, 1951-1961', originally printed in small type in the left-hand margin of Reyner Banham's article 'Design by Choice: 1951-1961', *Architectural Review*, 130 [London, July 1961, 43-8; reprinted in Mary Banham, et al., eds, *A Critic Writes: Essays by Reyner Banham*, Berkeley and Los Angeles: University of California Press, 1997] 67-78.

ARCHIGRAM
Spray Plastic House [1961]

Why don't rabbits burrow rectangular burrows? Why didn't early man make rectangular caves?

Supposition: Architect ... Client wanting single-storey house in the landscape

Phase I, Burrows ... Purchase foamed polystyrene block 40ft by 40ft by 15ft and suitable burrowing tools, e.g., electric hedge-cutter, blowlamp. Block placed on site, burrowing commences, kids carving out playroom, etc., parents carving rest. Architects advising.

Phase 2, Dissolve ... House burrow completed. Enter burrow with plastic and fibreglass spray machinery, (with client) spray burrow under supervision of plastic engineer. Client chooses regions of surfaces to be transparent or translucent, the spray mixture alters accordingly.

Phase 3, Completion ... Shell entered by architect and service consultant and client. Client decides upon regions of lighting, wall, floor heating, sinks, power points.

Archigram [David Green], 'Spray Plastic House', *Archigram*, 1 [London, 1961; reprinted in *Archigram*, Paris: Éditions du Centre Pompidou, 1994] 45.

Reyner BANHAM
On Trial 6: The Spec-Builders: Towards a Pop Architecture [1962]

The presence of an article on Pop art in a series devoted to architectural realizations of the potentials of technology, may appear to need some justification, but this is not so. Justification is needed only in the eyes of those who have tried to build up technology as a moral discipline, following a mistaken reading of the intentions of Mies van der Rohe, or an accurate reading of the mistaken conclusions of [Le Corbusier's] *Vers une Architecture*. Technology is morally, socially and politically neutral, though its exploitation may require adjustments of social and political structures, and its consequences may call moral attitudes in question. And the Pop arts, being almost all of them inconceivable without a high level of mechanization and mass-production, are integral with technology, which does not discriminate between recordings of John Glenn heard through the ionosphere, and recordings of Cliff Richard heard through an echo-chamber. Technology is a commonwealth of techniques exploited to serve a disparity of human needs.

However, if this study needs no justification, the instance at which it has been written needs some explanation, since it depends on two circumstances that have no apparent connection, save a temporal coincidence. One circumstance is the continuing improvement in architectural quality of certain classes of speculative housing, which raises the question of the present state of popular taste. The other circumstance, which gives a precise time-mark for this study, is that certain types of fine art, notably painting, in which elements of Pop art are employed, have recently attained a level of official success that marks a breakthrough for a kind of sensibility that takes fine and Pop equally in its stride. Since it is believed in some circles that any revolution or upheaval in the pure arts must, of some historical necessity, be followed by an equivalent upset in architecture, it is anticipated that the cordon-sanitaire between Pop art and architecture is about to be breached like a metropolitan green belt, and a Pop architecture emerge about 1966.

This 'necessity' will not stand up to historical examination, however. The supposed causal connection between painting and architecture may have been true of the 1920s, and it may be possible to reflect it back on the Renaissance, but it is far from a universal pattern. And in any case, it has been rendered vacuous by events of the past thirty years. On the painting side this development occupies only fifteen years at the maximum. Pioneer studies of Borax styling, such as those that appeared in *Architectural Review* in 1948, were resumed at the Institute of Contemporary Arts in the early fifties, but in an altered tone of voice – approval, not deprecation. This set in motion a series of repercussions among the painters

under ICA influence (e.g. John McHale's cover for 'Machine Made America', *Architectural Review*, May 1957), created a school of Pop art fanciers in the Royal College of Art, and led to awards and other recognitions for artists like Peter Blake and David Hockney – the latter's style can be seen in the illustrations of the 'Teenage Bar of the Canberra', *Architectural Review*, October 1961, and he received a John Moores award in 1962, as did Peter Blake.

That this was an extension, revolutionary and perhaps beneficial, of the iconography of the Fine Arts, is clear – but it is not clear how it might benefit architecture. The fundamental reason why it will have little to say to the arts of building and town-making is that architects and planners have got there already. For instance, the collage-effect of violent juxtaposition of advertising matter with older art forms, which appears in, say, Peter Blake's work as clusters of fan-club badges on realistic paintings of the human form, was being widely discussed in architectural circles around the time of the Festival of Britain and the Hoddesdon meeting of CIAM, or, in *Architectural Review*, as early as December 1952, when the editors took Professor Guyatt smartly to task for his 'aesthetically purist' views on advertising in the townscape.

The fact is that architecture, in a capitalist society, deals in real property and is therefore a branch of commerce. Furthermore, since it creates visible forms, it is apt to become a branch of advertising as well, and in this latter sense there has been a Pop architecture for some time now – Albert Kahn's Ford Pavilion at the New York World's Fair of 1939 is probably the true ancestor of the genre, and its progeny are in various ways widely diffused throughout the US in the form of exclamatory hamburger bars, and other roadside retail outlets. At this point some discriminations of style, method, intention and content are necessary, because it is still – alas – necessary to explain the difference between Pop art and Folk Art. Many critics would clearly like to believe that a Pop architecture would turn out something like the towers of Simon Rodilla or the fantasy palace of 'Facteur' Cheval at Hauterive. But in spite of the good facteur's mastery of Beaux-Arts façade composition, or Rodilla's intuitive genius in engineering, these are Folk Art. They lack the imagery of dreams that money can buy that characterizes Pop art; desirable possessions and accessible gratifications, handily packaged, seductively displayed, mass-produced and ubiquitously available. Neither the palace at Hauterive nor the towers at Watts are marketable goods.

Clearly, the Royal College painters are handling Pop art in their pictures much as if it were a particularly noisy form of Folk Art, and there is about them, quite frequently, a Marie-Antoinette air of Fine Art people dressed up *hoi polloi* (even though some of them privately *consume* Pop art in the ordinary teenage way). But architecture can become involved in Pop art at its own level and according to the same set of Madison Avenue rules. One way has already been discussed: it can serve as a selling point for some desirable standardized product that is too complex or too expensive to be dispensed from slot machines, and in this sense we have had a sort of Pop architecture in Britain since the beginnings of the Granada and Odeon chains of cinemas. Or, the other way in which architecture

can be a part of the Pop world is in becoming, in itself, a desirable standardized product, and in this sense we have had a Pop architecture in Britain ever since the more progressive and aggressive speculative builders decided that it was time for housing to quit the neotechnic phase and to take over current advertising and marketing techniques, instead of methods that still smacked of the transfer of fiefs from one vassal to another. Since buildings, despite Buckminster Fuller, are still too heavy to be sent to supermarkets, the consumers instead must be mobile and locally numerous, and these more modern merchandizing techniques can only be employed in heavily motorized conurbations. We have had a Pop architecture in Britain, to be precise, ever since SPAN set up shop at Ham Common.

It will certainly be objected that buildings of the sort that have been discussed above are not architecture. The cordon-sanitaire between architecture and Pop art, to which reference was made earlier, represents a very deep-seated desire, as old as the reformist sentiments of the Pioneers of Modern Architecture, that the profession should not be contaminated by commercialism, that architecture should remain a humane 'consultant' service to humanity, not styling in the interest of sales promotion. Yet SPAN housing is unquestionably accepted as architecture, for all that it is a nearly-standardized, almost mass-produced, accessible and attractively packaged product. The question of where to draw a line between architecture and commerce becomes almost unanswerable as soon as one tries to draw it, and even if it were to be drawn so far towards one extreme as to only *just* exclude, say, hamburger bars, it would still need an architect with a large capacity for self deception, or a very small practice, before he could say that, professionally, he had never stepped over that line. The preparation of rendered perspectives to present a scheme to clients is only one case in point […]

At present, the service of keen Pop taste does not appear to interfere with accepted architectural practice at all – it is very nice work indeed for an architect with an eye for cost-control and residential densities. But once the market researchers come in, this situation will change. It has already become apparent that detailed user-research (purely functional) may play havoc with architects' preferences in planning and space-manipulation; market research is bound to bear largely on matters of style as well, and this will, inevitably, be even more painful. But that critical size has not yet been reached, and the situation remains, as they say, manipulative. It is up to architects to make what they can of conditions in which it is temporarily possible for them to mould the creation of a keen Pop taste in architecture without coming under the discipline of those commercial rituals that normally operate in the field of Pop merchandising, and to operate the amoral techniques of technology according to the morality of architecture. Of course, the alternative, to miss the opportunity, is always open to them.

Reyner Banham, 'On Trial 6: The Spec-Builders: Towards a Pop Architecture', *Architectural Review*, 132 [London, July 1962] 43-6.

Donald JUDD
In the Galleries: Roy Lichtenstein [1962]

For one thing, I like Lichtenstein's work better than before, and for another, it has improved. The few drawings he had in a group show at the gallery last spring were very good; so are the paintings in the present exhibition. The first time I saw Lichtenstein's paintings I was puzzled by their being comics and was disinterested in their obsolescent composition; all the same I was interested in their unusual quality. Generally in that case you revise your ideas of the meaningless or disagreeable elements. There are good reasons for the comics and the composition. Obviously, now, both are basic to the dominant quality. Perhaps the composition should somehow be less traditional, but how or why it should be pretty vague. Lichtenstein's spectacular ability in composition seems necessary; something has clearly to be art – that is, already developed and recognizable. The proficiency in composition, the evident art, is half of the idea. In addition, the traditional composition isn't all of the composition, all of the form. Mostly it involves the placement of the areas. In *Conversation* two large heads fill the upper corners. Between them and running to the bottom, and extending, although broken, to the lower corners, is a more or less single dark area, variously dark blue, black and red. The man's fingers, stencilled like the faces, are placed in the middle and at the bottom of the dark section. His thumb sticks up the centre. The three-way arrangement, the hand in the lower centre and the thumb dividing the dark section are forms that go back, through everything, to the early Renaissance. (It's funny, incidentally, that the best composition in years, in the word's ordinary sense, is seen only as a copy.) The comics are a form of representation themselves and a fairly cursory and schematic one. Lichtenstein is representing this representation – which is very different from simply representing an object or a view. The main quality of the work comes from the contrast between the comic panel, apparently copied, and the art, nevertheless present. The enlarged, commercial scheme has an unusual space, colour and surface, and some other things. It does involve some novel ways of composing: the relationships of the areas as patterns of flat colour, of two dark colours closely valued, and of differently coloured and scaled Ben Day dots; the shapes made by the comic stylizations are odd, such as the concentric ones of an explosion or those of swirling water – waves and flames are similar – or lines of speed. The Ben Day patterns and their various juxtapositions I like a lot. *Conversation* has larger dots than usual in the two faces. In the girl's lips the dots are smaller and are paired; the stencil was moved slightly and the dots repeated. The repetition is also used, but with red and blue, in the shadow along the side of a cannonading fighter plane. The dots are obviously mechanical and have a curious brittleness and lightness, something of the surface quality of printed things generally. Lichtenstein's colour is pretty straight and

unharmonized. The printed quality and the paintings' nature as a representation of a representation are part of the same idea. This idea is related to questioning, for example, the method, the general way you are dealing with certain problems, in contrast to considering those singly. The paintings are dealing with an idea of something, rather than with something itself. They are twice removed. Similarly, they suggest metalinguistics, in which the indications of reality that a word seems to possess are not accepted as a basis for thought, but rather a word's usage is examined. 'Is' was once taken literally and discussed as if it were existence itself; now it is considered as a word, as a convention. *Wham!*, *Torpedo Los*, *Conversation*, *In the Car* and *I Don't Care, I'd Rather Sink* are all broad and powerful paintings.

Donald Judd, 'In the Galleries: Roy Lichtenstein', *Arts Magazine* [New York, April 1962, 32-3; reprinted in Donald Judd, *Complete Writings 1959-75*, ed. Kasper Koenig, Halifax, Nova Scotia: Nova Scotia College of Art and Design, 1975].

John COPLANS
The New Painting of
Common Objects [1962]

An exhibition assembled by Walter Hopps at the Pasadena Art Museum, with the following dramatis personae:

OUT OF NEW YORK
Roy Lichtenstein, age 42, previously an abstract expressionist living in New Jersey. First one man show of new work, Leo Castelli Gallery, New York, fall 1961.

James Dine, age 35, major figure in 'Happenings' in New York ('Car Crash', Rubin Gallery, 1960). One man exhibition, Martha Jackson Gallery, fall 1961.

Andy Warhol, age 38, for several years a very successful commercial artist for top Manhattan fashion magazines, who, without exhibiting or even being thought of as a serious artist, developed new work over past two years in almost total seclusion.

OUT OF DETROIT
Philip Hefferton, age 29, sometime jazz trombonist and serious artist previously working in an abstract expressionist style.

Robert Dowd, age 28, a serious artist also previously working in an abstract expressionist style.

OUT OF OKLAHOMA CITY
Edward Ruscha, age 24, and *Joseph Goode*, age 25. In student exhibitions at the Chouinard Art Institute in Los Angeles their first adventures into their current work were received with ridicule and clamorous agitation. An ugly point was reached when an enraged faculty member burned a work of Ruscha, when hung on the Institute walls. Ruscha makes a livelihood in the field of commercial art, which he abhors, while Goode works at the Chouinard Institute doing odd jobs.

OUT OF NORTHERN CALIFORNIA
Wayne Thiebaud, age 42, assistant professor of art, University of California at Davis.

Practically every movement in the last thirty years has had a strong theoretical basis. Mondrian dealt with the glorious world of pureform, a metaphysical vision of architectonic space, Ernst and Dalí with the vista of psychosexual imagery, abstract expressionism with the vista of surface light and colour of actuality, in exchange for the actuality of paint (but with a certain duality of tension between the two factors rather than a complete overthrow). Given these preoccupations, with certain exceptions, a whole visual environment was being ignored. The lack of an empirical base and direct perceptual contact with the everyday world had serious consequences, leading to an inevitable trivialization of form and content. Without the knowledge of the theoretics of Yves Klein's art, for example, it is impossible to decode his paintings.

Neither philosophical newness nor modernism of metaphysics has ever necessarily led to the deepest art. The intuitive understanding of this position differentiates to a great degree the American artist from his European counterpart and the result has been an art of direct response to life rather than to 'problems'. The proverbial dumbness of most younger artists on the West Coast, for example, is a reflection not only of their deep understanding of the lie of the evolution of progress, but also an affirmation of the basis of both Jazz and Beat poetry, that art springs directly from life, with all its anguish.

Man, having engineered a society to an undreamed of state of mass production, now labours solely in order to consume with the same ferocity as he produces. He is constantly, and with enormous pressure, subjected to visual effects conditioning him to selling and consumption, that is, message carrying, to inform and to induce him to act. This new art of Common Objects springs from the lashback of these visual effects and has nothing to do with any form of descriptive realism. Lichtenstein's painting of a hand holding a hairspray tells you nothing about a hairspray, any more than one of Cezanne's apples tells you about an apple: both are formal devices, but with an important difference. Cezanne's apple is mute, but Lichtenstein's hairspray carries a moral judgment. Lichtenstein's blown-up image of the artwork of the ad brings out a true and most pointed flavour of the situation. The vulgarity of the image itself is shocking in the way the howl of the Beat poets is, in comparison, for example, to the cultured cantos of Robert Graves.

The sense of crisis precipitated in Lichtenstein's painting is totally missing in Thiebaud's paint act; Thiebaud's art is a coincidence: he lacks the guts and the total commitment of the others in this group. Lichtenstein's painting is deliberate, outrageous and daring. Thiebaud begs the issue. The anguish of the situation is not well enough reflected; he titillates rather than creates a distillation that can either lead to or bare the heart of the issues. Thiebaud is both clever and flippant rather than deeply perceptive, a polite slap instead of a murderous wound.

James Dine, somewhat like Frank Stella, uses the stylistic device of a series system, as in mathematics, but this device should not be confused with architectonic balance. He paints in series, eight separate but contiguous panels, on each panel a nearly, but not quite, flattened-out tit. He implies a comic paradise – an acre of tits. 'I am surrounded by all good things,' but at the same time there is highlighted the desperate and horrible depersonalization of contemporary American women (remember Magritte's imagery?). Although linked to surreal imagery, the format of his work probably derives from the problem of time sequences in his Happenings. But Jasper Johns' work (see chronology) is probably the focal point to which many ideas can be hooked. Even if a somewhat shaky terminus, every one 'got through' via his insight. Dine paints something he likes to look at (tits and rainbows in this exhibition). His realistic rainbows are not an abstraction – he writes 'rainbow' on them. Of all these painters, Dine, because of his complex and sophisticated background, is the most esoteric and does not fit too happily in the exhibition title.

Warhol, with his now famous Campbell soup images, refers to his work as a kind of portraiture. His images can be read as a pun on people, how much alike they are, how all that changes is the name. His S & H Green Stamp painting reminds us of a hive of grey flannel clerks, all identically clothed, all working for a pay cheque, to be spent on identical goods in identical supermarts to get identical stamps to redeem them for identical goods to be put in identical homes and be shared with stereotyped wives.

The isolated and lonely figure is thematic in American literature and constantly reoccurs, but here is a totally different approach from a humble nobody, a young unknown American painter named Goode, who has painted two of the loneliest paintings imaginable. They represent a totally new and radically different approach to the quest for identity. Each canvas rests on a squat white platform; the painted surface of the canvas, almost monochromatic, is slightly anthropomorphized into motion, but quite blurred and formless. On the platform, immediately in front of the painting, stands a milk bottle, covered completely with paint of a single flat hue, only the shape reminding us of a milk bottle. The nearest parallel would be the work of Cornell, because he is completely outside the logical mainstream of art, with a personal poetic logic, more poetic than logical. He sets a standard in the use of concrete objects not to be surpassed, creating a whole new sense and logic of structure in our time. Goode has absorbed this new sense and uses it to create two most powerful, deeply moving and mysterious paintings.

Both Dowd and Hefferton paint American banknotes and seem to antedate Larry Rivers chronologically. In any event whether they do or not is unimportant, because their performance puts Rivers in the shade. Both painters have a high degree of painterly quality of paint, use loose colour

over colour, dragged and dry-edge brush marks, impasto and drips, a heritage from the whole gamut of abstract expressionist painting technique. Hefferton uses his money as a device to make some excellent and imaginative portraits of Lincoln and Jackson and in one case substitutes a family portrait. But his handling of the portraits is so fine that he induces a freak love for these stereotyped heroes. Both these artists have a fixation on Lincoln. Dowd's Lincoln has a brash funereal quality. All his paintings have a high degree of paint sophistication, using blurring as a formal device almost as if his art does not depend on a precise environment. His typography on the notes is also used to create almost dada word puns.

Ruscha's art reminds us of the visual humour of Mondrian's 'Broadway Boogie Woogie', but he is impressive for his creation of a totally new visual landscape. On the upper half of his paintings, almost like a heading, is the name of a product, Spam, Sunmaid (raisins) and Fisk (tires) while on the lower half is an image of the product. But he combines a beautiful use of typography with an exquisite sense of placing and extraordinary colour to upset our whole aesthetic balance.

CHRONOLOGY: THE COMMON OBJECT AND ART

1890
Eugene Atget photographs the banal urban image.

1916
Impact in New York of the friendship of Duchamp, Man Ray and Joseph Stella. Both Stella and Man Ray produce collages and assemblages of ready-mades.

1920s
Arthur Dove produces unique collage/assemblage work. Stieglitz photographs the banal urban image.

1930s
Joseph Cornell begins to use commonplace concrete objects themselves in a complex symbolism.

Walker Evans, one of a whole wave of American photographers of commonplace, cheap and mass-produced man-made imagery.

Frederick Somer's photographs.

1940s
Wallace Berman's precise pop culture drawings with startling irrational imagery, specific portraits of the pop and jazz heroes, in precisely rendered common technique.

William Copley, the painter, links to his sophisticated knowledge of European Surrealism a banal American imagery.

Kurt Schwitters in 1947 makes a number of collages, notably one from the *Phantom* and *Prince Valiant* comic strips, of a sexy blonde being reached for by a bunch of assorted men, for his New York show at Rose Fried Gallery. Schwitters dies a week before his opening, and the exhibition is cancelled.

Von Dutch Holland, itinerant custom coach craftsman of the Southern California hot rod world, conceives and executes the striping motif of hot rod decoration;

deliberately corny science fiction images of bug eyed monsters with ray guns driving hot rods, with puns, politicians' heads, etc., inset in cartoon bubbles. (See hot rod magazines from 1947 to date.)

Moholy Nagy dies in 1946; students at the Institute of Design turn away from Bauhaus concepts of design and typography and return to common everyday American sources for ideas. Notably Aaron Siskind, Robert Nickel, Harry Callahan, photographers, and H. C. Westermann, an assemblage and construction artist.

Judson Crews' random sliced slick magazine images with poetry.

1950s
Hassel Smith's objects and collages as photographed by Bern Porter.

In 1951, exhibition of 'Common Art Accumulations' at the Place Bar, San Francisco, by Hassel Smith and others. (Complete American flag iconography.)

In 1952, Wally Hedrick, displaced Los Angeles artist, feeds banal and ironic reflections into his paintings and junk metal sculptures.

Eduardo Paolozzi, in London, shows 'found images' from advertising material, projecting them on to a screen. First public exhibition of this subject matter at the London Institute of Contemporary Arts under the title 'Parallel of Life and Art'.

Robert Rauschenberg, Jasper Johns and Ray Johnson working on the New York scene. Johnson pioneers the use of the cheapest graphic techniques and images in his approach to graphic art.

In 1954 Lawrence Alloway coins the phrase 'pop art' and defines it, which later Richard Hamilton redefined to today's usage. Hamilton makes huge blow-up of 'pop art' collage for the 1956 'This is Tomorrow' exhibition at London's Whitechapel Art Gallery.

In San Francisco, J de Feo in 1954, Fred Martin in 1954, Robert La Vine in 1954, Joan Brown in 1955, Roy de Forest in 1957 and Richard Kegwin create constructions, assemblages, drawings and paintings.

In Southern California, Ed Kienholz in 1954 makes constructions and assemblage objects; at the same time Billy Al Bengston makes paintings, drawings and collage objects (wind-up cookies, etc.). John Reed makes paintings, drawings and sculptures of World War II fighter planes and George Herms in 1958 makes assemblages. A number of important artists such as Bruce Conner come in on the tail end of the Fifties.

In Italy, the Galerie Schwarz in Milan exhibits 'pop artists' such as Enrico Baj who collages pop images with textiles.

In England a whole movement of pop painters develops in the late Fifties.

John Coplans, 'The New Paintings of Common Objects', *Artforum*, 1:6 [New York, November 1962, 26-9; reprinted in Steven Henry Madoff, ed., *Pop Art: A Critical History*, Berkeley and Los Angeles: University of California Press, 1997] 43-6.

G.R. SWENSON
The New American 'Sign Painters' [1962]

A golden hand with a pointing finger (applied in gold leaf to a piece of now broken glass) hangs on a wall in Stephen Durkee's studio. It was once a sign of commerce and direction; now the hand, slightly etched and reworked by its owner, points nowhere and is a sign with a life of its own. The shining hand tells us more about its owner and his attitudes towards the world than about its original context.

This kind of sign has recently appeared in the paintings of a number of younger artists. Words, trade marks, commercial symbols and fragments of billboards are moulded and fused into visual statements organized by the personality of the artist; they cannot be understood through formulae or some conventional pattern of visual grammar one or more remove from experience. The artists have shared – for the last few years, at least – a common interest in the ubiquitous products of their artisanal cousins, the painters of commercial signs and designers of advertising copy.

Like all artists who are unwilling to imitate, these painters force a re-examination of the nature of painting and its changing relation to the world. James Dine and Robert Indiana are proving that, as Rauschenberg puts it, 'there is no poor subject'. Roy Lichtenstein, James Rosenquist and Andrew Warhol are proving you can have recognizable references (so-called Images) without regressing to earlier fashions. Richard Smith and Stephen Durkee, with their striking individuality and their formal sensitivity, bring diversity and depth to the newest phase of the continuing revolution that characterizes painting in the twentieth century.

The content of their work is direct. It points to objects that are commonplace. Their techniques are without ceremony or pretence. Ordinary objects which prick our associative faculties, along with a technique almost shocking in its simplicity, create the tone of this new painting. At the same time, although composed of fragments which may derive from Wall Street and Madison Avenue, the subject of these works, to use a phrase of George Heard Hamilton, 'is not what the world looks like, but what we mean to each other'.

Both James Dine and Robert Indiana regularly introduce words into their paintings. In a painting dominated by two necktie shapes, Dine prints the word 'TIE' twice. On a strip that looks like a riveted metal place, Indiana stencils the words 'THE AMERICAN REAPING COMPANY'. Like words on signboards they insist on our attention. They are not subordinated to the composition as in a Cubist collage, nor are they used as a psychological pun as in some Surrealist painting (for example, when an image of a pipe bears the inscription, 'this is not a pipe').

The visual references in the works of Dine and Indiana are readily and easily recognized. Dine sews buttons down the centre of a canvas that is painted in the pattern of a

5. Eugene Atget

6. Joseph Cornell

7. Walker Evans

heavy overcoat. He puts twelve cloth neckties into one picture, covers it all with green paint and calls it *Twelve Ties in a Landscape*. Indiana makes more subtle and oblique references. In *The American Dream*, the circle with highway numbers stencilled on it is the same yellow and black as stop signs; the double row of triangles in *The Great Reap* suggests the cutting edge of a mowing machine. He uses words to conjure unlikely presences. *The American Gas Works*, a black, yellow and white painting with those words stencilled in it, conjures a metaphorical meter-reader; the incongruity of his imaginary presence is heightened by the decorative elegance of 'hard edge' visual variations of the theme. The words and numbers stencilled into the painting tighten the composition and, like arrows, indicate the direction the eye should travel. The meter-clocks lack hands, but the painting is kept from fantasy by the vigour of its colour, the straightforwardness of the composition and the tension between a beautiful appearance and incongruous subject matter. Dine's concern with the abstract nature of the anatomy and its coverings is bold and questioning; Indiana's concern with unsuspected artistic juxtapositions is subtle and concrete.

There is something impudent in these works, something so simple-minded and obvious as to be unexpected. We find Dine mocking the meanings we conventionally invest in words and images. Both the word and the image in his work may refer to something well-known, like hair; in combining the two Dine has changed them both and revealed our arbitrary ideas of them. The image is merely an illusion we read into the work; yet it would also be an illusion to believe that we see only black, brown and flesh-coloured oil paints squeezed out of a tube. The printed word seems superfluous; even in terms of pure composition the dotted 'I' between 'HA' and 'R' is somewhat irrelevant. The redundant word underscores both the liveliness of objects and the deadness of definitions. The word and image have been wilfully related until they – and our ideas of them – seem naked and slightly obscene. Repetition has blurred their commonness.

Both Dine and Indiana come from the Midwest: twenty-seven years old, Dine was born and raised in Ohio; Indiana, six years older, was born and raised in Indiana and Illinois. Both now live and work in New York; they are aware of each other's work, but disclaim mutual influences.

Dine even dissociates his present work from the 'Happenings' he himself was doing merely a year or two ago. The sculpture of one of his associates in the 'Happenings', Claes Oldenburg, can be (and has been) superficially linked to Dine's work; but Oldenburg's papier-maché pastries deal – as one of their major interests – with the difference between illusion and reality. That difference is largely irrelevant to Dine's work; Dine takes for granted that the way in which each of us knows the world is 'reality' to us and 'illusion' to anyone who disagrees with us.

Indiana, if he admits influences at all, prefers to associate his work with that of his friends Ellsworth Kelly and Jack Youngerman. His present style seems to have

grown out of an interest in an old circular cooper stencil he found when he moved into his loft; he liked the shapes of the lettering and their purely formal possibilities. When he finally used the stencil, however, the resulting words and even statements were not simply forms and their meanings not simply spice in an abstract composition; they were used by him to express concrete, vivid meanings – to convey the substance of an aesthetic idea on which his forms then commented.

Roy Lichtenstein, James Rosenquist and Andrew Warhol have all had actual experience with commercial art. Thirty-nine-year-old Lichtenstein, a native of New York who now lives and teaches in New Jersey, had brief experience with industrial design and display work while living in Ohio. Several years ago he did some experiments using comic book designs as the formal basis for Abstract-Expressionist painting; in his recent work he has straightforwardly used the colours, stencils and Ben-Day dots of the comic strips as basic elements in his style.

Lichtenstein places a large face of a girl in one of his pictures; the girl may be pure although we cannot be sure, especially since the words 'It's … It's not an ENGAGEMENT RING, is it?' are written in the balloon next to her. To the left of the girl is a smaller man; size is the principal indication of space in these paintings. Partly because they are stencilled, the outlines do not contain mass or volumes, the space between them is as vacant as that between the wires of a mobile. The dots seem to waver like molecules; because of the regularity and the amount of white space between them, however, the screen of dots (by convention a solid in the comic strips) suggests merely a transparent plane. The picture is a stringent but amusing exposure of visual as well as social habits.

Although Lichtenstein attempts to make his colour seem mass-produced, the objects he reproduces (for example, a kitchen range or a baked potato) seem neatly chosen and carefully arranged; they are not merely symbols of a type, just as his people are not merely symbols of general human traits. He is sometimes forced to vary the colour he uses for the dots to make them seem the same 'mass-produced' colour as his solid areas; his paintings force us to find something important, amusing or inflated in a cliché, in an ordinary event or in tabloid heroism.

James Rosenquist, born in North Dakota in 1933, learned some of his present techniques while painting twenty-foot-high faces of mothers and other All-Americans on Times Square. As a commercial billboard painter he had to try to see the images he painted with his mind's eye, asking himself how they looked three blocks behind him. The size and familiarity of the objects in his paintings at the present time, and the explosive force with which they are presented, seem to place us between the picture and the position from which its fragments were meant to be seen; the space of the picture comes forward to surround us.

Rosenquist uses recognizable fragments of our environment as echoes. The radiator grill of an automobile, canned spaghetti and two people kissing have ready associations and everyday references, although they are likely to have been dulled through commercial

familiarity; by combining them in *I Love You with My Ford* Rosenquist has pointed up the death of our senses which has made these three things equally indifferent and anonymous.

The painting is also concerned with how love is made. The upper section, an obsolescent 49 Ford, comments on things which change (car models), or persist (making love in cars). The progressive enlargement of scale in the three sections parallels the increasing intimacy and loss of identity in the sexual act. The artist changes his palette from grisaille to a vivid orange in the lower section. Like the interlocking forms which tie the left and right panels together visually, every aspect is ultimately seen for its importance to the whole. It is not simply rebellion when Rosenquist says, 'I want to avoid the romantic quality of paint.' He speaks in the tradition of anti-Romantic Realist Courbet (not anti-Romantic Classicist Ingres), objecting to imitated moods and rarified atmospheres (not to the ignoring of rules).

Andrew Warhol was born in Philadelphia in 1931[1] and now lives in New York; until recently, he depended entirely on commercial shoe designs and advertising layouts for a living. Partially in reaction to the artificial neatness of the commercial designs, he often used to make a drip or blot in the painting he did for his own interest; he made those 'accidents', however, seem quite painterly – they had a beauty often found in the intentional 'carelessness' of some New York School painting. In one painting of an old can of Campbell's soup, the texture of the weathered tin surface behind the tattered label has a quality of lofty elegance. In a black-and-white painting of an enormous Coke bottle done early in 1961, nervous scratches are made in an enclosed area and a 'mistake' is corrected with some handsome white paint brushwork. A recent black Coke bottle has none of those references to art; the painted bottle is larger and a trademark to its right runs off the right-hand side of the picture as if the 6-foot-high canvas were not large enough. The older picture provided a setting and its own scalar referents; the sense of a disproportionately increased scale in the later work results from the bottle being related to the familiar object we often hold in our hand rather than to the size of the stretchers on which the canvas is tacked. Our awareness is not so much of a Coca-Cola billboard as of the shrunken size of the world we occupy; an image from a sign, never intended to be so consciously seen in focus, is stripped of its original signification. Far from symbolizing a civilization, the image loses even its ability to symbolize a product. It signifies a specific common object; the shape, size and colour of its presentation characterize an attitude towards objects to which we seldom pay conscious attention, but which make up the preconceptions of our everyday visual experience […]

The seven young painters described here revitalize our sense of the contemporary world. They point quite coolly to things close at hand with surprising and usually delightful results. A nineteenth-century landscape painter once said that Manet's *Fifer* looked like a tailor's signboard. To this Zola responded, 'I agree with him, if by that he means that … the simplification effected by the

artist's clear and accurate vision produces a canvas quite light, charming in its grace and naïveté and acutely real.'

1 [Warhol's date of birth is now known to have been 1928.] Gene Swenson, 'The New American "Sign Painters"', *ARTnews*, 61:5 [New York, September 1962, 44-7; 60-2; reprinted in Steven Henry Madoff, *Pop Art: A Critical History*, Berkeley and Los Angeles: University of California Press, 1997] 34-38.

Michael FRIED
New York Letter: Warhol
[1962]

Of all the painters working today in the service — or thrall — of a popular iconography Andy Warhol is probably the most single-minded and the most spectacular. His current show at the Stable appears to have been done in a combination paint and silk-screen technique; I'm not sure about this, but it seems as if he laid down areas of bright colour first, then printed the silk-screen pattern in black over them and finally used paint again to put in details. The technical result is brilliant, and there are passages of fine, sharp painting as well, though in this latter respect Warhol is inconsistent: he can handle paint well but it is not his chief, nor perhaps even a major concern, and he is capable of showing things that are quite badly painted for the sake of the image they embody. And in fact the success of individual paintings depends only partly (though possibly more than Warhol might like) on the quality of paint-handling. Even more it has to do with the choice of subject matter, with the particular image selected for reproduction — which lays him open to the danger of an evanescence he can do nothing about. An art like Warhol's is necessarily parasitic upon the myths of its time, and indirectly therefore upon the machinery of fame and publicity that market these myths; and it is not at all unlikely that the myths that move us will be unintelligible (or at best starkly dated) to generations that follow. This is said not to denigrate Warhol's work but to characterize it and the risks it runs — and, I admit, to register an advance protest against the advent of a generation that will not be as moved by Warhol's beautiful, vulgar, heart-breaking icons of Marilyn Monroe as I am. These, I think, are the most successful pieces in the show, far more successful than, for example, the comparable heads of Troy Donahue — because the fact remains that Marilyn is one of the overriding myths of our time while Donahue is not, and there is a consequent element of subjectivity that enters into the choice of the latter and mars the effect. (Epic poets and pop artists have to work with the mythic material as it is given: their art is necessarily impersonal, and there is barely any room for personal predilection.) Warhol's large canvas of Elvis Presley heads fell somewhere between the other two.

Another painting I thought especially successful was the large match-book cover reading 'Drink Coca-Cola'; though I thought the even larger canvas with rows of Coke bottles rather cluttered and fussy and without the clarity of the match-book, in which Warhol's handling of paint was at its sharpest and his eye for effective design at its most telling. At his strongest — and I take this to be in the Marilyn Monroe paintings — Warhol has a painterly competence, a sure instinct for vulgarity (as in his choice of colours) and a feeling for what is truly human and pathetic in one of the exemplary myths of our time that I for one find moving; but I am not at all sure that even the best of Warhol's work can much outlast the journalism on which it is forced to depend.

Michael Fried, 'New York Letter: Warhol', *Art International*, 6 [20 December 1962, 57; reprinted in Michael Fried, *Art and Objecthood: Essays and Reviews*, Chicago: The University of Chicago Press, 1998] 287-8.

Henry GELDZAHLER, Stanley KUNITZ, Hilton KRAMER, Leo STEINBERG, Dore ASHTON, Peter SELZ
A Symposium on Pop Art
[1962]

As interest in pop art has spread quickly not only from 77th Street to 57th Street but indeed from coast to coast, the Department of Painting and Sculpture Exhibitions at the Museum of Modern Art thought it might be enlightening to organize a panel discussion on the subject. I therefore invited five distinguished critics to participate in a symposium on 13 December 1962. These participants were selected for their different points of view as well as for their past contributions to American art criticism.

We chose the term 'pop art' because it seems to describe the phenomenon better than a name like New Realism, which has also been applied to such divergent forms as Germany's Neue Sachlichkeit of the twenties and France's Réalités Nouvelles of the forties. The term neo-Dada was rejected because it was originally coined in the pejorative and because the work in question bears only superficial resemblance to Dada, which, it will be remembered, was a revolutionary movement primarily intended to change life itself.

The panel was not expected to come up with a definition of pop art at this stage, but rather to present prepared papers and to engage in a lively discussion. I introduced the evening by presenting a number of slides, including photographs of window displays and billboards taken by Russell Lee for the Farm Security Administration in the thirties; these, although they were documentary in purpose, are similar to some of the new work when presented in this context. Limiting myself only to American practitioners of this art, I showed slides of relevant work by Robert Rauschenberg and Jasper Johns, by the so-called sign painters Roy Lichtenstein, Robert Indiana, James Rosenquist, Andy Warhol and Wayne Thiebaud, by those as diverse as Claes Oldenburg, Peter Saul, James Dine and Tom Wesselmann, as well as by artists whose sculptures and assemblages are only iconographically related to pop art: H.C. Westermann, Edward Kienholz, Niki de Saint Phalle and Marisol [...] — Peter Selz

HENRY GELDZAHLER

It is always a simple matter to read inevitability back into events after they have happened, but from this vantage point it seems that the phenomenon of pop art was inevitable. The popular press, especially and most typically *Life* Magazine, the movie close-up, black and white, technicolour and wide screen, the billboard extravaganzas, and finally the introduction, through television, of this blatant appeal to our eye into the home — all this has made available to our society, and thus to the artist, an imagery so pervasive, persistent and compulsive that it had to be noticed. After the heroic years of Abstract Expressionism a younger generation of artists is working in a new American regionalism, but this time, because of the mass media, the regionalism is nationwide, and even exportable to Europe, for we have carefully prepared and reconstructed Europe in our own image since 1945 so that two kinds of American imagery, Kline, Pollock and De Kooning on the one hand, and the pop artists on the other, are becoming comprehensible abroad.

Both Clement Greenberg and Harold Rosenberg have written that increasingly in the twentieth century, art has carried on a dialogue with itself, art leads to art, and with internal sequence. This is true still, even with the external references pop art makes to the observed world. The best and most developed post-Abstract Expressionist painting is the big single-image painting, which comes in part out of Barney Newman's work — I am thinking of Ellsworth Kelly, Kenneth Noland, Ray Parker and Frank Stella, among others — and surely this painting is reflected in the work of Lichtenstein, Warhol and Rosenquist. Each of these painters inflates his compulsive image. The aesthetic permission to project their immense pop images derives in part from a keen awareness of the most advanced contemporary art. And thus pop art can be seen to make sense and have a place in the wider movement of recent art.

I have heard it said that pop art is not art, and this by a museum curator. My feeling is that it is the artist who defines the limit of art, not the critic or the curator. It is perhaps necessary for the art historian, who deals with closed issues, to have a definition of art. It is dangerous for the critic of contemporary art to have such a definition. Just so there is no unsuitable subject for art. Marcel Duchamp and Jasper Johns have taught us that it is the artist who decides what is art, and they have been convincing philosophically and aesthetically.

Pop art is a new two-dimensional landscape painting, the artist responding specifically to his visual environment. The artist is looking around again and painting what he sees. And it is interesting that this art does not look like the new humanism some critics were so eagerly hoping for. It points up again the fact that

responsible critics should not predict, and they should not goad the artist into a direction that criticism would feel more comfortable with. The critic's highest goal must be to stay alert and sensitive to what the artist is doing, not to tell him what he should be doing.

We live in an urban society, ceaselessly exposed to mass media. Our primary visual data are for the most part secondhand. Is it not then logical that art be made out of what we see? Has it not been true in the past? There is an Ogden Nash quatrain that I feel is apposite:

I think that I shall never see
A billboard lovely as a tree
Perhaps unless the billboards fall
I'll never see a tree at all.

Well, the billboards haven't fallen, and we can no longer paint trees with great contemporary relevance. So we paint billboards.

A proof I have heard that pop art cannot be serious is that it has been accepted so readily. As everyone knows, the argument goes, great art is ignored for years. We must examine this prejudice. Why are we mistrustful of an art *because* it is readily acceptable? It is because we are still working with myths developed in the years of alienation.

The heroism of the New York School has been to break through and win acceptance for the high and serious purpose of American painting. There is now a community of collectors, critics, art dealers and museum people, a rather large community, that has been educated and rehearsed to the point that there is no longer any shock in art.

For the first time in this century there is a class of American collectors that patronizes its advanced artists. The American artist has an audience, and there exists a machinery, dealers, critics, museums, collectors, to keep things moving and keep people on their toes. Yet there persists a nostalgia for the good old days when the artist was alienated, misunderstood, unpatronized. The new situation is different. People *do* buy art. In this sense too there is no longer, or at least not at the moment, such a thing as an avant-garde. Avant-garde must be defined in terms of audience, and here we have an audience more than ready to stay with the artist. One even gets the idea that shock has become so ingrained that the dealer, critic and collector want and expect it.

The general public has not become appreciably more aware of good painting, but the audience for advanced art, partly because of the influence of the Museum of Modern Art, is considerably wider than it has ever been in this country.

Through our writers and art historians we have become very conscious of the sequence of movements, of action and reaction. The clichés and tools of art writing have become so familiar that we can recognize a movement literally before it fully happens. About a year and a half ago I saw the work of Wesselmann, Warhol, Rosenquist and Lichtenstein in their studios. They were working independently, unaware of each other, but with a common source of imagery. Within a year and a half they have had shows, been dubbed a movement, and we are here discussing them at a symposium. This is instant art history, art history made so aware of itself that it leaps to get ahead of art.

The great body of imagery from which the pop artists draw may be said to be a common body, but the style and decisions of each are unmistakable. The choice of colour, composition, the brush stroke, the hardness of edge, all these are personal no matter how close to anonymity the artist may aspire in his desire to emulate the material of his inspiration, the anonymous mass media. The pop artists remain individual, recognizable and separate. The new art draws on everyday objects and images. They are isolated from their ordinary context, and typified and intensified. What we are left with is a heightened awareness of the object and image, *and* of the context from which they have been ripped, that is, our environment. If we look for attitudes of approval or disapproval of our culture in this art, of satire or glorification of our society, we are oversimplifying. Surely there is more than satire in Hogarth, the Longhis, Daumier, Toulouse-Lautrec. There is a satirical aspect in much of this art, but it is only that, one aspect.

Pop art is immediately contemporary. We have not yet assimilated its new visual content and style. The question at hand is not whether it is great art; this question is not answerable, or even interesting, just now. I think the point is *not* to make an immediate ultimate evaluation, but to admit the possibility that this subject matter and these techniques are and can be the legitimate subject matter and technique of art. And the point is too to realize that pop art did not fall from the heavens fully developed. It is an expression of contemporary sensibility aware of contemporary environment and growing naturally out of the art of the recent past.

HILTON KRAMER

Perhaps I should begin my remarks on the phenomenon of pop art, neo-Dada, New Realism, or whatever we finally agree to call it, on a positive note (since there will be much to say in the negative) and admit straightaway that I do believe it represents a significant historical breakthrough, as we say, in one – but only one – respect. It represents something new, not so much in the history of art as in the history of art criticism, for criticism, from its beginnings, has suffered from the humiliating predicament of having to deal with a class of objects – namely, works of art – which were far more interesting than anything that might be said about them. With the coming of pop art, this humiliation has at last been abated. It has, to all appearances, been triumphantly overcome. The relation of the critic to his material has been significantly reversed, and critics are now free to confront a class of objects, which, while still works of art more or less, are art only by default, only because they are nothing else, but about which almost anything critics say will engage the mind more fully and affect the emotions more subtly than the objects whose meaning they are ostensibly elucidating.

Pop art is, indeed, a kind of emancipation proclamation for the art critic, and while I hesitate to labour the point unduly, it may just conceivably be possible that *some*, though surely not all, of the interest this movement has generated among critics – and among museums, too, and museum symposia – is traceable to the sense they have of being placed by this new development in a more advantageous position vis-à-vis the work of art than they have heretofore enjoyed.

Why is it the case, as I emphatically believe it to be, that this work is interesting for what is said *about* it rather than for what it, intrinsically, is? Primarily, I think, because it is so preponderantly contextual in its mode of address and in its aesthetic existence; so crucially dependent upon cultural logistics outside itself for its main expressive force. It neither creates new forms nor gives us new ways of perceiving the visual materials out of which it is made; it takes the one from the precedents of abstract art and the other from the precedents of window display and advertising design. It adopts and adapts received ideas and received goods in both spheres – form and content – synthesizing nothing new, no new visual fact of aesthetic meaning, in the process. The critic Sidney Tillim, in writing about Oldenburg's last exhibition, said: '... at no time in Oldenburg's work was there ever a possibility for form to have a destiny'; and to this correct observation I would myself add: There was neither the possibility of content having a destiny, for the brute visual facts of the popular culture all around us, and upon which Oldenburg was drawing, had already endowed this material with a destiny that only a formal and psychological and social imagination of the greatest power and magnitude could hope to compete with and render artistically meaningful.

Pop art derives its small, feeble victories from the juxtaposition of two clichés: a cliché of form superimposed on a cliché of image. And it is its failure to do anything more than this that makes it so beguiling to talk about and write about – that makes pop art the conversation piece *par excellence* – for it requires talk to complete itself. Only talk can effect the act of imaginative synthesis which the art itself fails to effect.

Why, then, are we so interested in it just now, so interested in the art and in the talk?

In answering this more general question, it seems to me imperative to grasp the relation of this development to the current popularity of abstract painting, and particularly abstract painting which has been so extreme (whatever its other achievements may be) in denuding art of complex visual incident. This poverty of visual incident in abstract painting has given rise to practically every new development of the last couple of years; happening, pop art, figure painting, monster-making, kinetic art – all have in common, whatever their differences, the desire to restore to complex and recognizable experience its former hegemony over pure aestheticism. And it is as part of this desire that the taste for pop art must be understood – again, I emphasize, a contextual meaning rather than an intrinsic, creative one.

Pop art carries out a moderately successful charade – but a charade only – of the two kinds of significance we are particularly suckers for at the present moment: the Real and the Historical. Pop art seems to be about the real world, yet it appears to its audience to be sanctified by tradition, the tradition of Dada. Which is to say, it makes itself dependent upon something outside art for its

expressive meaning, and at the same time makes itself dependent upon the myths of art history for its aesthetic integrity. In my opinion, both appeals are fraudulent.

But pop art does, of course, have its connections with art history. Behind its pretensions looms the legendary presence of the most overrated figure in modern art: Mr Marcel Duchamp. It is Duchamp's celebrated silence, his disavowal, his abandonment of art, which has here – in pop art – been invaded, colonized and exploited. For this was never a real silence. Among the majority of men who produced no art, and experienced little or none, Duchamp's disavowal was devoid of all meaning. Only in a milieu in which art was still created, worried over, and found to be problematical as well as significant and necessary, could Duchamp's silence assume the status of a relevant myth. And just so, it is only in the context of a school of painting which has radically deprived art of significant visual events that pop art has a meaning. Place it in any other visual context and it fades into insignificance, as remote from our needs as the décor in last year's Fifth Avenue windows.

Duchamp's myth does carry a moral for pop art. If his silence means anything – and it surely means much less than has been made of it – its meaning is more biographical than historical. At a certain point in Duchamp's development as an artist, the experience and objects of modern life defeated his ability to cope with them. This is not an uncommon development in the life of an artist, but Duchamp was perhaps the first to turn his aesthetic impotence into a myth of superior powers. His ready-mades were simply the prologue to the silence that followed. It was *not* Duchamp, but artists like Mondrian (in his 'Boogie-Woogie' paintings) and Stuart Davis (in his paintings of New York) and David Smith (in the very way he used factory materials) who told us what it felt like to live in this particular civilization at this particular moment in history.

Pop art does not tell us what it feels like to be living through the present moment of civilization – it is merely part of the evidence of that civilization. Its social effect is simply to reconcile us to a world of commodities, banalities and vulgarities – which is to say, an effect indistinguishable from advertising art. This is a reconciliation that must – now more than ever – be refused, if art – and life itself – is to be defended against the dishonesties of contrived public symbols and pretentious commerce.

DORE ASHTON

When Lawrence Alloway first discussed pop art he explained that it was based 'on the acceptance of mass-produced objects just because they are what is around'. The throwaway materials of cities as they collect in drawers, closets and empty lots are used, he said, so that 'their original identity is solidly kept'. For Alloway it was essential that the 'original status' of junk be maintained. He bared the naturalistic bias of pop art when he insisted that 'assemblages of such material come at the spectator as bits of life, bits of the city'.

The urgent quest for unadorned or common reality, which is the avowed basis of pop art, was again asserted by Alloway two years after. In an introduction to Jim Dine's catalogue he flatly poses pop art as an antidote to idealism: he suggests that aesthetic tradition tends to discount the reality of subject matter, stressing art's formality 'which can be made a metaphor of an ideal order'.

And here is the crux of the matter: the contemporary artist, weary and perplexed by the ambiguities of idealism (as in Abstract Expressionism, for instance) decides to banish metaphor. Metaphor is necessarily a complicating device, one which insists on the play of more than one element in order to effect an image. The pop artist wants no such elaborate and oblique obligation. He is engaged in an elementary game of naming things – one at a time.

Perhaps the movement can be seen as an exacerbated reaction to the Romantic movement, so long ascendant in modern art history, in which artists were prepared to endure an existence among things that have no name.

Or perhaps pop art is a defensive movement against overwhelming Romantic isolation. Baudelaire said that the exclusive passion of art is a canker which devours everything else. Perhaps this generation is fearful of being devoured – fearful of life itself.

The impatient longing to reduce reality to the solid simple object which resists everything – interpretation, incorporation, juxtaposition, transformation – appears again and again in modern art history. But it is always delusive. The artist who believes that he can maintain the 'original status' of an object deludes himself. The character of the human imagination is expansive and allegorical. You cannot 'think' an object for more than an instant without the mind's shifting. Objects have always been no more than cues to the vagabond imagination. Not an overcoat, not a bottle dryer, not a Coca-Cola bottle can resist the onslaught of the imagination. Metaphor is as natural to the imagination as saliva to the tongue.

The attitude of the pop artist is diffident. He doesn't aspire to interpret or re-present, but only present. He very often cedes his authority to chance – either as he produces his object, or as it is exposed to the audience which is expected to complete his process. The recent pop artist is the first artist in history to let the world into his creative compound without protest.

A few brief history notes: Apollinaire said Picasso used authentic objects which were 'impregnated with humanity' – in other words, he used them metaphorically. When Duchamp exhibited his urinal he was careful to insist that it was significant because he, Duchamp, had chosen it. Schwitters wrote that 'every artist must be allowed to mould a picture with nothing but blotting paper, provided he is capable of moulding a picture'.

But by the time pop art appears, the artist as master image-maker is no longer assertive. He gladly allows Chance to mould his picture, and is praised for it, as when John Cage praises Rauschenberg because he makes no pretence at aesthetic selection. There is a ring of Surrealism and Lautréamont in Cage's observation that between Rauschenberg and what he picks up is the quality of an encounter – but not the metaphorical encounter of sewing machine and umbrella – only a chance encounter in the continuum of random sensation he calls life.

In the emphasis on randomness and chance, on the virtual object divested of associations, on the audience as participant, and in his rebellion against metaphor, the pop artist generally begs the question of reality. He refuses to take the responsibility of his choices. He is not the only one. Alain Robbe-Grillet, commenting on his filmscript *Last Year at Marienbad*, parallels him when he says that the spectator can do with it what he likes; he, the author, had nothing decisive in mind.

The contemporary aesthetic, as exemplified by many pop artists and certain literary and musical figures, implies a voluntary diminution of choices. The artist is expected to cede to the choice of vulgar reality; to present it in unmitigated form. Conventionally, choice and decision are the essence of a work of art, but the new tendency reduces the number and quality of decisions to a minimum. To the extent that interest in objects and their assemblage in non-metaphorical terms signifies a reduction of individual choices, pop art is a significant sociological phenomenon, a mirror of our society. To the extent that it shuns metaphor, or any deep analysis of complex relations, it is an impoverished genre and an imperfect instrument of art.

Far from being an art of social protest, it is an art of capitulation. The nightmare of poet Henri Michaux, who imagines himself surrounded by hostile objects pressing in on him and seeking to displace his 'I', to annihilate his individuality by 'finding their centre in his imagination', has become a reality for many would-be artists. The profusion of things is an overwhelming fact that they have unfortunately learned to live with.

I can see the movement as cathartic – art protecting itself from art. But catharsis is by no means an adequate response to the conundrum of contemporary life.

LEO STEINBERG

I have put down three questions: First: Is it art? Second: If it is – if pop art is a new way in art – what are its defining characteristics? And Third: Given its general characteristics (if definable), how in any particular case do you tell the good art from the bad? Since I have only seven minutes, if I can't answer these questions, I can at least complicate them.

The question 'Is it art?' is regularly asked of pop art, and that's one of the best things about it, to be provoking this question. Because it's one that ought to be asked more or less constantly for the simple reason that it tends to be constantly repressed. We get used to a certain look, and before long we say, 'Sure it's art; it looks like a De Kooning, doesn't it?' This is what we might have said five years ago, after growing accustomed to the New York School look. Whereas ten years earlier, an Abstract Expressionist painting, looking quite unlike anything that looked like art, provoked serious doubts as to what it was.

Now I think the point of reformulating this question time and again is to remind us that if there is a general principle involved in what makes a work of art, we have yet to establish it. And I mean specifically this: Do we decide that something is art because it exhibits certain general characteristics? Or because of the way we respond to it? In other words, exactly what is it that the artist creates?

Victor Hugo, after reading *Les Fleurs du Mal*, wrote to Baudelaire and in five words summed up a system of

aesthetics: 'You create a new shudder.' This implies that what the artist creates is essentially a new kind of spectator response. The artist does not simply make a thing, an artefact, or in the case of Baudelaire, a poem with its own beat and structure of evocation and image. What he creates is a provocation, a particular, unique and perhaps novel relation with reader or viewer.

Does pop art then create anything new – a new shudder – or not? The criticism of pop art is that it fails to do it. We are told that much of it is prefigured in Dada, or in Surrealism, or worse still, that it simply arrests what advertisements and window displays throw at us every hour. In other words, there is not sufficient transformation or selection within pop art to constitute anything new.

This I cannot accept because I think there is nothing new under the sun except only man's focus of attention. Something that's always been around suddenly moves into the centre of vision. What was peripheral becomes central, and that's what's new. And therefore it really doesn't help the discussion of any artistic experience to point out that you can find antecedents for every feature of it. And so I still think it justified to apply to pop art the remark that Victor Hugo applied to Baudelaire: it creates a new shudder.

Just what is it that's new about it? I will limit myself to my own experience; it involves Roy Lichtenstein, who paints what appear to be mere blowups of comic-book illustrations. When I first saw these paintings, I did not like them, and I don't like them now. But I saw in them a new approach to an old problem, that of relating the artist to the bourgeois, the square, the Philistine or pretentious hipster. We remember that twentieth-century art came in with the self-conscious slogan *Epater le bourgeois*: to outrage or needle the bourgeois, keep him as uncomfortable and worried as possible. This programme lasted roughly through the 1930s, when it was pursued chiefly by the Surrealists. The heroic years of Abstract Expressionism in New York after the Second World War brought another approach, an approach so organic that it was hardly formulated; it simply ignored the bourgeois. The feeling was, 'They don't want us, we don't want them.' The artists developed a thoroughgoing camaraderie: 'We know what we're doing, the rest of the world never will. We'll continue to paint for each other.' This surely was a radically different phase in the relationship of artist and middle class.

And when I saw these pictures by Lichtenstein, I had the sensation of entering immediately upon a third phase in twentieth-century painting. The idea seemed to be to out-bourgeois the bourgeois, to move in on him, unseat him, play his role with a vengeance – as if Lichtenstein were saying, 'You think you like the funnies. Wait till you see how I like the funnies!'

I think it has something to do with God and idolatry, God being understood as the object of man's absolute worship. (I know no other way of defining the word.) Wherever people worship respectably, there is rivalry among worshippers to show who worships the most. Where the object of worship is disreputable, we pretend that our respect for it is very casual or a matter of mere necessity. And now Lichtenstein and certain others treat

mass-produced popular culture as Duccio would treat the Madonna, Turner the Sea, Picasso the Art of Painting – that is to say, like an absolute good. Something like this is now going on, I think; the artists are moving in, naïvely or mockingly, each in his way, an uninvited priesthood for an unacknowledged, long-practiced cult. And this may be why, as Mr Geldzahler was able to tell us, several pop artists were working along the same lines for years, though in ignorance of one another.

Whether their productions are works of art I am not prepared to say at this point. But that they are part of the history of art, of its social and psychological history, is beyond question. And if I say that I am not prepared to tell whether they are art or not, what I mean is that I cannot yet see the art for the subject. When I tell you, as I told Mr Lichtenstein, that I don't like his paintings, I am merely confessing that in his work the subject matter exists for me so intensely that I have been unable to get through to whatever painterly qualities there may be.

This leads me to the second question I had wanted to touch upon. We have here one characteristic of pop art as a movement or style: to have pushed subject matter to such prominence that formal or aesthetic considerations are temporarily masked out. Our eyes will have to grow accustomed again to a new presence in art: the presence of subject matter absolutely at one with the form.

One thing I'm sure of: critics who attack pop art for discarding all aesthetic considerations talk too fast. They forget that artists always play peekaboo. Sometimes – and I am now thinking of all the history of painting – sometimes they play with latent symbolism, at other times they disguise their concern with pure form. Today, for some reason, these pop artists want the awareness of form to recede behind the pretence of subject matter alone, and this creates a genuine difficulty. Why they assign this new role to subject matter, after almost a century of formalist indoctrination, is not easy to say.

I see that some critics of pop art denounce it as a case of insufferable condescension. Several writers regard it as ineffectual satire (I myself see almost nothing satirical in pop art). Others think it's simple conformity with middle-class values. And there is always the possibility that the choice of pop subjects is artistically determined; that the variegated ready-made, pictorial elements he now uses furnish the artist with new richness of incident both in surface and depth, while allowing him not to worry about 'the integrity of the picture plane'. For since the elements employed in the picture are known and seen to be flat (being posters, cartoons, ads, etc.), the overall flatness of the picture-as-object is taken care of, and the artist, confronting new problems galore, faces one old problem the fewer. But it is obviously impossible to declare whether pop art represents conformity with middle-class values, social satire, effective or otherwise, or again a completely asocial exploration of new, or newly intriguing, formal means. It is impossible to give one answer because we are not dealing with one artist. We are asked to deal with many. And so far, there has been no attempt around this table to differentiate between them. And the fact that there has been no such differentiation encourages me to say some-thing here which, I hope, won't sound too pedagogical.

There are two ways of treating an exhibition experience, especially one like the recent pop-art show at Sidney Janis'. One way consists of the following steps: First: Walk around the show, noting the common features. Second: Describe these features in one or more generalizations. Third: Evaluate your abstracted generalizations and, if you find them wanting, condemn the whole movement.

The other way begins in the same manner. Walking around, you observe this and that, passing by all the works that do nothing to you. Then, if any one work seems at all effective, open up at once and explore it as far as you can. Lastly, ponder and evaluate your reaction to this single work; and this, strangely enough, also yields a first generalization: If this one work in the show produced a valid experience, e.g., a new shudder, then the whole movement is justified by its proven ability to produce a valid work. The generalization emerges from the more intense experience of the particular. This is another way of doing it, and I prefer it, not only because I enjoy thinking about one work at a time, but also because the artists we are discussing share no common intention [...]'

1 [As his time was up, Steinberg concluded here and did not expand upon his third question.]

Leo Steinberg, et al., 'A Symposium on Pop Art', 1962, *Arts Magazine* [New York, April 1963, 35-45; reprinted in full, including Stanley Kunitz's paper and the following panel discussion, in Steven Henry Madoff, ed., *Pop Art: A Critical History*, Berkeley and Los Angeles: University of California Press, 1997] 39-41.

Reyner BANHAM
Who is this 'Pop'? [1963]

'Dear Vidiots
Boeing along to Honolulu – can see the islands like Bonestells in the sea. Now to make that Waikiki scene, loot goodies for home consumers. Bully for former IG-man, hey?
Love from Pop'

WHO IS THIS 'POP'?
What right has he to call himself by a name that is now sacred, accepted in those stratospheric realms of art where prizes are awarded, gallery reputations made. A scrutiny of his vocabulary may give us some insight into this 'Pop'. *Vidiots*, for a start, is hardly an endearing term by which to address one's offspring ...

POP'S VOCABULARY
VIDIOTS: formerly a term of pejoration, now purely descriptive – one trained in the use of the mass media, originally TV (*Video* in US usage). The word 'trained' is vital to the present meaning of *Vidiot*. At first it meant 'trained' in the Pavlovian sense of 'equipped with reliably conditioned reflexes' – people who developed uncontrollable leg-actions whenever a commercial said '... don't walk, *Run*, NOW to your dealer for a giant family sized pack.' Then followed a subtle change of meaning to

pick up the sense of 'one so conditioned to the medium that she can eat, knit, smoke, talk and read a book, all at the same time as watching the screen'. From this only a further shift of emphasis was required to make 'trained' carry the sense of 'one skilled in the use of the medium' and thus, by extension, to anyone trained to extract every subtlety, marginal meaning, overtone or technical nicety from any of the mass media. A Pop art connoisseur, as opposed to a fine art connoisseur. The opposition, however, is only one of taste, otherwise the training required to become a connoisseur is the same. Thus the fine art connoisseur starts by acquiring a Pavlovian conditioning that causes him to run, not walk, to the Tate Gallery every time he reads the art-column in the *Observer*; later he becomes so thoroughly at home with the medium that he can flirt, drink sherry and make smarty-pants conversation while looking at the pictures; and finally he acquires sufficient skill to distinguish between abstract and representational art, and begins to get something out of what he is looking at. Neither the Pop art fancier nor the fine art connoisseur will be able to get anything much out of Royal College Pop art painting however: both will be convinced that they are being taken for a ride.

BOEING: one of the things that have changed since we first began the systematic study of Pop art is the status of transports of delight. Even fairly square bodies of opinion, such as the Council of Industrial Design, have now caught up with the idea that car-styling makes some kind of reference to the forms of jet aircraft. This was certainly true once – Pop needs must love the highest when it sees it, and the 'highest' in Pop means the summit in any related field. Thus, in the early Fifties, cars, as a form of transport, took their style from the summit of transportation, which in those days was jet flying. (As symbols of sex, power and wealth, of course, cars looked to other summits – that is why the Rolls Royce has a radiator shaped like the portico of the Royal Exchange.) But styling deals – as all Pop art deals – with dreams that money can *just* buy (it is axiomatic that any pop product looks as if it come out of one drawer higher than its price would suggest) while the summits are, by definition, dreams that money just *can't* buy – Claudia Cardinale membership of the Clan, lunch at the Palace – and now that a broad section of consumers can expect to fly jet to next year's holiday, if not this one, jet travel is purchasable and no longer a summit – car-styling has visibly gone off the jet kick. Supersonic flight remains, but has no definitive and instantly recognizable forms for the stylists to ape; space-travel has such forms, but try to imagine a car in the shape of a Mercury capsule. In any case, car styling is a dead Pop art at present; the Minis and the compacts buried an epoch, and cars ceased to be Number One status symbol. Only a few types of transportation gather any stardust now – big hairy motor-bikes; small boats with two very large outboard motors on them; private or chartered aircraft, preferably with French jet engines.

BONESTELL: only rarely can the creators of basic Pop imagery be identified, but Chesley Bonestell is certainly one of those who have issued fundamental coinage for the

stylists and entertainers to trade with. In collaboration with Space-brains like Willy Ley and Wernher von Braun, and information sources like the Hayden Planetarium, he has created the bulk of the accessible imagery of space-flight, from our common image of moonscape, to the un-streamlined, orbitally-built space-ship. Most of this was in *Life*, *Colliers*, etc, but there were also two notable films, *Destination Moon* and *Conquest of Space*, on which he advised. Period pieces by the high-discard standards of Pop art today, yet the archetypal visions survive everywhere you look. But electronic 'space-music', which is the aural equivalent of Bonestell, seems to have no single inventor. Rather, it seems to have sprung, like a number of Pop art phenomena, from the sudden collision of a keen, far-out taste and the technical means to satisfy it. Space music did not audibly exist before *The Forbidden Planet*, when it emerged fully-blown as a new sound to dig.

MAKE THE SCENE: something wrong here – the whole point about the product culture of which Pop art is part, is that you don't have to go and get anything, it comes to you, processed and pre-packed, reliable and standardized. So you don't go to Honolulu, Rome, Tahiti, Bali, because you can't make these scenes as you make the coffee-bar or Palais scenes. The reasons are curious, but obvious, if you stop to think. In the real, these exotic places have alien cultures (even Rome is profoundly alien to most Anglo-Saxon consumers) and they have dead or embarrassing patches between the accepted high spots – slums, factories, beggars, humdrum people in humdrum houses. So the only scenes that can be made are either completely artificial ones (Butlin's, but also Miami) or small enough to keep under control (Cheddar Gorge, but also Capri) or both (Venice). The other places, as they function in Pop art, are abstractions, visual images made by condensing the whole into a few select views. Thus, Rome is the Spanish Steps, Trevi, the colonnade of St Peter's, Moravia interviewing Claudia Cardinale in his pent-house, three cafés on the Corso and Anita Eckberg; portable and transmissible images that are truer than the facts. To make the scene and observe the facts first-hand is to transgress against the Consumptuary Laws, and those who do so must accept their responsibilities and package their memories carefully before they say a word about their trip, back home in Scranton, Penge or Duisburg-Ruhrort.

GOODIES: most vital new concept in Pop since *gimmick*, and still very tricky for squares to handle; not yet capable of definition, it must be described circumferentially. When Yogi Bear scents 'goodies' in someone's picnic spread he identifies fancy food, a relish his diet does not normally afford. When a teacher at a mid-Western university asks 'What goodies did you bring back from Chicago?' he means wit, funnies, frivols, like genuine Brand-X cigarettes, Japanese wrestling magazines, foreign paper-backs from Krogh and Brentano's – in sum, things the drug store doesn't stock. But when a hot-rodder advertises, say, 'a real cherry Dodge '56 V-8 stroker with Jahns, Iskenderian speed goodies', he means nothing inessential or functionless. He is talking about special camshafts, pistons, pipe-work and other etceteras all

meant to make that rod really go. But these are all optional extras that you don't get FOB Detroit when you buy the heap in the first place. Like, all goodies are extra, clip-on improvements that make the eyes pop by promising a better diet, life, car. But there is also a sense in which goodies must come in a fairly compact package – the pistons, cams and pipes are a 'speed kit' for instance, Yogi's bonanza of tasty snacks is normally found all together in a picnic basket or on a table, the Chicago loot will be found crammed into the academic brief-case – and there is good reason to suspect that the original goodies were the plastic give-aways in cereal packets. Peter Blake's Pop art paintings are a mass of goodies, usually, so are most of the New American Dreamer paintings and objects, such as Oldenburg's *Cakes*, described by Sidney Tillim as among 'the booty' recently acquired by the Museum of Modern Art – goodies for egg-heads.

CONSUMER: Pop culture is about things to use and throw away. Only an economist could conceive such a flat contradiction in terms as 'consumer durables' – there is no Pop architecture to speak of, and never will be in any ultimate sense, because buildings are too damn permanent. The aesthetics of Pop depend on a massive initial impact and small sustaining power, and are therefore at their Popiest in products whose sole object is to be consumed, that *must* be consumed, whether physically, like soft serve ices, or symbolically, like daily papers that can only last twenty-four hours by definition. In fact, physical and symbolic consumability are equal in Pop culture, equal in status and meaning – something that Nabakov dimly perceived in that celebrated passage from *Lolita*.

In the gay town of Lepingville I bought her four books of comics, a box of candy, and box of sanitary pads, two cokes, a manicure set … a portable radio, chewing gum, a transparent rain-coat, sun-glasses, some more garments …

All this rule of goodies are consumable, and on this scale of values books and disposable sanitary towels are equally periodical. It is this that really galls fine art people about the Pop arts; printed words are the sacred tablets of their culture; they build libraries, universities and literary supplements to maintain their permanency, while Pop consumers treat them like coke and chewing gum. The addition of the word *expendable* to the vocabulary of criticism was essential before Pop art could be faced honestly, since this is the first quality of an object to be consumed. Unfortunately, expendability is also one of the qualities of everything made by man – not even the Pyramids are proof against wear – and once the principle had been enunciated it looked like yet another way in which Pop art was taking the mickey out of the Fine Arts. Sure enough, the boys were soon to be heard talking about 'Fine-Art consumers', which brings us to

I.G.: the boys in question were the Independent Group at the ICA, whose activities around 1953–55 are at the bottom of all conscious Pop art activities in Fine-Art circles. The

basic vocabulary, including the words *Pop art* themselves (analogy with Pop music), came into circulation *via* the IG, even if they weren't invented by them; so did the systematic study of the iconography of car-styling, science-fiction, Westerns, the rock 'n' roll industry, advertising. It has been a source of the greatest grim humour to IG veterans like the present author to watch those who were quick to damn the IG as frivolous, conformist, etc., and its manifestations as 'sophisticated meddling with unsophisticated tastes', to watch all these Basil Taylors and John Bergers and Francis Newtons, trying to catch up, taking over our vocabulary and trying not to adopt our attitude. There is one very good reason why the IG were with it so long before anyone else, something that was clearly never understood by Basil Taylor, who actually produced that bit about 'sophisticated meddling'. The key figures of the IG – Lawrence Alloway, John McHale, Eduardo Paolozzi, Richard Hamilton, Frank Cordell, even myself – were all brought up in the Pop belt somewhere. American films and magazines were the only live culture we knew as kids – I have a crystal clear memory of myself, aged sixteen, reading a copy of *Fantastic Stories* while waiting to go on in the school play, which was Fielding's *Tom Thumb the Great*, and deriving equal relish from the *recherché* literature I should shortly be performing, and the equally far out pulp in my hand. We returned to Pop in the early fifties like Behans going to Dublin or Thomases to Llaregub, back to our native literature, our native arts.

Is 'Pop' really with it, then? He is too much with it! Far from being a normal consumer of expendable goods he knows about origins and sources; worse, he was a member of the dreaded Independent Group. He is of one those who have helped to create the mental climate in which the Pop art painters have been able to flourish in England (there is a direct line from the Independent Group to Peter Blake and the Royal College) and the New American Dreamers in the USA. Like them, he knows too much to believe that there is anything such as an 'unsophisticated consumer', knows that all consumers are experts, have back-stage knowledge of something or other, be it the record charts or the correct valve timing for doing the ton, and that all experts are consumers at some time, if only of English detective novels, the most completely standardized, pre-digested, pre-packed and universally available product on the market. Like all Pop art consumers he is *knowing*, Pop art is sophistication for all. *Vidiot* is no term for abuse.

Reyner Banham, 'Who is this "Pop"?', *Motif*, 10 [London, 1963, 3–13; reprinted in Reyner Banham, *Design by Choice*, London: Academy Editions, 1981] 94–6.

John COPLANS
American Painting and Pop Art [1963]

Although this exhibition is the first to attempt a collective look in considerable depth at the current phenomenon of

what for the time being is broadly labelled as Pop art' (as well as those artists who now appear as harbingers of this new art), it has been preceded by a series of important museum exhibitions within the last year that have examined various aspects of the heterogeneous activity:

September 1962
'The New Painting of Common Objects' organized by Walter Hopps at the Pasadena Art Museum

March 1963
'Six Painters and the Object' organized by Lawrence Alloway at the Solomon R. Guggenheim Museum, New York

April 1963
'Popular Art' organized by Mr and Mrs C. Buckwalter at the Nelson Gallery of the Atkins Museum, Kansas City

April 1963
'Pop Goes the Easel' organized by Douglas MacAgy at the Contemporary Art Museum, Houston

April 1963
'The Popular Image Exhibition' organized by Alice Denney at the Washington Gallery of Modern Art

July 1963
'Six More' organized by Lawrence Alloway at the Los Angeles County Museum (mainly a repeat of the Pasadena Exhibition) and show with the travelling version of 'Six Painters and the Object'

Abstract Expressionism, the first brilliant flowering of a distinctly American sensibility in painting, is a movement in which the prime innovators and the most important artists are largely based in New York. Another characteristic is that, without exception, all the early work of the painters in this movement can be seen as a direct confrontation of, and struggle with, the dominating influences of European painting. In contrast, Pop art reveals a complete shift of emphasis in both geographical location and subject matter. The first body of work that has emerged from this new movement is widely dispersed between the two coasts – this simultaneous eruption is an important factor neglected by all the organizers of previous exhibitions, with the exception of Pasadena's 'New Painting of Common Objects'. It points up several aspects of the new art that have received little consideration in the past. The curious phenomenon, particularly in these times of easy communication, of a group of artists widely separated geographically, who appear at roughly the same time with images startlingly different from those which dominated American painting for two decades and yet strikingly similar to each other's work, points to the workings of a logic within the problems of American painting itself rather than to the logic of dealers and pressure groups. If the logic of Abstract Expressionism was hammered out in fiery quarrels in Greenwich Village bars by the most intensely speculative group of painters America has yet produced, the logic of

this new art, by a quite different but equally valid process, forced itself on artists geographically isolated from one another and yet faced with the same crisis.

The subject matter most common to Pop art is for the most part drawn from those aspects of American life which have traditionally been a source of dismay to American intellectuals, and a source of that glib derision of 'American culture' so common among Europeans: the comic strip, mass-media advertising, and Hollywood. Some critics argue that the employment of this subject matter places the artists in the morally indefensible position of complacent – if not joyous – acceptance of the worst aspects of American life. Others, however, insist upon finding a negative moral judgment implicit in the work. The artists, for the most part, remain silent or, worse, perversely make public statements feeding the fury of the party they consider more absurd. For of course neither position approaches the real problems of this new art or searches the nature of the crisis which has brought it forth. That crisis is essentially the same crisis the Abstract Expressionist painters faced, and solved so brilliantly in their own way: the problem of creating a distinctly American painting, divorced from the stylistic influences and aesthetic concerns of a tradition of European art which has lain like a frigid wife in the bed of American art since the Armory show. (And why hasn't anyone seen the re-creation of the Armory show as the greatest irony possible in the light of this new American painting?) If, during the last decade, Abstract Expressionism has been thought of – at least in this country – as finally having solved the problem of the creation of a distinctly American art, here is a whole new generation which has engendered widespread confusion by thinking otherwise. Seen from this point of view the painters of the soup can, the dollar bill, the comic strip, have in common not some moral attitude towards their subject matter that some say is positive and others say is negative, *but a series of painting devices which derive their force in good measure from the fact that they have virtually no association with a European tradition*. The point is so utterly plain that one is astonished at how often it has been missed. For these artists, the Abstract Expressionist concern with gesture, with the expressive possibilities of sheer materials is out – *all* Expressionistic concerns (and Impressionistic ones as well), abstract or otherwise, are out. A sophisticated concern with compositional techniques, formal analysis or drawing, is also out, and indeed Lichtenstein will depart from his usual comic-strip paintings to lampoon a famous Picasso Cubist painting, or a well-known art book's diagramming of the composition of an important Cézanne.

A further challenge to this new direction in art is that of shallowness. This condemnation is based upon the principle that transformation *must occur* in order to differentiate an art image from a similar image in the real world. Certain artists within the broad category of the movement, it is claimed, in particular Warhol and Lichtenstein, fail to effect such a transformation, and if they do, it is so minute as to be of relatively no importance. The very essence of this new art lies precisely in its complete break from a whole tradition of European

aesthetics. This is accomplished by the particular choice of subject matter which is put into a new fine art context. This *is* the transformation.

While it would seem neither to damn nor approve the material of its inspiration – indeed to appear totally disinterested in the moral problems it raises – Pop art does take subtle and incisive advantage of deeply rooted cultural meanings and demonstrates how for the artist the seemingly common and vulgar everyday images, messages and artefacts of a mass-communicating and consuming society can give rise to the deepest metaphysical speculations. Warhol's rigid, simple, mass-produced, and standardized symmetry is only a point of departure behind which lies an assertive individuality, despite his non-committal painting technique. Hefferton's deliberate and highly disciplined suppression of the decorative quality of paint by substituting a non-aesthetic and primitive handling is also totally personal and at the same time his images insidiously recall a host of associations concerning 'political expediency'. Lichtenstein's flattened, blown-up, and arrested images from the comics subtly pose real issues of the crisis of identity. In contrast to these three, Goode in his highly ambiguous milk bottle paintings employs a rich sensuous quality of paint. Oldenberg's painted plaster edibles parody the anxious, violent type of caricature and expressive use of colour that has marked so much of modern art since Van Gogh but which has now become an inexpressive formal device and cliché in academic circles. If some of these images are deadpan, an underlying violence seeps through as in Ruscha's calculated word images.² Blosum's cool, detached and simply painted monotone image of twenty-five minutes ticking away on a parking meter may appear indifferent to the tortured quality of life, the subject matter of the human condition painters, but it is in fact loaded with suppressed anxiety.

What at first sight appears to be a rather restricted movement employing a narrow range of imagery is in fact enormously rich in the variety of artists it encompasses; at the same time this is not meant to imply that there are no sharp qualitative differences among these artists as in those of any other movement. What is of intense interest, however, is that these artists are looking at and using the most thoroughly and massively projected images of our time – images so looked at that they have become accepted, overlooked and unseen – as a raw material for art.

The emergence of this new art forces the re-evaluation of those artists in the past who have seemed merely eccentric or whose imagery and direction seemed peripheral to the course of American painting since World War II. Obviously Stuart Davis and Gerald Murphy, both considerably influenced by Léger, anticipate certain aspects of Pop art in imagery and technique – Davis for his use of blown-up sign fragments and references to popular culture and jazz, Murphy for his billboard style and American vulgarism. A more recent forerunner activity than that of Davis and Murphy spanned the last fifteen years in various cities. In Paris it was the American expatriate William Copley, a post-Surrealist with imagery full of cheesecake eroticism, patriotic folklore and

sophisticated vulgarism. In New York were Larry Rivers with an imagery derived from American folklore and contemporary popular sources, but without the radical innovation of technique that would separate his work from Abstract Expressionism, and Ray Johnson, a pioneer in the use of the cheapest graphic techniques. In San Francisco Wally Hedrick traced ironic reflections on to radios, television cabinets, and refrigerators, and Jess Collins 'rewrote' the action and content of comic strips by collaging within existing printed images. Another curious figure is Von Dutch Holland, the southern Californian hot rod striper, a genuinely popular artist whose eccentric imagery and high craft technique combined with a visionary attitude was admired by younger artists. The two key and most significant artists who are usually included within the Pop category are Jasper Johns³ and Robert Rauschenberg, but they should rather be regarded as direct precursors who provided the momentum, concentrated insights and focus of ideas that triggered the broad breakthrough of this new art, Rauschenberg for his concern with art as a *direct* confrontation of life, transforming his environment into art in a strange, compelling new way, and Johns for the potent questions he raised on the discontinuous quality of symbols. Billy Al Bengston⁴ appears to be one of the first artists to have recognized exactly what Johns and Rauschenberg were opening up [;] from 1959 on he completed a broad spectrum of work within the new idiom, but his more recent penumbric, hard-surfaced optical images are more concerned with a heightened awareness of the strange beauty and perfection of materials and have little to do with Pop art.

1 A phrase coined by Lawrence Alloway in the early Fifties
 to describe the strong forerunner activity in this
 direction by Eduardo Paolozzi, Richard Hamilton and
 others in London. Its subsequent usage cannot, however,
 be made his responsibility. The value of Alloway's
 consistent insight into this movement, incidentally,
 cannot be overestimated.

2 Ruscha is the first artist in the movement to have
 published, in an edition of one hundred copies, a book
 entitled *Twentysix Gasoline Stations*. A series of
 photographed images, it should be regarded as a small
 painting.

3 See Alan R. Solomon's perceptive introduction to the
 catalogue of the exhibition 'The Popular Image' at the
 Washington Gallery of Modern Art, 1963, for a statement
 on Rauschenberg's and Johns' contribution.

4 Dine, who occupies a halfway position between assemblage
 and the new art, had a one-man exhibition at the Martha
 Jackson Gallery, New York, in January 1962. It was
 Bengston's dealer, Irving Blum of the Ferus Gallery, Los
 Angeles, who gave the first one-man exhibition in July
 of 1962 to Warhol, a critical artist in the new movement,
 who made a clean break with his *Campbell's Soup Can*
 series.

John Coplans, 'American Painting and Pop Art', *Pop Art USA*,
[Oakland, California: Oakland Art Museum, 1963] 13-14.

Ellen H. JOHNSON
The Living Object [1963]

Sophisticated, vulgar, ephemeral, lasting, harsh and tender, Claes Oldenburg's work is poignantly alive. The *Two Girl's Dresses* hanging on the wall of his studio in New York's Lower East Side are as full of movement as the dresses dancing in the wind in front of the dingy shops in his neighbourhood; but Oldenburg's creations have a compelling aesthetic and human presence. Unforgettable images, they are as personal, evocative and touching as Van Gogh's *Chair*. Oldenburg's painted sculpture dresses, shirts and shoes, in their subtle undulations and projections, bear traces of the human body; they are still warm with life, a life that is there through his art. While the range of his expressive force extends from gay to ominous, even the most appealing little strawberry tart has something of the blunt power which is so arresting in works like the *Big Standing Shirt*.

To an artist who declares himself 'fond of materials which take the quick direct impress of life', restriction to the conventional domain of sculpture or painting would be oppressively limiting and the barriers between the two mediums, increasingly threatened in modern art, are completely dissolved in Oldenburg's work. Of painted sail cloth stuffed with foam rubber, or of enamelled plaster built up with burlap or muslin on a chicken-wire base, Oldenburg's objects are both painting and sculpture. Some are in the round and others, like the dresses, pyjamas and sewing-machine, are wall-pieces, reliefs made to be seen primarily from one side; but with their richly painted humps and hollows they are also like canvases with a curiously mobile irregular substance pushing from the back. When traditional sculpture is coloured, the paint is usually 'added', rather than given an independent existence as it is in Oldenburg's where the paint flows free and drips and splashes in a moving surface. Colour is used as a painter uses it – arbitrarily, to construct and accentuate, or when desirable to reduce volume and space.

Like most artists of his generation (or even since the first scrap of paper was pasted to a cubist canvas) Oldenburg wants to demolish the distinctions between art and reality, at the same time insisting on the aesthetic autonomy of the created object. As he isolates fragments of his experiences and fixes on them obsessively, he creates images of shocking intensity, more powerful than reality. Thus, the deeper the realism the less illusion and the more startling the creation. By his insistence on both – original object and created object – he recharges the age-old dialogue between art and reality. In his words, 'Recreating experience is the creation of another reality, a reality according to the human experience, occupying the same space as the other, more hostile, reality of nature. A reality with tears, or as if a piece of pie had attained a state of moral responsibility.'

Oldenburg is a deeply sensuous artist, appealing as much to touch, taste and smell as to the loftier sense of sight. The *Slice of Chocolate Cake* with its thick caramel

8. Claes Oldenburg

icing is so luscious that one's mouth may well water in contemplating it. He pushes the realism (and the humour) further by pricing the merchandise in his 'Store' at $69.95, etc. and by his manner of presenting it: men's shirts and shorts in cardboard boxes, pastries in glass cases and on little serving dishes, a ham and a tray of frankfurters and a kettle of stew on a stove. In one sense, you can't get more realistic than that, and such extreme realism makes more pungent the ironic realization that these are *created* objects: far from being sweet, sticky and melting, the cake is nasty, solid plaster. (Not a new joke, but still a funny one to people who enjoy marble sugar-loaves.) No one would be any more tempted to bite into an Oldenburg pie, even those in natural scale, than into a Cézanne apple.

Always conscious of the evocative power of scale, Oldenburg plays with it, sometimes playing it straight and natural and sometimes putting the objects or fragments of objects in startling, haunting over-size. Something of the effect he wanted to get in installing his 11-foot long ice-cream cone and 4 x 7-foot hamburger in the Green Gallery was that of big cars displayed in shop-windows uptown. The monumental scale of his new pieces not only affords Oldenburg the challenge, so essential to contemporary artists, to work big, but it also underlines the basic irony in the battle between natural object and created object. As there is a give and take between reality and art, between Oldenburg's experience and his recreation of it, so is there a constant interchange between materials and form, each giving play to the other. (Likewise, his 'Happenings' spring from his plastic art as it grows out of them, poetically, spatially and technically.)

Scaled to size or expanded majestically, Oldenburg's pies, sandwiches and cakes are not intended to attack the materialist-centred American in the way in which Hess interprets Thiebaud's dessert-filled canvases as 'major social criticism preaching revulsion by isolating the American food habit'. Oldenburg is not throwing the pies back in the public's face; he is not so much condemning us or 'urging us … to leave the new Gomorrah … to flee to the desert and eat locusts and pray for faith' as he is sharing with us his personal experience through the vitality of his art. Granted that part of his experience, on which he comments consciously or unconsciously, is the immense, vulgar and wonderful American love of things, that is not the totality of his reference (let alone the reality of his art). 'I am for an art that takes its form from the lines of life, that twists and extends impossibly and accumulates and spits and drips, and is sweet and stupid as life itself' (see his complete, poetic statement for the catalogue of *Environments, Situations, Spaces* show, Martha Jackson Gallery, May–June 1961). Although one cannot deny that the rough, even violent power of his imagery may harbour a caustic appraisal, as well as open acceptance, of whatever is, still Oldenburg does not preach. He is both too detached and too committed in his art to do that. His subjects and materials are chosen because they are at hand, they are his, and in their cheapness and immediacy they are the most fitting tools for his art in which he celebrates so eloquently the life of the city, dirty, cheap, absurd, ephemeral, always on the move going nowhere. He loves his environment as tenderly and bitterly as

Beckett loves Estragon and Vladimir and he takes us with him through the 'harsh, sweet poetry' of his work. After seeing Oldenburg's Store, or a performance of his theatre, one feels compelled to walk and linger through the Lower East Side, suddenly aware of the curious, tawdry beauty of store-windows full of stale *hors d'oeuvres*, hamburgers on Rheingold ads, stockinged legs – of five big old caps standing in a stately row on wooden mounts, of human cast-offs wandering aimlessly or hopefully loitering around the noisy bars. As a poet, Oldenburg does not speak directly of human beings, but their presence inescapably haunts his art. To walk along East Third Street is to walk with Oldenburg – it is somewhat like the sensation when driving around Aix and l'Estaque of driving through a Cézanne canvas. But with Oldenburg the sensation is at once more scattered and more immediate and the young American's transformation of his environment is more shocking and strange.

Immediate and ephemeral as Oldenburg's objects may be in character and material, they fix and hold the warmth of the moment, capturing 'the timeless with time'. Moreover, his objects are permanent symbols of human life, of simple, essential activities: bread, shirts, shoes; sewing-machine, iron, cash register. On first impression the cash register and other 'machines' in the Store looked surprisingly nostalgic and old-fashioned for a man so committed to the present and the ephemeral, but it soon became apparent that it is not so much a matter of industrial design which separates them from the latest IBM sterility as it is their used, lived-with character, not to mention their formal exuberance and sobriety. And it is not Park Avenue but the ragged, tattered human and paper-filled streets of lower New York whose sights, smell and feel Oldenburg so powerfully evokes.

The emotive content of Oldenburg's work is heightened by the importance which he gives to the feeling of time. In the shirts and shoes there is a quality of the immediate past, of the present in the dresses blowing in the wind or the icing running down the side of a cake, of the immediate future in the expectation contained in a letter, or the tempting promise of the pastries and in the whole idea of a store, with infinite possibilities of finding exciting, desirable things. Oldenburg's time range is close and concentrated; immediate past, present, and immediate future are all elements of an extended present, sustained in his objects (as well as his Happenings). The immediacy, the look of life on the wing, recalls the work of the earlier New York painters as do many other elements of Oldenburg's art (giving the lie to those critics who see him as revolting against de Kooning, etc.): the expansive size of the work, its subjective, autobiographical nature, the search for identity in the act of painting, its dripping, lively physical character and its harsh, impure expressiveness.

It has frequently been pointed out that the older generation's projection of the picture's space out into our world, engulfing the spectator and demolishing the barrier between him and the work of art, finds its natural outcome in the spatial Environments and Happenings of the younger artists. Among Oldenburg's work in these mediums are *Snapshots from the City, The Street, The Store*, and the Ray Gun Theatre which presented five

pieces, each in two versions and two performances, during the winter and spring of 1962. (Ray Gun is a name Oldenburg began using in 1960 in a show with Dine at the Judson Gallery. 'It's a name I imagined. Spelled backwards it sounds like New York and it's all sorts of things. It's me and it has mystic overtones.' He calls his studio the Ray Gun Manufacturing Company.) For each of his 1962 Happenings (he tends to prefer the word 'performances'), Oldenburg, his wife and other members of the cast usually spent three evenings talking it over, exchanging ideas, working out the time, the objects and the spatial compositions. One of his problems is to give his performers free rein while still controlling the action and character of the whole production. In his performances, people are the material which Oldenburg's sensibilities work on, people and objects, in absurd, touching, strange and commonplace events. Although, in his aesthetic detachment, he treats people as objects and emotions as objects, his work is deeply moving.

In the Ray Gun Theatre there are no professional actors, no dialogue and no script, but no Happening is completely unplanned or lacking in sound and action. There is no audience in the traditional sense, only a small almost exclusively 'in' group (limited to about 35) jammed together in a narrow passage so physically involved with the performers that one suddenly feels long hair being brushed in one's face or a leg dangling in front of one's nose or swill splashing on one's ankles. It is messy, vulgar and enchanting. The spectator is transfixed as at a circus, expecting and welcoming the unexpected. It is even more like the ancient mysteries; the spectator's participation is emotional, sensory, mystic. Oldenburg's pieces are performed for a public of initiates, often in tense darkness suddenly broken by startling light as something happens in each of the three sections, but no one can see exactly what is happening because distance and angle obscure two of the areas and the third is too shockingly close, surrounding, suffocating. What happens cannot be known; it can only be felt by those who are over-sensitive to things, colours, shapes, to darkness and light, to sound and silence, to movement and suspension of time. Far from primitive, Happenings are the mysteries of the sophisticated.

Sensitivity to the absurd is a mark of extreme sophistication and Happenings have obviously some of the same roots as the Theatre of the Absurd, but they are 'farther out' and more abstract. In the Theatre of the Absurd persons lose importance but they are not reduced completely to objects and both intellect and sentiment somehow still work together in a coherent way; [Eugene Ionesco's] *Bald Soprano* is a highly polished, inescapable satire. In the Ray Gun repertory some of the pieces have a little plot but most have none at all and things rarely 'mean anything'; certainly they never mean the same thing to everyone. Improvised in appearance, impermanent and irrelevant, they are over much too soon, about 30 minutes. One of the performances ended with a girl dressed in a little blue burlesque costume, passing pink ice-cream directly from her fingers to the spectators' mouths. This outrageous act was a pretty little piece of irony, spoofing one of the basic ideas of Happenings – audience

participation. Producing a Happening may sound a little like having someone direct The Game, a kind of charade which we used to play, but the Ray Gun Theatre is conceived, directed and presented by an artist who creates living, moving sculpture with people, objects and events as he does with foam rubber, cloth, latex, chicken-wire, plaster and enamel in his no less moving 'still life' sculpture. Man is no longer the measure of things, but with Oldenburg things still measure the man because, as Picasso observed, 'The artist is a receptacle for emotions, regardless of whether they spring from heaven, from earth, from a scrap of paper, from a passing face, or from a spider's web. That is why he must not distinguish between things. *Quartiers de noblesse* do not exist among objects.'

Ellen H. Johnson, 'The Living Object', *Art International* [New York, January 1963] 42-5.

Jill JOHNSTON
The Artist in a Coca-Cola World [1963]

During this past November the Sidney Janis Gallery gave an exhibition of what they called New Realism, and they collected work from five countries for it. The swing away from Abstract Expressionism, the prevalent style of the 50s, reached the dimension of a new movement in the past year. The artists involved have been called – besides New Realists – Factualists, Neo-Dadaists, Commonists, and Pop artists.

In 1960 the Martha Jackson Gallery gave two New Media shows. They included many artists using a tremendous variety of 'found' materials, junk and domesticated, in such different kinds of construction that the terms used to tell what things were were almost as numerous as the things themselves. The shows located the origins of the recent preoccupation with the 'object' in the early Cubist collages, the Dada manifestations, the later Surrealist combinations, and the amazing Marcel Duchamp. They also revealed the most recent influence of Robert Rauschenberg. But because the shows didn't include paintings proper, the similar influence of Jasper Johns, especially his subject matter of several years ago (the flags, targets, and numbers), was not in evidence.

About the time of the Museum of Modern Art's Assemblage exhibition last year, there was an interesting panel at the Museum conducted by William Seitz. There have been a number of panels since then. And shortly after the Janis show this season, on 13 December, there was another panel at the Museum, moderated by Peter Selz.

The subject was 'Pop art', and the title was a good indication of a coalition in the art world. As in any coalition, the opposition is aroused, the controversy is mobilized, and lots of hogwash stars flying around. Although the point of these panels would appear to be an elucidation of the subject at hand (presumably some portion of the public is confused about current events and desirous of an evaluation by the authorities), the real purpose of these

meetings, I think, is to make the bind of a general motion tighter. The writers and speakers create air currents between the artists and the people at large, an activity that tends to draw all interested parties – including the museums, galleries and collectors – into the political orbit of the present concern called a Movement. Thus what is said is not so important: in fact it is usually irrelevant. It's a kind of community function, and the greater the stir the better.

On the latest Museum panel the participants were excellent representatives of the public because they barked up all the dark alleys that always manage to confuse the actual situation, thereby assisting in the death of experience and the continuation of politics. One of those dark, impenetrable alleys is the popular topic: What Is Art? Henry Geldzahler, young assistant curator of American painting and sculpture at the Metropolitan Museum of Art (who made the only substantial, knowledgeable statement on the panel) offered the sensible observation at the outset that the artists are the ones who decide what is art. Mr Geldzahler would naturally think this way, because he is given to looking at things as they are.

Another member of the panel, Leo Steinberg, approaches this state with a warm-blooded sincerity that is only partially trapped by the mental exercises of academic criticism. He expressed his basic sentiments by quoting Victor Hugo as having said to Baudelaire that a thing is art 'when it creates a new shudder'. At one point in the discussion he took Hilton Kramer to task for his lines in *The Nation* on the Janis show which damned everything before observing anything in particular. In his own statement, which was a mammoth complaint against almost everything, Mr Kramer attacked Duchamp as though he was the arch-villain of the century. (During the intermission someone told me that Duchamp, who was present for the incrimination proceedings, remarked that perhaps Mr Kramer was 'insufficiently light-hearted'.)

By landing hard on Duchamp, Kramer was struggling in one of the crucial dark alleys of thinking about art in this century. Theories of art seem pretty useless to me except in so far as they tend to divert people from experiencing what there is to experience. From this point of view it can be worthwhile to trace a confusion of thought.

Duchamp makes a good scapegoat if you don't like all the things that have been happening these past ten years. Yet his presentation of the Readymade (e.g. the urinal) was just one manifestation of the interest in 'everyday life' as material for art that preoccupied artists in the early part of the century. And the important thing about Duchamp is that he was not interested in the object as material for art, he presented his Readymades as a statement of fact about the world.

IRONIC INTENTION

If the choice of an object inevitably expresses something about the person making that choice (as well as affecting the viewer, simply by presentation and by transference to a new surrounding) then you might think of the Readymade as a work of art. Anyway, there was an ironic intention in Duchamp's Readymade which implied the presence of

art. Find something, affix your name to it, and call it art if you like.

But beyond such considerations Duchamp was pointing past the object to express a philosophy of indifference in a world of facts and events. As Arp said: 'The purpose of Dada was to destroy the swindle of reason perpetrated on man and restore him to his humble place in nature.' With such a world-view there could be no interest in bringing order out of chaos. Chaos is a condition of man and nature, and probably for the first time in the history of Western art there was a movement among artists to relax and enjoy it. 'There is no solution because there is no problem.'

These ways of thought and action are foreign to the Western mind, and I believe this accounts for much of the misunderstanding over what has happened in art in this century that has anything to do with Duchamp at all. In order to explain the Dada period most commentators, constitutionally unable to accept a philosophy that seemed to bask in chaos, resorted to social criticism. It is, therefore, always its most superficial aspect – anti-war, anti-bourgeoisie – that is stressed in the talk of that period. There was its negative aspect, of course – something new is always negative in its comment on the past – but the real impulse of the period was a great affirmative surge forward and one of the most inspired efforts to break through the impasse of man as separate from nature.

Recent developments in art have little, often nothing, to do with Duchamp and Dada. Most of the artists in the Janis show, as well as many others not included in the show, are concerned with the 'formal' arrangement of material as the West has known it for centuries. Their lineage in contemporary history goes back primarily to the first collage inclusions by Braque and Picasso. First there was the motion to incorporate the object (our environment) into the painting, later into the sculpture; then came the Environment proper, and more recently the Happening, which is the most inclusive example of the kind of interpenetration of art and life first suggested by the collage.

PALPABLE SOURCES

Now there has been a curious admixture of that personal removal expressed by the Readymade and that personal involvement embodied in the formal arrangement. Two of the most exciting mixtures in the Janis exhibition were by Claes Oldenburg and George Segal. Oldenburg's painted plaster food, clothing, and other living accessories are as personal as any sculpture has ever been. Yet most of his objects simulate the original product to the point of arousing the same desire associated with the original. And to make the original source even more palpable, Oldenburg puts some of his objects in their real-life settings and containers, like the stove or the glass food cases.

George Segal's white plaster figures are astonishing evocations of the ordinary – the result of a brilliant idea. The idea was to make sculpture in plaster directly from a live model, then put the sculpture back in its original setting. It is difficult to convey the strange poetic power of a scene like his 'Dinner Table'. It is something like the photographic image which arrests a real moment with

vivid directness and simplicity. Like the photographer, Segal had to make subtle decisions in the 'arrangement' of the scene: the gestures and spatial relationships. But in solid sculptured form the image looms instantaneously monumental.

A REAL TASTE

Tom Wesselmann's complex compositions (collage-assemblages) are beautiful examples of the convergence of several modern preoccupations in a new pictorial scheme of another personal nature. Wesselmann uses the 'found' object, collage materials and conventional paint to make a classically organized art object. Like Oldenburg he leaves a real taste in your mouth, because he makes popular culture as it comes to us through advertising and other agents bigger than life by vivid handling. You might say that the only contemporary thing about Wesselmann is his subject matter. Its formal nature is quite traditional, and you can see various influences from the past fifty years, too; the clean, hard edge of Mondrian in stripes and divisions of areas; the voluptuous curve in the *Great American Nude* from, say, Modigliani; the flatness from many sources; the juxtaposed coordination of whole or fragmentary elements (including symbols of both past and present) from Cubism, Dada, and choices and arrangements are completely original. And those choices (the outsized advertising paper display cut-outs, the up-to-date interior fixtures) are the material content of the times, as the content of art always has been.

The popular content in the painting of James Rosenquist (juxtaposing enlarged fragments from commercial billboard posters), of Roy Lichtenstein (comic-strip subjects and techniques), of Andy Warhol (e.g., the simulated Campbell's soup can), and of Wayne Thiebaud (painterly rows of pastry) stands out clearly for what it is. The treatment in each case is highly individual and reveals a craft that is both of and beyond its subject matter. Here also, the degree of personal removal or involvement (as well as the proximity to, or distance from, the real-life object) is somehow revealed, however confusingly, in the result.

One unique example of the combined influence of Duchamp-Dada and formal use of the 'object' is the work of Arman, the Frenchman. Arman collects one object for each work (faucets, sabres, eyeglasses, dolls' hands, etc.) and puts them in a repetitive 'all-over' arrangement, often as though they were pick-up-sticks and he lets them fall as they would. This makes an exciting concentration on one object that induces involvement in that object's multiple aspects as well as the specific feeling (tactile and visual) of that object. There's a certain indifference in both the choice and the partially haphazard arrangement. But there is also calculation and beauty. And the all-over arrangement suggests that infinite extension which is central to the dominant world-view, originating in science, of our century.

RELEASE OF WILL

Regardless of all the curious blends and cross-breeding revealed in the work of artists lumped into New Realism, Pop art, or whatever, this contemporary boom of interest in the object is primarily a direction apart from Duchamp. The world-view suggested by Duchamp and other Dadaists has trickled through to another important current in contemporary art.

The man most responsible for the revival of interest in self-removal and the reunion with nature thereby is John Cage. Because Cage is a composer, most of the activity in chance methodology and related attitudes involving the release of will has been in music. However, among painters George Brecht has been prominent in pursuing this Zen-like philosophy through actions which speak beyond themselves as a way of non-action. Brecht has determined object-constructions through the use of the Table of Random Numbers. He has presented objects which invite manipulation, by play and/or rearrangement and by removal, which suggests destruction of the object. He has presented 'events' which are simple extensions or abstracted fragments of what one does in the ordinary course of any day. And he has been a consistent 'mail' man. Through the mails Brecht offers neatly printed suggestions or reminders of everyday occurrences. Another well-known mailman is Ray Johnson. And [three] other artists involved in this kind of art/non-art are Robert Watts, Robert Morris and Walter De Maria. (The last is currently showing a number of plywood boxes at 9 Great Jones Street, where he shares an exhibition with Robert Whitman.)

The work of these artists invites contemplation of the object as a suggestion of life without the necessity of attachment. As such, the object is all-important for itself, not for any personal value, but rather for the way any object (event) in life from moment to moment can be considered just as important. This means to see, hear, experience, then to let go. Thus the Idea behind the work is crucial. The ideas in the work of those artists who were represented in the Janis exhibition are artistic ideas. They are the ideas of subject matter (no less than an English landscape or a Dutch interior) and of traditional plastic values. And where the idea seems more prominent than the personal involvement, there is that effort to be abstract, often in a geometric style, that is also well known in the history of art.

Jill Johnston, 'The Artist in a Coca-Cola World', *Village Voice* [New York, 31 January 1963].

Jasper JOHNS, Andy WARHOL, Claes OLDENBURG
Interviews recorded by Billy Klüver [1963]

JASPER JOHNS
Johns […] The difference lies in what a different technique can be used to mean. So if you do one thing and then you do another thing that's different, obviously different, you'll tend not to be able to attach the same meaning to these

two things. My early paintings seem to me to have been about, partly, what we were talking about earlier, accuracy, and questioning whether there are such things — so that they tended to be a sum of corrections in terms of painting, in terms of brushstrokes. So that there are many, many strokes and everything is built up on a very simple frame but there is a great deal of work in it, and the work tends to correct what lies underneath constantly until finally you quit and you say 'It's this one.' It seems to me that the work I make now is more concerned with … I don't know what it's more concerned with … It is less concerned with accuracy — it's taken — since there didn't seem to be any such thing anyway, it was never achieved. My more recent work seems to be involved with the nature of various technical devices, not questioning them in terms of their relation to the concept of accuracy. It seems to me that the effect of the more recent work is that it is more related to feeling or emotion or … (pause) … Let's say emotional or erotic content in that there is no superimposition of another point of view immediately in terms of a brushstroke, so that one responds directly to the physical situation rather than to a complex physical situation which immediately has to be resolved intellectually. So it seems to me the earlier paintings would appear to be more intellectual because of this. Because everything is very close, variations are slight and the lines and everything that follows are very clear. So one only has a dual situation in the early paintings. You questioned whether it is a painting or whether it is what is being represented. I think in the more recent paintings you don't question that. You know what is painting and you know what the objects are that are involved, and you may or may not know what the sense of it is. That's your own business. They are also less arbitrary. However, I think the current idea would be the opposite, because they have no references outside of the actions which were made. The earlier paintings refer to specific designs or lines or whatever, which had to be dealt with, and the liveliness of the painting tends to be what I called earlier corrections, very complex set of corrections, in relationship to these lines. Whereas the more recent works don't have that involvement. There isn't the constant attempt to do something over and over in the more recent works. Like drawing a straight line — you draw one and it's crooked and you draw another on top of it and it's crooked a different way and then you draw another one and eventually you have a very rich thing on your hands which is not a straight line.

If you can do that then it seems to me you are doing more than most people. The thing is, it is very difficult to know oneself whether one is doing that or not, whether you mean what you do; and there is the other problem of the way you do it and whether sometimes you do more than you mean, or you do less than you mean […]

ANDY WARHOL
Warhol Boo … Is that enough?
Henry Geldzahler Where are we?
Warhol I can't remember.
Geldzahler Where are we?
Warhol At a party?

Geldzahler I asked Tom Wesselmann. This is Andy Warhol we're talking to now. I asked Tom Wesselmann a lot of questions about uptown and down-town but they weren't very interesting. That's Andy, he can't think of anything to say.

Warhol That's my minute isn't it?

Geldzahler Come on.

Warhol I don't know what to say. What do you think I should say, John?

Geldzahler This is John Chamberlain who's not in the show. Hi John!

John Chamberlain How do you do?

Warhol There's no background music?

Geldzahler Oh yes there is.

Warhol You can't hear it.

Geldzahler This mike is omnidirectional. It picks up everything. I'm not supposed to be in this much. It's supposed to be the artists.

Warhol Oh!

Geldzahler Do you know what you are doing?

Warhol No.

Geldzahler Do you ever know what you are doing? Do you have an idea what a painting is going to look like before you do it?

Warhol Yes.

Geldzahler Does it end up looking like what you expected it to look?

Warhol No.

Geldzahler You're surprised?

Warhol No. That's the wrong ... Go on and ask me something else that's marvellous.

Geldzahler How can you interview an artist who can't talk? (*Laughs*) It's completely ridiculous.

Warhol Can you be silent for a week? I mean a minute?

Geldzahler Talk ... something ...

Warhol No! What am I to say? [...]

CLAES OLDENBURG

Geldzahler What does this Store represent to you, in a sense, when you come from the Street to the Store? People come into the Store and what is it ...

Oldenburg The Street was an outside form and it was a deliberately non-colouristic form and a linear form and an extended form and an infinite form. The Store is entirely different. It is inside. It is limited. It is full of colour. It's warm. The Street's cold. People, when they walk down the Street, they look into the Store and they don't look very much at the Street. The Street is really reality and the Store a sort of unreality. The Store is sort of idealism, and I guess I play with idealism; I mean the way advertising plays with idealism. Nobody can ever make a cake look the way it looks in the advertisement. It's kind of a dream, so the Store is a dream compared to the Street which is reality.

Partly the Store is my fascination with very simple-minded notions of what's beautiful, which are sometimes accidental as a result of mechanical processes and so on. It's all that people have. In another way, it's a fascination with the limitations of beauty as far as people are con-cerned in a mass society, and what they have to work with in a city mass society. So my Store ... See when you walk down Orchard Street at one time it's a very idealistic thing because it's very beautiful, in a funny kind of way, and yet it's very disappointing because all the stuff is created by machines and it's really very dull, you know. But what people see into it is more, maybe, than what's there. So, I'm working with a sort of stunted beauty.

I'm against the notion there is a world of art and then a world of real things; and that one thing has to be brought out of the world of real things into the world of art to matter. See? But I'm more inclined to put the thing somewhere halfway between the real world and the world of art, because nothing is interesting to me unless it's halfway. Unless it's very ambiguous, unless it's a little bit inside and a little bit outside. The beauty of the Store was that it was almost a real store, see, but it wasn't quite a real store, so that this confusion existed, so that when people went away they saw the real things with half the confusion of seeing my things. Now it works both ways. Artists can come in and say this is not art, this is a hamburger. And other people can come in and say this is not a hamburger, it's art. It's in the middle ground, and that is where I want to be.

I find it very hard to separate my theories from my action. I don't. It's very hard to see exactly what I do when the crucial act of doing comes because that's an arbitrary act, and up to that point there are all sorts of theoretical possibilities which may seem better or be more respectable somehow. I think the act of art is a very arbitrary and very dogmatic act. I think what I do is I take possession of the object and I only allow as much of the object in as I want. I really make a possession of the object so that when I use the object I use it on my own terms and it tends to have a life which is my own life. It tends to be a projection rather than an elimination of myself. That's what I think is true. Now, I have all kinds of notions.

I would like to treat the object as if it were outside of me and as if I knew what it was, and as if I could grasp it outside of myself; as if I could give it its own existence. But I have this feeling that even when I look at an object I am doing something creative.

It's a creative act. And I have a feeling of total relativity in regard to the object and no notion of its actual existence so that I am inclined to accept the notion that I have of it as the only possible notion, but then I do amend that a great deal by other people's notions. I tend generally to regard – this is hard to understand – everything that is seen as subjective, that is, all reality is subjective; and yet distinguish between my perception and, say, another person's perception. That is to say the glass I am looking at will look one way to me and one way to you [...]

Billy Klüver, *On Record: 11 Artists 1963, Interviews by Billy Klüver* [New York: Experiments in Art and Technology, 1981; transcript of 33 ⅓ record *Interviews with Artists participating in the Popular Image Exhibition, Washington Gallery of Modern Art*, 18 April – 2 June 1963, produced 1963].

Roy LICHTENSTEIN, Andy WARHOL, Robert INDIANA
What is Pop Art? Interviews with Gene Swenson, I [1963]

ROY LICHTENSTEIN

Gene Swenson What is Pop Art?

Roy Lichtenstein I don't know – the use of commercial art as subject matter in painting, I suppose. It was hard to get a painting that was despicable enough so that no one would hang it – everybody was hanging everything. It was almost unacceptable to hang a dripping paint rag, everybody was accustomed to this. The one thing everyone hated was commercial art; apparently they didn't hate that enough either.

Swenson Is Pop Art despicable?

Lichtenstein That doesn't sound so good, does it? Well, it is an involvement with what I think to be the most brazen and threatening characteristics of our culture, things we hate, but which are also powerful in their impingement on us. I think art since Cézanne has become extremely romantic and unrealistic, feeding on art; it is utopian. It has had less and less to do with the world, it looks inward – neo-Zen and all that. This is not so much a criticism as an obvious observation. Outside is the world; it's there. Pop art looks out into the world; it appears to accept its environment, which is not good or bad, but different – another state of mind.

'How can you like exploitation?' 'How can you like the complete mechanization of work? How can you like bad art?' I have to answer that I accept it as being there, in the world.

Swenson Are you anti-experimental?

Lichtenstein I think so, and anti-contemplative, anti-nuance, anti-getting-away-from-the-tyranny-of-the-rectangle, anti-movement-and-light, anti-mystery, anti-paint-quality, anti-Zen, and anti all of those brilliant ideas of preceding movements which everyone understands so thoroughly.

We like to think of industrialization as being despicable. I don't really know what to make of it. There's something terribly brittle about it. I suppose I would still prefer to sit under a tree with a picnic basket rather than under a gas pump, but signs and comic strips are interesting as subject matter. There are certain things that are usable, forceful and vital about commercial art. We're using those things – but we're not really advocating stupidity, international teenagerism and terrorism.

Swenson Where did your ideas about art begin?

Lichtenstein The ideas of Prof. Hoyt Sherman [at Ohio State University] on perception were my earliest important influence and still affect my ideas of visual unity.

Swenson Perception?

Lichtenstein Yes. Organized perception is what art is all about.

Swenson He taught you 'how to look'?

Lichtenstein Yes. He taught me how to go about learning how to look.

Swenson At what?

Lichtenstein At what, doesn't have anything to do with it. It is a process. It has nothing to do with any external form the painting takes, it has to do with a way of building a unified pattern of seeing ... in Abstract-Expressionism the paintings symbolize the idea of ground-directedness as opposed to object-directedness. You put something down, react to it, put something else down, and the painting itself becomes a symbol of this. The difference is that rather than symbolize this ground-directedness I do an object-directed appearing thing. There is humour here. The work is still ground-directed; the fact that it's an eyebrow or an almost direct copy of something is unimportant. The ground-directedness is in the painter's mind and not immediately apparent in the painting. Pop art makes the statement that ground-directedness is not a quality that the painting has because of what it looks like ... This tension between apparent object-directed products and actual ground-directed processes is an important strength of Pop art.

Swenson Antagonistic critics say that Pop art does not transform its models. Does it?

Lichtenstein Transformation is a strange word to use. It implies that art transforms. It doesn't, it just plain forms. Artists have never worked with the model – just with the painting. What you're really saying is that an artist like Cézanne transforms what we think the painting ought to look like into something he thinks it ought to look like. He's working with paint, not nature; he's making a painting, he's forming. I think my work is different from comic strips – but I wouldn't call it transformation; I don't think that whatever is meant by it is important to art. What I do is form, whereas the comic strip is not formed in the sense I'm using the word; the comics have shapes but there has been no effort to make them intensely unified. The purpose is different, one intends to depict and I intend to unify. And my work is actually different from comic strips in that every mark is really in a different place, however slight the difference seems to some. The difference is often not great, but it is crucial. People also consider my work to be anti-art in the same way they consider it pure depiction, 'not transformed'. I don't feel it is anti-art.

There is no neat way of telling whether a work of art is composed or not; we're too comfortable with ideas that art is the battleground for interaction, that with more and more experience you become more able to compose. It's true, everybody accepts that; it's just that the idea no longer has any power.

Swenson Abstract-Expressionism has had an almost universal influence on the arts. Will Pop Art?

Lichtenstein I don't know. I doubt it. It seems too particular – too much the expression of a few personalities. Pop might be a difficult starting point for a painter. He would have great difficulty in making these brittle images yield to compositional purposes ... Interaction between painter and painting is not the total commitment of Pop, but it is still a major concern – though concealed and strained.

Swenson Do you think that an idea in painting – whether it be 'interaction' or the use of commercial art – gets progressively less powerful with time?

Lichtenstein It seems to work that way. Cubist and Action Painting ideas, although originally formidable and still an influence, are less crucial to us now. Some individual artists, though – Stuart Davis, for example – seem to get better and better.

Swenson A curator at the Modern Museum has called Pop Art fascistic and militaristic.

Lichtenstein The heroes depicted in comic books are fascist types, but I don't take them seriously in these paintings – maybe there is a point in not taking them seriously, a political point. I use them for purely formal reasons, and that's not what those heroes were invented for ... Pop Art has very immediate and of-the-moment meanings which will vanish – that kind of thing is ephemeral – and Pop takes advantage of this 'meaning', which is not supposed to last, to divert you from its formal content. I think the formal statement in my work will become clearer in time. Superficially, Pop seems to be all subject matter, whereas Abstract-Expressionism, for example, seems to be all aesthetic ...

I paint directly – then it's said to be an exact copy, and not art, probably because there's no perspective or shading. It doesn't look like a painting of something, it looks like the thing itself. Instead of looking like a painting of a billboard – the way a Reginald Marsh would look – Pop Art seems to be the actual thing. It is an intensification, a stylistic intensification of the excitement which the subject matter has for me; but the style is, as you said, cool. One of the things a cartoon does is to express violent emotion and passion in a completely mechanical and removed style. To express this thing in a painterly style would dilute it; the techniques I use are not commercial, they only appear to be commercial – and the ways of seeing and composing and unifying are different and have different ends.

Swenson Is Pop Art American?

Lichtenstein Everybody has called Pop Art 'American' painting, but it's actually industrial painting. America was hit by industrialism and capitalism harder and sooner and its values seem more askew ... I think the meaning of my work is that it's industrial, it's what all the world will soon become. Europe will be the same way, soon, so it won't be American; it will be universal.

ANDY WARHOL

Andy Warhol Someone said that Brecht wanted everybody to think alike. I want everybody to think alike. But Brecht wanted to do it through Communism, in a way. Russia is doing it under government. It's happening here all by itself without being under a strict government; so if it's working without trying, why can't it work without being Communist? Everybody looks alike and acts alike, and we're getting more and more that way.

I think everybody should be a machine.

I think everybody should like everybody.

Swenson Is that what Pop Art is all about?

Warhol Yes. It's liking things.

Swenson And liking things is like being a machine?

Warhol Yes, because you do the same thing every time. You do it over and over again.

Swenson And you approve of that?

Warhol Yes, because it's all fantasy. It's hard to be creative and it's also hard not to think what you do is creative or hard not to be called creative because everybody is always talking about that and individuality. Everybody's always being creative. And it's so funny when you say things aren't, like the shoe I would draw for an advertisement was called a 'creation' but the drawing of it was not. But I guess I believe in both ways. All these people who aren't very good should be really good. Everybody is too good now, really. Like, how many actors are there? There are millions of actors. They're all pretty good. And how many painters are there? Millions of painters and all pretty good. How can you say one style is better than another? You ought to be able to be an Abstract-Expressionist next week, or a Pop artist, or a realist, without feeling you've given up something. I think the artists who aren't very good should become like everybody else so that people would like things that aren't very good. It's already happening. All you have to do is read the magazines and the catalogues. It's this style or that style, this or that image of man – but that really doesn't make any difference. Some artists get left out that way, and why should they?

Swenson Is Pop Art a fad?

Warhol Yes, it's a fad, but I don't see what difference it makes. I just heard a rumour that G. quit working, that she's given up art altogether. And everyone is saying how awful it is that A. gave up his style and is doing it in a different way. I don't think so at all. If an artist can't do any more, then he should just quit; and an artist ought to be able to change his style without feeling bad. I heard that Lichtenstein said he might not be painting comic strips a year or two from now – I think that would be so great, to be able to change styles. And I think that's what's going to happen, that's going to be the whole new scene. That's probably one reason I'm using silk screens now. I think somebody should be able to do all my paintings for me. I haven't been able to make every image clear and simple and the same as the first one. I think it would be so great if more people took up silk screens so that no one would know whether my picture was mine or somebody else's.

Swenson It would turn art history upside down?

Warhol Yes.

Swenson Is that your aim?

Warhol No. The reason I'm painting this way is that I want to be a machine, and I feel that whatever I do and do machine-like is what I want to do.

Swenson Was commercial art more machine-like?

Warhol No, it wasn't. I was getting paid for it, and did anything they told me to do. If they told me to draw a shoe, I'd do it, and if they told me to correct it, I would – I'd do anything they told me to do, correct it and do it right. I'd have to invent and now I don't; after all that 'correction', those commercial drawings would have feelings, they would have a style. The attitude of those who hired me had feeling or something to it; they knew what they wanted, they insisted; sometimes they got very emotional. The process of doing work in commercial art was machine-like, but the attitude had feeling to it.

EVERYBODY LOOKS ALIKE AND ACTS ALIKE AND WE'RE GETTING MORE AND MORE THAT WAY I THINK EVERYBODY SHOULD BE A MACHINE

Andy WARHOL, interview with Gene Swenson, 'What is Pop Art? Answers from 8 Painters, Part I', 1963

Swenson Why did you start painting soup cans?

Warhol Because I used to drink it. I used to have the same lunch every day, for twenty years, I guess, the same thing over and over again. Someone said my life has dominated me; I liked that idea. I used to want to live at the Waldorf Towers and have soup and a sandwich, like that scene in the restaurant in *Naked Lunch* …

We went to see *Dr No* at Forty-second Street. It's a fantastic movie, so cool. We walked outside and somebody threw a cherry bomb right in front of us, in this big crowd. And there was blood. I saw blood on people and all over. I felt like I was bleeding all over. I saw in the paper last week that there are more people throwing them – it's just part of the scene – and hurting people. My show in Paris is going to be called 'Death in America'. I'll show the electric-chair pictures and the dogs in Birmingham and car wrecks and some suicide pictures.

Swenson Why did you start these 'Death' pictures?

Warhol I believe in it. Did you see the *Enquirer* this week? It had 'The Wreck that Made Cops Cry' – a head cut in half, the arms and hands just lying there. It's sick, but I'm sure it happens all the time. I've met a lot of cops recently. They take pictures of everything, only it's almost impossible to get pictures from them.

Swenson When did you start with the 'Death' series?

Warhol I guess it was the big plane crash picture, the front page of a newspaper: 129 DIE. I was also painting the Marilyns. I realized that everything I was doing must have been Death. It was Christmas or Labour Day – a holiday – and every time you turned on the radio they said something like, '4 million are going to die'. That started it. But when you see a gruesome picture over and over again, it doesn't really have any effect.

Swenson But you're still doing 'Elizabeth Taylor' pictures.

Warhol I started those a long time ago, when she was so sick and everybody said she was going to die. Now I'm doing them all over, putting bright colours on her lips and eyes.

My next series will be pornographic pictures. They will look blank; when you turn on the black lights, then you see them – big breasts and … If a cop came in, you could just flick out the lights or turn on the regular lights – how could you say that was pornography? But I'm still just practising with these yet. Segal did a sculpture of two people making love, but he cut it all up, I guess because he thought it was too pornographic to be art. Actually it was very beautiful, perhaps a little too good, or he may feel a little protective about art. When you read Genet you get all hot, and that makes some people say this is not art. The thing I like about it is that it makes you forget about style and that sort of thing; style isn't really important.

Swenson Is 'Pop' a bad name?

Warhol The name sounds so awful. Dada must have something to do with Pop – it's so funny, the names are really synonyms. Does anyone know what they're supposed to mean or have to do with, those names? Johns and Rauschenberg – Neo-Dada for all these years, and everyone calling them derivative and unable to transform the things they use – are now called progenitors of Pop. It's funny the way things change. I think John Cage has been very influential, and Merce Cunningham, too, maybe.

Did you see that article in the *Hudson Review* ['The End of the Renaissance?', Summer 1963]? It was about Cage and that whole crowd, but with a lot of big words like radical empiricism and teleology. Who knows? Maybe Jap and Bob were Neo-Dada and aren't any more. History books are being rewritten all the time. It doesn't matter what you do. Everybody just goes on thinking the same thing, and every year it gets more and more alike. Those who talk about individuality the most are the ones who most object to deviation, and in a few years it may be the other way around. Some day everybody will think just what they want to think and then everybody will probably be thinking alike; that seems to be what is happening.

ROBERT INDIANA

Swenson What is Pop?

Robert Indiana Pop is everything art hasn't been for the last two decades. It is basically a U-turn back to a representational visual communication, moving at a break-away speed in several sharp late models. It is an abrupt return to Father after an abstract fifteen-year exploration of the Womb. Pop is a re-enlistment in the world. It is shuck the Bomb. It is the American Dream, optimistic, generous and naïve …

It springs newborn out of a boredom with the finality and over-saturation of Abstract-Expressionism which, by its own aesthetic logic, is the END of art, the glorious pinnacle of the long pyramidal creative process. Stifled by this rarefied atmosphere, some young painters turn back to some less exalted things like Coca-Cola, ice-cream sodas, big hamburgers, super-markets and 'EAT' signs. They are eye-hungry; they pop …

Pure Pop culls its techniques from all the present-day communicative processes: it is Wesselman's TV set and food ad, Warhol's newspaper and silkscreen, Lichtenstein's comics and Ben Day, it is my road signs. It is straight-to-the-point, severely blunt, with as little 'artistic' transformation and delectation as possible. The self-conscious brush stroke and the even more self-conscious drip are not central to its generation. Impasto is visual indigestion.

Swenson Are you Pop?

Indiana Pop is either hard-core or hard-edge. I am hard-edge Pop.

Swenson Will Pop bury Abstract-Expressionism?

Indiana No. If A-E dies, the abstractionists will bury themselves under the weight of their own success and acceptance; they are battlers and the battle is won; they are theoreticians and their theories are respected in the staidest institutions; they seem by nature to be teachers and inseminators and their students and followers are legion around the world; they are inundated by their own fecundity. They need birth control.

Swenson Will Pop replace Abstract-Expressionism?

Indiana In the eternal What-Is-New-in-American-Painting shows, yes; in the latest acquisitions of the avant-garde collectors, yes; in the American Home, no. Once the hurdle of its non-objectivity is overcome. A-E is prone to be as decorative as French Impressionism. There is a harshness and matter-of-factness to Pop that doesn't exactly make it the interior decorator's Indispensable Right Hand.

Swenson Is Pop here to stay?

Indiana Give it ten years perhaps; if it matches A-E's 15 or 20, it will be doing well in these accelerated days of mass-medium circulation. In twenty years it must face 1984.

Swenson Is Pop aesthetic suicide?

Indiana Possibly for those Popsters who were once believing A-Eers, who abandoned the Temple for the street; since I was never an acolyte, no blood is lost. Obviously aesthetic 'A' passes on and aesthetic 'B' is born. Pity more that massive body of erudite criticism that falls prostrate in its verbiage.

Swenson Is Pop death?

Indiana Yes, death to smuggery and the Preconceived-Notion-of-What-Art-Is diehards. More to the heart of the question, yes, Pop does admit Death in inevitable dialogue as Art has not for some centuries; it is willing to face the reality of its own and life's mortality. Art is really alive only for its own time; that eternally-vital proposition is the bookman's delusion. Warhol's auto-death transfixes us; DIE is equal to EAT.

Swenson Is Pop easy art?

Indiana Yes, as opposed to one eminent critic's dictum that great art must necessarily be difficult art. Pop is Instant Art … Its comprehension can be as immediate as a Crucifixion. Its appeal may be as broad as its range; it is the wide-screen of the Late Show. It is not the Latin of the hierarchy, it is vulgar.

Swenson Is Pop complacent?

Indiana Yes, to the extent that Pop is not burdened with that self-consciousness of A-E, which writes tortuously in its anxiety over whether or not it has fulfilled Monet's Water-Lily-Quest-for-Absolute/Ambiguous-Form-of-Tomorrow theory; it walks young for the moment without the weight of four thousand years of art history on its shoulders, though the grey brains in high places are well arrayed and hot for the Kill.

Swenson Is Pop cynical?

Indiana Pop does tend to convey the artist's superb intuition that modern man, with his loss of identity, submersion in mass culture, beset by mass destruction, is man's greatest problem, and that Art, Pop or otherwise, hardly provides the Solution – some optimistic, glowing, harmonious, humanitarian, plastically perfect Los Chord of Life.

Swenson Is Pop pre-sold?

Indiana Maybe so. It isn't the Popster's fault that the A-Eers fought and won the bloody Battle of the Public-Press-Pantheon; they did it superbly and now there is an art-accepting public and a body of collectors and institutions that are willing to take risks lest they make another Artistic-Over-sight-of-the-Century. This situation is mutually advantageous and perilous alike to all painters, Popsters and non-Popsters. The new sign of the Art Scene is BEWARE – Thin Ice. Some sun-dazed Californians have already plunged recklessly through.

Swenson Is Pop the new morality?

Indiana Probably. It is libertine, free and easy with the old forms, contemptuous of its elders' rigid rules.

Swenson Is Pop love?

Indiana Pop IS love in that it accepts all … all the meaner

aspects of life, which, for various aesthetic and moral considerations, other schools of painting have rejected or ignored. Everything is possible in Pop. Pop is still pro-art, but surely not art for art's sake. Nor is it any Neo-Dada anti-art manifestation: its participants are not intellectual, social and artistic malcontents with furrowed brows and fur-lined skulls.

Swenson Is Pop America?

Indiana Yes. America is very much at the core of every Pop work. British Pop, the first-born, came about due to the influence of America. The generating issue is Americasm [sic], that phenomenon that is sweeping every continent. French Pop is only slightly Frenchified; Asiatic Pop is sure to come (remember Hong Kong). The pattern will not be far from the Coke, the Car, the Hamburger, the Jukebox. It is the American Myth. For this is the best of all possible worlds.

Roy Lichtenstein, Andy Warhol, Robert Indiana: interviews by Gene Swenson, excerpt from 'What is Pop Art? Answers from 8 Painters, Part I', *ARTnews*, 62:7 [New York, November 1963]

Tom WESSELMANN, James ROSENQUIST
What is Pop Art? Interviews with Gene Swenson, II [1964]

TOM WESSELMANN

Gene Swenson What is Pop art?

Tom Wesselmann I dislike labels in general and Pop in particular, especially because it over-emphasizes the material used. There does seem to be a tendency to use similar materials and images, but the different ways they are used denies any kind of group intention.

When I first came to painting there was only de Kooning – that was what I wanted to be, with all its self-dramatization. But it didn't work for me. I did one sort of non-objective collage that I liked, but when I tried to do it again I had a kind of artistic nervous breakdown. I didn't know where I was. I couldn't stand the insecurity and frustration involved in trying to come to grips with something that just wasn't right, that wasn't me at any rate.

Swenson Have you banished the brushstroke from your work?

Wesselmann I'm painting now more than I used to because I'm working so big; there's a shortage of collage material. So brushstrokes can occur, but they are often present as a collage element; for example, in one big still-life I just did there's a tablecloth section painted as if it were a fragment from an Abstract Expressionist painting inserted into my picture. I use de Kooning's brush knowing it is his brush.

One thing I like about collage is that you can use anything, which gives you that kind of variety; it sets up reverberations in a picture from one kind of reality to another. I don't attach any kind of value to brushstrokes, I just use them as another thing from the world of existence.

My first interest is the painting which is the whole, final product. I'm interested in assembling a situation resembling painting, rather than painting; I like the use of painting because it has a constant resemblance to painting.

Swenson What is the purpose of juxtaposing different kinds of representations?

Wesselmann If there was any single aspect of my work that excited me, it was that possibility – not just the differences between what they were, but the aura each had with it. They each had such a fulfilled reality; the reverberations seems a way of making the picture more intense. A painted pack of cigarettes next to a painted apple wasn't enough for me. They are both the same kind of thing. But if one is from a cigarette ad and the other a painted apple, they are two different realities and they trade on each other; lots of things – bright strong colours, the qualities of material images from art history or advertising – trade on each other. That kind of relationship helps establish a momentum throughout the picture – all the elements are in some way very intense. Therefore throughout the picture all the elements compete with each other. At first glance, my pictures seem well-behaved, as if – that is a still-life, OK. But these things have such crazy gives and takes that I feel they get really very wild.

Swenson What does aesthetics mean to you and your work?

Wesselmann Aesthetics is very important to me, but it doesn't deal with beauty or ugliness – they aren't values in painting for me, they're beside the point. Painting relates to both beauty and ugliness. Neither can be made. (I try to work in the gap between the two.) I've been thinking about that, as you can see. Perhaps 'intensity' would be a better emphasis. I always liked Marsicano's quote – from *ARTnews* – 'Truth can be defined as the intensity with which a picture forces one to participate in its illusion.' Some of the worst things I've read about Pop art have come from its admirers. They begin to sound like some nostalgia cult – they really worship Marilyn Monroe or Coca-Cola. The importance people attach to things the artist uses is irrelevant. My use of elements from advertising came about gradually. One day I used a tiny bottle picture on a table in one of my little nude collages. It was a logical extension of what I was doing. I use a billboard picture because it is a real, special representation of something, not because it is from a billboard. Advertising images excite me mainly because of what I can make from them. Also I use real objects because I need to use objects, not because objects need to be used. But the objects remain part of a painting because I don't make environments. My rug is not to be walked on.

Swenson Is Pop art a counter-revolution?

Wesselmann I don't think so. As for me, I got my subject matter from Hans Memling (I started with 'Portrait Collages') and de Kooning gave me content and motivation. My work evolves from that.

Swenson What influences have you felt in your work from, say, Dada?

Wesselmann When I first came across it, I respected it and thought it was pretty good; but it didn't have anything to do with me. As my work began to evolve I realized – not

consciously, it was like a surprise – that maybe it had something to do with my work.

It was the same with Rauschenberg. When I saw his painting with the radios in it I thought it was fine, OK, but it had no effect on me. It ceased to exist for me except in Rauschenberg's world. Much later I got interested in the addition of movement to painting, so a part of the painting was attached to a motor. An interest in using light and sound followed – I put in a television. But not only for the television image – who cares about television images? – but because I cared about the dimension it gave to painting, something that moved, and gave off light and sound. I used a radio and when I did I felt as if I were the first who'd ever used a radio. It's not that I think of that as an accomplishment – it's just that Rauschenberg didn't seem an immediate factor in it. He was, of course; his use of objects in paintings made it somehow legitimate; but I used a radio for my own reasons …

I've been painting more, lately, in these big works. I'm more and more aware of how audacious the act of painting is. One of the reasons I got started making collages was that I lacked involvement with the thing I was painting; I didn't have enough interest in a rose to paint it. Some of this, I think, comes from the painting of the fifties – I mean, for a painter the love of flowers was gone. I don't love roses or bottles or anything like that enough to want to sit down and paint them lovingly and patiently. Now with these big pictures, well, there aren't enough billboards around and I have to paint a bowl – and I don't have any feelings about bowls or how a bowl should be. I only know I have to have a bowl in that painting. Here, in this picture I'm working on, I made this plain blue bowl and then I realized it had to have something on it. I had to invent a bowl and – god! – I couldn't believe how audacious it was. And it's threatening too – painting something without any conviction about what it should be.

Swenson Do you mean that collage materials permit you to use an image and still be neutral towards the object represented?

Wesselmann I think painting is essentially the same as it has always been. It confuses me that people expect Pop art to make a comment or say that its adherents merely accept their environment. I've viewed most of the paintings I've loved – Mondrians, Matisses, Pollocks – as being rather deadpan in that sense. All painting is fact, and that is enough; the paintings are charged with their very presence. The situation, physical ideas, physical presence – I feel that is the comment.

JAMES ROSENQUIST

James Rosenquist I think critics are hot blooded. They don't take very much time to analyze what's in the painting …

OK, the critics can say [that Pop artists accept the mechanization of the soul]. I think it's very enlightening that if we do, we realize it instead of protesting too much. It hasn't been my reason. I have some reasons for using commercial images that these people probably haven't thought about. If I use anonymous images – it's true my images have not been hot blooded images – they've been

anonymous images of recent history. In 1960 and 1961 I painted the front of a 1950 Ford. I felt it was an anonymous image. I wasn't angry about that, and it wasn't a nostalgic image either. Just an image. I use images from old magazines – when I say old, I mean 1945 to 1955 – a time we haven't started to ferret out as history yet. If it was the front end of a new car there would be people who would be passionate about it, and the front end of an old car might make some people nostalgic. The images are like no-images. There is a freedom there. If it were abstract, people might make it into something. If you paint Franco-American spaghetti, they won't make a crucifixion out of it, and also who could be nostalgic about canned spaghetti? They'll bring their reactions but, probably, they won't have as many irrelevant ones …

The images are now, already, on the canvas and the time I painted it is on the canvas. That will always be seen. That time span, people will look at it and say, 'why did he paint a '50 Ford in 1960, why didn't he paint a '60 Ford?' That relationship is one of the important things we have as painters. The immediacy may be lost in a hundred years, but don't forget that by that time it will be like collecting a stamp; this thing might have ivy growing around it. If it bothers to stand up – I don't know – it will belong to a stamp collector, it will have nostalgia then. But still that time reference will mean something …

I have a feeling, as soon as I do something, or as I do something, nature comes along and lays some dust on it. There's a relationship between nature – nature's nature – and time, the day and the hour and the minute. If you do an iron sculpture, in time it becomes rusty, it gains a patina and that patina can only get to be beautiful. A painter searches for a brutality that hasn't been assimilated by nature. I believe there is a heavy hand of nature on the artist. My studio floor could be, some people would say that is part of me and part of my painting because that is the way I arranged it, the way things are. But it's not, because it's an accidental arrangement; it is nature, like flowers or other things …

[Paint and paint quality] are natural things before you touch them, before they're arranged.

James Rosenquist, Tom Wesselmann: Interviews by Gene Swenson, excerpt from 'What Is Pop Art? Answers from 8 Painters, Part II', ARTnews [New York, February 1964].

Claes OLDENBURG, Roy LICHTENSTEIN, Andy WARHOL

A Discussion with Bruce Glaser [1964/66]

Bruce Glaser Claes, how did you arrive at the kind of image you are involved with now? Did it evolve naturally from the things you were doing just before?

Claes Oldenburg I was doing something that wasn't quite as specific as what I'm doing now. Everything was there,

but it was generalized and in the realm of imagination, let's say. And, of course, an artist goes through a period where he develops his 'feelers' and then he finds something to attach them to, and then the thing happens that becomes the thing that he wants to be or say.

So I had a lot of ideas about imaginary things and fantasies which I experimented with in drawings, sculptures and paintings, in every conceivable way I could. Through all this I was always attracted to city culture, because that's the only culture I had. Then around 1959, under the influence of Dubuffet, and the novelist Celine, I started to work with city materials and put my fantasy into specific forms. Then, under the influence of friends like Jim Dine and Roy Lichtenstein and Andy and all these people, the images became even more specific. But I can go back to my earlier work and find a toothpaste tube or a typewriter, or any of the things that appear in my present work, in more generalized forms.

Glaser You mention that some of the other artists who work with Pop imagery had some effect on you, yet it is often said by advocates of Pop art that it arose spontaneously and inevitably out of the contemporary milieu without each Pop artist having communication about, or even awareness of, what other Pop artists were doing. Are you suggesting something contrary to this?

Oldenburg There is always a lot of communication between artists because the art world is a very small one and you can sense what other people are doing. Besides, America has a traditional interest in pop culture. In Chicago, where I spent a lot of time, people like June Leaf and George Cohen were working very close to a Pop medium in 1952. George Cohen used to go to the dime store and buy all the dolls he could find and other stuff like that. Even though he used them for his own personal image there has always been this tendency.

Also, in California, where I've spent some time, the tradition of getting involved with pop culture goes way back. But I don't think the particular subject matter is as important as the attitude. It's a deeper question than just subject matter.

Glaser Roy, how did you come upon this imagery?

Roy Lichtenstein I came upon it through what seems like a series of accidents. But I guess that maybe they weren't completely accidental. Before I was doing this I was doing a kind of Abstract Expressionism, and before that I was doing things that had to do with the American scene. They were more Cubist and I used early American paintings by Remington and Charles Wilson Peale as subject matter.

But I had about a three year period, just preceding this, in which I was doing only abstract work. At that time I began putting hidden comic images into those paintings, such as Mickey Mouse, Donald Duck and Bugs Bunny. At the same time I was drawing little Mickey Mouses and things for my children, and working from bubble gum wrappers, I remember specifically. Then it occurred to me to do one of these bubble gum wrappers, as is, large, just to see what it would look like. Now I think I started out more as an observer than as a painter, but, when I did one, about half way through the painting I got interested in it as a painting. So I started to go back to what I considered serious work because this thing was too strong for me. I

began to realize that this was a more powerful thing than I had thought and it had interest.

Now, I can see that this wasn't entirely accidental. I was aware of other things going on. I had seen Claes' work and Jim Dine's at the 'New Forms, New Media' show [sic] (Martha Jackson Gallery, 1960), and I knew Johns, and so forth. But when I started the cartoons I don't think that I related them to this, although I can see that the reason I felt them significant was partly because this kind of thing was in the air. There were people involved in it. And I knew Happenings. In fact, I knew Allan Kaprow who was teaching with me at Rutgers. Happenings used more whole and more American subject matter than the Abstract Expressionists used. Although I feel that what I am doing has almost nothing to do with environment, there is a kernel of thought in Happenings that is interesting to me.

Glaser How did you get involved with Pop imagery, Andy?

Andy Warhol I'm too high right now. Ask somebody else something else.

Glaser When did you first see Andy's work?

Lichtenstein I saw Andy's work at Leo Castelli's about the same time I brought mine in, about the spring of 1961. And I hear that Leo had also seen Rosenquist within a few weeks. Of course, I was amazed to see Andy's work because he was doing cartoons of Nancy and Dick Tracy and they were very similar to mine.

Glaser Many critics of Pop art are antagonistic to your choice of subject, whether it be a comic strip or an advertisement, since they question the possibility of it having any philosophical content. Do you have any particular programme or philosophy behind what you do?

Oldenburg I don't know, and I shouldn't really talk about Pop art in general, but it seems to me that the subject matter is the least important thing. Pop imagery, as I understand it, if I can sever it from what I do, is a way of getting around a dilemma of painting and yet not painting. It is a way of bringing in an image that you didn't create. It is a way of being impersonal. At least that is the solution that I see, and I am all for clear definitions.

I always felt, for example, that Andy was a purist kind of Pop artist in that sense. I thought that his box show was a very clear statement and I admire clear statements. And yet again, maybe Andy is not a purist in that sense. In art you could turn the question right around and the people that are most impersonal turn out to be the most personal. I mean, Andy keeps saying he is a machine and yet looking at him I can say that I never saw anybody look less like a machine in my life.

I think that the reaction to the painting of the last generation, which is generally believed to have been a highly subjective generation, is impersonality. So one tries to get oneself out of the painting.

Glaser In connection with this I remember a show of yours at the Judson Street Gallery in 1959 which reflected your interest in Dubuffet, and that work clearly had a very personal touch. Your drawings and objects then were not made in the impersonal way that Roy uses a stencil or Andy a silkscreen.

Lichtenstein But don't you think we are oversimplifying things? We think the last generation, the Abstract

Expressionists, were trying to reach into their subconscious, and more deeply than ever before, by doing away with subject matter. Probably very few of those people really got into their subconscious in a significant way although I certainly think the movement as a whole is a significant one. When we consider what is called Pop art – although I don't think it is a very good idea to group everybody together and think we are all doing the same thing – we assume these artists are trying to get outside the work. Personally, I feel that in my own work I wanted to look programmed or impersonal but I don't really believe I am being impersonal when I do it. And I don't think you could do this. Cézanne said a lot about having to remove himself from his work. Now this is almost a lack of self-consciousness and one would hardly call Cézanne's work impersonal.

I think we tend to confuse the style of the finished work with the method through which it was done. We say that because a work looks involved, as though interaction is taking place, that significant interaction is really taking place. And when a work does not look involved, we think of it merely as the product of a stencil or as though it were the same comic strip from which it was copied. We are assuming similar things are identical and that the artist was not involved.

But the impersonal look is what I wanted to have. There are also many other qualities I wanted to have as an appearance. For example, I prefer that my work appear so literary that you can't get to it as a work of art. It's not that I'm interested in confounding people but I do this more as a problem for myself. My work looks as if it is thought out beforehand to such a degree that I don't do anything but put the colour on. But these are appearances and they are not what I really feel about it. I don't think you can do a work of art and not really be involved in it.

Glaser You are lessening the significance of appearances but appearances can hardly be dismissed as a reflection of your intentions.

Lichtenstein But part of the intention of Pop art is to mask its intentions with humour.

Glaser Another thing; one may say he wants to make a work of art that is not self-conscious and that he doesn't want to give the appearance of a self-conscious work of art, but it doesn't matter whether you use an industrial method or whether you use a method that emphasizes the artist's hand. Whatever the case may be, we assume that if the artist has been working for any length of time he will acquire a certain lack of consciousness in the way he uses that particular method. As a result, consciousness, or the lack of it, becomes less of an issue.

Oldenburg I think we are talking of impersonality as style. It's true that every artist has a discipline of impersonality to enable him to become an artist in the first place, and these disciplines are traditional and well known – you know how to place yourself outside the work. But we are talking about making impersonality a style, which is what I think characterizes Pop art, as I understand it, in a pure sense.

I know that Roy does certain things to change his comic strips when he enlarges them, and yet it's a matter of the degree. It's something that the artist of the last

generation, or for that matter of the past, would not have contemplated.

Lichtenstein I think that's true. I didn't invent the image and they wanted to invent the image.

Oldenburg That's right. And Andy is the same way with his Brillo boxes. There is a degree of removal from actual boxes and they become an object that is not really a box. In a sense they are an illusion of a box and that places them in the realm of art.

Glaser Would you say that this particular ambiguity is the unique contribution of Pop art or is it the subject matter?

Oldenburg Subject matter is certainly a part of it. You never had commercial art apples, tomato cans or soup cans before. You may have had still life in general, but you never had still life that had been passed through the mass media. Here for the first time is an urban art which does not sentimentalize the urban image but uses it as it is found. That is something unusual. It may be one of the first times that art focuses on the objects that the human being has created or played with, rather than the human being. You have had city scenes in the past but never a focus on the objects the city displays.

Glaser Is it fair to say that it is only to the subject matter that Pop art owes its distinction from other movements, and that there are relatively few new elements of plastic invention in your work?

Lichtenstein I don't know, because I don't think one can see things like plastic invention when one is involved.

Oldenburg If I didn't think that what I was doing had something to do with enlarging the boundaries of art I wouldn't go on doing it. I think, for example, the reason I have done a soft object is primarily to introduce a new way of pushing space around in a sculpture of painting. And the only reason I have taken up Happenings is because I wanted to experiment with total space or surrounding space. I don't believe that anyone has ever used space before in the way Kaprow and others have been using it in Happenings. There are many ways to interpret a Happening, but one way is to use it as an extension of painting space. I used to paint but I found it too limiting so I gave up the limitations that painting has. Now I go in the other direction and violate the whole idea of painting space.

But the intention behind this is more important. For example, you might ask what is it that has made me make cakes and pastries and all those other things. I would say that one reason has been to give a concrete statement to my fantasy. In other words, instead of painting it, to make it touchable, to translate the eye into the fingers. That has been the main motive in all my work. That's why I make things soft that are hard and why I treat perspective the way I do, such as with the bedroom set, making an object that is a concrete statement of visual perspective. But I am not terribly interested in whether a thing is an ice cream cone or a pie or anything else. What I am interested in is that the equivalent of my fantasy exists outside of me, and that I can, by imitating the subject, make a different kind of work from what has existed before.

Glaser What you say is very illuminating. How does this fit in with your intentions, Roy?

Lichtenstein Well, I don't think I am doing the same thing

Claes is doing. I don't feel that my space is anything but traditional, but then I view all space as traditional. I don't dwell on the differences in viewing space in art history. For example, I can see the obvious difference between Renaissance and Cubist painting but I don't think it matters. The illusion of three-dimensional space is not the basic issue in art. Although perspective as a scientific view of nature was the subject matter of Renaissance art, that perspective is still two-dimensional. And I think that what Cubism was about was that it does not make any difference, and they were restating it, making a formal statement about the nature of space, just as Cézanne had made another formal statement about the nature of space. So I would not want to be caught saying that I thought I was involved in some kind of spatial revolution. I am interested in putting a painting together in a traditional but not academic way. In other words, I am restating the idea of space because the form is different from the forms that preceded me.

I think, like Claes, I am interested in objectifying my fantasies and I am interested in the formal problem more than the subject matter. Once I have established what the subject matter is going to be I am not interested in it any more, although I want it to come through with the immediate impact of the comics. Probably the formal content of Pop art differs from Cubism and Abstract Expressionism in that it doesn't symbolize what the subject matter is about. It doesn't symbolize its concern with form but rather leaves it subject matter raw.

Glaser Claes, I want to find out a bit more about the nature of Dubuffet's influence on you which we mentioned before. Your early work seemed to explore the same areas of primitive art and expression on the subconscious that he is interested in.

Oldenburg Yes, that's true, but mainly Dubuffet is interesting because of his use of material. In fact, that is one way to view the history of art, in terms of material. For example, because my material is different from paint and canvas, or marble or bronze, it demands different images and it produces different results. To make my paint more concrete, to make it come out, I used plaster under it. When that didn't satisfy me I translated the plaster into vinyl which enabled me to push it around. The fact that I wanted to see something flying in the wind made me make a piece of clothing, or the fact that I wanted to make something flow made me make an ice cream cone.

Glaser I think it may even be fair to say that Dubuffet's work is one of the main precedents for Pop art in so far as he was interested in banal and discredited images. And as you say, he worked with common or strange materials such as dirt and tar, or butterfly wings, to create his new imagery.

Now, I would like to pick up something else we were talking about before, namely the possible implications of style in regard to Roy's work. I have had the feeling in looking at some of your paintings that they have more affinities with certain current styles of abstract art than with other kinds of Pop art. Your clearer, direct image, with its hard lines and its strong impact relate you to artists such as Al Held, Kenneth Noland or Jack Youngerman. Because of these connections, discounting subject matter,

I wondered whether you might be involved in some of the same stylistic explorations they are.

Lichtenstein Yes, I think my work is different from theirs and no doubt you think so too, but I also think there is a similarity. I am interested in many of these things, such as showing a similarity between cartooning and certain artists. For example, when I do things like explosions they are really kinds of abstractions. I did a composition book in which the background was a bit like Pollock, or Youngerman. Then I also have done the Picasso and Mondrians, which were obviously direct things, but they are quite different in their meaning than the other less obviously related analogies to abstract painting. I like to show analogies in this way in painting and I think of them as abstract painting when I do it. Perhaps that is where the deeper similarity lies, in that once I am involved with the painting I think of it as an abstraction. Half the time they are upside down, anyway, when I work.

Warhol Do you do like what Claes does with vinyl ketchup and french-fried potatoes?

Lichtenstein Yes, it's a part of what you do, to make something that reminds you of something else.

Oldenburg This is something I wonder about. I know I make parodies on artists, as with the vinyl ketchup forms which have a lot of resemblance to Art, but why? I wonder why we want to level these things. Is it part of the humbling process? Maybe it is because I have always been bothered by distinctions — that this is good and this is bad and this is better, and so on. I am especially bothered by the distinction between commercial and fine art, or between fine painting and accidental effects. I think we have made a deliberate attempt to explore this area, along with its comical overtones. But still the motives are not too clear to me as to why I do this.

Lichtenstein Nor with me either, nor even why I say I do it.

Oldenburg I don't want to use this idea as an instrument of ambition or facetiousness or anything like that. I want it to become work. But I am never quite sure why I am doing it.

Glaser There is a question in my mind as to whether much of the subject matter of Pop art is actually satirical. I have felt so many times that the subject matter and the technique are, indeed, an endorsement of the sources of Pop imagery. It is certainly true that there are some satirical elements in this work, but apparently that doesn't concern you too much. I wonder then, whether you are not saying that you really like this banal imagery.

Lichtenstein I do like aspects of it.

Oldenburg If it was just a satirical thing there wouldn't be any problem. Then we would know why we were doing these things. But making a parody is not the same thing as a satire. Parody in the classical sense is simply a kind of imitation, something like a paraphrase. It is not necessarily making fun of anything, rather it puts the imitated work into a new context. So if I see Arp and I put that Arp into the form of some ketchup, does that reduce the Arp or does it enlarge the ketchup, or does it make everything equal? I am talking about the form and not about your opinion of the form. The eye reveals the truth that the ketchup looks like an Arp. That's the form the eye sees. You do not have to reach any conclusions about which is better. It is just a matter of form and material.

Lichtenstein In the parody there is the implication of the perverse and I feel this in my own work even though I don't mean it to be that, because I don't dislike the work that I am parodying. The things that I have apparently parodied I actually admire and I really don't know what the implication of that is.

Glaser There is an ambiguity here too, part endorsement, part satire.

Oldenburg Anyhow there is something very beautiful in putting art back into the present world and breaking down the barriers that have been erected for the appreciation of art. Nevertheless, I would like to say that I have a very high idea of art. I am still romantic about that. This process of humbling it is a testing of the definition of art. You reduce everything to the same level and then see what you get.

Lichtenstein I am very interested in a thing that seems to happen in the visual arts more than anywhere else. There is the assumption by some people that similar things are identical. If you were to do the same thing in music and play something that sounded like a commercial, it would be very hard to vary it from the commercial or not have it immediately obvious that you are 'arting' it somehow, or making it aesthetic. Your only alternative would be to play this thing — whatever it is — the simple tune, as is. If you did anything to it, it would immediately be apparent, and this is not true in the visual arts. Maybe this is one reason why this sort of thing has not been done in music. Although it has had parallels in which commercial material is used it is always obviously transformed.

Glaser You are saying that one of the purposes of the subject matter of Pop art is to confuse the spectator as to whether the advertisement, comic strip or movie magazine photographs is really what it seems to be.

Lichtenstein This is true. In my own work there is a question about how much has been transformed. You will discover the subjects really are if you study them, but there is always the assumption that they are the same, only bigger.

Glaser Well, even if there is a transformation, it is slight, and this has given rise to the objection that Pop art has encroached on and plundered the private pleasure of discovering interest in what are ordinarily mistaken as banal subjects. For example, if one privately enjoyed aspects of the comics, today one finds this pleasure made public in the galleries and museums.

Lichtenstein I'm crying …

Warhol Comic strips now give credit to the artist. They say 'art by'. Comic books didn't give credit in the past.

Oldenburg It would be interesting to study the effect of this on the average commercial artist who still remains a problem child. He is generally trying to figure out who he is and what he is doing. Maybe this will make them do more crazy things. I don't know.

Warhol Commercial artists are richer.

Glaser That is a difference too. But I am more interested in the problems that come up in regard to your interest in popular imagery. For example, with you Claes, if at one time you saw in this material the possibility of exploring some kind of fantastic world, what you actually have done is to take the world of popular imagery and use it to a point where it is now becoming commonplace in museums and

seen and talked about by cultured people, by critics and collectors. Your imagery no longer has any clear relationship to the public that the original popular image had, and the implication of this is that you may, in fact, have abandoned a very vital connection with a very large, but visually naïve public.

Oldenburg We did not establish that my art had any clear relation to the public in the first place. I think the public has taken it for its own uses just as it takes everything you do for its own uses. You can't legislate how the public is going to take your art.

Glaser You did say that you were still interested in the idea of high art?

Oldenburg I am interested in distinguishing the artist as a creator from certain other people. If I make an image that looks very much like a commercial image I only do it to emphasize my art and the arbitrary act of the artist who can bring it into relief somehow. The original image is no longer functional. None of my things have ever been functional. You can't eat my food. You can't put on my clothes. You can't sit in my chairs.

Glaser Traditional art is like that too. You can't eat a still life.

Oldenburg But they haven't been so physical, nor so close to you so that they looked as if you could eat them, or put them on or sit in them.

Warhol But with your bedroom set you can sleep in it.

Oldenburg You can sleep in it on my terms. But to get back to the idea of high art, I believe there is such a profession as being an artist and there are rules for this, but it is very hard to arrive at these rules.

Glaser What is your feeling about the audience that reacts to Pop art? Did you ever think that with such imagery you might be able to reach a larger audience or do you want the same traditional art audience?

Lichtenstein When you are painting you don't think of the audience but I might have an idea of how an audience would see these paintings. However, I don't think that Pop art is a way of reaching larger groups of people.

Glaser Some commentators, having noticed the greater popularity and reception of Pop art, have said that this is so because it is representational rather than abstract.

Lichtenstein I don't think Pop has found any greater acceptance than the work of the generation preceding.

Oldenburg There is a sad, ironic element here which almost makes me unhappy. I have done a lot of touring in this country and abroad for Pop shows and Happenings, deliberately, to learn how people feel about this outside of New York. There is a disillusionment that follows. When you come to a town they think you are going to be something like the Ringling Brothers. They expect you to bring coke bottles and eggs and that they are going to eat it and like it, and so on. But then, when they find that you are using different things you begin to grate on them.

Warhol Yes, but the wrong people come, I think.

Oldenburg But I hate to disillusion anybody, and you find people becoming disillusioned because it turns out to be just the same old thing — Art.

Glaser Andy, what do you mean by the wrong people coming?

Warhol The young people who know about it will be the

people who are more intelligent and know about art. But the people who don't know about art would like it better because it is what they know. They just don't think about it. It looks like something they know and see every day.

Oldenburg I think it would be great if you had an art that could appeal to everybody.

Warhol But the people who really like art don't like the art now, while the people who don't know about art like what we are doing.

Glaser Then you do believe that the public is more receptive to Pop art than to Abstract Expressionism?

Warhol Yes. I think everybody who likes abstract art doesn't like this art and they are all the intelligent and marvellous people. If the Pop artists like abstract art it is because they know about art.

Glaser The criticism of Pop art has been that it reflects a growing tendency towards neo-conservatism that is apparent in certain areas of American life. On the most superficial level, reference is made to its turning away from abstraction and back to the figure. But on a more serious level, objections are raised about what seems to be the negation of humane qualities which the more liberal segments of our society, rightly or wrongly claim as their special preserve. Superficially, one can point to the fact that you use industrial processes in making your work and deny the presence of the artist's hand. There is also Andy's statement, 'I wish I were a machine.'

Lichtenstein This is apolitical. For that matter, how could you hook up abstraction with liberal thinking? Probably most artists may be more liberal politically. But Pop art doesn't deal with politics, although you may interpret some of Andy's paintings, such as those with the police dogs or the electric chairs, as liberal statements.

Oldenburg Andy, I would like to know, when you do a painting with a subject matter such as this, how do you feel about it? In the act of setting it up the way you do, doesn't that negate the subject matter? Aren't you after the idea of the object speaking for itself? Do you feel that when you are repeating it the way you do, that you are eliminating yourself as the person extracting a statement from it? When I see you repeat a race riot I am not so sure you have done a race riot. I don't see it as a political statement but rather as an expression of indifference to your subject.

Warhol It is indifference.

Glaser Isn't it significant that you chose that particular photograph rather than a thousand others?

Warhol It just caught my eye.

Oldenburg You didn't deliberately choose it because it was a 'hot' photograph?

Warhol No.

Oldenburg The choice of these 'hot' subjects and the way they are used actually brings the cold attitude more into relief.

Glaser Perhaps in dealing with feelings in such a way one may be exploring new areas of experience. In that case it would hardly be fair to characterize Pop art as neo-conservative. It might be more worthwhile to consider its liberating quality in that what is being done is completely new.

Originally broadcast over radio station WBAI, New York, June 1964, edited for publication in September-October 1965, first published as Bruce Glaser, 'Oldenburg, Lichtenstein, Warhol: A Discussion', *Artforum* [New York, February 1966, 20-24; reprinted in Steven Henry Madoff, ed., *Pop Art: A Critical History*, Berkeley and Los Angeles: University of California Press, 1997].

Donald JUDD
Claes Oldenburg [1964]

Most of the work in this show is different from Oldenburg's other work and is even better. It is some of the best being done. The show is fairly various: there are several soft objects, a switch, toaster, typewriter, tube of toothpaste, telephone; and some other vinyl things, French fries and string beans; also canvas 'ghost' models for the soft objects; a double wall plug and a double wall switch are hard objects. A ping-pong table and the paddles are parallelogrammatic, like the furniture in Oldenburg's bedroom suite, which isn't praised as it merited. A vacuum cleaner and an ironing board are like those of the thirties. There is a blue cloth shirt with a brown corduroy tie on, which is the size of a mobile clothing rack. A piece of pie and some small pieces of plaster painted with enamel, probably earlier work. Some of the drawings for the new work are good, and some, most of those on black paper, are comparatively glib, possibly too near a shot at the quality of the swank modern furniture Oldenburg's interested in. The vinyl switch is a softened vermillion, maybe flamingo coloured. It sags from its four corners; it's a swag. The rectangle of the switch is partially stuffed with kapok, and the two switches, set side by side, not above and below, are filled. The switches fit in pockets in the rectangle and can be switched on and off. I think Oldenburg's work is profound. I think it's very hard to explain how. The swag of flamingo vinyl seems to be a switch. It is grossly enlarged and soft, flaccid, changed and changeable. It seems to be like breasts but doesn't resemble them, isn't descriptive, even abstractly. There aren't two breasts, just two nipples. The two switches are too distinct to be breasts. As nipples though, they are too large for the chest. Also they can be directed up or down, on and off. The whole form of the mammarian switch is a basic emotive one, a bio-psychological one, an archetypal sense of breasts. Their size is felt as enormous and the nipples seem most important. The switch doesn't suggest this single, profound form, as do the breasts of Lachaise's women, but is it, or nearly it. This sort of basic form occurs in most of Oldenburg's work. The form is single, as it is felt, is single in form, is without discrete parts. It's enough. The emotive form is equated to a man-made object. This show, incidentally, is of things from the home; before that the things were from the store and before from the street. Ordinarily the figures and objects depicted in a painting or sculpture have a shape or contain shapes that are emotive. Oldenburg makes one of those subordinate shapes the whole form. Real anthropomorphism is subverted by the grossly anthropomorphic shapes, man-made, not shapes of natural things or people. The preferences of a person or millions are unavoidably incorporated in the things made, either through choice or acquiescence. Nothing made is completely objective, purely practical or merely present. And of course everything after it's made is variously felt. Part of the switch's anthropomorphism is that it's changing – as if melting and sliding in time. The hard objects are as grossly hard and geometric as these are soft. There are few artists as good as Oldenburg.

Donald Judd, 'Claes Oldenburg', *Arts Magazine* [New York, September 1964]; reprinted in Donald Judd, *Collected Writings, 1959-75*, ed. Kasper Koenig, Halifax, Nova Scotia: Nova Scotia College of Art and Design, 1975].

Robert ROSENBLUM
Pop Art and Non-Pop Art
[1964]

So sensitive are the art world's antennae to the symptoms of historical change that, in 1962, when some New York galleries began to exhibit pictures of vulgar subject matter, a new movement, Pop art, was instantly diagnosed and the mindless polemics began. As usual, the art in question was seldom looked at very closely and questions of definition and discrimination were ignored. Instead, things were quickly lumped together into a movement which called for wholesale approval or rejection. Presumably, one had to take sides, and various critics were considered to be either vigorously for or against it. But what was 'it'? Considering that 'it' was equated with viewpoints as divergent as those of Barry Goldwater and Terry Southern, one suspected that less violent politicking and more temperate thinking and seeing were in order. In fact, the term Pop art soon blanketed a host of artists whose styles, viewpoints and quality could hardly have been more unlike. When one insisted that names be named, things got foggier. Were Rivers, Rauschenberg, Johns Pop artists? Well, yes and no. And what about Marisol, George Segal, Peter Saul? Well, maybe. But arguments, without names and definitions, continued.

If some common denominator was felt to run through all these artists thoughtlessly bracketed together, it was probably a question of subject matter. But here was an odd turn of aesthetic events. How, after all the formalist experience of our century, could a new kind of art be defined on this basis alone, and didn't this give rise to contradictions? If admirers of de Kooning usually scorned Andy Warhol, hadn't both artists painted Marilyn Monroe? And were Warhol's Coca-Cola bottles really to be mentioned in the same breath as George Segal's or Rauschenberg's? Using iconographical criteria, Pop art produced illogical groupings, but logic never seemed to bother the art-political parties that insisted on condemning or praising Pop art without saying what it was. Writers who could never have paired two 1930s artists of the urban scene, Reginald Marsh and Stuart Davis, because their pictures looked so different, had no trouble pairing new artists who had in common only the fact that, on occasion, they depicted George Washington,

238

dollar bills or sandwiches.

If Pop art is to mean anything at all, it must have something to do not only with *what* is painted, but also with the *way* it is painted; otherwise, Manet's ale bottles, Van Gogh's flags and Balla's automobiles would qualify as Pop art. The authentic Pop artist offers a coincidence of style and subject, that is, he represents mass-produced images and objects by using a style which is also based upon the visual vocabulary of mass production. With such a criterion, the number of artists properly aligned with the movement dwindles rapidly. Thus, when Rivers and Rauschenberg introduce fictive or real cigarette wrappers and news photos into their canvases, they may be treading upon the imagery of Pop art but in no way touching upon the more fundamental issue of style. Painting as they do with techniques dependent on de Kooning's dedication to virtuoso brushwork and personal facture, they cling to pictorial formulae of the 1950s that are, in fact, largely rejected by the younger artists of the 1960s. Even some of these still offer a hybrid mixture of Pop subject and non-Pop style, as in the case of Peter Saul, who fuses Donald Duck and TV commercials with Gorky; or Wayne Thiebaud, who arranges cafeteria still lifes under a creamy impasto of pastel sweetness derived from Diebenkorn. And in the case of the recent work of Jasper Johns, who may have fathered Pop painting in his early flags and Pop sculpture in his ale cans, there is the curious phenomenon of increasingly wide discrepancy between the geometrically lucid objects represented and the abstract painterly milieu that clouds them.

In terms of definition, and not necessarily of quality, the real Pop artist not only likes the fact of his commonplace objects, but more important, exults in their commonplace look, which is no longer viewed through the blurred, kaleidoscopic lenses of abstract expressionism, but through magnifying glasses of factory precision. When Roy Lichtenstein paints enlarged Ben-Day dots, raw primary colours, and printer's-ink contours inspired by the crassest techniques of commercial illustration, he is exploring a pictorial vocabulary that would efface the handicraft refinements of chromatic nuance, calligraphic brushwork, and swift gesture pursued in the 1950s. When Andy Warhol claims he likes monotony, and proceeds to demonstrate this by painting ten times twenty cans of Campbell's soup, he uses the potential freshness of overt tedium as an assault upon the proven staleness of the de Kooning epigones' inherited compositional complexity. When James Rosenquist becomes infatuated with the colour of Franco-American spaghetti or a slick magazine photograph of a Florida orange, he employs these bilious commercial hues as tonics to the thinning blood of chromatic preciosity among belated admirers of Guston or Rothko. And when Robert Indiana salutes the heraldic symmetry, the cold and evenly-sprayed colours of road signs, he is similarly opposing the academy of second-hand sensibility that inevitably followed the crushing authority of the greatest abstract expressionists.

Thus, artists like Lichtenstein, Warhol, Rosenquist, Indiana, Wesselmann, the recent Oldenburg (but not Rivers, Rauschenberg, Johns, Dine, Thiebaud, Marisol) all share a style that would stem the flow of second-

generation adherents to the styles of the American old masters of the 1950s. It is no accident that most pictorial values affirmed by the older generation have been denied by the newer one. A late Romantic imagery referring to remote myth and sublime nature is replaced by machine-made objects from ugly urban environments. Gently stained or shaggily encrusted brushstrokes are negated by an insistence upon hygienic, impersonal surfaces that mimic the commercial techniques in which several Pop artists were, in fact, professionally trained (Rosenquist, as a billboard artist; Warhol, as a fashion illustrator). Structures of shifting, organic vitality are challenged by regularized patterns of predictable, mass-produced symmetry. Colours of unduplicable subtlety are obliterated by the standardized harshness of printer's red, yellow and blue.

This historical pattern of rejection is familiar. One thinks particularly of the Post-Impressionist generation, when an artist like Seurat controverted Impressionism through an almost mechanized system of brushstrokes, colours, shapes, contours and expressions, often inspired by such 1880s Pop imagery as fashion plates and posters. In the case of the 1960s Pop artists, this rebellion against the parental generation carried with it an espousal, both conscious and unconscious, of the grandparental one. In fact, any number of analogies can be made between the style and subject of Pop artists and of those modern masters active between the wars. The purist, machine-oriented shapes and imagery of Léger, Ozenfant, Le Corbusier and De Stijl are often revived in the current enthusiasm for poster-clean edges, surfaces, and colours (Lichtenstein, for example, provides many parallels to Léger's industrial images of the 1920s and has twice paraphrased Mondrian's black rectilinear armatures and primary hues). More particularly, American art before Abstract Expressionism has begun to strike familiar chords, so that artists like Charles Demuth, Joseph Stella, Stuart Davis and the newly resuscitated Gerald Murphy all take on new historical contours as predecessors, when considered in the light of the 1960s. (Davis's Cubist Lucky Strike cigarette wrapper of 1921 suddenly becomes a prototype for Warhol's flattened Campbell's soup can; Stella's *Brooklyn Bridge* and Demuth's *I Saw the Figure Five in Gold* are explicitly restated by Indiana; Niles Spencer's and Ralston Crawford's immaculate cityscapes and highways are re-echoed in Allan d'Arcangelo's windshield views.) Even Edward Hopper, whose 1964 retrospective occurred at a time of maximum receptivity (in 1955, he might have looked merely provincial), has taken on the stature of a major pictorial ancestor. His poignant, American-scene sentiment of the 1930s and 1940s survives not only in those inert, mummified plaster figures of George Segal who suffocate amid the ugliness of coke machines and neon signs, but also in the poker-faced exploitation by anti-sentimental Pop artists of the anaesthetizing blankness and sterility of a commercial America. And the time may soon come, too, when the WPA mural style of the 1930s will look like a respectable grandparent to Rosenquist's public billboard imagery of giant urban fragments.

If the most consistent Pop artists can be located in the heretic position of refusing to believe in those aesthetic

values of the 1950s which, with the irony of history, have suddenly become equated with venerable humanist traditions rather than with chimpanzee scrawls, are they, in fact, so singular in their rebellion? The most vigorous abstract art of the last five years has also stood in this relation to the oppressive grandeur of de Kooning, Pollock, Kline, Guston, Rothko, Still and Newman, and soon the cleavage between Pop art and non-Pop art (solely an iconographical, not a stylistic, distinction) will no longer seem real. So obtrusive was the subject matter of Lichtenstein's or Warhol's first Pop paintings that spectators found it impossible to see the abstract forest for the vulgar trees. Anybody, we heard, could copy a comic strip or a soup can, the implication being that, as in the case of criticism directed against Caravaggio or Courbet, the Pop artist dumbly copied ugly reality without enhancing it by traditional pictorial idealizations. Yet disarming subject matter has a way of receding so rapidly that it becomes well-nigh invisible. When first exhibited, the early flags of Jasper Johns looked like such unadulterated replications of the Stars and Stripes that most spectators dismissed them as jokes of a Dadaist trickster. Today, within a decade of their creation, the same flags look like old-master paintings, with quivering, exquisitely wrought paint surfaces not unlike Guston's, and with formal distinctions that permit us to talk casually about Johns's white flags, grey flags, or flags on orange grounds just as we might talk about Matisse's blue, red or green still lifes. In the same way, the initially unsettling imagery of Pop art will quickly be dispelled by the numbing effects of iconographical familiarity and ephemeral or enduring pictorial values will become explicit. Then, one hopes, the drastic qualitative differences among Pop artists should become clear even to those polemicists who think all Pop art is either good, bad or irrelevant.

Already the gulf between Pop and abstract art is far from unbridgeable, and it has become easy to admire simultaneously, without shifting visual or qualitative gears, the finest abstract artists, like Stella and Noland, and the finest Pop artists, like Lichtenstein. The development of some of the Pop artists themselves indicates that this boundary between Pop and abstract art is an illusory one. Thus, Indiana began as a hard-edged abstractionist in the vein of Ellsworth Kelly and Leon Polk Smith. That he then introduced highway words like EAT or USA 66 into his emblematic geometries should not obscure the fact that his pictures are still essentially allied to Kelly and Smith, who, for purposes of art-political argument, would be forced to run on another ticket. And some of the recent landscapes of Lichtenstein, if taken out of context, might even be mistaken for chromatic abstractions or new optical paintings. This party-split between Pop and Non-Pop art – the result of argumentative factions and rapid phrase-makers – is no more real than the line one might draw between, say, the abstract work of Léger and Stuart Davis and the work in which their urban subject matter is still clearly legible. Pop imagery may be momentarily fascinating for journalists and would-be cultural historians, but it should not be forgotten that the most inventive Pop artists share with their abstract contemporaries a sensibility to bold

magnifications of simple, regularized forms – rows of dots, stripes, chevrons, concentric circles; to taut, brushless surfaces that often reject traditional oil techniques in favour of new industrial media of metallic, plastic, enamel quality; to expansive areas of flat, unmodulated colour. In this light, the boundaries between Pop and abstract art keep fading. Al Held's giant paintings recall abstract billboards; Krushenick's blown-up, primary-hued patterns look like image-less comic strips; Dan Flavin's pure constructions of fluorescent light tubes smack of New York subways and shop windows. Art is never as pure or impure as aesthetic categories would make it. Who would want to separate Mondrian's Broadway Boogie-Woogie from its urban inspiration? Who would want to ignore the geometric rightness of Hopper's realist wastelands? For the time being, though, we shall go on hearing wearisome defenses of and attacks upon some vague domain called Pop art, a political slogan that can only postpone the responsibility of looking at, defining, and evaluating individual works by individual artists.

Robert Rosenblum, 'Pop Art and Non-Pop Art', *Art and Literature*, 5 [Summer 1964; reprinted in Suzi Gablik and John Russell, eds, *Pop Art Redefined*, London: Thames & Hudson/New York: Praeger, 1969] 53-6.

Susan SONTAG
Notes on Camp [1964]

[...] 1. To start very generally: Camp is a certain mode of aestheticism. It is one way of seeing the world as an aesthetic phenomenon. That way, the way of Camp, is not in terms of beauty, but in terms of the degree of artifice, of stylization.

2. To emphasize style is to slight content, or to introduce an attitude which is neutral with respect to content. It goes without saying that the Camp sensibility is disengaged, depoliticized – or at least apolitical.

3. Not only is there a Camp vision, a Camp way of looking at things. Camp is as well a quality discoverable in objects and the behaviour of persons. There are 'campy' movies, clothes, furniture, popular songs, novels, people, buildings ... This distinction is important. True, the Camp eye has the power to transform experience. But not everything can be seen as Camp. It's not all in the eye of the beholder [...]

9. As a taste in persons, Camp responds particularly to the markedly attenuated and to the strongly exaggerated. The androgyne is certainly one of the great images of Camp sensibility. Examples: the swooning, slim, sinuous figures of pre-Raphaelite painting and poetry; the thin, flowing, sexless bodies in Art Nouveau prints and posters, presented in relief on lamps and ashtrays; the haunting androgynous vacancy behind the perfect beauty of Greta Garbo. Here, Camp taste draws on a mostly unacknowledged truth of taste: the most refined form of sexual attractiveness (as well as the most refined form of sexual pleasure) consists in going against the grain of one's sex. What is most beautiful in virile men is something feminine; what is most beautiful in feminine women is something masculine ... Allied to the Camp taste for the androgynous is something that seems quite different but isn't: a relish for the exaggeration of sexual characteristics and personality mannerisms. For obvious reasons, the best examples that can be cited are movie stars. The corny flamboyant femaleness of Jayne Mansfield, Gina Lollobrigida, Jane Russell, Virginia Mayo; the exaggerated he-man-ness of Steve Reeves, Victor Mature. The great stylists of temperament and mannerism, like Bette Davis, Barbara Stanwyck, Tallulah Bankhead, Edwige Feuillière.

10. Camp sees everything in quotation marks. It's not a lamp, but a 'lamp'; not a woman, but a 'woman'. To perceive Camp in objects and persons is to understand Being-as-Playing-a-Role. It is the farthest extension, in sensibility, of the metaphor of life as theatre [...]

Susan Sontag, 'Notes on Camp', 1964, from *Against Interpretation and Other Essays* [New York: Farrar, Straus & Giroux, 1966; reprinted London: Vintage, 1994] 277; 279-80.

Brian O'DOHERTY
Bruce Conner and His Films [1965]

Since art has turned itself inside out – from the self to the environment, from total abstraction to the object – there have naturally been changes in the way artists function. Instead of the artist as pure artist, his horizon physically limited by the four sides of a canvas, and his eye turned inward on the clash of self-renewing forces, we are apparently getting a different kind of animal – the all-rounder who can perform within the category of what we think of as 'art', and outside it, in other areas, when he so feels.

In recent years we have had the artist as a sort of pre-theatrical impresario (Happenings), as performer (notably Robert Morris and Robert Rauschenberg), and more recently as moviemaker – including Andy Warhol and today's example, Bruce Conner. The artist as moviemaker is an old story – Man Ray, Cocteau and Dalí produced the classics – but there's a difference now, in much the same way that neo-Dada turned out not to be Dada at all, but Pop, although some persist in not seeing the difference.

Thus one can look at Bruce Conner's exhibition at the Alan Gallery, and his two films *A Movie* (1958) and *Cosmic Ray* (1962) – 12 and 4 minutes long respectively – as expressions of the same attitude and fundamentally the same technique applied to a different medium. At the moment assemblage as a technique is permeating all the arts with extraordinary vigor.

Conner's assemblages have curtained off a special horror-corner in art in recent years. Deeply melodramatic, they provoke hostility by their careful offensiveness. There is a love of ugliness presented with a *fin-de-siècle* sense of connoisseurship – vulgarity and bad taste (or what we associate with them) consciously invited in and preserved in an environment where they retain enough to shock but not to disrupt. Take one piece: a scorched, melted head with a few teeth biting out from it; nearby a bride from a wedding cake whose groom is laid out under glass nearby. It's called 'November 22nd, 1963'.

It is Grand Guignol with a difference. Most of his pieces find the same sore spot and rub; flowers take on the paralysis of graveyard bouquets; girlie photos make the viewer feel like a corpse remembering former pleasures; lace associates directly with arsenic; flickering votive lamps desecrate instead of sanctify. The detritus and debris of old nylons, comic strips, wrappers, beads, cigarette butts, are accumulated in a sort of inspired excess that becomes a curious digestive process in which fire seems catalytic – everything burned and singed so it looks as if one puff of air would disperse the whole flimsy structure. The afterlife of these discarded things is as precarious as an assemblage of shadows.

In *A Movie* the technique is exactly the same – a montage of found materials from fact (newsreels) and fiction (old movies). Clichés and horrors make a rapid collage in which destruction and sex follow each other in images of pursuit (cowboys and Indians, all kinds of cars, engines, an elephant) and falling (parachutes, bombs, planes) until finally a diver disappears through a hole in the bottom of the sea – the ultimate exit. The entire thing is prefaced by a girl from a shady movie lazily undressing. By the time *A Movie* is over she has retroactively become an Eve or Circe or Prime Mover.

Some of the collage images are so well known (the *Hindenberg* in flames, Mussolini and Petacci hanging upside down, the Tacoma suspension bridge undulating like a piece of malignant rubber) that they send the mind pinwheeling out of the movie on a tangent while the next sequence is also demanding attention – a very new kind of split-level effect the way Conner does it.

For the film clips of reality are used as object – not as objects prompting surrealist associations, but as objects from real life loudly claiming attention while being forced into a relationship to contribute to the movie. The movie is split open again and again by real life hurting through it. This is remarkably like the effect Robert Rauschenberg gets in his latest paintings.

The shorter film ties up closely with a piece called *Spiral Flesh* from the exhibition at the Alan Gallery – an elbow-shaped jig-saw of what looks like fingers rotating to prompt serialized associations of the human form. *Cosmic Ray* turns the female nude into a piece of animated protoplasm that pulses, expands, bursts like a bubble, overlaid by a measles of blips and flashes and numbers (and eventually more sinister images) – like an X ray of a teenager's mind when Ray Charles sings 'What Did I Do?' which he does on the accompanying soundtrack. It is a Pop art masterpiece, with a sophistication of means, a control of ambiguous effects and expressive intent far removed from Surrealism. Conner clarifies the artistic usage of 'reality' – objects and photographs and film clips – in a new way of coping with the environment. His films are revolutionary.

Brian O'Doherty, 'Bruce Conner and His Films' [first published in slightly different version, the *New York Times*, 26 April 1964; reprinted in Gregory Battcock, ed., *The New American Cinema*, New York: E.P. Dutton, 1967] 194-6.

Ed RUSCHA
Interview with John Coplans
[1965]

John Coplans This [*Various Small Fires and Milk*, 1964] is the second book of this character you have published?

Edward Ruscha Yes, the first, in 1962, was *Twentysix Gasoline Stations*.

Coplans What is your purpose in publishing these books?

Ruscha To begin with – when I'm planning a book, I have a blind faith in what I'm doing. I'm not inferring I don't have doubts, or that I haven't made mistakes. Nor am I really interested in books as such, but I am interested in unusual kinds of publications. The first book came out of a play with words. The title came before I even thought about the pictures. I like the word 'gasoline' and I like the specific quality of 'twenty-six'. If you look at the book you will see how well the typography works – I worked on all that before I took the photographs. Not that I had an important message about photographs or gasoline, or anything like that – I merely wanted a cohesive thing. Above all, the photographs I use are not 'arty' in any sense of the word. I think photography is dead as a fine art; its only place is in the commercial world, for technical or information purposes. I don't mean cinema photography, but still photography, that is, limited edition, individual, hand-processed photos. Mine are simply reproductions of photos. Thus it is not a book to house a collection of art photographs – they are technical data like industrial photography. To me, they are nothing more than snapshots.

Coplans You mean there's no design play within the photographic frame?

Ruscha No.

Coplans But haven't they been cropped?

Ruscha Yes, but that arises from the consciousness of layout in the book.

Coplans Did you collect these photos as an aid to painting, in any way?

Ruscha No, although I did subsequently paint one of the gasoline stations reproduced in the first book – I had no idea at the time that I would eventually make a painting based on it.

Coplans But isn't the subject matter of these photos common to your paintings?

Ruscha Only two paintings. However, they were done very much the same way I did the first book. I did the title and layout on the paintings before I put the gasoline stations in.

Coplans Is there a correlation between the way you paint and the books?

Ruscha It's not important as far as the books are concerned.

Coplans I once referred to *Twentysix Gasoline Stations* and said 'it should be regarded as a small painting' – was this correct?

Ruscha The only reason would be the relationship between the way I handle typography in my paintings. For example, I sometimes title the sides of my paintings in the same manner as the spine of a book. The similarity is only one of style. The purpose behind the books and my paintings is entirely different. I don't quite know how my books fit in. There is a whole recognized scene paintings fit into. One of the purposes of my book has to do with making a mass-produced object. The final product has a very commercial, professional feel to it. I'm not in sympathy with the whole area of hand-printed publications, however sincere. One mistake I made in *Twentysix Gasoline Stations* was in numbering the books. I was testing – at that time – that each copy a person might buy would have an individual place in the edition. I don't want that now.

Coplans To come back to the photos – you deliberately chose each subject and specially photographed them?

Ruscha Yes, the whole thing was contrived.

Coplans To what end? Why fires and why the last shot, of milk?

Ruscha My painting of a gas station with a magazine has a similar idea. The magazine is irrelevant, tacked onto the end of it. In a like manner, milk seemed to make the book more interesting and gave it cohesion.

Coplans Was it necessary for you, personally, to take the photographs?

Ruscha No, anyone could. In fact, one of them was taken by someone else. I went to a stock photograph place and looked for pictures of fires, there were none. It is not important who took the photos, it's a matter of convenience, purely.

Coplans What about the layout?

Ruscha That is important, the pictures have to be in the correct sequence, one without a mood taking over.

Coplans: This one – I don't know what it is – some kind of fire, looks rather arty.

Ruscha Only because it's a kind of subject matter that is not immediately recognizable.

Coplans Do you expect people to buy the book, or did you make it just for the pleasure?

Ruscha There's a very thin line as to whether this book is worthless or has any value – to most people it's probably worthless. Reactions are very varied; for example, some people are outraged. I showed the first book to a gasoline station attendant. He was amused. Some think it's great, others are at a loss.

Coplans What kind of people say it's great – those familiar with modern art?

Ruscha No, not at all. Many people buy the book because they are curiosities. For example, one girl bought three copies, one for each of her boyfriends. She said it would be a great gift for them, since they had everything already.

Coplans Do you think your books are better made than most books that are marketed today?

Ruscha There are not many books that would fit into this style of production. Considered as a pocket book, it's definitely better than most. My books are as perfectly made as possible.

Coplans Would you regard the book as an exercise in the exploration of the possibilities of technical production?

Ruscha No, I use standard and well-known processes; it can be done quite easily, there is no difficulty. But as a normal, commercial project most people couldn't afford to print books like this. It's purely a question of cost.

Coplans Do you know a book called *Nonverbal Communication* by Ruesch and Kees?

Ruscha Yes, it's a good book, but it has a text that explains the pictures. It has something to say on a rational level that my books evade. The material isn't collated with the same intent at all. Of course, the photographs used aren't art photographs, but it's for people who want to know about the psychology of pictures or images. This [*Various Small Fires and Milk*] is the psychology of pictures. Although we both use the same kind of snapshots, they are put to different use. *Nonverbal Communication* has a functional purpose, it's a book to learn things from – you don't necessarily learn anything from my books. The pictures in that book are only an aid to verbal content. That's why I've eliminated all text from my books – I want absolutely neutral material. My pictures aren't that interesting, nor the subject matter. They are simply a collection of 'facts'; my book is more like a collection of 'readymades'.

Coplans You are interested in some notion of the readymade?

Ruscha No, what I'm after is a kind of polish. Once I've decided all the detail – photos, layout, etc. – what I really want is a professional polish, a clear-cut machine finish. This book is printed by the best book printer west of New York. Look how well made and crisp it is. I'm not trying to create a precious limited edition book, but a mass-produced product of high order. All my books are identical. They have none of the nuances of the handmade and crafted limited edition book. It's almost worth the money to have the thrill of seeing 400 exactly identical books stacked in front of you.

Edward Ruscha, John Coplans, 'Concerning "Various Small Fires": Edward Ruscha Discusses His Perplexing Publications', *Artforum*, 3:5 [February 1965].

Bob DYLAN
Desolation Row [1965]

They're selling postcards of the hanging
They're painting the passports brown
The beauty parlour is filled with sailors
The circus is in town
Here comes the blind commissioner
They've got him in a trance
One hand is tied to the tight-rope walker
The other is in his pants
And the riot squad they're restless
They need somewhere to go
As Lady and I look out tonight
From Desolation Row [...]

Praise be to Nero's Neptune

The Titanic sails at dawn
And everybody's shouting
'Which Side Are You On?'
And Ezra Pound and T. S. Eliot
Fighting in the captain's tower
While calypso singers laugh at them
And fishermen hold flowers
Between the windows of the sea
Where lovely mermaids flow
And nobody has to think too much
About Desolation Row [...]

Bob Dylan, 'Desolation Row', 1965; Copyright renewed by Special Rider Music, 1993.

Lawrence ALLOWAY
Popular Culture and Pop Art
[1969]

Before it is possible to describe the links between popular culture and Pop art, we need to define them separately; otherwise any proposed relationship of the two subjects will dissolve amorphously. Recently the term Pop art has been applied to comic strips and to paintings taken from them; to both commercial and underground movies; to architecture and to fashion. As I shall argue that Pop art is more than a fashion, more than an expendable movement before Op art came along and wiped it out, it is necessary to firm up our definitions.

The aesthetics of twentieth-century art, or much of it, derive from the eighteenth-century separation of the arts from one another. Art was defined as, strictly, pure painting, sculpture, architecture, music or poetry and nothing but these five media could be properly classified as fine art. This act of tight discrimination was powerfully reinforced in the succeeding centuries. Nineteenth-century Aestheticism sought the pure centre of each art in isolation from the others and twentieth-century formal theories of art assumed a universal equilibrium that could be reached by optimum arrangements of form and colour. This view of the arts as fundamentally self-referring entities has been, of course, amazingly fruitful, but the continued authority of art as pure visibility, to the exclusion of other kinds of meaning, is now in doubt. No sooner were the arts purified by eighteenth-century definitions than the supporters of pure fine art declared their differences from the popular audience which was not committed to high art. Fielding, Goldsmith and Dr Johnson all recorded their alarm at the taste for realism and sensationalism displayed by the gross new public for novels and plays. Anxieties were expressed about the effects of novels on young ladies which are very like the fears (and fantasies) of parents and teachers in the 1950s about the effect of horror comics on children and about the effect of violence on TV in the sixties. Connections exist between fine and popular art, but they are not numerous: Hogarth worked for a socially differentiated public, with paintings intended for an affluent and sophisticated audience and prints aimed at a mass audience. Goya drew on English political prints for his execution picture, May 3, 1808. Daumier alternated between the directed messages of his political cartoons and the autonomous paintings. Toulouse-Lautrec's posters were pasted on kiosks in the streets of Paris. Despite such individual reconciliations of fine and popular art, of elite artist and public taste, the two taste groups have remained antagonists.

As the popular arts became increasingly mechanized and progressively more abundant, elite resistance hardened correspondingly. Popular culture can be defined as the sum of the arts designed for simultaneous consumption by a numerically large audience. Thus, there is a similarity in distribution and consumption between prints and magazines, movies, records, radio, TV, and industrial and interior design. Popular culture originates in urban centres and is distributed on the basis of mass production. It is not like folk art which, in theory at least, is hand-crafted by the same group by which it will be consumed. The consumption of popular culture is basically a social experience, providing information derived from and contributing to our statistically normal roles in society. It is a network of messages and objects that we share with others.

Popular culture is influential as it transmits prompt and extensive news, in visual, verbal and mixed forms, about style changes that will affect the appearance of our environment or about political and military events that will put our accepted morality under new pressures. There is a subtle and pervasive, but only half-described, feedback from the public to the mass media and back to the public in its role as audience. The media have expanded steadily since the eighteenth century, without a break or major diversion. The period after World War II was Edenic for the consumer of popular culture; technical improvements in colour photography in magazines, expansion of scale in the big screens of the cinema, and the successful addition of new media (long-playing records and television). In addition, cross-references between media increased, so that public communication transcended its status of 'relaxation' (the old rationalization for reading detective stories) or invisible service (such as providing essential political and national news).

It is necessary to refer to the Canadian Roman Catholic essayist Marshall McLuhan at this point. He celebrates pop culture, in his way, but believes that the arrival of a new medium consigns prior media to obsolescence. It is true that each new channel of communication has its effect on the existing ones, but so far the effect has been cumulative and expansive. The number of possibilities and combinations increases with each new channel, whereas McLuhan assumes a kind of steady state of a number of messages which cannot be exceeded. Consider the relation of movies and TV. At first movies patronized the tiny screen and the low definition image in asides in films; then movies began to compete with TV by expanding into large screens (CinemaScope and Cinerama, for instance) and by using higher definition film stock (for example, Vista Vision). (Three-dimensional movies were resurrected but did not get out of the experimental stage.) Today TV shows old movies (more than two years old) continually and in so doing has created a new kind of Film Society audience of TV-trained movie-goers. In addition to making TV films, Hollywood is making sexier and tougher films, leaving the delta of Good Family Entertainment to TV largely. Movies, now, are more diversified and aimed at more specialized audiences, which is not what McLuhan's theory (which would expect the extinction of the movie) requires. After World War II the critical study of pop culture developed in ways that surpassed in sophistication and complexity earlier discussions of the mass media. To Marxists, pop culture was what the bosses doped the people with and to Freudians it was primal fantasy's latest disguise, with a vagina dentata in every crocodile snapping in the cave under the mad doctor's laboratory. The new research was done by American sociologists who treated mass communications objectively, as data with a measurable effect on our own lives. There may be an analogy here with the post-war move among historians away from heroes and dominant figures to the study of crowds. Previously the past had been discussed in terms of generals' decisions, monarchs' reigns and mistresses' fortunes, with the rest of the world serving as an anonymous backing. The practice of treating history as a star system was not really subverted by debunking portraits of the great, à la Lytton Strachey, which preserved, though ironically, the old ratio of hero and crown. The real change came with the study of population and communities. Demography is giving to normal populations something of the legibility of contour that biography confers on individuals. The democratization of history (like the sociological study of mass communications) leads to an increase of complexity in the material to be studied, making it bulge inconveniently beyond the classical scope of inquiry.

In the post-war period an uncoordinated but consistent view of art developed, more in line with history and sociology than with traditional art criticism and aesthetics. In London and New York artists then in their twenties or early thirties revealed a new sensitivity to the presence of images from mass communications and to objects from mass production assimilable within the work of art. Öyvind Fahlström, writing about another artist, Robert Rauschenberg, described the artist as 'part of the density of an uncensored continuum that neither begins nor ends with any action of his'. Instead of the notion of painting as technically pure, organized as a nest of internal correspondences, Fahlström proposed the work of art as a partial sample of the world's continuous relationships. It follows that works demonstrating such principles would involve a change in our concept of artistic unity; art as a rendezvous of objects and images from disparate sources, rather than as an inevitably aligned set-up. The work of art can be considered as a conglomerate, no one part of which need be causally related to other parts; the cluster is enough. Eduardo Paolozzi's work from the early fifties to date has investigated the flow of random forms and the emergence of connectivity within scatter.

Accompanying the view of art as a sample from a continuum is a lack of interest in the idea of the masterpiece, a staple of earlier theories of art. In place of the feeling of awe at a great man's greatest moment,

artists and critics became more interested in representative and typical works. The whole life of the man, rather than his record-breaking peak, is what was interesting. Related to this shift of emphasis was a reduction in the high evaluation of permanence. Art was separated from its supposed function as a symbol of eternity, as an enemy of time, and accepted as a product of time and place. Its specificity, its historical identity, was its value, not its timelessness. Parallel to this anti-idealist view of art an aesthetics of expendable art was developed in England in the fifties. Its purpose was to handle the ephemeral popular arts which were no longer, it was speculated, different in kind from the art called 'fine'.

As popular culture became conspicuous after World War II, as history and sociology studied the neglected mass of the past and the neglected messages of the present, art was being changed, too. It is not, as ultimistic writers have it, that the emergence of a new style obliterates its predecessors; what happens is that everything changes but the past's continuity with the present is not violated. As an alternative to an aesthetic that isolated visual art from life and from the other arts, there emerged a new willingness to treat our whole culture as if it were art. This attitude opposed the elite, idealist and purist elements in eighteenth- to twentieth-century art theory. It was recognized in London for what it was ten years ago, a move towards an anthropological view of our own society. Anthropologists define culture as all of a society. This is a drastic foreshortening of a very complex issue in anthropology, but to those of us brought up on narrow and reductive theories of art, anthropology offered a formulation about art as more than a treasury of precious items. It was a two-way process: the mass media were entering the work of art and the whole environment was being regarded, reciprocally, by the artists as art, too.

Younger artists in London and New York did not view pop culture as relaxation, but as an ongoing part of their lives. They felt no pressure to give up the culture they had grown up in (comics, pop music, movies). Their art was not the consequence of renunciation but of incorporation. Richard Hamilton has referred, accurately, to his work of the period as 'built up of quotations'. The references are not to the Apollo Belvedere or the Farnese Hercules, but to Charlton Heston as Moses, The Weapon Shops of Isher, Vikki Dougan. If these references are now obscure, it doesn't matter any more than the exact identity of the bad poets in Pope's Dunciad matter. They can be identified but, in any case, the twentieth-century experience of overlapping and clustered sign-systems is Hamilton's organizing principle, which we can all recognize.

Pop art is neither abstract nor realistic, though it has contacts in both directions. Peter Blake and Malcolm Morley, for instance, both British artists, have moved from Pop art to a photograph-based realism. In New York, on the other hand, an artist like Roy Lichtenstein has been moving in the direction of abstract art, not only by parodistic references to its old-fashioned geometric style, but by the formality of his own arrangements. The core of Pop art, however, is at neither frontier; it is, essentially, an art about signs and sign-systems. Realism is, to offer a minimal definition, concerned with the artist's perception

of objects in space and their translation into iconic, or faithful, signs. However, Pop art deals with material that already exists as signs: photographs, brand goods, comics, that is to say, with pre-coded material. The subject matter of Pop art, at one level, is known to the spectator in advance of seeing the use the artist makes of it. Andy Warhol's Campbell soup cans, Roy Lichtenstein's comic strips, are known, either by name, or by type, and their source remains legible in the work of art. What happens when an artist uses a known source in popular culture in his art is rather complex. The subject of the work of art is doubled: if Roy Lichtenstein or Paolozzi uses Mickey Mouse in his work, Mickey is not the sole subject. The original sign-system of which Mickey is a part is also present as subject. The communication system of the twentieth century is, in a special sense, Pop art's subject. Marilyn Monroe, as used by Andy Warhol and Hamilton, is obviously referred to in both men's art, but in addition, other forms of communication are referred to as well. Warhol uses a photographic image that repeats like a sheet of contact prints and is coloured like the cheapest colour reproduction in a Spanish-language American film magazine. The mechanically produced image of a beautiful woman, known to be dead, is contrasted with the handwritten annotations that deface the image of flesh, in Hamilton's My Marilyn.

There has been some doubt and discussion about the extent to which the Pop artist transforms his material. The first point to make is that selecting one thing rather than another is, as Marcel Duchamp established, enough. Beyond this, however, is the problem raised by Lichtenstein who used to say of his paintings derived from comics: 'You never really take. Actually you are forming.' He wanted to compose, not to narrate, but this is precisely what transformed his source. I showed early comic strip paintings by Lichtenstein to a group of professional comic strip artists who considered them very arty. They thought his work old-fashioned in its flatness. Lichtenstein was transforming after all, though to art critics who did not know what comics looked like, his work appeared at first as only copies. In fact, there was a surreptitious original in the simulated copy. Pop art is an iconographical art, the sources of which persist through their transformation; there is an interplay of likeness and unlikeness. One way to describe the situation might be to borrow a word from the 'military-industrial complex': commonality, which refers to equipment that can be used for different purposes. One piece of hardware is common to different operations; similarly a sign or a set of signs can be common to both popular culture and Pop art. The meaning of a sign is changed by being recontextualized by the artist, but it is not transformed in the sense of being corrected or improved or elaborated out of easy recognition.

The success of Pop art was not due to any initial cordiality by art critics. On the contrary, art critics in the fifties were in general hostile, and they still are. One reason for this is worth recording because it is shared by Clement Greenberg and Harold Rosenberg, to name the supporters of irreconcilable earlier modernisms. Greenberg with his attachment to the pure colour surface and Rosenberg with his commitment to the process of art,

are interested only in art's unique identity. They locate this at different points, Greenberg in the end product and Rosenberg in the process of work, but Pop art is not predicated on this quest for uniqueness. On the contrary, Pop art reveals constantly a belief in the translatability of the work of art. Pop art proposes a field of exchangeable and repeatable imagery. It is true that every act of communication, including art, has an irreducible uniqueness; it is equally true, that a great deal of any message or structure is translatable and homeomorphic. Cross-media exchanges and the convergence of multiple channels is the area of Pop art, in opposition to the pursuit of artistic purity.

Thus Pop art is able to share, on the basis of translatability and commonality, themes from popular culture. An analogue of Pop art's translatability is the saturation of popular culture with current heroes of consumption, such as the Beatles who are on records and record sleeves, movies, magazines of all kinds, radio, boutiques, who have been widely imitated, although in America a new generation of teeny boppers has already rejected them. Any event today has the potential of spreading through society on a multiplicity of levels, carried by a fat anthology of signs. It is impossible to go into the full extent of the connections between popular culture and Pop art, but the extent of the situation can be indicated by a few representative cases. Robert Stanley's series of two-tone, black on white, paintings of trees had not been exhibited or written about in art journals when they were featured in Cheetah, a smart American teenage magazine. Lichtenstein made a cover for Newsweek when the magazine ran a Pop art survey two years ago and Robert Rauschenberg silkscreened a cover for Time on the occasion of a story on Bonnie and Clyde. Here, artists who draw on the field of mass communications are themselves contributing to it. Some of the best photographs of Edward Kienholz's environmental sculptures appeared in a girlie magazine, Night and Day, and the Sergeant Pepper disc of the Beatles has an elaborate Peter Blake sleeve (the next one is by Richard Hamilton). As art is reproduced in this way it becomes itself pop culture, just as Van Gogh and Picasso, through endless reproduction, have become mass-produced items of popular culture. Van Gogh would have welcomed it because he had the greatest respect for clichés, which he regarded as the authorized expression of mankind, a kind of common property that especially binds us together.

Although the cliché is one of the most powerful resources of pop culture, and although we all consume popular culture in one form or another, there are obstacles to its appreciation. Its pervasiveness has caused it to be taken for granted and all consumers of pop culture are rather specialized. Agatha Christie readers (yes, her books are still in print) are not Ian Fleming's readers who, probably, put down Donald Hamilton (he writes the Matt Helm spy stories), whose readers, in their turn, could not possibly stand the tranquillity of Agatha Christie, and so on. However, it is necessary to take one area of pop culture away from its specialists to indicate something of its possible sophistication. The reason for choosing comic books is that the genre is in a flourishing state of present,

though the fact has not become a part of general knowledge yet.

In the United States there has been a revival of the costume comic (such heroes as Batman and Superman), with story lines frequently derived from the paranoid science fiction of pulp magazines of the forties, but updated in a bright baroque style, knowing and confident. There was a time-lag before Mod fashions were accepted in the comics, just as in the movies, but now the traditional story lines run like secret rivers through a hip mise-en-scene. (Wonder Woman, for example, has just got a 1960s body and costume, in place of her 1940s model, which looked as if it would stay forever without becoming classic.) In the forties, comic books were sexy but after the Korean war they were cleaned up, though sex heroines may reappear at any minute among the multi-levelled displays of words and images. Italian comic books, the fumetti, aimed at adults, are openly sadistic and sexual but have a far less complex narrative style than American comics aimed at teeny boppers and teenagers. The fumetti proceed in a stately and explicit narrative, whereas American comics are intricately structured. A high level of decoding skill is required of the reader-viewer. The best parodies of comics are found in other comics, not only in the celebrated *Mad* but in comic books like *Ecch*, the brawling comedy of which is close to the vernacular style of a group of Chicago painters, The Hairy Who. They produce their own comic books, following the layouts of straight comics but swelling into a Rabelaisian inflation of Americana. These random notes make the point, I hope, that the maze of signs in Pop art is not only the product of artists' sophistication but is present, also, in their source material, which surrounds us, is underfoot.

In New York the first large paintings derived from comic strips were by Andy Warhol in 1960, such as his *Dick Tracy*. The following year Lichtenstein made his first painting of this type, a scene of Mickey Mouse and Donald Duck. Though actually taken from a bubble gum wrapper the style of drawing and the kind of incident resemble comic strips based on Walt Disney's film cartoon characters. Previously Lichtenstein had done Cubist versions of nineteenth-century cowboy paintings and of World War I dog-fights, 'the Hell's Angels kind of thing', to quote the painter. The contrast of popular subjects (cowboys and Indians, old planes) and their Picasso-esque treatment is certainly proto-Pop. Lichtenstein did not know Warhol's slightly earlier work and was, as I hope this indicates, on a track that led logically to the comics. Early Pop art, in fact, is peppered with convergences of separate artists on shared subjects. The fact of simultaneous discovery is, I think, a validation of the seriousness of the movement and refutes criticism of Pop art as a sudden or momentary affair. It would not have developed spontaneously in different places in the fifties, had it not been an authentic response to a historical situation.

The different uses that have been made of comics substantiate the continued independence of the artists after they had become aware of their common interest. Lichtenstein has never used famous figures of the comics, as Warhol took Dick Tracy or Mel Ramos took Batman. His paintings derive from specific originals, but the reference is always to realistic and anonymous originals. He uses war comics and love comics in preference to named heroes or fantastic comics. Ramos, on the contrary, began a series of Batman paintings in 1962, taken directly from Bob Kane's originals (and other artists who draw Batman) but rendered in succulent paint. Ramos then switched to painting sex heroines from precode comics and here became engaged in historical research in erotic iconography. (Mysta of the moon; Glory Forbes, Vigilante; Gale Allen, Girl squadron leader; Futura, are some of the names.) Then, in the June 1966 *Batman*: 'At the Gotham City Museum, Bruce Wayne, Millionaire Sportsman and Playboy (Batman), and his young ward Dick Grayson (Robin), attend a sensational "Pop" art show.' On the walls are full-length, fine art portraits that resemble the paintings of Mel Ramos. Here is a feedback circuit that goes from comics to artist and back to comics [...]

Lawrence Alloway, 'Popular Culture and Pop Art', *Studio International* [London, July/August 1969] 17–21.

Andy WARHOL
Interview with Benjamin H.D. Buchloh [1985]

Benjamin Buchloh: I am currently doing research on the reception of Dada and Duchamp's work in the late 1950s, and I would like to go a bit into that history if you don't mind. I read, I think in Stephen Koch's book, that in the mid-sixties you were working on a movie project on or with Duchamp which apparently has never been released? Was it actually a project?

Andy Warhol: No, it was just an idea. I mean, I shot some pictures, but not really. They're just little sixteen-millimeters. But the project only would have happened if we had been successful at finding somebody, or a foundation, to pay for it. Since I was doing these twenty-four-hour movies, I thought that it would have been great to photograph him for twenty-four hours.

Buchloh: You knew him well enough at the time to have been able to do it?

Warhol: Well, not well enough, but it would have been something he would have done. We just were trying to get somebody to pay for it, like just for the filming, and to do it for twenty-four hours, and that would have been great.

Buchloh: So it never came about?

Warhol: No. I didn't know him that well; I didn't know him as well as Jasper Johns or Rauschenberg did. They knew him really well.

Buchloh: But you had some contact with him?

Warhol: Well, yeah, we saw him a lot, a little bit. He was around. I didn't know he was that famous or anything like that.

Buchloh: At that time, the late fifties and early sixties, he was still a relatively secret cult figure who just lived here.

Warhol: Well, even all the people like Barney Newman and all those people, Jackson Pollock and Franz Kline, they were not well known.

Buchloh: In retrospect it sometimes seems unbelievable that the reception process of Duchamp's work should have taken so long.

Warhol: But some people like Rauschenberg went to that great school called Black Mountain College, so they were aware of him.

Buchloh: So you think that it was through John Cage that the Duchamp reception was really generated? One of the phenomena that has always interested me in your work is the onset of serialization. Your first paintings, such as *Popeye* or *Dick Tracy*, are still single images of readymades, and it seems that by 1961–62 you changed into a mode of serial repetition.

Warhol: I guess it happened because I ... I don't know. Everybody was finding a different thing. I had done the comic strips, and then I saw Roy Lichtenstein's little dots, and they were so perfect. So I thought I could not do that, the comic strips, because he did them so well. So I just started other things.

Buchloh: Had you seen accumulations by Arman at that time, since he had just begun his serial repetitions of similar or identical ready-made objects a few years before, and that seems such a strange coincidence?

Warhol: No, well, I didn't think that way. I didn't. I wasn't thinking of anything. I was looking for a thing. But then I did a dollar bill, and then I cut it up by hand. But you weren't allowed to do dollar bills that looked like dollar bills, so you couldn't do a silkscreen. Then I thought, well how do you do these things? The dollar bill I did was like a silkscreen, you know; it was commercial – I did it myself. And then somebody said that you can do it photographically – you know they can just do it, put a photograph on a screen – so that's when I did my first photograph, then from there, that's how it happened.

Buchloh: But how did you start serial repetition as a formal structure?

Warhol: Well, I mean, I just made one screen and repeated it over and over again. But I was doing the reproduction of the thing, of the Coca-Cola bottles and the dollar bills.

Buchloh: That was in 1962. So it had nothing to do with a general concern for seriality? It was not coming out of John Cage and concepts of musical seriality; those were not issues you were involved with at the time?

Warhol: When I was a kid, you know, John Cage came – I guess I met him when I was fifteen or something like that – but I didn't know he did serial things. You mean ... but I didn't know about music.

Buchloh: Serial form had become increasingly important in the early 1960s, and it coincided historically with the introduction of serial structures in your work. This aspect has never really been discussed.

Warhol: I don't know. I made a mistake. I should have just done the Campbell Soups and kept on doing them. Because then, after a while, I did like some people, like, you know, the guy who just does the squares, what's his name? The German – he died a couple of years ago; he does the squares – Albers. I liked him; I like his work a lot.

Buchloh: When you did the Ferus Gallery show in Los Angeles, where you showed the thirty-three almost identical Campbell Soup paintings, did you know at that time about Yves Klein's 1957 show in Milan where he had exhibited the eleven blue paintings that were all identical

in size, but all different in price?

Warhol: No, he didn't show them in New York until much later. No, I didn't know about it. But didn't he have different-sized pictures and stuff like that? But then Rauschenberg did all-black paintings before that. And then before Albers, the person I really like, the other person who did black-on-black paintings.

Buchloh: You are thinking of Ad Reinhardt's paintings?

Warhol: Right. Was he working before Albers?

Buchloh: Well, they were working more or less simultaneously and independently of each other, even though Albers started earlier. There is another question concerning the reception process which I'm trying to clarify. People have speculated about the origins of your early linear drawing style, whether it comes more out of Matisse, or had been influenced by Cocteau, or came right out of Ben Shahn. I was always surprised that they never really looked at Man Ray, for example, or Picabia. Were they a factor in your drawings of the late 1950s, or did you think of your work at that time as totally commercial?

Warhol: Yeah, it was just commercial art.

Buchloh: So your introduction to the work of Francis Picabia through Philip Pearlstein took place much later?

Warhol: I didn't even know who that person was.

Buchloh: And you would not have been aware of Man Ray's drawings until the sixties?

Warhol: Well, when I did know Man Ray he was just a photographer, I guess. I still don't know the drawings really.

Buchloh: His is a very linear, elegant, bland drawing style. The whole New York Dada tradition has had a very peculiar drawing style, and I think your drawings from the late fifties are much closer to New York Dada than to Matisse.

Warhol: Well, I worked that way because I like to trace, and that was the reason, just tracing outlines of photographs.

Buchloh: That is, of course, very similar to the approach to drawing that Picabia took in his engineering drawings of the mechanical phase around 1916. I wasn't quite sure to what degree that kind of information would have been communicated to you through your friend Philip Pearlstein, who had, after all, written a thesis on Picabia.

Warhol: When I came to New York I went directly into commercial art, and Philip wanted to too. But he had a really hard time with it, so he kept up with his paintings. And then you know, I didn't know much about galleries, and Philip did take me to some galleries, and then he went into some more serious art. I guess if I had thought art was that simple, I probably would have gone into gallery art rather than commercial, but I like commercial. Commercial art at that time was so hard because photography had really taken over, and all of the illustrators were going out of business really fast [...]

Benjamin H.D. Buchloh, extract of interview with Andy Warhol, 1985 [excerpts published in *October*, 70, Fall 1994; reprinted in Martha Buskirk and Mignon Nixon, eds, *The Duchamp Effect*, Cambridge, Massachusetts: MIT Press, 1996] 37-40.

Benjamin H.D. <u>BUCHLOH</u>
Andy Warhol's One-Dimensional Art, 1956–1966
[1989]

SERIAL BREAKDOWN AND DISPLAY

Repeated discussions of Warhol's Pop iconography and, even more, his work's subsequent pictorialization have detached the work from Warhol's intricate reflection on the status and substance of the painterly object and have virtually ignored his efforts to incorporate exhibition context and display strategies into the conception of his painting. Features that were aggressively anti-pictorial in their impulse, and evidently among Warhol's primary concerns in the early exhibitions, have been obliterated in the process of his work's acculturation. This is true of his notorious debut exhibition at Irving Blum's Ferus Gallery in Los Angeles in 1962, as well as his second exhibition at that gallery a year later; it is also true of numerous proposals (most often rejected by curators and dealers) for some of the subsequent exhibitions from 1963 to 1966. On the one hand, the installation of the thirty-two paintings at the Ferus Gallery was determined by the number of varieties of Campbell's Soup available at that time (Warhol actually used a list of Campbell's products to check off the flavours he had already painted). Thus, the number of objects in the first presentation of Warhol's work was determined by the apparently random and external factor of a product line and its variations. (What other latent systems, one should ask on this occasion, normally determine the number of high art objects in an exhibition?) On the other hand, the paintings' *mode of display* was as crucial as the principle of serial repetition and their commercial, readymade iconography. Standing on small white shelves running along the perimeter of the gallery in the way that display shelves for consumer goods would normally function in a store, the paintings were nevertheless appended to the wall in the way pictures would be traditionally installed in a gallery. Finally, there is the inevitable dimension of Warhol's own biography, inserted into these paintings (and it is not important whether the remark is truthful or yet another *blague*), explaining why he chose the Campbell's Soup image:

> Because I used to drink it. I used to have the same lunch every day, for twenty years, I guess, the same thing over and over again. Someone said my life has dominated me; I liked that idea.

All three factors anchor the work in distinct framing systems that effect its reading beyond the merely iconographic 'scandal' of Pop imagery for which it became mostly known. What has been misread as provocative banality is, in fact, the specificity of the paintings' reified existence, which ruins the traditional expectation of an aesthetic object's universal legibility. Warhol's work abolishes that claim with the same vehemence with which those systems of everyday determination abolish the experience of subjectivity.

Yet at the same time, these paintings are imbued with an eerie concreteness and corporeality, which had distinguished Piero Manzoni's *Merda d'artista* just a year before. But Warhol differs here – as in his relationship to Johns's imagery – in that he transferred the universality of corporeal experience on to the paradoxical level of mass cultural specificity (not 'natural' bodily production, such as in Manzoni's cans of human excrement, but rather product consumption forms the material base of physical experience).

The absurdity of the aesthetic decision-making process as subjective act becomes all the more obvious in the infinite variation of the same (e.g., the details of the soup labels' design and information). It is precisely in this exact imitation of minute variations and in the paintings' exact obedience to the officially available range of products that the series of Campbell's Soup paintings goes far beyond what has been perceived as a mere iconographic scandal. Inevitably, the Campbell's Soup series of 1962 and its installation recall a crucial moment of neo avantgarde history when seriality, monochromy, and mode of display had broken down the unified and unique character of the easel painting: Yves Klein's installation of eleven identical blue monochrome paintings in the Galleria Apollinaire in Milan in 1957 (repeated a few months later in Paris). Commenting on his exhibition, Klein said:

> All of these blue propositions, all alike in appearance, were recognized by the public as quite different from one another. The amateur passed from one to another as he liked and penetrated, in a state of instantaneous contemplation, into the worlds of the blue ... The most sensational observation was that of the 'buyers'. Each selected out of the ... pictures that one that was his, and each paid the asking price. The prices were all different of course.

Klein's installation (along with his commentary on it) reveals both the degree of similarity between his attitude and Warhol's serial breakdown of Modernist painting, and the radical difference between the two propositions, separated by five years. While Klein's high culture conservatism clearly was intended to create a paradox, paralleling that of painting's simultaneous commodity form and its desperately renewed metaphysical aspirations, Warhol's position of relentless affirmation cancelled any such aspirations and liquidated the metaphysical dimension of the Modernist legacy by rigorously subjecting each painting to the framing device of an identical product-image and price.

The serial breakdown of the painterly object and its repetition within the display were not just a topical idea for his first exhibition; they constituted a crucial aesthetic strategy. In 1968 Warhol was approached by Mario Amaya to install his first European retrospective exhibition at the Institute of Contemporary Art in London. Warhol suggested installing the series of thirty-two *Campbell's Soup* paintings throughout all the spaces allocated for this show, to make them the exclusive subject of the 'retrospective'. Amaya refused this proposal just as the curators at the Whitney Museum in New York in 1970 refused Warhol's proposal to install only *Flower* paintings

or *Cow Wallpaper* (glued backward on to the exhibition walls) as the sole contents of his retrospective exhibition at that institution.

For his second exhibition at the Ferus Gallery in Los Angeles in 1963 (the first one seems to have been at best a *succès de scandale*, judging by the fact that none of the paintings, offered at $300.00 each, were sold), Warhol suggested once again a 'monographic' exhibition, the recently produced series of single and multiple *Elvis* images, silkscreened on large monochrome silver surfaces. In fact, he apparently suggested that the 'paintings' should be installed as a 'continuous surround', and he shipped a single continuous roll of canvas containing the silkscreened images to Los Angeles.

As in his first installation in Los Angeles, this proposition threatened the boundaries of painting as an individually defined and complete pictorial unit. But now it not only subverted what remained of that status via serial repetition, but destroyed it altogether by the sheer spatial expansion of serial repetition. What had been a real difficulty for Pollock, the crucial decision of how and where to determine the size and the cut of the expanded field of painterly action – or, as Harold Rosenberg put it, to cross over into the production of 'apocalyptic wallpaper' – had become a major threat for Abstract Expressionist painting. In expanding the canvas into architectural dimensions, Warhol now embraced this threat in a deliberate transgression of those sacred pictorial limits that ultimately only confine the commodity.

It was utterly logical that soon thereafter Warhol would conceive an installation of actual wallpaper for his supposedly final exhibition as a 'painter' at the Leo Castelli Gallery in 1966 – wallpaper imprinted with the by now notorious (then utterly bland) image of a cow, that animal whose reputation it is to have a particularly vapid and fixed gaze. Juxtaposed with the *Cow Wallpaper* was Warhol's series of floating silver 'pillows', the *Silver Clouds*, which moved through the gallery, animated by air and the viewers' body movements. Rumour has it that Warhol said of the *Cows*, 'This is all of us.' But the decor would not have needed that statement to make its point: all of Modernism's most radical and utopian promises (to evolve from pictorial plane through sculptural object to architectural space, to shift the viewer from iconic representation to the self-reflexive, the indexical sign, and the tactile mode of participation, to abandon the confines of the private viewing mode of the easel painting in favour of the space of simultaneous collective perception) are annihilated in this farcical sacking of the Modernist legacy, the gracefully atopian *finale* of the first ten years of Warhol's art.

Until 1966, Warhol's art (as opposed to his films) thus oscillated constantly between an extreme challenge to the status and credibility of painting and a continued deployment of strictly pictorial means, operating within the narrowly defined framework of pictorial conventions. Inevitably, the question arises (and it has been asked again and again) whether or why Warhol never crossed the threshold into the actual conception (or, rather reconstitution) of the readymade. Except for the occasional joke campaign, such as signing actual

Campbell's soup cans, Warhol never used the three dimensional readymade object in its unaltered industrial state, as a raw object of consumption. Yet at the same time he went further than any of his Pop art peers (not, however, as far as many of his peers in the Fluxus context) to challenge traditional assumptions about the uniqueness, authenticity, and authorship of the pictorial object, the very foundations upon which high Modernist art had rested until Duchamp defined the readymade in 1917, and upon which the reconstruction of Modernism had rested in the New York School context until the arrival of Warhol in 1962.

Again and again, Warhol tantalized collectors, curators, and art dealers by generating doubts about the authenticity and authorship of his work. He succeeded temporarily in destabilizing his own market:

I made multiple colour silkscreen printing – like my comic strip technique. Why don't you ask my assistant Gerard Malanga some questions? He did a lot of my paintings.

Two explanations, contradicting each other to some extent, seem appropriate. The first is that Warhol emerged from a local tradition of artists who had distinguished themselves by pictorializing the Dada legacy in their critical engagement with the heroic tradition of the New York School. And it was to the power and success of Johns and Rauschenberg that Warhol aspired in the early 1960s, not to the increasing marginalization that awaited artistic practices that had abandoned picture production (such as Happenings and Fluxus, for example). The critical distance that Warhol wanted to insert between himself and his two major predecessors had to occur first of all within the means of painting (rather than by abandoning painting abruptly in favour of 'pure' readymades). Warhol, therefore, had to work through the last phases of the pictorialization begun by Rauschenberg and Johns and go to the threshold of painting's abolition – a consequence that would soon emerge, mediated to a considerable degree by Warhol's work, in the context of Minimal and Conceptual art.

The second explanation is more speculative. It assumes that the reason Warhol was so deeply involved with the pictorial medium, the autonomy of aesthetic conventions, and the stability of artistic categories inherent in that medium was that he had learned gradually to accept the relative conventionality of his audience and of the institutional control and valorization of that medium. Therefore, he decided not to transgress these conservative limitations inherent in painterly practice and refrained from acquiring (or reconstituting) the status of the unaltered readymade in any of his works until 1966. Perhaps it was Warhol's skeptical and opportunistic positivism (to anticipate that all radical gestures within the framework of an institutionalized and industrialized high art production would inevitably and ultimately generate marketable artistic objects, would end up as mere 'pictures' in a gallery, merely legitimizing the institutional and discursive conventions from which they emerged) that allowed him to avoid the mistakes inherent in Duchamp's radical proposition of the readymade. Duchamp had, in fact, been oblivious to both the false

radicality of the readymade and the problem of its inevitable aestheticization. One of the rare comments Duchamp actually made about Warhol's work seems to indicate that he himself understood that implication, after all, when looking at Warhol's work: 'What interests us is the *concept* that wants to put fifty Campbell Soup cans on a canvas' […]

Benjamin H.D. Buchloh, extract from 'Andy Warhol's One-Dimensional Art, 1956-1960' [*Andy Warhol*, ed. Kynaston McShine, New York: The Museum of Modern Art, 1989; reprinted in Benjamin H.D. Buchloh, *Neo-Avantgarde and Culture Industry. Essays on European and American Art from 1955 to 1975*, Cambridge, Massachusetts: MIT Press, 2000] 506-12.

COLONIZATION OF THE MIND
While Pop was celebrated in New York as a quintessentially American movement, a more dispassionate and oblique stance was taken by European artists such as Marcel Broodthaers and Öyvind Fahlström, who also wrote for magazines and newspapers. There Pop was seen as part of a larger tradition, as an intrusion into European cultural differences, and as an exotic, iconoclastic riposte to bourgeois conservatism. Structural analysis and semiotics were also applied to Pop and became useful as critical methodologies in the work of Roland Barthes and Umberto Eco.

Jonas MEKAS
Movie Journal [1959–65]

18 November 1959

PULL MY DAISY AND THE TRUTH OF CINEMA

Alfred Leslie and Robert Frank's *Pull My Daisy* has finally been premiered at Cinema 16, and those who saw it will now (I hope) understand why I was so enthusiastic about it. I don't see how I can review any film after *Pull My Daisy* without using it as a signpost. As much of a signpost in cinema as *The Connection* is in modern theatre. Both *The Connection* and *Pull My Daisy* clearly point towards new directions, new ways out of the frozen officialdom and mid-century senility of our arts, towards new themes, a new sensibility.

The photography itself, its sharp, direct black and white, has a visual beauty and truth that is completely lacking in recent American and European films. The hygienic slickness of our contemporary films, be they from Hollywood, Paris or Sweden, is a contagious sickness that seems to be catching through space and time. Nobody seems to be learning anything, either from Lumière or from the neo-realists: Nobody seems to realize that the quality of photography in cinema is as important as its content, its ideas, its actors. It is photography that is the midwife, that carries life from the street to the screen, and it depends on photography whether this life will arrive on the screen still alive. Robert Frank has succeeded in transplanting life—and in his very first film. And that is the highest praise I can think of. Directorially, *Pull My Daisy* is returning to where the true cinema first began, to where Lumière left off. When we watch Lumière's first films—the train coming into the station, the baby being fed, or a street scene—we believe him, we believe he is not faking, not pretending. *Pull My Daisy* reminds us again of that sense of reality and immediacy that is cinema's first property.

One should not misunderstand me: There are many approaches to cinema, and it depends on one's consciousness, sensitivity and temperament which style one chooses, and it also depends on which style is more characteristic to the times. The style of neo-realism was not a sheer accident. It grew out of the post-war realities, out of the subject matter. It is the same with the new spontaneous cinema of *Pull My Daisy*. In a sense, Alfred Leslie, Robert Frank and Jack Kerouac, the film's author-narrator, are only enacting their times in the manner the prophets do: The time expresses its truths, its styles, its messages and its desperations through the most sensitive of its members—often against their own consciousness. It is therefore that I consider *Pull My Daisy*, in all its inconsequentiality, the most alive and the most truthful of films.

9 February 1961

MARILYN MONROE AND THE LOVELESS WORLD

Marilyn Monroe, the saint of Nevada Desert. When everything has been said about *The Misfits*, how bad the film is and all that, she still remains there, MM, the saint. And she haunts you, you'll not forget her.

It is MM that is the film. A woman who has known love, has known life, has known men, has been betrayed by all three, but has retained her dream of man, love, and life. She meets these tough men, Gable, Clift, Wallach, in her search for love and life; she finds love everywhere and she cries for everyone. She is the only beautiful thing in the whole ugly desert, in the whole world, in this whole dump of toughness, atom bomb, death.

Everybody has given up their dreams, all the tough men of the world have become cynics, except MM. And she fights for her dream—for the beautiful, innocent and free. It is she who fights for love in the world, when the men fight only wars and act tough. Men gave up the world. It is MM who tells the truth in this movie, who accuses, judges, reveals. And it is MM who runs into the middle of the desert and in her helplessness shouts: 'You are all dead, you are all dead!'—in the most powerful image of the film—and one doesn't know if she is saying those words to Gable and Wallach or to the whole loveless world.

Is MM playing herself or creating a part? Did Miller and Huston create a character or simply recreate MM? Maybe she is even talking her own thoughts, her own life? Doesn't matter much. There is so much truth in her little details, in her reactions to cruelty, to false manliness, nature, life, death, that she is over-powering, one of the most tragic and contemporary characters of modern cinema, and another contribution to The Woman as a Modern Hero in Search of Love. (See *Another Sky*; *The Lovers*; *Hiroshima, Mon Amour*; *The Savage Eye*, etc., etc.)

It's strange how cinema, bit by bit, can piece together a character. Cinema is not only beautiful compositions or well-knit stories; cinema is not only visual patterns or play of light. Cinema also creates human characters.

We are always looking for 'art', or for good stories, drama, ideas, content in movies—as we are accustomed to in books. Why don't we forget literature and drama and Aristotle! Let's watch the face of man on the screen, the face of MM, as it changes, reacts. No drama, no ideas, but a human face in all its nakedness—something that no other art can do. Let's watch this face, its movements, its shades; it is this face, the face of MM, that is the content and story and idea of the film, that is the whole world, in fact.

2 May 1963

ON THE BAUDELAIREAN CINEMA

There are many good reasons for barking about it. Lately, several movies have appeared from the underground which, I think, are marking a very important turn in independent cinema. As *Shadows* and *Pull My Daisy* marked the end of the avant-garde-experimental cinema tradition of the forties and fifties (the symbolist-surrealist cinema of intellectual meanings), now there are works

13. Eve Arnold

appearing which are marking a turn in the so-called New American Cinema – a turn from the New York realist school (the cinema of 'surface' meanings and social engagement) towards a cinema of disengagement and new freedom.

The movies I have in mind are Ron Rice's *The Queen of Sheba Meets the Atom Man*; Jack Smith's *The Flaming Creatures*; Ken Jacobs' *Little Stabs at Happiness*; Bob Fleischner's *Blonde Cobra* – four works that make up the real revolution in cinema today. These movies are illuminating and opening up sensibilities and experiences never before recorded in the American arts; a content which Baudelaire, the Marquis de Sade and Rimbaud gave to world literature a century ago and which Burroughs gave to American literature three years ago. It is a world of flowers of evil, of illuminations, of torn and tortured flesh; a poetry which is at once beautiful and terrible, good and evil, delicate and dirty.

A thing that may scare an average viewer is that this cinema is treading on the very edge of perversity. These artists are without inhibitions, sexual or any other kind. These are, as Ken Jacobs put it, 'dirty-mouthed' films. They all contain homosexual and lesbian elements. The homosexuality, because of its existence outside the official moral conventions, has unleashed sensitivities and experiences which have been at the bottom of much great poetry since the beginning of humanity.

Blonde Cobra, undoubtedly, is the masterpiece of the Baudelairean cinema, and it is a work hardly surpassable in perversity, in richness, in beauty, in sadness, in tragedy. I think it is one of the great works of personal cinema, so personal that it is ridiculous to talk about 'author's' cinema. I know that the larger public will misinterpret and misunderstand these films. As there are poets appreciated only by other poets (William Carlos Williams was such a poet for many years), so there is now a cinema for the few, too terrible and too 'decadent' for an 'average' man in any organized culture. But then, if everybody would dig Baudelaire, or Sade, or Burroughs, my God, where would humanity be?

14 November 1963
ON SCORPIO RISING
Kenneth Anger's new movie, *Scorpio Rising*, is about the motorcycle-riding death. It is a brilliant movie by a brilliantly obsessed filmmaker. What is the movie about? Motorcycles. Scorpios. Brando. Death. Fetishes. Brute force. It is many things. Slowly, without hurrying, in poisonously sensuous colours,

Anger shows, or more truly lets the subject reveal itself, bit by bit, motion by motion, detail by detail, belts, knobs, chrome, chests, pedals, rings, boots, leather jackets, rituals and mysteries of the motorcycle youth, steel and chrome perversions.

It has a strange fascination, this world that so many of us do not know. 'Evil works, evil really works' – *Blonde Cobra*. Evil attracts. Scorpios attract. The pull of fascist strength, muscle and steel and speed. Didn't we all want, sometimes, to ride the streets like black steel devils? Oh, and there is the world of things of spirit, of love, of subtle emotions, of meditation, of flowers. We wonder if

one denies, or strengthens, provokes the other.

Anger does not moralize or stress or take stands: He only presents the theme, as a poet, fully and roundly, so that after Anger there is nothing to say on the subject, everything is in his movie, hinted, suggested, much more than what we see in it after the first or second viewing. He put it under the sign of Scorpio and left it there, which is a moral in itself, I guess. Scorpio rises. Scorpio will always rise as long as there are stars in heaven and man on earth.

30 July 1964
WARHOL SHOOTS EMPIRE
Andy Warhol is unquestionably the most productive filmmaker in the world today. In less than a year he has completed fifteen movies, most of which are features: *Sleep* (six hours), *Eat*; *Kiss*; *Haircut*; *Naomi and Rufus Kiss*; *The End of Dawn*; *Salome and Delilah*; *Tarzan and Jane Regained Sort of*; *Thirteen Most Beautiful Boys*; *Blow Job*; *Dance Movie*; *Dinner at Daley's*; *The Rose Without Thorns*; *Soap Opera*; and *Empire* (eight hours).

Last Saturday I was present at a historical occasion: the shooting of Andy Warhol's epic *Empire*. From 8 p.m. until dawn the camera was pointed at the Empire State Building, from the 41st floor of the Time-Life Building. The camera never moved once. My guess is that *Empire* will become the *Birth of a Nation* of the New Bag Cinema. The following are excerpts from a conversation with the Warhol crew – Henry X., John Palmer, Marie Desert and the poet Gerard Malanga:

John Why is nothing happening? I don't understand.
Henry What would you like to happen?
John I don't know.
Henry I have a feeling that all we're filming is the red light.
Andy Oh, Henry!!!
Henry Andy?! NOW is THE TIME TO PAN.
John Definitely not!
Henry The film is a whole new bag when the lights go off.
John Look at all that action going on. Those flashes. Tourists taking photos.
Andy Henry, what is the meaning of action?
Henry Action is the absence of inaction.
Andy Let's say things intelligent.
Gerard Listen! We don't want to deceive the public.
John We're hitting a new milestone.
Andy Henry, say Nietzsche.
Henry Another aphorism?
John B movies are better than A movies.
Andy Jack Smith in every garage.
Marie Someday we're all going to live underground and this movie will be a smash.
John The lack of action in the last three 1200-foot rolls is alarming!
Henry You have to mark these rolls very carefully so as not to get them mixed up.
Jonas Did you know that the Empire State Building sways?
Marie I read somewhere that art is created in fun.
Jonas What?
Gerard During the projection, we should set up window panes for the audience to look through. Andy, The Empire

State Building is a star!
John Has anything happened at all?!
Marie No.
John Good!
Henry The script calls for a pan right at this point. I don't see why my artistic advice is being constantly rejected.
Henry to Andy The bad children are smoking pot again.
John I don't think anything has happened in the last hundred feet.
Gerard Jonas, how long is this interview supposed to be?
Jonas As much as you have.
Andy An eight-hour hard-on!
Gerard We have to maintain our cool at all times.
John We have to have this film licensed.
Andy It looks very phallic.
Jonas I don't think it will pass.
John Nothing has happened in the last half-hour. The audience viewing Empire will be convinced after seeing the film that they have viewed it from the 41st floor of the Time-Life Building, and that's a whole bag in itself. Isn't that fantastic?
Jonas I don't think the last reel was a waste.
Henry to John I think it's too playful.

3 August 1964
ON CINEMA VERITÉ, RICKY LEACOCK AND WARHOL
With the Direct Cinema series, the Gallery of Modern Art – the Huntington Hartford Museum – has inaugurated its film screenings. Direct Cinema, a term introduced by Louis Marcorelles, is beginning to replace the earlier cinema verité term. It describes that cinema which is taken 'directly' from life, as opposed to filming staged events. The new term is less confusing than the old one at least in one respect: Reality, staged or not staged, is true in itself. As Chris Marker has said, '*Verité n'est pas le but mais, peut-etre, la route*' (The truth is not the aim – it is more likely the way.)

The Direct Cinema began in Canada, France and the United States at the same time. In France, Jean Rouch and Chris Marker (and later Reichenbach, Morin, Rosier); in Canada, Brault, Juneau, Koenig; in the United States, Leacock, Pennebaker, Maysles. In each country Direct Cinema took a different national character. Chris Marker, for instance, is the pure mind, in the best Cartesian tradition (like Resnais and Bresson). He is always seeking the truth behind the surface; organizing and bending his visual materials to illustrate his own philosophy, his own ideas on what 'really is' (his idea of Siberia, of Cuba, of China, etc.). Canadians are no philosophers; in most of the Canadian Direct Cinema films the directors are following a moral attitude. There is always a bag of oats in front of the horse.

Leacock, Pennebaker and Maysles, in their public statements, and to the best of their abilities in their work, try to keep their own ideas and morals out. They insist that the ideas should come from their materials. Most of their films have been badly marred, in that respect, by added commentaries and moralistic editors. Whatever the flaws, the beauty and originality of Leacock's and Maysles' work are in its being not about ideas but about people. The passion of Leacock, Maysles, Brault and Pennebaker

for the Direct Cinema has produced many side developments. The new camera techniques and new thematic materials have influenced a number of low budget independent features. Stanton Kaye's Georg is the latest inspired application of the Direct Cinema techniques to a staged event.

It is the work of Andy Warhol, however, that is the last word in the Direct Cinema. It is hard to imagine anything more pure, less staged and less directed than Andy Warhol's *Eat*, *Empire*, *Sleep*, *Haircut* movies. I think that Andy Warhol is the most revolutionary of all filmmakers working today. He is opening to filmmakers a completely new and inexhaustible field of cinema reality. It is not a prediction but a certainty that soon we are going to see dozens of *Eat*, *Haircut* or *Street* movies done by different filmmakers, and there will be good and bad and mediocre *Eat* movies, and very good *Eat* movies, and someone will make a masterpiece *Eat* movie. What to some still looks like actionless nonsense, with the shift of our consciousness which is taking place will become an endless variety and an endless excitement of seeing similar subjects or the same subject done differently by different artists. Instead of asking for Elephant Size Excitement we'll be able to find aesthetic enjoyment in the subtle play of nuances.

There is something religious about this. It is part of that 'beat mentality' that Cardinal Spellman attacked this week. There is something very humble and happy about a man (or a movie) who is content with eating an apple. It is a cinema that reveals the emergence of meditation and happiness in man. Eat your apple, enjoy your apple, it says. Where are you running? Away from yourself? To what excitement? If all people could sit and watch the Empire State Building for eight hours and meditate upon it, there would be no more wars, no hate, no terror – there would be happiness regained upon earth.

11 March 1965
THE PREMIÈRE OF *EMPIRE*
The première of Andy Warhol and John Palmer's eight-hour epic *Empire* movie took place at the Cinematheque last Saturday night. It was a glorious event and a glorious day for the Empire State Building. Ten minutes after the film started, a crowd of thirty or forty people stormed out of the theatre into the lobby, surrounded the box office, Bob Brown and myself, and threatened to beat us up and destroy the theatre unless their money was returned. 'This is not entertainment! This movie doesn't move!' shouted the mob. Oh what a blind eye! They were threatening to solve the question of the new vision and new cinema by breaking chairs on our heads. The gulf is still widening between the old and the new. The old will fall off by itself soon, like a dead potato [...]

29 April 1965
ON FILM REVOLUTION
Here is another column of ramblings. My head is rambling because I have seen a beautiful movie and I have plenty to think about. My readers, particularly those who think that I am out of my head anyway, I hope will not mind my ravings.

Much has been said about truth in cinema. We even have the so-called 'cinema verité', the 'cinema of truth'. I have written much nonsense about truth in cinema myself. There was a time, four, five years ago, when we had too much of one kind of cinema: pale, tired Hollywood cinema. The avant-garde, the independents were sleeping. There was a need to stir things up, to exaggerate things, to talk about 'cinema truth', about 'spontaneous cinema', plotless cinema, slice-of-life cinema, New York cinema. John Cassavetes' *Shadows* and Alfred Leslie and Robert Frank's *Pull My Daisy* came like a blast of fresh wind, they made us breathe easier; Leacock came; soon the avalanche of the underground started rolling.

But now, I feel, the cinema has been freed from the Hollywood 'regime'. The filmmaker is free from 'professional' techniques, from Hollywood subject matter, from plot routines, from Hollywood lighting. I have a feeling that now the independent, underground, experimental filmmaker is free not only from Hollywood cinema but from the underground cinema techniques as well. What I mean is that during these last four years, often through anarchy, often through his nuttiness, often through conscious rejection of Hollywood, the filmmaker has gained a new freedom. Now he can use any technique he wants. His vocabulary has increased from a Lilliput to, at least, a Webster. If he wants, he can swing his camera around his head; or he can lock his camera down to a tripod; he can overexpose, or use a balanced lighting; he can use 8mm or 16mm or 35mm or any other size he feels like. Don't be surprised at all if within this coming year you see the underground movie-makers going into all possible sizes of cameras and screens. Hollywood has remained frozen and therefore is dying, it cannot be revived even with fresh blood. The underground, however, is coming up, free, strong and kicking.

ANDY WARHOL AND TRUTH
What made me think about all this, really, is the last two films by Andy Warhol, his two sound movies, *Vinyl* and *Poor Little Rich Girl*. I will come to *Vinyl* some other time – but *Poor Little Rich Girl*, in which Warhol records seventy minutes of Edith Sedgwick's life, surpasses everything that the cinema verité has done till now; and by that I mean filmmakers such as Leacock, Rouch, Maysles, Reichenbach. It is a piece that is beautiful, sad, unrehearsed, and says about the life of the rich girl today more than ten volumes of books could say. It was an old dream of Cesare Zavattini to make a film two hours long which would show two hours from the life of a woman, minute by minute. It was up to Andy Warhol to do it, to show that it could be done, and done beautifully. Miss Sedgwick happened to be the most suitable person for such a film, with the proper personality; with a rich, complex, and very open personality, able to relax in front of a camera and be free and not hide anything and reflect everything. It is not an easy part to play, it is not an easy film to make. Nothing much really happens in the film, if we want action. Miss Sedgwick goes about her make-up business, she listens to rock 'n' roll music; she answers a telephone call which disturbs her; she dresses up; she keeps up a continuous conversation with a man outside of

the frame; she strolls around in her room. That's it, more or less. But you have to see it – and it was a privilege of those thirty or forty people who stayed at the City Hall Cinema last Monday, after most of the audience walked out on Andy Warhol, expecting another *Empire* – it was the privilege of those few to see, with amazement, how beautiful the film was, and how much could be read into this unbelievably simple film – how rich it really is.

Jonas Mekas, extracts from 'Movie Journal' column, *Village Voice* [New York, 1959-65; reprinted in Jonas Mekas, *Movie Journal: The Rise of the New American Cinema*, 1959-1971, New York: Collier Books/Macmillan, 1972] 5-6, 63-4, 85-6, 97, 150-1, 184-6.

Gerhard RICHTER
Letter to a Newsreel
Company [1963]

Dear Mr Schmidt,
We take the liberty of drawing your attention to an unusual group of young painters' with an unusual exhibition. We are exhibiting in Düsseldorf, on former shop premises in the section of Kaiserstrasse that is due for demolition. This exhibition is not a commercial undertaking but purely a demonstration, and no gallery, museum or public exhibiting body would have been a suitable venue.

The major attraction of the exhibition is the subject matter of the works in it. For the first time in Germany, we are showing paintings for which such terms as Pop art, Junk Culture, Imperialist or Capitalist Realism, New Objectivity, Naturalism, German Pop and the like are appropriate. Pop art recognizes the modern mass media as a genuine cultural phenomenon and turns their attributes, formulations and content, through artifice, into art. It thus fundamentally changes the face of modern painting and inaugurates an aesthetic revolution. Pop art has rendered conventional painting – with all its sterility, its isolation, its artificiality, its taboos and its rules – entirely obsolete, and has rapidly achieved international currency and recognition by creating a new view of the world.

Pop art is not an American invention, and we do not regard it as an import – though the concepts and terms were mostly coined in America and caught on more rapidly there than here in Germany. This art is pursuing its own organic and autonomous growth in this country; the analogy with American Pop art stems from those well-defined psychological, cultural and economic factors that are the same here as they are in America.

We take the view that the *Wochenschau* ought to document this first exhibition of 'German Pop art', and we ask you to consider the possibility of a report. If you would like further detailed information on us, our work, and our ideas, we shall be glad to supply them.

We look forward to hearing from you.
Yours truly,
Gerd Richter

1 The painters Manfred Küttner, Konrad Lueg, Sigmar Polke and Gerhard Richter.

Gerhard Richter, Letter of 24 April 1963; reprinted in
Gerhard Richter, *The Daily Practice of Painting: Writings
1962-1993*, ed. Hans Ulrich Obrist [London, Thames & Hudson,
1995] 15-16.

Konrad LUEG, Gerhard RICHTER

Living with Pop: Programme and Report [1963]

The exhibition 'Leben mit Pop – eine Demonstration für den Kapitalistischen Realismus', Düsseldorf, 11 October 1963

Please note that the number assigned to you is: PROGRAMME (roman numerals) CATALOGUE (letters) for a Demonstration for Capitalist Realism

LIVING WITH POP
Friday, 11 October 1963, Flingerstrasse 11, Düsseldorf

i) Start 8 p.m. Report to 3rd floor.

A
Waiting room, 3rd floor (décor by Lueg and Richter)

ii) When your number is called, visit Room No. 1, 3rd floor. Disciplined behaviour is requested.

B
Room No. 1: sculptures by Lueg and Richter
(plus one work on loan from Professor Beuys)
(Couch with Cushions and Artist
Floor Lamp with Foot Switch
Trolley Table
Chair with an Artist
Gas stove
Chair
Table, Adjustable, with Table Setting and Flowers
Tea Trolley, Laid
Large Cupboard with Contents and Television
Wardrobe with loan from Professor Beuys)

iii) When your number is called (approx. 8:45 p.m.), visit other exhibition rooms on 2nd and 1st floors and ground floor. During this tour (Polonaise), please refrain from smoking.

C
Exhibition rooms on several floors (selected by Lueg and Richter) (52 bedrooms, 78 living rooms, kitchens and nurseries, paintings by both painters; guests of honour, Messrs. Schmela and Kennedy)

On completion of tour, see A, etc.
Subject to alteration.
Thank you for your attention.

Konrad Lueg and Gerd Richter

REPORT
[12 September 1963.] Planning of exhibition in furniture store, Düsseldorf. Available space consists of one room on 3rd floor of office block, floor area 32m².

A number of exhibition concepts were rejected, and it was resolved to hold a demonstration as follows:

a) The whole furniture store, exhibited without modification.

b) In the room set aside for the exhibition, a distilled essence of the demonstration. An average living room as a working exhibit, i.e., occupied, decorated with suitable utensils, foods, drinks, books, odds and ends, and both painters. The individual pieces of furniture stand on plinths, like sculptures, and the natural distances between them are increased, to emphasize their status as exhibits.

c) Programmed sequence of the demonstration for 11 October 1963.

List of rooms to be viewed on 11 October 1963:

i) Passage lined with window displays (26 large windows). Office entrance. Lift to 3rd floor.

ii) Waiting room (large landing on 3rd floor). On the walls: 2 boards inscribed WAITING ROOM. 14 pairs of roebuck antlers (shot in Pomerania, 1938–42). On display: 39 simple chairs, on each a copy of the *Frankfurter Allgemeine* for 11 October 1963. On the stairs lie assorted picture magazines; by the lift stand two life-size figures (paper on wire mesh, varnished and repainted), representing the art dealer Alfred Schmela and President John F. Kennedy. The space is lit by cold, rather dim fluorescent light.

iii) Exhibition room. On 9 white plinths stand the following items. A tea trolley bearing a vase of flowers, and on its lower shelf the works of Churchill and the home-making magazine *Schöner Wohnen*. A cupboard with assorted contents. A wine-red chair. A gas stove. A green chair, occupied by K. Lueg (dark suit, white shirt, tie). A small occasional table; on it, a television set (showing News followed by 'The Adenauer Era'). A small standard lamp. A couch; reclining thereon, with a detective story, G. Richter (blue suit, pink shirt, tie). A table set for coffee for two, with cut marble cake and napfkuchen and coffee in cups, plus 3 glasses and a plastic bag containing 3 bottles of beer and 1 bottle of grain spirit. The walls are painted white, with no pictures or other adornment. Next to the door is a wardrobe, containing the official costume of Prof. J. Beuys (hat, yellow shirt, blue trousers, socks, shoes; to which 9 small slips of paper are attached, each marked with a brown cross; beneath is a cardboard box containing Palmin and margarine). The room is lit by very bright, warm fluorescent light, and by the standard lamp; there is a persistent smell of pine air-freshener.

iv) Extensive furniture exhibition of all current styles on 4 floors (81 living rooms, 72 bedrooms, kitchens, individual pieces. Store rooms. Tightly packed alcoves, cubicles, rooms, stairs and passages filled with furniture, carpets, wall decorations, appliances, utensils).
In a number of installations in the bedroom and living-room sections, paintings by Lueg and Richter are on show.
By K. Lueg: *Four Fingers; Praying Hands; Bockwursts on Paper Plate; Coathanger.*
By G. Richter: *Mouth; Pope; Stag; Neuschwanstein Castle.*
These rooms are lit normally.

8:00 p.m. Two store employees stand at the entrance, giving out individually numbered programmes. A total of 122 visitors were counted in, a small proportion of whom left before the end of the event.

The visitors take the lift to the 3rd Floor and enter the WAITING ROOM. Loudspeakers all over the building broadcast dance music and the voice of an announcer, who welcomes the visitors and summons them in numerical order to view the exhibition room, which they do in groups of 6-10 individuals every 3-5 minutes. The first visitors to be called enter the room hesitantly. The room soon fills up. By approximately 8:30 the announcements are being ignored, and everyone simply squeezes in. The food and drink in the exhibition is consumed by the visitors, and some of the contents of the cupboard are looted.

8:35 p.m. The exhibited artists descend from their plinths. They and the voice on the loudspeakers request the visitors to begin the grand tour.

Richter leads a first group to the bedroom department on the 2nd floor; Lueg follows with more visitors.

The loudspeakers continue to broadcast dance music, interspersed with selected texts from furniture catalogues. From the 2nd floor the tour proceeds to the living-room department below, and then on through the store room to the kitchen department in the basement.

Most of the visitors fail to observe the prescribed itinerary and scatter or stray into the various departments.

By approximately 9 p.m., all the visitors have reached the kitchen department. They seat themselves in the 41 display kitchens and drink the beer provided. One visitor (an art student) protests against the Demonstration by removing all his clothing except a pair of swimming trunks. He is escorted from the building with his clothes under his arm.
By 9:30 p.m. the last visitor has left the building.

Konrad Lueg and Gerhard Richter, 'Living with Pop. A
Manifestation for Capitalist Realism', Düsseldorf, 11
October 1963; reprinted in Gerhard Richter, *The Daily
Practice of Painting: Writings 1962-1993*, ed. Hans Ulrich
Obrist [London, Thames & Hudson, 1995] 18-21.

Jean-Luc GODARD

Le Mépris [Contempt] [1963]

Moravia's novel is a nice, vulgar one for a train journey, full of classical, old-fashioned sentiments in spite of the modernity of the situations. But it is with this kind of novel that one can often make the best films.

I have stuck to the main theme, simply altering a few details, on the principle that something filmed is automatically different from something written, and therefore original. There was no need to try to make it different, to adapt it to the screen. All I had to do was film it as it is: just film what was written, apart from a few details, for if the cinema were not first and foremost film, it wouldn't exist. Méliès is the greatest, but without Lumière, he would have languished in obscurity.

Apart from a few details. For instance, the transformation of the hero who, in passing from book to screen, moves from false adventure to real, from Antonioni inertia to Laramiesque dignity. For instance also, the nationality of the characters: Brigitte Bardot is no longer called Emilia but Camille, and as you will see she trifles none the less with Musset. Each of the characters, moreover, speaks his own language which, as in *The Quiet American*, contributes to the feeling of people lost in a strange country. In another town, wrote Rimbaud; two weeks, adds Minnelli, several tones lower. Here, though, two days only: an afternoon in Rome, a morning in Capri. Rome is the modern world, the West; Capri, the ancient world, nature before civilization and its neuroses. *Le Mépris*, in other words, might have been called *In Search of Homer*, but it means lost time trying to discover the language of Proust beneath that of Moravia, and anyway that isn't the point.

The point of *Le Mépris* is that these are people who look at each other and judge each other, and then are in turn looked at and judged by the cinema — represented by Fritz Lang, who plays himself, or in effect the conscience of the film, its honesty. (I filmed the scenes of *The Odyssey* which he was supposed to be directing in *Le Mépris*, but as I play the role of his assistant, Lang will say that these are scenes made by his second unit.)

When I think about it, *Le Mépris* seems to me, beyond its psychological study of a woman who despises her husband, the story of castaways of the Western world, survivors of the shipwreck of modernity who, like the heroes of Verne and Stevenson, one day reach a mysterious deserted island, whose mystery is the inexorable lack of mystery, of truth that is to say. Whereas the Odyssey of Ulysses was a physical phenomenon, I filmed a spiritual odyssey: the eye of the camera watching these characters in search of Homer replaces that of the gods watching over Ulysses and his companions.

A simple film without mystery, an Aristotelian film, stripped of appearances, *Le Mépris* proves in 149 shots that in the cinema as in life there is no secret, nothing to elucidate, merely the need to live — and to make films.

Jean-Luc Godard, 'Cinq à la Zéro. *Le Mépris*', *Cahiers du Cinema*, 146 [Paris, August 1963, 31; trans. Tom Milne, in Milne and Jean Narboni, eds, *Godard on Godard*, London: Martin Secker and Warburg, 1972; reprinted, New York: Da Capo Press, 1986] 200-1.

Jack SMITH
The Memoirs of Maria Montez, or Wait for Me at the Bottom of the Pool [1963–64]

The dust settled. O finally! Maria Montez was propped up beside the pool which reflected her ravishing beauty. A chunk fell off her face showing the grey under her rouge. How can we get to it? We must retrieve it or else scrape off all her flesh and start all over. Best to fish the chunk out of the pool and pat it back into shape. It'll show as a blotch on her cheek but we can shoot around that. Somebody will have to go out there with a pole.

The make-up lady is in back trying to bring Florence Bates back to life. She can't leave the butter churn or Florence may go rancid. Actually any clever character actress could play the make-up woman in Chinese drag. We need all the character actresses to impersonate the staff which doesn't exist. They just went home. I hate to ask Charles to get up because he has a thousand strings going out of his asshole leading to everybody on the lot and would stir up so much dust and tear up his ass. O sit down, Charles … Come back, Oh he's stumbled against Miss Montez and his leg is snagged in her veils; the pole is lodged in her cunt. O she's all farted up now plus it'll be years before the dust settles.

We will go on with this scene; we'll pretend it's a sirocco scene and just restore Miss Montez's face. We'll have to use what's left of her leg because some of her face got stepped on. I'll put her in a voluminous cloak that will show only her face. The leading man can have his head buried in a chunk of her hair. That'll prop him up. Actually we could use some one alive in this scene because his face won't show but who could stand the smell from her decomposed body.

The love scene by the pool is finally being shot. There's no indication that the camera is working though. But if we had to worry about that we'd all go mad. *We!* I'm the only one here. The chunk of putrid meat in the pool showed up in all the shots.

The scaffolding around the vast Vapid Lot slipped. It rumbled and crumbled but didn't fall to the ground. More scaffoldings would be constructed around the crumbling scaffolding to keep it up. But the weight of the old scaffolding would weaken the new scaffolding and another crust of scaffolding would be built around the whole. Long ago the Movie Studio itself had fallen and now only repetition memories filmed themselves there. But the walls could never be located to be rebuilt if anyone cared to look as no one did because they had fallen into a powder among the maze of scaffolding. And the scaffolding was thick; it provided a thick wall of green darknesses behind which the entire lot strove incessantly to create a film the name and subject of which was forgotten long ago strove as in an endless hopeless dream to attempt to start to try to start this film with no personnel, a leading man dying of old age, a dead leading lady, a decomposing beloved old

character actress, no leadership or funds, or coffee money but certain gorgeous colour rouged subjective images and a couple of marvellous fantasticated, Etruscated, ruined sets.

The décor hangs down in tendrils and dust settles over all. There are strangled bodies hanging in the tendrils. They were the set decorators. They sway and moulder flaking, flaking. The tendrils disappear in a network of scaffolding.

The set disappears in shadows, disappears in scaffolding. Miss Montez is disappeared from view. She has sunk into the décor or it has sifted down on her. I think the scene should be shot anyway because she may be in there somewhere but we just can't see her but it'll come out on the film.

THE TAKE
A few layers of scaffolding are left standing. Maria Montez is chatting and smiling beside the white lily flowering pool. She is wrapped in white gauzy-mers. As she plays the scene the make-up lady furtively dabs make-up on her. She stumbles and leaves a red smear across Miss Montez's mouth, then the mouth falls off. The rouge pot falls on the set. Blend it out evenly! Don't stop the take. Miss Montez whips up a fan over her mouth for the rest of the take. She gets up and laughs in the leading man's face. He glows orange with make-up. The air around him is orange. His eyes, swimming with adoration, follow her. He touches her veil as she sweeps past him. Orange smear. His arm falls off. The fat make-up lady runs in and puts it back as a shower of white flowers swirls down to create a distraction. Everything is going beautifully. Miss Montez poises for a moment on the stairs, one shapely leg coming out of her slit, pointing towards mecca on its gold kid ankle strap wedgie. She speaks her last line of dialogue her teeth glitter behind the fan. 'Vait for me at the bottom of the pool.' She runs down the stairs and a couple hundred white doves are released as she stumbles and rolls screaming down a million flights of stairs and the shot ends.

THE POOL
The leading man realizes he has been duped at the bottom of the pool. But the pool is beautiful. There are gorgeous aqua arabesques on the bottom and they wave in the water. In brilliant blue shadows actors drown. The scene steeps in gorgeous purples and above Maria Montez covered with rouge lowers her fan, grinning. Her eyes close and the make-up lady runs up and forces them open.

Rushes come back that no one remembers taking or how they fit into the movie. Rushes of blank film, of sets not on the lot, of empty, ruined, demolished sets. Sets with no people on them. The cameraman weeps. Endlessly long shots of deserted sets of pre-World War Monte Carlo ballroom sets empty. Sets that never existed on the shambles lot.

Jack Smith, 'The Memoirs of Maria Montez, or Wait for Me at the Bottom of the Pool', *Film Culture*, 31 [New York, Winter 1963-64] 3-4.

Umberto ECO
A Reading of Steve Canyon
[1964]

On 11 January 1947 Milton Caniff publishes the first instalment of the Steve Canyon comic strip. As is customary, the name of the hero provides the title for the new saga as a whole. But this is the only preliminary information available to the general reader at the point when he plunges into the new story and makes contact with its 'characters'. Otherwise, he is aware that Caniff wrote the *Terry and the Pirates* strip, but in this comic he is being introduced to a quite different narrative situation. For his own part the author is aware that in the course of the first instalment he must capture the interest and above all the complicity of the general public. This potential reading public is extremely diversified: at one stage it comprised about 30 million daily readers for *Terry*. In order to carry out his project the author has a specific range of creative tools to choose from. He is also conscious, whether we like it or not, that he must operate within a highly stylized language, with precisely drawn boundaries. The critic's task, therefore, is to follow the author through the strip so as to pick out the 'mode' in which he has pre-cast his message. Next we can attempt to decode his message, paying special attention to its structure, trying to detect its signs and the relation between these signs in reference to a given code. For the author proceeds in strict adherence to this code, and works on the assumption that it is familiar to his readers.

The page reproduced here is made up of four strips, three of which contain three pictures. The top strip has only two story pictures (or frames), since one of the pictures has been widened so as to contain the title.

FIRST FRAME: This is a hand-held shot, since the frame suggests a movie camera located on or near the hero's shoulder. The scene appears as though observed through the eyes of a single person, and it seems to move out towards the audience as this person moves forward into the scene. Here the only glimpse we catch of the character who is to be Steve Canyon is a patch of his overcoat, with wide sloped shoulders cut in 'raglan fashion'. The fact that this shoulder belongs to Canyon is verified by the policeman's remark, as he greets him with a confidential Irish tone ('Me sister', 'ye'). The policeman's cordiality is underlined by the sweeping gesture of his hand and a wide grin. This is the type of policeman we should all like to meet in time of need; he resembles the standard cop in Hollywood comedy. Rather than being a policeman, he represents an icon of *The Policeman*, the friendly Arm of the Law. The dialogue goes: 'Why, it's Stevie Canyon! Me sister in Shannon writes that ye paid her a personal call!' Now the fact that the policeman thanks Steve (using the confidential diminutive 'Stevie') for a kind turn to his sister tells us something relevant about the hero: he adopts a deferential attitude to the Law and is concerned with good *human relations*.

SECOND FRAME: Here Steve is clearly at the entrance to a big building. The relations between Steve and the doorman are the same as those between Steve and the policeman. Whereas the policeman represented Authority, the doorman merely stands for himself. If Steve favours him with friendship and good-will, this is simply because his skill at *human relations* is non-mercenary, completely spontaneous. The dialogue shows that Steve likes small children and that he goes on trips to exotic countries. His laconic answer 'Good!' suggests a kind-hearted man, but at the same time someone who doesn't indulge in emotional rhetoric. The doorman also gives us the hinted information that Steve is coming home after a long absence.

THIRD FRAME: This is the most ambiguous picture in the whole sequence. What Steve was doing during his long absence or where he has been is not made clear. His relationship with the blind news-vendor is equally uncertain. Their dialogue shows that they have done business together. This gives added interest to the figure of Canyon, and contributes an early element of suspense. Also the news-vendor calls him 'Captain', which allows the reader a glimpse of military experience in the hero's past. The date is 1947, and contemporary readers would interpret 'military past' as meaning heroic activities in an occupied zone. Steve calls the vendor 'Sarge', so their relationship assumes a tone of long-standing comradeship. They project the image of men who have given each other a hand at times of peril, united by bonds of manly collaboration. War is the testing-ground of human affections, the school of friendship, the theatre of initiative. Against this kind of background, the deal between Steve and the vendor can be seen as an adventure with strong overtones of risk, but not on the wrong side of the law. One can hardly harbour suspicions against a man blind in war. The reader is bound to feel a liking for him, and this liking reflects back to Steve, who enters the fourth frame fully established as 'our' hero.

FOURTH FRAME: Steve comes out of the hand-held shot; the camera has swivelled backwards and panned left. Steve now appears in profile, but we don't yet see his face. It is a good thing for the reader to enjoy the anticipation and build up a mental picture of the man's personality before assigning it to a face. And Steve's personality is more sharply delineated by his encounter with the little flower-girl. She moves towards him with perfect confidence, and a dialogue shows that he is concerned with her mother's welfare.

FIFTH FRAME: By now the construction of Steve's personality is completed. The moment to reveal his face is coming closer. In this picture the reader is given a glimpse of the hero's face by reflection. The handsomeness and personal appeal of Steve Canyon, now specifically stated by his appearance from behind (tall build, wavy blond hair), could also be worked out from the ecstatic reaction of the two lift-girls.

The second girls' remark ('R-R-Rajah!') provides us with a new item of information: 'R-r-rajah!' is a deformation of the word 'Roger', which in aircraft pilots' jargon stands for 'OK'. The fact that the girl uses such an expression to express excitement when talking with Steve allows us to guess that he is known as an aviator. Finally, this fifth frame in the sequence strengthens an impression already taking shape in the preceding pictures, that the scene is set in a high-rise building, an office block at the centre of an industrial metropolis, in an area of professional prestige.

SIXTH FRAME: At last Steve Canyon's face appears: masculine looks, striking features, a countenance which is lined and tense, in other words — vigour and maturity. The general reference is to Hollywood stereotypes, in a line that goes from Van Johnson to Cary Grant. Hence our liking for Steve's face is not based on the evocative function of the plastic fact, but on the 'sign' role which the plastic fact takes on, making it refer like a hieroglyph to a series of general notions of virility which are part of an old, familiar code to the readers. The simple graphic outline of the head 'stands for' something else: it is a linguistic item that has *passed into convention*. In short, we can say that Steve is an iconographic element that can be studied iconologically, like the miniature of a saint with its canonical attributes and a fixed kind of beard or aureola.

Steve now opens the door of his office. We know that it is his office because of the name printed towards the bottom of the glass on the door. As for his business venture, this can be seen as increasing the air of uncertainty together with the general glamour of his situation. Playing on the financial term 'Ltd', the title of Steve's business is given as 'Horizons Unlimited'. These horizons suggest anything from export, archaeological research, and air transport to police investigation, smuggling or the purchase of nuclear secrets. More likely, considering the evidence of the following pictures, is the hypothesis of a kind of all-purpose agency working on the professional acceptance of risk. Inside the office is the secretary (in the process of telling someone on the other end of the telephone that Steve has just arrived). She too stands for a prototype, that can be classified by the preferential code of the 1940s. She represents a discreet mingling of Mediterranean and Oriental glamour, and this refers in turn to the two main theatres of war, from which the Americans subsequently imported their models for post-war eroticism. The girl is attractive and yet she emanates an air of personal candour not without its hint of virtue. The modern reader may be unfamiliar with the conventions of the Forties, but he should try to grasp the iconographic function in the secretary's polka-dot blouse. This pattern hints emphatically at virtuousness, in the Manichean division between good and evil which forms the basis of any typology of the comic strip. In the succeeding pictures the contrast between this fresh, spotted blouse and the slinky black silk of the 'vamp' is made even sharper.

SEVENTH FRAME: After the typological indications provided by the preceding picture, the seventh has an interlocutory function. It serves to introduce new elements at the conceptual plane, by way of the dialogue. It has a

Steve Canyon, comic strip by Milton Caniff, 1964, reproduced in Umberto Eco, *Apocalittici e Integrati* [Bompiani, Milan, 1965]

direct relationship to the scene in the eighth frame. The secretary hands Steve the 'phone call which she was answering while he came in the door, and tells him the name of the interlocutor.

The dialogue is rich in incidental notations. The name of the male secretary on the line suggests the image of a 'daisy', and when he does appear, it will be easy to associate such a comic name with his vacuousness. Miss Calhoon's Christian name is 'Copper', which stands for a metal as well as a red-head. The description of her professional activities requires no comment, but the nickname Steve gives her is interesting since 'copperhead' recalls the name of a snake. This explains the following play on words between her 'howl' (the she-wolf) and her 'hiss' (the reptile). But Steve's attitude is off-hand right from the outset.

EIGHTH FRAME: Here the presentation of the interior is exemplary: luxurious furnishing in 'Art Deco', with overtones of twentieth-century 'directional', dating from the 1920s–30s. Copper Calhoon's male secretary dresses like an operetta magnate. His face, which will appear more clearly from the next frame, does not cancel out the impression of ostentatious comfort that emanates from every garment he is wearing.

Given the secretary, one should be able to deduce his boss: Copper Calhoon emerges from behind an enormous desk, sheathed in a black suit that covers her from neck downwards. She will appear in sharper detail from the following frames of the comic, but right from the start we tend to characterize her as a skilful blend of Snow White, the Veronica Lake of *I Married a Witch* and Hedy Lamarr. Though she is the prototype of the *femme fatale*, in her case the outright references to the industrial matriarch are sublimated into the most explicit erotic trademarks of the film world: everything in the woman which is supposed to refer to economic power is transferred to the plane of *glamour*, and this process is carried out with full awareness that the operation is psychologically implausible. Copper Calhoon is implausible because the reader must interpret her immediately as a symbol for power, prestige, dubious legality and authority over other people. In this sense only an absolutely conventional symbology, magnifying the obvious ingredients of the character, will lead the reader to the correct interpretation of Miss Calhoon. Otherwise the dialogue between Steve and the male secretary would lose its particular thrust: '… But what if I don't want to place my services at the command of Miss Copper Calhoon?'

NINTH FRAME: At this stage the secretary appears dumbstruck. The reader will notice how his stupefaction is rendered at the three self-complementary levels of *design*, *concept* and *sound*. The stupor shown on Mr Dayzee's face is a standard stylization. Equally, the content of the strip at this point is communicated by conventional devices: 'Mister Canyon! People do not refuse when summoned by Copper Calhoon!' The secretary can only refer to normal habit, which has been brutally infringed by Steve's tactic. What is more curious is the way in which the secretary's first exclamation is elevated to a special sound level, by recourse to thick-set types which translate the intenseness of the sound by the heaviness of its sign.

Also at the levels of sound and design is the curious 'whining' effect which is used for the pronunciation of 'Mister Canyon'. 'Mister' is sub-divided into two syllables, of which the first is underlined. This graphic device conveys a whole emotional acceleration. Naturally, the fact that we use the word 'curious' to define the devices employed to carry off the situation in the text can be explained by a methodological requirement: one has to interpret the whole strip by assuming a kind of 'virginity' on the part of the reader, and accepting this as a working hypothesis. In real-life reading, much of the graphic stylization examined up to now is based on widely-accepted conventions which allow the average reader of comic strips to grasp the full import of the message straightaway. At this level the ninth frame offers two more types of information. One is given by Canyon's ironic reply: 'And all this time I thought I was a people! Good morrow, Mr Doozie!' – where the name has been altered and the greeting 'Good day' given incorrectly. The second piece of information is conveyed by Copper. She now appears in more detail, widening the possibilities suggested by the preceding frame (her long cigarette, her black gloves, accessories which accentuate the *fatale* image), but also astute and resourceful: she follows the phone conversation on an extension, in full control of the situation.

TENTH FRAME: The frame picks up the closing stage of the dialogue (a number of intermediate remarks are taken for granted). Steve says 'Mr Dizzy', which is another, even more insulting deformation of the secretary's name, since 'dizzy' implies that he is not completely *compos mentis*. Steve's closing phrase acts as further confirmation that he is an aviator: 'solo flight' is part of pilot's jargon. Steve's whole reply conveys the image of bold gestures by a man who likes to be independent even in the face of financial need or danger. Notice that Steve's own secretary comments that it would have been nice to have money for the office rent, but she can't expect her boss to get into regular habits like that.

ELEVENTH FRAME: At the iconographical level this adds no new information, except for the long spiral of smoke that Copper emits before she starts talking, the sign for a long pause. But apart from the fact that even the 'spiral of smoke' is rendered by a conventional device (i.e. *that* sign can only mean a spiral of smoke in the cosmos of the comic strip), what is really significant here is the dialogue. The male secretary says precisely what the reader might have expected from his appearance. But Copper cuts short the chatter with 'I want that man!! … Get him!', which gives her a definite personality and seems to pave the way for exciting developments in the story. The fact that the instalment finishes here is not accidental. The eleven frames have set up a *crescendo* effect with remarkable skill. The effect of this technique is to bring the reader to a natural climax in the closing scene. In the space of just one page, Caniff has succeeded in sketching a group of characters and setting their story in motion. Nothing has actually *happened* yet, but from this moment onwards the reader is firmly convinced that all kinds of things *could* happen. If the word 'suspense' has any meaning at all, we surely have a concrete example of it here, and one should note that this has been achieved without resorting to violence, or presenting a traditional *coup de scène*. A single page has summoned in one blow a whole community of readers, and these are unlikely to abandon their hero from this point on.

My analysis of the *Steven Canyon* strip suggests a series of theoretical conclusions about the language of the comic story, and I propose to set these out schematically under eight headings:

1. We have identified the elements of an *iconography*. Even though this may refer to stereotypes that have been devised in other areas (for example, the cinema), it employs graphic tools that belong to the comic-strip *genre*. We only chose to pick out the spiral of cigarette smoke, but by examining a much wider sample in this field one could identify dozens of figurative elements that have been fixed into canonical motifs: there are different procedures for *the visualization of a metaphor or a simile*, as when a character sees stars, or has his heart bounding around, or feels his head spinning, or snores like a buzz-saw. They are rendered by an elementary symbology which is immediately comprehensible to the reader. In the same category are the drops of saliva which stand for lust, or the shining light-bulb, which means that a character has had a sudden 'good idea'. All these iconographic elements go to make up a network of conventions that constitute the authentic symbolic repertoire of the comic strip. They allow us to speak of the *semantics of comics*.

2. The fundamental idea in this *semantics of comics* is the device of the 'balloon'. If the balloon is drawn according to certain rules, and is connected to the face of a character by a sharp point, then it means 'words spoken by'. If it is joined up to the character by a series of bubbles, it means 'words thought by'. If the balloon has a zig-zag edge all round, like the teeth of a saw, then it can variously stand for fear, anger, excitement, outburst, or explosion, according to a carefully gradated standardization of the speaker's moods. Another fundamental item is the graphic sign used to convey sound-level, freely drawing on the onomatopoeic resources of the author's language. We find a fairly rigorous tabulation of noises, which can vary from the 'zip' of a passing bullet to the 'crack' of a rifle, the 'smack' of a punch, the 'slam' of a door closing, the 'swish' of a blow that misses the opponent's face, the different kinds of thud as he hits the ground, from 'blomp' to 'ploff', the 'sigh' or 'sob' of semi-tearful reflection, the 'gulp' of consternation, the 'mumble' as the brain cells go to work, or the 'rattle' caused by hidden rodents or insects as they attack the fabric of a building. Many of these are already recognizable onomatopoeias; they lose the role of *linguistic sign* and turn into the visual equivalent of a given noise; they gain a fresh 'sign' function in the conventional semantics of the comic strip.

3. The various semantic elements of the comic strip are

arranged into a *syntax of frame composition*. Some decisive manifestations of this syntax have already been observed in the *Steve Canyon* story. It takes us from the banal, virtually two-dimensional frame to a whole range of elaborations on the presentation of comic pictures. Sometimes the draughtsman is so carried away that he indulges in a kind of virtuosity which is technically redundant in so far as the message of the comic story is concerned, but suggests a sophisticated movie photographer at work. This accounts for the looming perspective of a building seen from the ground when there is no psychological reason for this expressionistic trick. Often the semantics of the strip depends on a close inter-relationship between word and picture: at a simple level they serve to complement each other's deficiencies. Thus the words can convey an attitude which the picture is unable to express in all its implications. Or else the spoken part is deliberately neoplastic, and continually intrudes to explain what the pictures have already made explicit, as though an underdeveloped reading public needed rigorous manipulation: there are typical examples of this trend in the *Superman* comics. Or again, we meet a kind of ironic independence between the picture and the text. Examples of this can be found in comic strips where the main story is set in the foreground, but further behind is a sub-scene featuring surrealist devices, like the little men exiting from the frame of the picture in the MacManus of 'Jiggs' and 'Maggie', or *Smokey Stover*. At other times this independence between pictures and text is not a joke by the author, but the visual element running wild with its own exuberant ideas. We meet highly *soigné* frames where the multiplication of local colour in the background goes way beyond the communicative requirements of the *message* at that stage in the story, but enriches the scene with a wealth of secondary anecdotes that can be appreciated in their own right, rather like the realistic touches in a highly-wrought still life. Finally, there are cases where the visual detail is carefully fitted with matching remarks by the characters, so that the overall effects suggests a good film sequence. This is the distinctive feature in the *Steve Canyon* strip which was examined above.

4. The relationship between one frame and the next is governed by a series of *montage* rules. I have used the term 'montage', though the reference to the cinema should not make us forget that the montage in a comic strip is different from a film, which merges a series of stills into a continuous flux. The comic strip, on the other hand, breaks up the story's *continuum* into a few essential components. Obviously the reader welds these parts together in his imagination and then perceives them as a continuous flow. In my own analysis of the *Steve Canyon* page I tended to resolve a series of static moments into a dynamic sequence. Indeed, Evelyn Sullerot has pointed out the essential continuity of the comic sequence in an analysis of Italian *fotoromanzi* (series stories in comic form with real photographs in which paid actors perform the situations in the text). Sullerot was interested in the readers' capacity to remember the story line of the *fotoromanzo*. She showed how when they were quizzed,

many readers recalled scenes that never existed in the story on the page, but could be worked out on the basis of two juxtaposed photographs. She considers a sequence made up of two frames: a firing squad in the process of shooting; the corpse of the condemned man lying on the ground. When they were asked about this sequence, the subjects of the test tended to describe at some length an imaginary third frame showing the condemned man falling to the ground.

5. In the *Steve Canyon* page, the various formal elements in the story (frames, montage, and so on) served as an accompaniment to the action. But they were recognized by the reader as explicit devices. In some other comics there is a tendency for the formal structure of the story to be turned to comic effect, or invite sarcastic comment. This can happen where there is a *physical exit from the frame*, or where there is an authentic staging of *action on the frame*. Even more amusingly, a direct rapport can be set up between the strip character and the draughtsman: 'Gould, this time you've gone too far,' says an accusing character in a 1936 *Dick Tracy* strip, turning to the artist who has led him into a particularly tricky situation. In these cases the artist's intervention in the story may be depicted by the end of a pencil or a paint brush which invades the frame to change its arrangement, *from outside*.

6. The comic's formal elements condition the *kind of plot* which the story is to take on. In the *Steve Canyon* story we observed a cinematographic plot. However, in many other cases the plot's *structure* can be different, especially where it involves the repetition of single features rather than a progressive development. *The World of Charlie Brown* and *Superman* offer interesting examples of this trend.

7. The analysis of *Steve Canyon* and the characters surrounding him affords us a glimpse of *character typology*, clearly defined by recognizable stereotypes. *Steve Canyon* is particularly suggestive of stereotypes, rather than just 'types', and we can speak of the 'stereotype' as an indispensable element of the comic's typology. If we look back at the main heroes of the comic strip in the period between the Wars, we are bound to notice that the 'adventure' is simplified to an extreme point: The Phantom, i.e. the Mysterious Wandering Adventurer; Mandrake, i.e. magic; Gordon, i.e. Space Travel; X9, i.e. Secret Investigator; Jungle Jim, i.e. the Hunter; Tim Tyler, i.e. the Young Lads Who Have Been Allowed to go on Adventures, and so on and so forth. At a subsidiary level, each of these heroes represents Spiritual Elevation, Tough Humour, Physical Appeal, Astuteness, and so on.

8. Lastly, we can say that *Steve Canyon* demonstrates the possibility of an *ideological declaration* in the brief space of eleven frames. In *Steve Canyon* we detect the following as declared values: Handsomeness, Willingness to Take Risks, Indifference to the Profit Motive (tempered by due respect for Money as a possible goal, though it must be made without Moral Compromise). There is also Generosity, Kindness, Virility, Sense of Humour. These, at

least, are the Values incarnated by the figure of Steve. But the total effect of the page is to remind us of certain over-all Values: Good Relations with the Law, Friendliness with the Less Privileged, Prestige Symbols, Mysteriousness, Sultry Fascination, Sex Appeal, and so on. The page marks a substantial adherence to the values of an American way of life tinged with the Hollywood Legend. Hence the main character and his adventure can be characterized as a model for the average reader. A similar ideological declaration with a different key could be identified in the comic strip *Terry and the Pirates*, but also in serials like *Joe Palooka*, *Dick Tracy* or *Dennis the Menace*. In other cases, such as *Superman*, one can identify a sharper lesson in favour of conformism.

In short, an analysis of one comic strip's linguistic elements (i.e. its iconographic conventions and fixed stereotypes employed as a standard sign function) has helped us to sketch the main communicative potential of the comic strip, without involving us in any discussion of its intrinsic merit. The conclusion that emerges from this analysis must, in the first instance, be as follows: our 'reading' of the *Steve Canyon* page has confronted us with the fact that the comic strip represents an autonomous literary sub-genre, possessing its own structural patterns, an original mode of communication with the reader and an interpretative code which the reader already shares and which the author refers to constantly in order to organize his message.

This message is conveyed in accordance with a whole range of tacitly accepted formative rules. It is directed consciously at the average intelligence, imagination and taste of the strip's adopted readers.

Umberto Eco, 'La lettura di Steve Canyon', 1964, first published in *Apocalittici e Integrati* [Bompiani, Milan, 1965; trans. Bruce Merry, *Twentieth-Century Studies*, 7/8, Canterbury, England, December 1976; reprinted in *Comic Iconoclasm*, ed. Sheena Wagstaff, London: Institute of Contemporary Arts, 1987] 24.

Arthur C. DANTO
The Artworld [1964]

Hamlet: *Do you see nothing there?*
The Queen: *Nothing at all; yet all that is I see.*
– William Shakespeare: *Hamlet*, Act III, Scene IV

Hamlet and Socrates, though in praise and deprecation respectively, spoke of art as a mirror held up to nature. As with many disagreements in attitude, this one has a factual basis. Socrates saw mirrors as but reflecting what we can already see; so art, in so far as mirror-like, yields idle accurate duplications of the appearances of things, and is of no cognitive benefit whatever. Hamlet, more acutely, recognized a remarkable feature of reflecting surfaces, namely that they show us what we could not otherwise perceive – our own face and form – and so art, in so far as it is mirror-like, reveals us to ourselves, and is, even by Socratic criteria, of some cognitive utility after all. As a philosopher, however, I find Socrates' discussion

defective on other, perhaps less profound grounds than these. If a mirror-image of *o* is indeed an imitation of *o*, then, if art is imitation, mirror-images are art. But in fact mirroring objects no more is art than returning weapons to a madman is justice; and reference to mirrorings would be just the sly sort of counter-instance we would expect Socrates to bring forward in rebuttal of the theory he instead uses them to illustrate. If that theory requires us to class *these* as art, it thereby shows its inadequacy: 'is an imitation' will not do as a sufficient condition for 'is art'. Yet, perhaps because artists *were* engaged in imitation, in Socrates' time and after, the insufficiency of the theory was not noticed until the invention of photography. Once rejected as a sufficient condition, mimesis was quickly discarded as even a necessary one; and since the achievement of Kandinsky, mimetic features have been relegated to the periphery of critical concern, so much so that some works survive in spite of possessing those virtues, excellence in which was once celebrated as the essence of art, narrowly escaping demotion to mere illustrations.

It is, of course, indispensable in Socratic discussion that all participants be masters of the concept up for analysis, since the aim is to match a real defining expression to a term in active use, and the test for adequacy presumably consists in showing that the former analyzes and applies to all and only those things of which the latter is true. The popular disclaimer notwithstanding, then, Socrates' auditors purportedly knew what art was as well as what they liked; and a theory of art, regarded here as a real definition of 'Art', is accordingly not to be of great use in helping men to recognize instances of its application. Their antecedent ability to do this is precisely what the adequacy of the theory is to be tested against, the problem being only to make explicit what they already know. It is *our* use of the term that the theory allegedly means to capture, but we are supposed able, in the words of a recent writer, 'to separate those objects which are works of art from those which are not, because ... we know how correctly to use the word "art" and to apply the phrase "work of art".' Theories, on this account, are somewhat like mirror-images on Socrates' account, showing forth what we already know, wordy reflections of the actual linguistic practice we are masters in.

But telling artworks from other things is not so simple a matter, even for native speakers, and these days one might not be aware he was on artistic terrain without an artistic theory to tell him so. And part of the reason for this lies in the fact that terrain is constituted artistic in virtue of artistic theories, so that one use of theories, in addition to helping us discriminate art from the rest, consists in making art possible. Glaucon and the others could hardly have known what was art and what not: otherwise they would never have been taken in by mirror-images.

I

Suppose one thinks of the discovery of a whole new class of artworks as something analogous to the discovery of a whole new class of facts anywhere, viz., as something for theoreticians to explain. In science, as elsewhere, we often accommodate new facts to old theories via auxiliary

hypotheses, a pardonable enough conservatism when the theory in question is deemed too valuable to be jettisoned all at once. Now the Imitation Theory of Art (IT) is, if one but thinks it through, an exceedingly powerful theory, explaining a great many phenomena connected with the causation and evaluation of artworks, bringing a surprising unity into a complex domain. Moreover, it is a simple matter to shore it up against many purported counterinstances by such auxiliary hypotheses as that the artist who deviates from mimeticity is perverse, inept or mad. Ineptitude, chicanery or folly are, in fact, testable predications. Suppose, then, tests reveal that these hypotheses fail to hold, that the theory, now beyond repair, must be replaced. And a new theory is worked out, capturing what it can of the old theory's competence, together with the heretofore recalcitrant facts. One might, thinking along these lines, represent certain episodes in the history of art as not dissimilar to certain episodes in the history of science, where a conceptual revolution is being effected and where refusal to countenance certain facts, while in part due to prejudice, inertia and self-interest, is due also to the fact that a well-established, or at least widely credited theory is being threatened in such a way that all coherence goes.

Some such episode transpired with the advent of Post-Impressionist paintings. In terms of the prevailing artistic theory (IT), it was impossible to accept these as art unless inept art: otherwise they could be discounted as hoaxes, self-advertisements or the visual counterparts of madmen's ravings. So to get them accepted *as* art, on a footing with the *Transfiguration* (not to speak of a Landseer stag), required not so much a revolution in taste as a theoretical revision of rather considerable proportions, involving not only the artistic enfranchisement of these objects, but an emphasis upon newly significant features of accepted artworks, so that quite different accounts of their status as artworks would now have to be given. As a result of the new theory's acceptance, not only were Post-Impressionist paintings taken up as art, but numbers of objects (masks, weapons, etc.) were transferred from anthropological museums (and heterogeneous other places) to *musées des beaux arts*, though, as we would expect from the fact that a criterion for the acceptance of a new theory is that it account for whatever the older one did, nothing had to be transferred out of the *musée des beaux arts* — even if there were internal rearrangements as between storage rooms and exhibition space. Countless native speakers hung upon suburban mantelpieces innumerable replicas of paradigm cases for teaching the expression 'work of art' that would have sent their Edwardian forebears into linguistic apoplexy.

To be sure, I distort by speaking of a theory: historically, there were several, all, interestingly enough, more or less defined in terms of the IT. Art-historical complexities must yield before the exigencies of logical exposition, and I shall speak as though there were one replacing theory, partially compensating for historical falsity by choosing one which was actually enunciated. According to it, the artists in question were to be understood not as unsuccessfully imitating real forms but as successfully creating new ones,

quite as real as the forms which the older art had been thought, in its best examples, to be creditably imitating. Art, after all, had long since been thought of as creative (Vasari says that God was the first artist), and the Post-Impressionists were to be explained as genuinely creative, aiming, in Roger Fry's words, 'not at illusion but reality'. This theory (RT) furnished a whole new mode of looking at painting, old and new. Indeed, one might almost interpret the crude drawing in Van Gogh and Cézanne, the dislocation of form from contour in Rouault and Dufy, the arbitrary use of colour planes in Gauguin and the Fauves, as so many ways of drawing attention to the fact that these were *non-imitations*, specifically intended not to deceive. Logically, this would be roughly like printing 'Not Legal Tender' across a brilliantly counterfeited dollar bill, the resulting object (counterfeit *cum* inscription) rendered incapable of deceiving anyone. It is not an illusory dollar bill, but then, just because it is non-illusory it does not automatically become a real dollar bill either. It rather occupies a freshly opened area between real objects and real facsimiles of real objects: it is a non-facsimile, if one requires a word, and a new contribution to the world. Thus, Van Gogh's *Potato Eaters*, as a consequence of certain unmistakable distortions, turns out to be a non-facsimile of real-life potato eaters; and in as much as these are not facsimiles of potato eaters, Van Gogh's picture, as a non-imitation, had as much right to be called a real object as did its putative subjects. By means of this theory (RT), artworks re-entered the thick of things from which Socratic theory (IT) had sought to evict them: if no *more* real than what carpenters wrought, they were at least no *less* real. The Post-Impressionist won a victory in ontology.

It is in terms of RT that we must understand the artworks around us today. Thus Roy Lichtenstein paints comic-strip panels, though ten or twelve feet high. These are reasonably faithful projections on to a gigantesque scale of the homely frames from the daily tabloid, but it is precisely the scale that counts. A skilled engraver might incise *The Virgin and the Chancellor Rollin* on a pinhead, and it would be recognizable as such to the keen of sight, but an engraving of a Barnett Newman on a similar scale would be a blob, disappearing in the reduction. A *photograph* of a Lichtenstein is indiscernible from a photograph of a counterpart panel from *Steve Canyon*; but the photograph fails to capture the scale, and hence is as inaccurate a reproduction as a black-and-white engraving of Botticelli, scale being essential here as colour there. Lichtensteins, then, are not imitations but *new entities*, as giant whelks would be. Jasper Johns, by contrast, paints objects with respect to which questions of scale are irrelevant. Yet his objects cannot be imitations, for they have the remarkable property that any intended copy of a member of this class of objects is automatically a member of the class itself, so that these objects are logically inimitable. Thus, a copy of a numeral just *is* that numeral: a painting of 3 is a 3 made of paint. Johns, in addition, paints targets, flags, and maps. Finally, in what I hope are not unwitting footnotes to Plato, two of our pioneers — Robert Rauschenberg and Claes Oldenburg — have made genuine beds.

Rauschenberg's bed hangs on a wall, and is streaked

with some desultory housepaint. Oldenburg's bed is a rhomboid, narrower at one end than the other, with what one might speak of as a built-in perspective: ideal for small bedrooms. As beds, these sell at singularly inflated prices, but one *could* sleep in either of them: Rauschenberg has expressed the fear that someone might just climb into his bed and fall asleep. Imagine, now, a certain Testadura — a plain speaker and noted philistine — who is not aware that these are art, and who takes them to be reality simple and pure. He attributes the paintstreaks on Rauschenberg's bed to the slovenliness of the owner, and the bias in the Oldenburg bed to the ineptitude of the builder or the whimsy, perhaps, of whoever had it 'custom-made'. These would be mistakes, but mistakes of rather an odd kind, and not terribly different from that made by the stunned birds who pecked the sham grapes of Zeuxis. They mistook art for reality, and so has Testadura. But it was meant to *be* reality, according to RT. Can one have mistaken reality for reality? How shall we describe Testadura's error? What, after all, prevents Oldenburg's creation from being a misshapen bed? This is equivalent to asking what makes it art, and with this query we enter a domain of conceptual inquiry where native speakers are poor guides: *they* are lost themselves.

II

To mistake an artwork for a real object is no great feat when an artwork is the real object one mistakes it for. The problem is how to avoid such errors, or to remove them once they are made. The artwork is a bed, and not a bed-illusion; so there is nothing like the traumatic encounter against a flat surface that brought it home to the birds of Zeuxis that they had been duped. Except for the guard cautioning Testadura not to sleep on the artworks, he might never have discovered that this was an artwork and not a bed; and since, after all, one cannot discover that a bed is not a bed, how is Testadura to realize that he has made an error? A certain sort of explanation is required, for the error here is a curiously philosophical one, rather like, if we may assume as correct some well-known views of P.F. Strawson, mistaking a person for a material body when the truth is that a person *is* a material body in the sense that a whole class of predicates, sensibly applicable to material bodies, are sensibly, and by appeal to no different criteria, applicable to persons. So you cannot *discover* that a person is not a material body.

We begin by explaining, perhaps, that the paintstreaks are not to be explained away, that they are *part* of the object, so the object is not a mere bed with — as it happens — streaks of paint spilled over it, but a complex object fabricated out of a bed and some paintstreaks: a paint-bed. Similarly, a person is not a material body with — as it happens — some thoughts superadded, but is a complex entity made up of a body and some conscious states: a conscious-body. Persons, like artworks, must then be taken as irreducible to *parts* of themselves, and are in that sense primitive. Or, more accurately, the paintstreaks are not part of the real object — the bed — which happens to be part of the artwork, but are, *like* the bed, part of the artwork as such. And this might be generalized into a rough characterization of artworks that happen to contain real

objects as parts of themselves: not every part of an artwork *A* is part of a real object *R* when *R* is part of *A* and can, moreover, be detached from *A* and seen *merely* as *R*. The mistake thus far will have been to mistake *A* for *part* of itself, namely *R*, even though it would not be incorrect to say that *A* is *R*, that the artwork is a bed. It is the 'is' which requires clarification here.

There is an *is* that figures prominently in statements concerning artworks which is not the *is* of either identity or predication; nor is it the *is* of existence, of identification, or some special *is* made up to serve a philosophic end. Nevertheless, it is in common usage, and is readily mastered by children. It is the sense of *is* in accordance with which a child, shown a circle and a triangle and asked which is him and which his sister, will point to the triangle saying 'That is me'; or, in response to my question, the person next to me points to the man in purple and says 'That one is Lear'; or in the gallery I point, for my companion's benefit, to a spot in the painting before us and say 'That white dab is Icarus'. We do not mean, in these instances, that whatever is pointed to stands for, or represents, what it is said to be, for the *word* 'Icarus' stands for or represents Icarus: yet I would not in the same sense of *is* point to the word and say 'That is Icarus'. The sentence 'That *a* is *b*' is perfectly compatible with 'That *a* is not *b*' when the first employs this sense of *is* and the second employs some other, though *a* and *b* are used nonambiguously throughout. Often, indeed, the truth of the first *requires* the truth of the second. The first, in fact, is incompatible with 'That *a* is not *b*' only when the *is* is used nonambiguously throughout. For want of a word I shall designate this the *is of artistic identification*; in each case in which it is used, the *a* stands for some specific physical property of, or physical part of, an object; and, finally, it is a necessary condition for something to be an artwork that some part or property of it be designable by the subject of a sentence that employs this special *is*. It is an *is*, incidentally, which has near-relatives in marginal and mythical pronouncements. (Thus, one *is* Quetzalcoatl; those *are* the Pillars of Hercules.)

Let me illustrate. Two painters are asked to decorate the east and west walls of a science library with frescoes to be respectively called *Newton's First Law* and *Newton's Third Law*. These paintings, when finally unveiled, look, scale apart, as follows:

A B

As objects I shall suppose the works to be indiscernible: a black, horizontal line on a white ground, equally large in each dimension and element. *B* explains his work as follows: a mass, pressing downward, is met by a mass pressing upward: the lower mass reacts equally and oppositely to the upper one. *A* explains his work as follows: the line through the space is the path of an isolated particle. The path goes from edge to edge, to give the

sense of its *going beyond*. If it ended or began within the space, the line would be curved: and it is parallel to the top and bottom edges, for if it were closer to one than to another, there would have to be a force accounting for it, and this is inconsistent with its being the path of an *isolated* particle.

Much follows from these artistic identifications. To regard the middle line as an edge (mass meeting mass) imposes the need to identify the top and bottom half of the picture as rectangles, and as two distinct parts (not necessarily as two masses, for the line could be the edge of *one* mass jutting up — or down — into empty space). If it is an edge, we cannot thus take the entire area of the painting as a single space: it is rather composed of two forms, or one form and a non-form. We could take the entire area as a single space only by taking the middle horizontal as a *line* which is not an edge. But this almost requires a three-dimensional identification of the whole picture: the area can be a flat surface which the line is *above* (*Jet-flight*), or *below* (*Submarine-path*), or *on* (*Line*), or *in* (*Fissure*), or *through* (*Newton's First Law*) — though in this last case the area is not a flat surface but a transparent cross section of absolute space. We could make all these prepositional qualifications clear by imagining perpendicular cross sections to the picture plane. Then, depending upon the applicable prepositional clause, the area is (artistically) interrupted or not by the horizontal element. If we take the line as *through* space, the edges of the picture are not really the edges of the space: the space goes beyond the picture if the line itself does; and we are in the same space as the line is. As *B*, the edges of the picture can be *part* of the picture in case the masses go right to the edges, so that the edges of the picture are *their* edges. In that case, the vertices of the picture would be the vertices of the masses, except that the masses have four vertices more than the picture itself does: here four vertices would be part of the art work which were not part of the real object. Again, the faces of the masses could be the face of the picture, and in looking at the picture, we are looking at these faces: but *space* has no face, and on the reading of *A* the work has to be read as faceless, and the face of the physical object would not be part of the artwork. Notice here how one artistic identification engenders another artistic identification, and how, consistently with a given identification, we are *required* to give others and *precluded* from still others: indeed, a given identification determines how many elements the work is to contain. These different identifications are incompatible with one another, or generally so, and each might be said to make a different artwork, even though each artwork contains the identical real object as part of itself — or at least parts of the identical real objects as parts of itself. There are, of course, senseless identifications: no one could, I think, sensibly read the middle horizontal as *Love's Labour's Lost* or *The Ascendency of St Erasmus*. Finally, notice how acceptance of one identification rather than another is in effect to exchange one *world* for another. We could, indeed, enter a quiet poetic world by identifying the upper area with a clear and cloudless sky, reflected in the still surface of the water below, whiteness kept from whiteness only by the unreal boundary of the horizon.

And now Testadura, having hovered in the wings throughout this discussion, protests that *all he sees is paint*: a white painted oblong with a black line painted across it. And how right he really is: that is all he sees or that anybody can, we aesthetes included. So, if he asks us to show him what there is further to see, to demonstrate through pointing that this is an artwork (*Sea and Sky*), we cannot comply, for he has overlooked nothing (and it would be absurd to suppose he had, that there was something tiny we could point to and he, peering closely, say 'So it is! A work of art after all!'). We cannot help him until he has mastered the *is of artistic identification* and so *constitutes* it a work of art. If he cannot achieve this, he will never look upon artworks: he will be like a child who sees sticks as sticks.

But what about pure abstractions, say something that looks just like *A* but is entitled *No. 7*? The 10th Street abstractionist blankly insists that there is nothing here but white paint and black, and none of our literary identifications need apply. What then distinguishes him from Testadura, whose philistine utterances are indiscernible from his? And how can it be an artwork for him and not for Testadura, when they agree that there is nothing that does not meet the eye? The answer, unpopular as it is likely to be to purists of every variety, lies in the fact that this artist has returned to the physicality of paint through an atmosphere compounded of artistic theories and the history of recent and remote painting, elements of which he is trying to refine out of his own work; and as a consequence of this his work belongs in this atmosphere and is part of this history. He has achieved abstraction through rejection of artistic identifications, returning to the real world from which such identifications remove us (he thinks), somewhat in the mode of Chi'ing Yuan, who wrote:

Before I had studied Zen for thirty years, I saw mountains as mountains and waters as waters. When I arrived at a more intimate knowledge, I came to the point where I saw that mountains are not mountains, and waters are not waters. But now that I have got the very substance I am at rest. For it is just that I see mountains once again as mountains, and waters once again as waters.

His identification of what he has made is logically dependent upon the theories and history he rejects. The difference between his utterance and Testadura's 'This is black paint and white paint and nothing more' lies in the fact that he is still using the *is* of artistic identification, so that his use of 'That black paint is black paint' is not a tautology. Testadura is not at that stage. To see something as art requires something the eye cannot decry – an atmosphere of artistic theory, a knowledge of the history of art: an artworld.

III

Mr Andy Warhol, the Pop artist, displays facsimiles of Brillo cartons, piled high, in neat stacks, as in the stockroom of the supermarket. They happen to be of wood, painted to look like cardboard, and why not? To paraphrase the critic of the *Times*, if one may make the

facsimile of a human being out of bronze, why not the facsimile of a Brillo carton out of plywood? The cost of these boxes happens to be 2 x 10³ that of their homely counterparts in real life – a differential hardly ascribable to their advantage in durability. In fact the Brillo people might, at some slight increase in cost, make their boxes out of plywood without these becoming artworks, and Warhol might make *his* out of cardboard without their ceasing to be art. So we may forget questions of intrinsic value, and ask why the Brillo people cannot manufacture art and why Warhol cannot *but* make artworks. Well, his are made by hand, to be sure. Which is like an insane reversal of Picasso's strategy in pasting the label from a bottle of Suze on to a drawing, saying as it were that the academic artist, concerned with exact imitation, must always fall short of the real thing: so why not just *use* the real thing? The Pop artist laboriously reproduces machine-made objects by hand, e.g., painting the labels on coffee cans (one can hear the familiar commendation 'Entirely made by hand' falling painfully out of the guide's vocabulary when confronted by these objects). But the difference cannot consist in craft: a man who carved pebbles out of stones and carefully constructed a work called *Gravel Pile* might invoke the labour theory of value to account for the price he demands; but the question is, What makes it art? And why need Warhol *make* these things anyway? Why not just scrawl his signature across one? Or crush one up and display it as *Crushed Brillo Box* ('A protest against mechanization …') or simply display a Brillo carton as *Uncrushed Brillo Box* ('A bold affirmation of the plastic authenticity of industrial …')? Is this man a kind of Midas, turning whatever he touches into the gold of pure art? And the whole world consisting of latent artworks waiting, like the bread and wine of reality, to be transfigured, through some dark mystery, into the indiscernible flesh and blood of the sacrament? Never mind that the Brillo box may not be good, much less great art. The impressive thing is that it is art at all. But if it is, why are not the indiscernible Brillo boxes that are in the stockroom? Or *has* the whole distinction between art and reality broken down?

Suppose a man collects objects (ready-mades), including a Brillo carton; we praise the exhibit for variety, ingenuity, what you will. Next he exhibits nothing but Brillo cartons, and we criticize it as dull, repetitive, self-plagiarizing – or (more profoundly) claim that he is obsessed by regularity and repetition, as in [Robbe-Grillet's] *Marienbad*. Or he piles them high, leaving a narrow path; we tread our way through the smooth opaque stacks and find it an unsettling experience, and write it up as the closing in of consumer products, confining us as prisoners: or we say he is a modern pyramid builder. True, we don't say these things about the stockboy. But then a stockroom is not an art gallery, and we cannot readily separate the Brillo cartons from the gallery they are in, any more than we can separate the Rauschenberg bed from the paint upon it. Outside the gallery, they are pasteboard cartons. But then, scoured clean of paint, Rauschenberg's bed is a bed, just what it was before it was transformed into art. But then if we think this matter through, we discover that the artist has failed,

really and of necessity, to produce a mere real object. He has produced an artwork, his use of real Brillo cartons being but an expansion of the resources available to artists, a contribution to *artists' materials*, as oil paint was, or *tuche*.

What in the end makes the difference between a Brillo box and a work of art consisting of a Brillo Box is a certain theory of art. It is the theory that takes it up into the world of art, and keeps it from collapsing into the real object which it is (in a sense of *is* other than that of artistic identification). Of course, without the theory, one is unlikely to see it as art, and in order to see it as part of the artworld, one must have mastered a good deal of artistic theory as well as a considerable amount of the history of recent New York painting. It could not have been art fifty years ago. But then there could not have been, everything being equal, flight insurance in the Middle Ages, or Etruscan typewriter erasers. The world has to be ready for certain things, the artworld no less than the real one. It is the role of artistic theories, these days as always, to make the artworld, and art, possible. It would, I should think, never have occurred to the painters of Lascaux that they were producing *art* on those walls. Not unless there were neolithic aestheticians.

The artworld stands to the real world in something like the relationship in which the City of God stands to the Earthly City. Certain objects, like certain individuals, enjoy a double citizenship, but there remains, the RT notwithstanding, a fundamental contrast between artworks and real objects. Perhaps this was already dimly sensed by the early framers of the IT who, inchoately realizing the nonreality of art, were perhaps limited only in supposing that the sole way objects had of being other than real is to be sham, so that artworks necessarily had to be imitations of real objects. This was too narrow. So Yeats saw in writing 'Once out of nature I shall never take/My bodily form from any natural thing.' It is but a matter of choice: and the Brillo box of the artworld may be just the Brillo box of the real one, separated and united by the *is* of artistic identification. But I should like to say some final words about the theories that make artworks possible, and their relationship to one another. In so doing, I shall beg some of the hardest philosophical questions I know.

I shall now think of pairs of predicates related to each other as 'opposites', conceding straight off the vagueness of this *demodé* term. Contradictory predicates are not opposites, since one of each of them must apply to every object in the universe, and neither of a pair of opposites need apply to some objects in the universe. An object must first be of a certain kind before either of a pair of opposites applies to it, and then at most and at least one of the opposites must apply to it. So opposites are not contraries, for contraries may both be false of some objects in the universe, but opposites cannot both be false; for of some objects, neither of a pair of opposites *sensibly* applies, unless the object is of the right sort. Then, if the object is of the required kind, the opposites behave as contradictories. If *F* and non-*F* are opposites, an object *o* must be of a certain kind *K* before either of these sensibly applies; but if *o* is a member of *K*, then *o* either is *F* or non-*F*, to the exclusion of the other. The class of pairs of opposites that

sensibly apply to the $(ô)Ko$ I shall designate as the class of *K-relevant predicates*. And a necessary condition for an object to be of a kind *K* is that at least one pair of *K*-relevant opposites be sensibly applicable to it. But, in fact, if an object is of kind *K*, at least and at most one of each *K*-relevant pair of opposites applies to it.

I am now interested in the *K*-relevant predicates for the class *K* of artworks. And let *F* and non-*F* be an opposite pair of such predicates. Now it might happen that, throughout an entire period of time, every artwork is non-*F*. But since nothing thus far is both an artwork and *F*, it might never occur to anyone that non-*F* is an artistically relevant practice. The non-*F*-ness of artworks goes unmarked. By contrast, all works up to a given time might be *G*, it never occurring to anyone until that time that something might both be an artwork and non-*G*; indeed, it might have been thought that *G* was a *defining trait* of artworks when in fact something might first have to be an artwork before *G* is sensibly predicable of it – in which case non-*G* might also be predicable of artworks, and *G* itself then could not have been a defining trait of this class.

Let *G* be 'is representational' and let *F* be 'is expressionist'. At a given time, these and their opposites are perhaps the only art-relevant predicates in critical use. Now letting '+' stand for a given predicate *P* and '–' for its opposite, non-*P*, we may construct a style matrix more or less as follows:

F	G
+	+
+	–
–	+
–	–

The rows determine available styles, given the active critical vocabulary: representational expressionistic (e.g., Fauvism); representational nonexpressionistic (Ingres); nonrepresentational expressionistic (Abstract Expressionism); nonrepresentational non-expressionist (hard-edge abstraction). Plainly, as we add art-relevant predicates, we increase the number of available styles at the rate of 2*n*. It is, of course, not easy to see in advance which predicates are going to be added or replaced by their opposites, but suppose an artist determines that *H* shall henceforth be artistically relevant for his paintings. Then, in fact, both *H* and non-*H* become artistically relevant for *all* painting, and if his is the first and only painting that is *H*, every other painting in existence becomes non-*H*, and the entire community of paintings is enriched, together with a doubling of the available style opportunities. It is this retroactive enrichment of the entities in the artworld that makes it possible to discuss Raphael and De Kooning together, or Lichtenstein and Michelangelo. The greater the variety of artistically relevant predicates, the more complex the individual members of the artworld become; and the more one knows of the entire population of the artworld, the richer one's experience with any of its members.

In this regard, notice that, if there are *m* artistically relevant predicates, there is always a bottom row with *m* minuses. This row is apt to be occupied by purists. Having

scoured their canvases clear of what they regard as inessential, they credit themselves with having distilled out the essence of art. But this is just their fallacy: exactly as many artistically relevant predicates stand true of their square monochromes as stand true of any member of the Artworld, and they can *exist* as artworks only in so far as 'impure' paintings exist. Strictly speaking, a black square by Reinhardt is artistically as rich as Titian's *Sacred and Profane Love*. This explains how less is more.

Fashion, as it happens, favours certain rows of the style matrix: museums, connoisseurs, and others are makeweights in the Artworld. To insist, or seek to, that all artists become representational, perhaps to gain entry into a specially prestigious exhibition, cuts the available style matrix in half: there are then 2*n*/2 ways of satisfying the requirement, and museums then can exhibit all these 'approaches' to the topic they have set. But this is a matter of almost purely sociological interest: one row in the matrix is as legitimate as another. An artistic breakthrough consists, I suppose, in adding the possibility of a column to the matrix. Artists then, with greater or less alacrity, occupy the positions thus opened up: this is a remarkable feature of contemporary art, and for those unfamiliar with the matrix, it is hard, and perhaps impossible, to recognize certain positions as occupied by artworks. Nor would these things be artworks without the theories and the histories of the Artworld.

Brillo boxes enter the artworld with that same tonic incongruity the *commedia dell'arte* characters bring into *Ariadne auf Naxos*. Whatever is the artistically relevant predicate in virtue of which they gain their entry, the rest of the Artworld becomes that much the richer in having the opposite predicate available and applicable to its members. And, to return to the views of Hamlet with which we began this discussion, Brillo boxes may reveal us to ourselves as well as anything might: as a mirror held up to nature, they might serve to catch the conscience of our kings.

Arthur C. Danto, 'The Artworld', *The Journal of Philosophy*, 61 [New York, 15 October 1964, 571-84; reprinted in *Aesthetics: A Critical Anthology*, ed. George Dickie, Richard Sclafani and Ronald Robelin, New York: St. Martin's Press, 1986].

Reyner **BANHAM**
A Clip-on Architecture
[1963–65]

A CELL WITH SERVICES

Alison and Peter Smithson, innovators of so many things in the British architecture of the Fifties, produced late in 1955 (for exhibition the subsequent year) a design for a plastic House of the Future. It was a seasonable commission – Ionel Schein produced one at the same period for the Exposition des Arts Menagers in Paris, and Monsanto's plastic house which later found a home at Disneyland is of the same vintage. The Smithson version, however, was more sophisticated than the others in a

number of ways. Conceived in terms of a mass-produced product of the 1980s, it attempted to face the practicalities of mass-marketing by exhibiting something like an architectural version of Detroit styling, and an approximation to Detroit production engineering in that it consisted of a number of large, non-repeating components; i.e. like the fenders or hood of a car they occurred only once in each assembled product (unlike the components of the endless designs discussed above) and the attainment of an economically long production run would have depended on the production of a great number of house units. Now, although each house was to be a self-contained unit in itself, stuffed with futurist household gadgetry, the project did involve an alternative form of endlessness or indeterminacy. All the rooms were to be lit from a central oval patio in the middle of the house, and the only hole in the external walls was for the door on one of the long sides. With three blank walls, the houses could be pushed together into endless rows, two deep, back to back, and this town-planning proposition was part of the design from the start. In this the Smithson House of the Future differed from other standard of living machines like Fuller's Dymaxion House, or Schein's Maison Plastique, which were virtually impossible to assemble into larger wholes, but – like them – it was a fully serviced dwelling unit, complete and self-sufficient. In this, it differed again from the repeating units of the Llewelyn Davies concept of endless architecture. Where he had identified repeating structural units that could be added up into a usable volume, the Smithsons were offering usable volumes that could be added up into something more complex. The concept was less intellectually pellucid, but more emotionally appealing – it is difficult to identify oneself with a pair of vertical mullions, an underwindow air-conditioner and an area of tinted glass, but easy to identify with a room you can stand up and walk about in.

The Smithsons, in the free-ranging way, went off now on a different architectural tack, but Ionel Schein, with his partner Jaques Coulon, probed further into the possibilities of the repetitive cell in the remaining years of the fifties, producing a series of projects for habitable units that came to look more and more like industrial designers' products, and less and less like architecture. Their mobile book-exhibition project contained provision for joining the cells together in such a way that you could walk through; the mobile motel unit took the aesthetic further and added to it so high a degree of servicing that it became almost an independent living-capsule, capable of being popped off into orbit. Mobile and transportable, both units had made the psychological and aesthetic break necessary to free themselves from architecture's time-honoured roots in the ground – Europe, irresolutely and too late, had re-invented the American mobile home, but then immediately went on to offer one possibility further. A young Belgian architect, Jaques Baudon interrupted his military service long enough to submit for a competition in 1959, a house-design that added an essential further concept – the connector between the units. Apart from the living room, which was of totally indeterminate form and construction according to the whim of the inhabitants, each other function – sleeping, bathroom, kitchen – was

housed in a separate capsule reached from a corridor-tube made up of standard branching sections; but adding more sections you could provide clip-on points for more functional capsules, and create a house of any size.

THE CLIP-ON CONCEPT

It was at about this point in time that I first remember using the phrase 'clip-on' in connection with architecture. It must have been in circulation for at least a year before I used it in print in the Architectural Review in February 1960 and its meaning was to some extent fixed by conversational usage before then. The sort of ideas that belonged to the concept at that time I can now best reconstruct from some notes for an unpublished article on the Clip-on Philosophy which were written down in 1961. The epitome of the clip-on concept at that time was the outboard motor, whose consequences for the theory of design intrigued many of us at that time, in the following terms: given an Evinrude or a Johnson Seahorse, you can convert practically any floating object into a navigable vessel. A small concentrating package of machinery converts an undifferentiated structure into something having function and purpose. But, equally, the undifferentiated object might be a paper cup full of raw black coffee, and the clip-on could be the packets of sugar and cream and the stirring stick which convert to the particular cup of coffee that suits your taste.

The architectural equivalent of this, at face value, would be one of Bucky Fuller's 'Mechanical Wings', the trailer full of mechanical goodies that converts any old shack or hole in the ground into a habitable dwelling. Or, to go back to the Baudon project, the tent, dome or plastic bubble that serves as a living room is the undifferentiated structure, and all the specialized capsules on their connecting corridor constitute the clip-on. The Smithson House, or the Schein/Coulon motel unit are more in the nature of a clip-together architecture, but as soon as they begin to be clipped together they raise a problem which neatly turns the clip-on concept inside out. When more than 'two or three are gathered together' (in the words of the Anglican liturgy) a second factor appears as a necessary corollary of their aggregation. Services, communication and other manifestations of interdependency will have to be consciously designed at the same time as the units themselves – the result of not doing so can be seen in the overhead jungle of wires and marginal slummery of so many American trailer camps. If the units are simply spread on the ground, then the circulation of men and vehicles among them will become a determinant of the layout – as with the corridors of Baudon's house, or even the way the Smithson houses stack with their doors outwards, thus fixing the spines of communication along the sides of the super-blocks into which they aggregate. If the units are stacked vertically, then some form of external structure will be needed to take up their cumulative weight; and if any substantial number are to be serviced with water, air, gas, piped music or you-name-it, then those services are going to thicken up into some pretty impressive ducts and trunking in places. So you reverse the proposition. The generalized structure becomes the source of power, service and support, and the

specialized clip-ons become the habitable units. The outboard analogy has to be replaced by something more like the connection of domestic appliances to the house's electrical supply – which is why the Archigram group use the term 'Plug-In' instead of clip-on for their urban projects. But too much should not be made of this distinction between extreme forms of the two concepts: technically they are often intimately confused in a single project, and the aesthetic tradition overruns niceties of mechanical discrimination. The aesthetic is still the Clip-on Aesthetic. But multiplied by a wild, swinging, pop-art vision that is a long way from the intellectual austerities of the speculations of Kallman or Llewelyn Davies.

So, while the architecture of the establishment rusticates in the picturesque prefabrication techniques of the tile-hung schools of the CLASP system (Consortium of Local Authorities Special Programme), while British Railways prepared to drop into place the first of their plastic switchgear huts (serviced cells if ever there were) and Llewelyn Davies and Weeks began to square up to the design of their endless and indeterminate hospital at Northwick Park (where even the repetition of the structural units goes on an indeterminate pattern) … while, in short, possibilities of the fifties were being translated into the practicalities of the sixties, younger architects yet were about to set up a new set of projected possibilities, in which a conscious element of play upon the life-enhancing potentials of the most advanced urban technologies becomes a major animating force.

A MACHINE TO LIVE IT UP IN

And I mean 'play'. The Fun Palace project – announced as the First Giant Space Mobile in the World – is a mechanized shrine to Homo Ludens, conceived in the first instance by Joan Littlewood, that astounding blend of social conscience and strolling player who put before the world for the first time such theatrical knockouts as The Quare Fellow, Oh What a Lovely War, and like that. Her fanatical belief in spontaneity and audience participation led her to conceive of a place, a zone, a total probability, in which the possibility of participating in practically everything could be caused to exist, from political rallies to Graeco-Roman wrestling, table tennis to choral song, dervish dancing, model drag-racing or just goofing and falling about, where even the simple business of walking about or finding where to go next would be rewarding or stimulating.

This could doubtless have been achieved by means of a large number of single-purpose buildings in a park of rest and culture, but by the time Joan and her team of 'younger creative nuts' (she calls them) finished with the idea they had a giant erector toy, compact enough to fit on a tight urban lot, but big with the potential of manufacturing spaces for all purposes. It is not, however, a large building which can be variously subdivided; it is simply a kit of parts and a space-grid of supports and services which can pick up, assemble and animate the parts to suit whatever purpose comes along, and then put everything back in the box in the morning. The space-grid consists of vertical towers full of works, from toilets to electronics, carrying a system of gantry cranes on their heads to manoeuvre the

parts into position, and with their feet resting in heavy servicing plant (including sewage disposal – since the FP is a piece of 10-year-expendable urban equipment, a degree of detachment from permanent mains services is to everybody's advantage).

Day by day this giant neo-futurist machine will stir and re-shuffle its movable parts – walls and floors, ramps and walks, steerable moving staircases, seating and roofing, stages and movie screens, lighting and sound-systems – sometimes bursting at the seams with multiple activities, sometimes with only a small part walled in, but with the public poking about the exposed walks and stairs, pressing buttons to make things happen themselves. This, when it happens (and it is on the cards that it will, somewhere, soon) will be indeterminacy raised to a new power: no permanent monumental interior space or heroic silhouette against the sky will survive for posterity to remember the designers by – Cedric Price (architect), Frank Newby (structural engineer) and Gordon Pask (systems consultant). If it is going to be a monument to anything, it will be to architecture's silent partners, the invisible and long-suffering mechanical servitors who keep most buildings going, but never get thanks or acknowledgement for it. For the only permanently visible elements of the FP will be the 'life-support' structure on which the transient architecture will be parasite. You can do this for a single giant 'Anti-building' (the FP is sufficiently worked out in detail for construction to start more or less tomorrow) but could you do it for a whole city?

PLUG-INSVILLE

Archigram can't tell you for certain whether Plug-in City can be made to work, but it can tell you what it might look like. Archigram has developed over the past four years from a student protest broadsheet to something between an architectural space comic and a magazine of protest. Rather suddenly, in 1964 it became an architectural magazine of international standing – issue number 4, which was all space comic with a pop-up zoom-city in its centre spread, was taken up and quoted all over the world from Architectural Forum to L'Architecture d'Aujourd'hui, and Peter Cook, the editor, has had requests for number 5 from even further afield than that. The strength of Archigram's appeal stems from many things, including youthful enthusiasm in a field (city planning) which is increasingly the preserve of middle-aged caution. But chiefly it offers an image-starved world a new vision of the city of the future, a city of components on racks, components in stacks, components plugged into networks and grids, a city of components being swung into place by cranes. They make no bones about being in the image business – like the rest of us they urgently need to know what the city of the future is going to look like, because one of the most frustrating things to the arty old Adam in most of us is that the wonders of technology have a habit of going invisible on us. It is no use cyberneticists and O and R men telling us that a computerized city might look like anything or nothing: most of us want it to look like something, we don't want form to follow function into oblivion. So, Archigram's visions of Zoom City, Computer City, Off-the-Peg City, Completely Expendable City and

Plug-in City, may evoke yawns of impatience from the expert servants of the silent servitors mentioned above, but practically everyone concerned with architecture as constructed form (including plastics engineers) over-responds to the plug-in vision. They may reject it or accept it, but Archigram's kit of interchangeable living cells and support structures seems to be the first effective image of the architecture of technology since Bucky Fuller's Geodesic domes first captivated the world 15 years ago. The difference from Fuller hardly needs to be rubbed in, except to hope that the opposite mistake will not be made. Fuller offered (offers) a manner of thinking radically about the control of the environment, but the architectural profession ran off with the pretty bubble that housed the environment and soon got bored with playing with it. A lot of po-faced technicians are going to pooh-pooh Plug-in City's technological improbabilities and brush it off as a Kookie teenage Pop art frivol, and in the process the formal lessons of the Plug-in City might be missed.

Put as tersely as possible, those lessons say this: a plug-in city must look like a plug-in city. If people are to enjoy manipulating this kind of adaptable mechanical environment (and if they don't enjoy it, we have gained nothing over previous environments) then they will have to be able to recognize its parts and functions, so that they can understand what it is doing to them, and they can understand what they are doing to it. And many of the future environments of man on this crowded little planet are probably going to have to be quite as highly mechanized as Archigram's Plug-in metropolis [...]

Reyner Banham, 'A Clip-On Architecture', *Design Quarterly*, 63 [Minneapolis, 1963, 3-30; reprinted in *Architectural Design*, 35, London, November 1965] 534-535.

Cedric PRICE
Fun Palace [1965]

At a time when most artefacts, systems and institutions are in an increasingly rapid state of change, the lack of constructive progress in basic problems of enclosure and movement is not merely depressing but also extremely dangerous. It is a cause for total concern when one of the major obstacles to the improvement through change of many activities is primarily hampered by the restriction of their enclosures.

No example is clearer than that of large industrialized cities and conurbations. Here, not only convenience is marred, but the actual potential of twentieth-century urban living remains unexploited due to the criminally long-lasting dross in which the community is housed. In addition, much new planning and design, often resulting in building legislation, is of the 'band-aid' variety. Thus, when the first feasibility study was done on the validity of providing a particular structure to encourage the aims of Joan Littlewood's Fun Palace concept it was essential that any proposed design should reinforce the activities housed in it.

In addition, since the social concept of the Fun Palace is primarily a people's workshop or university of the

streets, the self-participatory element of the activities must extend to a degree of control by the users of their physical environment.

Inbuilt flexibility or its alternative, planned obsolescence, can be satisfactorily achieved only if the time factor is included as an absolute design factor in the total design process. Such calculated awareness of the time factor related to the enclosing of activities and their interrelationship must extend to an assessment of the valid life-span of the total complex, assessed primarily in socio-urban terms.

This, in relation to the London siting of the Fun Palace, has been fixed at ten years. There is a large degree of, one hopes inspired, guesswork in this figure.

However, having fixed it, it provides an extremely definitive range of requirements and aims in the determination of means of access, site, structural system, materials, servicing and component design of the whole. [...]

Immediate site considerations include the utilizing of the adjacent areas and buildings as additional environmental conditioners. The majority of the adjacent development is industrial, part-derelict, and productive of noise, dust and noxious fumes. Such surroundings would be detrimental to small single-cell social amenity buildings, but in relation to the Fun Palace they can be controlled or even exploited. Thus gas holders are illuminated from the main structure, while derelict areas are converted into varied pedestrian approach and viewing routes.

In order to achieve the degree of flexibility in the provision of activity enclosures it is necessary to be able to construct such enclosures rapidly from a limited kit of parts and for the final particular variation or tuning-up to depend on the additive use of environmental control equipment. Required enclosures, whether total or partial, can be roughly divided into two categories – small-scale cell-type with a high degree of servicing and large volumes requiring a lower degree of servicing. Kitchens, restaurants, workshops and lavatories are included in the first category while auditoria, cinema and meeting halls come in the second.

Although most of the listed activities and amenities offered are already available to an urban, or at least metropolitan, public their inter-accessibility achieved by juxtaposition not only enhances freedom of choice, but also creates new activities, at present without name, which result from this concentrated fluidity.

The positive delight in changing one's mind, spying and eavesdropping is catered for without damage to the particular activity.

Flexibility in the construction and destruction of enclosures is alone insufficient to achieve the degree of immediacy of change required by the brief. Thus means of movement and access throughout the complex also needed to be capable of adjustment. Therefore with the exception of the fixed three-dimensional grid of means of escape, all the public movement routes above the totally unobstructed ground level are capable of adjustment. The radial, base-fixed escalators from the ground deck give varied access above ground while portable walkways –

moving and static, level and inclined – are fixed in conjunction with decks of particular activities.

Re-routing through the whole complex is capable of rapid change which takes into account evident desire lines on the part of the users.

The degree of spatial variation resulting from participant motivation is comparatively high. The control of the physical environment, due to the size of the structure and the inbuilt equipment, such as the high-level suspension grid and full-span travelling crane, is achieved by an additive rather than total method. That is, adverse conditions are eliminated separately rather than collectively and affinity grouping of activities is related to physical as well as social conditioning.

Such control simplifies the nature of particular barriers or screening and can be contrasted with the total control required over noise, heat, dust, moisture and vibration in the thin walling of an automobile.

The materials used in the construction of the enclosures require a far shorter life-span than the ten years allotted to the protected steel of the overall framework. Their application and use will in themselves provide useful test-bed conditions while their limited life will prevent unnecessary prolongation of the pattern of activity they house.

The whole complex, in both the activity it enables and the resultant structure it provides, is in effect a short-term toy to enable people, for once, to use a building with the same degree of meaningful personal immediacy that they are forced normally to reserve for a limited range of traditional pleasures.

Cedric Price, 'Fun for Everyone: Fun Palace', *Link* [Gloucester, England: Gloucester College of Art, June/July 1965].

Hans HOLLEIN
Statements on Architecture [1965–68]

Limited, traditional definitions of architecture and its means have lost their validity. Today the goal of our activities is the environment as a whole and all the media by which it is determined: from television to atmospheric conditioning, transportation to clothing, telecommunications to shelter.

This extension of the human sphere and the way it is formed goes far beyond a built statement. Today everything has become architecture. 'Architecture' is just one of many means, is just a possibility.

Man creates artificial conditions. This is Architecture.

Physically and psychologically man replicates, transforms and expands his physical and psychic sphere. He determines 'environment' in its widest sense. According to his needs and wishes he uses the means necessary to satisfy these needs and to fulfil his dreams. He expands his body and mind. He communicates.

Architecture is a medium of communication.

For thousands of years, not only shelter from the

climate and the weather but the artificial transformation and determination of man's world were achieved by the means of building. The building was the essential manifestation and expression of man.

Advances in science and technology, as well as changes in society and its needs and demands, confront us with entirely different realities. (Today a TV set can take the place of a school or a museum.)

New, alternative media for determining our environment are emerging.

There is a change in the significance of 'meaning' and 'effect'. Architecture affects. The way I take possession of an object – how I use it – becomes important. A building can become entirely information, or rather its message may be experienced through informational means such as printed and televisual media. In fact it is almost no longer of any importance whether, for example, the Acropolis or the Pyramids exist in physical reality, as most people are aware of them through other media in any case, not through their own experience. Indeed their importance, the role they play, is based on this effect of information. Thus buildings can exist as simulations only.

An early example of the extension of building through communications media is the tele-phone booth: a building of minimal size extended into global dimensions. A similar environment, more directly related to the human body and in an even more concentrated form, is the jet-pilot's helmet, which extends his awareness through telecommunications, bringing him into a direct relationship with the vast expanses he navigates. The development of space capsules and space suits leads further towards the synthetic and extreme formulations of contemporary architecture. Here is a 'house' – far more perfect than any building – which allows complete control of bodily functions, providing food and the disposal of waste, all combined with maximum mobility.

These highly developed possibilities for determining physical environments lead towards the notion of psychic environments. Released from the basic necessities of physical shelter, one can sense a new freedom. Man can now finally be the centre of the creation of an individual environment.

The extension of architectural media beyond pure tectonic building and its derivations has led to experiments with new structures and new materials – means which have been used in other fields for many years. Thus we now have 'sewn' architecture, for example, and 'inflatable' architecture.

However, these are still material means, still 'building materials'. Little experimentation of any consequence has been conducted using non-material means (such as light, temperature, smell) to determine an environment, to determine space.

Just as the use of already existing methods has vast areas of application, so could the use of lasers, for example, lead to totally new determinations and experiences. Finally the controlled use of chemicals and drugs to regulate bodily functions and temperatures, as well as to create artificial environments, has barely begun.

Architects have to stop thinking in terms of buildings only.

Built, physical architecture, freed from the technological limitations of the past, will work more intensely with spatial as well as psychological ambiences.

The process of erecting structures will acquire a new meaning; spaces will more consciously be endowed with haptic, optic and acoustic properties.

A true architecture of our time will have to redefine itself and expand its means. Many areas outside traditional building will enter the realm of architecture, as architecture and 'architects' will have to enter new fields.

All are architects. Everything is architecture.

Hans Hollein, translated excerpts from writings, 1965-68 [including 'Zukunft der Architektur', Bau, 1, Vienna, 1965, 8-11; 'Alles ist Architektur', Bau, 1/2, Vienna, 1968, 1-28].

Marcel BROODTHAERS
Interview with J-M.
Vlaeminckx [1966]

Jean-Michel Vlaeminckx Marcel Broodthaers, you are Belgian. You make Pop. During 1964 you exhibited works at the Galerie Saint-Laurent and also at Contemporains. What, in your view, are the origins of Pop art?

Marcel Broodthaers I think two roots can be seen here: first, a tradition stemming from Picabia, Marcel Duchamp and Magritte; second, the development of American industrial society, with all of its alienation.

Vlaeminckx You cite Magritte among the precursors of Pop, but wasn't Magritte more of a Surrealist than a Dadaist?

Broodthaers Magritte was never completely integrated with the Surrealist group; he stayed on the margins. There were always certain elements of caricature in his work which represent our own times well. I'm thinking particularly of a canvas from 1935 called *Le Voyageur* [*The Traveller*].' His influence in New York is much more considerable than you would suppose. One should note that Magritte is not, I think, particularly happy to be, in some way, the father of Pop art, yet his art is an art of ideas. The image is surrendered to a cluster of extra-visual impressions; he is not a painterly artist. In Magritte's work there are many more features that foreshadow Pop art than there are in Dada.

Vlaeminckx Why has Magritte refused the paternity of Pop, even a distant one?

Broodthaers An artist's name in the end hardly belongs to him; there is just the influence exerted by his work. As for Magritte's own opinion of Pop art, I don't think it would be particularly cordial. In the Netherlands some major shows of Pop art were presented in parallel with a surrealist exhibition where Magritte, Delvaux, Verelk and other Belgian artists were represented. Now, if one wanted, quite straightforwardly, to trace out Magritte's influence on a specific type of art, I think comparing his works with those of the American artists would certainly be more interesting and convincing.

Vlaeminckx You don't think Pop art can be equated with

the often pejoratively used label 'neo-Dadaism'?

Broodthaers There may be a case for seeing in Dada the origins of Pop art, but society has changed so much since the Dada era that all comparisons with it draw us into a certain degree of confusion with Dada, and with Surrealism. I think Pop art is an original expression of our times, or rather of the present moment. Pop art developed first in American society. The American way of life has characteristics – stemming from its industrialization – which invade, absolutely, all the domains of private life. In the United States, nothing takes place according to the pattern of an individual's life. The American lifestyle is composed of a series of evasions which end up adding one to the other, neutralizing and finally completely annulling the pleasures of existence which a human being normally possesses. Admittedly, we can see the same phenomenon arising in Europe. More and more, European life is equally dominated by refrigerators and neon signs. It's for this reason that I think Pop art is not really an artform that came from America and installed itself in Europe, but rather is an art that expresses this society, which struggles to a certain degree against it and which, finally, has its *raison d'être* in our industrialized Europe. In Europe, individual life still exists, but it will not be for long. You only have to walk on the beaches or along a motorway to grasp how the organization of leisure, for example, has acquired a character of uniformity and tedium which is contrary to the very notion of holidays and relaxation.

Vlaeminckx In summary, Pop art could be defined as an opposition to the homogeneous civilization which conditions us …

Broodthaers Pop art could be defined as a form of revolt against this civilization which at the same time raises our consciousness of it – this leisure civilization and its realities. A Pop work is a taking stock of a certain reality.

Vlaeminckx A demystification?

Broodthaers Exactly. Pop art – in contrast to painting, which is often constrained by an aesthetic bias – has a social objective. Pop addresses itself to all the world. It is a popular art.

Vlaeminckx What is its rapport with social realism, official popular art?

Broodthaers A rapport in reverse. Let's say this would be the black humour of social realism.

Vlaeminckx In France there's a group of artists, based around the critic Pierre Restany, who are known as the 'new realists'. What is it that separates them from Pop?

Broodthaers Yes, in Latin countries Pop art takes another name. There's a whole series of French artists who make paintings, objects and sculptures which adhere to this tendency, such as Martial Raysse, and above all Arman, who makes industrial accumulations. He stacks up toothpaste tubes, combs or other cheap, expendable objects under perspex. They are presented in such a way that, while they have the characteristics of artworks, they are linked by a kind of umbilical cord to everyone's lived reality, because all the world goes to the department stores, everybody is a witness to the industrial accumulation produced by our environment. But Restany's movement is, above all, accepting towards the forms of modern civilization. Almost to the point of

glorification. They seek a new aesthetic which measures up to the civilization in which they live. Whereas Pop is from the outset an opposition. Rauschenberg often remarks that in the United States every artist is an opponent.

Vlaeminckx What is your relationship with the plastic element?

Broodthaers I place ideas before visual forms. The medium of expression must be subordinated to the idea. With Pop, I've acquired an indifference towards the visual that I didn't have with poetry. However, I recently discovered that to express an idea with facility, it was necessary to play with plastic elements. In certain respects one always falls back on the plastic elements of art.

Vlaeminckx It's inevitable; the substance is inseparable from the form. But, tell me, how did you come to Pop?

Broodthaers At first I thought it was derisive and simplistic. I even wrote an article against it: 'Pop: Made in USA'. I confounded Pop art and the American juke-box. Afterwards, I looked again and accepted it.

Vlaeminckx Pop drew on advertising techniques for its self-presentation. Now, advertising draws on Pop to present its products. How do you explain this phenomenon?

Broodthaers People are victims of the advertising environment to such a degree that they can no longer see the advertisement. They aren't conscious that advertising techniques exist. Because they are addressed to their unconscious they obey these techniques, which precisely the artists of advertising, let us say of Pop, reveal to human consciousness. It is here that advertising makes its contribution as a form of artistic expression. By using advertising techniques in order to denounce them, 'Pop' artists have, from a certain angle, sustained advertising. It provides them with the currency for their exchange […]

1 In Magritte's painting *Le Voyageur* [1937] in a dusky sky
 floats a sphere composed of accumulated objects: an
 armchair, a table-top, a sculpted torso, etc. [trans.]
Marcel Broodthaers and J-M. Vlaeminckx, 'Entretien avec
Marcel Broodthaers', *Degré Zero* [Brussels, 1965; reprinted
in *Marcel Broodthaers par lui-même*, ed. Anna Hakens, Gent:
Ludion, 1998]. Translation by Ian Farr in consultation with
Maria Gilissen, 2005.

Öyvind FAHLSTRÖM
Object-making [1966]

Why should it be meaningful to make objects if one is an American artist?

In the United States, as we know, objects (goods) have an ecstatic quality – so that they can be sold, so that new objects can be made, so that more people have the means to buy more objects. If the U.S. is half a warfare state with a strategic industry 'for the good of the nation' (of politicians, the military and industrialists), the remainder is a market state 'for the good of the individual' (of industry). To accelerate this crazy treadmill, Americans are reminded from the time they wake up in the morning until the time they lose consciousness, that goods are fetishes

which make them better Americans, mothers, millionaires, stars, fighters, mistresses and cowboys.

The tiresome thing about African fetishes is that they can only be, for us, beautiful shapes and a form of exoticism. The engaging thing about Claes Oldenburg's objects is that besides sculpting basic shapes and 'character signs' inherent in universal, everyday objects, he deals with the fetish qualities which ecstatic objects radiate. (Oldenburg has never made objects which are unpainted, 'pure' sculpture). Furthermore, his objects are not like everyday objects since they are generally oversized; they are not intended to be used, only to radiate.

Every hamburger or typewriter by Oldenburg becomes a monument to the ecstatic object. Recently, Oldenburg has also begun to make projects for monuments in New York consisting of colossal objects. (If this is really necessary. In Europe, monuments are erected to Garibaldi or the Unknown Soldier. In the U.S., for example, the puffing Camel cigarette billboard in Times Square has become a national triumphal arch erected to the Unknown Consumer – otherwise it would surely have been pulled down, as the Camel brand is almost extinct.)

Because Claes Oldenburg conducts experiments into the object's pleasure magic it does not follow that he translates the bourgeois clichés of Madison Avenue. Likewise, the external difference of his objects from everyday objects is not an expressionistic manifestation of Oldenburg's ego. The marked character or personality which his objects possess is rather the result of a perspicacious, friendly and lyrical, crazy recording of the milieu in which the artist lives at the moment he is making them.

In form, material and dimension, or 'style', his earlier papier mâché-like objects and reliefs say something about New York's shabby, seething and hectic Slavic/Puerto Rican Lower East Side. The big pieces of furniture are concerned with the (white) West Coast Americans; the frank and naïve, grown-up mentality of Los Angeles and Hollywood. His French delicatessen objects, the smallest he has made, say something about dry, sober, finicky Parisian gourmets. The recent medium-sized objects from New York have, with the artist, emerged from the slums. Like the new middle-class, jet-set bourgeoisie of parties and private views they are spinelessly blasé or plump and positive.

He can be seen as BIG, SOFT, STRONG. The most striking thing about his objects is that they are SOFT. In earlier years, the content of his objects dealt entirely with softness: clothes, meat, cakes. Since then, most of the objects made by Oldenburg have been soft (with the principal exception of the French objects) while their subjects have been hard. Why is all art hard? Hard and taut like a canvas, hard and brittle like a sculpture, drifting towards sublimation and the rigours of the super-ego? Does this perhaps give the impression of changelessness, perfection or eternal life?

But the object which yields is stronger. It is the same with Oldenburg himself; when he directs his performances, it seems as though he is always yielding to circumstances, materials, people. This allows people, material or space to be themselves, but in the end what

results is always a characteristically Oldenburg work. But to yield to people does not mean that Oldenburg does so out of kindness or with the intention of improving them, as in psychological drama. They are entirely subordinated to Oldenburg's vision, but within it they have life. In the same way, I imagine that nowadays he manages to direct his army of assistants who sew for him: impoverished women artists and dancers, rich housewives, professional seamstresses and, first and foremost, his wife Pat. Without her stitching and her contributions to his performances, Oldenburg, as we know him, would not exist.

Oldenburg's quality of involved detachment means that he can plunge into and grope about in a sea of people just as easily as he can root around in the Salvation Army's boxes of tattered and faded old clothes on Second Avenue. (Pat's and his way of looking through their address book and ringing up candidates for the Happenings was like a virtuoso pianist looking over his music.) It must have been the same when he plunged into the slums of Chicago during his prehistoric years as a crime reporter.

In the same way, he was busy browsing his way through the Lower East Side when my wife Barbro and I first met him in the autumn of 1961. For the most part, Puerto Ricans lived in this area and, every now and then, neighbours threw bricks through the windows in the yard so that Claes had to put up bars.

For us artists, the Lower East Side at the time represented a rugged idyll, an inspiring small town. When we had parties we invented new dances, spoke in tongues, cast off our clothes and pelted each other with pats of butter. The landlords came and roughed us up. In the afternoon, Claes worked shelving books at the art school, The Cooper Union. In the evenings sometimes Dick Bellamy (who with the Green Gallery launched Pop Art) looked in and borrowed Oldenburg's rickety bathtub and lay in it reading *Vogue*.

Öyvind Fahlström, 'Object-Making', originally published in
Studio International [London, December 1966] trans. Peter
and Birgit Bird. Translation revised by Sharon Avery-
Fahlström and Lars Hjelmstedt, 2005.

John LENNON, Paul McCARTNEY
I Am the Walrus [1967]

I am he as you are he as you are me
and we are all together
See how they run like pigs from a gun
see how they fly
I'm crying
Sitting on a cornflake
Waiting for the van to come
Corporation T-shirt, stupid bloody Tuesday
Man you've been a naughty boy
you let your face grow long

I am the eggman
they are the eggmen

I am the walrus
Goo goo g' joob

Mr city policeman sitting
pretty little policemen in a row
See how they fly like Lucy in the sky
See how they run
I'm crying
I'm crying, I'm crying
Yellow matter custard
Dripping from a dead dog's eye [...]

Lennon/McCartney, 'I Am the Walrus', Northern Songs, 1967.

Jean BAUDRILLARD
Pop – An Art of Consumption? [1970]

MASS MEDIA CULTURE

As we have seen,[1] the logic of consumption can be defined as a manipulation of signs. The symbolic relation of interiority, the symbolic relations of creation are absent from it: it is all exteriority. The object loses its objective finality, its function, and becomes the term of a much wider combinatory, of groups of objects where its value is one of relation. Furthermore, it loses its symbolic meaning, its age-old anthropomorphic status, and tends to dissipate in a discourse of connotations, which are themselves also relative to one another within the framework of a totalitarian cultural system, that is to say, one which is able to integrate significations from anywhere.

We have taken as our basis the analysis of *everyday* objects. But there is another discourse on the object, that of art. A history of the evolution of the status of objects and their representation in art and literature would be revealing on its own. After having traditionally played a wholly symbolic and decorative role in art, objects in the twentieth century have ceased to be tied to moral or psychological values, they have ceased to live by proxy in the shadow of man and have begun to assume an extraordinary importance as autonomous elements in an analysis of space (cubism, etc.) Thus they have dispersed, to the very point of abstraction. Having feted their parodic resurrection in Dada and Surrealism, destructured and volatilized by the Abstract, now they are apparently reconciled with their image in Nouvelle Figuration and Pop art. It is here that the question of their contemporary status is raised: it is further brought to our attention by this sudden rise of objects to the zenith of artistic figuration.

In a word: is Pop art the contemporary art form of that logic of signs and of their consumption which is being discussed here, or is it only an effect of fashion and thus purely an object of consumption itself? The two are not contradictory. One can grant that Pop art transposes an object-world while quite accepting that it also results (according to its own logic) in objects pure and simple. Advertising shares the same ambiguity.

Let us formulate the question another way: the logic of consumption eliminates the traditional sublime status of artistic representation. Quite literally, there is no longer any privileging of the object over the image in essence or signification. One is no longer the truth of the other: they coexist *in extenso* and in the very same logical space, where they equally 'act' as signs[2] (in their differential, reversible, combinatory relation). Whereas all art up to Pop was based on a vision of the world 'in depth',[3] Pop itself claims to be homogeneous with that *immanent order of signs* – homogeneous with their industrial and serial production, and thus with the artificial, manufactured character of the whole environment – homogeneous with the *in extenso* saturation as much as culturalized abstraction of this new order of things.

Does it succeed in 'rendering' this systematic secularization of objects, in 'rendering' this new descriptive environment in all its exteriority – such that nothing remains of the 'inner light' which gave prestige to all earlier art? Is it an art of the *non-sacred*, that is to say, an art of pure manipulation? Is it itself a non-sacred art, that is to say productive and not creative of objects?

Some will say (and Pop artists themselves) that things are rather more simple. They do the thing because they are taken with it; after all, they're having a good time, they look around and paint what they see – it's spontaneous realism, etc. This is false: Pop signifies the end of perspective, the end of evocation, the end of witnessing, the end of the creative gesture and, not least of all, the end of the subversion of the world and of the malediction of art. Not only is its aim the immanence of the 'civilized' world, but its total integration in this world. Here there is an insane ambition: that of abolishing the annals (and the foundations) of a whole culture, that of transcendence. Perhaps there is also quite simply an ideology. Let us clear away two objections: 'It is an American art' – in its object material (including the obsession with 'stars and stripes'), in its empirical pragmatic, optimistic practice, in the incontestably chauvinist infatuation of certain patrons and collectors who are 'taken in' by it, etc. Even though this objection is tendentious, let us reply objectively: if all this is *Americanism*, Pop artists can only adopt it according to their own logic. If manufactured objects 'speak American', it is because they have no other truth than this mythology which overwhelms them – and the only logical course is to integrate this mythological discourse and to be integrated in it oneself. If the consumer society is caught up in its own mythology, if it has no critical perspective on itself, and *if this is precisely its definition*,[4] then no contemporary art can exist which, in its very existence and practice, is not compromised by, party to this opaque obviousness of things. Indeed, this is why Pop artists paint objects according to their real appearance, since it *is only thus, as readymade signs, 'fresh from the assembly line', that they function mythologically*. This is why they preferably paint the initials, marks, slogans borne by these objects and why, ultimately, they can paint only that (Robert Indiana). Not as a game or as 'realism', but a recognition of the obvious fact of consumer society: namely, that the truth of objects and products is their *mark*. If that is 'Americanism', then Americanism is the very logic of contemporary culture, and Pop artists could hardly be reproached for making it evident.

No more than they could be reproached for their commercial success, and for accepting it without shame. Even worse, condemned and thus reinvested with a sacred function. It is logical for an art that does not oppose the world of objects but explores its system, to enter itself into the system. It is even the end of a certain hypocrisy and radical illogicality. In contrast with earlier painting (since the end of the nineteenth century), *signed* and commercialized in terms of the signature (the Abstract Expressionists carried this triumphant inspiration and this shameless opportunism to a higher plane), Pop artists reconcile the object of painting and the painting-object. Coherence or paradox? Through its predilection for objects, through this infinite figuration of 'marked' objects and material consumables, and through its commercial success, Pop art is the first to explore the status of its own art-object as 'signed' and 'consumed'.

Yet this logical enterprise, whose extreme consequences one would not but applaud were they to contravene our traditional *moral* aesthetic, is coupled with an ideology into which it is not far from sinking. An ideology of Nature, of an Awakening ('Wake Up') and of authenticity, which evokes the best moments of bourgeois spontaneity.

This 'radical empiricism', 'uncompromising positivism', 'antiteleologism' (Mario Amaya, *Pop as Art*) sometimes assumes a dangerously *initiatic* aspect. Oldenburg: 'I drove around the city one day with Jimmy Dine. By chance we drove through Orchard Street, both sides of which are packed with small stores. As we drove I remember having a vision of "The Store". I saw, in my mind's eye, a complete environment based on this theme. Again it seemed to me that I had discovered a new world, I began wandering through stores – all kinds and all over – *as though they were museums*. I saw objects displayed in windows and on counters as precious works of art.' Rosenquist: 'Then suddenly, the ideas seemed to flow towards me through the window. All I had to do was seize them on the wing and start painting. Everything spontaneously fell into place – the idea, the composition, the images, the colours, everything started to work on its own.' It appears that, on the theme of 'Inspiration', Pop artists are in no way inferior to earlier generations. This theme implies, since Werther, the ideality of a *Nature* to which it suffices to be faithful in order that it be true. It is simply necessary to awaken it, reveal it. We read in John Cage, musician and theorist-inspirator of Rauschenberg and Jasper Johns: '... art should be an affirmation – not an attempt to bring order ... but simply a way of *waking up* to the very life we are living, which is so excellent, once one gets one's mind and one's desire out of the way and lets it act of its own accord'. This acquiescence to a revealed order – the universe of images and of manufactured objects shining through to a basic *nature* – leads to professions of a mysticorealist faith: 'A flag was just a flag, a number was simply a number' (Jasper Johns), or again John Cage: 'We must set about discovering a means to let sounds be themselves' – which assumes an essence of the object, a level of absolute reality which is never that of the everyday environment, and which with regard to it

constitutes quite frankly a surreality. Wesselmann thus speaks of the 'superreality' of an ordinary kitchen.

In brief, we are in total confusion, and we find ourselves before a kind of behaviourism arising from a juxtaposition of visible things (something like an impressionism of consumer society) coupled with a vague Zen or Buddhist mystique of stripping down the Ego and Super-ego to the 'Id' of the surrounding world. There is also Americanism in this curious mixture!

But above all there is a grave equivocation and inconsistency. For by not presenting the surrounding world for what it is, that is to say, primarily an artificial field of manipulable signs, a total cultural artefact where what comes into play is not sensation or vision, but a differential perception and a tactical game of significations – by presenting it as revealed nature, as essence, Pop has a double connotation: first, as the ideology of an integrated society (contemporary society = nature = ideal society – but we've seen that this collusion is part of its logic); and on the other hand, it reinstates the whole *sacred process of art*, which destroys its basic objective.

Pop wants to be the art of the commonplace (this is the very reason it calls itself Popular Art): but what is the commonplace if not a metaphysical category, a modern version of the category of the sublime? The object is only commonplace in its use, at the moment when it is used (Wesselmann's transistor 'that walks'). The object ceases to be commonplace the moment it signifies: as we have seen, the 'truth' of the contemporary object is no longer to be useful for something, but to signify; no longer to be manipulated as an instrument, but as a sign. And the success of Pop, in the best instances, is that it shows it to us as such.

Andy Warhol, whose approach is the most radical, is also the one who best epitomizes the theoretical contradictions in the practice of this painting, and the difficulties the latter has in envisaging its true object. He says: 'The canvas is an entirely ordinary object, as much as this chair or this poster' (always that will to absorb, to reabsorb art, revealing both American pragmatism – terrorism of the useful, blackmail of integration – and something like an echo of the mystique of sacrifice). He adds: 'Reality needs no intermediary, one simply has to isolate it from its surroundings and put it down on the canvas.' Now that is the whole question in point: for the ordinariness of this chair (or hamburger, car fin or pin-up face) is exactly its context, and mainly the serial context of all similar or slightly dissimilar chairs, etc. Ordinariness is the *difference in repetition*. By isolating the chair on the canvas, I relieve it of all ordinariness, and, at the same time, I relieve the canvas of its whole character as an everyday object (by which, according to Warhol, it should have absolutely resembled the chair). Such an impasse is well known: art can no more be absorbed in the everyday (canvas = chair) than it can grasp the everyday as such (the chair isolated on the canvas = the real chair). Immanence and transcendence are equally impossible: they are two sides of the same dream.

In short, there is no essence of the everyday, of the ordinary, and thus no art of the everyday: this is a mystical aporia. If Warhol (and others) believe in it, this is because they delude themselves with regard to the very status of art and of the artistic act – which is not at all rare among artists. Moreover, with regard to the mystical nostalgia at the very level of the act, of the productive gesture: 'I want to be a machine,' says Warhol, who paints in effect by stencilling, screen-printing, etc. Now, for art to pose as machine-like is the worst kind of vanity, and for whoever enjoys – willingly or not – the status of creator to dedicate himself to serial automatism is the greatest affectation. Yet it is difficult to accuse either Warhol or the Pop artists of bad faith: their exacting logic collides with a certain sociological and cultural status of art, about which they can do nothing. It is this powerlessness which their ideology conveys. When they try to desacralize their practice, society sacralizes them all the more. Added to which is the fact that their attempt – however radical it might be – to secularize art, in its themes and its practice, leads to an exaltation and an unprecedented manifestation of the sacred in art. Quite simply, Pop artists forget that for the picture not to become a sacred super-sign (a unique object, a signature, an object of noble and magical commerce), the author's content or intentions are not enough: it is the structures of culture production which are decisive. In the end, only rationalizing, like any manufacturer, the market for painting could desacralize it and return the picture to everyday objects.[5] Perhaps this is neither thinkable nor possible nor even desirable – who knows? In any event, it is a borderline situation: once there, either you stop painting or you continue at the cost of regressing into the traditional mythology of artistic creation. And through this sliding, the classical pictorial values are retrieved: Oldenburg's 'expressionist' treatment, Wesselmann's fauvist and Matissian one, Lichtenstein's 'art nouveau' and Japanese calligraphy, etc. What have we to do with these legendary resonances? What have we to do with these effects which say, 'It's still all the same painting?' The logic of Pop is elsewhere, not in an aesthetic computation or a metaphysics of the object.

Pop could be defined as a *game*, and a manipulation, of different levels of mental perception: a kind of mental Cubism which seeks to diffract objects not according to a spatial analysis, but according to modalities of perception elaborated throughout the centuries on the basis of a whole culture's intellectual and technological apparatus: objective reality, image-reflection, figuration by drawing, technological figuration (the photo), abstract schematization, the discursive utterance, etc. On the other hand, the use of the phonetic alphabet and industrial techniques have imposed schemes of division, doubling, abstraction, repetition (ethnographers tell of the Primitives' bewilderment upon discovering several books *absolutely* alike: their whole vision of the world is turned upside down). In these various modes one can see the myriad figures of *a rhetoric of designation*, of recognition. And this is where Pop comes into play: it works on the differences between these different levels or modes, and on the perception of these differences. Thus the screenprint of a lynching is not an evocation: it presupposes this lynching transmuted into a news item, into a journalistic sign by virtue of mass communications – a sign taken to yet another level by screenprinting. The same photo repeated presupposes the unique photo, and, beyond that, the real being whose reflection it is: moreover, this real being could figure in the work without destroying it – it would only be one more combination.

Just as there is no order of reality in Pop art, but levels of signification, there is no real space – the only space is that of the canvas, that of the juxtaposition of different elements/signs and of their relations; neither is there any real time – the only time is that of the reading, that of the differential perception of the object and its image, of such an image and the same repeated, etc., the time necessary for a *mental correction*, for an *accommodation* to the image, to the artefact in its relation to the real object (it is not a question of a reminiscence, but of the perception of a *local, logical* difference). Neither is this reading searching for an articulation or a coherence, but a coverage *in extenso*, a statement of successive order.

It can be seen that the activity Pop prescribes (once again, in its ambition of rigour) is far from our 'aesthetic sensibility'. Pop is a 'cool' art: it requires neither aesthetic ecstasy nor affective or symbolic participation ('deep involvement'), but a kind of abstract involvement or *instrumental curiosity*. Retaining a little of that child-like curiosity or naïve enchantment of discovery – and why not? – Pop can also be seen as comic-book religious images, or as a Book of Hours of consumption, but which above all brings into play intellectual reflexes of decoding, of deciphering, etc., those of which we will come to speak.

In conclusion, Pop art is not a popular art. For the popular culture ethos (if that indeed exists) rests precisely on an unambiguous realism, on linear narration (and not on repetition or the diffraction of levels), on allegory and the decorative (this is not Pop art, since these two categories refer back to 'something' essential), and on emotive participation linked to the moral of life's uncertainties.[6] It is only on a rudimentary level that Pop art can be understood as a 'figurative' art: a coloured imagery, a naïve chronicle of consumer society, etc. It is true that Pop artists are also happy to claim this. Their candour is immense, as is their ambiguity. With regard to their humour, or to that attributed to them, here again we are on unstable ground. It would be instructive, in this regard, to register the reactions of viewers. With many, the works provoke a laughter (or at least the inclination to a laughter) which is moral and obscene (these canvases are obscene in the classical view). Then, a smile of derision, but whether it judges the objects painted or the painting itself it is difficult to know. A smile which becomes a willing accomplice: 'That can't be serious, but we are not going to be scandalized, and after all perhaps ...' All more or less twisted up in the shameful desolation of not knowing how to take it. That said, Pop is at once full of humour and humourless. In all logic it has nothing to do with subversive, aggressive humour, with the telescoping of surrealist objects. It is not at all concerned to short-circuit objects in their function, but to juxtapose them in order to analyze their relations. This move is not terrorist;[7] rather, at the very most, it conveys effects derived from cultural isolation. In fact, it is a question of something else. Let us not forget, by taking us back to the system described, that a 'certain smile' is one of the *obligatory signs of*

consumption: it no longer indicates a humour, a critical distance, but only recalls that transcendent critical value materialized today in a knowing wink. This false distance is everywhere, in spy films, with Godard, in modern advertising which continually uses it as a cultural allusion, etc. Ultimately, in this 'cool' smile, you can no longer distinguish between the smile of humour and that of commercial complicity. This is what also happens in Pop art – after all, its smile epitomizes its whole ambiguity: it is not the smile of critical distance, it is the smile of *collusion*.

1 This text is taken from Jean Baudrillard, *La société de consommation: ses mythes, ses structures*, Paris, Gallimard, 1970, pp. 174-185 – from the section entitled 'La culture mass-médiatique'.[Translator.]

2 Cf Boorstin, *The Image*.

3 The Cubists: again, it is the 'essence' of space which they seek, an unveiling of the 'secret geometry', etc. Dada or Duchamp or the Surrealists: here objects are stripped of their [bourgeois] function and made to stand out in their subversive banality, recalling the lost essence and an order of authenticity evoked by the absurd. Ponge: his seizing upon the naked and concrete object is still a poetic consciousness or perception in action. In brief, all art 'without which things would only be what they are' feeds (before Pop) on transcendence.

4 Cf below: *The Consumption of Consumption*.

5 In this sense, the truth of Pop concerns the earning capacity and promotion, not the contract and the gallery of painting.

6 'Popular' art is not attached to objects, but always primarily to man and his exploits. It would not paint a delicatessen or the American flag, but a-man-eating or a-man-saluting-the-American-flag.

7 In fact, we often read this 'terrorist' humour into it. But through a critical nostalgia on our part.

Jean Baudrillard, from *La Société de Consommation: ses mythes et ses structures. Collection 'Le point de la question'*, 4 [Paris: S. G. P. P./distributed by Denoël, 1970; trans. Paul Foss, in Paul Taylor, ed., *Post-Pop Art*, Cambridge, Massachusetts: MIT Press, 1989] 33-44.

Andreas HUYSSEN
The Cultural Politics of Pop: Reception and Critique of US Pop Art in the Federal Republic of Germany [1975]

In the mid 1960s, when the student movement broadened its criticism of the university system to include attacks on West German society, politics and institutions in general, a wave of pop enthusiasm swept the Federal Republic. The notion of pop that attracted people almost magically not only referred to the new art by Warhol, Lichtenstein, Wesselmann and others; it also stood for beat and rock music, poster art, the flower child cult and the drug scene – indeed for any manifestation of 'subculture' and 'underground'. In short, pop became the synonym for the new life style of the younger generation, a life style which rebelled against authority and sought liberation from the norms of existing society. As an 'emancipation euphoria' spread, mainly among high school and university students, pop in its broadest sense became amalgamated with the public and political activities of the anti-authoritarian New Left.

Consequently, the conservative press once more decried the general decay of Western culture, not deeming it necessary to investigate whether the protest – political or apolitical – was in any way legitimate. The traditionally conservative cultural critics reacted accordingly. Since they preferred to meditate in seclusion about Kafka and Kandinsky, experimental literature and abstract expressionism, they denounced Pop art as non-art, supermarket-art, Kitsch-art and as a coca-colonization of Western Europe.[1] But various branches of industry and business (producing and marketing records, posters, films, textiles) understood immediately that the youth movement created needs that could be exploited economically. New markets opened up for cheap silk screens and small sized graphic works. Mini-galleries were inaugurated as frequently as mini-boutiques.[2] The art experts, of course, continued to feud about whether Pop should or should not be accepted as a legitimate form of art.

Meanwhile, a predominantly young art audience had begun to interpret American Pop art as protest and criticism rather than affirmation of an affluent society.[3] It would be worthwhile to examine why this view of Pop as critical art was much more widespread in Germany than in the US. The strong German tradition of cultural criticism (*Kulturkritik*) certainly has something to do with the difference in reception; another factor, however, was that in Germany the Pop reception coincided with the student movement, while in the US Pop preceded university unrest. When Pop artists exhibited commodities or declared that serial productions of Coca Cola bottles, filmstars or comic strips were art works, many Germans did not see these works as affirmative reproductions of mass-produced reality; they preferred to think that this art was intended to denounce the lack of values and criteria in art criticism and that it sought to close the gap between high or serious, and low or light, art. The works themselves only partially suggested such an interpretation, but it was strengthened by the needs and interests of individual recipients, determined as they were by age, class origin and contradictions of consciousness. The interpretation of Pop as critical art was certainly fostered in Europe by the fact that European artists of the 1960s, whose works were often exhibited together with American Pop works, were indeed trying to develop an art of social criticism. The crucial factor, however, was the atmosphere created by anti-authoritarian protest and its adherence to Marcuse's cultural theories, an atmosphere that cast an aura of social criticism over many cultural phenomena which appear quite different from today's perspective.

When I saw the Pop *Documenta* in Kassel in 1968 and the famous Ludwig collection on exhibit in Cologne's Wallraf-Richartz-Museum, I found sensual appeal and excitement not only in the works by Rauschenberg and Johns, but especially in those by Warhol, Lichtenstein, Wesselmann and Indiana. I, like many others, believed that Pop art could be the beginning of a far reaching democratization of art and art appreciation. This reaction was as spontaneous as it was false. Right or wrong notwithstanding, the very real feeling of liberation which many art spectators experienced at that time was more important: Pop seemed to liberate art from the monumental boredom of Informel and Abstract Expressionism; it seemed to break through the confines of the ivory tower in which art had been going around in circles in the 1950s. It seemed to ridicule the deadly serious art criticism which never acknowledged fantasy, play and spontaneity. Pop's almost indiscriminate use of bright colours was overwhelming. I was won over by its obvious enjoyment of play, its focus on our daily environment, and at the same time by what I took to be its implied critique of this same environment. Art audiences were expanding considerably. In the 1950s, most art exhibits had been exclusive events for a small circle of experts and buyers. In the 1960s, hundreds, even thousands of people came to the opening of a single exhibition. No longer did exhibitions take place only in small galleries; modern art invaded the big art institutes and the museums. Of course, it was still a bourgeois audience, including many young people, many students. But one was tempted to believe that the expansion of interest in art would be unlimited. As for the derogatory and condemning judgments by conservative critics, they only seemed to prove that the new art was indeed radical and progressive. The belief in consciousness raising by means of aesthetic experience was quite common in those days.

Still something else recommended this art to the younger generation. The realism of Pop, its closeness to objects, images and reproductions of everyday life, stimulated a new debate about the relationship between art and life, image and reality, a debate that filled the culture pages of the national newspapers and weeklies. Pop seemed to liberate high art from the isolation in which it had been kept in bourgeois society. Art's distance 'from the rest of the world and the rest of experience'[4] was to be eliminated. A new avenue seemed to lead almost by necessity to the bridging of the traditional gap between high and low art. From the very beginning, Pop proclaimed that it would eliminate the historical separation between the aesthetic and the non-aesthetic, thereby joining and reconciling art and reality. The secularization of art seemed to have reached a new stage at which the work of art rid itself of the remnants of its origins in magic and rite. In bourgeois ideology, the work of art – in spite of its almost complete detachment from ritual – still functioned as a kind of substitute for religion; with Pop, however, art became profane, concrete and suitable for mass reception. Pop art seemed to have the potential to become a genuinely 'popular' art and to resolve the crisis of bourgeois art, which had been evident since the beginning of this century.

Those who had confidence in the critical nature and

emancipatory effect of Pop art were well aware of this crisis of bourgeois art. In Thomas Mann's *Doctor Faustus* it results in the pact between the composer Adrian Leverkühn and the devil, whose help became a prerequisite for all of Leverkühn's compositions. In the novel the devil speaks as an art critic:

But the sickness is general, and the straightforward ones shew the symptoms just as well as the producers of back-formations. Does not production threaten to come to an end? And whatever of serious stuff gets on to paper betrays effort and distaste [...] Composing itself has got too hard, devilishly hard. Where work does not go any longer with sincerity how is one to work? But so it stands, my friend, the masterpiece, the self-sufficient form, belongs to traditional art, emancipated art rejects it.[5]

Why, one asks, has composing become so difficult? Why is the masterwork a thing of the past? Changes in society? The devil answers: 'True, but unimportant. The prohibitive difficulties of the work lie deep in the work itself. The historical movement of the musical material has turned against the self-contained work.'[6] The emancipated art on which Thomas Mann's devil elaborates is still a highly complex art which can neither break out of its isolation nor resolve the radical opposition of aesthetic illusion (*Schein*) and reality. It is well known that Thomas Mann took ideas from Adorno's philosophy of music and integrated them into the novel. The devil speaks Adorno's mind. Adorno himself always insisted on the separation of art and reality. For him, serious art could only negate the negativity of reality. It is only through negation, he believed, that the work maintains its independence, its autonomy, its claim to truth. Adorno found such negation in the intricate writings of Kafka and Beckett, in the prohibitively difficult music of Schoenberg and Berg. After reading Thomas Mann's novel one might come to the conclusion that the crisis of art takes place in a realm hermetically sealed off from the outer world and from the production relations of art that any modern artist must deal with. But Adorno's arguments have to be understood within the framework of his analysis of culture industry (*Kulturindustrie*), which is contained in his *Dialektik der Aufklärung* (1947), co-authored with Max Horkheimer.[7] To Adorno, it seemed necessary and unavoidable that serious art negate reality; this view was a result of his American experiences, which convinced him that in the modern, rationally organized capitalist state even culture loses its independence and is deprived of its critical substance. The manipulative praxis of this culture industry – Adorno thought mainly of record, film, and radio production – subordinates all spiritual and intellectual creation to the profit motive. Adorno again summed up his conclusions – equally pessimistic for high and low art – in a 1963 radio lecture:

Culture industry is the purposeful integration of its consumers from above. It also forces a reconciliation of high and low art, which have been separated for thousands of years, a reconciliation which damages both. High art is deprived of its seriousness because its effect is programmed; low art is put in chains and deprived of the

unruly resistance inherent in it when social control was not yet total.[8]

It follows that art in a traditional sense has become unconceivable today.

Certainly the Pop enthusiasts of the 1960s found less support in Adorno's thesis of total manipulation than in Marcuse's demand for a sublation (*Aufhebung*) of culture which they believed Pop art was about to initiate. In his essay 'The Affirmative Character of Culture', which was first printed in 1937 in the *Zeitschrift für Sozialforschung* and republished by Suhrkamp in 1965, Marcuse reproached classical bourgeois art for secluding itself from the realities of social labour and economic competition and for creating a world of beautiful illusion, the supposedly autonomous realm of the aesthetic which fulfills longings for a happy life and satisfies human needs only in an unreal and illusory way:

There is a good reason for the exemplification of the cultural ideal in art, for only in art has bourgeois society tolerated its own ideals and taken them seriously as a general demand. What counts as utopia, fantasy and rebellion in the world of fact is allowed in art. There affirmative culture has displayed the forgotten truths over which 'realism' triumphs in daily life. The medium of beauty decontaminates truth and sets it apart from the present. What occurs in art occurs with no obligation.[9]

Marcuse believed that the utopia of a better life expressed in bourgeois art need only be taken at its word. Then, by necessity, the autonomy of art would be eliminated and art would be integrated into the material life process. This elimination of affirmative culture would go together with a revolution of the patterns of bourgeois life: 'Beauty will find a new embodiment when it no longer is represented as real illusion but, instead, expresses reality and joy in reality.'[10] Habermas has pointed out that in 1937, in view of fascist mass art, Marcuse could have had no delusions about the possibility of a false sublation of culture.'[11] But thirty years later, the student revolt in the US, France and Germany seemed to be initiating precisely the transformation of culture and the radical change of life patterns, which Marcuse had once hoped for.[12]

Since Pop art had a strong impact in the Federal Republic only in the second half of the 1960s, its reception coincided with the high point of the anti-authoritarian revolt and with attempts to create a new culture. This would explain why Pop art was accepted in the Federal Republic (but not in the US) as an ally in the struggle against traditional bourgeois culture, and why many people believed that Pop art fulfilled Marcuse's demand that art not be illusion but express reality and the joy in reality. There is an unresolved contradiction inherent in this interpretation of Pop art: how was it possible that an art expressing sensual joy in our daily environment could at the same time be critical of this environment? One might also ask to what extent Marcuse was misunderstood on these matters. It remains highly doubtful whether Marcuse would have interpreted Pop art as a sublation of culture. It is true that Marcuse spoke of the integration of culture into the material life process, but

he never explained this idea in detail. If this deficiency is one side of the coin, the other is Marcuse's insistence on bourgeois idealist aesthetics. An example: when Marcuse praises the songs of Bob Dylan, he lifts them out of the material life process and sees in them the promise for a liberated, utopian society of the future. Marcuse's emphasis on this anticipatory, utopian role of the work of art owes as much to bourgeois aesthetics as does Adorno's thesis of the work of art as a total negation of existing reality. But it was just this idealism in Marcuse's thought that appealed to the early student movement, and his influence on the Pop reception in the Federal Republic makes Pop's links with the anti-authoritarian revolt evident [...]

THE BENJAMIN DEBATE

Capitalist culture industry inevitably produces a minimum of art and a maximum of trash and kitsch. Therefore, the task is to change culture industry itself. But how can it be done? Critical art alone does not suffice, since in the best of cases, its success remains limited to consciousness raising. As early as 1934, Walter Benjamin noted that 'the bourgeois apparatus of production and publication is capable of assimilating, indeed of propagating, an astonishing amount of revolutionary themes without ever seriously putting into question its own continued existence or that of the class which owns it.'[13] Critical theory did not lead out of this dead end street. A return to Benjamin and Brecht, however, seemed to provide a new perspective and new possibilities. It is signifiant that in the Federal Republic interest in Benjamin initiated by Adorno's and Tiedemann's editions led to an attack on the Frankfurt editors. They were reproached with playing down the importance of Brecht and Marxism for the late Benjamin.[14]

Interest in Benjamin's theses about materialist aesthetics reached a high point after 1968, when the student movement left its anti-authoritarian phase and tried to develop socialist perspectives going beyond 'protest against the system' and the 'great refusal'. The notion of manipulation, on which Adorno's theory of culture industry and Marcuse's theory of one-dimensional man were based, was legitimately criticized, but the critique went too far, frequently ending up as a complete rejection of both Adorno and Marcuse. Their place was now taken by the Benjamin of the mid-1930s. Two of his essays, 'The Author as Producer' and 'The Work of Art in the Age of Mechanical Reproduction', became particularly influential. It is worth mentioning that Adorno and Horkheimer had conceived the chapter on culture industry in *Dialektik der Aufklärung* as a reply to Benjamin's 1936 reproduction essay; the latter is also related to Marcuse's essay 'The Affirmative Character of Culture', which, like Benjamin's piece, was first published in the *Zeitschrift für Sozialforschung*. Both essays deal with the sublation (*Aufhebung*) of bourgeois culture, albeit in very different ways.[15]

Benjamin was influenced by Brecht, whose major ideas had evolved out of experiences in the Weimar Republic. Like Brecht, Benjamin tried to develop the revolutionary tendencies of art out of the production

relations of capitalism. His point of departure was the Marxist conviction that capitalism generates productive forces that make the abolition of capitalism both possible and necessary. For Benjamin, the productive forces in art are the artist himself and the artistic technique, especially the reproduction techniques used in film and photography. He acknowledges that it took much longer for the production relations of capitalist society to make an impact on the superstructure than it took them to prevail at the basis, so much longer that they could only be analyzed in the 1930s.[16] From the very beginning of the essay on reproduction Benjamin insists upon the primacy of revolutionary movement at the basis. But the dialectics of the conditions of production leave their mark on the superstructure too. Recognizing this, Benjamin emphasizes the value of his theses as a weapon in the struggle for socialism. While Marcuse believes that the function of art will change after the social revolution, Benjamin sees change developing out of modern reproduction techniques, which drastically affect the inner structure of art. Here lies the importance of Benjamin for a materialist aesthetics still to be written.

Both essays by Benjamin make several references to Dada and cast a new light on the Pop debate. Benjamin found the 'revolutionary strength of Dada'[17] in its testing of art for authenticity: by using new means of artistic production, the Dadaists proved that this criterion of bourgeois aesthetics had become obsolete. In the reproduction essay Benjamin wrote:

The Dadaists attached much less importance to the sales value of their work than to its uselessness for contemplative immersion. The studied degradation of their material was not the least of their means to achieve this uselessness. Their poems are 'word salad' containing obscenities and every imaginable waste product of language. The same is true of their paintings, on which they mounted buttons and tickets. What they intended and achieved was a relentless destruction of the aura of their creations, which they branded as reproductions with the very means of production.[18]

Benjamin recognized that Dada had been instrumental in destroying the bourgeois concept of an autonomous, genial and eternal art. Contemplative immersion, which had been quite progressive in an earlier phase of bourgeois emancipation, since the late nineteenth century had served to sabotage any kind of social praxis geared towards change. During the decline of middle-class society, 'contemplation became a school for asocial behaviour'.[19] It is the undeniable merit of the Dadaists that they exposed this problem in their works. Benjamin did not overlook the fact that the Dada revolt was ultimately unsuccessful, however. He explored the reasons for its failure in a 1929 essay on surrealism:

If it is the twofold task of revolutionary intellectuals to overthrow bourgeois intellectual domination and to make contact with the proletarian masses, they have failed almost completely to deal with the second part of their task because it cannot be mastered by contemplation.[20]

Out of negation alone, neither a new art nor a new society can be developed. It was also Benjamin, of course, who praised John Heartfield for salvaging the revolutionary nature of Dada by incorporating its techniques into photomontage.[21] Heartfield, who like other leftist intellectuals (Grosz, Piscator) had joined the KPD in 1918, published his photomontages in such working class publications as AIZ (*Arbeiter Illustrierte Zeitung*) and *Volks-Illustrierte*.[22] He fulfilled two of Benjamin's major demands – the application and use of modern artistic techniques (photography and montage), and partisanship and active participation of the artist in the class struggle. For Benjamin, the key question was not the position of a work of art *vis-à-vis* the productive relations of its time, but rather its position *within* them.[23] Nor does Benjamin ask, what is the position of the artist *vis-à-vis* the production process, but rather, what is his position *within it?* The decisive passage in 'The Author as Producer' reads:

Brecht has coined the phrase 'functional transformation' (Umfunktionierung) to describe the transformation of forms and instruments of production by a progressive intelligentsia – an intelligentsia interested in liberating the means of production and hence active in the class struggle. He was the first to address to the intellectuals the far-reaching demand that they should not supply the production apparatus without, at the same time, within the limits of the possible, changing that apparatus in the direction of Socialism.[24]

In opposition to Adorno, Benjamin held a positive view of modern reproduction techniques as they were applied in art. This disagreement can be traced to their respectively different understanding of capitalism, rooted in different experiences and formed at different times. To put it simply, Adorno was looking at the US of the 1940s, Benjamin at the Soviet Union of the 1920s. Another important factor is that, like Brecht, Benjamin saw great potential in the 'Americanism' introduced in Germany in the 1920s, while Adorno never overcame his deep mistrust of anything American. Both authors, however, have to be criticized for a distortion of perspective which makes it problematic to apply their theories in the 1970s. Just as we should question Adorno's view of the US, we should be sceptical about Benjamin's idealizing enthusiasm for the early Soviet Union, which sometimes borders on a proletcult position. Neither Adorno's thesis of the total manipulation of culture (cf. his one-dimensional interpretation of jazz), nor Benjamin's absolute belief in the revolutionizing effects of modern reproduction techniques, has withstood the test of time. Benjamin, to be sure, was aware that mass production and mass reproduction in no way automatically guaranteed art an emancipatory function – not when art was subjected to the capitalist production and distribution apparatus. But it was not until Adorno that a theory of manipulated art under the capitalist culture industry was fully developed.

This leads us back to the Pop debate. According to Benjamin's theory, the artist, merely by seeing himself as producer and operating with the new reproduction techniques, would come closer to the proletariat. But this did not happen to the Pop artist, because the role that reproduction techniques play in today's art is totally different from what it was in the 1920s. At that time reproduction techniques called the bourgeois tradition into question; today they confirm the myth of technological progress on all levels. And yet, modern reproduction techniques have a progressive potential even today. The technical innovation at the heart of Warhol's work is the use of photography combined with the silk screen technique. Because this technique makes the unlimited distribution of art works possible, it has the potential to assume a political function. Like film and photography, the silk screen destroys the century-old aura[25] of the work of art, which, according to Benjamin, is the prerequisite for its autonomy and authenticity. It is not surprising that in 1970 a Warhol monograph – using Benjamin's and Brecht's categories – claimed that Warhol's opus was *the* new critical art of our times.[26] The author, Rainer Crone, was right to view the silk screen technique in the light of Benjamin's thesis that 'to an ever greater degree the work of art reproduced becomes the work of art designed for reproducibility.'[27] Warhol, Crone claimed, forces the observer to redefine the role of painting as a medium. One might object that such a redefinition already had been made necessary by Dada. There is a more important objection to be made, however. Crone's interpretation is based exclusively on an analysis of Warhol's artistic techniques; he completely ignores Benjamin's linking of artistic technique and political mass movement. Benjamin, who found his model in the revolutionary Russian film, wanted the bourgeois contemplative reception of art replaced by a collective reception. Yet, when Pop art is shown today in the Museum of Modern Art or in the Wallraf-Richartz-Museum in Cologne, the reception remains contemplative and thus Pop remains a form of autonomous bourgeois art. Crone's Warhol interpretation can only be regarded as a failure because he lifts Benjamin's theories out of their political context and neglects all the problems that would be posed by an application of those theories to today's art. A major contradiction of Crone's approach is that on the one hand, he supports Warhol's attack on the autonomy of art and the originality of the artist, and on the other hand, writes a book which glorifies the originality of Warhol and of his art. The aura absent from Warhol's works is thus reintroduced in a kind of star cult, in the 'auratization' of the artist Andy Warhol.

In another context, however, Benjamin's theories can be related to Pop art. Benjamin trusted in the capacity of revolutionary art to stimulate the needs of the masses and to turn into material force when those needs could only be satisfied by collective praxis. That Pop was seen as a critical art at the time of the anti-authoritarian protest cannot be understood if one adheres to the thesis art equals commodity. Viewed from Benjamin's perspective, however, this interpretation was valid so long as the Pop reception was part of a political movement in the Federal Republic. We can also understand now that the interpretation of Pop as a progressive art had to change once the anti-authoritarian student movement foundered on its internal and external contradictions. By that time, of

course, Pop had already been co-opted by the museums and collectors as the newest form of high art [...]

1 See Jost Hermand, *Pop International* [Frankfurt am Main, 1971] 47-51.

2 In the early Sixties there were less than a thousand galleries in the FRG; in 1970 the number of galleries had more than doubled. See Gottfried Sello, 'Blick zurück im Luxus', *Die Zeit*, 44 [1 November 1974] 9.

3 See Hermand, *Pop International*, 14; Jürgen Wissmann, 'Pop art oder die Realität als Kunstwerk', *Die nicht mehr schönen Künste*, ed. H.R. Jauss [Munich, 1968] 507-30.

4 Alan R. Solomon, 'The New Art', *Art International*, 7:1 [1963] 37.

5 Thomas Mann, *Doctor Faustus*, trans. H.T. Lowe-Porter [New York, 1948] 238, ff.

6 Ibid., 240.

7 Theodor W. Adorno and Max Horkheimer, *Dialektik der Aufklärung* [Frankfurt am Main, 1969]. English translation published by Seabury Press, New York, 1974.

8 Theodor W. Adorno, 'Résumé über die Kulturindustrie', *Ohne Leitbild* [Frankfurt am Main, 1967] 60.

9 Herbert Marcuse, 'The Affirmative Character of Culture', *Negations: Essays in Critical Theory* [Boston, 1968] 114.

10 Ibid., 131.

11 Jürgen Habermas, 'Bewusstmachende oder rettende Kritik - die Aktualität Walter Benjamins', *Zur Aktualität Walter Benjamins* [Frankfurt am Main, 1972] 178, ff.

12 See Herbert Marcuse, *An Essay on Liberation* [Boston, 1969]; later, of course, Marcuse differentiated and modified his theses on the basis of new developments within the student revolt, underground and counter-culture; see Herbert Marcuse, *Konterrevolution und Revolte* [Frankfurt am Main, 1973].

13 Walter Benjamin, 'The Author as Producer', *Understanding Brecht* [London, 1973] 94.

14 The debate took place in *Das Argument*, 46 [March, 1968], *Alternative*, 56/57 [October/December, 1967], and *59 60* [April/June, 1968], *Merkur*, 3 [1967] and *1-2* [1968], and *Frankfurter Rundschau*. For a detailed bibliography see *Alternative*, 59/60 [April/June, 1968] 93.

15 For differences between Benjamin and Marcuse see Habermas, 'Kritik', 177-85.

16 Walter Benjamin, 'The Work of Art in the Age of Mechanical Reproduction', in *Marxism & Art*, edited by Berel Lang and Forrest Williams [New York, 1972] 282.

17 Benjamin, 'Author as Producer', 94.

18 Ibid., 296.

19 Ibid.

20 Walter Benjamin, 'Der Sürrealismus', *Angelus Novus* [Frankfurt am Main, 1966] 214.

21 Benjamin, 'Author as Producer', 94.

22 See the first book of Heartfield's work published in the Federal Republic: John Heartfield, *Krieg im Frieden* [Munich, 1972].

23 Ibid., 87.

24 Ibid., 93.

25 For an explanation of Benjamin's notion of aura see Habermas, 'Kritik', Michael Scharang, *Zur Emanzipation der Kunst* [Neuwied, 1971] 7-25. Lienhard Wawrzyn, *Walter Benjamins Kunsttheorie. Kritik einer Rezeption* [Neuwied, 1973], especially 25-39.

26 Crone, *Warhol*.

27 Benjamin, 'Mechanical Reproduction', 287.

Andreas Huyssen, 'The Cultural Politics of Pop: Reception and Critique of US Pop Art in the Federal Republic of Germany', *New German Critique*, 4 [Milwaukee, Wisconsin, 1975, 77-97; reprinted in Paul Taylor, ed., *Post-Pop Art*, Cambridge, Massachusetts: MIT Press, 1989].

Roland BARTHES
That Old Thing, Art [1980]

As all the encyclopaedias remind us, during the 1950s certain artists at London's Institute of Contemporary Arts became advocates of the popular culture of the period: comic strips, films, advertising, science fiction, pop music. These various manifestations did not derive from what is generally called an Aesthetic but were entirely produced by Mass Culture and did not participate in art at all; simply, certain artists, architects and writers were interested in them. Crossing the Atlantic, these products forced the barrier of art; accommodated by certain American artists, they became works of art, of which culture no longer constituted the being, merely the reference: origin was displaced by citation. Pop art as we know it is the permanent theatre of this tension: on one hand, the mass culture of the period is present in it as a revolutionary force which contests art; and on the other, art is present in it as a very old force which irresistibly returns in the economy of societies. There are two voices, as in a fugue – one says: 'This is not Art'; the other says, at the same time: 'I am Art.'

Art is something which must be destroyed – a proposition common to many experiments of Modernity.

Pop art reverses values. 'What characterizes Pop is mainly its use of what is despised' (Lichtenstein). Images from mass culture, regarded as vulgar, unworthy of an aesthetic consecration, return virtually unaltered as materials of the artist's activity. I should like to call this reversal the 'Clovis Complex': like Saint Remi addressing the Frankish king, the god of Pop art says to the artist: 'Burn what you have worshipped, worship what you have burned.' For instance: photography has long been fascinated by painting, of which it still passes as a poor relation; Pop art overturns this prejudice: the photograph often becomes the origin of the images Pop art presents: neither 'art painting' nor 'art photograph', but a nameless mixture. Another example of reversal: nothing more contrary to art than the notion of being the mere reflection of the things represented; even photography does not support this destiny; Pop art, on the contrary, accepts being an *imagery*, a collection of reflections, constituted by the banal reverberation of the American environment: reviled by high art, the copy returns. This reversal is not capricious, it does not proceed from a simple denial of value, from a simple rejection of the past; it obeys a regular historical impulse; as Paul Valéry noted (in *Pièces sur l'Art*), the appearance of new technical means (here, photography, serigraphy) modifies not only art's forms but its very concept.

Repetition is a feature of culture. I mean that we can make use of repetition in order to propose a certain typology of cultures. Popular or extra-European cultures (deriving from an ethnography) acknowledge as much, and derive meaning and pleasure from the fact (we need merely instance today's minimal music and disco); Occidental high culture does not (even if it has resorted to repetition more than we suppose, in the baroque period). Pop art, on the other hand, repeats – spectacularly. Warhol proposes a series of identical images (*White Burning Car Twice*) or of images which differ only by some slight variation of colour (*Flowers, Marilyn*). The stake of these repetitions (or of Repetition as a method) is not only the destruction of art but also (moreover, they go together) another conception of the human subject: repetition affords access, in effect, to a different temporality: where the Occidental subject experiences the ingratitude of a world from which the New – i.e., ultimately, Adventure – is excluded, the Warholian subject (since Warhol is a practitioner of these repetitions) abolishes the pathos of time in himself, because this pathos is always linked to the feeling that something has appeared, will die, and that one's death is opposed only by being transformed into a second something which does not resemble the first. For Pop art, it is important that things be 'finite' (outlined: no evanescence), but it is not important that they be finished, that work (is there a work?) be given the internal organization of a destiny (birth, life, death). Hence we must unlearn the boredom of the 'endless' (one of Warhol's first films, **** [*Four Stars*], lasted twenty-five hours; *Chelsea Girls* lasts three and a half). Repetition disturbs the person (that classical entity) in another fashion: by multiplying the same image, Pop art rediscovers the theme of the Double, of the Doppelgänger; this is a mythic theme (the Shadow, the Man or the Woman without a Shadow); but in the productions of Pop art, the Double is harmless – has lost all maleficent or moral power, neither threatens nor haunts: the Double is a Copy, not a Shadow: *beside*, not *behind*: a flat, insignificant, hence irreligious Double.

Repetition of the portrait induces an adulteration of the person (a notion simultaneously civic, moral, psychological, and of course historical). Pop art, it has also been said, takes the place of a machine; it prefers to utilize mechanical processes of reproduction: for example, it freezes the star (Marilyn, Liz) in her image as *star*: no more soul, nothing but a strictly imaginary status, since the star's being is the icon. The object itself, which in everyday life we incessantly personalize by incorporating into our individual world – the object is, according to Pop art, no longer anything but the residue of a subtraction: everything left over from a tin can once we have mentally amputated all its possible themes, all its possible uses. Pop art is well aware that the fundamental expression of the person is style. As Buffon said (a celebrated remark, once known to every French schoolboy): 'Style is the man.' Take away style and there is no longer any (individual) man. The notion of style, in all the arts, has therefore been linked, historically, to a humanism of the person. Consider an unlikely example, that of 'graphism': manual writing,

long impersonal (during Antiquity and the Middle Ages), began to be individualized in the Renaissance, dawn of the modern period; but today, when the person is a moribund idea, or at least a menaced one, under the pressure of the gregarious forces which animate mass culture, the personality of writing is a fading art. There is, as I see it, a certain relation between Pop art and what is called 'script', that anonymous writing sometimes taught to dysgraphic children because it is inspired by the neutral and, so to speak, elementary features of typography. Further, we must realize that if Pop art depersonalizes, it does not make anonymous: nothing is more identifiable than Marilyn, the electric chair, a telegram, or a dress, as seen by Pop art; they are in fact *nothing but that*: immediately and exhaustively identifiable, thereby teaching us that identity is not the person: the future world risks being a world of identities (by the computerized proliferation of police files), but not of persons.

A final feature which attaches Pop art to the experiments of Modernity: the banal conformity of representation to the thing represented. 'I don't want a canvas,' Rauschenberg says, 'to look like what it isn't. I want it to look like what it is.' The proposition is aggressive in that art has always regarded itself as an inevitable detour that must be taken in order to 'render' the truth of the thing. What Pop art wants is to desymbolize the object, to give it the obtuse and matte stubbornness of a fact (John Cage: 'The object is a fact, not a symbol'). To say the object is asymbolic is to deny it possesses a profound or proximate space through which its appearance can propagate vibrations of meaning: Pop art's object (this is a true revolution of language) is neither metaphoric nor metonymic; it presents itself cut off from its source and its surroundings; in particular, the Pop artist does not stand *behind* his work, and he himself has no depth: he is merely the surface of his pictures: no signified, no intention, anywhere. Now the fact, in mass culture, is no longer an element of the natural world; what appears as fact is the stereotype: what everyone sees and consumes. Pop art finds the unity of its representations in the radical conjunction of these two forms, each carried to extremes: the stereotype and the image. Tahiti is a fact, in so far as a unanimous and persistent public opinion designates this site as a collection of palm trees, of flowers worn over one ear, of long hair, sarongs, and languorous, enticing glances (Lichtenstein's *Little Aloha*). In this way, Pop art produces certain *radical images*: by dint of being an image, the thing is stripped of any symbol. This is an audacious movement of mind (or of society): it is no longer the fact which is transformed into an image (which is, strictly speaking, the movement of metaphor, out of which humanity has made poetry for centuries), it is the image which becomes a fact. Pop art thus features a philosophical quality of things, which we may call *facticity: the factitious* is the character of what exists as fact and appears stripped of any justification: not only are the objects represented by Pop art factitious, but they incarnate the very concept of facticity – that by which, in spite of themselves, they begin to signify again: they signify that they signify nothing.

For meaning is cunning: drive it away and it gallops back. Pop art seeks to destroy art (or at least to do without

it), but art rejoins it: art is the counter-subject of our fugue.

The attempt has been made to abolish the signified, and thereby the sign; but the signifier subsists, persists, even if it does not refer, apparently, to anything. What is the signifier? Let us say, to be quick about it: the thing perceived, augmented by a certain thought. Now, in Pop art, this supplement exists – as it exists in all the world's arts.

First of all, quite frequently, Pop art changes the level of our perception; it diminishes, enlarges, withdraws, advances, extends the multiplied object to the dimensions of a signboard, or magnifies it as if it were seen under a jeweller's *loupe*. Now, once proportions are changed, art appears (it suffices to think of architecture, which is an art of the *size of things*): it is not by accident that Lichtenstein reproduces a loupe and what it enlarges: *Magnifying Glass* is in a sense the emblem of Pop art.

And then, in many works of Pop art, the background against which the object is silhouetted, or even out of which it is made, has a powerful existence (rather of the kind clouds had in classical painting): there is an importance of the grid. This comes, perhaps, from Warhol's first experiments: serigraphs depend on textile (textile and grid are the same thing); it is as if our latest modernity enjoys this manifestation of the grid, at once consecrating the raw material (grain of the paper in Twombly's work) and the mechanization of reproduction (micro-pattern of the computer portraits). Grid is a kind of obsession (a thematics, criticism would have said not long ago); it participates in various exchanges; its perceptual role is inverted (in Lichtenstein's aquarium, water consists of polka dots); it is enlarged in a deliberately infantile fashion (Lichtenstein's sponge consists of holes, like a piece of Gruyère); the mechanical texture is exemplarily imitated (again, Lichtenstein's *Large Spool*). Here art appears in the emphasis on what should be insignificant.

Another emphasis (and consequently another return of art): colour. Of course, everything found in nature and *a fortiori* in the social world is coloured; but if it is to remain a factitious object, as a true destruction of art would have it, its colour itself must remain *indeterminate*. Now, this is not the case: Pop art's colours are intentional and, we might even say (a real denial), subject to a *style*: they are intentional first of all because they are always the same ones and hence have a thematic value; then because this theme has a value as meaning: Pop colour is openly chemical; it aggressively refers to the artifice of chemistry, in its opposition to Nature. And if we admit that, in the plastic domain, colour is ordinarily the site of pulsion, these acrylics, these flat primaries, these lacquers, in short these colours which are never shades, since nuance is banished from them, seek to cut short desire, emotion: we might say, at the limit, that they have a moral meaning, or at least that they systematically rely on a certain frustration. Colour and even substance (lacquer, plaster) give Pop art a meaning and consequently make it an art; we will be convinced of this by noticing that Pop artists readily define their canvases by the colour of the objects represented: *Black Girl, Blue Wall, Red Door* (Segal), *Two Blackish Robes* (Dine).

Pop is an art because, just when it seems to renounce

all meaning, consenting only to reproduce things in their platitude, it stages, according to certain methods proper to it and forming a style, an object which is neither the thing nor its meaning, but which is: its signifier, or rather: the Signifier. Art – any art, from poetry to comic strips – exists the moment our glance has the Signifier as its object. Of course, in the productions of art, there is usually a signified (here, mass culture), but this signified, finally, appears in an *indirect* position: obliquely, one might say; so true is it that meaning, the play of meaning, its abolition, its return, is never anything but a *question of place*. Moreover, it is not only because the Pop artist stages the Signifier that his work derives from and relates to art; it is also because this work is *looked at* (and not only seen); however much Pop art has depersonalized the world, platitudinized objects, dehumanized images, replaced traditional craftsmanship of the canvas by machinery, some 'subject' remains. What subject? The one who looks, in the absence of the one who makes. We can fabricate a machine, but someone who looks at it is not a machine – he desires, he fears, he delights, he is bored, etc. This is what happens with Pop art.

I add: Pop is an art of the essence of things, it is an 'ontological' art. Look how Warhol proceeds with his repetitions – initially conceived as a method meant to destroy art: he repeats the image so as to suggest that the object trembles before the lens or the gaze; and if it trembles, one might say, it is because it seeks itself: it seeks its essence, it seeks to put this essence before you; in other words, the trembling of the thing acts (this is its effect-as-meaning) as a pose: in the past, was not the pose – before the easel or the lens – the affirmation of an individual's essence? Marilyn, Liz, Elvis, Troy Donahue are not presented, strictly speaking, according to their contingency, but according to their eternal identity: they have an 'eidos', which it is the task of Pop art to represent. Now look at Lichtenstein: he does not repeat, but his task is the same: he reduces, he purifies the image in order to intercept (and offer) what? its rhetorical essence: here art's entire labour consists not, as in the past, in streamlining the stylistic artifices of discourse, but on the contrary, in cleansing the image of everything in it which is not rhetoric: what must be expelled, like a vital nucleus, is the code essence. The philosophical meaning of this labour is that modern things have no essence other than the social code which manifests them – so that ultimately they are no longer even 'produced' (by Nature), but immediately 'reproduced': reproduction is the very being of Modernity.

We come full circle: not only is Pop art an art, not only is this art ontological, but even its reference is finally – as in the highest periods of classical art – Nature; not of course the vegetal, scenic, or human (psychological) Nature: Nature today is the social absolute, or better still (for we are not directly concerned with politics) the Gregarious. The new Nature is accommodated by Pop art, and moreover, whether it likes it or not, or rather whether it admits it or not, Pop art criticizes this Nature. How? By imposing a *distance* upon its gaze (and hence upon our own). Even if all Pop artists have not had a privileged relation with Brecht (as was Warhol's case during the sixties), all of them practice, with regard to the object, that

repository of the social relation, a kind of 'distancing' which has a critical value. However, less naïve or less optimistic than Brecht, Pop art neither formulates nor resolves its criticisms: to pose the object 'flat out' is to pose the object at a distance, but it is also to refuse to say how this distance might be corrected. A cold confusion is imparted to the consistency of the gregarious world (a 'mass' world); the disturbance of our gaze is as 'matte' as the thing represented – and perhaps all the more terrible for that. In all the (re-) productions of Pop art, one question threatens, challenges: '*What do you mean?*' (title of a poster by Allen Jones). This is the millennial question of that very old thing: Art.

Roland Barthes, 'That Old Thing, Art', Pop Art [Venice, Palazzo Grossi, 1980; reprinted in Roland Barthes, *The Responsibility of Forms: Critical Essays on Music, Art and Representation*, trans. Michael Howard, Berkeley and Los Angeles: University of California Press, 1985] 198-206.

Mike KELLEY
Myth Science [1995]

Happily, Öyvind Fahlström is now starting to be recognized for what he was: one of the most complex artists of the 1960s. While to my mind he is a complete 'original', until recently Fahlström was considered a minor player in the drama of pop art. He was perceived by the champions of pop as, at best, somewhat naïve, and, at worst, a mere throwback to surrealism or agitprop. Why? Well, because he allowed the 'political' to enter his work, because he was interested in issues of narrative, and because his work was compositionally 'busy'. His deviation from pop standards was explained away by the fact that he was European. In America the battle lines were drawn: any hints of the old abstract expressionism, and its distant father, surrealism, would be excised from the serious artwork. Psychoanalytic references were taboo, and social concerns were something quaintly old-fashioned, antiquated matters that concerned Grandpa in the 1930s. Pop art was youth culture formalism. Despite its surface topicality, pop was 'timeless', its images meaningless. Only their compositional position, centralized and uninflected, was important. Pop reflected a world where all meaning was surface meaning – a uniform gloss. You could choose to read this as social commentary, if you were so inclined. It was up to you. But while different critics embraced pop in various ways, one thing was certain: compared to the 'cool' of artists like Warhol and Lichtenstein, Fahlström was 'hot'. Some thought Fahlström was telling a retrograde, anti-pop tale, dressing it up in pop's fashionable clothing.[1]

More recently, the supporters of the agitprop sensibility have championed Fahlström.[2] These critics accept the same divisions, they believe in the same insurmountable chasm dividing the 'formal' from the 'political', but they stand on the 'hot' side. They want Fahlström alongside them, espousing social truths in a popular language aimed at the masses. But Fahlström's work is not as simple as that.

In fact, Fahlström is a formalist of sorts. His arrangements of topical and historical materials have no more narrative coherence than the image combinations of James Rosenquist or Robert Rauschenberg. Fahlström is interested in having his work function optically. By this I mean that he sets things up in such a way that one is prompted to look through the image as 'content' to see it as pure form. His use of the silhouette promotes this effect. Yet, unlike Rauschenberg, for example, Fahlström acknowledges that the viewer always *attempts to* '*read*' a collection of images and make sense of them, and does this in terms of a common – socialized – visual language. His work is overtly about this impulse to read, which he plays with and subverts in various complex ways. The exchange between legibility and opacity produces, he suggests, 'the thrill of tension and resolution, of having both conflict and non-conflict (as opposed to "free form" where in principle everything is equal).'[3] Thus, while Fahlström constructs image constellations that are impossible to read as simple narrative, he strives to keep them from becoming 'noncommittal'.[4] He differentiates his practice in this regard from Rauschenberg's, which, he says, 'tends to neutralize all statements through a pattern of relationships and thus achieves a state of total weightlessness of ... elements'.[5] At the time, there was a tendency to see this 'flattening' as a kind of artistic nihilism, and, in fact, the pop artists were first perceived as neodadaists. Fahlström, by contrast, saw his use of fracture and levelling as 'constructive and thus not Dada at all'.[6]

Fahlström's tactics have more in common with the ambitions of the conceptualists than with those of the pop artists. But while his interest in game strategies as an organizational principle clearly links him to conceptual art, Fahlström's use of popular imagery is inconsistent with most conceptualist practice. Conceptual artists generally kept their distance from material associated with 'low culture', focusing instead on 'informational' forms like photography and typography. Fahlström, however, had little regard for uniformity of style, feeling these kinds of class-based image distinctions were unimportant. For him, style was largely irrelevant apart from the content and experience it could convey. He felt painting should remain 'invisible'; it should be a carrier of meaning and not remain simply self-referential.[7] This indifference to the 'fetishistic' aspect of the artwork led him to conclude that artworks should, preferably, be produced as multiples.[8] Today – in the wake of a neoconceptualist generation that accepts as a given the 'postmodern' plurality of styles – it is easier to see Fahlström's practice as a kind of deconstruction deploying the popular signs which surround us every day, rather than as an exercise in raising 'low' cultural material to the lofty realm of fine art.

This deconstruction is predicated on the construction of an artistic world – in the form of a model. Fahlström's preference is for multipart works, the various elements of which are organized in complex interrelationships that imply system and narration. This tendency inclined his work towards art that had decisive spatial and temporal aspects: work that was *theatrical*. We can see such a turn even in his early abstract paintings, done while he was still

living in Sweden. Pontus Hultén describes Fahlström's presentations of *Ade-Ledic-Nander II* between 1955 and 1957 as a kind of performance. Fahlström would exhibit the painting covered by a sheet with holes cut in it so that only sections were exposed.[9] He would then 'explain' these areas to the assembled company by reading from a thick, typed manuscript that contained his written analysis and 'topographical maps' of the work.[10] He claimed that this presentation in parts prevented the audience from becoming distracted by other elements of the painting during the analytic process. But it was not only the presentation of the painting that was organized in this manner: Fahlström composed it using the same process, covering the part of the canvas he was not working on so as not to be seduced by overall aesthetic considerations or competing details.[11] His method called for the construction of separate cells whose interrelationships were revealed only when the entire work was completed. This compositional technique reflects Fahlström's geopolitical views, which called for urban decentralization and communalism.[12] The overall 'equality' of composition is to be read as democratic, rather than nihilistic and chaotic. Each part is as important as every other part of the painting, but each is considered in turn, first as an autonomous unit, then in relation to the system as a whole. The whole thus becomes more than a sum of its parts, more than a mere compilation.

At this time, Fahlström's pictorial 'signs' were still abstract, recalling, on the surface at least, the pictographic matrixes of some of the late surrealist artists of the 1940s and 50s who came under the influence of Jungian theory (Adolf Gottlieb's work comes to mind).[13] But if we look more closely, their concerns are almost antithetical. Fahlström doesn't offer an array of timeless or 'primitive', archetypal signs, referring to some universal ur-language. His abstract marks are grouped typographically and imbued with specific character traits. These marks interact in the pictorial field in a very specific – and narrative – manner determined by a complex set of gamelike rules. The painting can be read as a kind of model universe, with composition acting as the visual clue allowing us to unravel its 'politics'. Fahlström invented three character-forms that dominate his painting – the Ades, the Ledics, and the Nanders – which he describes as akin to alien 'clans' involved in a struggle for power.[14] Hans Hofmann's 'push-pull' precept[15] is reenvisioned in social terms: compositional tension symbolizes dialectical argumentation. The written narrative accompanying *Ade-Ledic-Nander II* has a sci-fi flavour; its title is derived from a short story by the science fiction writer A. E. van Vogt.[16] Science fiction is a genre where the shift of time is a transparent device; everyone knows that the futures it describes are actually versions of the present illustrated in the terms of a parable.

Easily misinterpreted as ahistorical, Fahlström's abstract pictographs were soon replaced by overtly 'timely' ones. In *Feast on Mad*, a drawing from 1958–59, various graphic elements taken from comic illustrations in the popular satirical *Mad* magazine[17] are decontextualized and rearranged in a chaotic cluster. In *Sitting* (1962), elements taken from DC adventure and superhero comics are

similarly decontextualized (there are recognizable details of Batman's cape). Here, however, the original context is more obvious. The painting is composed in a compartmentalized fashion recalling the sequential frames used in comic book narratives, but presented in such a way that the frames no longer read sequentially. Again, Fahlström's use of the comic book image is not an exercise in high/low displacements (as in Lichtenstein, for example); instead, he plays with temporality and narrative. For Fahlström the comic strip was a narrative form situated halfway between the novel and film,[18] and he was interested in it for this reason, not because it represented kitsch in general. Comic books offered a potentially rich pictorial source reflecting contemporary mythologies, values, and belief systems in clear image tropes comprehensible to the culture at large. By the end of the 1960s, Fahlström was also using photographic images taken from the popular press, both serious and tabloid. Presented in their normal narrative context, these image tropes remain invisible and thus 'natural'. Using a technique similar to collage, Fahlström reveals that these tropes are manufactured, often arbitrarily coded, and thus 'unnatural'. As manmade images, they are politicized; and Fahlström re-presents them as deliberately constructed towards specific social ends. Fahlström's interest in the liquidity of meaning, in image signification defined by context, led him soon after to abandon fixed composition. Shifts of relationship, implied earlier through simultaneous depictions of a sign in various interactions within the visual field, were replaced by a decision to make the various elements in the paintings movable, thus facilitating the possibility of changing *over time*.[19] In *Sitting … Six Months Later* (1962), the elements of the painting have been magnetized and can be moved about, producing a 'variable painting' – a kind of latent kinetic artwork. Fahlström continued to produce variable paintings until his untimely death in 1976 […]

1 See, e.g., Barbara Rose, 'Dada Then and Now', in Steven Henry Madoff, ed., *Pop Art: A Critical History* [Berkeley: University of California Press, 1997] 58 [originally published in *Art International*, January 1963] 23-28.

2 See e.g., Barry Schwartz, *The New Humanism: Art in a Time of Change* [New York: Praeger, 1974] 124: 'Some will argue that Fahlström's art is an oversimplification, that political questions require a more complex analysis. Sure.'

3 Öyvind Fahlström, 'Take Care of the World' [1966], in Thomas M. Messer, *Öyvind Fahlström* [New York: Solomon R. Guggenheim Foundation, 1982] 64.

4 'Obviously, most artworks [neo-Dada, Pop art, conceptual art] use data that are "noncommittal", "unimportant" per se. Will facts about economic exploitation or torture techniques destroy the balance and make the works "propaganda"?' Öyvind Fahlström, 'Propaganda' [1973], in *Öyvind Fahlström: The Installations*, ed. Sharon Avery-Fahlström in cooperation with Eva Schmidt and Udo Kittelmann [Ostfildern: Cantz Verlag, 1995] 78.

5 Öyvind Fahlström, 'Jim Dine' [1963], in John Russell and Suzi Gablik, *Pop Art Redefined* [New York: Praeger, 1969]

67.

6 Öyvind Fahlström, 'Hipy Papy Bthuthdth Thuthda Bthuthdy', from 'Manifesto of Concrete Poetry' [1953], in Messer, *Öyvind Fahlström*, 29.

7 'The painting as a handmade object would then decrease in significance compared with a painting that exists for the experience, the content, that it can convey. Become invisible painting.' Öyvind Fahlström, 'The Invisible Painting' [1960], in *Öyvind Fahlström: The Installations*, 31.

8 Fahlström, 'Take Care of the World', 64.

9 Pontus Hultén, 'Öyvind Fahlström, Citizen of the World' [1979], in Messer, *Öyvind Fahlström*, 106.

10 Öyvind Fahlström, 'Notes on "*Ade-Ledic-Nander II*"' [1955-57] and 'Some Later Developments' [1965], in Messer, *Öyvind Fahlström*, 32; see also Lasse Söderberg, 'Öyvind Fahlström', in Carmen Alborch, *Fahlström* [Valencia: IVAM, Centre Julio González, 1992] 129 [note 19].

11 Hultén, 'Öyvind Fahlström, Citizen of the World', 106.

12 Öyvind Fahlström, 'S.O.M.B.A. [Some of My Basic Assumptions]: Variable Painting 1972-73', in Messer, *Öyvind Fahlström*, 99.

13 Adolf Gottlieb [1903-74] co-founded a group called The Ten with Mark Rothko in 1935. He co-signed, again with Rothko, a notable letter to the *New York Times* in 1943 which declared their commitment to 'tragic and timeless' subject matter and 'spiritual kinship with primitive and archaic art'. In *Surrealism in Exile and the Beginning of the New York School* [Cambridge, Massachusetts: MIT Press, 1995], Martica Sawin notes that 'during 1942 Gottlieb developed the style for which he became known, usually referred to as pictographic' [297]. Influenced by the surrealists, Gottlieb acknowledged his interest in Freud and Jung, but tended to disavow his relation to so-called primitive art.

14 Fahlström, 'Notes on "*Ade-Ledic-Nander II*"' and 'Some Later Developments', 32.

15 Hans Hofmann [1909-66] was a German abstract painter who opened a painting school in New York in 1933. The famous teacher of many of the New York School painters, his theory of 'push and pull' composition is outlined in 'The Search for the Real in the Visual Arts', in Hans Hofmann, *Search for the Real and Other Essays*, ed. Sara T. Weeks and Bartlett H. Hayes, Jr. [Cambridge, Massachusetts: MIT Press, 1986] 40-48.

16 Fahlström, 'Notes on "*Ade-Ledic-Nander II*"', 32.

17 *Mad* magazine was founded by William M. Gaines in 1952.

18 Suzi Gablik, 'Öyvind Fahlström' [1966], in Russell and Gablik, *Pop Art Redefined*, 72.

19 'The factor of time in paintings becomes material through the many, in principle infinite, phases in which the elements appear. As earlier, in my "world" pictures, such as "*Ade-Ledic-Nander*" and "Sitting …" a form would be painted on ten different places on the canvas, now it may be arranged in ten different ways during a period of time.' Öyvind Fahlström, 'Manipulating the World' [1964], in Messer, *Öyvind Fahlström*, 45.

Mike Kelley, 'Myth Science', in *Öyvind Fahlström; The Installations*, ed. Sharon Avery-Fahlström in cooperation with Eva Schmidt and Udo Kittelmann [Ostfildern: Cantz verlag, 1995; reprinted in Mike Kelley, *Foul Perfection: Essays and Criticism*, ed. John C. Welchman, Cambridge, Massachusetts: MIT Press, 2003] 158-64.

SPECTACULAR TIME

As the influence of Pop spread into movies, television, architecture and urbanism, artists were viewed as radical, even revolutionary figures whose actions or statements could undermine and even threaten governments. Art itself as a separate field or discipline was criticized as insufficiently radical, and creativity was bestowed on moments of everyday life and on ordinary people. The humour and irony implicit in the unrealized colossal monuments of Oldenburg was also recognized as a liberating force.

Guy DEBORD
Critique of Separation [1961]

We don't know what to say. Sequences of words are repeated; gestures are recognized. Outside us. Of course some methods are mastered, some results are verified. Often it's amusing. But so many things we wanted have not been attained, or only partially and not like we imagined. What communication have we desired, or experienced, or only simulated? What real project has been lost?

The cinematic spectacle has its rules, its reliable methods for producing satisfactory products. But the reality that must be taken as a point of departure is dissatisfaction. The function of the cinema, whether dramatic or documentary, is to present a false and isolated coherence as a substitute for a communication and activity that are absent. To demystify documentary cinema it is necessary to dissolve its 'subject matter'.

A well-established rule is that any statement in a film that is not illustrated by images must be repeated or else the spectators will miss it. That may be true. But this same type of miscommunication constantly occurs in everyday encounters. Something must be specified but there's not enough time, and you are not sure you have been understood. Before you have said or done what was necessary, the other person has already gone. Across the street. Overseas. Too late for any rectification.

After all the empty time, all the lost moments, there remain these endlessly traversed postcard landscapes; this distance organized between each and everyone. Childhood? Why, it's right here — we have never emerged from it.

Our era accumulates power and imagines itself as rational. But no one recognizes these powers as their own. Nowhere is there any entry to adulthood. The only thing that happens is that this long restlessness sometimes eventually evolves into a routinized sleep. Because no one ceases to be kept under guardianship. The point is not to recognize that some people live more or less poorly than others, but that we all live in ways that are out of our control.

At the same time, it is a world that has taught us how things change. Nothing stays the same. The world changes more rapidly every day; and I have no doubt that those who day after day produce it against themselves can appropriate it for themselves.

The only adventure, we said, is to contest the totality, whose centre is this way of living, where we can test our strength but never use it. No adventure is directly created for us. The adventures that are presented to us form part of the mass of legends transmitted by the cinema or in other ways; part of the whole spectacular sham of history.

Until the environment is collectively dominated, there will be no real individuals — only spectres haunting the objects anarchically presented to them by others. In chance situations we meet separated people moving randomly. Their divergent emotions neutralize each other and reinforce their solid environment of boredom. As long as we are unable to make our own history, to freely create situations, our striving towards unity will give rise to other separations. The quest for a unified activity leads to the formation of new specializations.

And only a few encounters were like signals emanating from a more intense life, a life that has not really been found.

What cannot be forgotten appears in dreams. At the end of this type of dream, half asleep, the events are still for a brief moment taken as real. Then the reactions they give rise to become clearer, more distinct, more reasonable; like on so many mornings the memory of what you drank the night before. Then comes the awareness that it's all false, that 'it was only a dream', that the new realities were illusory and you can't get back into them. Nothing you can hold on to. These dreams are flashes from the unresolved past, flashes that illuminate moments previously lived in confusion and doubt. They provide a blunt revelation of our unfulfilled needs.

Here we see daylight, and perspectives that now no longer have any meaning. The sectors of a city are to some extent decipherable. But the personal meaning they have had for us is incommunicable, as is the secrecy of private life in general, regarding which we possess nothing but pitiful documents.

Official news is elsewhere. Society broadcasts to itself its own image of its own history, a history reduced to a superficial and static pageant of its rulers — the persons who embody the apparent inevitability of whatever happens. The world of the rulers is the world of the spectacle. The cinema suits them well. Regardless of its subject matter, the cinema presents heroes and exemplary conduct modelled on the same old pattern as the rulers.

This dominant equilibrium is brought back into question each time unknown people try to live differently. But it was always far away. We learn of it through the papers and newscasts. We remain outside it, relating to it as just another spectacle. We are separated from it by our own nonintervention. And end up being rather disappointed in ourselves. At what moment was choice postponed? When did we miss our chance? We haven't found the arms we needed. We've let things slip away.

I have let time slip away. I have lost what I should have defended.

This general critique of separation obviously contains, and conceals, some particular memories. A less recognized pain, a less explicable feeling of shame. Just what separation was it? How quickly we have lived! It is to this point in our haphazard story that we now return.

Everything involving the sphere of loss — that is, what I have lost myself, the time that has gone; and disappearance, flight; and the general evanescence of things, and even what in the prevalent and therefore most vulgar social sense of time is called wasted time — all this finds in that strangely apt old military term, *lost children*, its intersection with the sphere of discovery, of the exploration of unknown terrains, and with all the forms of quest, adventure, avant-garde. This is the crossroads where we have found ourselves and lost our way.

It must be admitted that none of this is very clear. It is a completely typical drunken monologue, with its incomprehensible allusions and tiresome delivery. With its vain phrases that do not await response and its overbearing explanations. And its silences.

The poverty of means is intended to reveal the

scandalous poverty of the subject matter.

The events that occur in our individual existence as it is now organized, the events that really concern us and require our participation, generally merit nothing more than our indifference as distant and bored spectators. In contrast, the situations presented in artistic works are often attractive, situations that would merit our active participation. This is a paradox to reverse, to put back on its feet. This is what must be realized in practice. As for this idiotic spectacle of the filtered and fragmented past, full of sound and fury, it is not a question now of transforming or 'adapting' it into another neatly ordered spectacle that would play the game of neatly ordered comprehension and participation. No. A coherent artistic expression expresses nothing but the coherence of the past, nothing but passivity.

It is necessary to destroy memory in art. To undermine the conventions of its communication. To demoralize its fans. What a task! As in a blurry drunken vision, the memory and language of the film fade out simultaneously. At the extreme, miserable subjectivity is reversed into a certain sort of objectivity: a documentation of the conditions of noncommunication.

For example, I don't talk about her. False face. False relation. A real person is separated from the interpreter of that person, if only by the time passed between the event and its evocation, by a distance that continually increases, a distance that is increasing at this very moment. Just as a conserved expression remains separate from those who hear it abstractly and without any power over it.

The spectacle as a whole is nothing other than this era, an era in which a certain youth has recognized itself. It is the gap between that image and its consequences; the gap between the visions, tastes, refusals and projects that previously characterized this youth and the way it has advanced into ordinary life.

We have invented nothing. We adapt ourselves, with a few variations, into the network of possible itineraries. We get used to it, it seems.

No one returns from an enterprise with the ardour they had upon setting out. Fair companions, adventure is dead.

Who will resist? It is necessary to go beyond this partial defeat. Of course. And how to do it?

This is a film that interrupts itself and does not come to an end.

All conclusions remain to be drawn; everything has to be recalculated.

The problem continues to be posed – in continually more complicated terms. We have to resort to other measures.

Just as there was no profound reason to begin this formless message, so there is none for concluding it.

I have scarcely begun to make you understand that I don't intend to play the game.

Guy Debord, *Critique de la séparation*, text of the voice-over soundtrack of Debord's film of the same title [Paris, 1961; trans. Ken Knabb, in Guy Debord, *Complete Cinematic Works*, Oakland, California: AK Press Inc., 2003] 29-39.

Hunter S. THOMPSON
Hell's Angels [1966]

THE DOPE CABALA AND A WALL OF FIRE

[…] The controlled-experiment people felt that public LSD orgies would lead to disaster for their own research. There was little optimism about what might happen when the Angels – worshipping violence, rape and swastikas – found themselves in a crowd of intellectual hipsters, Marxist radicals and pacifist peace marchers. It was a nervous thing to consider even if everybody could be expected to keep a straight head … but of course that was out of the question. With everyone drunk, stoned and loaded, there was nobody capable of taking objective notes, no guides to soothe the flip-outs, no rational spectator to put out fires or hide the butcher knives … no control at all.

People who regularly attended [Ken] Kesey's parties were not so worried as those who'd only heard about them. The enclave was public only in the sense that anyone who felt like it could walk through the gate on the bridge. But once inside, a man who didn't speak the language was made to feel very self-conscious. Acid freaks are not given to voluble hospitality; they stare fixedly at strangers, or look right through them. Many guests were made fearful, and never came back. Those who stayed were mainly the bohemian refugee element, whose sense of interdependence led them to spare each other the focus of their personal hostilities. For that there was always the cops, across the creek, who might come crashing in at any moment.

But even among the Pranksters there was enough uncertainty about the Angels that the first party was noticeably light on LSD. Then, once the threat of violence seemed to fade, there was acid in great profusion. The Angels used it cautiously at first, never bringing their own, but it didn't take them long to cultivate sources on their own turf … so that any run to La Honda was preceded by a general mustering of the capsules, which they would take down to Kesey's and distribute, for money or otherwise.

Once the outlaws accepted LSD as a righteous thing, they handled it with the same mindless zeal they bring to other pleasures. Earlier that summer the consensus was that any drug powerful enough to render a man incapable of riding a bike should be left alone … but when the general resistance collapsed, after several Kesey parties, the Angels began to eat LSD as often as they could get their hands on it – which was often indeed, due to their numerous contacts in the underground drug market. For several months the only limit on their consumption was a chronic shortage of cash. Given an unlimited supply of the acid, probably half the Hell's Angels then extant would have charred their brains to cinders in less than a month. As it was, their consumption pushed the limits of human toleration. They talked of little else, and many stopped talking altogether. LSD is a guaranteed cure for boredom, a malady no less prevalent among Hell's Angels than any other segment of the Great Society … and on afternoons at the El Adobe, when nothing else was happening and there was not much money for beer, somebody like Jimmy or Terry or Skip would show up with the caps and they would all take a peaceful trip to Somewhere Else.

Contrary to all expectations, most of the Angels became oddly peaceful on acid. With a few exceptions, it made them much easier to get along with. The acid dissolved many of their conditioned reflexes. There was little of the sullen craftiness or the readiness to fight that usually pervades their attitude toward strangers. The aggressiveness went out of them; they lost the bristling, suspicious quality of wild animals sensing a snare. It was a strange thing, and I still don't quite understand it. At the time I had an uneasy feeling that it was a lull before the storm, that they weren't really taking enough to get the full effect and that sooner or later the whole scene would be razed by some kind of hellish delayed reaction. Yet there was plenty of evidence that the drug was taking hold. The Angels have no regard for what psychiatrists consider the limits of safe dosage; they doubled and tripled the recommended maximums, often dropping 800 or 1,000 micrograms in a twelve-hour span. Some went into long fits of crying and wailing, babbling incoherent requests to people nobody else could see. Others fell into catatonic slumps and said nothing for hours at a time, then sprang to life again with tales of travelling to distant lands and seeing incredible sights. One night Magoo wandered off in the woods and became panic-stricken, screaming for help until somebody led him back to the light. On another night Terry the Tramp was convinced that he'd died as a person and come back to life as a rooster which was going to be cooked on the bonfire just as soon as the music stopped. Toward the end of every dance he would rush over to the tape recorder, shouting 'NO! No! Don't let it stop!' An outlaw whose name I forget 'skied' down an almost perpendicular two-hundred-foot cliff in full view of the police; everyone cheered as he leaped off the brink and somehow kept his balance while the heels of his boots kicked up huge sprays of dirt. The only outburst of violence involved an Angel who tried to strangle his old lady on Kesey's front steps less than a half hour after swallowing his first – and last – capsule.

My own acid-eating experience is limited in terms of total consumption, but widely varied as to company and circumstances … and if I had a choice of repeating any one of the half dozen bouts I recall, I would choose one of those Hell's Angels parties in La Honda, complete with all the mad lighting, cops on the road, a Ron Boise sculpture looming out of the woods, and all the big speakers vibrating with Bob Dylan's 'Mr Tambourine Man'. It was a very electric atmosphere. If the Angels lent a feeling of menace, they also made it more interesting … and far more alive than anything likely to come out of a controlled experiment or a politely brittle gathering of well-educated truth-seekers looking for wisdom in a capsule […]

Hunter S. Thompson, *Hell's Angels* [New York: Ballantine Books/Random House, Inc., 1966] 233-5.

Andy WARHOL
Nothing to Lose: Interview with Gretchen Berg [1967]

Andy Warhol I'd prefer to remain a mystery; I never like to give my background and, anyway, I make it all different every time I'm asked. It's not just that it's part of my image not to tell everything, it's just that I forget what I said the day before and I have to make it up over again. I don't think I have an image, anyway, favourable or unfavourable. I'm influenced by other painters, everyone is in art: all the American artists have influenced me; two of my favourites are Andrew Wyeth and John Sloan; Oh, I love them, I think they're great. Life and living influence me more than particular people. People in general influence me; I hate just objects, they have no interest for me at all, so when I paint I just make more and more of these objects, without any feeling for them. All the publicity I've gotten … it's so funny, really … it's not that they don't understand me, I think everyone understands everyone, non-communication is not a problem, it's just that I feel I'm understood and am not bothered by any of the things that're written on me: I don't read much about myself anyway, I just look at the pictures in the articles, doesn't matter what they say about me; I just read the textures of the words.

I see everything that way, the surface of things, kind of mental Braille, I just pass my hands over the surface of things. I think of myself as an American artist; I like it here, I think it's so great. It's fantastic. I'd like to work in Europe but I wouldn't do the same things, I'd do different things. I feel I represent the US in my art but I'm not a social critic: just paint those objects in my paintings because those are the things I know best. I'm not trying to criticise the US in any way, not trying to show up any ugliness at all: I'm just a pure artist, I guess. But I can't if I take myself very seriously as an artist: I just hadn't thought about it. I don't know how they consider me in print, though.

I don't paint any more, I gave it up about a year ago and just do movies now. I could do two things at the same time but movies are more exciting. Painting was a phase I went through. But I'm doing some floating sculpture now: silver rectangles that I blow up and that float. Not like Alexander Calder mobiles, these don't touch anything, they just float free. They just had a retrospective exhibition of my work that they made me go to and it was fun: the people crowded in so much to see me or my paintings that they had to take the pictures off the walls before they could get us out. They were very enthusiastic, I guess. I don't feel I'm representing the main sex symbols of our time in some of my pictures, such as Marilyn Monroe or Elisabeth Taylor, I just see Monroe as just another person. As for whether it's symbolical to paint Monroe in such violent colours: it's beauty, and she's beautiful and if something's beautiful it's pretty colours, that's all. Or something. The Monroe picture was part of a death series I was doing, of people who had died by different ways. There was no profound reason for doing a death series, no 'victims of their time'; there was no reason for doing it at all, just a surface reason.

I delight in the world; I get great joy out of it, but I'm not sensuous. I've heard it said that my paintings are as much a part of the fashionable world as clothes and cars: I guess it's starting that way and soon all the fashionable things will all be the same: this is only the beginning. It'll get better and everything will be useful decoration. I don't think there's anything wrong with being fashionable or successful, as for me being successful, well … uhhh … it just gives you something to do, you know. For instance, I'm trying to do a business here at the Factory and a lot of people just come up and sit around and do nothing. I just can't have that, because of my work.

It didn't take me a long time to become successful, I was doing very well as a commercial artist, in fact, I was doing better there than with the paintings and movies which haven't done anything. It didn't surprise me when I made it; it's just work … it's just work. I never thought about becoming famous, it doesn't matter … I feel exactly the same way now I did before … I'm not the exhibitionist the articles try to make me out as but I'm not that much of a hard-working man, either: it looks like I'm working harder than I am here because all the paintings are copied from my one original by my assistants, like a factory would do it, because we're turning out a painting every day and a sculpture every day and a movie every day. Several people could do the work that I do just as well because it's very simple to do: the pattern's right there. After all, there are a lot of painters and draughtsmen who just paint and draw a little and give it to someone else to finish. There are five Pop artists who are all doing the same kind of work but in different directions: I'm one, Tom Wesselmann, whose work I admire very much, is another. I don't regard myself as the leader of Pop art or a better painter than the others.

I never wanted to be a painter; I wanted to be a tap-dancer. I don't even know if I'm an example of the new trend in American art because there's so much being done here and it's so good and so great here, it's hard to tell where the trend is. I don't think I'm looked up to by a large segment of young people, though kids seem to like my work, but I'm not their leader, or anything like that. I think that when I and my assistants attract a lot of attention wherever we go it's because my assistants look so great and it's them that the people are really staring at, but I don't think I'm the cause of the excitement.

We make films and paintings and sculpture just to keep off the streets. When I did the cover for the *TV Guide*, that was just to pay the rent at the Factory. I'm not being modest, it's just that those who help me are so good and the camera when it turns on just focuses on the actors who do what they're supposed to do and they do it so well. It's not that I don't like to speak about myself, it's that there really isn't anything to say about me. I don't talk very much or say very much in interviews; I'm really not saying anything now. If you want to know all about Andy Warhol, just look at the surface: of my paintings and films and me, and there I am. There's nothing behind it. I don't feel my position as an accepted artist is precarious in any way, the changing trends in art don't frighten me, it really just doesn't make any difference; if you feel you have nothing to lose, then there's nothing to be afraid of and I have nothing to lose. It doesn't make any difference that I'm

accepted by a fashionable crowd: it's magic if it happens and if it doesn't, it doesn't matter. I could be just as suddenly forgotten. It doesn't mean that much. I always had this philosophy of: 'It really doesn't matter.' It's an Eastern philosophy more than Western. It's too hard to think about things. I think people should think less, anyway. I'm not trying to educate people to see things or feel things in my paintings; there's no form of education in them at all.

I made my earliest films using, for several hours, just one actor on the screen doing the same thing: eating or sleeping or smoking; I did this because people usually just go to the movies to see only the star, to eat him up, so here at last is a chance to look only at the star for as long as you like, no matter what he does and to eat him up all you want to. It was also easier to make.

I don't think Pop art is on the way out; people are still going to it and buying it but I cannot tell you what Pop art is; it's too involved; it's just taking the outside and putting it on the inside or taking the inside and putting it on the outside, bringing the ordinary objects into the home. Pop art is for everyone. I don't think art should be only for the select few; I think it should be for the mass of American people and they usually accept art anyway. I think Pop art is a legitimate form of art like any other, Impressionism, etc. it's not just a put-on. I'm not the High Priest of Pop art, that is, popular art, I'm just one of the workers in it. I'm neither bothered by what is written about me nor what people may think of me reading it.

I just went to high school, college didn't mean anything to me.

The two girls I used most in my films, Baby Jane Holzer and Edie Sedgwick are not representative of current trends in women or fashion or anything, they're just used because they're remarkable in themselves. *Esquire* asked me in a questionnaire who would I like to have play me and I answered Edie Sedgwick, because she does everything better than I do. It was just a surface question, so I gave them a surface answer. People say Edie looks like me, but that wasn't my idea at all: it was her own idea and I was so surprised: she has blonde short hair, but she never wears dark glasses …

I'm not more intelligent than I appear … I never have time to think about the real Andy Warhol, we're just so busy here … not working, busy playing because work is play when it's something you like.

My philosophy is: every day's a new day. I don't worry about art or life: I mean, the war and the bomb worry me but usually, there's not much you can do about them. I've represented it in some of my films and I'm going to try and do more, such as *The Life of Juanita Castro*, the point of which is it depends on how you want to look at it. Money doesn't worry me, either, though I sometimes wonder where is it? Somebody's got it all! I won't let my films be shown for free. I'm working principally with Ronald Tavel, a playwright, who's written about ten movies for me; he writes the script and I sort of give him an idea of what I want and now he's doing the films as off-Broadway plays.

I don't really feel all these people with me every day at the Factory are just hanging around me, I'm more hanging around *them*. (Oh, those are great pants, where did you

get them? Oh, I think they're so great.) I haven't built up a defence against questions that try to go below the surface, I don't feel I'm bothered that much by people. I feel I'm very much a part of my times, of my culture, as much a part of it as rockets and television. I like American films best, I think they're so great, they're so clear, they're so true, their surfaces are great. I like what they have to say: they really don't have much to say, so that's why they're so good. I feel the less something has to say the more perfect it is. There's more to think about in European films.

I think we're a vacuum here at the Factory: it's great. I like being a vacuum; it leaves me alone to work. We are bothered, though, we have cops coming up here all the time, they think we're doing awful things and we aren't. People try to trap us sometimes: a girl called up here and offered me a film script called *Up Your Ass* and I thought the title was so wonderful and I'm so friendly, that I invited her to come up with it, but it was so dirty that I think she must have been a lady cop. I don't know if she was genuine or not but we haven't seen her since and I'm not surprised. I guess she thought that was the perfect thing for Andy Warhol. I don't resent situations like that but I'm not interested in subjects like that, that's not what I'm pushing, here in America. I'm just doing work. Doing things. Keeping busy. I think that's the best thing in life: keeping busy.

My first films using the stationary objects were also made to help the audiences get more acquainted with themselves. Usually, when you go to the movies, you sit in a fantasy world, but when you see something that disturbs you, you get more involved with the people next to you. Movies are doing a little more than you can do with plays and concerts where you just have to sit there and I think television will do more than the movies. You could do more things watching my movies than with other kinds of movies: you could eat and drink and smoke and cough and look away and then look back and they'd still be there. It's not the ideal movie, it's just my kind of movie. My films are complete in themselves, all 16mm, black and white, me doing my own photography, and the 70-minute ones have optical sound which is rather bad which we will change when we get a regular sound tape-recorder. I find editing too tiring myself. Lab facilities are much too tacky and uncertain, the way they are now. They're experimental films; I call them that because I don't know what I'm doing. I'm interested in audience reaction to my films: my films now will be experiments, in a certain way, on testing their reactions. I like the filmmakers of the New American Underground Cinema, I think they're terrific. An Underground Movie is a movie you make and show underground, like at the Film Maker's Cinémathêque on 41 St. I like all kinds of films except animated films, I don't know why, except cartoons. Art and film have nothing to do with each other: film is just something you photograph, not to show painting on. I just don't like it but that doesn't mean it's wrong. Kenneth Anger's *Scorpio Rising* interested me, it's a strange film ... it could have been better with a regular sound track, such as my *Vinyl*, which dealt with somewhat the same subject but was a sadism-masochism film. *Scorpio* was real but *Vinyl* was real and not real, it was just a mood.

I don't have strong feelings about sadism and masochism, I don't have strong feelings on anything. I just use whatever happens around me for my material. I don't collect photographs or articles for reference material, I don't believe in it. I used to collect magazine photographs for my paintings, though.

The world fascinates me. It's so nice, whatever it is. I approve of what everybody does: it must be right because somebody said it was right, I wouldn't judge anybody. I thought Kennedy was great but I wasn't shocked at his death: it was just something that happened. (Why do you look like a cowboy today, with that neckerchief?) It isn't for me to judge it. I was going to make a film on the assassination but I never did. I'm very passive. I accept things. I'm just watching, observing the world. Slavko Vorkapich was just telling you how to make movies his way, that's why I sold my ticket after going to the Museum of Modern Art to his first lecture.

I plan to do some more films soon, in 35mm: perhaps an autobiography of myself. My newest film is *The Bed*, from a play by Bob Heidy that played at the Café Cino, in which we'll use a split screen, one side static of two people in bed and the other, moving, of the lives of these two for two years. All my films are artificial, but then everything is sort of artificial, I don't know where the artificial stops and the real starts. The artificial fascinates me, the bright and shiny ...

I don't know what will happen to me in ten years ... the only goal I have is to have a swimming pool in Hollywood. I think it's great, I like its artificial quality. New York is like Paris and Los Angeles is so American, so new and different and everything is bigger and prettier and simpler and flat. That's the way I like to see the world. (Gerard, you should get a haircut, that style doesn't suit you at all.) It's not that I've always been looking for a kind of Los Angeles paradise; I wouldn't be taken over by Hollywood, I'd just do what I always like to do. Or something. (Oh, hi, David.)

My Hustler was shot by me, and Charles Wein directed the actors while we were shooting. It's about an ageing queen trying to hold on to a young hustler and his two rivals, another hustler and a girl; the actors were all doing what they did in real life, they followed their own professions on the screen. (Hello, Barbara.) I've been called: 'Complex, naïve, subtle and sophisticated' – all in one article! They were just being mean. Those are contradictory statements but I'm not full of contradictions. I just don't have any strong opinions on anything. (Hi, Randy.) It's true that I don't have anything to say and that I'm not smart enough to reconstruct the same things every day, so I just don't say anything. I don't think it matters how I'm appreciated, on many levels or on just one. The death series I did was divided into two parts: the first on famous deaths and the second on people nobody ever heard of and I thought that people should think about them sometime: the girl who jumped off the Empire State Building or the ladies who ate the poisoned tunafish and people getting killed in car crashes. It's not that I feel sorry for them it's just that people go by and it doesn't really matter to them that someone unknown was killed so I thought it would be nice for these unknown people to be remembered by those who, ordinarily, wouldn't think of

them. (Oh, hi, Paul.) I wouldn't have stopped Monroe from killing herself, for instance; I think everyone should do whatever they want to do and if that made her happier, then that's what she should have done. (There's something burning here, I think. Don't you smell something?) In the eight heads I did of Jacqueline Kennedy in the death series, it was just to show her face and the passage of time from the time the bullet struck John Kennedy to the time she buried him. Or something. The United States has a habit of making heroes out of anything and anybody, which is so great. You could do anything here. Or do nothing. But I always think you should do something. Fight for it, fight, fight. (There is something burning here! Danny, will you please get up? You're on fire! Really, Danny, we're not kidding now. *Now* will you get up? I mean, really, Danny, it's not funny. It's not even necessary. I *knew* I smelt something burning!) That was one of my assistants; they're not all painters, they do everything: Danny Williams used to work as a sound man for the film-making team of Robert Drew and Don Alan Pennebaker, Paul Morrissey is a film-maker and Gerard Malanga, a poet. We're going into show business now, we have a rock and roll group called The Velvet Underground, they practice at the Factory. I'm in their act, I just walk on in one scene. But anybody who comes by here is welcome, it's just that we're *trying* to do some *work* here ...

I think the youth of today are terrific; they're much older and they know more about things than they used to. When teenagers are accused of doing wrong things, most of the time, they're not even doing wrong things, it was just other people who thought they were bad. The movies I'll be doing will be for younger people; I'd like to portray them in my films, too. I just tore out an article about the funeral of one of the motorcycle gang leaders where they all turned up on their motorcycles and I thought it was so great that I'm going to make a film of it one day. It was fantastic ... they're the modern outlaws ... I don't even know what they do ... what *do* they do?

I think American women are all so beautiful, I like the way they look, they're terrific. The California Look is great but when you get back to New York you're so glad to be back because they're stranger looking here but they're more beautiful even, the New York Look. I read an article on me once that described my machine-method of silk-screen copying and painting: 'What a bold and audacious solution, what depths of the man are revealed in this solution!' What does *that* mean? My paintings never turn out the way I expect them to but I'm never surprised. I think America is terrific but I could work anywhere – anywhere I could afford to live. When I read magazines I just look at the pictures and the words, I don't usually read it. There's no meaning to the words, I just feel the shapes with my eye and if you look at something long enough, I've discovered, the meaning goes away ... the film I'm working on now is a 70-minute aria with the Puerto Rican female impersonator, Mario Montez, called *Mr Stompanato*. I think the questions usually asked me in interviews should be more clever and brighter, they should try to find out more about me. But I think newspaper reporting is the only way to write because it tells what's happening and doesn't give anyone's

opinion. I always like to know 'what's happening'.

There's nothing really to understand in my work. I make experimental films and everyone thinks those are the kind where you see how much dirt you can get on the film, or when you zoom forward, the camera keeps getting the wrong face or it jiggles all the time: but it's so easy to make movies, you can just shoot and every picture really comes out right. I didn't want to paint anymore so I thought that the way to finish off painting for me would be to have a painting that floats, so I invented the floating silver rectangles that you fill up with helium and let out of your window … I like silver … and now we have a band, the Velvet Underground, who will belong to the biggest discothêque in the world, where painting and music and sculpture can be combined and that's what I'm doing now.

Interviews are like sitting in those Ford machines at the World's Fair that toured you around while someone spoke a commentary; I always feel that my words are coming from behind me, not from me. The interviewer should just tell me the words he wants me to say and I'll repeat them after him. I think that would be so great because I'm so empty I just can't think of anything to say.

I still care about people but it would be so much easier not to care … it's too hard to care … I don't want to get too involved in other people's lives … I don't want to get too close … I don't like to touch things … that's why my work is so distant from myself …

Gretchen Berg, 'Andy Warhol: Nothing to Lose', interview published in *Cahiers du Cinéma in English* [New York, 1967; French trans. *Cahiers du Cinéma*, Paris, October 1968]. Pre-publication typescript from the Archives of The Andy Warhol Museum, Pittsburgh; Founding Collection, Contribution The Andy Warhol Foundation for the Visual Arts, Inc.

Gregory BATTCOCK
Four Films by Andy Warhol
[1967]

Potentially the most influential of the New York filmmakers is Andy Warhol, a comparative newcomer to cinema, to which he turned only after having acquired a considerable reputation in the plastic arts. The early films of this artist were deceptively simple: they had a minimum of content and were made with a minimal technique. Warhol first became well known as a filmmaker for his use of the still image – the device whereby the action of the screen is reduced to small variations in the posture of a single image. Action is even further reduced, in most of Warhol's films made prior to 1965, by the filmmaker's refusal to move the camera. And it may not be far-fetched to draw an analogy between this film approach, on the one hand, and the approach towards painting followed by the Minimal painter, on the other, in which attitudes towards the surface, the shape of the canvas, and scale and proportion are criticized.

Early Warhol movies emphasized the cinema as a medium for experiencing time, rather than movement or event. They include *Empire*, made by focusing a camera on the Empire State Building for several hours, and *Sleep*, which applied the same technique to the subject of a sleeping man. In this period, Warhol made scarcely more effort to direct the action (or inaction) when making films with waking human actors than when working with a building or an 'actor' who was fast asleep. Thus *Henry Geldzahler*, *The Thirteen Most Beautiful Boys*, *Eat*, and *Haircut*, the titles of which precisely delineate their contents, are essentially similar to *Empire* and *Sleep*. The following observations on *Empire* can be applied, with only slight modifications, to all the other films in this group.

Since it may be assumed that the first purpose of *Empire* is to present the essential character of film as a medium, it may then be asked why wasn't a blank or exposed film simply run through the projector? Simply because, while doing so might suffice as a provocative statement, the use of plain film, which is uniform in colour, would make impossible the exhibition of contrast and gradations between black and white; and the black-and-white dialectic is probably the second most important restriction and distinction of the film medium. The decision to film *an object* thus made possible the presentation of the full range of tones from black to white. It might be argued here that filming a block of wood could certainly present the full range (black, white, grey) of tones. Why, then, was the Empire State Building used?

If a block of wood were filmed, the audience would be forced to consider that block of wood as *art*, as sculpture – junk or 'found', Abstract Expressionist or Dada; a concern that would be irrelevant to the purposes, or subject, of the movie. The choice of the Empire State Building seems logical. It's not some faceless building in Queens that demands identification or clarification, nor is it a building from which any aesthetic pleasure or stimulation can be gained (at least not at this time). It is, simply, a big nothing – perhaps the biggest nothing, except for the Pan Am Building, around. It's better known, more familiar, seemingly more permanent than the newer colossus uptown. It's New York, America – yet not a monument like the Statue of Liberty with which one can identify emotionally, either in glorification or vilification.

As if to emphasize that the selection of the Empire State Building is primarily a device by which to present the full range of tones from black to white, the first reel of this long (eight-hour) movie shows the dramatic change of all the original darks or blacks to lights, and the original lights gradually moving through the entire spectrum to blacks. During the first fifteen minutes the image of the building is obscured almost entirely by fog. This provides a dramatic beginning, and one that acknowledges traditional methods of film art. It recalls the first appearance of Garbo in *Anna Karenina*, when the face of the actress is almost totally obscured by steam from a train. Dramatic evolution is confined to the first reel, leaving the rest of the film free to concentrate on a more important limitation of the medium.

In this work Warhol has clearly dismissed the idea that 'movement' is an essential characteristic of movies. Movement can, after all, be presented and experienced in other media – the dance, theatre, now even sculpture – so Warhol has chosen not to deal with it in the film essay on the re-identification of the essential message of cinema. Sound is dispensed with also, and its absence is consistent with the object photographed, since the Empire State Building does not, *qua* building, make noise.

Silence has been dramatically employed in films almost since sound became available. Generally, sound has been erased from portions of films to heighten the dramatic impact of certain scenes, such as the mirror scene in the Marx Brothers film *Duck Soup* (1933). The documentary, or non-fiction character of *Empire* is not altered by the absence of sound, and its message is appropriate to the electronic age. Black and white and everything in between is one subject of this film. Another, even more important, is time.

Warhol's decision to film the slow passing of dusk and night emphasizes the importance that he as artist gives to the element of time. In commercial films events are rarely presented in their full time span. Time is distorted in such films – usually by compression. The time in *Empire* is distorted in a different way. It is distorted, perhaps, simply by its *not* being distorted when one would reasonably expect it to be. In addition, the action in the first reel is clearly speeded up, possibly so that the change from day to night, the major 'event' in the film, could be summarily disposed of in order to clear the way for the timeless 'real' time of the unchanging image of the building. Time is perhaps the most important single element that distinguishes film from the other visual art forms. In looking at still objects, the viewer chooses his own time. In dance and the theatre, time is, to some extent, controlled by the director and performers. Warhol then, may not force the viewer to look at his films – in which case there is only one thing left to do, and that is, to sit through them.

The intellectual content of *Empire* clearly overshadows the visual, and the exaggerated time element is in opposition to the 'telescoping' of incidents typical of the commercial cinema. In *Empire* and his other early films, Warhol reexamines communicative procedures in art. In so doing, he has focused upon the very *presence* of the art object itself in a way that recalls modern handling of some commercial products. Indeed, the presence of an object, and its intrusion upon the audience, or consumer, is receiving renewed attention in several areas. Recent advertisements for a new television set read: 'New Westinghouse Jet Set. Doesn't stare back at you. It's considerate television.' In film, of course, the time is decided by the film – that is, by the filmmaker. The projector runs at a predetermined speed; the projectionist is not yet an artist.

The subject of *Empire* is, then, an investigation of the presence and character of film – a legitimate if not a requisite concern for the artist. And the terms established for this investigation are the black and white of film technology and the obvious, yet frequently denied, limitation of time.

Empire is now a classic of the avant-garde. In a short period it has received extraordinary acceptance, which suggests it appeared at the right moment. Whatever influence it may have had, film will not be quite the same again. Neither, perhaps, will the Empire State Building.

From the deadpan 'new realism' just described, with its mind-destroying concentration on insignificant incidents and situations, Warhol has recently moved on to more explicit ironics.

In *Horse* Warhol produced an apparently straightforward parody of the traditional Western – complete with oppressed Mexican (played by Tosh Carrillo), sheriff, boy outlaw, and cowboy – that yet succeeds in revealing the disguised eroticism of the genre. Ron Tavel, who wrote and directed *Horse* and *Vinyl*,' also wrote *Screen Test* (with Mario Montez) – a transitional work in both form and content. It is one of the first of Warhol's sound films, yet the still camera is retained.

In *Screen Test*, as in other still-image pictures, slight variations of image become all the more important because of their scarcity. Presence of the Abstract Expressionist sensitivity heightens their impact and therefore makes the films much more interesting. The strong black-and-white contrasts in *Screen Test* demand a consideration of the flat negative-positive values of the surface, and as in a painting by Franz Kline, it is uncertain whether it is a line or a plane, a white picture on a black ground or a black on white – and it doesn't really matter. The usual half-tone pictorial characteristics seem somehow absent from the picture and bring the picture more towards painting; at the same time the film limitations, which give the work its identity, are not denied.

A single actor, 'in drag', is shown on the screen for the entire duration of *Screen Test*. Mario Montez is certainly at his best here, for he seems to expose himself utterly in this new revelation of the duality of acting and experience. In effect, the experience cannot be separated from the acting, and the question of determining whether or not Montez is actually acting is thrust upon the audience. His totally convincing performance is heightened by the rather sloppily applied make-up and wig, which speak of Genet and Greenwich Avenue in a startlingly real and cruel manner. And if the wig, make-up, and sex are distortions, so also is the length of the screen test – seventy minutes.

The sound of *Screen Test* consists of two voices: the off-stage voice of Ron Tavel commands the actor to repeat over and over certain words and phrases self-consciously chosen and frequently vulgar and juvenile; Montez does so with embarrassed distaste.

The burden of appreciating the film rests squarely on the audience. The audience, never catered to, is abused, exposed, and ridiculed. It is, at the same time, very much considered. The use of film as a device to torment its audience may be understood as an intellectual challenge; certainly it forces an alert viewer to come to new terms with art. The popular value structure is shattered and not in the terms of the value structure. When engaged in the protest and destruction that is art, Warhol does not subscribe to the notion that calls for the toppling of the old order within the terms of the older order. By demonstrating consistent respect for his medium, he will challenge the existing order on all levels, using his own terms, even though they will be unacceptable to most people and delay acceptance of his art. Quick acceptance of a statement which attempts to subvert within the conditions and restrictions of the status quo and

according to its lexicon is to be expected, even though that statement must ultimately be false. If *Sleep* or *Empire* were films to turn on to, *Screen Test* is actively interesting because the viewer is forced into an immediate and not altogether unfamiliar involvement.

As has already been intimated, the actual subject of all Warhol's early movies is film itself and its attendant hypocrisies. *Screen Test* is no exception, though its apparent subject may be transvestism. Here too the intellectual content dominates the visual; the film apes Hollywood and movies in general. In presenting these disturbing challenges to the nature of the medium, Warhol hinders understanding and sympathy by his choice of vehicle. However, sexual dualism as represented on the screen can be taken as further proof of Warhol's intent to unmask the sexual fraud of the contemporary cinema. The usual presentation of sex is a product of the art of packaging technology and it is illusion, façade and gesture that we buy and that Montez's posturing lays bare.

Representative of the next stage in Warhol's development as a cinematic artist is *Kitchen*, a film noteworthy for the changes it introduces in the concept of the 'superstar', a concept that Warhol is credited with contributing to the iconography of the underground cinema. In the introduction of this latest device, Warhol consciously refers, yet again, to the basic structure of the professional Hollywood cinema. This time the star system itself becomes the subject of scrutiny. In the early still-image movies, the so-called superstar was the sole figurative element recognizable on the screen. More recently, as critical attention has been directed to attempts to identify and license the superstar, Warhol has been engaged in changing the use and presentation of the whole idea. The changes can be seen moving in several directions. Peculiarities of the set, props, script, and audio elements are exploited in a levelling-off process that, in *Kitchen*, acts as a bridge between the earlier films and such new works as *The Chelsea Girls*. Paradoxically, the real superstar in *Kitchen* is the least obtrusive, and the one who behaves mostly like a prop. His participation in the film is less than marginal, and many of the props are assigned a more aggressive role. Though he is always on the set, only at the end of the film is the non-super superstar (played by René Ricard) allowed genuine human identity as he socializes on an equal level with the other people in the film. Here Warhol is obviously trying to equalize in prominence all figurative elements – both figures and objects. Thus the resultant redistribution of emphasis is of a type associated with painting. If the characteristic feature of the superstar in *Kitchen* is seen as a confusion of identity on one hand, coupled with a questioning of traditional patterns of communication on the other, then the real superstar is the most silent and inanimate one […]

1 Starring Carrillo and Edie Sedgwick.

Gregory Battcock, 'Four Films by Andy Warhol', *The New American Cinema* [New York: E.P. Dutton, 1967] 233–52.

Dan GRAHAM
Oldenburg's Monuments
[1968]

With the boom in proposals for public monuments recently, architectural critics continue to view the monument as something suspect. 'Spurious and over-simplified; at best hollow; at worst a mockery,' writes Ada Louise Huxtable. And the only major monument project undertaken lately by an architect of reputation, Philip Johnson's proposed monument to immigration on abandoned Ellis Island, could easily be read as camp. It is planned to consist of a cylindrical building resembling an open, hollowed-out, truncated 'column' three hundred feet in diameter and one hundred and thirty feet high with the names of the sixteen million immigrants who had passed engraved upon its walls. Adjacent to this *Wall of Sixteen Million*, the monument site would also consist of the 'stabilized ruins' of the old administration buildings, planted with vines growing over and through the gutted, empty structures. (Emily Genauer thinks that '*The Wall of Sixteen Million* doesn't sound like the beginning of life. It sounds, rather, like death. It recalls the listing of names on the monuments in Europe and Israel to those who died in concentration camps. There is nothing at all to memorialize at Ellis Island on an oversized gas tank – horrid association – or the vine-shrouded ruins of ugly administration buildings.')'

While Johnson's 'decadent' proposal is perhaps half-consciously camp, the 'unconscious' *naïveté* of Claes Oldenburg's *Monument to Immigration*, consisting of a reef to be placed in the centre of New York Harbour, is calculated 'naturally' so that as time passes 'wreck after wreck (should) occur until there was a huge pile of rusty and broken ship hulls'. Two versions of a monument for Ellis Island proposed by Oldenburg, one of a giant shrimp and the other a giant frankfurter, parody the shape of these 'ships that pass down the Hudson into the Bay'.

More than food, the universal element in Oldenburg's monuments is usually sex, which he views as the underlying (or overlying) basis for monumentality in a group of 'geo-pornographic' projections. One of these, a *Ski Jump Monument* set on a hill near Oslo, seems to recall the form of early menhirs, which had their origins as phallic cult objects in early religion. Its general appearance is of a 'saucer-shaped front of a penis set on end like a radar receiver. In the centre is an oval hole through which the sky is visible, and an enormous tear-shaped form … at a distance … would seem to be a drop of sperm at the bottom of the hill'. The earth mound (the earliest known form of monument) represented a symbolic womb of 'Mother Earth' and dated from the time when Man viewed himself as both immanent and integral to Nature's 'workings'. Oldenburg's *Underground Drainpipe* – a symbolic vagina – alludes to the archetype. 'From above ground', the artist writes, the monument would appear to be a 'large rectangular area that is kept always well cultivated. In the centre is a little hole, almost

unnoticeable, like a golf-hole. If you lie on your stomach on the grass (you can) look down into the hole about eight hundred feet to the bottom of the underground drainpipe … (It) was conceived as a tomb.'

The advent of the early civilizations of Sumer and Egypt saw the transformation of the earth *mound* into a phallic *spire*, initially a ziggurat and then a pyramid. As Man's aspirations were now directed towards transcendence of the forces of Nature, so he conceived of his new monuments as symbolic 'bridges' enabling transport to a 'higher' world than earth after his death. Man's attitude had become more grasping as well as he sought now wilfully to subjugate and appropriate Nature's 'treasures': the so-called 'rape of nature'. Oldenburg's *Door Handle and Lock for Stockholm* projects upon the landscape – represented as an immense locked door in the process of being opened by the monument – a giant key symbolically screwed into the earth. The myth is as the projection of Man's sexual relations with a hypostatized 'Nature', and monuments – meant to be imposing – would be symbolic 'erections' representing the wilfull imposition of man's (societal) 'organ' on the 'body' of 'Mother Nature'.

Life for civilized man had become more of a struggle; making a living was termed labour. A lust for life – part of his newly aspired-to 'stature' – found satisfaction in the laying bare of Nature's 'secrets' for mankind's exploitative use. Oldenburg's *Leg Monument for the Thames Estuary at Low Tide* is an enormous human leg striding upon the 'face' of the landscape symbolizing this 'stance'. Man's reach, unfortunately, was fated always to exceed his grasp ('the impossible dream') as he didn't quite possess the tools or knowledge to gain complete (Faustian) mastery.

A similar attitude in the Romantic Era came to be applied to the artist's work life. Laying claim to the secrets of Nature's inner workings through a privileged inner vision, he struggled to wrest from life a unique meaning. She was the raw material needing completion. The artist in turn felt completed by his work, which connected him in some mysterious way to the source of life. (Sometimes, paradoxically, this even involved identification with Nature; for instance, in the 'creative process' where, through a 'labour of love', he would give 'birth' to the finished work of art.)

Death, the inseparable twin of life, idolized by the Romantics, traditionally has been memorialized by the type of grandiose monument which Oldenburg's *Sullivan Tomb* parodies. One of six proposals for the city of Chicago (where his drawings and models for monuments were recently exhibited in the new Museum of Contemporary Art), the tomb is a mock memorial to one of the city's Great Men, Louis Sullivan. The Tomb is based on the anecdote 'that he spent the final years of his life sleeping on the floor of a small closet under a bare light bulb'. It is designed as a simple monolith with a shadowing overhang (like the left wing of the Chicago Art Institute). Inside would be a 'gigantic six-hundred foot lying figure of Sullivan, in brown metal … (which at first sight would) seem to be a mountain', and complex, 'painstaking reproductions in metal and concrete, of the Master's works' illuminated by 'a dim light' emanating from 'an enormous light bulb of the ordinary kind, in the heights of the space'.

Apposite to the Tomb is the *Fallen Hat Monument* in memory of Adlai Stevenson, whose non-memorable modern death is represented as a modest moment. 'It would be a small obstacle on the street … [close to where Stevenson] fell near Grosvenor Square. The London streets have twenty-four inch rectangular stones. The fallen hat is set into such a rectangle. It would be a modest-size monument for anyone who died on the street.'

The traditional monument, as distinguished from all other things that are present, has been meant to endure forever. However, Oldenburg has altered this in proposals for temporary or semi-permanent monuments, which, rather than attempting to 'withstand' or 'make their mark on' Nature, are temporal through their contingent interrelationship with a specific environment. An example is a giant copper ball proposed for the River Thames in London, 'based on the form of a toilet float which is connected by a long rod to the centre of one of the bridges' of this dirty river and would rise and fall with the going out and coming in of the approximately sixteen-foot tides. Oldenburg's 'obstacle' monuments, such as the *Monument to Immigration* and his 1965 five-hundred-ton solid concrete *War Memorial* designed for the intersection of Canal Street and Broadway in New York City, are unnatural intrusions causing the 'natural' to function 'unnaturally' in a 'natural' way. By blocking the intersection of the four streets, the *War Memorial*, by precipitating their occurrence, *a priori* memorializes 'natural calamities' such as war.

When asked for a work by a committee which exhibited outdoor sculpture in various sites in the city of New York this fall, Oldenburg originally proposed the creation of a massive traffic jam which would be programmed by parking buses at a number of intersections – somewhat analogous to his *War Memorial*. It was finally decided that he do a more temporary monument, nearly instantaneous in fact and invisible after its completion. A six-by-six foot grave was dug and immediately covered by professional grave diggers on a selected site in Central Park, the artist's medium being earth.[2] The *Moving Bat* proposal for Chicago, instead of using 'invisibility' literally, uses it as metaphoric hyperbole in the Ripley 'believe it or not' style: '*The Bat* is a cone-shaped metal form about the height of the former Plaza Hotel, placed with the narrower end down at the south-east corner of North Avenue and Clark Street. *The Bat* is kept spinning at an incredible speed, so fast it would burn one's fingers up to the shoulders to touch it. However, the speed is invisible and to the spectators the monument appears to be standing absolutely still.'

1 Johnson's other government project is a memorial to the late President John F. Kennedy, to be built of concrete in a park a short distance from where Kennedy was assassinated in Dallas, Texas. Mrs Kennedy had asked for something 'simple, modest and dignified'; a simple monument composed of seventy-two upright slabs of pre-cast concrete – roughly booth-shaped – is proposed. It will be fifty feet square and thirty feet high.

2 A sculpture by Carl Andre consisted of a conical pile of sand 'composed' with gravity [and with levity] when the sand was dropped by the artist from directly above what

would be [in context] a grave site. The element of time would 'decompose' the sculpture, just as the 'body' [buried beneath] disintegrates into invisibility. Sol LeWitt's proposal for an as yet unconsummated outdoor exhibition of 'earth-moving' would be entirely invisible. It would consist of a buried cube containing something unseen – accomplishing nothing and burying the issue [of monumentality] forever.

Dan Graham, 'Oldenburg's Monuments', *Artforum*, 6:5 [New York, January 1968; reprinted in Rudi H. Fuchs and Benjamin H.D. Buchloh, eds, *Dan Graham Articles*, cat., Eindhoven: Stedelijk Van Abbemuseum, 1977].

HELTER SKELTER

Writing on Pop itself became extravagantly Pop in the 'New Journalism' of Tom Wolfe ('The Kandy-Kolored Tangerine Flake Streamline Baby'), Hunter S. Thompson ('Hell's Angels') and Nik Cohn ('Awopbopaloobopalopbamboom'). As the artists were so articulate about their own work, and as art historians were constitutionally not attuned to the network of references to be drawn between architecture, film, music, fashion and ephemera, more serious appraisal has had to wait for the era of 'cultural studies'.

Tom WOLFE
The Kandy-Kolored Tangerine Flake Streamline Baby [1965]

LAS VEGAS

[...] Las Vegas is the only town in the world whose skyline is made up neither of buildings, like New York, nor of trees, like Wilbraham, Massachusetts, but signs. One can look at Las Vegas from a mile away on Route 91 and see no buildings, no trees, only signs. But such signs! They tower. They revolve, they oscillate, they soar in shapes before which the existing vocabulary of art history is helpless. I can only attempt to supply names — Boomerang Modern, Palette Curvilinear, Flash Gordon Ming-Alert Spiral, McDonald's Hamburger Parabola, Mint Casino Elliptical, Miami Beach Kidney. Las Vegas' sign makers work so far out beyond the frontiers of conventional studio art that they have no names themselves for the forms they create. Vaughan Cannon, one of those tall, blond Westerners, the builders of places like Las Vegas and Los Angeles, whose eyes seem to have been bleached by the sun, is in the back shop of the Young Electric Sign Company out on East Charleston Boulevard with Herman Boernge, one of his designers, looking at the model they have prepared for the Lucky Strike Casino sign, and Cannon points to where the sign's two great curving faces meet to form a narrow vertical face and says:

'Well, here we are again — what do we call that?'

'I don't know,' says Boernge. 'It's sort of a nose effect. Call it a nose.'

OK, a nose, but it rises sixteen stories high above a two-story building. In Las Vegas no far-seeing entrepreneur buys a sign to fit a building he owns. He rebuilds the building to support the biggest sign he can get up the money for and, if necessary, changes the name. The Lucky Strike Casino today is the Lucky Casino, which fits better when recorded in sixteen stories of flaming peach and incandescent yellow in the middle of the Mojave Desert. In the Young Electric Sign Co. era signs have become the architecture of Las Vegas, and the most whimsical, Yale-seminar-frenzied devices of the two late geniuses of Baroque Modern, Frank Lloyd Wright and Eero Saarinen, seem rather stuffy business, like a jest at a faculty meeting, compared to it. Men like Boernge, Kermit Wayne, Ben Mitchem and Jack Larsen, formerly an artist for Walt Disney, are the designer-sculptor geniuses of Las Vegas, but their motifs have been carried faithfully throughout the town by lesser men, for gasoline stations, motels, funeral parlours, churches, public buildings, flophouses and sauna baths.

Then there is a stimulus that is both visual and sexual — the Las Vegas buttocks décolletage. This is a form of sexually provocative dress seen more and more in the United States, but avoided like Broadway message-embroidered ('Kiss Me, I'm Cold') underwear in the fashion pages, so that the euphemisms have not been established and I have no choice but clinical terms. To achieve buttocks décolletage a woman wears bikini-style shorts that cut across the round fatty masses of the buttocks rather than cupping them from below, so that the outer-lower edges of these fatty masses, or 'cheeks', are exposed. I am in the cocktail lounge of the Hacienda Hotel, talking to managing director Dick Taylor about the great success his place has had in attracting family and tour groups, and all around me the waitresses are bobbing on their high heels, bare legs and décolletage-bare backsides, set off by pelvis-length lingerie of an uncertain denomination. I stare, but I am new here. At the White Cross Rexall drugstore on the Strip a pregnant brunette walks in off the street wearing black shorts with buttocks décolletage aft and illusion-of-cloth nylon lingerie hanging fore, and not even the old mom's-pie pensioners up near the door are staring. They just crank away at the slot machines. On the streets of Las Vegas, not only the show girls, of which the town has about two hundred fifty, bona fide, in residence, but girls of every sort, including, especially, Las Vegas' little high-school buds, who adorn what locals seeking roots in the sand call 'our city of churches and schools', have taken up the chic of wearing buttocks décolletage step-ins under flesh-tight slacks, with the outline of the undergarment showing through fashionably. Others go them one better. They achieve the effect of having been dipped once, briefly, in Helenca stretch nylon. More and more they look like those wonderful old girls out of *Flash Gordon* who were wrapped just once over in Baghdad pantaloons of clear polyethylene with only *Flash Gordon* between them and the insane red-eyed assaults of the minions of Ming. It is as if all the hip young suburban gals of America named Lana, Deborah and Sandra, who gather wherever the arc lights shine and the studs steady their coiffures in the plate-glass reflection, have convened in Las Vegas with their bouffant hair above and anatomically stretch-pant-swathed little bottoms below, here on the new American frontier. But exactly!

None of it would have been possible, however, without one of those historic combinations of nature and art that creates an epoch. In this case, the Mojave Desert plus the father of Las Vegas, the late Benjamin 'Bugsy' Siegel.

Bugsy was an inspired man. Back in 1944 the city fathers of Las Vegas, their Protestant rectitude alloyed only by the giddy prospect of gambling revenues, were considering the sort of ordinance that would have preserved the town with a kind of Colonial Williamsburg dinkiness in the motif of the Wild West. All new buildings would have to have at least the façade of the sort of place where piano players used to wear garters on their sleeves in Virginia City around 1880. In Las Vegas in 1944, it should be noted, there was nothing more stimulating in the entire town than a Fremont Street bar where the composer of 'Deep in the Heart of Texas' held forth and the regulars downed fifteen-cent beer.

Bugsy pulled into Las Vegas in 1945 with several million dollars that, after his assassination, was traced back in the general direction of gangster-financiers. Siegel put up a hotel-casino such as Las Vegas had never seen and called it the Flamingo — all Miami Modern, and the hell with piano players with garters and whatever that was all about. Everybody drove out on Route 91 just to

ONE CAN LOOK AT LAS VEGAS FROM A MILE AWAY ON ROUTE 91 AND SEE NO BUILDINGS, NO TREES, ONLY SIGNS. BUT SUCH SIGNS! THEY TOWER. THEY REVOLVE, THEY OSCILLATE, THEY SOAR IN SHAPES BEFORE WHICH THE EXISTING VOCABULARY OF ART HISTORY IS HELPLESS. I CAN ONLY ATTEMPT TO SUPPLY NAMES – BOOMERANG MODERN, PALETTE CURVILINEAR, FLASH GORDON MING-ALERT SPIRAL, MCDONALD'S HAMBURGER PARABOLA, MINT CASINO ELLIPTICAL, MIAMI BEACH KIDNEY. LAS VEGAS' SIGN MAKERS WORK SO FAR OUT BEYOND THE FRONTIERS OF CONVENTIONAL STUDIO ART THAT THEY HAVE NO NAMES THEMSELVES FOR THE FORMS THEY CREATE.

Tom WOLFE, The Kandy-Kolored Tangerine Flake Streamline Baby, 1965

gape. Such shapes! Boomerang Modern supports, Palette Curvilinear bars, Hot Shoppe Cantilever roofs and a scalloped swimming pool. Such colours! All the new electrochemical pastels of the Florida littoral: tangerine, broiling magenta, livid pink, incarnadine, fuchsia demure, Congo ruby, methyl green, viridine, aquamarine, phenosafranine, incandescent orange, scarlet-fever purple, cyanic blue, tessellated bronze, hospital-fruit-basket orange. And such signs! Two cylinders rose at either end of the Flamingo – eight stories high and covered from top to bottom with neon rings in the shape of bubbles that fizzed all eight stories up into the desert sky all night long like an illuminated whisky-soda tumbler filled to the brim with pink champagne [...]

Tom Wolfe, 'Las Vegas [What?]', *The Kandy-Kolored Tangerine Flake Streamline Baby* [New York: Farrar, Straus & Giroux, 1965].

Robert VENTURI
A Justification for a Pop Architecture [1965]

Robert Venturi, all wind but no fury;
Why can't he stop just going Pop?
– Anonymous

I went to an architectural conference on computers recently and the microphones didn't work, or rather, their mechanical defects disrupted the lofty proceedings with Bronx-salutes. This grating juxtaposition of form versus content symbolized for me the condition of our architecture in relation to what is versus what ought to be, to the contradiction between the short-term and the long-term, the immediate and the speculative.

Architecture always relates to practice before speculation. Like the politician, the architect is expedient because he deals with things as they are. As an artist, he is the maker whose impetus comes from the immediate over the speculative. *His* question is 'Does it?' rather than 'Ought it?' *His* visions are only incidentally visionary. This inherent dichotomy is exaggerated today.

In speculating on the reality of the dawning electronic age for architecture Serge Chermayeff at this same conference decried the irrelevant expressionism of our current architecture. And soundly, I think. But I question his lumping into the same mould all kinds of Pop architecture, as he called it.

Electronic technology is the speculative problem for architecture now. Not many architects can go electronic significantly in either their methods or their expression. The Federal government and the big industry it supports have largely directed expensive computer research towards the enterprises of war or, as is said, national security, over the forces for the enhancement of life. The practising architect must admit this. In simple terms his budget and his techniques for architecture relate more to 1875 than 1975.

The Pop architect admits it. He makes a virtue of

necessity. He accepts convention. He doesn't pretend to be technically advanced beyond his means. Nor does he risk what might be called an electronic expressionism to parallel the industrial expressionism which much of early modern architecture consisted of. Even Mies van der Rohe as late as 1940 represented a superficial adaptation of Albert Kahn's vernacular industrial vocabulary of exposed steel in his own fire-resistant building.

Pop architecture embraces the commonplace, or rather the just obsolete commonplace, as the actual elements of building. And the architect accepts his role as combiner of old clichés ('decadent banalities') in new contexts as his condition within a society which directs its best efforts, its big money, its elegant technologies elsewhere. Pop architecture can be the real expression of concern, in an indirect way, for society's own inverted scale of values.

In any case, I am compelled to recognize how my predicament is nearer the screeching microphone than the humming console.

Our experience is complex and contradictory, and the programme in architecture is complex and contradictory; our architecture must reflect this.

We talk a lot about simplicity and I'm not against simplicity, but against simplification, and there's a great difference. In modern architecture a sun screen is nothing else, a support is seldom an enclosure, because the double functioning element is abhorrent to the modern architect. The column is the modern manifestation of structural support, saying only one thing, only incidentally spatial, not *making* space. Very pure – saying only one thing. The vestigial element is even more abhorrent to modern architecture. The modern architect doesn't want anything vestigial – it is a prejudice and hangover from the past. To the extent that a building has that, it is not good, because a building must be purely what it is. I like to be tentative; everything is that way, anyhow. As soon as you reach the pure thing it is obsolete. I love the balloon frame historically for this reason; it is a frame and also a skin structure. It grew out of the earlier heavier frame structures, and it is an impure thing. Corbu takes the pure thing – Villa Savoye is a pure configuration of columns – and then he moves over one or two columns to get the ramp in, yet he has this closed order and clarity of the Mediterranean. Villa Savoye is precisely formed yet randomly gouged.

Standardization is accepted as an enriching product of our technology, yet it is dreaded for its potential domination and brutality. But the architect can employ standardization unstandardly. Alvar Aalto has an artful recognition of the circumstantial and contextual, and the inevitable limits of the order of standardization. You can use the commonplace in a certain way so it isn't commonplace – standardization with an irrationality that is rational because it accommodates itself to the contradictions of a complex reality.

Robert Venturi, 'A Justification for a Pop Architecture', *Arts & Architecture* [Los Angeles, April 1965] 22.

Reyner BANHAM
Triumph of Software [1968]

If we *needed* the concept of a fur-lined spaceship (and we did, even if we didn't know it), we have it now. We also have a female astronaut stripping off in free fall, beginning very conventionally with the gloves like any old gipsy rose. And behind her, in the fur-lined control module, there are a rococo nude in plaster and an airlock door panelled with a section of Seurat's *Dimanche à la Grande Jatte*. And all this before the credit titles are properly out of the way, to sum up what *Barbarella* is going to be all about for its devotees; thus:

Item: an unexceptionally straight-up-and-down view of sex – Jane Fonda's clean little surf-girl face (Nancy Sinatra might have been even better in the part!) and Terry Southern's sanitized *Candy*-coloured script combine to produce a love-object about as kinky as the All England Lawn Tennis and Croquet Club.

Item: a preoccupation with a kind of environment that, if not always fur-lined, is always with-it – so much so that it will become what the film is remembered to have been about in the rather specialized circles where it is remembered.

And item: a trickle of visual jokes – art-jokes, rather – that need an audience of at least DipAd complementary studies level. Since the movies are the one visual art-form whose criticism we entrust to the visually ignorant, all this art-jokery completely missed the assembled body critical at the press show, and I would like to congratulate the four people who laughed in the same places as I did, not one of them a major weekly or daily critic as far as could be seen.

Predictably, therefore, *The Guardian* doubted if it would ever become a cult movie. I have news for you, mate: old, cold news. *Barbarella* has been a cult movie for months, ever since the first stills were in *Playboy* and the colour supps, and were pinned up in architecture student pads and studios across the world. For *Barbarella*, unlike most feature movies, which are about two years behind the visual times for unavoidable mechanical reasons, is barely twelve months out of date. Style-wise, it falls about halfway between the Million Volt Light-Sound Raves at the London Roundhouse at the beginning of last year, and the great Arthur Brown/Jools/Inflatable rave organized by Architectural Association students there at the end of the year.

Compare Stanley Kubrick's *2001*, since everybody does. My spouse's verdict that this film's psychedelic (eh?) sequences 'would have been great if they had been at Hornsey two years ago' marks the point at which Kubrick most nearly caught up with the live visual culture of now. The rest of the movie was like Pompeii re-excavated, the kind of stuff that Richard Hamilton had in his *Man, Machine and Motion* exhibition back in 1955. All that grey plastic and crackle-finish metal, and knobs and switches, all that ... yech ... *hardware*!

But *Barbarella* is the first post-hardware SF movie of any consequence. By one of those splendid coincidences

15. Stanley Kubrick

16. Roger Vadim

that used to make German historians believe in the Zeitgeist (and which English historians always miss) the film was premiered here in the same week that a company called Responsive Environments Corporation went public on the New York stock exchange. Whatever the company is about, *Barbarella* is about responsive environments, of one sort or another, and so has been the architectural underground for the last three years or so; and from where I stand, I can't see how this could avoid becoming a cult movie. Responsive environments in the sense of not being rigid and unyielding; articulated only by hinges between disparate rigid parts: an ambience of curved, pliable, continuous, breathing, adaptable surfaces [...]

All along, brittle hardware is beaten by pliable software. Barbarella out-yields the Excessive Machine, and the monumental structure of the city of Sogo finally falls to subterranean software: the dreaded Mathmos. Roughly speaking, the Mathmos is (cut-price French metaphysics aside) a blend of a Mark Boyle/UFO light show, detergent commercials, and a circa-1940 pulp novel trying to describe orgasm (you know: iridescent liquid fire seems to surge up through her etcetera and like that). If you could get it in cans, it would be a great product. You could pour it on the carpet and have a psychedelic wade-in.

In the city of Sogo, however, it glints gunkily around in paramoebic blobs under the glass floors, doubling the roles of a communal libido-sewer and the London Electricity Board. 'It feeds upon our evil, and in return gives us heat, light and power.'

It has to be kept under glass, literally, because otherwise it will destroy the city. This is a conventional type of SF situation, too corny in itself to be worth commenting on; but in the context of *Barbarella*, it seems to reveal something of the inner tensions between the logic of the Now and the restraints of past tradition that SF shares with all other human activities, in spite of its preoccupation with futures.

At first sight, the city of Sogo is ridiculous. It doesn't look like Sodom, Sybaris or Las Vegas, which is understandable. But neither does it look like anything that could grow naturally out of the inflatable/fur-lined technology that dominates the rest of the movie, and the software culture within it. Instead, the city looks — both without and within — uncommonly like an architectural student megastructure of the post-*Archigram* age: multi-storey frames carrying nodes and capsules of living-space above ground, a labyrinth of tunnels below.

But historically this is reasonable. Both *Barbarella* in its original French cartoon-strip form, and *Archigram*'s plug-in city project are half-jokey European intellectual derivatives from basic US pulp SF. Both stand in a tradition of environmental visions that runs back visually through the comics, and verbally through texts like Isaac Asimov's *Caves of Steel* (now in Panther paperback; don't just sit there, go and buy it!), to futurist architectural visions of the nineteen-teens and ultimately to basic sources like H.G. Wells — notably *The Sleeper Awakes*, which is still a sacred text among architects.

This tradition conserves an essentially nineteenth-century vision of the urban environment — densely built, over-populated, low on privacy, violent, serviced by public transport. If that sounds just like New York, it is also a city type whose built form would make Colin Buchanan feel at home, the kind of city that most architects would prefer to Los Angeles, the city seen (like Cumbernauld town centre) as a single artefact, '*le plus grand outil de l'homme*' (Le Corbusier: how did you guess?). Asimov had the vision and craft to construct an alternative city in another book of his, *The Naked Sun*; but it is a pretty rare thing in SF. *Barbarella* holds determinedly to the grand old Wellsian tradition, and Sogo is seen, in distant views, as a singular construction on top of a hill.

Is seen as a piece of hardware, that is. And just as present technology and culture make it possible and necessary to construct alternatives to the high-density architect-preferred city, so the extrapolation of present culture and technology, along the vectors implicit in *Barbarella* (and *Archigram* too), makes the survival of the Wellsian artefact-city inconceivable. *Archigram* has acknowledged the logic of its situation by progressively abandoning its megacity visions in favour of ever more compact, adaptable and self-contained living capsules which, by last summer, had shrunk to the proportions of a rather complex suit which could be inflated (for real; the prototype worked) to provide everybody with their own habitable bubble of innocence [...]

Reyner Banham, 'Triumph of Software', *New Society*, 12:318 [London, 31 October 1968, 629–30; reprinted in Reyner Banham, *Design by Choice*, London: Academy Editions, 1981] 133–6.

Nik COHN
The Rolling Stones [1969]

In Liverpool one time, early in 1965, I was sitting in some pub, just next to the Odeon cinema, and I heard a noise like thunder.

I went outside and looked around but I couldn't see a thing. Just this noise of thunder, slowly getting closer, and also, more faint, another noise like a wailing siren. So I waited but nothing happened. The street stayed empty.

Finally, after maybe five full minutes, a car came round the corner, a big flash limousine, and it was followed by police cars, by police on foot and police on motorbikes, and they were followed by several hundred teenage girls. And these girls made a continuous high-pitched keening sound and their shoes banged down against the stone. They ran like hell, their hair down in their eyes, and they stretched their arms out pleadingly as they went. They were desperate.

The limousine came up the street towards me and stopped directly outside the Odeon stage door. The police formed cordons. Then the car door opened and the Rolling Stones got out, all five of them and Andrew Loog Oldham, their manager, and they weren't real. They had hair down past their shoulders and they wore clothes of every colour imaginable and they looked mean, they looked just impossibly evil.

In this grey street, they shone like sun gods. They didn't seem human, they were creatures off another planet, impossible to reach or understand but most exotic, most beautiful in their ugliness.

They crossed towards the stage door and this was what the girls had been waiting for, this was their chance, so they began to surge and scream and clutch. But then they stopped, they just froze. The Stones stared straight ahead, didn't twitch once, and the girls only gaped. Almost as if the Stones weren't touchable, as if they were protected by some invisible metal ring. So they moved on and disappeared. And the girls went limp behind them and were quiet. After a few seconds, some of them began to cry [...]

As manager, what Oldham did was to take everything implicit in the Stones and blow it up one hundred times. Long-haired and ugly and anarchic as they were, Oldham made them more so and he turned them into everything that parents would most hate, be most frightened by. All the time, he goaded them to be wilder, nastier, fouler in every way and they were — they swore, sneered, snarled and, deliberately, they came on cretinous.

It was good basic psychology: kids might see them the first time and not be sure about them, but then they'd hear their parents whining about those animals, those filthy long-haired morons, and suddenly they'd be converted, they'd identify like mad.

(This, of course, is bedrock pop formula: find yourself something that truly makes adults squirm and, straightaway, you have a guaranteed smash on your hands. Johnnie Ray, Elvis, P.J. Proby, Jimi Hendrix — it never fails.)

So their first single, *Come On*, got to the edge of the twenty, and then *I Wanna Be Your Man* was number ten, and *Not Fade Away* was number three and, finally, *It's All Over Now* was number one. Their initial album did a hundred thousand in a week and, by this time, they were running hot second to the Beatles and they kept it like that for two years solid. Later on, in America, they even temporarily went ahead.

All this time, Oldham hustled them strong: he was hectic, inventive, and he pulled strokes daily. Less obviously, he was also thorough, he worked everything out to the smallest spontaneous detail. Well, the Stones were really his fantasy, his private dream-child and, healthy narcissist as he was, he needed them to be entirely perfect.

The bit I liked best, about both Oldham and the Stones themselves, was the stage act. In every way, both individually and collectively, it expressed them just right.

Charlie Watts played the all-time bombhead drummer, mouth open and jaw sagging, moronic beyond belief, and Bill Wyman stood way out to one side, virtually in the wings, completely isolated, his bass held up vertically in front of his face for protection, and he chewed gum endlessly and his eyes were glazed and he looked just impossibly bored.

Keith Richards wore T-shirts and, all the time, he kept winding and unwinding his legs, moving uglily like a crab, and was shut-in, shuffling, the classic fourth-form drop-

out. Simply, he spelled Borstal.

Brian Jones had beautiful silky yellow hair to his shoulders, exactly like a Silvikrin ad, and he wasn't queer, very much the opposite, but he camped it up like mad, he did the whole feminine thing and, for climax, he'd rush the front of the stage and make to jump off, flouncing and flitting like a gymslip schoolgirl.

And then Mick Jagger: he had lips like bumpers, red and fat and shiny, and they covered his face. He looked like an updated Elvis Presley, in fact, skinny legs and all, and he moved like him, so fast and flash he flickered. When he came on out, he went bang. He'd shake his hair all down in his eyes and he danced like a whitewash James Brown, he flapped those tarpaulin lips and, grotesque, he was all sex.

He sang but you couldn't hear him for screams, you only got some background blur, the beat, and all you knew was his lips. His lips and his moving legs, bound up in sausage-skin pants. And he was outrageous: he spun himself blind, he smashed himself and he'd turn his back on the audience, jack-knife from the waist, so that his arse stuck straight up in the air, and then he'd shake himself, he'd vibrate like a motor, and he'd reach the hand mike through his legs at you, he'd push it right in your face. Well, he was obscene, he was excessive. Of course, he was beautiful [...]

Nik Cohn, extract from 'Awopbopaloobopalopbamboom', *Pop from the Beginning* [London: Weidenfeld & Nicolson, 1969].

Laura MULVEY

Fears, Fantasies and the Male Unconscious *or* 'You Don't Know What is Happening, Do You, Mr Jones?' [1972]

To decapitate equals to castrate. The terror of the Medusa is thus a terror of castration that is linked to the sight of something. The hair upon the Medusa's head is frequently represented in works of art in the form of snakes, and these once again are derived from the castration complex. It is a remarkable fact that, however frightening they may be in themselves, they nevertheless serve actually as a mitigation of the horror, for they replace the penis, the absence of which is the cause of the horror. This is a confirmation of the technical rule according to which a multiplication of penis symbols signifies castration. (Freud, 'The Medusa's Head')

In 1970 Tooth's Gallery in London held a one-man show of sculptures by Allen Jones which gained him the notoriety he now enjoys throughout the Women's Movement. The sculptures formed a series, called 'Women as Furniture', in which life-size effigies of women, slave-like and sexually provocative, double as hat-stands, tables and chairs. The original of *Chair* is now

in the Düsseldorf home of a West German tycoon, whose complacent form was recently photographed for a *Sunday Times* article, sitting comfortably on the upturned and upholstered female figure. Not surprisingly, members of Women's Liberation noticed the exhibition and denounced it as supremely exploitative of women's already exploited image. Women used, women subjugated, women on display: Allen Jones did not miss a trick.

Since 1970 Allen Jones's work has developed and proliferated in the same vein. It has won increasing international acclaim, with exhibitions in Italy, Germany, Belgium and the United States, as well as Britain. He is one of the shining properties in the stable of Marlborough Fine Art, the heaviest and most prestige-conscious of the international art traders. He has expanded his interests beyond painting and sculpture proper into stage design, coffee-table books, luxury editions, film and television. The Allen Jones artistic octopus extends its tentacles into every nook and cranny where the image of woman can be inserted and spotlighted.

At first glance Allen Jones seems simply to reproduce the familiar formulas which have been so successfully systematized by the mass media. His women exist in a state of suspended animation, without depth or context, withdrawn from any meaning other than the message imprinted by their clothes, stance and gesture. The interaction between his images and those of the mass media is made quite explicit by the collection of source material which he has published. *Figures*[1] is a scrapbook of cuttings out of magazines, both respectable (*Nova*, *Harper's Bazaar*, *Life*, *Vogue*, *Sunday Times*, supplement and so on) and non-respectable (*Exotique*, *Female Mimics*, *Bound*, *Bizarre* and so on). There are also postcards, publicity material, packaging designs and film stills (*Gentlemen Prefer Blondes*, *Barbarella*, *What's New, Pussycat?*). *Projects*,[2] his second book, records, sketches and concepts (some unfinished) for stage, film and TV shows, among them *Oh Calcutta!* and Kubrick's *A Clockwork Orange* and includes more source material as an indication of the way his ideas developed.

By publishing these clippings Allen Jones gives vital clues, not only to the way he sees women, but to the place they occupy in the male unconscious in general. He has chosen images which clearly form a definite pattern, which have their own visual vocabulary and grammar. The popular visuals he produces go beyond an obvious play on the exhibitionism of women and the voyeurism of men. Their imagery is that of a fetishism. Although every single image is a female form, not one shows the actual female genitals. Not one is naked. The female genitals are always concealed, disguised or supplemented in ways which alter the significance of female sexuality. The achievement of Allen Jones is to throw an unusually vivid spotlight on the contradiction between women's fantasy presence and real absence from the male unconscious world. The language which he speaks is the language of fetishism, which speaks to all of us every day, but whose exact grammar and syntax we are usually only dimly aware of. Fetishistic obsession reveals the meaning behind popular images of women.

It is Allen Jones's mastery of the language of 'basic fetishism' that makes his work so rich and compelling. His use of popular media is important not because he echoes them stylistically (pop art) but because he gets to the heart of the way in which the female image has been requisitioned, to be recreated in the image of man. The fetishist image of women has three aspects, all of which come across clearly in his books and art objects. First: woman plus phallic substitute. Second: woman minus phallus, punished and humiliated, often by women plus phallus. Third: woman as phallus. Women are displayed for men as figures in an amazing masquerade, which expresses a strange male underworld of fear and desire.

THE LANGUAGE OF CASTRATION ANXIETY

The nearer the female figure is to genital nakedness, the more flamboyant the phallic distraction. The only example of frontal nudity in his work, a sketch for *Oh Calcutta!*, is a history of knickers, well-worn fetishist items, in which the moment of nakedness is further retrieved by the fact that the girls are carrying billiard cues and an enormous phallus is incorporated into the scenery. In the source material, a girl from *Playboy* caresses a dog's head on her lap; another, on the cover of a movie magazine, clutches an enormous boa constrictor as it completely and discreetly entwines her. Otherwise there is an array of well-known phallic extensions to divert the eye: guns, cigarettes, erect nipples, a tail, whips, strategically placed brooches (Marilyn Monroe and Jane Russell in *Gentlemen Prefer Blondes*), a parasol, and so on, and some, more subtle, which depend on the visual effect of shadows or silhouettes.

Women without a phallus have to undergo punishment by torture and fetish objects ranging from tight shoes and corsetry, through rubber goods to leather. Here we can see the *sadistic* aspect of male fetishism, but it still remains fixated on objects with phallic significance. An ambiguous tension is introduced within the symbolism. For instance, a whip can be simultaneously a substitute phallus and an instrument of punishment. Similarly, the high heel on high-heeled shoes, a classic fetishist image, is both a phallic extension and a means of discomfort and constriction. Belts and necklaces, with buckles and pendants, are both phallic symbols and suggest bondage and punishment. The theme of *woman bound* is one of the most consistent in Allen Jones's source material: at its most vestigial, the limbs of pin-up girls are bound with shiny tape, a fashion model is loaded with chains, underwear advertisements, especially for corsets, proliferate, as do rubber garments from fetishistic magazines. Waists are constricted by tight belts, necks by tight bands, feet by the ubiquitous high-heeled shoes. For the television show illustrated in *Projects* Allen Jones exploits a kind of evolved garter of black shiny material round the girls' thighs, which doubles, openly in one case, as a fetter. The most effective fetish both constricts and uplifts, binds and raises, particularly high-heeled shoes, corsets or bras and, as a trimming, high neck bands holding the head erect.

In *Projects* the theme of punishment can be seen in

the abandoned plan for the milkbar in the film of *A Clockwork Orange* (infinitely more subtle in its detailed understanding of fetishism than the kitsch design Kubrick finally used for the movie). The waitress is dressed from neck to fingertip to toe in a rubber garment with an apron, leaving only her buttocks bare, ready for discipline, while she balances a tray to imply service. The same theme can be traced in his women-as-furniture sculptures. In *Figures*, the background and evolution of the sculptures is made clear. Gesture, bodily position and clothing are all of equal importance. *Hat-Stand* is based on the crucial publicity still from *Barbarella*, which unites boots, binding, leather and phallic *cache-sexe* in the image of a girl captive who hangs ready for torture, her hands turned up in a gesture which finally becomes the hat-peg. A similar design for an hors-d'oeuvre stand derives from a Vargas drawing of a waitress who sums up the spirit of service and depersonalization.

Another aspect of the theme of punishment is that the castrated woman should suffer spanking and humiliation at the hands of the man-woman, the great male hope. Characterized in Eneg's drawings for *Bound* (reproduced in *Figures*) by tight belt, tight trousers, mask and constricted neck (while a female woman carries a soon-abandoned handbag), the man-woman emerges with full force of vengeance in *Projects* as Miss Beezley in *Homage to St Dominic's* ('to be played by a 7-foot woman – *or a man would do*. With 6-inch platform heels "she" would be 18 inches taller than the school "girls"'). And again in *The Playroom* (another abandoned stage project) the transvestite owner, 'an elderly "woman"' chases the children. A series of paintings shows sexually ambiguous figures in which a man walks into female clothing to become a woman or male and female legs are locked as one.

Finally, in *Männer Wir Kommen*, a show for West German television, which is illustrated in *Projects* by stills, notes and sketches, Allen Jones adds yet another dimension to his use of fetishistic vocabulary. The close-ups and superimpositions possible on television gave him the chance to exploit ambiguities of changed scale and proportion. The spectator is stripped of normal perceptual defences (perspective, normal size relationships) and exposed to illusion and fantasy on the screen. As sections of the female body are isolated from the whole and shown in close-up, or as the whole body shrinks in size and is superimposed on a blown-up section, Allen Jones develops even further the symbolic references of woman to man and subjects her form to further masculinization.

His previous work preserved the normal scale of the female body physically, although it distorted it symbolically. *Männer Wir Kommen* contains some imagery of this kind: *Homage to Harley* uses the motorcycle and the nozzle in their classic role as phallic extensions, with the women in natural proportion to them (women with boots and bound necks and black bands around their thighs). But by far the most striking image is that of the entire figure of one girl, shrunk in scale though symbolically erect, superimposed as a phallic substitute on the tight black shiny shorts of

another. A series of freeze-frames from the show, female manikins strategically poised, makes Allen Jones's point blindingly clear.

More close-ups in the television sketch carry the female body further into phallic suggestion. Girls like human pillars supporting a boxing ring have bared breasts divided by shiny pink material fastened to their necks. A single frame, from breast to neck only, makes the breasts look like testicles with the pink material functioning as a penis. Female bodies and fragments of bodies are redeployed to produce fantasy male anatomies. A similar emphasis on breasts divided by a vertical motif can be seen in the source material: the torture harness in the *Barbarella* still, Verushka's single-strap bikini in a fashion photograph. There is a strong overlap between the imagery of bondage and the imagery of woman as phallus built into fetishism. The body is unified to a maximum extent into a single, rigid whole, with an emphasis on texture, stiffness caused by tight clothing and binding, and a general restriction of free movement.

In *Figures* there is a consistent theme of women as automata, with jerking, involuntary, semaphore-like movements, suggestive of erection. These automata often have rhythmic movements (Ursula Andress dancing in a series of stills like an animated doll, the Rockettes, Aquamaid water-skiers in Florida), uniforms in which the conception of duty and service is combined with strictness and rigidity (for instance, a cutting from the *Daily Express* in which 'Six Model Girls Step Smartly Forward for Escort Duty') and, most important of all, the stiffness induced by wearing tight clothes which constitute a second slithery skin (rubber garments transforming the body into a solid mass from fingertip to toe, one-piece corsets, synthetic garments ranging from perspex to nylon). An identification develops between the phallus and woman herself. She must be seen in her full phallic glory.

THE FETISHIST'S COLLECTION OF SIGNS

To understand the paradoxes of fetishism, it is essential to go back to Freud. Fetishism, Freud first pointed out, involves displacing the sight of woman's imaginary castration into a variety of reassuring but often surprising objects – shoes, corsets, rubber gloves, belts, knickers and so on – which serve as *signs* for the lost penis but have no direct connection with it. For the fetishist, the sign itself becomes the source of fantasy (whether actual fetish objects or else pictures or descriptions of them) and in every case the sign is the sign of the phallus. It is man's narcissistic fear of losing his own phallus, his most precious possession, which causes shock at the sight of the female genitals and the subsequent fetishistic attempt to disguise or divert attention from them.

A world which revolves on a phallic axis constructs its fear and fantasies in its own phallic image. In the drama of the male castration complex, as Freud discovered, women are no more than puppets; their significance lies first and foremost in their lack of a penis and their star turn is to symbolize the castration which men fear. Women may seem to be the subjects of an endless parade

of pornographic fantasies, jokes, day-dreams and so on, but fundamentally most male fantasy is a closed loop dialogue with itself, as Freud conveys so well in the quotation about the Medusa's head. Far from being a woman, even a monstrous woman, the Medusa is the sign of a male castration anxiety. Freud's analysis of the male unconscious is crucial for any understanding of the myriad ways in which the female form has been used as a mould into which meanings have been poured by a male-dominated culture.

Man and his phallus are the real subject of Allen Jones's paintings and sculptures, even though they deal exclusively with images of women on display. From his scrapbooks we see how the mass media provide material for a 'harem cult' (as Wilhelm Stekel describes the fetishist's penchant for collections and scrapbooks in his classic psychoanalytic study) in which the spectre of the castrated female, using a phallic substitute to conceal or distract attention from her wound, haunts the male unconscious. The presence of the female form by no means ensures that the message of pictures or photographs or posters is about women. We could say that the image of woman comes to be used as a sign, which does not necessarily signify the meaning 'woman' any more than does the Medusa's head. The harem cult which dominates our culture springs from the male unconscious and woman becomes its narcissistic projection.

Freud saw the fetish object itself as phallic replacement so that a shoe, for instance, could become the object on which the scandalized denial of female castration was fixated. But, on a more obvious level, we could say with Freud in 'The Medusa's Head' that a *proliferation* of phallic symbols must symbolize castration. This is the meaning of the parade of phallic insignia borne by Allen Jones's harem, ranging from precisely poised thighs, suggestive of flesh and erection, through to enormous robots and turrets. Castration itself is only rarely alluded to in even indirect terms. In one clipping an oriental girl brandishes a large pair of scissors, about to cut the hair of a man holding a large cigar. In another, a chocolate biscuit is described in three consecutive pictures: *c'est comme un doigt* (erect female finger), *avec du chocolat autour* (ditto plus chocolate), *ça disparaît très vite* (empty frame), then larger frame and triumphant return, *c'est un biscuit: Finger de Cadbury* (erect biscuit held by fingers).

There is one exception to this: the increasingly insistent theme of women balancing. Female figures hang suspended, on the point of coming down (the phallic reference is obvious). Anything balanced upright – a woman walking a tightrope or balancing a tray or poised on the balls of her feet – implies a possible catastrophe that may befall. The sculptures of women as furniture, especially the hat-stand, freeze the body in time as the erect pose seems to capture a moment, and also they are suspended, cut off from any context, to hang in space. In addition, the formal structure of some of Jones's earlier paintings – three-dimensional flights of steps leading steeply up to two-dimensional paintings of women's legs poised on high heels – describe an ascension: erect

posture and suspension and balance are fused into one illusionistic image.

In his most recent paintings, exhibited this summer at the Marlborough Galleries, Allen Jones develops the theme of balance much further. A number of the paintings are of women circus performers, objects of display and of balance. Here the equation 'woman = phallus' is taken a step further, almost as if to illustrate Freud's dictum that 'the remarkable phenomenon of erection which constantly occupies the human phantasy, cannot fail to be impressive as an apparent suspension of the laws of gravity (of the winged phalli of the ancients)'. In *Bare Me*, for example, the phallic woman, rigid and pointing upwards, holding her breasts erect with her hands, is standing in high heels on a tray-like board balanced on two spheres. She is on the way up, not down. Loss of balance is possible, but is not immediate.

But in other paintings this confidence is undercut. The defiance of gravity is more flamboyant than convincing. The same devices – high heels, walking on spheres – which compel an upright, erect posture can also point to its precariousness. The painting *Whip* is derived from a brilliant Eneg drawing of two women, castrator and castrated: a woman lassoed by a whipcord is slipping off a three-legged stool. In the painting, we can see only the toppling stool, but there can be no doubt from comparison with the Eneg source that the real absence – symbolic castration – is intended. In another painting, *Slip*, both figures from the same Eneg drawing are combined into one and loss of balance becomes the explicit theme. Dancers on points, waitresses carrying trays, women acrobats teetering on high heels or walking the tightrope – all are forced to be erect and to thrust vertically upwards. But this phallic deportment carries the threat of its own undoing: the further you strive up, the further you may fall.

In *Männer Wir Kommen* the reverse side of the phallic woman, the true horror of the fetishist, can be seen in one startling sequence. The female body, although still bound in a tight corset and with a snake necklace wound around her neck, has a flamboyant, scarlet scar over her genitals. The surrounding *mise en scène* consists of enormous eggs, containing bound women rising from a foetus-like position while, in another sequence, maggot-like women's limbs emerge from equally enormous apples. The scar breeds the putrescence of pregnancy and nothing but decay can come out of the apple. The apple and the egg are the only non-fetishistic images of women to appear in Allen Jones's work. Infested by manikin maggots, they are the eternal companions of the scar.

Most people think of fetishism as the private taste of an odd minority, nurtured in secret. By revealing the way in which fetishistic images pervade not just specialized publications but the *whole of the mass media*, Allen Jones throws a new light on woman as spectacle. The message of fetishism concerns not woman, but the narcissistic wound she represents for man. Women are constantly confronted with their own image in one form or another, but what they see bears little relation or relevance to their own unconscious fantasies, their own hidden fears and desires. They are being turned all the time into objects of display, to be looked at and gazed at and stared at by men. Yet, in a real sense, women are not there at all. The parade has nothing to do with woman, everything to do with man. The true exhibit is always the phallus. Women are simply the scenery onto which men project their narcissistic fantasies. The time has come for us to take over the show and exhibit our own fears and desires.

1 Allen Jones, *Figures* [Berlin: Galerie Mikro, and Milan: Edizioni 0, 1969].

2 Allen Jones, *Projects* [London: Mathews Miller Dunbar, and Milan: Edizioni 0, 1971].

Laura Mulvey, 'Fears, Fantasies and the Male Unconscious *or* 'You Don't Know What is Happening, Do You, Mr Jones?', written in 1972, first published in *Spare Rib* [London, 1973; reprinted in Laura Mulvey, *Visual and Other Pleasures*, London: MacMillan/Bloomington, Indiana: Indiana University Press, 1989] 6–13.

Ian MACDONALD
Revolution in the Head [1994]

TOMORROW NEVER KNOWS

Straight after finishing *Rubber Soul*, The Beatles wearily embarked on their final tour of Britain – thankfully brief compared with earlier ones and followed by three idle months, the longest period of free time they'd had since 1962. During this lay-off, they went on holiday, hung out in the latest clubs in London, decorated their houses, bought themselves new cars, and absorbed ideas and influences useful for their next album.

While Harrison devoted himself to Indian music and McCartney to classical, Lennon had become interested in exploring his mental 'inner space' with LSD. Since there was no 'acid' subculture in Britain in 1966, he lacked any guidance to this dangerous drug and so turned to a product of the American scene: *The Psychedelic Experience*, a manual to mind expansion by renegade Harvard psychologists Timothy Leary and Richard Alpert.

Wishing to give the unpredictable acid 'trip' a frame of reference comparable with the mystical systems of Catholicism and Islam, Leary and Alpert had selected *The Tibetan Book of the Dead*, an ancient tome designed to be whispered to the dying so as to steer them through the delusory states which, according to Tibetan Buddhism, hold sway between incarnations. Leary and Alpert chose this holy book because they believed LSD to be a 'sacramental chemical' capable of inducing spiritual revelations. Leary had met Aldous Huxley, another Lennon fancy, in 1960 and been struck by his prediction that the drug would make mystical experience available to the masses and produce a 'revival of religion which will be at the same time a revolution'. Huxley, though, had been talking, in characteristically patrician terms, of 'self-transcendence', a state in which both individual consciousness and the material universe around it cease to seem real – a wildly impractical basis for anything structured enough to be called a religion.

Leary, moreover, tended to vulgarise Huxley by speaking of self-transcendence and LSD as if they were the same thing, thereby turning a chemical process into an end in itself. The indulgent self-gratification this implied had no religious connotations at all. In fact, the religious camouflage disguising Leary's psychedelic ideology concealed a hidden agenda which would have been sinister if it hadn't been motivated chiefly by arrogant naïveté.

Among the commonest of the 'altered states' induced by LSD is depersonalization or 'ego-loss'. In this condition, awareness of self as a separate entity dissolves in what Jung termed 'oceanic consciousness': the sense that all things are one and individual awareness an illusion. It was the resemblance between depersonalization and the self-transcendence of mysticism that impressed Huxley when he took mescalin and LSD in the mid-Fifties. Mystics, though, usually work within systems of controlled development through meditation. Depersonalization – if that is what they experience, and not something quite different – could never take them by surprise. By contrast, the LSD trip, while steerable to a limited extent, is produced by an invasive force interacting at unpredictable strengths with the body's own fluctuating chemistry. The drug, not the subject, is in control.

That LSD was Russian roulette played with one's mind must have been clear to Leary, yet so excited was he by its 'revolutionary' potential that he threw caution to the wind by advocating it as a social cure-all. The revolution he envisaged had nothing in common with Lenin's, being based on a blend of post-Freudian psychology, Zen, and New Left utopianism. The enemy was The System: the materialistic machine which processed crew-cutted US youths through high school into faceless corporations or the army – an 'uptight' society of 'straights' so estranged from their bodies and feelings that sex had become a source of guilt for them assuageable only by setting fire to the living flesh of Vietnamese peasants. The core of this System, according to the acid analysis, was the unfeeling rational intellect, the mind divorced from its body, the ego separated from the rest of creation. In some brands of humanist psychology, this disembodied ego was seen as a censorious inner parent whose role was to thwart the natural (and thus, to new wave theorists, unquestionably healthy) desires of the childlike Id. Soon the ego would become identified by the peace movement with the military-industrial complex (manifested in the form of the Pentagon), by feminists with 'patriarchy', and by Left radicals with the bourgeois 'privilege' of privacy. During 1965–68 – the height of Leary's influence – the ego was colloquially referred to as 'the head': a citadel of fearful mirrors to be 'liberated' by acid invasion. In short, during the late Sixties the ego was thought of as something nasty to get rid of, which is why depersonalization under LSD so interested Leary.

Unfortunately, playing with concepts like satori and 'ego-death' is exceedingly dangerous. So real, for example, is the individual soul to Tibetan Buddhism that *The Tibetan Book of the Dead* assumes there to be little chance of stopping it reincarnating. Leary and Alpert's *The Psychedelic Experience*, on the other hand, amounts

to a humanist soft-sell for the vague proposition that, through losing self-importance and seeing life as a game, we cease struggling and become reconciled to a meaningless – and hence goalless, and hence peaceful – existence. Leaving aside the desirability of a world peopled by passive adherents of 'the cosmic giggle' (and passing over the tenuous link between meaninglessness and peacefulness), there is, contrary to Leary's assurances, no guarantee of predictable results from LSD, which is capable of inducing anything from suicidal self-negation to paranoid megalomania. All that is certain is that if you exhort people to sacrifice their sense of self to a drug, the chances of disaster are high. Accordingly, as the use of LSD spread under Leary's influence, a trail of 'acid casualties' followed in its wake – individuals who had left their identity in some uncharted zone of inner space and were now incapable of functioning in the supposedly illusory real world. Among those thus permanently disabled over the next few years were some of the most sensitive and talented people in pop. John Lennon nearly became one of them.

According to Albert Goldman, Lennon took LSD for the third time in January 1966. Apparently intending a serious voyage of self-discovery, he used the instructions given in *The Psychedelic Experience*, reading its paraphrase of *The Tibetan Book of the Dead* on to a tape-recorder and playing it back as the drug took effect. The result was spectacular and he hastened to capture it in song, taking many of his lines directly from Leary and Alpert's text – above all its rapturous invocation of the supposed reality behind appearances: The Void. As *The Void*, the song was the first to be recorded for *Revolver*. Under its eventual title, *Tomorrow Never Knows*, it introduced LSD and Leary's psychedelic revolution to the young of the Western world, becoming one of the most socially influential records The Beatles ever made.

While later thankful to have escaped its clutches, Lennon always acknowledged that LSD changed him in some ways for the better. Those who knew him in 1966 say his personality suddenly softened, his aggression giving way to a noticeably mellower mood. The drug had a similar impact on his music, playing a role in his most imaginative creations: *Strawberry Fields Forever*, *A Day in the Life* and *I am the Walrus*. Yet of all Lennon's LSD-driven songs, *Tomorrow Never Knows* is most directly about the drug. Commencing with a line from *The Psychedelic Experience*, the song takes its title from a saying of Starr's, analogous to the hippie maxim 'Be here now'. Typically horizontal, Lennon's lazy Mixolydian melody rises and falls over a C drone on bass, tambura, and sitar, producing a mild polychord when it drifts to B flat (as in Harrison's *If I Needed Someone*). The influence of Indian music is obvious, but there is a precedent for both the high-lying one-note bass and the track's broken drum-pattern: *Ticket to Ride*. (Both drum-patterns were suggested by McCartney.)

In his account of the Sgt Pepper sessions, Goldman remarks that, compared with contemporary American studios, Abbey Road was primitive and The Beatles were fools to put up with its limitations when they could have followed The Rolling Stones to Los Angeles and obtained the same effects with half the trouble. Indeed, The Beatles were often frustrated by EMI's rigid studio regime and obtuse slowness in upgrading to eight-track. (McCartney has recently revealed that the group briefly considered recording in America in 1966 but found that EMI's contractual clauses made this option prohibitively expensive.) Yet Goldman misses the point. Apart from familiarity and convenience of access, Abbey Road offered a very particular sound, not to mention an aura of homely English eccentricity which colours (and arguably fostered the character of) The Beatles' best work. More than this, its shoestring ethos mothered the most dazzling aural invention to emerge from any studio in Britain or America during the late Sixties (or since). With his engineers Geoff Emerick and Ken Scott, George Martin created a sound-world for The Beatles which astonished their better-equipped counterparts in the USA. American singer/producer Tommy James recalls whole studios being torn apart and put back together again in search of a drum sound The Beatles could get that American technicians couldn't: 'What they did, everything they did, became state of the art.'

The first of these unique drum sounds was created for Starr's mesmeric part for *Tomorrow Never Knows*. Performed mainly on a pair of slack-tuned tom-toms – damped, compressed, and recorded with massive echo – it created the image of a cosmic tabla played by a Vedic deity riding in a storm-cloud. This, though, was only the start of a production which, in terms of textural innovation, is to pop what Berlioz's *Symphonie fantastique* was to nineteenth-century orchestral music. Beginning on 6 April with the basic rhythm track (tambura drone, guitars, bass, drums, organ, piano, tambourine), the group continued the following day by overdubbing tape-loops made at home on their Brennell recorders. The tape-loop – a length of taped sound edited to itself to create a perpetually cycling signal – is a staple of sound-effect studios and the noise-art idiom known as *musique concrete*. Pop music, though, had heard nothing like this before, and the loops The Beatles created for *Tomorrow Never Knows* were especially extraordinary.

There were five in all, each running on an auxiliary deck fed on to the multitrack through the Studio 2 desk and mixed live: (1) a 'seagull'/'Red Indian' effect (actually McCartney laughing) made, like most of the other loops, by superimposition and acceleration (0:07); (2) an orchestral chord of B flat major (0:19); (3) a Mellotron played on its flute setting (0:22); (4) another Mellotron oscillating in 6/8 from B flat to C on its string setting (0:38); and (5) a rising scalar phrase on a sitar, recorded with heavy saturation and acceleration (0:56). The most salient of these are (5), which forms the first four bars of the central instrumental break and subsequently dominates the rest of the track, and (3) which, working in cross-rhythm, invites the audience to lose its time-sense in a brilliantly authentic evocation of the LSD experience. (The second half of the instrumental break consists of parts of McCartney's guitar solo for *Taxman* slowed down a tone, cut up, and run backwards.)

With its fade-out Goons-style piano, the soundscape of *Tomorrow Never Knows* is a riveting blend of anarchy and awe, its loops crisscrossing in a random pattern of colliding circles. Even Lennon's voice track is unprecedented. During the first half of the song, it was put through a new Abbey Road invention: automatic double-tracking (ADT). For the second half, Lennon wanted to sound like the Dalai Lama and thousands of Tibetan monks chanting on a mountain top. George Martin solved this by sending the voice track through the revolving speaker in a Leslie cabinet, a process which required physically breaking into the circuitry. (Though the effect was startling – the last aural coup in an album of stunning effects – Lennon remained unsatisfied, wishing the monks had been hired instead.)

As a pure sound-event, *Tomorrow Never Knows* remains exhilarating – yet it is easy, thirty years later, to underestimate its original cultural impact. Part of this is due to an intervening change in Western musical habits. Wheeling in on a fade-up, the whirring drone of darkly glittering sitar-tambura harmonics, seemed, in 1966, like an unknown spiritual frequency tuning in – an impact lessened for subsequent generations conditioned to pedal-point harmony by 'ambient' synthesizer pieces and monochordal 'rave' music. When *Tomorrow Never Knows* appeared, drones had been absent from Western music since the passing of the religious 'organum' style in the twelfth century. Only the fringe experimentalist La Monte Young was ahead of The Beatles in embracing the Indian drone with reference to its original context: a cosmic keynote resounding through space – the reverberation of the universe-engendering voice of Brahma the creator. Serving notice that the ensuing music will contain no tonal 'progress' – no change of key or chord (not quite true in the case of *Tomorrow Never Knows*) – the Indian drone, as brought into First World culture by this track, challenges not only seven centuries of Western music, but the operating premise of Western civilization itself. When Lennon's voice rises out of the seething dazzle of churning loops, the first words it utters, 'Turn off your mind', are a mystic negation of all progressive intellectual enterprise. The message: it is not the contents of one's mind which matter; rather, what counts is the quality of the containing mind itself – and the emptier, the better. This proposition, now a truism in Western fringe thinking, and happily travestied in the Ecstasy subculture of 'psychedelic' dance music, was radically subversive in 1966. *Tomorrow Never Knows* launched the till-then elite-preserved concept of mind-expansion into pop, simultaneously drawing attention to consciousness-enhancing drugs and the ancient religious philosophies of the Orient, utterly alien to Western thought in their anti-materialism, rapt passivity, and world-sceptical focus on visionary consciousness.

In Britain, the fourteen tracks from *Revolver* were released to radio stations in twos and threes throughout July 1966, building anticipation for what would clearly be a radical new phase in the group's recording career. The most extreme departure on the album, *Tomorrow Never Knows* was held back till last, resounding over the airwaves only days before *Revolver*, with its groundbreaking black-and-white psychedelic cover, finally appeared in the shops. The strategy served to establish

that The Beatles had initiated a second pop revolution –
on which, while galvanizing their existing rivals and
inspiring many new ones, left all of them far behind.

Lennon, meanwhile, became psychologically
addicted to LSD, taking it daily and living in one long,
listless, chemically altered state. Gradually fatigue and
sensory overload conspired with Leary's prescription for
voluntary ego-death to dissolve his sense of self. For the
next two years, by his own account, he had little grasp of
his own identity. Living in a passive, impressionable
condition dominated by LSD, he clung to the ideology of
the psychedelic revolution despite an increasing
incidence of the 'bad trips' which Leary had claimed were
impossible after ego-death. By 1968 – at which point
Leary was merrily hailing The Beatles as 'Divine
Messiahs, the wisest, holiest, most effective avatars the
human race has yet produced, prototypes of a new race of
laughing freemen' – Lennon was a mental wreck
struggling to stitch himself back together. Luckily, his
constitution was robust enough to avert physical
collapse, while the scepticism that balanced his questing
gullibility warded off a permanent eclipse of his reason.
Many others like him never came back.

Ian MacDonald, 'Tomorrow Never Knows', *Revolution in the
Head* [London: Fourth Estate, 1994; reprinted London:
Pimlico, 2005] 164-70.

ARTISTS' BIOGRAPHIES

Ken ADAM [Klaus Adam, b. 1921, Berlin] emigrated to Britain in 1934. Trained as an architect, he began working for film studios in 1947, becoming an acclaimed art director who devised highly innovative sets for films such as the James Bond series from the early 1960s onwards, and Stanley Kubrick's *Dr Strangelove* [1964]. Retrospectives include Serpentine Gallery, London [1999].

Kenneth ANGER [Kenneth Wilbur Anglemyer, b. 1927, Santa Monica, California] was a founding figure in post-war American avant-garde cinema. In the late 1940s he developed an aesthetic based on the silent film era to convey fetishistic, ritual and occult messages via the iconography of popular culture, as suggested in the title of his 1959 book *Hollywood Babylon*. His films include *Fireworks* [1947], *Puce Moment* [1949], *Eaux d'Artifice* [1953], *Inauguration of the Pleasure Dome* [1954-66], *Scorpio Rising* [1963] and *Kustom Kar Kommandos* [1965].

Michelangelo ANTONIONI [b. 1912, Ferrara] began working in Rome in 1940 as a documentary filmmaker. In the 1960s he developed cinematic fictions in which narrative is displaced by enigmatic situations and visual effects which disrupt characters' and viewers' certainties about purposeful action and the representation of reality. His films include *L'Avventura* [*The Adventure*, 1960], *La Notte* [*The Night*, 1961], *L'Eclisse* [*The Eclipse*, 1962], *Il Deserto rosso* [*Red Desert*, 1964], *Blow-Up* [1966] and *Zabriskie Point* [1970].

Diane ARBUS [Diane Nemerov, b. 1923, New York, d. 1971, New York] was a documentary and magazine photographer based in New York, where she found most of her subjects during the 1950s and 1960s. These included marginalized groups, 'typical American citizens' and wealthy celebrities, all surveyed as intense personal encounters. Retrospectives include The Museum of Modern Art, New York [1971] and San Francisco Museum of Modern Art [2003].

Allan D'ARCANGELO [b. 1930, Buffalo, New York, d. 1998, New York] was a painter who in the early 1960s developed a hard-edge style with Pop affinities, portraying highway travel and road signs. Solo exhibitions include Thibaut Gallery, New York [1963] and Neuberger Museum, State University of New York [1978].

ARCHIGRAM [Warren Chalk, 1927-88, Peter Cook, b. 1936, Dennis Crompton, b. 1933, David Greene, b. 1937, Ron Herron, 1930-94, Mike Webb, b. 1937] was the name chosen by these London-based architects to present their radical projects between 1961 and 1974. Their expanded concept of architecture included such projects as a Spray Plastic House, a Plug-in City, a Walking City and living pods and capsules. Exhibitions include 'Living City', Institute of Contemporary Arts, London [1964]. Retrospectives include Centre Georges Pompidou, Paris [1994].

ARCHIZOOM [architects Andrea Branzi, b. 1939, Gilberto Corretti, b. 1941, Paolo Deganello, b. 1940, Massimo Morozzi, b. 1941; joined in 1968 by designers Dario Bartolini, b. 1943 and Lucia Bartolini, b. 1944] were a Florence-based studio that worked under this name and with Superstudio, between 1966 and 1974. Initially influenced by Archigram, they devised radical projects for buildings, interiors and products. Exhibitions include 'Superarchittetura', Pistoia [1966] and Modena [1967] and 'Centre for Eclectic Conspiracy' at the Milan Triennale [1968].

ARMAN [Armand Fernandez, b. 1928, Nice], based in New York since 1972, met Yves Klein in 1948, collaborating with him during the 1950s. A founder-member of the Nouveaux Réalistes, in 1960 he began exhibiting *Poubelles* (transparent containers of garbage) and *Accumulations* (junk assemblages in cases). In later work he sliced, smashed and incinerated these materials. Solo exhibitions include 'Le Plein', Galerie Iris Clert [1960] and retrospective, Houston Museum of Fine Arts [1992].

Richard ARTSCHWAGER [b. 1924, Washington, D.C.] studied with the purist painter Amedée Ozenfant in New York in 1953, then became a furniture maker, gradually turning to art. From 1962 he has focused on grisaille paintings on Celotex, and objects, often made of such materials as formica. Solo exhibitions include Leo Castelli Gallery, New York [1965] and retrospectives, Whitney Museum of American Art, New York [1988] and Fondation Cartier pour l'art contemporain, Paris [1994].

David BAILEY [b. 1938, London] taught himself photography, 1948-53, by 1960 becoming a fashion photographer for *Vogue* magazine and *The Sunday Times*, the *Daily Telegraph*, and magazines such as *Elle* and *Glamour*. His *Box of Pin-ups* [1964] and *Goodbye Baby and Amen* [1969] are quintessential photographic documents of the Pop era. Retrospectives include Victoria & Albert Museum, London [1983] and Barbican Art Gallery, London [1999].

Clive BARKER [b. 1940, Luton, England] after art college worked in a car factory and then at a jewelry shop. He used production-line materials – leather and chrome-plated metal – in his earliest objects, from 1962. By the late 1960s he was making plated, reflective facsimiles of everyday items. Solo exhibitions include Robert Fraser Gallery, London [1968]; retrospectives include Whitford Fine Art, London [2003].

BEN [Ben Vautier, b. 1935, Naples] is based in Nice, where he first settled in 1949, opening a shop there in 1954 which he had transformed by the decade's end into a living artwork, after encountering the work of Duchamp and Daniel Spoerri. In 1962 he met George Maciunas and became a leading artist and theorist in the Fluxus movement. Retrospectives include Musée d'art moderne et contemporain, Nice [2001].

Billy Al BENGSTON [b. 1934, Dodge City, Kansas] radically changed his work after seeing reproductions of Jasper Johns' *Flag* and *Target* paintings. In California he adopted preconceived motifs such as hearts, chevrons and motorcycle logos. In the early 1960s he was widely exhibited as a 'West Coast Pop' painter. He was first exhibited at Ferus Gallery, Los Angeles, in 1958 and at Martha Jackson Gallery, New York, in 1962. Retrospectives include Contemporary Arts Museum, Houston [1988] and tour.

Wallace BERMAN [b. 1926, Staten Island, New York, d. 1976, Topanga Canyon, California] was a leading figure in the West Coast's 1950s Beat community, a pioneer of assemblage and mail art. From 1963 onwards he made verifax collages with images derived from diverse media sources. Retrospectives include University Art Museum, Berkeley, California [1979].

Peter BLAKE [b. 1932, Dartford, Kent] trained as a graphic artist before studying at the Royal College of Art [1953-56] after which he spent a year in Europe studying folk and popular art. From 1959 he developed a form of collage-derived painting, as well as collage works, incorporating popular iconography and ephemera. In 1967 he co-designed the cover for the Beatles' *Sgt. Pepper* album. Solo exhibitions include Portal Gallery, London [1962]. Retrospectives include Tate Gallery, London [1983] and Liverpool [2000].

Derek BOSHIER [b. 1937, Portsmouth, England] was briefly associated with Pop between 1959 and 1962, when he studied at the Royal College of Art with Hockney, Kitaj, Jones, Phillips and Caulfield. His paintings of the time portrayed American consumer products and symbols with an incisive, political engagement. Solo exhibitions include Robert Fraser Gallery, London [1965] and Whitechapel Art Gallery, London [1973].

Pauline BOTY [b. 1938, London, d. 1966, London] was the only woman painter in the British Pop art movement, introducing a female perspective into the Pop lexicon. A contemporary of Blake, Hockney, Boshier and others at the Royal College of Art, she was included in the BBC film *Pop Goes the Easel* [1962]. The first major retrospective of her work was at Whitford Fine Art and The Mayor Gallery, London [1998].

Mark BOYLE [b. 1934, Glasgow, d. 2005, London], his wife the artist **Joan HILLS** and later their children, collaborated on artworks as The Boyle Family. With Hills in the 1950s he conceived of a total form of art which would be an objective examination of reality. Their investigations led to the light and sound environments of the mid 1960s that initiated their collaborations with the band Soft Machine and Jimi Hendrix. Retrospectives include Hayward Gallery, London [1986] and Scottish National Gallery of Modern Art [2003].

George BRECHT [b. 1926, New York City] studied in New York with John Cage in the late 1950s, becoming a founder-member and theorist of the Fluxus movement. As well as devising scores for 'events', he went on in the 1960s to make assemblages of everyday objects. Solo exhibitions include Reuben Gallery, New York [1959] and retrospectives, Kunsthalle Bern [1978] and Ludwig Museum, Cologne [2005].

Marcel **BROODTHAERS** [b. 1924, Brussels, d. 1976, Cologne] first came into contact with Magritte in 1940. In the mid 1960s he progressed from poetry and critical writing to making actions, objects, images, films and installations that questioned the status of cultural media and institutions. Retrospectives include Galerie national du Jeu de Paume, Paris [1991] and tour.

R. **BUCKMINSTER FULLER** [b. 1895. Milton, Massachusetts, d. 1983, Los Angeles] was a mathematician, engineer, futuristic architect and utopian thinker who developed the concepts of 'tensegrity' and 'synergetics' in the dymaxion car and house [mid 1930s], the geodesic dome [patented in 1954] and floating cities [late 1960s]. These self-sustaining, ecologically economical structures use the most advanced technology.

Rudy **BURCKHARDT** [Rudolph Burckhardt, b. 1914, Basel, d. 1999, Maine] was a photographer, filmmaker and painter. His photographs of streets, storefronts and signs [c.1939-59] foreshadowed the work of artists such as Ed Ruscha. In the 1960s he associated with Pop artists such as James Rosenquist, photographing their work. His first photography retrospective was held at IVAM, Valencia, in 1998.

Donald **CAMMELL** [b. 1934, Edinburgh, d. 1996, Hollywood] and the cinematographer Nicolas **ROEG** [b. 1928, London] collaborated as co-directors on *Performance* [1968] starring Mick Jagger, James Fox and Anita Pallenberg. Cammell wrote the screenplay for *The Touchables* [1968], in which a male Pop star languishes in a clear plastic dome designed by Arthur Quarmby. Cammell combined study of avant-garde filmmakers such as Kenneth Anger with a home-movie approach to produce a document of self destructiveness at the end of the 1960s.

Patrick **CAULFIELD** [b. 1936, London] studied at the Royal College of Art [1960-63] and until 1965 used household enamel paints on hardboard for his hard-edge outline paintings of mundane objects. He disavowed a Pop connection, aligning his work with Gris, Léger and Magritte, and moving on to traditional subjects - interiors, landscape and still life. Solo exhibitions include Robert Fraser Gallery, London [1965] and retrospectives, Tate Gallery, London [1981] and Hayward Gallery, London [1999].

CÉSAR [César Baldaccini, b. 1921, Marseille, d. 1998, Paris] was a sculptor who

in 1958 began to produce *Compressions* of scrap iron, from 1960 directing compression of cars with a hydraulic press and participating in Nouveau Réalisme events. In 1967 he began making *Expansions* - poured coloured polyurethane fluid that rapidly expanded and solidified.. Solo exhibitions include Galerie Lucien Durand, Paris [1954] and retrospective, Galerie national du Jeu de Paume, Paris [1997].

John **CHAMBERLAIN** [b. 1927, Rochester, Indiana] studied at Black Mountain College [1955-56] where he encountered the ideas of John Cage and others. From 1958, in New York, he made welded assemblages of scrap metal, by the early 1960s using compressed car body parts. In the mid 1960s he experimented with plastics and car lacquer. Solo exhibitions include retrospective, The Museum of Contemporary Art, Los Angeles [1986].

Bruce **CONNER** [b. 1933, McPherson, Kansas] is a filmmaker, artist and photographer, based in San Francisco. A key figure in the West Coast Beat scene, with his first film, *A Movie* [1958], he pioneered the collage/ montage of B-movies, newsreels and other diverse sources. In the early 1960s he was also among the first to use Pop music for soundtracks, and to film material from a TV screen. His first retrospective was '2000 BC: The Bruce Conner Story Part II', Walker Art Center, Minneapolis [2000] and tour.

Sister **CORITA** [Frances Kent, b. 1918, Fort Dodge, Iowa, d. 1986, Boston] was a nun who taught art at the Immaculate Heart College, Los Angeles, until 1968 when she left the order and moved to Boston. Her screenprints used a Pop idiom to transform corporate-style slogans into messages for love, peace and justice. Her work is in public collections at the Corita Art Center, Los Angeles; The Museum of Modern Art, New York; Victoria & Albert Museum, London; Bibliothèque Nationale de France, Paris.

Roger **CORMAN** [b. 1926, Detroit] has produced or directed over 300 low-budget, independent 'B' movies since the 1950s, creating cult classics such as *The Wild Angels* [1966] and *Death Race 2000* [1975] through his skilful use of pop-culture formulae including gangsters, bikers, hippies or science fiction scenarios. He has worked with actors Jack Nicholson and Peter Fonda and directors Scorsese and Coppola.

Robert **CRUMB** [b. 1943, Philadelphia] is a subversive, satirical cartoon artist.

Discovered by Harvey Kurtzman, formerly of *MAD* magazine, in the early 1960s, by 1967 he launched his own underground *Zap Comix* from San Francisco, with characters such as Fritz the Cat and Joe Blow embodying the anathema and repressed unconscious of puritan America. Retrospectives include Whitechapel Art Gallery, London [2005].

Guy **DEBORD** [b. 1931, Paris, d. 1994, Paris] was a French theorist and filmmaker. With Asger Jorn and others he formed the Situationist International in 1957. Their ideas, such as dérive, détournement, unitary urbanism and psychogeograhy, have influenced many artists, architects and critics of capitalism. His books include *The Society of the Spectacle* [1967].

Jim **DINE** [b. 1935, Cincinatti] was instrumental in setting up a counter-movement to gestural abstraction with his New York environments and events of the late 1950s. Events/ environments include Car Crash, Reuben Gallery, New York [1959] and The House, Judson Gallery, New York [1960]. Retrospectives include the Solomon R. Guggenheim Museum, New York [1999].

WALT DISNEY IMAGINEERING has been the name since 1984 of the creative partnership originally known as WED Enterprises, selected by Walt [Elias] Disney in the early 1950s as an integrated concept planning, design and installation team for the first Disneyland Park in Anaheim, California. It has been responsible for numerous technological innovations in areas such as special effects and interactive technology. Imagineering's headquarters are in Glendale, California.

Rosalyn **DREXLER** [b. 1925, New York] is a painter, writer and dramatist based in Newark, New Jersey. Marginalized from art history until the 1990s, she is now recognized as an innovative contemporary of the New York Pop painters, who introduced a proto-feminist critique of mass-media imagery in her paintings of the mid 1960s. Solo exhibitions include Mitchell Algus Gallery, New York [2000].

Marcel **DUCHAMP** [b. 1887, Blainville Crevon, France, d. 1968, Neuilly-sur-Seine] since his first selection of readymade objects for display [1913-17] began a dialogue that was re-explored and developed in the 1960s by artists as diverse as Broodthaers, Dine, Hamilton and Warhol. From 1915 living in New York, he was a key influence for Cage, Johns, Rauschenberg and the Fluxus artists in the

1950s. His first retrospectives were during the Pop years, at Pasadena Art Museum [1963] organized by Walter Hopps and the Tate Gallery, London [1966] organized by Richard Hamilton.

ERRÓ [Gudmundur Gudmundsson, b. 1932, Olafsvik, Iceland] settled in Paris in 1958, where he interacted with the Surrealists and emergent Nouveau Réaliste and Fluxus artists, painting, making films and collaborating with Jean-Jacques Lebel on Happenings in the early 1960s. As the Vietnam war escalated he responded with a politicized form of figurative painting. Solo exhibitions include Kunstmuseum Luzern [1975] and Museum Moderner Kunst, Vienna [1996].

Öyvind **FAHLSTRÖM** [b. 1928, São Paulo, d. 1976, Stockholm] was an artist and writer based, from 1961, alternately in New York and Stockholm. In the early 1950s he co-founded the concrete poetry movement and developed a lexicon of painted forms he referred to as signifiguration. After 1961 his gradual incorporation of elements from comics, news media and other sources led him to produce increasingly politicized work in diverse and innovative forms. A major touring retrospective was organized by the Museu d'Art Contemporani de Barcelona in 2001.

Robert **FRANK** [b. 1924, Zurich] is a photographer and filmmaker, based in the United States since 1950, who realized the potential of structuring photographic sequences in ways analogous to filmmaking. His unprecedented 1955-57 visual diary of travel across the United States was first published in France as *Les Américains* in 1958. He was also a Beat filmmaker [*Pull My Daisy*, 1959] and developed fly-on-the-wall documentary in his portrait of the Rolling Stones on tour [*Cocksucker Blues*, 1972]. Retrospectives include Tate Modern, London [2004] and tour.

Lee **FRIEDLANDER** [b. 1934, Aberdeen, Washington] has since moving to New York in 1956 been an innovator in the tradition of photographers such as Walker Evans and Robert Frank. Often in his street images and roadside scenes single or multiple mirror reflections, or indices of the photographer's presence invite speculation on registers of representation and potential meaning. Retrospectives include The Museum of Modern Art, New York [2005].

Jean-Luc **GODARD** [b. 1930, Paris] was an influential film critic for *La Gazette du cinéma*, *Arts* and *Cahiers du cinéma* before he

became the leading proponent of new wave cinema from 1959 until his turn towards an overtly Marxist, didactic approach during the late 1960s. His practice has returned to the notion that cinema comes into being through its own reflection upon and evaluation of itself and its history. This paralleled concerns in the work of artists such as Roy Lichtenstein and Gerhard Richter. His magnum opus, begun in the late 1980s, is *Histoire[s] du cinéma*, a video work whose subject is the entire history of film.

Ernö **GOLDFINGER** [b. 1902, Budapest, d. 1987, London] studied in Paris in the early 1920s, where he met Le Corbusier and worked with Auguste Perret on reinforced concrete architecture in which structural elements were exposed. He moved to London in 1934 but only received significant commissions after provisions in the 1956 Housing Act encouraged public authorities to construct high-rise buildings. His housing projects such as Trellick Tower [completed 1972] exemplify the 'New Brutalism' which Reyner Banham championed in the mid 1950s.

Joe **GOODE** [b. 1937, Oklahoma City] studied advertising design at the Chouinard Art Institute, Los Angeles [1959-61], alongside his friend Ed Ruscha. Their early paintings were included in 1962 in 'New Paintings of Common Objects', Pasadena Art Museum. Goode's 'milk bottle' series was followed in 1964 by a 'staircase' series. Solo exhibitions include Dilexi Gallery, Los Angeles [1962] and Fort Worth Art Center [1972].

Dan **GRAHAM** [b. 1942, Urbana, Illinois] has since the mid 1960s produced a body of art and theory that engages with the social and ideological functions of cultural systems. Architecture, popular music, video and television are among the subjects of his investigations in writings, performance, video, installations and architectural/sculptural works. Retrospectives include Fundação de Serralves, Museu de Arte Contemporânea, Porto [2001] and tour.

Red **GROOMS** [Charles Rogers Grooms, b. 1937, Nashville, Tennessee] studied at the New School of Social Research, New York, in 1956 and with painter Hans Hofmann in 1957. In 1958 he made painting-performances, which developed into Happenings based on modern metropolitan life; these led to his 'sculpto-pictoramas' of the mid 1960s. He was included in 'Four Happenings', Reuben Gallery, New York [1960]. Retrospectives include Whitney Museum of American Art, New York [1987].

Raymond **HAINS** [b. 1926, Saint-Brieuc, Côtes-du-Nord] first met Jacques de la Villeglé while studying in Rennes in 1945. Both independently and in collaboration they made décollages from torn posters since 1949. Hains' perspective on décollage derived from his 'hypnogogic' photographs of typography through a distorting lens. In the mid 1960s he made Pop objects such as giant matchboxes, exhibited at Galerie Iris Clert, Paris, in 1965. Retrospectives include Centre Georges Pompidou, Paris [1976; 2001].

Richard **HAMILTON** [b. 1922, London] was from 1952 a leading member of the Independent Group based at the Institute of Contemporary Arts, London, which analysed popular mass culture. He co-organized 'This is Tomorrow', Whitechapel Art Gallery, 1956. His collages and paintings of this period are considered among the earliest Pop works. In 1963 he began screenprinting, exploring relationships between painting and industrial technologies of representation. In 1960 he published his translation of Marcel Duchamp's *Green Box* notes for '*Large Glass*' [1915-23], remaking the work with Duchamp's approval in 1966. Solo exhibitions include Hanover Gallery, London [1964], Kunstmuseum, Winterthur [2002] and retrospectives, Tate Gallery, London [1970 and 1992], Museu d'Art Contemporani de Barcelona [2003].

Duane **HANSON** [b. 1925, Alexandria, Minnesota, d. 1996, Davie, Florida] developed a form of super-realistic sculpture in the late 1960s. He took Polaroids of a clothed subject, then made figures from casts of the model's unclothed body, adding wigs, etc., for waxwork-like verisimilitude. Early works dealt with political issues; later works the everyday in his native Midwest. His first major retrospective was at Memphis Brooks Museum of Art, Tennessee, in 1999.

Nigel **HENDERSON** [b. 1917, London, d. 1984, Essex, England] first met Duchamp when installing his work at Peggy Guggenheim's London gallery in the late 1930s, and Hamilton and Paolozzi when studying at the Slade School of Art, London, in 1947. To the Independent Group he contributed his Bethnal Green photographs [1948-52], photograms and collages. His wide frame of reference embraced Art Brut, documentary photography and Surrealism. Solo exhibitions include Institute of Contemporary Arts, Dover Street, London [1961].

David **HOCKNEY** [b. 1937, Bradford, England] is a painter and photographer, based in Los Angeles since the mid 1960s. A Royal College of Art contemporary of Boshier, Caulfield, Jones, Kitaj, Phillips [1959-62], he was identified with Pop for his early paintings' references to graffiti and commercial packaging. He began his Californian pool paintings in 1964. Solo exhibitions include Kasmin Gallery, London [1963] and retrospective, Los Angeles County Museum of Art [1988] and tour.

Hans **HOLLEIN** [b. 1934, Vienna] studied architecture in Chicago and California before establishing his Vienna practice in 1964. Reacting against Mies van der Rohe's constructional functionalism he explored the technological and media environment, using collages and drawings to conceptualize his ideas. He has designed many influential public buildings, such as the Städtisches Museum Abteiberg, Mönchengladbach, Germany.

Dennis **HOPPER** [b. 1936, Dodge City, Kansas] is an actor, filmmaker, photographer and artist. In the early 1950s he associated with Beat artists and writers, then became a film actor in Nicholas Ray's *Johnny Guitar* [1953] and *Rebel Without a Cause* [1955]. In the mid 1960s he regained a cult status as a 'screen test' subject of Warhol. He directed *Easy Rider* in 1969. Since the mid 1980s he has had leading roles in films such as David Lynch's *Blue Velvet* [1986].

Robert **INDIANA** [Robert Clarke, b. 1928, Newcastle, Indiana] is a poet, painter and sculptor whose work combines vernacular references such as sign painting with hard-edge formalism, in an exploration of American symbolism. Solo exhibitions include Stable Gallery, New York [1962; 1966] and retrospective, Portland Museum of Art [1999].

Alain **JACQUET** [b. 1939, Neuilly-sur-Seine, France] made his first critical intervention in Pop with his 'camouflage' series [1962-63] in some of which he painted commercial logos over iconic images such as Jasper Johns' *Flag*. A cut-up 'camouflage' of a Lichtenstein was sold in pieces as a comment on art consumerism. From 1964, in association with Mimmo Rotella, Pol Bury and other 'Mec Art' artists, he explored relationships between painting and mass-production. Solo exhibitions include Galerie Breteau, Paris [1961] and retrospective, Centre Georges Pompidou, Paris [1993].

JESS [Jess Collins, b. 1923, Long Beach, California] first exhibited his paste-up collages and junk assemblages at The Place, one of San Francisco's Beat poet and artists' bar/galleries, in 1954. From then to 1959 he worked on the *Tricky Cad* series of altered *Dick Tracy* cartoons, after which he began his *Translations* series of thick impasto paintings 'translated' from found images. Retrospectives include Museum of Fine Arts, Dallas [1977] and Mable Ringling Museum of Art, Sarasota, Florida [1983].

Gérard **JOANNÈS** was a graphic artist who collaborated in 1967 with Raoul Vaneigem on a series of posters announcing issues of *Situationniste Internationale*. Based on comic-strip stories they showed students discussing situationist ideas, and became associated with the May 1968 revolution. They were exhibited in 'On the Passage of a few people through a rather brief moment in time: The Situationist International 1957-1972', Centre Georges Pompidou, Paris [1989] and tour.

Jasper **JOHNS** [b. 1930, Augusta, Georgia, USA] was among Pop art's most important precursors with his *Flag* and *Target* paintings of the mid 1950s, reproduced widely in magazines after their first exhibition in 1958. Solo exhibitions include Leo Castelli Gallery, New York [1958] and Galerie Rive Droite, Paris [1959; 1961]. Retrospectives include The Jewish Museum, New York [1964] and The Museum of Modern Art, New York [1996].

Ray **JOHNSON** [b. 1927, Detroit, d. 1995, New York] was from 1949-52 a member of American Abstract Artists, exhibiting abstract work alongside such painters as Ad Reinhardt. In the mid 1950s, after meeting Rauschenberg and Twombly, he began making collages from newspaper and magazine images. In the mid 1960s he pioneered mail art, founding the New York Correspondance [sic] School of Art [1968-73]. Solo exhibitions include Marian Willard Gallery, New York [1965] and retrospective, Whitney Museum of American Art [1999].

Allen **JONES** [b. 1937, Southampton, England] was a short-lived Royal College of Art contemporary of Boshier, Kitaj, *et al.*, expelled a year after his enrolment in 1959. At first focusing on colour, the human figure and subtle eroticism, he developed an identifiably Pop style in his fetishistic paintings of women in the mid 1960s and his fibreglass sculptures of Barbarella-like figures in 1969. Retrospectives include Walker Art Gallery, Liverpool [1979] and Barbican Art Gallery, London [1995].

Asger JORN [Asger Oluf Jorgensen, b. 1914, Vejrum, Jutland, d. 1973 Århus, Denmark] studied painting under Fernand Léger in Paris in 1936. Returning there from Denmark after the war he met Constant [Nieuwenhuys] and in the late 1940s they joined other artists advocating total freedom of expression to form COBRA [acronym for Copenhagen, Brussels, Amsterdam]. He went on to participate in the Situationist International from 1957 to 1961. Retrospectives include Arken Museum of Modern Art, Denmark [2002] and tour.

Alex KATZ [b. 1927, New York] began in the late 1950s to develop a style of abstract-figurative painting and drawing, centred on portraits of his wife Ada, family and friends. His figures recall the style of hand-painted film and advertising posters. Solo exhibitions include Stable Gallery, New York [1960; 1961] and retrospectives, Whitney Museum of American Art [1986] and The Saatchi Collection, London [1998].

Edward KIENHOLZ [b. 1927, Fairfield, Washington, d. 1994, Hope, Idaho] with critic and curator Walter Hopps opened the Ferus Gallery, Los Angeles, in 1957. The gallery presented the first West Coast shows of Warhol, Ruscha, Bengston and others. In 1961 Kienholz made his first 'tableau', *Roxy's*, a recreation of an entire brothel, with surrealist overtones; later he introduced the 'concept tableau', which could be realized whenever more funds were available. Solo exhibitions include Café Galleria, Los Angeles [1955] and retrospectives, Los Angeles County Museum of Art [1966] and Whitney Museum of American Art, New York [1996].

R.B. KITAJ [b. 1932, Cleveland, Ohio] completed his art studies at the Royal College of Art, London [1959-61], coinciding with the British 'Pop' generation, although five years their senior and with a more profound engagement with literature, history and politics. His work with images from photography and film brought some of his paintings and prints close to Pop in the early 1960s. Retrospectives include Hirshhorn Museum and Sculpture Garden, Washington, D.C. [1982] and tour; Tate Gallery, London [1994].

William KLEIN [b. 1928, New York] studied painting under Fernand Léger in Paris in 1948, remaining in France thereafter. By the mid 1950s he was pushing the boundaries of photography, using high-grain film, wide angles, extreme close-ups (often blurred) and high-contrast prints in his 1954 photo-diary

of New York, followed by studies of Rome [1960], Moscow and Tokyo [both 1964]. Until the 1980s Klein then concentrated on filmmaking, starting with his 'Pop' film *Broadway by Light* [1958]. His other films include *Qui êtes-vous, Polly Magoo?* [1966] and *Mr Freedom* [1967-68]. Retrospectives include Centre Georges Pompidou [2005].

Yayoi KUSAMA [b. 1929, Matsumoto, Japan] is an artist and writer who worked in New York from 1958 to the late 1960s. Her paintings, sculpture and installations are characterized by serial repetition of patterns and forms. Her 1960s work had affinities with that of contemporaries Donald Judd, Andy Warhol, the Nouveaux Réalistes and the Zero group. Solo exhibitions include the Castellane Gallery, New York [1964], and retrospective, Los Angeles County Museum of Art [1989] and tour.

John LENNON [b. 1940, Liverpool, d. 1980, New York] is best known as the singer, guitarist and co-songwriter with Paul McCartney for The Beatles pop group. After he met the Fluxus artist and musician Yoko Ono in London in 1966 he collaborated with her on art projects and exhibited his own drawings. Once married in 1969 they created anti-Vietnam war peace actions such as their *Bed-In*, and *War Is Over* posters and broadcasts. Exhibitions include 'You Are Here', Robert Fraser Gallery, London [1968] and erotic lithographs, London Arts Gallery, London [1970].

Roy LICHTENSTEIN [b. 1923, New York, d. 1997, New York] after meeting artists such as Dine and Oldenburg began in 1961 to paint in a radically different style, deriving his compositions directly from printed cartoon strips and advertisements. From 1964 onwards he 'Lichtensteinized' many other types of subject matter, as well as historical styles of representation. Solo exhibitions include Leo Castelli Gallery, New York [1962; 1963; 1964], Ferus Gallery, Los Angeles [1963; 1964], Galerie Ileana Sonnabend, Paris [1965] and retrospectives, Pasadena Art Museum [1967] and Solomon R. Guggenheim Museum, New York [1969; 1994].

Konrad LUEG [Konrad Fischer, b. 1939, Düsseldorf, d. 1996, Düsseldorf] was the pseudonym of renowned gallery owner Konrad Fischer, during the early 1960s when he was a painter and co-founder (with Gerhard Richter and Sigmar Polke) of the German counterpart to Pop art, Capitalist Realism. Between 1962 and 1966 he exhibited at the galleries

Schmela, Düsseldorf and René Block, Berlin. He covered these spaces in newspaper cuttings and wallpaper patterns, on which he displayed his paintings of cypher-like figures.

John McHALE [1922-1978] was a member of the Independent Group who in the mid 1950s made sculpture 'kits' for mass-production, collages exploring mass communication, and photographs of American roadside diners and signs. He collaborated with Richard Hamilton and John Voelcker in 'This is Tomorrow', Whitechapel Art Gallery, London [1956]. He was the author of the influential essay 'The Plastic Parthenon' [first published in *Dot-Zero* magazine, Spring 1967] and the books *Buckminster Fuller* [1960] and *The Future of the Future* [1969]. In 1962 he moved to the USA with his wife Magda Cordell McHale, also a former IG artist.

Charles MOORE [b. 1925, Benton Harbor, Michigan, d. 1993] was a teacher and practising architect who rejected modernist formalist principles in response to the awareness of environment fostered by mass cultural forms. Placing the symbolic preferences of the client first, and thus allowing for style variations ranging from wooden shed to Palladian, he is considered one of the founders of postmodern architecture. Among the buildings he collaborated on are the Sea Ranch Condominium, near San Francisco [1964-65] and the Hood Museum of Art, Hanover, New Hampshire [1981-85].

Malcolm MORLEY [b. 1931, London] is a British painter based in New York since 1958. A contemporary of Peter Blake, Richard Smith and Joe Tilson at the Royal College of Art, London, 1954-57, in New York he met Artschwager, Lichtenstein and Warhol. In 1964 he began his paintings of ships based on photographs, which developed into a 'superrealist' style that lasted until its 'cancellation' in the painting *Race Track* [1970]. Retrospectives include Whitechapel Art Gallery, London [1983] and Hayward Gallery, London [2001].

Claes OLDENBURG [b. 1929, Stockholm] settled in New York in 1956. In the late 1950s he began to stage events in Art Brut-like environments with crudely painted shapes and junk found on the streets. These were followed by The Store [1961], where he blurred distinctions between art and commerce. By 1965 he had explored 'hard', 'soft' and 'ghost' replicas of everyday objects and begun proposals for giant objects

as civic monuments. Solo exhibitions include Judson Gallery, New York [1959], Dwan Gallery, Los Angeles [1963], Galerie Ileana Sonnabend, Paris [1964], Sidney Janis Gallery, New York [1964; 1965; 1966; 1967]. Retrospectives include The Museum of Modern Art, New York [1969] and Solomon R. Guggenheim Museum, New York [1995].

Eduardo PAOLOZZI [b. 1924, Leith, Scotland, d. 2005, London] studied at the Slade School of Art, London, 1944-47, then visited Paris where he met artists associated with Dada, Surrealism and their legacies. Returning to London he associated with the Independent Group, in 1952 presenting a slide lecture of scrapbook collage images at the Institute of Contemporary Arts. Published and exhibited since 1972, these are now considered among the first Pop artworks. The last of his Pop-related works, made in the 1960s, are robot-like cast metal figures, finished in bright colours that echo his silkscreen prints. Retrospectives include Tate Gallery, London [1971] and Scottish National Gallery of Modern Art, Edinburgh [2004].

D.A. PENNEBAKER [b. 1925, Evanston, Illinois] was instrumental in developing the Direct Cinema style of documentary filmmaking, also known as *cinéma vérité*. He joined the New York Filmmakers' Co-op in 1959 and made his first behind-the-scenes documentary about an election campaign: *Primary* [1960]. *Don't Look Back* [1967] followed Bob Dylan's 1965 concert tour in England. In the 1960s Pennebaker worked with Jimi Hendrix and Otis Redding at the Monterey Pop Festival in 1967 [*Monterey Pop*, 1968].

Peter PHILLIPS [b. 1939, Birmingham, England] studied at the Royal College of Art, London, with Boshier, Caulfield, Hockney, Jones and Kitaj, 1959-62. His early work combined the influence of Jasper Johns' *Flag* and *Target* paintings with imagery derived from board games, logos and pin-ups. From 1964 to 1966 he travelled in the USA, where he adopted a larger scale, and airbrush techniques. In 1967 he moved to Zurich and in 1988 to Mallorca. Retrospectives include Westfälischer Kunstverein, Münster [1972] and Walker Art Gallery, Liverpool [1982].

Michelangelo PISTOLETTO [b. 1933, Biella, Italy] studied advertising in the 1950s. In 1960 he exhibited his first portraits set against metallic backgrounds, at Galleria Galatea, Turin. His 'mirror' paintings followed, in which lifesize painted figures are superimposed on mirrored surfaces. From

the late 1960s he produced more diverse work as a leading Arte Povera artist. Retrospectives include Forte di Belvedere, Florence [1982], Staatliche Kunsthalle, Baden-Baden [1988] and Museu d'Art Contemporani de Barcelona [2000].

Sigmar **POLKE** [b. 1941, Oels, Lower Silesia, now Olesnica, Poland] grew up in East Germany then moved to the West in 1953, studying at the Staatliche Kunstakademie, Düsseldorf, 1961-67, under Joseph Beuys. He is unconstrained by style and materials; for example his 'dot paintings' of the mid 1960s echo Lichtenstein's but blur and rearrange dot patterns to create unexpected images. Solo exhibitions include Galerie René Block, Berlin [1966] and retrospectives, Musée d'art moderne de la Ville de Paris [1988] and the Kunst- und Ausstellungshalle der Bundesrepublik Deutschland, Bonn [1997] and tour.

Cedric **PRICE** [b. 1934, Stone, Staffordshire, England, d. 2003, London] from the time he founded his own practice in 1960 was a visionary architect whose mainly unbuilt projects profoundly influenced future architecture and planning. His central belief was that new technology could give the public unprecedented control over their environment. His unrealized Fun Palace [1960-61] was the ancestor of the Centre Pompidou as well as pioneering, in its proposed siting, urban reclamation and regeneration. Retrospectives include The Design Museum, London [2005].

Arthur **QUARMBY** is an architect based in Huddersfield, England, who was a pioneer in the 1960s of the use of moulded and prefabricated plastics in architecture, ranging from multiple units for industrial and domestic structures to inflatable domes. He is the author of *The Plastics Architect* [Pall Mall Press, 1974]. In 1975 he designed and built the first modern earth sheltered house in Britain, 'Underhill', in Yorkshire. He is President of the British Earth Sheltering Association, which promotes these environmentally sound buildings.

Mel **RAMOS** [b. 1935, Sacramento, California] was taught by the painter Wayne Thiebaud at Sacramento State College [1954-58]. He began to paint cartoon characters during 1961-62, in an impasto style similar to Thiebaud's. In 1963 he introduced female characters and the following year developed a more graphic, 'commercial' style, portraying curvaceous pin-up girls posed, semi-

ironically, with consumer goods. Solo exhibitions include Paul Bianchini Gallery, New York [1964; 1965], and retrospectives, Oakland Art Museum, California [1977] and Kunstverein, Lingen, Austria [1994] and tour.

Robert **RAUSCHENBERG** [b. 1925, Port Arthur, Texas] studied in Paris [1948-49] followed by Black Mountain College, North Carolina, where he met composer John Cage, choreographer Merce Cunningham, poet Charles Olson and artist Cy Twombly. Their shared ideas led him to explore 'the gap between art and life' in his Combines of the mid 1950s, and collaborations with performance and dance companies. Solo exhibitions include Betty Parsons Gallery, New York [1951], Leo Castelli Gallery, New York [1958], Galleria La Tartaruga, Rome [1959] and retrospectives, The Jewish Museum, New York [1963] and Solomon R. Guggenheim Museum, New York [1998].

Martial **RAYSSE** [b. 1936, Golfe-Juan, near Nice] was one of the founding artists of the Nouveau Réalisme group, in the early 1960s making assemblages of mass-produced objects, mainly of brightly coloured plastic. Solo exhibitions include Galerie Longchamp, Nice [1957], Stedelijk Museum, Amsterdam [1965], Dwan Gallery, Los Angeles [1967] and retrospectives, Centre Georges Pompidou, Paris [1981] and Galerie national du Jeu de Paume, Paris [1992].

Ron **RICE** [b. 1935, New York, d. 1964, Mexico] was an avant-garde filmmaker who collaborated with the performer Taylor Mead, whom he first met in San Francisco in the late 1950s. His films include *The Flower Thief* [1960], *Senseless* [1962], *Queen of Sheba Meets the Atom Man* [1963, final version completed by Mead in 1982] and *Chumlum* [1964]. The filmmaker and critic Jonas Mekas described the work of Bob Fleischner, Ken Jacobs, Rice and Jack Smith as a new form of 'Baudelairian Cinema', a cinematic equivalent to the writings of William Burroughs.

Gerhard **RICHTER** [b. 1932, Dresden] like Sigmar Polke, moved from what was then East Germany to the West to study at the Staatliche Kunstakademie, Düsseldorf [1961-64]. With Konrad Lueg they collaborated on the launch of Capitalist Realism. Since the early 1960s Richter has archived photographic images and used them as the basis for many of his paintings. Retrospectives include Städtische Kunsthalle, Düsseldorf [1986], Museum Boymans-van Beuningen [1989] and The Museum of Modern Art, New York [2002] and tour.

James **ROSENQUIST** [b. 1933, Grand Forks, North Dakota] studied and practised abstract painting while working as a commercial billboard painter [1953-54 and 1957-60]. In 1960 he began to incorporate the subject matter and style of his advertising work into fragmentary compositions. Solo exhibitions include Green Gallery, New York [1962; 1964], Dwan Gallery, Los Angeles [1964], Galerie Ileana Sonnabend, Paris [1965], 'James Rosenquist: F-111', Leo Castelli Gallery, New York [April-May 1965] and retrospectives, Denver Art Museum [1985] and Solomon R. Guggenheim Museum [2003].

Mimmo **ROTELLA** [b. 1918, Cantanzaro] studied in Naples then settled in Rome in 1945. He began making décollages using torn street posters in 1953, first exhibiting them in 1954. In 1960 he began to exhibit with the French décollageistes Hains and Villeglé, and to participate in Nouveau Réalisme exhibitions. In 1963, with Alain Jacquet, Pol Bury and others, he developed 'Mec Art', which explored mechanical reproduction. Solo exhibitions include Galleria Chiurazzi, Rome [1951] and retrospective, Musée d'art moderne et contemporain, Nice [2004].

Ed **RUSCHA** [b. 1937, Omaha, Nebraska] studied commercial art at the Chouinard Art Institute, Los Angeles. In 1961 he travelled across Europe, and also began making his first paintings of words. In 1963 he began a series of artist's books, such as *Twentysix Gasoline Stations* [1963] and *Nine Swimming Pools and a Broken Glass* [1968]. Solo exhibitions include Ferus Gallery, Los Angeles [1963] and retrospectives, Museum of Contemporary Art, Los Angeles [1990], Hirshhorn Museum and Sculpture Garden, Smithsonian Institution, Washington, D.C. [2000] and 'Ed Ruscha and Photography', Whitney Museum of American Art, New York [2004].

Lucas **SAMARAS** [b. 1936, Kastoria, Greece] moved to New York in 1948. He studied at Rutgers University, New Brunswick, with Allan Kaprow and George Segal [1955-59] and participated in Happenings at the Reuben Gallery, New York, with Red Grooms and Claes Oldenburg in 1959. He began making boxes in 1960, first introducing self-portraits in 1963. In 1964 he recreated his bedroom in the Green Gallery, New York, and in 1965 began his *Transformations* series of manipulated Polaroid self-portraits. Solo exhibitions include Green Gallery, New York [1961; 1964], Pace Gallery, New York [1965; 1966] and retrospectives, Whitney Museum of American Art, New York [1972; 2000].

Peter **SAUL** [b. 1934, San Francisco] lived in Holland, Paris and Rome, 1956-64, returning to California, 1964-74. His expressionistic paintings are politically engaged precursors of the 'graffiti' style of the early 1980s. Solo exhibitions include Allan Frumkin Gallery, New York [1962; 1963; 1964; 1966] and retrospective, Musée de l'Abbaye Sainte-Croix Chateauroux, France [1999] and tour.

Carolee **SCHNEEMANN** [b. 1939, Fox Chase, Pennsylvania] is a mixed media and performance artist based in New York. In works such as *Eye Body: 36 Transformative Actions* [1963] she integrated her own naked body into an assemblage/environment, inflecting a feminist perspective on the innovations represented by Rauschenberg's Combines and the environments/actions of Dine, Kaprow and Oldenburg. Other works bearing a critical relation to Pop include *More than Meat Joy*, first performed at the Festival de la Libre Expression, Paris [1964]. Retrospectives include New Museum of Contemporary Art, New York [1998].

Kurt **SCHWITTERS** [b. 1887, Hannover, d. Ambleside, England, 1948] was a leading member of the Berlin group of Dadaists until the Second World War, arriving in London as a refugee in 1941. During the 1920s and 1930s he produced a kind of collage or assemblage of materials such as printed ephemera which he called Merz, after the 'merz' in 'Commerz'. He also worked as a commercial graphic designer. In London he used comic strips brought from the USA by American soldiers in his last collages, which were unexhibited at his death but rediscovered in the early 1960s and viewed retrospectively as proto-Pop artworks.

George **SEGAL** [b. 1924, New York] studied art 1941-49 and had his first exhibition of paintings in 1953. He began sculpting with plaster over a burlap and wire support in 1958, casting from live models from 1961. He created entire environments in which the plaster figures represented people engaged in mundane tasks. Solo exhibitions include Green Gallery, New York [1962; 1964], Sidney Janis Gallery, New York [1965], and retrospectives, Museum of Contemporary Art, Chicago [1968] and Montreal Museum of Fine Arts [1997].

Colin **SELF** [b. 1941, Norwich, England] studied at the Slade School of Art, London, 1961-63. Remaining at a critical distance from most of his Royal College Pop contemporaries, he used a Pop lexicon, inflected with traces of Surrealism, to

explore undercurrents of sexual fetishism and violence in consumer society and its products, the pervasive threat of nuclear annihilation, and the psychological space of the cinema and its architecture. Solo exhibitions include Robert Fraser Gallery, London [1964], Piccadilly Gallery, London [1965] and Tate Gallery, London [1995].

Martin **SHARP** [b. 1942, Sydney] is a cartoonist and graphic artist who was based in London from 1966 to 1970. He was the artist for the subversive underground magazine *Oz*, which folded after an obscenity trial in 1971. He was also instrumental in popularizing psychedelic art in Britain, producing posters of his drawings for albums and concerts of Bob Dylan, Jimi Hendrix and others. Solo exhibitions include Art Gallery of South Australia, Adelaide [2000].

Jack **SMITH** [b. 1932, Columbus, Ohio, d. 1989, New York] was a filmmaker, photographer, performer and artist. After moving to New York in 1953, he met the young filmmaker Ken Jacobs, whose *Blonde Cobra* [1959] is a portrait of Smith. Smith's *Flaming Creatures* [1962], with its transvestite orgy, became an immediate cult classic and was the subject of an obscenity trial in 1964. Warhol met Smith in 1963; they shared a star, the performer Mario Montez. Solo exhibitions include Limelight Gallery [photographs], New York [1960] and retrospective, P.S.1 Contemporary Art Center, New York [1997].

Richard **SMITH** [b. 1931, Letchworth, England] was a contemporary of Peter Blake and Joe Tilson at the Royal College of Art, London, 1954-57. Inspired by the New York School painters, he went there in 1959, making his first large scale paintings in 1960 before returning to London the following year. He worked again in New York from 1963 to 1965 and moved there permanently in 1976. His work hovers between abstraction and subliminal reference to commercial designs such as cigarette packet graphics. Solo exhibitions include Green Gallery, New York [1961], Whitechapel Art Gallery, London [1966] and retrospective, Tate Gallery, London [1975].

Alison **SMITHSON** [Alison Gill, b. 1928, Sheffield, England, d. 1993] and Peter **SMITHSON** [b. 1923, Stockton-on-Tees, England, d. 2003] as founder members of the Independent Group formulated an architecture that would exploit the low cost and pragmatism of mass-produced, pre-fabricated components. Influential projects such as Hunstanton Secondary Modern School, Norfolk [1949-54] and House of the Future [1956] responded to the social realities of the occupier rather than external formulaic principles. Retrospectives include the Design Museum, London [2003].

Daniel **SPOERRI** [Daniel Isaak Feinstein, b. 1930, Galaţi, Romania] moved to Switzerland in 1942, where he participated in avant-garde theatre, starting to make art in 1959. In 1960 he began his 'Tableau-pièges', in which the residues of a meal would be 'trapped' on a table top and exhibited as an artwork. His actions and works of the early 1960s explore chance and the idea of the readymade. Solo exhibitions include Galleria Schwarz, Milan [1961] and Centre Georges Pompidou, Paris [1990].

Frank **TASHLIN** [Francis Fredrick von Taschlein, b. 1913, Weehawken, New Jersey, d. 1972, Hollywood] was a film director who made the unusual progression from drawing animated cartoons such as the Looney Tunes series of the mid 1930s to writing gags for actors Lucille Ball and the Marx Brothers in the mid 1940s, and finally directing film comedies such as *The Girl Can't Help It* [1956] and *Will Success Spoil Rock Hunter?* [1957]. Their underlying structures of narrative and comic timing were influential on the early work of Jean-Luc Godard.

Paul **THEK** [b. 1933, Brooklyn, d. 1988, New York] was primarily a painter until the mid 1960s when he produced the *Technological Reliquaries*, a series of wax sculptures which resemble raw meat or human limbs, encased in Plexiglas vitrines. Full body casts followed, such as the self-portrait *Death of a Hippy* [1967]. Retrospectives include Institute of Contemporary Art, Philadelphia [1977] and Witte de With Centre for Contemporary Art, Rotterdam [1995] and tour.

Wayne **THIEBAUD** [b. 1920, Mesa, Arizona] worked during the 1940s as a freelance cartoonist and illustrator before studying painting [1949-52]. By the early 1960s his canvases had progressed to close-up views of subjects such as cake displays, which combined compositions often reminiscent of cropped commercial photography with a painterly impasto technique. Solo exhibitions include Allan Stone Gallery, New York [1962; 1964] and retrospectives, Pasadena Art Museum [1968] and San Francisco Museum of Modern Art [1985].

Joe **TILSON** [b. 1928, London] is a painter, sculptor and graphic artist based in London,

Venice and Cortona, who studied at the Royal College of Art, London, 1952-55. The works of his Pop period [1961-69] explore the interplay between visual, textual and three-dimensional elements, in carved and painted wooden objects, reliefs and screenprints. Solo exhibitions include Marlborough Fine Art, London [1962], British Pavilion, Venice Biennale [1964] and retrospectives, Museum Boymans van-Beuningen, Rotterdam [1973] and Royal Academy of Arts, London [2002].

Jean **TINGUELY** [b. 1925, Fribourg, d. 1991, Bern] in the 1950s developed kinetic sculptures resembling functionless machines, made from discarded waste objects. In 1960 he presented his auto-destructive work *Hommage à New York* at The Museum of Modern Art, New York. While in New York he and his partner the artist Niki de Saint Phalle met Robert Rauschenberg and Jasper Johns, who collaborated with Saint Phalle on some of her 'Tir à volonté' ['Shoot at will'] works. He was included in 'International Exhibition of the New Realists', Sidney Janis Gallery, New York [1962]. Retrospectives include Centre Georges Pompidou, Paris [1997].

Robert **VENTURI** [b. 1925, Philadelphia], Denise **SCOTT BROWN** [Denise Lakofski, b. 1931, Nkana, Zambia] and Steven **IZENOUR** [b. 1940, New Haven, Connecticut] of architectural practice Venturi, Scott Brown & Associates, are based in Los Angeles. In 1950s London Scott Brown encountered the work of the Smithsons and the Independent Group. In the mid 1960s Venturi, Scott Brown and Izenour made a detailed study of Los Angeles street architecture, published in 1972 as *Learning from Las Vegas*. Venturi and Scott Brown have written extensively and curated exhibitions, advocating an architecture that arises from consumer-generated forms. They view their work as a continuation of modernism (although others have viewed it as exemplifying postmodern architecture).

Jacques de la **VILLEGLÉ** [b. 1926, Quimper, Brittany] studied painting, then architecture, in Rennes and Nantes in the 1940s. In 1945 he met Raymond Hains and after moving to Paris in 1949 he collaborated with Hains on some of the earliest décollages. He was a founder member of the Nouveaux Réalistes in 1960 and has continued to work with torn posters and language. Solo exhibitions include the studio of François Dufrêne, Paris [1959] and retrospectives, Moderna Museet, Stockholm [1971] and Magasin, Centre national d'art, Grenoble [1988].

Andy **WARHOL** [b. 1928, Pittsburgh, d. 1987, New York] was an artist and filmmaker who made some of the most transformative contributions to Pop representation from his first comic-strip based paintings [c. 1960-61] onwards. A successful commercial artist, Warhol began using silkscreen paintings in 1962. In November 1963 he established the Factory at 231 East 47th Street, New York, becoming a central figure in the New York art and underground filmmaking scene. In 1968 he was shot and seriously injured by a Factory acolyte, Valerie Solanas. Solo exhibitions include Ferus Gallery, Los Angeles [1962; 1963], Stable Gallery, New York [1962; 1964], Leo Castelli Gallery, New York [1964; 1966], Galerie Ileana Sonnabend, Paris [1964]. Retrospectives include Institute of Contemporary Art, Philadelphia [1965] and The Museum of Modern Art, New York [1989]. The Andy Warhol Museum, the largest collection of his work, opened in Pittsburgh in 1994.

Robert **WATTS** [b. 1923, Burlington, Indiana, d. 1987, Vermont] studied mechanical engineering in the early 1940s before studying art, producing abstract paintings, experimental film and kinetic structures during the 1950s. From 1960 he was associated with the Fluxus movement, staging events and producing ephemeral objects such as fake stamps. In the mid 1960s he began to fabricate chrome-plated replicas of everyday objects. Retrospectives include Leo Castelli Gallery, New York [1990].

John **WESLEY** [b. 1928, Los Angeles] began painting in the late 1950s after working as an aircraft riveter and then as an illustrator in an aircraft engineering department. He moved to New York in 1960, developing a hard-edge style to depict ironically or erotically suggestive figures and sometimes emblems that play on repetition and decorative framing devices. Solo exhibitions include Robert Elkon Gallery, New York [1963; 1967; 1969] and retrospectives, Stedelijk Museum, Amsterdam [1993] and P.S.1 Contemporary Art Center, New York [2000].

Tom **WESSELMANN** [b. 1931, Cincinnati, d. 2004, New York] was recognized as one of the leading New York Pop artists from 1962 onwards when he first exhibited works from his *Still Life* and *Great American Nude* series of paintings with collage, which continued throughout the 1960s. In 1962 he began to combine painting and collage with assemblage of mundane domestic found objects, notably in the *Bathtub Collage* works started in 1963. Solo exhibitions include Tanager Gallery, New

AUTHORS' BIOGRAPHIES

York [1961], Sidney Janis Gallery, New York [1966], Galerie Sonnabend, Paris [1966] and retrospective, Musée d'art moderne et contemporain, Nice [1996] and tour.

Robert WHITMAN [b. 1935, New York] co-founded EAT [Experiments in Art and Technology] with Robert Rauschenberg and engineers such as Billy Klüver in 1966, to facilitate artists' experimentation with new technologies. His works use live performance, slide projection, film and other media. Solo exhibitions include the Jewish Museum, New York, and the Museum of Contemporary Art, Chicago [both 1968] and The Museum of Modern Art, New York [1973]. His performances have toured to the Moderna Museet, Stockholm [1987; 1989] and the Centre Pompidou, Paris [2001; 2002].

Gary WINOGRAND [b. 1928, New York, d. 1984, New York] was a street photographer and documenter of urban life. A prolific and incisive user of the snapshot aesthetic, his year-long American road trip, echoing Robert Frank's, was collected in the series *1964*. Solo exhibitions include Image Gallery, New York [1960], The Museum of Modern Art, New York [1963; 1977; retrospectives, 1988; 1998] and International Center of Photography, New York [2002].

Lawrence ALLOWAY [1926-90] was a British critic of art and contemporary culture, a central figure in the Independent Group, and the first published writer to use the term Pop art, in the late 1950s. After moving to the USA he became a museum curator and a writer and editor at *Artforum* magazine. His books include *American Pop Art* [1974] and *Topics in American Art Since 1945* [1975]. A bibliography of his writings is included in *The Independent Group: Postwar Britain and the Aesthetics of Plenty* [1990].

Dore ASHTON is Professor of Art History at the Cooper Union, New York. A distinguished American art critic since the late 1950s, she is the author of numerous monographs on artists of the post-1945 period. Her books include *Modern American Sculpture* [1968], *The New York School: A Cultural Reckoning* [1973] and *American Art Since 1945* [1982].

Reyner BANHAM [1922-88] was a British critical writer on architecture, design and contemporary culture, a key theoretical figure in the Independent Group and an advocate for the work of the Smithsons and later Archigram. He moved to the USA in 1976. His books include *Los Angeles: The Architecture of Four Ecologies* [1973] and *Theory and Design in the First Machine Age* [1980].

Roland BARTHES [1915-1980] was a French critic, literary theorist and exponent of semiology. His analyses of signifying systems in contemporary culture, such as advertising, car design and cinematic imagery, collected in *Mythologies* [1957], were highly influential in Europe, and published in English in 1967.

Gregory BATTCOCK [1937-1980] was an American art critic, painter and lecturer in art history. A close associate of his artist contemporaries such as Warhol, he was a frequent contributor to *Arts Magazine*, *Art and Literature* and *Film Culture*. He was among the first to document the art of his time in his anthologies such as *The New Art* [1966], *The New American Cinema* [1967], *Minimal Art* [1968] and *Idea Art* [1973].

Jean BAUDRILLARD is a French critical theorist who was influenced by the ideas of the Situationists in the late 1960s. He later developed an influential analysis of contemporary society in which the sense of the real is replaced by a condition marked by

simulations and simulacra. His works include *Le Système des objets* [1968], *For a Critique of the Political Economy of the Sign* [1972; trans. 1981] and *Simulacra and Simulations* [1981; trans. 1983].

Benjamin H.D. BUCHLOH is Professor of Twentieth-century and Contemporary Art at Barnard College, New York. Based in Germany until 1977, he edited the magazine *Interfunktionen*. He later became an editor of the journal *October*. His books include *Neo-Avantgarde and Culture Industry: Essays on European and American Art from 1955 to 1975* [2001]. He is a co-author, with Yve-Alain Bois, Hal Foster and Rosalind Krauss, of *Art Since 1900* [2005].

John CAGE [1912-1992] was a composer, writer and artist, who in the early 1950s investigated the role of randomness in scores and performance. He was a major influence on many artists in the late 1950s and early 1960s, such as George Brecht and Robert Rauschenberg. His books include *Silence: Lectures and Writings by John Cage* [1961].

Nik COHN [b. 1946] is a novelist and historian of rock music and culture, who now writes for the *Guardian*. His books include *Awopbopaloobop Alopbamboom: Rock from the Beginning* [1969], written at the age of 22.

John COPLANS [1920-2003] was a South-African critic, curator and artist who was a co-founder and editor of *Artforum*, originally based in San Francisco 1962-65, then Los Angeles until 1967 when it moved to New York. He was also curator at Pasadena Art Museum from 1967 to 1971. His books include *Serial Imagery* [1968], *Andy Warhol* [1970], *Roy Lichtenstein* [1972]. A selection of his writings, 1963-81, was published as *Provocations* [1996].

Arthur C. DANTO is Professor of Philosophy at Columbia University, New York. He is also a longstanding art critic for *The Nation* and an influential writer on contemporary art and aesthetics. His many collected writings include *Beyond the Brillo Box: The Visual Arts in Post-Historical Perspective* [1992].

Bob DYLAN [Robert Zimmerman, b. 1941] is an American musician whose unique fusion of folk, country and rhythm and blues, and highly literate lyrics, was discovered when

he performed in New York bars at the beginning of the 1960s. He made a controversial cross-over into electric rock with the song *Like a Rolling Stone* in 1965 and became like Jimi Hendrix an icon of psychedelic culture in the late 1960s.

Umberto ECO is an Italian semiotician, philosopher, specialist in mediaeval history and novelist. In the 1960s he published semiotic analyses of contemporary culture in magazines such as *Il Verri*. His books include *A Theory of Semiotics* [1976].

Alan FLETCHER is a renowned British graphic designer, art director for Phaidon Press and a founder of the design practice Pentagram. At the Royal College of Art in the 1950s he contributed to *Ark* magazine and was closely associated with the artists of the Pop generation.

Michael FRIED is Professor of Art History at Johns Hopkins University, Baltimore. Clement Greenberg's theories were a point of departure for his early 1960s criticism, reprinted in his *Art and Objecthood* [1998].

Henry GELDZAHLER [1935-94] was a modernist art historian and curator who was closely associated with Warhol among other artists since the start of the 1960s when he worked at the Metropolitan Museum of Art, New York, where he later became the first curator of the museum's contemporary [now twentieth-century] department.

Allen GINSBERG [1926-1997] was one of the leading Beat poets, who met William Burroughs and Jack Kerouac in New York in the early 1950s and settled in San Francisco in 1955, where his public readings of his poem *Howl* were an important moment in the launch of a Pop counter-culture.

Thom GUNN [1929-2004] was a British poet who emigrated to the USA in 1954 and settled in San Francisco in 1960. In his work of the 1950s he introduced subjects such as Hell's Angels and Elvis Presley into lyric poetry.

Andreas HUYSSEN is Professor of German and Comparative Literature at Columbia University and a founding editor of *New German Critique*. His books include *After the Great Divide: Modernism, Mass Culture, Postmodernism* [1986].

Ellen H. JOHNSON [1910-1992] was Professor of Art since 1948, and Curator of Modern Art since 1973 at Oberlin College, Ohio. A contributor to art critical debates in the 1960s, she was the author of *Claes Oldenburg* [1971] and *Modern Art and the Object: A Century of Changing Attitudes* [1995].

Jill JOHNSTON [b. 1929] is a British-born feminist writer and activist who became a well-known art critic and columnist for the *Village Voice* in the early 1960s, when she was closely associated with the Judson Dance Group and Gallery, New York.

Donald JUDD [1928-1994] was one of the leading exponents of Minimal art and also one of the leading non-academic American art critics of his generation. His writings about the work of his contemporaries are included in his *Complete Writings*, two volumes: 1959-1975 [1976] and 1975-1986 [1987].

Mike KELLEY [b. 1954] is among the influential generation of American artists that emerged at the end of the 1970s. Also a writer and curator, he was influenced by Öyvind Fahlström and Paul Thek and contributed to the recognition of their importance. His writings are collected in two volumes: *Foul Perfection: Essays and Criticism* [2003] and *Minor Histories: Statements, Conversations, Proposals* [2004].

Billy KLÜVER [1927-2004] was a Swedish-born scientist and engineer who moved to the United States in 1954. He became an engineer at Bell Labs in 1958 and collaborated with many artists on the development of new media art, including Jean Tinguely [*Hommage à New York*, 1960], John Cage, Jasper Johns, Yvonne Rainer, Robert Rauschenberg, Robert Whitman and Andy Warhol. With Rauschenberg, Whitman and others he co-founded E.A.T. [Experiments in Art and Technology] in 1966.

Hilton KRAMER is editor and publisher of the *New Criterion*, and an art critic for the *New York Observer*. A prolific writer of polemical criticism, on the Pop period he has published *The Age of the Avant-Garde: An Art Chronicle of 1956-1972* [1975].

Ian MacDONALD [1948-2003] was a writer on music who was recognized as an authority on the work of the composer Shostakovich and on the music of The Beatles. He was an editor at *New Musical Express* [1972-75] and also wrote lyrics and songs. He was the author of *Revolution in the Head: The Beatles' Records and the 1960s* [1994; revised 1997], and *The*

People's Music [2003].

Marshall McLUHAN [Herbert Marshall McLuhan, 1911-1980] was a theorist whose first book, *The Mechanical Bride: Folklore of Industrial Man* [1952] analysing the social messages and effects conveyed by the mass media, which was influential on the Independent Group, formed the same year. In *The Gutenberg Galaxy* [1962] he argued that reduction of communications to the visual field alone had fragmented a holistic, 'tribal' consciousness; but that the 'global village' was being regained through multisensory new technologies. Later books include *The Medium is the Massage* [1967].

Greil MARCUS [b. 1945] is an American writer on art, music and popular culture and a frequent contributor to art journals such as *Artforum*. His books include *Mystery Train: Images of America in Rock 'n' Roll Music* [1975], *Lipstick Traces: A Secret History of the Twentieth Century* [1989], *The Dustbin of History* [1997] and *Like a Rolling Stone: Bob Dylan at the Crossroads* [2005].

Jonas MEKAS [b. 1922] is a Lithuanian-born poet, filmmaker and film critic who studied philosophy and romance languages in Mainz, Germany, before settling in New York in 1949. From the 1950s onwards he has been a leading exponent and champion of avant-garde filmmaking and criticism. Throughout the 1960s he contributed the 'Movie Journal' column to the *Village Voice*. He also founded the journal *Film Culture* and the Anthology Film Archives in New York. His 1960s film criticism is collected in *Movie Journal: The Rise of a New American Cinema, 1959-1971* [1972].

Laura MULVEY [b. 1941] is Professor of Film and Media Studies at Birkbeck College, University of London. A feminist critical theorist and filmmaker, in her work of the 1970s, published in *Spare Rib* and *Seven Days*, she investigated spectatorial identification in essays such as 'Visual Pleasure and Narrative Cinema' [1975]. Between 1974 and 1982 she collaborated on six films with Peter Wollen, the author of *Signs and Meaning in the Cinema* [1969]. She began making solo film and video works in the 1990s. Her books include *Visual and Other Pleasures* [1989].

Brian O'DOHERTY is an Irish critic based in the United States, where he is a Professor at Long Island University, and also an artist under the name of Patrick Ireland. A former art critic for the *New York Times* and editor-in-chief of *Art in America*, he participated

closely in the changing notions of art theory and practice in the 1960s and 1970s. His books include *Object and Idea* [1967], *American Masters: The Voice and the Myth* [1973; revised 1988] and *Inside the White Cube: The Ideology of the Gallery Space* [1976; revised 1986].

Frank O'HARA [1926-1966] was a poet based in New York since 1951 when he began working for The Museum of Modern Art, where in 1960 he was appointed as an assistant curator. He was a close associate of the abstract expressionist artists and other contemporary artists and poets and wrote literary, art and music criticism, working as editorial associate for *ARTnews*, 1953-55. In his 1959 text 'Personism: A Manifesto' he proposed a form of personal, spur-of-the-moment poetry which he compared to a note or phone call between two friends.

Carl PERKINS [1932-1998], the son of poor tenant farmers in Tennessee, was one of the inventors of the rockabilly music that emerged from a fusion of rhythm and blues and country music in the mid 1950s. In 1956 he wrote the chart-topping hit 'Blue Suede Shoes'. After the Elvis era, The Beatles performed versions of a number of his songs.

Pierre RESTANY [1930-2003], born in Morocco, was an influential French critic and curator, based for much of his life in Italy, where he had a long association with *Domus* magazine. In 1960 he launched the Nouveau Réaliste movement with a travelling exhibition and manifesto. From 1985 he directed the magazine *d'ars*, also publishing many monographs on artists of the 1950s and 1960s such as Yves Klein.

Robert ROSENBLUM [b. 1927] is Professor of Modern European Art at New York University's Institute of Fine Arts. An authority on European eighteenth and nineteenth-century painting, he has also been a noted critic of contemporary art from the late 1950s to the present. Among his most influential books is *Modern Painting and the Northern Romantic Tradition: Friedrich to Rothko* [1975].

Susan SONTAG [1933-2004] was a critical essayist, novelist, dramatist and filmmaker. During the early 1960s she was closely associated with a number of artists, such as Joseph Cornell, and theorists, such as Roland Barthes. She contributed reviews and articles to periodicals such as *The Nation* and published some of the most influential essays

of the time, collected in *Against Interpretation* [1966].

Leo STEINBERG [b. 1920] is an Emeritus Professor at the University of Pennsylvania. An art historian and critic, in the early 1960s he was based in New York with contemporaries such as Jasper Johns, on whom he wrote a monograph in 1963, and Robert Rauschenberg, whose collages were the focus of his groundbreaking lecture of March 1968 at The Museum of Modern Art, New York, that became known as 'Other Criteria'. His books include *Other Criteria: Conversations with Twentieth-Century Art* [1972].

Gene SWENSON [1934-1968] was one of the most committed proponents of Pop art, as a critic and curator. He was an editorial associate of *ARTnews*, 1961-65, writing reviews of the work of Dine, Indiana, Lichtenstein, Rosenquist, Warhol and Wesselmann, among others, followed by a series of interviews, 1963-64. In 1965 he curated 'The Other Tradition' at the Institute of Contemporary Art, Philadelphia, which proposed an alternative, anti-formalist history of twentieth-century art, traced from Dada and Surrealism to Pop.

Hunter S. THOMPSON [1937-2005] was a pioneering writer who broke the established rules of journalism in order to connect with and convey the counter-culture of the 1960s, becoming a new kind of participant-observer. Living among people whose outcast status mirrored his own 'gonzo' life, he wrote for *Time* magazine and later *Rolling Stone*, on the lifestyle of Hell's Angels, hippies, migrants, drifters and others. His books include *Hell's Angels* [1967] and *Fear and Loathing in Las Vegas* [1972].

Tom WOLFE [b. 1931] later known for his satirical novels was, like Thompson, a rule-breaker in the 1960s, contributing freely written, unconventional articles on such subjects as hot-rod and custom-car culture to magazines such as *Esquire* and *Rolling Stone*. A collection of these articles was published in 1965 as *The Kandy-Kolored Tangerine-Flake Streamline Baby*, followed by *The Electric Kool-Aid Acid Test* [1967] the classic account of Californian psychedelic culture and its genesis.

BIBLIOGRAPHY

See also bibliographic references in the Documents section

1960. Les Nouveaux Réalistes Musée d'art moderne de la Ville de Paris, 1986

2000 BC: The Bruce Conner Story Part II eds. Peter Boswell, Bruce Jenkins and Joan Rothfuss, Walker Art Center, Minneapolis, 2000

6 Painters and the Object Solomon R. Guggenheim Museum, New York, 1963

À 40° au-dessus de Dada Galerie J, Paris, 1961

Alloway, Lawrence 'Technology and Sex in Science Fiction: A Note on Cover Art', *Ark*, 17, Summer 1956

_____ *American Pop Art*, Whitney Museum of American Art, New York, 1974

Amaya, Mario *Pop as Art: A Survey of the New Super-Realism*, Studio Vista, London, 1965

Ameline, Jean-Paul *Les Nouveaux Réalistes*, Éditions du Centre Pompidou, Paris, 1992

American Pop Art and the Culture of the Sixties New Gallery of Contemporary Art, Cleveland, Ohio, 1976

Americans 1963 The Museum of Modern Art, New York, 1963

Amerikanste Pop-Kunst Moderna Museet, Stockholm, 1964

Années Pop, Les ed. Mark Francis, Éditions du Centre Pompidou, Paris, 2001

Archigram Éditions du Centre Pompidou, Paris, 1994

Architectural Design Special issués: 'Pneumatics', June 1967; 'Pneu World', June 1968

Arman Galerie nationale du Jeu de Paume, Paris, 1998

Artschwager, Richard ed. Richard Armstrong, Whitney Museum of American Art, New York, 1988

Bailey, David, and Peter Evans *Goodbye Baby & Amen. A Saraband for the Sixties*, Condé Nast, London, 1969

Bande dessinée et figuration narrative Musée des arts décoratifs, Paris, 1967

Banham, Reyner *Megastructure: Urban Futures of the Recent Past*, Thames & Hudson, London, 1980

_____ *Design by Choice*, Academy Editions, London, 1981

_____ *A Critic Writes: Essays by Reyner Banham*, ed. Mary Banham, University of California Press, Berkeley and Los Angeles, 1997

Banes, Sally *Greenwich Village 1963: Avant-garde Performance and the Effervescent Body*, Duke University Press, Durham, North Carolina, 1993

Battcock, Gregory *The New Art: A Critical Anthology*, New York, 1973

Beat Culture and the New America 1950–1965 ed. Lisa Phillips, Whitney Museum of American Art, New York/Gallimard, Paris, 1996

Belz, Carl I. 'Three Films by Bruce Conner', *Film Culture*, 44, Spring 1967

Billy Al Bengston: Paintings of Three Decades Contemporary Arts Museum, Houston, 1988

Blam! The Explosion of Pop, Minimalism, and Performance 1958–1964, ed. Barbara Haskell, Whitney Museum of American Art, New York, 1984

Boatto, Alberto *Pop Art*, Laterza, Rome and Bari, 1983

Bockris, Victor *The Life and Death of Andy Warhol*, Da Capo Press, New York, 1997

Bourdon, David 'An interview with Ray Johnson', *Artforum*, 3:1, September 1964

_____ *Andy Warhol*, Harry N. Abrams, New York, 1989

Branzi, Andrea and Natalini Adolfo Introduction, *Superarchittetura*, Galleria Jolly 2, Pistoia, 1966

Brecht, George Museum Ludwig, Cologne, 2005

Brecht, George, Allan Kaprow, Robert Watts, *et al.* 'Project in Multiple Dimensions', 1957-58; published in *Robert Watts: The Invisible Man of Fluxus and Pop*, Museum Fridericianum, Kassel, 1999

Broodthaers, Marcel Galerie nationale du Jeu de Paume, Paris, 1991

Burckhardt, François, and Cristina Morozzi *Andrea Branzi*, Éditions Dis Voir, Paris, 1998

Carrick, Jill *Le Nouveau Réalisme. Fetishism and Consumer Spectacle in Postwar France*, Bryn Mawr College, Bryn Mawr, 1997

Cassavetes, John 'What's Wrong with Hollywood', *Film Culture*, 19, 1959

Chatman, Seymour, ed. Paul Duncan *Michelangelo Antonioni: The Complete Films*, Taschen, Cologne, 2004

Clouzot, Claire *William Klein: Les Films*, Marval, Paris, 1998

Codognato, Attilio ed., *Pop Art: Evoluzione di una Generazione*, Electa, Milan, 1980

Comic Art Show, The. Cartoons in Painting and Popular Culture ed. John Carlin and Sheena Wagstaff, Whitney Museum of American Art/ Fantagraphics, New York, 1983

Comic Iconoclasm ed. Sheena Wagstaff, Institute of Contemporary Arts, London, 1987

Compton, Michael *Pop Art*, Paul Hamlyn, London, 1970

Cook, Peter 'Zoom and "Real" Architecture', *Amazing Archigram*, 4, 1964

_____ *Architecture: Action and Plan*, Studio Vista, London/Reinhold Publishing Corporation, New York, 1967

_____ *Experimental Architecture*, Studio Vista, London, 1970

_____ *Archigram*, Studio Vista, London, 1972

Cooke, Lynne 'The Independent Group: British and American Pop Art, a "Palimpsestuous Legacy"', in *Modern Art and Popular Culture: Readings in High and Low*, eds Kirk Varnedoe and Adam Gopnik, The Museum of Modern Art, New York, 1990

Crow, Thomas. E. *The Rise of the Sixties: American and European Art in the Era of Dissent*, Harry N. Abrams, New York, 1996

D'Arcangelo, Allan. Paintings of the Early Sixties Neuberger Museum, Purchase, New York, 1978

Dalí, Salvador 'The King and the Queen Traversed by Swift Nudes', *ARTnews*, 58:2, April 1959

Debord, Guy *Panegyric*, Vols 1 & 2, Verso, London, 2005

Designing Disney's Theme Park: The Architecture of Reassurance ed. Karal Ann Marling, Canadian Center for Architecture, Montreal

Diawara, Manthia *The 1960s in Bamako: Malick Sidibé and James Brown*, Andy Warhol Foundation, New York, 2001

Douchet, Jean [with Cédric Anger] *Nouvelle Vague*, Éditions Hazan, Paris, 1998

Drury, Margaret *Mobile Homes: The Unrecognized Revolution in American Housing*, Praeger, New York, 1972

Dunlop, Beth *Building a Dream: The Art of Disney Architecture*, Harry N. Abrams, New York, 1996

Dylan, Bob *Chronicles*, Vol. 1, Simon & Schuster, New York, 2004

Environments, Situations, Spaces Martha Jackson Gallery, New York, 1961

Evans, Walker & Dan Graham Witte de With, Rotterdam/Whitney Museum of American Art, New York, 1992

Expendable Ikon, The. Works by John McHale Albright-Knox Art Gallery, Buffalo, New York, 1984. Texts by Lawrence Alloway, Reyner Banham, Richard Hamilton, John McHale.

Fahlström, Öyvind. Die Installationen/The Installations ed. Sharon Avery-Fahlström, with Eva Schmidt, Udo Kittelmann, Gesellschaft für Aktuelle Kunst, Bremen/Kölnischer Kunstverein, Cologne, 1995. Texts by Öyvind Fahlström, Mike Kelley, Jane Livingston

Fahlström, Öyvind. Another Space for Painting eds Sharon Avery-Fahlström, Manuel J. Borja-Villel, Jean-François Chevrier, Museu d'Art Contemporani de Barcelona, 2001

Feuerstein, Günther *Visionäre Architektur Wien 1958-1988*, Ernst & Sohn, Berlin, 1988

Film Culture 45, Summer 1964 [Special isssue on Andy Warhol]

Finch, Christopher *Pop Art: Object and Image*, Studio Vista, London/E.P. Dutton, New York, 1968

_____ *Image as Language: Aspects of British Art, 1950-1968*, Penguin, Harmondsworth, Middlesex, 1969

Fluxus: Selections from the Gilbert and Lila Silverman Collection ed. Clive Phillpot and Jon Hendricks, The Museum of Modern Art, New York, 1988

Foster, Hal *The Return of the Real: Art and Theory at the End of the Century*, MIT Press, Cambridge, Massachusetts, 1996

Francblin, Catherine *Les Nouveaux Réalistes*, Éditions du Regard, Paris, 1997

Friedman, Yona and Robert Aujame 'The Future [Mobile Architecture]', *Architectural Design*, August 1960

Frith, Simon *Art into Pop*, Routledge, London and New York, 1987

Fuller, Richard Buckminster *The Buckminster Fuller Reader*, ed. James Meller, Jonathan Cape, London, 1969

Gablik, Suzi 'Crossing the Bar', *ARTnews*, 64:6, October 1965

_____ 'Protagonists of Pop: Five Interviews conducted by Suzi Gablik', *Studio International*, July-August 1969

_____ and John Russell, *Pop Art Redefined*, Thames & Hudson, London and New York, 1969

Garrels, Gary ed., *The Work of Andy Warhol*, Discussions in Contemporary Culture, Dia Art Foundation, New York/Bay Press, Seattle, 1989

Gidal, Peter *Andy Warhol: Films and Paintings*, Studio Vista, London/E.P. Dutton, New York, 1971

Gillett, Charlie *The Sound of the City: The Rise of Rock and Roll*, Souvenir Press, London, 1971

Global Village: The 1960s ed. Stéphane Aquin, The Montreal Museum of Fine Arts, 2003

Graham, Dan *Rock My Religion: Writings and Art Projects, 1965-1990*, ed. Brian Wallis, MIT Press, Cambridge, Massachusetts, 1993

Greenberg, Clement 'Pop Art', undated lecture, c. early 1960s, first published in *Artforum*, October 2004

Grooms, Red 'A Statement', 1959, in Michael Kirby, *Happenings: An Illustrated Anthology*, E.P. Dutton, New York, 1966

Grushkin, Paul D. *The Art of Rock*, Artabras, New York, 1987

Hains, Raymond Musée d'art moderne et d'art contemporain, Nice, 2000

Hall of Mirrors: Art and Film after 1945 eds. Kerry Brougher and Russell Ferguson, The Museum of Contemporary Art/Monacelli Press, Los Angeles, 1996

Hall, Stuart and Paddy Whannel The Popular Arts, Hutchinson, London, 1964

Hamilton, Richard. Retrospective Walter König, Cologne, 2003

Hand-painted Pop: American Art in Transition 1955–62 cur. Donna De Salvo, Paul Schimmel, The Museum of Contemporary Art, Los Angeles, 1992.

Hansen, Al A Primer of Happenings & Time/Space Art, Something Else Press, New York, 1965

happening & fluxus ed. Harald Szeemann and Hans Sohm, Kölnischer Kunstverein, Cologne, 1970

Hebdige, Dick Subculture: The Meaning of Style, Methuen, London, 1979

_____ 'In Poor Taste: Notes on Pop', Block, 8, 1983

_____ Hiding in the Light: On Images and Things, Routledge, London and New York, 1988

Hendricks, Jon Fluxus Codex, Harry N. Abrams, New York, 1988

Hess, Alan Viva Las Vegas: After-Hours Architecture, Chronicle Books, San Francisco, 1993

Hickey, Dave Air Guitar: Essays on Art & Democracy, Art Issues, Los Angeles, 1997

Higgins, Dick and Wolf Vostell Poparchitektur: Concept Art Higgins Vostell, Droste Verlag, Düsseldorf, 1969

High & Low: Modern Art & Popular Culture ed. Kirk Varnedoe and Adam Gopnik, The Museum of Modern Art, New York, 1990

Hockney, David David Hockney by David Hockney, Thames & Hudson, London, 1976

Hollein, Hans and Walter Pichler Architektur, Galerie Nacht St. Stephan, Vienna, 1963

Hollein, Hans Historisches Museum der Stadt Wien, Vienna, 1995

Image in Progress Grabowski Gallery, London, 1962

In the Spirit of Fluxus ed. Elizabeth Armstrong and Joan Rothfuss, Walker Art Center, Minneapolis, 1993

Independent Group, The. Postwar Britain and the Aesthetics of Plenty ed. David Robbins, The Institute of Contemporary Arts, London/ The Museum of Contemporary Art, Los Angeles/MIT Press, Cambridge, Massachusetts, 1990. Includes texts by Lawrence Alloway, Magda Cordell McHale, Theo Crosby, Richard Hamilton, Eduardo Paolozzi, Denise Scott Brown, Alison and Peter Smithson, James Stirling

Inflatable Moment, The. Pneumatics and Protest in '68 ed. Marc Dessauce, Urban Center, New York/IFA, Paris/The Architectural League, New York, 1999

Internationale Situationiste Éditions Champ libre, Paris, 1975

Information. Joe Tilson, Peter Phillips, Allen Jones, Eduardo Paolozzi, Ronald B. Kitaj, Richard Hamilton Badischer Kunstverein, Karlsruhe, 1969

Jacquet, Alain. Oeuvres de 1951 à 1998 Musée de Picardie, Amiens, 1998

James, David E. Allegories of Cinema: American Film in the Sixties, Princeton University Press, Princeton, 1989

Jencks, Charles Architecture 2000: Predictions and Methods, Studio Vista, London/Praeger, New York, 1971

Johns, Jasper ed. Kirk Varnedoe, The Museum of Modern Art, New York, 1996

Johnson, Ellen H. 'The Image Duplicators – Lichtenstein, Rauschenberg and Warhol', Canadian Art, 23, January 1966

Johnson, Ray ed. Donna De Salvo, Whitney Museum of American Art, 1999

Joseph, Branden W. Random Order: Robert Rauschenberg and the Neo-Avant-Garde, MIT Press, Cambridge, Massachusetts, 2003

Kaprow, Allan 'The Legacy of Jackson Pollock', ARTnews, 57:6, October 1958

_____ Assemblage, Environments and Happenings, New York, 1966

_____ 'Pop Art: Past, Present and Future', The Malahat Review, 3, July 1967

Kellein, Thomas Fluxus, Thames & Hudson, London, 1995

Kitaj, R.B. Hirshhorn Museum and Sculpture Garden, Smithsonian Institution, Washington, D.C. Texts by John Ashbery, Joe Shannon, Jane Livingston

Koch, Stephen Stargazer: Andy Warhol's World and His Films, Praeger, New York, 1973

Koolhaas, Rem Delirious New York: A Retroactive Manifesto for Manhattan, Thames & Hudson, London/Oxford University Press, New York, 1970; Monacelli Press, New York, 1994 (2nd ed.)

Kozloff, Max 'Pop Culture, Metaphysical Disgust and the New Vulgarians', Art International, vi, 2, March 1962

Kultermann, Udo Art-Events and Happenings, Mathews Miller Dunbar, London, 1971

Kureishi, Hanif and Jon Savage eds., The Faber Book of Pop, Faber & Faber, London, 1995

LA Pop in the Sixties Newport Harbor Art Museum, Newport Beach, California, 1989

Landau, Royston New Directions in Architecture, Studio Vista, London/George Braziller, Inc., New York, 1968

Leacock, Richard 'For an Uncontrolled Cinema', Film Culture, 22-23, Summer 1961

Lebel, Jean-Jacques Le Happening, Éditions Denöel, Paris, 1966

Leider, Philip 'Joe Goode and the Common

Object', Artforum, 4:7, March 1966

Lichtenstein, Roy ed. Diane Waldman, Solomon R. Guggenheim Museum, New York, 1994

Lichtenstein, Claude and Thomas Schregenberger eds., As Found: The Discovery of the Ordinary, Lars Müller, Baden, 2001

Lippard, Lucy R. Pop Art, preface by Lawrence Alloway, Thames & Hudson, London, 1966; revised 1970

Livingstone, Marco Pop Art: A Continuing History, Thames & Hudson, London, 1990

_____ Pop Art UK. British Pop Art 1956-1972. Galleria Civica di Modena, 2004

Lobel, Michael Image Duplicator: Roy Lichtenstein and the Emergence of Pop Art, Yale University Press, New Haven, 2002

Loran, Erle 'Cézanne and Lichtenstein: Problems of "Transformation"', Artforum, 2:3, September 1963

MacDonald, Scott A Critical Cinema: Interviews with Independent Filmmakers, 3 vols, University of California Press, Berkeley, 1988-98

McCabe, Colin Godard: A Portrait of the Artist at 70, Bloomsbury, London, 2003

_____ Performance, British Film Institute, London, 1998

McLuhan, Marshall The Gutenberg Galaxy: The Making of Typographic Man, University of Toronto Press, 1962

_____ Understanding Media: The Extensions of Man, McGraw-Hill, New York, 1964

_____ and Quentin Fiore, Jerome Agel The Medium is the Massage, Random House, New York, 1967

Machine as Seen at the End of the Mechanical Age, The ed. K.G. Pontus Hultén, The Museum of Modern Art, New York, 1968

Madoff, Steven Henry ed., Pop Art: A Critical History, University of California Press, Berkeley and Los Angeles, 1997

Mahsun, Carol A. Pop Art and the Critics, UMI Research Press, Ann Arbor, Michigan, 1987

_____ ed., Pop Art: The Critical Dialogue, UMI Research Press, Ann Arbor, Michigan, 1988

Malanga, Gerard and Andy Warhol Screen Tests: A Diary, Kulchur Press, New York, 1967

Marcus, Greil Mystery Train: Images of America in Rock 'n' Roll Music, E.P. Dutton, New York, 1975

_____ Lipstick Traces: A Secret History of the Twentieth Century, Harvard University Press, Cambridge, Massachusetts, 1989

_____ Invisible Republic: Bob Dylan's Basement Tapes, Henry Holt, New York, 1997

Marshall, Richard D. Ed Ruscha, Phaidon Press, London and New York, 2002

Massey, Anne The Independent Group: Modernism and Mass Culture in Britain, 1945-1959, Macmillan, London, 1995

Melly, George Revolt into Style: The Pop Arts in Britain, Penguin, Harmondsworth, Middlesex, 1972

Michelson, Annette ed., Andy Warhol, October Books/MIT Press, Cambridge, Massachusetts, 2001

Modern Dreams: The Rise and Fall and Rise of Pop The Institute for Contemporary Arts, The Clocktower Gallery, New York/MIT Press, Cambridge, Massachusetts, 1988. Texts by Lawrence Alloway, Reyner Banham, Judith Barry

Moos, Stanislaus von Venturi, Scott Brown and Associates, The Monacelli Press, New York, 1999

Morley, Malcolm. In Full Colour Hayward Gallery, London, 2001

My Country 'Tis of Thee Text by G. Nordland, Dwan Gallery, Los Angeles, 1962

Mythologies quotidiennes Musée d'art moderne de la Ville de Paris, 1964

Neo-Dada: Redefining Art 1958–62 ed. Susan Hapgood, American Federation of Arts/ Universe Publications, New York, 1995

Neue Realisten & Pop Art Akademie der Kunste, Berlin, 1964

New Forms–New Media, I Martha Jackson Gallery, New York, 1960. Texts by Lawrence Alloway, Allan Kaprow

New Painting of Common Objects Pasadena Art Museum, 1962. Text by John Coplans

New Realists Sidney Janis Gallery, New York, 1962. Texts by John Ashbery, Pierre Restany

New York Painting and Sculpture: 1940–1970 ed. Henry Geldzahler, Metropolitan Museum of Art/E.P. Dutton, New York, 1970

Nieuwe Realisten Gemeentemuseum, The Hague, 1964

Nouveaux Réalistes, Les Galleria Apollinaire, Milan, 1960. Preface by Pierre Restany

Oldenburg Claes ed. Barbara Rose, The Museum of Modern Art, New York, 1970

Oldenburg, Claes: An Anthology Solomon R. Guggenheim Museum, New York, 1995

On the Passage of a Few People Through a Rather Brief Moment in Time: The Situationist International. 1957–1972 ed. Elizabeth Sussman, The Institute of Contemporary Art, Boston/MIT Press, Cambridge, Massachusetts, 1989. Texts by Troels Andersen, Mirella Bandini, Mark Francis, Thomas Y. Levin, Greil Marcus, Elisabeth Sussman, Peter Wollen, and Situationist anthology

Osterwold, Tilman Pop Art, Taschen Verlag, Cologne, 1989

Out of Actions: Between Performance and the Object. 1949–1979 ed. Paul Schimmel, The Museum of Contemporary Art, Los Angeles/Thames & Hudson, London, 1998

Paolozzi, Eduardo 'Metamorphosis of Rubbish: Mr Paolozzi Explains His Process', The Times,

298

London, 2 May 1958

Paris 1960–1980 Museum Moderner Kunst, Vienna, 1982

Paris–New York Éditions du Centre Georges Pompidou, Paris, 1977. Texts by Alfred Pacquement, Pontus Hultén

Pettena, Gianni *Superstudio 1966–1982: Storie, Figure, Architettura*, Electa, Florence, 1982

Pistoletto, Michelangelo Museu d'Art Contemporani de Barcelona, 2000

Pop Art ed. Suzi Gablik and John Russell, Hayward Gallery, London, 1969

Pop Art America–Europa dalla Collezione Ludwig Forti di Belvedere, Florence, 1987

Pop Art: An International Perspective ed. Dan Cameron and Marco Livingstone, Royal Academy of Arts, London, 1991

Pop Art and the American Tradition Milwaukee Art Center, 1965

Pop Art: US/UK Connections, 1956–66 The Menil Collection, Houston, 2001

Pop Art in England: Beginnings of a New Figuration 1947–63 Kunstverein, Hamburg, 1976

Pop Art: Nieuwe figuratie/Nouveau Réalisme Casino Communal, Knokke-le-Zoute, 1970. Texts by John Russell, Pierre Restany

Pop Art, Nouveau Réalisme Musée des Beaux-Arts, Brussels, 1965

Pop Art USA Oakland Art Museum, 1963. Text by John Coplans

Pop Art USA–UK Odakyu Grand Gallery, Tokyo, 1987. Texts by Lawrence Alloway, Marco Livingstone

Popular Image, The Washington Gallery of Modern Art, Washington, D.C., 1963. Text by Alan Solomon

Price, Cedric 'Fun Palace [Joan Littlewood and Cedric Price], with Frank Newby as consulting engineer and Gordon Pask as systems consultant', *Architectural Review*, January 1965

_____ feature in *Architecture d'Aujourd'hui*, December 1967

Quarmby, Arthur *Plastics and Architecture*, Praeger, New York, 1974

Quattordicesima Triennale di Milano Palazzo dell'Arte al Parco, Milan, 1968

Rancillac, Bernard *Le Regard idéologique*. Éditions Somogy et Guéna, Paris, 2000

Rauschenberg, Robert: The Early 1950s ed. Walter Hopps, The Menil Collection, Houston, 1991

Rauschenberg, Robert: A Retrospective ed. Walter Hopps and Susan Davidson, Solomon R. Guggenheim Museum, New York, 1997

Raysse, Martial Galerie nationale du Jeu de Paume, Paris, 1992

Reichardt, Jasia 'Pop Art and After, *Art International*, 7, February 1963

Restany, Pierre 'Le Nouveau Réalisme à la conquête de New York', *Art International*,

vii, 1, January 1963

_____ *Les Nouveaux Réalistes*, Paris, 1968, revised as *Le Nouveau Réalisme*, Paris, 1978

_____ 'Pop Art, un nouvel humanisme americain', *Aujourd'hui*, 55–56, January 1967

Richardson, John Adkins 'Dada, Camp, and the Mode Called Pop', *The Journal of Aesthetics and Art Criticism*, 24, Summer 1966

Richter, Gerhard Exhibition catalogue and catalogue raisonné, 3 vols, Kunst-und Austellungshalle der Bundesrepublik Deutschland, Bonn/Edition Cantz, Ostfildern, 1993

Rose, Barbara 'The New Realists, Neo-Dada, Le Nouveau Réalisme, Pop Art, the New Vulgarians, Common Object Painting, Know-nothing Genre', *Art International*, vii, 1, January 1963

_____ 'New York Letter: Pop Art Revisited', *Art International*, 6, December 1964

_____ 'ABC Art', *Art in America*, 53, October 1965

Rosenberg, Harold *The Anxious Object: Art Today and Its Audience*, Horizon, New York, 1964

Rosenquist, James. A Retrospective Solomon R. Guggenheim Museum, New York, 2003. Texts by Sarah Bancroft, Walter Hopps

Rotella, Mimmo. Rétrospective Musée d'art moderne et d'art contemporaine, Nice, 1999

Ruscha, Ed *Leave Any Information at the Signal: Writings, Interviews, Bits, Pages*, ed. Alexandra Schwartz, October Books/MIT Press, Cambridge, Massachusetts, 2002

Ruscha, Edward: Catalogue Raisonné of the Paintings. Volume I: 1958–1970 Gagosian Gallery, New York, Los Angeles and London/Steidl Verlag, Göttingen, 2004. Texts by Walter Hopps, Yve-Alain Bois

Russell, John 'Pop Reappraised', *Art in America*, 57, July–August 1969; see also Gablik, Suzi

Ryan, Susan Elizabeth *Robert Indiana. Figures of Speech*, Yale University Press, New Haven, 2000

Sandford, Mariellen R. ed., *Happenings and Other Acts*, Routledge, London and New York, 1995. Includes texts by Claes Oldenburg, Allan Kaprow, Jean-Jacques Lebel, Carolee Schneemann

Sandler, Irving 'New Cool Art', *Art in America*, 53, February 1965

_____ *American Art of the 1960s*, New York, 1988

Schwartz, Barry N. 'Psychedelic Art: The Artist Beyond Dreams', *Arts Magazine*, April 1968

Scott Brown, Denise 'Learning from Pop', *Casabella*, December 1971

Seckler, D.G. 'Folklore of the Banal', *Art in America*, 50, Winter 1962

Self, Colin 'Statement', *Studio International*, September 1967

Colin Self's Colin Selfs Institute of Contemporary Arts, London, 1986

Shapiro, David *Jim Dine: Painting What One Is*, Harry N. Abrams, New York, 1981

Signs of Life: Symbols in the American City cur. Denise Scott Brown in collaboration with Robert Venturi, Steven and Elizabeth Izenour, *et al*., Renwick Gallery, National Collection of Fine Arts, Smithsonian Institution, Washington, D.C., 1976

Sitney, P. Adams *Film Culture Reader*, Praeger, New York, 1970

Sixties Art Scene in London, The ed. David Mellor, Barbican Art Gallery/Phaidon Press, London, 1993

Smith, Jack: Flaming Creature: His Amazing Life and Times ed. Edward Leffingwell, Carole Kismaric, Marvin Heiferman, The Institute for Contemporary Art/PS1 Museum, New York, 1997

Smithson, Alison and Peter *Without Rhetoric: An Architectural Aesthetic*, Latimer New Dimensions, London, 1973

_____ *The Charged Void: Architecture*, Monacelli Press, New York, 2001

Sontag, Susan 'Jack Smith's Flaming Creatures', *The Nation*, 13 April 1964; reprinted in *Against Interpretation*, Farrar, Straus & Giroux, New York, 1966

Spoerri, Daniel 'Tableau-pièges' [December 1960], *Zero*, 3, July 1961

Steinberg, Leo *Other Criteria*, Oxford University Press, 1972

Structures gonflables Musée d'art moderne de la Ville de Paris, 1968

Superstudio *Superarchittetura* [with Archizoom], Pistoia, 1966; Modena, 1967

Sylvester, David 'Art in a Coke Climate', *Sunday Times Magazine*, 26 January 1964

Taylor, Paul ed., *Post-Pop Art*, Giancarlo Politi Editore, Milan/MIT Press, Cambridge, Massachusetts, 1989. Texts by Roland Barthes, Jean Baudrillard, Andreas Huyssen, Dick Hebdige, Dan Graham, David Deitcher, Mary Anne Staniszewski

This is Tomorrow Whitechapel Art Gallery, London, 1956. Texts by Lawrence Alloway, David Lewis, Reyner Banham

This is Tomorrow Today eds. Brian Wallis and Thomas Finkelpearl, The Institute for Contemporary Art/PS1 Museum, New York, 1987

Tillim, Sidney 'Further Observations on the Pop Phenomenon', *Artforum*, 3, November 1965

Times, The Chronicle and The Observer, The ed. Douglas Blau, Kent Fine Art, New York, 1990

Tono, Yoshiaki *The Pop Image of Man*, Mizue, Tokyo, 1971

Tuchman, Phyllis 'Pop! Interviews with George Segal, Andy Warhol, Roy Lichtenstein, James

Rosenquist and Robert Indiana', *ARTnews*, lxxiii, May 1974

Vanderbeek, Stanley 'On Science Friction', *Film Culture*, 22–23, Summer 1961

Venturi, Robert *Complexity and Contradiction in Architecture*, The Museum of Modern Art, New York, 1966

_____ Denise Scott Brown, Steven Izenour *Learning from Las Vegas*, MIT Press, Cambridge, Massachusetts, 1972

Walker, John A. *Cross-overs: Art into Pop/Pop into Art*, Comedia, London, 1987

Warhol, Andy *The Philosophy of Andy Warhol*, Harcourt Brace Jovanovich, New York, 1975

_____ with Paul Hackett, *POPism: The Warhol 60s*, New York, 1980

Warhol, Andy: A Retrospective ed. Kynaston McShine, The Museum of Modern Art, New York, 1989

Warhol, Andy. Catalogue Raisonné Volume 1: Paintings and Sculptures 1961–1963 ed. Georg Frei and Neil Printz, Phaidon Press, London and New York, 2002

Warhol, Andy. Catalogue Raisonné Volume 2: Paintings and Sculptures 1964–1965 ed. Georg Frei and Neil Printz; executive editor Sally King-Nero, Phaidon Press, London and New York, 2003

Warhol, Andy. das zeichnerische Werk 1942–1962 ed. Rainer Crone, Württenbergischer Kunstverein, Stuttgart, 1976

Warhol, Andy. The Late Work ed. Mark Francis, Prestel Verlag, Munich, 2004

Warhol Look, The: Glamour. Style. Fashion eds. Mark Francis and Margery King, Bulfinch, Boston, Massachusetts, 1996

Whiteley, Nigel *Pop Design: Modernism to Mod. Theory and Design in Britain 1955–72*, Design Council, London, 1987

Whiting, Cecile *A Taste for Pop: Pop Art, Gender and Consumer Culture*, Cambridge University Press, 1997

Wolf, Sylvia *Ed Ruscha and Photography*, Whitney Museum of American Art, New York, 2004

Wollen, Peter *Raiding the Icebox: Reflections on Twentieth-Century Culture*, Indiana University Press, Bloomington, 1993

_____ *Signs and Meaning in the Cinema*, Secker & Warburg/British Film Institute, London, 1969

Youngblood, Gene *Expanded Cinema*, Studio Vista, London/E.P. Dutton, New York, 1970

BIBLIOGRAPHY

INDEX

304

PUBLISHER'S ACKNOWLEDGEMENTS

We would like to thank all those who gave their generous permission to reproduce the listed material. Every effort has been made to secure all permissions and the editors and publisher apologize for any inadvertent errors or omissions. If notified, the publisher will endeavour to correct these at the earliest opportunity.

We would like to express our gratitude to all the artists, authors and their representatives who have contributed to the making of this volume; in particular: Sharon Avery-Fahlström, Öyvind Fahlström Archives, Museum of Contemporary Art, Barcelona; Mary Banham, London; Estate of Roland Barthes; Jean Baudrillard, Paris; Gretchen Berg, New York; Françoise Buisson, Centre Georges Pompidou, Paris; Eleanor Bron, London; Benjamin H.D. Buchloh, New York; Jacob Burckhardt, New York; Bruce Conner, San Francisco; Estate of John Coplans; Arthur C. Danto, New York; Umberto Eco, Milan; John Ferry, Estate of R. Buckminster-Fuller, Santa Barbara; Robert Frank, Gagosian Gallery, London, New York and Los Angeles, Maria Gilissen, Brussels; Dan Graham, New York; Richard Hamilton, Henley-on-Thames, England; Simon Herron; Lars Hjelmstedt, University of Uppsala, Sweden; Hans Hollein, Vienna; Dennis Hopper/Alta Light Productions, Los Angeles; Andreas Huyssen, New York; Mike Kelley, Los Angeles; William Klein, Paris; Julie Martin, Estate of Billy Klüver, New York; Greil Marcus; Jonas Mekas, Anthology Film Archives, New York; Laura Mulvey, London; Claes Oldenburg and Coosje van Bruggen, New York; Arthur Quarmby, Yorkshire (West Riding); Gerhard Richter, Cologne; Robert Rosenblum, New York; Ed Ruscha, Los Angeles; Simon Salama-Caro, New York; Sylvia Sleigh; Soraya Smithson, The Smithson Family Collection, Stamford, Lincolnshire; Joe and Jos Tilson, London; Venturi Scott Brown Associates, Los Angeles; Robert Watts Archive, New York; Matt Wrbican, Warhol Archives, The Andy Warhol Museum, Pittsburgh.

We would also like to acknowledge the following individuals and organizations: Sir Kenneth Adam, London; Albright-Knox Gallery, Buffalo, New York; Mitchell Algus Gallery, New York; Thomas Ammann Fine Art, Zurich; Anthology Film Archives, New York; Apple Corps, London; The Estate of Diane Arbus; Arman Studio, New York; ARTnews articles © 1963 & 1964 ARTnews, LLC, reprinted by permission of the publisher; David Bailey, Camera Eye Ltd, London; Becht Collection, Naarden, The Netherlands; The Boyle Family, London; Andrea Branzi, Milan; British Film Institute, London; The Estate of Rudy Burckhardt/Tibor de Nagy Gallery, New York; Canyon Cinema, San Francisco; Centre Canadien d'Architecture, Montreal; Centro de Arte Moderna, Fundação Calouste Gulbenkian, Lisbon; Christie's Images Ltd, London; 'The Rolling Stones' © 1965 Nik Cohn, reprinted by permission of International Creative Management Inc.; Magda Cordell-McHale, Buffalo, New York; Corita Art Center, Immaculate Heart Community, Los Angeles; Dennis Crompton, Archigram Archives, London. All Walt Disney Imagineering images, Walt Disney Imagineering Collection, Glendale, California © Disney Enterprises, Inc.; Disney characters © Disney Enterprises, Inc. Used by permission from Disney Enterprises, Inc. Documentation générale du Musée national d'art moderne, Centre Georges Pompidou, Paris; Friedrich Christian Flick Collection. All works by Robert Frank © Robert Frank. Fraenkel Gallery, San Francisco; Fredericks Fraser Gallery, New York; Galleria Civica d'Arte Moderna, Turin; David Geffen, Los Angeles; Howard Green Gallery, New York; Solomon R. Guggenheim Museum, New York; Hamburger Kunsthalle, Hamburg; Hirshhorn Museum and Sculpture Garden, Smithsonian Institution, Washington, D.C.; Hood Museum of Art, Dartmouth College, Hanover, New Hampshire; Indianapolis Museum of Art; IVAM; Instituto Valenciano de Arte Moderno, Valencia; Estate of Ray Johnson/Richard L. Feigen & Co., New York; 'In the Galleries: Roy Lichtenstein', 'Claes Oldenburg' © Judd Foundation/Licensed by VAGA, New York, NY; Edward Kienholz Estate/L.A. Louver Gallery, Venice, California; Michael Kohn Gallery, Los Angeles; Kunsthalle, Tübingen, Germany; Kunstmuseum, Basel; Yayoi Kusama, Tokyo; Ludwig Forum für Internationale Kunst, Aachen; Los Angeles County Museum of Art; Louisiana Museum of Modern Art, Humlebaek, Denmark; Jonathan Louwrie, London; The Estate of Ian MacDonald; Mayor Gallery, London; The Menil Collection, Houston; Robert Miller Gallery, New York; Moderna Museet, Stockholm; Musée d'art contemporain, Val de Marne/Vitry, France; Museum of Contemporary Art, Chicago; Museum Ludwig, Cologne; The Museum of Modern Art, New York; Museum Moderner Kunst Stiftung Ludwig, Vienna; Museum für Moderne Kunst, Frankfurt am Main; Musée national d'art moderne, Centre Georges Pompidou, Paris; Museum Tinguely, Basel; National Gallery of Art, Washington, D.C.; National Gallery of Canada, Ottawa; National Museum of Wales, Cardiff; S.I. Newhouse, Jr; Norfolk Contemporary Art Society/Norwich Castle Museum and Art Gallery, Norwich, Norfolk; Orange County Museum of Art, Newport Beach, California; PaceMacGill Gallery, New York; Philadelphia Museum of Art; Royal Institute of British Architects, London; RIBA Drawings Collection, Victoria & Albert Museum, London; Sammlung Frieder Burda; San Francisco Museum of Modern Art; Carolee Schneeman, New York; Kurt Schwitters Archiv, Sprengel Museum, Hannover; Sintra Museu de Arte Moderna, Sintra, Portugal; Stadt Köln, Rheinisches Bildarchiv, Cologne; Stedelijk Museum, Amsterdam; 'Notes on Camp' © 1964, 1966, renewed 1994 by Susan Sontag, reprinted by permission of Farrar, Straus and Girous, LLC and The Random House Group Ltd; Tate, London; Galerie Daniel Varenne, Geneva; Victoria & Albert Museum, London; Virginia Museum of Fine Arts, Richmond; Yale University Art Gallery, New Haven; Walker Art Center, Minneapolis; The Andy Warhol Foundation, New York; The Andy Warhol Museum, Pittsburgh; Whitford Fine Art, London; Whitney Museum of American Art, New York; William S. Wilson, New York; 'Las Vegas [What?]' © 1965, renewed 1993 by Tom Wolfe, reprinted by permission of Farrar, Straus and Giroux, LLC; and those private collectors who wish to remain anonymous.

PHOTOGRAPHERS

Albright-Knox Art Gallery: p. 119; © Photo CNAC/MNAM Dist. RMN/© Christian Bahier/Philippe Miegeat: p. 143; Martin Bühler/Kunstmuseum, Basel: p. 65; Poul Buchard/Strüwing: p. 135; Rudy Burckhardt: pp. 108–9; 158–9 [print Jacob Burckhardt, 2004]; 161; 162–3; Prudence Cumming Associates, London: p. 125; Susan Einstein: p. 78; Allan Finkelman: p. 155 [bottom]; David Gahr: p. 70 [right]; Geoffrey Clements: p. 82 [bottom]; Sheldon C. Collins, Jnr: p. 143 [bottom]; © 1960 Allegra Fuller Snyder, courtesy Buckminster Fuller Institute, Santa Barbara, California: p. 115; Hans Hammarskiöld/Tiofoto AB, Stockholm: p. 4; Richard Hamilton: p. 19 [left; centre]; Martha Holmes/Time & Life, Inc.: p. 81; James Isberner: p. 131 [bottom]; Robert R. McElroy: pp. 80, 83; Norman McGrath: p. 177; Ian McMillan: p. 182; © Photo CNAC/MNAM Dist. RMN/© Philippe Miegeat: p. 107; © Photo SCALA, Florence/Museum of Modern Art, New York 2004: pp. 52; 124; 158–9; Billy Name-Linich, New York: pp. 29; 164; National Gallery of Canada: p. 140; Kevin Noble, p. 54; John R. Pantlin [prints RIBA Photograph Library]: Eric Pollitzer: p. 134 [top]; p. 56; Reiner Ruthenbeck: p. 134 [bottom]; Steven Sloman: p. 141; Studio Hollein/Arch. Sina Baniahmad: p. 114 [top; middle]; Rheinische Bildarchiv, Cologne: p. 168; © Photo CNAC/MNAM Dist. RMN/© Adam Rzepka: p. 82 [top]; Axel Schneider, Frankfurt: p. 150; Ed van der Elsken: p. 106; Robert Watts Studio Archive, New York: p. 126; © The Estate of Gary Winogrand, courtesy Fraenkel Gallery, San Francisco: p. 147

AUTHOR'S ACKNOWLEDGEMENTS

Many thanks first to my friend and collaborator on this project Hal Foster, and to our editor Ian Farr, whose sympathy for the subject made the process a great pleasure. Ian's wider editorial role at Phaidon has been taken on in recent months by Tamsin Perrett, who has very successfully brought this project to completion. Editorial assistance and caption writing was kindly provided by Kathleen Madden and Aaron Moulton. I much appreciate the tireless work done by Adam Hooper, designer, and Bill Jones, production controller at Phaidon.

Much of the research is common to the catalogue for 'Les Années Pop' which I edited for MNAM, Centre Georges Pompidou, Paris in 2001; I thank my colleagues there for their contributions which survive into the present volume: Catherine Grenier, Jean-Michel Bouhours, Chantal Beret, Susan Morgan, Martin Bethenod, Françoise Marquet, Françoise Buisson, Valérie Séguéla and Isabelle Merly. Cristina Colomar is, as always, a constant support.

My consideration of Pop in its various forms is especially indebted to Matt Braddock, Dan Graham, Richard Hamilton and Rita Donagh, Walter Hopps, Fred Hughes, Claes Oldenburg and Coosje van Bruggen, and Peter Wollen. My early enthusiasm for the subject has not diminished but been enriched by later conversations with John Cale, Marianne Faithfull, and Patti Smith. As ever, the book is dedicated to Sheena, Queen of the Jungle.

Mark Francis
London, 2005

The development of modern and contemporary art has been dominated by fundamental, revolutionary movements and recurring themes. The Themes and Movements series is the first fully to examine twentieth-century and recent art by combining expert narrative, key works and original documents. Each book is introduced by a comprehensive Survey from a distinguished scholar who provides a thorough analysis of the theme or movement. The second section is dedicated to numerous illustrations of the Works themselves. This selection of key images is accompanied by extended captions which describe the principal ideas, processes and contexts underlying each artwork. Finally, with the Documents section, the series also offers direct access to the voice of the artist and to primary texts by critics, historians, curators, philosophers and theorists. A unique archive of the innovations, discourses and controversies that have shaped art today, these books are as exhaustive as a full-scale museum overview, presenting many of the most significant works of art associated with a particular tendency.